An Ambelling Cobler.

IRELAND'S PAINTERS

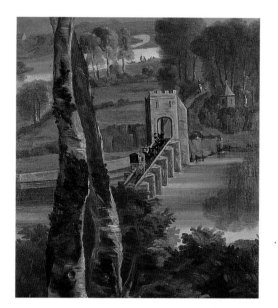

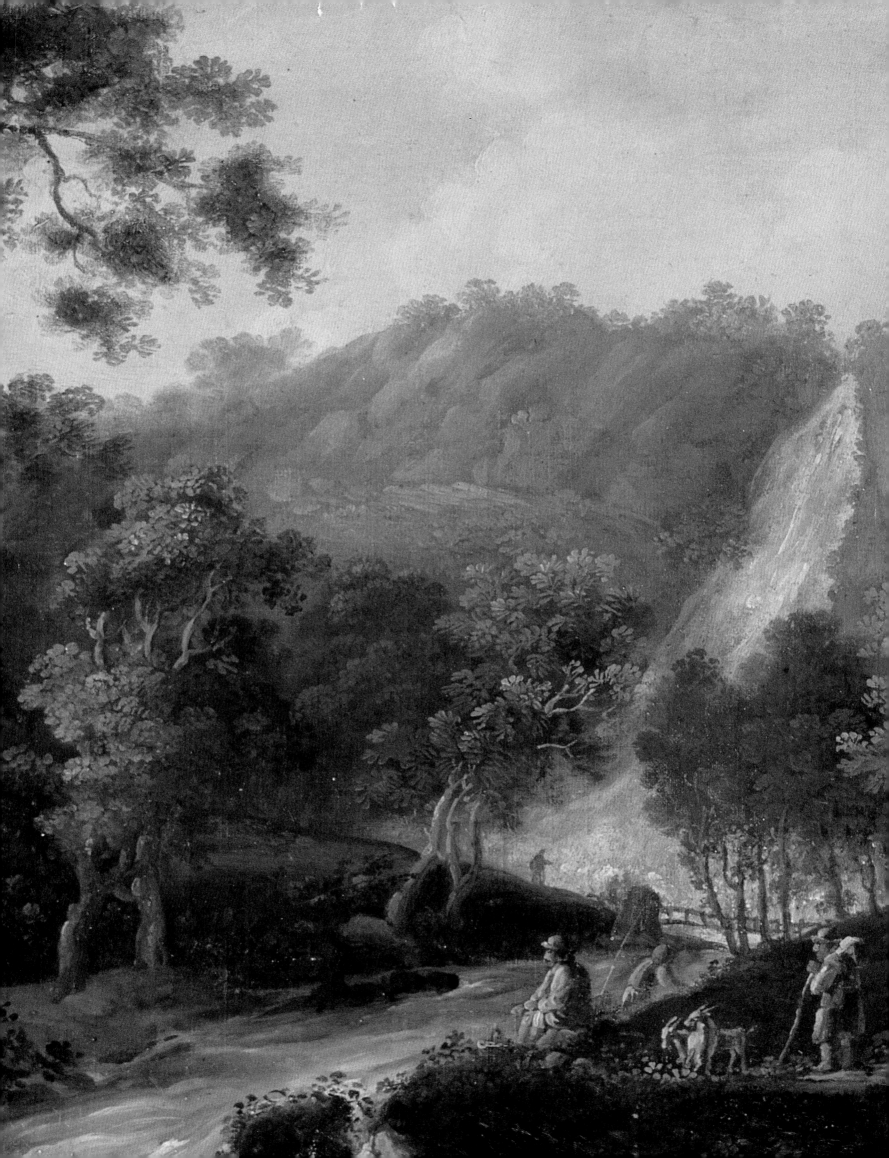

IRELAND'S PAINTERS

1600—1940

Anne Crookshank and the Knight of Glin

Published for
the Paul Mellon Centre for Studies in British Art
by Yale University Press, New Haven & London

Dedicated to John Williams alias Anthony Pasquin and again to W.G. Strickland, our predecessors.

Designed by Ruth Applin
Typeset in Van Dijck by Northern Phototypesetting Co. Ltd, Bolton and printed in Singapore

Library of Congress Cataloguing-in-Publication Data

Crookshank, Anne.
Ireland's painters / Anne Crookshank and the Knight of Glin.
p. cm.
Includes bibliographical references and index.
ISBN 0-300-09765-4
1. Painting, Irish. I. Knight of Glin, 1937—II. Title.
ND485 .C759 2002
759.2'915—dc21
2002004497

Half-title page
Detail of the Bridge to Enniskillen, from *Florencecourt view*, *c.*1765, by an anonymous artist,
National Trust for Northern Ireland, Florencecourt

Frontispiece
John Henry Campbell, *Powerscourt Waterfall*, detail of Fig. 260

Title page
*Silver Ticket for the Society of Artists, Dublin, William Street, c.*1765, Private collection

Endpapers
Hugh Douglas Hamilton, *Cries of Dublin, Drawn from The Life*, 1760, Private collection.
Courtesy of Pyms Gallery, London

Contents

Acknowledgements

A number of key people have helped in many ways to assemble this book. We are ever grateful to Brian Burns and Chryss O'Reilly for the vitally important financial assistance which has helped in employing research assistants and commissioning photographs. Further financial help for which many thanks are given was also provided by the Institute of Irish Studies.

Our research assistants were Brendan Rooney, before he went to the National Gallery of Ireland, and Eve McAulay. Between them they tried to keep us out of chaos as well as checking, finding and researching material and above all soothing our fevered brows. Without them we would never have finished. Mary Reade of Christie's with her patience and wit has kept us sane and Eithne Kavanagh ensured our correspondence was in order. Olda FitzGerald kindly put up with us doing this project. Elizabeth Mayes, Nicola Figgis, Brendan Rooney, Julian Campbell and Jane Fenlon all read sections of or the whole manuscript at different stages. The History of Art Department at TCD has been a marvellous support particularly Edward McParland who, apart from his learned comments, learnt to cook for us at the time of our first book and has kept us fed frequently ever since. Professor Roger Stalley helped with the medieval material and Brendan Dempsey was invaluable over photography. Nicola Figgis of UCD discussed many a point with us. Dr Síghle Bhreathnach-Lynch, curator of the Irish collection at the NGI, has been most helpful as has Hilary Pyle, the Yeats curator in the Gallery, and Fionnuala Croke, the exhibitions curator. The photographic departments of the NGI, UM, the Hugh Lane Gallery and TCD have shown great patience and given much help.

Carmel Naughton, former Chairman of the Board of Governors of the NGI and David Spearman, one of the governors, both gave their aid in various vital ways. Jane Fenlon assisted with the sixteenth and seventeenth centuries and Toby Barnard of Hertford College, Oxford has been extraordinarily generous with information on manuscript sources for Ireland's seventeenth- and eighteenth-century material culture. Likewise, Peter Murray, Director of the Crawford Municipal Art Gallery, Cork has both supplied information and taken photographs. Christopher Foley of Lane Fine Arts has taken a most useful benign interest throughout. Alan and Mary Hobart of Pym's Gallery, who are particularly concerned with Irish painting, have provided many beautiful transparencies. Christopher Gibbs, an old friend, and Philip Mould of Historical Portraits have been of signal help. William Laffan assembled the bibliography and provided many useful references.

This is also an opportunity to thank Jimmy and Therese Gorry of the Gorry Gallery in Dublin for their endless support. Robert and Sheelagh Goff and the late Cynthia O'Connor have always taken a keen interest. David Britton and Karen Reihill of the Frederick Gallery, Christopher Ashe of the Wellesley Ashe Gallery and Val Dillon have all shown great enthusiasm for the project. Jane Cunningham, Melanie Blake and the staff at the Courtauld Institute's Photographic Survey made trips to Ireland for photography and also nobly took many a picture in London and in remote areas of Great Britain. The auction houses, Christie's and Sotheby's, have been enormously generous in locating and providing photographs. Particular thanks go to Nick White and Bernard Williams of Christie's. Mention should also be made of the help from Bonhams.

Alistair Laing of the National Trust and Peter Marlowe in the National Trust of Northern Ireland have been very kind over photographs and new information.

Thanks must also go to all the collectors and owners who have allowed their pictures to be photographed and used as illustrations. Sadly for security reasons their names cannot be mentioned. Without them this book would not exist.

We cannot thank Yale University Press enough, John Nicoll, Sally Salvesen and Ruth Applin have shown

remarkable understanding of the authors and their problems. We have never met a publisher of such forebearance and helpfulness.

We also want to thank the Mellon Centre's librarians; the TCD librarians, especially Charles Benson, and the Witt Library of the Courtauld Institute of Art, especially John Sutherland.

Above all we must thank Brian Allen, Director of the Paul Mellon Centre for Studies in British Art, for his support and faith in the project from the beginning, and for the generosity of the Centre in its financial help for the book's publication.

As we have been writing this book over many years we fear our memories may have played us false and that we have left out a number of our kind friends and helpers. We apologise for this. We list those we remember: Philip MacEvansoneya, D.M. Beaumont, Charles Benson, Elizabeth Kirwan, Marie Louise Legg, Jane Meredith, Petra Coffey, Professor Michael McCarthy, Catherine Marshall, Mia Craig, Mary Bryan, Colette O'Dalaigh, Tovee O'Flanagan, Christopher Moore, David Griffin, Michael Wynne, Homan Potterton, David White, Kevin B. Nowlan, Valerie Pakenham, Grania McCardle, Joe MacDonnell, John and Eileen Harris, Richard Wood, Eileen Black, S. Brian Kennedy, Ronald and Mary Lightbown, Helen Moss, Bruce Arnold, Robert Towers, Kevin Whelan, Mary Kelleher, Christine Casey, W.E. Vaughan, Nicola Gordon Bowe, Rosemarie Mulcahy, Chris and Paul Johnson, Patrick Brown, Eamonn McEneanny, James O'Halloran, Eamonn Mallie, Ruth Sheehy, Andrew Bonar Law, Professor John Turpin, Frances Bailey, John Cornforth, Dean Robert McCarthy, Deborah Brown, Aidan Boyle, Simon Dickinson, David Ker, John Belmore, Alec and Hugh Cobbe, A.C. Elias Jr, Tim Knox, Carol Acton, Martyn Gregory, George Gordon, Richard Green, Lowell Lipson, Charlotte Grant, Bruce Webber of Berry-Hill Galleries, New York, Lady Roberts, Paul Sherwin, Bill Drummond, Aidan O'Boyle, Raymond Keaveney, Sergio Benedetti, Isobel Briggs, and the late Judge Francis Murnaghan of Baltimore and his wife Diana.

List of Abbreviations

BL	British Library
BM	British Museum
DS	Dublin Society
HMC	Historical Manuscripts Commission
NGI	National Gallery of Ireland
NG	London National Gallery, London
NPG	National Portrait Gallery, London
NT	National Trust
NTNI	National Trust for Northern Ireland
OPW	Office of Public Works
UCD	University College Dublin
TCD	Trinity College Dublin
PRONI	Public Record Office of the North of Ireland
RA	Royal Academy, London
RDS	Royal Dublin Society
RHA	Royal Hibernian Academy
RIA	Royal Irish Academy
UM	Ulster Museum
V & A	Victoria and Albert Museum, London
Hugh Lane Gallery	Hugh Lane Municipal Gallery of Modern Art, Dublin
Crawford Art Gallery	Crawford Municipal Art Gallery, Cork

We do not cite Pasquin, Strickland, Snoddy, and not always *The Painters of Ireland*, *Watercolours of Ireland* or *Irish Portraits*. The first three are dictionaries and the last three contain many illustrations mentioned in this book.

Introduction

Well over twenty years has elapsed since the publication of *The Painters of Ireland* in 1978, and since then a great deal of new material has been published by colleagues and students, all friends. As a result we felt we should pool these resources and our own work into one volume and seek out more and often unknown illustrative material. It is surprising that new artists still appear on the horizon and new ground is constantly being broken. However those with good memories will find some paragraphs little changed from the earlier book and we make no excuse for this, as the old paragraphs still seemed to hold up. Neither have we tried to suggest that there was an Irish School. The applied arts, furniture, silver, plasterwork and book binding, have features which are individual to Ireland, while painting is essentially in the European tradition.

The journal, *The Irish Arts Review*, founded by Brian de Breffni in 1984, later becoming an annual, has encouraged many to write for its well illustrated pages. In many cases research done in the Art History departments of Trinity College, University College and the National College of Art and Design has been first published in it. The research for the recently produced National Gallery catalogue of their holdings of eighteenth-century Irish paintings, took place almost concurrently with our research, and its two authors, Nicola Figgis and Brendan Rooney, together with ourselves, worked in tandem and threw many a morsel into the melting pot. Their work and ours overlaps at many points.

Another factor that encouraged us was the growing prosperity of our country over the last decade or so which has seen the burgeoning interest in collecting Irish paintings and other works of art. Hence many pictures began to surface in the sale rooms and dealers of London, Dublin and New York and these are being brought back to Ireland after their long sojourns abroad. It is also true that the prejudice against the art of colonial Ireland with its 'Ascendency' connotations is regarded now with less of a stigma than in former days. Pride in the work of Irish artists is beginning to develop and it is seen that the subject is part of Ireland's history and also that it is not merely a tiny off-shoot of English art, but also influenced by Italy and France, not to mention the Low Countries.

This book is written in the same vein as *The Painters of Ireland* and as we said then we have attempted to write a simple, chronological account of the history and development of Irish painting. Our new book could be described, as the old was in the bibliography of the new edition of Ellis Waterhouse's *Painting in Britain 1530–1790*, 'A general survey on traditional lines'. This is not because of any objections to the New Art History, but because we do not think this type of analysis can be attempted until a reasonable foundation of knowledge has been assembled. You need to know who the artists were, the society in which they lived and the patrons who bought their work. Irish history is not only hugely complex but also difficult to see behind the art of any period because of its wars, rebellions, violence, political undertones and even language problems. Until well into the nineteenth century the majority of Irish people owned no property and spoke only Irish. The artistic world was obviously largely made up of the upper and increasing middle classes.

The great period of Celtic art was of course the very early middle ages and everyone is familiar with its gold ornaments and the superb illustrated manuscripts of which the Book of Kells (*c*.800) is such an outstanding example. However, illustrated manuscripts[1] continued to be created with less brilliance in the later centuries. Architecture only began to develop fully after the Norman conquest at the end of the twelfth century. Many secular and religious buildings were decorated with wall paintings of which little survives, but panel paintings, except for one mention of an imported altarpiece in Athenry in Co. Galway,[2] are unknown until the sixteenth century.

This century saw first the destruction of the monasteries by Henry VIII; the sad religious divide

between Catholics and Protestants; and the Elizabethan conquest of the whole of the island of Ireland, completed in James I's reign. But one new artistic feature was that the major Hiberno-Norman families like the Butlers and FitzGeralds together with great Gaelic houses such as the O'Briens began to have their portraits painted and this fashion developed fairly rapidly in the next century.

Despite a short first chapter summarising the meagre evidence of the sixteenth and early seventeenth century our subject only starts to blossom after the restoration of Charles II in 1660 and the Lord Lieutenancy of James Butler, first Duke of Ormonde and his cousin and wife, Elizabeth Preston. The extraordinary grandeur shown in the furnishing and decoration of Kilkenny Castle is an indication of what happened in those peaceful years before the Williamite wars. A contemporary visitor was the eccentric London bookseller, John Dunton, who described the scene in Kilkenny in 1698:

> … the room where the Duke of Ormond dines, it was high-roofed, very large, and hung all around with gilded leather … the plate for the dinner was not less remarkable; there were three silver tankards embellished with curious figures, and so very large, … we ascended two pairs of stairs which brought us into a noble gallery, which for length, variety of gilded chairs, and curious pictures which adorn it, has no equal in the three kingdoms, and perhaps not in Europe.[3]

This last sentence is certainly hyperbole, but the writer goes on to describe the family portraits and continues to enthuse on the other pictures in an amusing and quaint fashion. The material world of the Ormondes has been recently intensely studied by a number of scholars.[4]

At the same time as this ducal magnificence amazed the viewers at Kilkenny, Dublin Castle and later at Kilmainham Hospital, founded by the Duke, many of the Old English and Gaelic Irish lived in a more primitive manner in their tower houses and later additions. They were more interested in their cattle, weapons and occasional pieces of plate rather than painting, though tapestries appear frequently in inventories from the sixteenth century to early in the eighteenth. However, many interiors, with their carved stone chimney pieces, were in fact more habitable than is sometimes thought. New settlers like the great Earl of Cork (d. 1643) built and rebuilt eight or nine houses and castles during the same period but few pictures are mentioned in his diaries, or his accounts or inventories and not a single definite portrait of the Earl survives. However, the art of portraiture was almost commonplace by the end of the seventeenth century due to the competence, and at times real mastery, of the first Irish born painter Garret Morphy, and his contemporary emigré Englishman, Thomas Pooley. The greatest painter resident in Ireland of that period who visited this country

for a few years was the Scotsman, John Michael Wright, whose portrait of a Highland chief Dunton noticed. His enchanting picture of the Talbot girls (NGI) is probably the finest portrait painted in Ireland in the seventeenth century. Rather later, the most important portrait painter of the first half of the eighteenth century was James Latham, sadly an artist completely unknown outside Ireland, and one who should be in all the books on British art. There were many other minor men but very rarely are they mentioned in documents, letters etc. The social position of the painter is indicated by the case of Archbishop King in the early eighteenth century, who as a young Fellow in Trinity College, Dublin, had his portrait painted as a gift for Sir Hans Sloane. Over a period of two to three years he corresponded with a London friend on every detail concerning the picture – who visited him in the studio when he was sitting, how the painting should be packed, how it should be shipped etc. – but only as a postscript to one of the last letters[5] does he bother to mention the artist's name, Ralph Holland, a little-known artist.

Portraits were of prime importance and families tended to keep these symbols of respectability even after they sold their family house. For instance, in Sheridan's *The Rivals*, Sir Lucius O'Trigger, an impoverished Irish braggart, says to his friend Acres in Bath, a vastly popular resort for the Irish:

> If I had a Blunderbuss Hall here I would show you a range of ancestry in the O'Trigger line, that would furnish the new room; and everyone of whom had killed his man! For though the mansion-house and dirty acres have slipped through my fingers, I thank Heaven our honour and the family-pictures are as fresh as ever.[6]

Though portraits remain right up to the present day a very important aspect of Irish art, landscape emerges towards the middle of the eighteenth century, in many cases as a complement of the family portraits, as showing the scenery around their newly built houses and their newly created landscape parks. It also shows an appreciation of nature, such as is seen in the Dargle gorge and Powerscourt waterfall, and of course the lakes and mountains of Killarney. George Barret, Thomas Roberts and William Ashford are among the finest proponents of Ireland's scenery, and can hold their own with most landscape painting in England and on the Continent at this time, particularly in the case of Thomas Roberts's delicate skills.

Patronage for subject pictures was, as in England, mostly kept to collecting the work of continental artists, many in the form of copies. Few artists seem to have succeeded in this genre. *The Continence of Scipio* (NGI), the one known work of Henry Brooke, is the only history picture we know from the eighteenth century. In the nineteenth century the situation changes, as do the subjects. In the exhibition catalogues, genre and religious subjects were regularly

shown. The grander traditional titles are painted largely by Irish painters in England, such as Danby and Maclise. The recurrent theme of the emigré Irish artist is as familiar now as it was from the seventeenth century onwards. Today more remain at home, but the most famous tend to make their names abroad.

William Preston, an enlightened essayist, remarked on this sad state of artistic affairs in 1796 when bewailing the prodigality and pretensions of the upper classes. He wrote:

> Meanwhile, the arts are little cultivated; such artists and men of genius as the country produces (notwithstanding the countenance of a few, who hold out, a bright example, but in vain to the men of rank and fortune, in *Ireland*) are driven, by the meagre encouragement, which their native soil affords, to emigrate, for daily bread. – Even those arts, which minister to the more refined pleasures, and elegant luxuries; how low, how deplorable an end, are they among us![7]

At roughly the same time, 1790, Joseph Cooper Walker, who had a keen interest in the arts and was a member of the Dublin Society, inspected their Schools and found them in disarray:

> unadorned by a single busto or picture of merit, to the model room; here I found a few mutulated casts huddled together; ... I had thought the room had more the appearance of a sepulchre or charnel house, than an apartment appropriated to the study of one of the most useful and elegant of the fine arts.[8]

He wrote a short summary of how a school of art should be run, what it should cost and how it should be housed, including a library.[9] He also followed Barry in considering that subject pictures were of the first importance in the students' training and he made a list of suitable Irish subjects from the legend of Cuchulain, the Battle of Clontarf and other historical subjects, including the nearly contemporary death of the harpist Carolan.

It was a major tragedy that the Academy and School of Painting, which was planned under the patronage of the Duke of Rutland, the Lord Lieutenant, was set aside when the Duke unexpectedly died in 1787. The Flemish artist, Peter de Gree (see chapter 11) was nominated Keeper and a National Gallery was to be erected and works of art purchased for the use of the students and for the benefit of the public. This was to have been run in tandem with the Dublin Society's Schools and would have added great impetus to Ireland's artistic life.[10]

The Act of Union of 1801 considerably diminished the patronage, such as it was, of the Irish nobility and gentry. Dublin was no longer a capital city, houses were closed down and London became the centre of the political world and of high society. In Dublin the Castle, the Viceregal court and the military put up a brave but sham show in emulation of London with its royal courts in Buckingham Palace and Windsor. The middle classes, who took over the town houses but had not the money to buy pictures, were interested in painting as exhibitions were held by various societies from 1800 and from 1826 in the newly founded Royal Hibernian Academy. The Royal Irish Institution, founded in 1813, held exhibitions of loans largely of old masters borrowed from the collections of the remaining aristocracy who had retired to the country. After 1852 the Irish industrial exhibitions held in Cork, as well as in Dublin a year later, included art exhibitions as part of their display. Even revolutionary movements such as the Young Irelanders had an interest in art as Thomas Davis,[11] their founder, even wrote an essay on the creation of a 'National Art'; first published in the magazines *The Nation* and *The Irish Monthly Magazine*. He complained about the state of the Royal Dublin Society Schools, and bewailed the fact that the superb casts supervised by Canova were in a garret in Cork. He also complained of the lack of a national gallery, but praised the work of the Irish Art Union and the Repeal Association. He was eager to encourage scenes of Irish everyday life such as fairs, wakes, the chapel and the hurling ground. In vain he tried to encourage Frederick William Burton to represent these genre scenes.[12] Daniel O'Connell, who looms so large on the political and religious scene, was painted and sculpted as an icon of the time and is one of the first to be depicted with a round tower, an Irish wolf hound, as well as shamrock – representing him as an Irish chieftain – the O'Connells of Derrynane were a very ancient Kerry family.

Lists of exhibited pictures show that portraits, landscapes, religious, and subject pictures were exhibited at the RHA and elsewhere, but, apart from portraits, it is amazing how few of them can now be identified. The portrait painters were the only artists who made any sort of living. It was only those Irish artists who lived in England who made a good living, men like Maclise, Danby and the sculptor Foley. Even then, they could be poor enough. James Arthur O'Connor left his family in dire poverty despite the popularity of his pictures today.

Much of the reason for the lack of patronage was the political situation, which as a result of the great famine, 1845–50, was dire for the landlords, and disastrous for the poor. It is estimated that one million people died and other millions emigrated to America and elsewhere. The country still has a population of only about half what it was in 1845, when the famine began.

The great literary renaissance at the end of the century saw a smaller, but still important, revival of painting. However, as George Moore pointed out, very few people went to the National Gallery and this situation continued until well into the 1950s, as the authors can confirm. Moore amusingly wrote (if in a jaundiced manner) in 1905 that the 'National Gallery is the most perfect image of the Sahara that I know.

Now and then one sees a human being hurry by like a Bedouin on the horizon … no one goes there except when it rains.'[13] He obviously failed to notice George Bernard Shaw who was a constant visitor and bequeathed a third of his fortune to the Gallery as thanks for the influence it had on him.

In our earlier book we took the story up to about 1920 and the early work of Yeats. This time we have ventured to the 1940s, and include a suggestion of how Irish art develops after that period. However, much has been written by Dorothy Walker and others, such as S. Brian Kennedy, Kenneth McConkey and Theo Snoddy, who took on the tremendous task of bringing Strickland's *Dictionary of Irish Artists* up to date. These writers have expertly considered the last fifty years so we only attempt to provide a foundation for further discussion, investigation and interpretation. When we published *The Painters of Ireland* some critics commented on our conversational style and many people ask how we collaborate. Indeed it is by conversation, as we discuss each sentence and compare it together. We hope that this book will be as successful as our last in encouraging further research in a field hardly considered, except by Strickland, before we began our long voyage.

Anne Crookshank
Knight of Glin
Trinity College, Dublin, 2002

Beginnings in the Sixteenth and Early Seventeenth Centuries

Painting in medieval Ireland was largely concerned with the brilliant art of illumination, from the great early Celtic manuscripts like the *Book of Durrow* and the *Book of Kells* through to the sixteenth century and the Dissolution of the Monasteries under Henry VIII. Wall painting, of which little survives, existed in religious and secular buildings. Some religious paintings, probably including a Last Supper, have been found in a tower house, Ardamullivan, near Galway, of around 1500,[1] and in others, such as Urlan Castle, Co. Clare,[2] hunting scenes survive, though in very fragmentary condition. Panel paintings are recorded in early accounts such as the late medieval Register of Athenry, and in 1423 William Butler and his wife are recorded as bringing back from Flanders a picture of the death and burial of the Virgin, bought for 40 marks, for the Dominican Friary of Athenry after it was burnt.[3]

The churches and monasteries[4] had hunting as well as religious scenes. Recently, the paintings found in the Abbey Church on Clare Island, Co. Mayo have been restored to reveal a hunting scene on the vault with a striking image of a gallowglass (mercenary soldier) in chainmail on horseback on the wall below (Figs 1 and 2). At the mother house of Abbey Knockmoy in East Galway, there are murals depicting subjects such as the martyrdom of St Sebastian. Other spirited archers decorate the north transept of Holycross, Co. Tipperary. The churches would have been very colourful, with much of their architectural detailing being painted and their woodwork in the form of polychromed statues, screens, and crucifixes. The floors would have been laid with colourful tiles. There is no record of any altarpiece in the second half of the fifteenth century in the diocese of Dublin, which was by far the richest area in the country, though inventories list quantities of vestments, plate, missals and other ecclesiastical furnishings, many in expensive materials such as silk and silver gilt. Only three images, presumably statues, are mentioned: one of St Catherine and two of the Virgin Mary.[5]

The greatest surviving example of medieval mural painting is in Cormac's chapel at Cashel and, though little remains on the ceiling, it has recently been identified as a Nativity Cycle, with emphasis on the Magi due to the royal status of the chapel. The paint on the sculpted heads is nearly complete. Originally, the chapel would have been ablaze with colour as scientific analysis has revealed that sophisticated paints were used.[6]

Of portraiture outside funerary effigies we also know nothing and the earliest known portraits of Irish persons were carried out in England. For instance, a magnificent Holbein drawing (Fig. 3) has recently been identified as being of James Butler, later ninth Earl of Ormond (d. 1546).[7] A fine, delicate portrait exists of *The Fair Geraldine* (NGI), daughter of Garret Oge FitzGerald, ninth Earl of Kildare, who was himself painted in 1530, aged forty-three, in the Anglo-German manner.[8] 'The Fair Geraldine's' brother, Gerald FitzGerald, the eleventh Earl (1525–85), who was known as the 'Wizard Earl', was painted in gilt etched Italian armour, probably during the reign of Queen Mary and by an artist from the Spanish Netherlands.[9] A portrait of 'Black Tom', Thomas Butler, tenth Earl of Ormond (d. 1614), attributed to Steven van der Meulen (*fl.*1543–68), is in the National Gallery of Ireland (Fig. 4).[10] They are the first of a series of Geraldine (FitzGerald) and Butler earls, none of which appears to us as being painted in Ireland, until we reach the seventeenth century. The breakup and decline of the great Hiberno-Norman houses and such Gaelic families as the O'Briens between the eighteenth and twentieth centuries has resulted in the scattering of these very important portrait collections.

In the later part of the sixteenth century, a few of the new English families brought portraits with them, an example being that of Sir Anthony Colclough (Dúchas Heritage Service), a wily Elizabethan soldier whose family settled in Tintern Abbey, Co. Wexford.

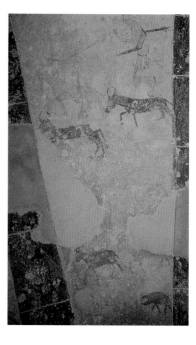

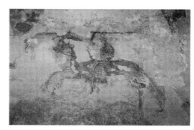

1 Anonymous, *Hunting Scene*, fresco, The Abbey Church, Clare Island, Co. Mayo

2 Detail of an armed warrior, fresco, The Abbey Church, Clare Island, Co. Mayo

3 Hans Holbein, *The ninth Earl of Ormonde, c.*1537, drawing, The Royal Collection

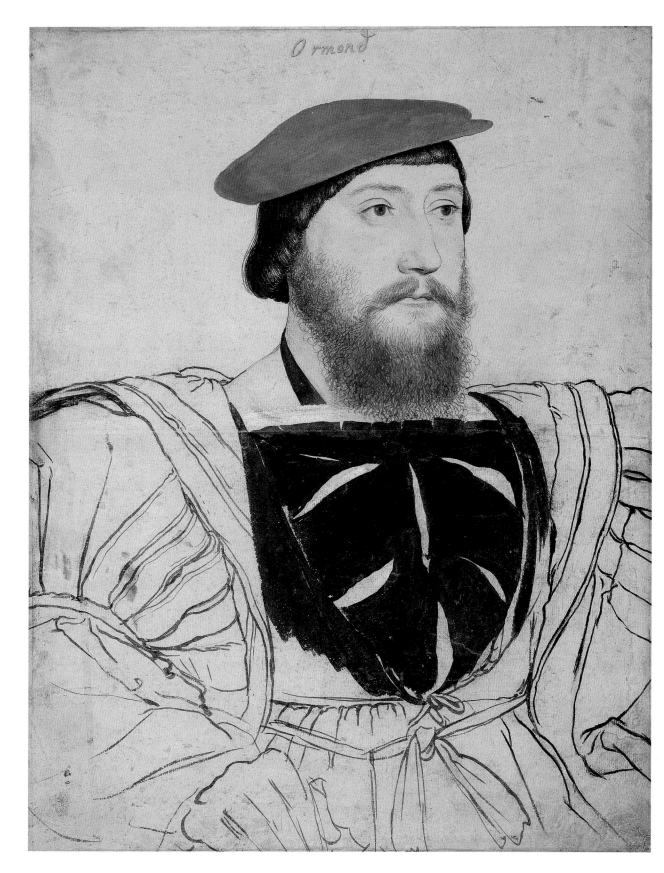

A further complication is that, of the remaining six-teenth- and early seventeenth-century pictures, a large number are copies, or else were painted when the sitter was abroad. The latter is true of the more famous historical figures, such as the great Hugh O'Neill, second Earl of Tyrone (of which no certain portrait exists but several putative examples are in private collections), Donal O'Sullivan Beare (Maynooth College)[11] and churchmen such as Luke Wadding (NGI). Six versions of the portrait of Adam Loftus, Lord Chancellor and first Provost of Trinity College, Dublin, exist in Trinity College alone, and only one may date from Loftus's lifetime. It is also true that the portraits of the 'Old Countess of Desmond' are not even likenesses of herself, but are usually ver-sions of Rembrandt's supposed painting of his mother.

4 Attributed to Steven van der Meulen, *Thomas Butler, tenth Earl of Ormonde (Black Tom)*, oil on canvas, National Gallery of Ireland, Dublin

The most famous icon of an English Elizabethan soldier in Ireland is Marcus Gheeraerts the Younger's whole-length portrait of Captain Thomas Lee (Fig. 5) in an imaginary costume but with the bare legs of an 'Irish Wood Kern'.[12]

The first record in the seventeenth century of painters working in Ireland occurs in the diaries of Richard Boyle, the Great Earl of Cork (1566–1643).[13]

These diaries are one of the fullest sources of social as well as political activities in the early part of the century. Literally everything the earl did is recorded and everything he paid for is listed in his accounts. We get a very clear picture of the concern he took over his furniture, clothes, jewellery and plate. Tapestry hangings are fairly frequently mentioned, for instance, the two sets he bought on 28 June 1624 from 'Mr Arthure of

5 Marcus Gheerhaerts the Younger, *Captain Thomas Lee*, oil on canvas, Tate, London

dublin merchant… six peeces for my dynying chamber at lismoor coste 57£ ster. thother of 5 peeces for the long chamber in yoghall, coste 55£'.[14] Later, he bought tapestries from the Kilkenny Castle sale of 1630. Mention of pictures is very rare. The earliest is an entry for 30 July 1617, when Lord Cork bought twelve pictures for his dining-room from a Dutch merchant. The description indicates that they were genre scenes depicting Dutch women in national costume.[15] On 16 November 1621, however, he 'paid the ffrench Lymner XII £ ster. for making my own, my wives, my mothers, Saraes, Dick and Joanes pictures, which picture of Saraes was sent to Mellifont and Dicks picture and Jynnes to Sir Edward Villiers'.[16] These were all members of his immediate family. No certain portrait of Lord Cork himself exists, though there are two pairs of the earl and his second wife which are clearly eighteenth-century concoctions. One pair were at Marston, the Cork and Orrery house in Somerset, and another similar are now at Lismore Castle Co. Waterford.

Other inventories tell the same story. For example, the inventory of the Castle of Maynooth (owned by the Earls of Kildare),[17] taken in 1578, lists very rich furnishings and tapestries, but no pictures. In the deep south-west, the situation was the same. For instance, Sir Hardress Waller made an inventory in 1642 of Castletown Waller, Co. Limerick,[18] when he claimed compensation for losses in the rebellion of 1641, a rising by the indigenous population against the new Protestant plantation landlords and their tenants and followers. This was particularly savage in the north of the country. In Waller's inventory, mention is made of tapestries valued at £100, a rich carpet, cushioned chairs, eleven beds with their bedding and, where they existed, canopies and hangings which were valued at £95. Similarly, a little earlier, in the wills of the first and fourth Earls of Thomond,[19] weapons and clothes are particularly prized and a great collection of silver plate is recorded, but no mention is made of furniture, wall hangings or family portraits, books or manuscripts. A few may have existed, but from the point of view of somebody making a will, livestock, plate, jewellery and rich apparel were more prized among Gaelic families and new settlers.

In the north, Randal McDonnell, second Earl of Antrim, in 1635 married a grand, rich English wife, Catherine Manners, widow of George Villiers, Duke of Buckingham, one of Charles I's favourites and a major collector of works of art. In 1638 she moved to Dunluce Castle, Co. Antrim with an incredible amount of luxurious furnishings, including two thirds of a mile of tapestries; sixty-six pairs of bed hangings and the costliest of fabrics, gold and silver lace, damasks and satins; a library; a globe; mirrors and carpets. But there were only fourteen individual pictures and a further number rolled up. What survived of all this grandeur after the 1641 rebellion was returned to England in 1642.[20]

The scarcity of pictures that these inventories and wills indicate is supported by the extreme rarity today

of sixteenth- and early seventeenth-century portraits of Irish people. Two datable panel portraits from the late sixteenth century are those of Donough (Fig. 7) and his wife, Slaney O'Brien,[21] of Lemeneagh, Co. Clare, which were painted by a Flemish artist in 1577. It is probable that these were painted in Ireland by a travelling artist such as those mentioned by Lord Cork. Few Irish families have portraits dating from the early seventeenth century, though some crude likenesses indicate that people were beginning to have their portraits painted. Such an example is Lord Cork's son-in-law, George, sixteenth Earl of Kildare, known as the 'Fairy Earl',[22] who was painted in 1633 with Kilkea Castle in the background (Fig. 6). The fourth Earl of Thomond was also painted. Another portrait is of Donough and Slaney O'Brien's great-granddaughter-in-law, the notorious Red Mary O'Brien, Máire Ruadh (Fig. 9), whose alarming visage suggests that the many tales of her tough treatment of her husbands may have some foundation in fact, though it may also be due to considerable overpainting. The portrait shows that she had elaborate Renaissance jewellery and a fine costume embellished with Flemish bobbin lace. In contrast to Red Mary is the portrait of a typical member of the new settler class, Thomas Maule, proudly displaying his seal of office as Surveyor General of the Customs of Ireland, a post he occupied from 1627. His formal stance, with column, curtain and seascape background, indicates an artist conversant with the mainstream of European and English portrait painting, however harsh its actual handling. A compassionate portrait of the period is that of Bishop Rothe of Ossory, who is simply depicted (Fig. 8). Rothe was the author of a tragic description of the results of an early plantation, when Protestant English settlers and their followers were given land, dispossessing the original Catholic owners.

6 Anonymous, *George FitzGerald, sixteenth Earl of Kildare*, ('Fairy Earl'), oil on canvas, Private collection

7 Anonymous (Flemish), *Donough O'Brien*, 1577, oil on canvas, Private collection

8 Anonymous, *Bishop Rothe*, c.1640, oil on canvas, Private collection

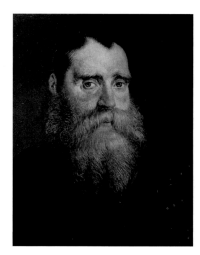

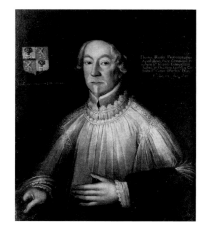

9 Anonymous, *Máire Rua O'Brien*,
oil on canvas, Private collection

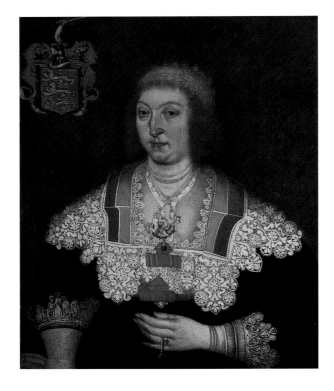

He says that the Lord Lieutenant 'expelled from their ancient possessions harmless poor people who have many children and no friends to take their part. They have nothing but flocks and herds, no trade but agriculture, no learning.'[23] He adds that 'they will fight for their cellars and hearths, and seek a bloody death near the graves of their fathers rather than be buried in foreign earth and alien sands'. His words evocatively describe this troubled and violent period of war, settlements and insurrections.

One of the first mentions of pictures in any quantity is in 1626, in the 'list of things carried away from Carrick [on Suir] by [Richard Preston], Earl of Desmond'.[24] These included forty-four pictures that adorned the gallery which still survives in the castle. It is impossible to hazard a guess at who painted any pictures of this period, though several artists must have been at work and we know that Colonel Rosworm, a German engineer[25] who was in Ireland before 1641, is said to have painted portraits. A whole length of Sir Audley Mervyn, an important political figure in the 1640s and a County Tyrone planter, is another early portrait, of which there are two versions, which we discuss later in chapter 3. A large part of the reason why so little survives is the amount of burning and pillaging, destruction and displacement which occurred during the 1641 uprising, the Catholic Confederacy of Kilkenny of the 1640s, the Cromwellian wars and later, during and after the Williamite campaigns. Even great families who kept their ancestral lands had periods of resettlement or attainder, or had their houses and chattels burnt, and many movables were therefore lost. It is ironic that far less survives from the seventeenth century in Ireland than in Scotland and even in the American colonies which were on the new frontiers of civilization.

2

Ireland's Restoration Period

The real history of Irish painting begins with the Restoration of the Stuart monarchy in 1660. For the next twenty-five years, a sustained period of peace gave the arts an opportunity to take root. Under the Restoration, societies such as the College of Physicians and the Dublin Philosophical Society were founded, in 1667 and 1683 respectively. William Molyneux (1656–98),[1] a Fellow of the Royal Society and a member of one of Ireland's most intellectual dynasties, was, with Sir William Petty (1623–87), the leading spirit in these institutions. The first corporate society in Ireland for artists in modern times was also founded under a Charter of Charles II in 1670 as the 'Guild of Cutlers, Painters-Steyners and Stationers',[2] commonly known as the Guild of St Luke. Some of its records still survive, but as they chiefly represented trades such as house painters, floor-cloth manufacturers, etc., they unfortunately do not help much over the identification of painters.[3] However, a number of artists are recorded in a list of pictures, now lost, which belonged to the Guild, and in the list of artist members. This includes several French and Dutch names and the portrait painters Gaspar Smitz (d. 1688) and Thomas Pooley (1646–1723), whose works are known. Most of the other names have sunk into total oblivion, such as George Bodeley (*fl. c.*1708), whose portrait of Queen Anne hung in the Guild's hall until 1841.

By a happy coincidence, the first Lord Lieutenant appointed in the Restoration period, James Butler, first Duke of Ormonde (1610–88), was also the principal patron of the arts in Ireland, with his wife and cousin, Elizabeth Preston. He had first-hand contact with European painting and sculpture when in exile with Charles II in France and the Low Countries. The Duchess returned to Ireland with her children under Cromwell in order to keep an eye on the huge Butler estates. She was allowed £2,000 per annum from her estates by the Commissioners of the Commonwealth, an enormous sum at that time, and from 1652 she is recorded as receiving some of her goods from France, including 'forty fyne pictures with their frames'.[4] She enlarged and restored Dunmore House near Kilkenny and furnished it lavishly, as can be seen from the contemporary inventories.[5] After the Restoration, the duke and duchess built up their collection both in English and Irish houses and eventually owned about five hundred pictures,[6] one of the largest collections in these islands at that time. The duchess, who was more engaged in collecting pictures than the duke, may have intended to use a member of the famous Dutch dealing family Uylenburgh, one of whom was Rembrandt's first wife, as her painter and probably agent. In fact, Uylenburgh died in Dublin almost immediately after his arrival there.[7] The Ormondes were in touch with the principal artistic figures in England, including Lely, who painted the duke (Kilkenny Castle), John Michael Wright the Elder and Grinling Gibbons, from whom they commissioned works for Kilkenny Castle, the duke's chief seat, and sought the advice of Hugh May and, through him, Sir Christopher Wren, on architectural details connected with the castle. Various descriptions and inventories of both Kilkenny and the house at Dunmore[8] survive and all show the incredible richness of the interiors – walls hung with Spanish leather; tapestries and pictures, including portraits of the Stuart court, a few religious pictures, many subject pictures, landscapes, sea pieces and still lives; and silver furniture, rich upholstery and hangings making a backdrop for a magnificent show of plate. The marble-floored banqueting house even had a ceiling painted with angels and a fountain playing in the centre.[9] John Dunton's highly coloured account is quoted in the introduction.

In the duchess's correspondence, a man called Robert Trotter (*fl.*1670–86) is frequently mentioned as a painter, and in recent years he has been identified as an artist as distinct from a house painter.[10] The duchess wrote to Captain Mathew, the duke's half-brother and agent, on 18 July 1670 about a dispute between Trotter 'the paynter' and Mr Millins, the

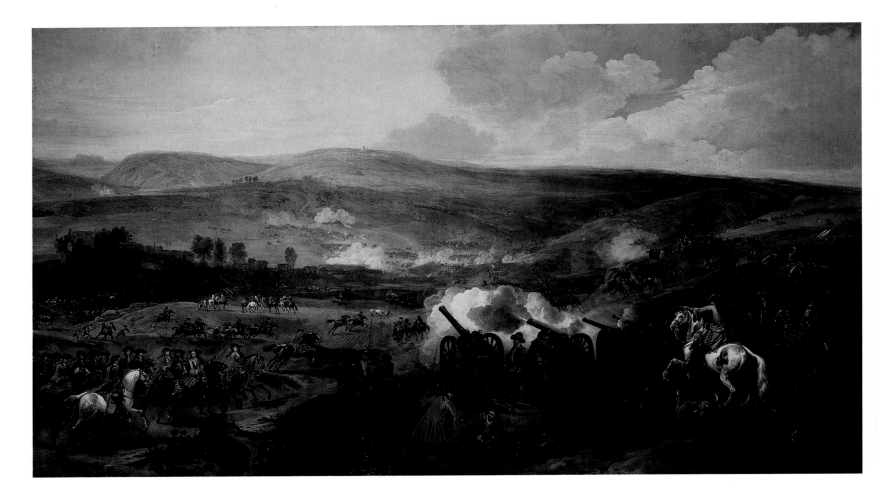

10 Jan Wyck, *The Battle of the Boyne*, oil on canvas, National Gallery of Ireland, Dublin

11 Dirck Maas, *View of Donore Hill with the Battle of the Boyne*, detail, drawing, The Royal Collection

tioned, and presumably, apart from pictures, he must have been employed at Kilkenny and Dunmore on overdoors, overmantels and decorative murals, even perhaps the angels on the ceiling of the banqueting hall.[13] In 1686, Trotter was recorded painting at Whitehaven in Cumberland[14] as one of two painters from Ireland. The second was probably the Dutch artist Jan Wyck (*c*.1640–1702), who painted a landscape view of Whitehaven in 1686.[15] Wyck returned to Ireland in time to paint the Siege of Derry and the Battle of the Boyne (Fig. 10) which is signed and dated 1693. Wyck may have used Maas's drawing (Fig. 11) which is signed and inscribed in French: 'Drawn on the spot 1st July 1690 by Thodor Maas painter to King William'.[16] Several features of this drawing appear almost identically in the Wyck. Maas's view of Donore Hill, which was the background for the Battle of the Boyne, was no doubt one of a number which were used as the basis of his paintings of the battle, an example still being in the Portland Collection at Welbeck. This was painted for William Bentinck, Earl of Portland, one of William III's generals and favourites, who fought at the Boyne.

Amongst Ormonde's entourage in 1662 was one James Gandy (1619–89), an Exeter portrait painter, supposedly a pupil of van Dyck. We have had great difficulty in tracing any works by this artist, due to the dispersal of the Ormonde collection at various different dates. Even Matthew Pilkington (see chapter 4) wrote in 1770:

caretaker, at Dunmore and went on to say that she did not know 'whoe is most in Fault, and beinge unwillinge to part with Trotter whoe I know to bee very abbell in his profeshone and knowinge beside in things of Buildinge…'.[11] In a linen inventory at Kilkenny, 'Panell Clothes'[12] for Trotter's paintings are men-

The cause of his being so totally unknown, was, his being brought into Ireland by the old Duke of Ormond, and retained in his service … There are at this time in Ireland, many portraits painted by him, of noblemen, and persons of fortune, which are very little inferior to Vandyck; either for expression, colouring, or dignity; and several of his copies after Vandyck, which were in the Ormond collection at Kilkenny, were sold for original paintings of Vandyck.[17]

A small oval portrait of Charles Cutliffe shows some van Dyckian features, as does a portrait of Elizabeth Bourke recorded as signed in an engraving illustrated in Grace's *Memoirs*.[18] They are probably works by James Gandy, as is possibly the portrait of Henrietta Maria after van Dyck, still in Kilkenny Castle.[19]

Some unnamed painters, such as the portrayer of *Captain William Jackson*[20] (d. 1688) of Jackson Hall, Co. Derry, 1667 (Fig. 12), appear on the scene at this point. Jackson is in armour and, though it is obviously a provincial picture, the portrait has considerable presence and shows a new professionalism. From the period of the 1660s and 70s, several other artists arrive from England, including Gaspar Smitz, a Dutch artist who first came to Dublin from England some time in the 1670s. He probably painted the youthful *Christopher Nugent, Lord Delvin* (NGI), who died before 1680, at this time and other members of the Nugent family, including Mary, Countess of Westmeath (NGI). These works are stylistically very close to documented works, such as Elizabeth Grace,[21] the second Marquess of Annandale and the second Earl of Yarmouth.[22] There are a number of portraits and religious pictures by Smitz in Hatfield House, Hertfordshire.[23] These include an *Annunciation* (Fig. 13) and *The Three Maries at the Sepulchre*. Vertue said of him:

Gaspar Smith came to Dublin from England was brought thither by Lady … whom he taught to draw and paint. there he head encouragement from her. and resided & painted portraits. livd and dyd there about 1707. Mr. Maubert had his first instructions in drawing and painting from him in dublin. Mr. Gandy of exeter had some instructions from him when in London … Gaspar Smith kept allwayes a Madam or Maulkin. who servd him when he wanted a Model for his Magdalens. that he painted those small kind of paintings was his greatest art.[24]

Walpole repeats this information, but adds that 'his flowers and fruit were so much admired, that one bunch of grapes sold there [i.e. in Ireland] for £40'.[25] An example of his still life can be seen in his portrait of a member of the Cecil family at Hatfield. Smitz was admitted free to the Guild of St Luke in 1681 and it is in the company's records that we find his death date, '1688', written in the margin in ink and pencil.[26] This

contradicts Vertue's date of 1707 and seems more likely, as no pictures can be attributed to him after 1688. A confusing feature of Smitz is that his name is sometimes given as Theodorus Hartcamp or Dirck Sauts and he signed works with these names, though not in Ireland or at Hatfield.[27]

Smitz was a picture restorer and probably an artist's colourman, as Sir John Perceval (d. 1686) visited him on 2 February 1686 in Dublin and 'of him bought some paints'.[28] A year earlier, on 19 January 1685, Smitz wrote a long letter to Perceval which we quote in full as it gives a remarkable picture of an artist restorer at work and indicates how many pictures were now in the country, brought in during the Restoration period. Smitz wrote:

1684–5, January 19, Dublin – I have sent you your pictures, and I question not but I have done them according to your expectation, and I am sure there was not any man besides my selfe in these parts that

12 Anonymous, *Captain William Jackson* (d.1688), late 1660s, oil on canvas, Ulster Museum

13 Gaspar Smitz, *The Annunciation*, oil on canvas, Private collection

cleaned and washed; and two of ym being so rotton as they woud scarce hold (by order of Mr Cooper) I have put them on new canvas; and taken care that every one of them were well and new strained for they were exceeding loose; so that they may be forth with vernished If at any time I may be capable of serving you in any wise I shall make it my study and be proud of the opertuny and if you have an accasion for any other kind of pictures as doore peeces chimly peeces &c: or frames of any sort let me but have the measure of pictuers or frame & I doubt not but to send them to you to your Satisfaction.

pray S^r let the bottele of vernish be kept verry close stop any aire, and when you use of it powr out no more at than will be sufficient for the peice, a little of it will go way for it must as I gave you caution before be laid on as thin as possible, and halfe a small glass will vernish all my Ld Straffords picture the rest if you keep it close may serve if you should have any occasion at any other time; it would be good 40 yeares hence.[29]

The Perceval family built a new fortified Dutch Palladian house, Burton, near Charleville, Co. Cork.[30] Their close relations, the Southwells, one of whom married Sir John Perceval, the first baronet, lived not far away in Kinsale. The Percevals are unusually well documented, as many of their papers survive in the British Library. They were among the few important Irish patrons of the arts even before 1660, and most of them had their portraits painted. Their correspondence mentions the purchasing of sculpture as well as paintings, and informs us about a number of the artists they favoured, including Thomas Pooley. Other Cork nabobs besides the Percevals and Southwells included the Earl of Orrery (1621–79), a younger son of Lord Cork, who had built an extravagant house at Charleville and also lived at Castlemartyr, Co. Cork, where he had a collection of pictures including subject pictures as well as portraits, as indeed did the Percevals.

All collectors had pictures of the royal family and employed English artists as well as Irish. The third Viscount Massereene seems to have been one of the few who disliked Irish painting, writing on 8 November 1683 that Dublin lacked 'workmen that are artists'. He favoured Lely to paint three portraits of his family and supply studio copies: 'my purpose is that everyone of my three children shall have such a picture at length'.[31] This attitude accounts for the number of copies and versions which exist of famous painters' work. Another major patron was the great entrepreneur and cartographer, Sir William Petty, who was regularly buying pictures in the 1650s in Dublin.[32] His memorable portrait by Isaac Fuller (NPG) shows him holding a skull and pointing at a book on anatomy. According to Nicholas Canny, this is appropriate, as Petty is 'anatomising Ireland with a view to prescribing a remedy for its reform'.[33]

Thomas Pooley, mentioned above, was born in 1646

could have done it for I found it much more difficult and tediouse in the performance than I imagined it woud be, I have likewise sent the frames, but pray Sir let those that open the case in which they are have a great care & open the two ends before the[y] open the cover;

I have also sent a bottele of vernish and a brush w^ch I woud have used in the manner following: viz Let them (for fear some dost or trash may have fallen on the pictures in ye carriage) take a clean sponge or a napkin; and with fair spring or river waeter gently wash over the pictuers. then w^th a dry cloth dry them well, and after 4 or 5 hauers, let them pour som of the vernish into a verry dry glass, and w^th the brush goe over the pictures as thin as possible they can, it cannot be laid on too thin, and if when it is thorow dry which will be in a dayes time. (you find it stands not out enough) they may goe it over once more but verry thin, and set it where no dust can come to it to dry, but let them be shure that no water touh the vernish,

As to the frames I am confident they cannot but please you; sin[c]e I am sure they are much the best that I have seen or had done for me, and I gave a better allowance to my guilder that the coulour might be as good & glorious as coud be made.

I have (if you will observed enlarged the pictures above 3 inches of a side to preserve the art for the future, and I may assure you the picture done by Sr: Anto: van Dike can hardly be valued and as to the other I have found it much better since I have cleaned it than I thought it was and were the two hands of pyramus but well done as the rest of the picture, I shoud imagine it an originall of Willburst [Thomas Willeborts], and vallue it no less than 50^ll sterl:

As for the other pictures I have had them all

near Bury St Edmunds, but in 1652 went with his family to Dublin, where his father was an attorney. He studied law in London. Strickland suggests that he learned and practised painting there, which is confirmed by the strong influence of Lely's style in his work. By 1674 he was painting a portrait of *Robert Southwell* at the sitter's house in Spring Gardens in London (Fig. 14).[34] He returned to Ireland in the train of the Earl of Essex in 1676.

The earliest mention of Pooley in Dublin is in a letter from Sir William Petty to his wife, dated Dublin, 16 February 1677–8, in which Petty writes about his portrait 'drawn this week … in a beard of 31 days growth and in my own hair without a periwig and in the simplest habit imaginable'. He states that it is not to be hung in the 'dining room or parlour',[35] clearly because it was too informal and intimate. Petty was connected with the Southwell family through his wife. By 1682, Pooley was well known in Dublin, as he painted three portraits for the Corporation of Charles II and William and Mary, being admitted to the Guild of St Luke in 1683. He achieved a fashionable clientele among the Anglo-Irish in the 1680s and Sir John Perceval visited him on 5 February 1686: 'This morning I went to Mr. Pooley the painter',[36] while Lord Clarendon, the Lord Lieutenant, also recorded a morning sitting on 13 January 1686–7.[37] He was raising his prices about this time, as Perceval's agent, William Cooper, writes: 'on 13 March 1686 Mr. Pooley made me pay £24 for Your picture and frame, which I'm tole is £5 more than he usually takes: but he insisted upon it and said he has not had less than £20 for a picture of that size this seven years'.[38] Strangely enough, he charged much less in 1700 for two portraits of Queen Mary and the Duke of Gloucester for the Royal Hospital, Kilmainham – they cost £16 and £10 respectively, including the frames.[39] His late works do not show the same talent as his most notable pictures, which date from 1670, of the three Perceval boys, the sons of Sir John. For the faces he uses a direct approach, though the cartouches and draperies are very Lelyesque and he is known to have copied portraits by Lely, including one of Elizabeth Dering, Lady Southwell (King's Weston, Gloucestershire). The lace in these children's portraits is, as usual, excellently painted. There are two versions of the portrait of Elizabeth Dering's father-in-law Robert Southwell (1607–77),[40] one of which is still at King's Weston. Pooley paints him in a landscape with a massive pair of gold-fringed gloves (Fig. 14) and, like the portrait of the boys, it is an early work, dated 1674. It, too, has a directness which gives it an air of benign authority. Another fine, clear portrait of a young man is the one thought to be of Jonathan Swift, *c*.1682, which is inscribed 'when a student in Dublin College' (Fig. 15). The attribution seems likely, because the Pooley family had married into the Swift family.[41] Some of his works, like the portrait of Sir Humphrey Jervas (TCD), painted in 1681–2 when he was Lord Mayor of Dublin,

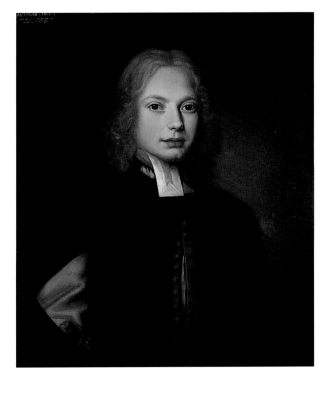

15 Thomas Pooley, *Jonathan Swift*, oil on canvas, Private collection

are so crudely executed that the sitter appears to have no neck. Other works by him which survive include the portrait of Dr Stearne in the College of Physicians of Ireland, signed 'TP', which is in a wrecked condition.

The whole-length portraits, of which Pooley painted some six, in the dining hall at the Royal Hospital, Kilmainham, are copies after Lely and Kneller. But the series is particularly interesting as it is the only official set of portraits, though by different artists, to survive in their original setting and frames in the British Isles. The series of portraits of ten 'Fire Judges' by John Michael Wright, which used to hang in the Guildhall in London, were badly damaged in the 1940s and only two survive.[42] The Butler family were also patrons of Pooley and he painted several head-and-shoulders of the first Duke of Ormonde. One canvas, now hanging in Kilkenny Castle, is described in an inventory as 'the Old Duke of Ormonde at length but shorter and less than the life';[43] in a later inventory it is attributed to Pooley. Another Ormonde portrait in a private collection shows a spectacular display of lace in his jabot.

In 1688, Randle Holme refers to 'Pooley for a face and Serville for drapery' in his *Academy of Armory*.[44] A Peter Serville (*fl*. 1684–95) was admitted to the Guild of St Luke in 1684 and is probably one and the same. He may have been used by Pooley as an assistant and drapery painter, as in at least one portrait of Charles II it was noticed during restoration that it was the work of two hands. After 1700, Pooley seems to have abandoned painting, as by now he was a man of property, an MP and held several sinecures. It is sad that after his early years this well-documented artist should usually have become so second rate, except for the drapery, which, after all, may not even be by him.

Though we do not know who taught Pooley, we suspect that Smitz was the first teacher of Garret

16 Jan Vandervaart, after Garret Morphy, *St Oliver Plunkett, Archbishop of Armagh*, engraving, Private collection

Morphy (or Morphey) (d. 1716), the first Irish-born artist of any stature. His origins are obscure, but it is obvious that he was closely connected with Smitz, whose dry manner his early work can resemble. This is exemplified by looking at his portrait of *Lady Jane Chichester*, daughter of the second Earl of Donegall, which, judging by the age of the sitter, dates from about 1675.[45] It is stiff and flatly painted, probably indicating that it is a youthful work, and it is likely that Morphy was born in the early 1650s. Smitz, who painted small whole-lengths himself, such as the *Earl of Yarmouth* at Hatfield House, may also have introduced Morphy to this genre, though it was quite commonplace in London at the time. Morphy became a student of Edmund Ashfield (*fl.*1669–76), probably when Ashfield set up on his own in 1673.[46] Ashfield was a Roman Catholic, and had worked as an assistant to John Michael Wright, also a Catholic, as was Morphy. This makes the *Lady Jane Chichester* puzzling, as it is a naïve picture for an artist who had already spent some time studying in London. Jane Fenlon suggests that it is unfinished.[47] In a contemporary comment, Morphy is described as 'Mr Ashifeld's man Garct-murfy painted faster than his master and did work for himself and his master too, his master not knowing tho' he could work faster than himself (or more)'.[48] Later, a description of Morphy's working methods is recorded as written by himself, '… the reason [for his speed] is that I lay the patches of colouring one by the other, so I have no more to do, but give them a little together so the work is done'.[49] This system was clearly employed in his later work but doesn't seem to appear at an early date.

His next datable work is the *St Oliver Plunkett* Catholic Archbishop of Armagh, engraved in 1681 by

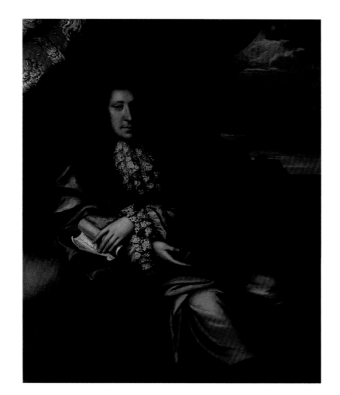

17 Garret Morphy, *Sir Abstrupus Danby* (d.1727), oil on canvas, Private collection

J. Vandervaart (Fig. 16), of which three versions certainly survive of indifferent quality (one in the NGI); it is likely that he turned out a number for an eager recusant market which he would have found in Yorkshire, where there are still a number of portraits by Morphy. These date from the later 1680s, when he is mentioned in the Portland papers as 'one Morphew a Roman Catholic painter drinking confusion to those who did not read his Majesty's [James II's] declaration was attacked and beaten by one of the King's officers quartering in those parts [York]'.[50] The Yorkshire Catholic families whom he painted include the Blands, the Lane-Foxes and the Danbys of Swinton, where, on one of the portraits, there is a partly decipherable inscription on a scroll, giving the date 1687 (Fig. 17).

His small whole-length of *The Countess of Kingston-upon-Hull* (Fig. 18),[51] which dates from between 1685 and 1690, is based on work by Dutch artists such as the Netschers, van der Werff and, Jane Fenlon thinks, John Michael Wright. Morphy only uses figures in the background of this one picture. In others of the same type, he puts the reclining figure in a plain landscape, as in the first *Lord Bellew* and *William Congreve*. It is interesting to note that the latter has been sold in continental sales in recent years as an Adrian van der Werff and also as a Gaspar Netscher.[52] However, other influences are noticeable, as both sitters lie robed beneath trees in the pose associated with the concept of melancholia, as portrayed in Isaac Oliver's portrait of the first Baron Herbert of Cherbury.[53] Another of the same type is of James Bryan (NGI) of Jenkinstown, Co. Kilkenny, which has a very beautiful landscape, though the face of the sitter is unusually sharp for Morphy; a seated figure, probably the third Earl of Donegall, is in the Ulster Museum. There is at least one other version of *Lord Bellew* and the backgrounds may be by another hand as the foliage in both is much more detailed than in *The Countess of Kingston-upon-Hull*.

Despite the fact that Morphy was paid £24 in 1686 for a whole-length portrait of the Duke of Newcastle, the picture of him which survives at Welbeck, Nottinghamshire, is unlike the rest of his *œuvre* and resembles the work of the Yorkshire artist, Comer (*fl.* 1668–1701), who painted a series of portraits for the Portlands between 1683 and 1685.[54] The account may refer to another painting now lost.[55]

Morphy may have been in England until after the Battle of the Boyne in 1690, the crucial battle in the Williamite campaign. His very fine portrait of Lady Neal O'Neill leaning on an urn with a skull and cross-bones is a *memento mori* to her husband, who died of wounds after the battle and whom Morphy also painted, probably posthumously. Though the pose of Lady Neal O'Neill owes something to Lely, Morphy did not care for his work. When talking to William Fever, a fellow pupil at Ashfield's, he said that 'Mr Lillys work is only like a dead colour glosse and dashed on and not finished like Van dikes work which I like best'.[56] Other portraits of these post-Boyne years are of the

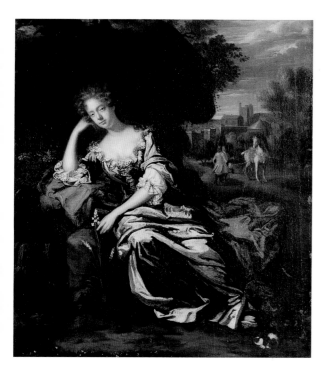

Molyneuxes, Viscounts Maryborough (NGl). The portraits of Lady O'Neill's daughters, Mrs Wogan and Mrs Segrave (NGI), show that their hairstyles and dress are very French and can be especially compared with Mary of Modena and the fashions at St Germain-en-Laye, where she and her husband, James II, held court. Many Jacobite Catholics, and certainly these O'Neills, had retreated to Paris after the Battle of the Boyne, before returning to homes in England and Ireland.

Collins Baker illustrates a signed portrait of Lady Santry and suggests a date of 1692.[57] It closely resembles a portrait of a Mrs Poole, which is one of the few signed works and is dated 1704. It has similar long pointed fingers, like those of a lay figure, but the composition is pleasantly simple and the face a very sensitive study. The longer fingers are found in many of his other works, including the *Henry Loftus of Loftus Hall*, a robust portrait of a successful Protestant, no doubt feeling triumphant and more secure after the success of the Williamite campaign. Other sitters were John Waller and his sister Elizabeth, Lady Shelburne, children of one of the regicides, Sir Hardress Waller. She was the widow of Sir William Petty, and Aubrey, in his *Brief Lives*, describes her as 'a very beautifull and ingeniose lady, browne, with glorious eies'.[58] It is sad that this portrait is now lost, but it was described in the King's Weston inventory as being 'in an oval of 18 inches diameter drawn in a vail by Mr Murfey in Dublin 1694'.[59] These sitters were Protestant and no doubt expediency was responsible for Morphy's change of clientele.

In 1696, Morphy painted Lady Mountjoy in an oval landscape, holding a dove and accompanied by Cupid to symbolize her recent marriage. The pose and accessories were taken directly from a portrait by the French artist, Henri Gascars (*c.*1635–1701). Lady

Mountjoy's portrait is also notable (as is Gascars's) for the cascades of frothy lace; and this flecked quality is almost an autograph of Morphy's later style, well illustrated in his portraits of the daughters of Sir Neal O'Neill mentioned above, which must date from the mid-1690s. It is also very evident in his portrait of *Mrs Fortescue* from the Co. Louth family of the Viscounts Clermont. Besides the Gascars influence, this work is painted in an elaborate cartouche of acanthus, fruit and flowers, and has a decidedly French building in the background.[60] Another frothy laced portrait is that of *Ursula Bunbury as St Agnes with a lamb* (Fig. 19), dated 1685, which indicates that Morphy had adopted this style while in England.

In his will, dated 1715 and proved on 12 May 1716, Morphy is described as 'of the city of Dublin, painter'. He is of the greatest significance in Irish painting, as he combined English with continental influences and was the first painter to raise the quality of Irish art from its first provincial fumblings to a more competent professional level. His sitters for the most part are a fascinating record of the Old English in Ireland. Those once powerful Catholic Norman families, such as the Nettervilles, the Whites of Leixlip and the Bellews, were soon to decline into obscurity, 'some to die on battlefields both here and in Europe. Those who remained either conformed to the new administration or retired from public life …'.[61]

Morphy's colouring is very distinctive. Collins Baker noticed his 'jammy reds'[62] but clearly never knew the *Mrs Poole*, with its fresh scarlet velvet and almost iridescent bluey-greys. Neither did he know the fine portrait of *Brigadier-General William Wolseley* (Fig. 20), signed and dated 1692, standing in magnificent damascened armour. This brings one to consider

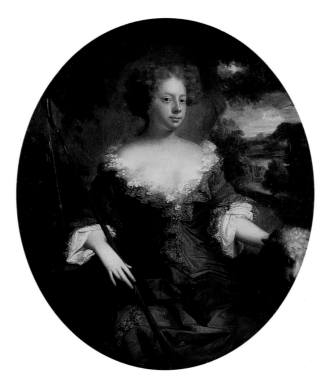

18 Garret Morphy, *Lady Kingston upon Hull*, oil on canvas, Private collection

19 Garret Morphy, *Ursula Bunbury, later Mrs Morgan*, oil on canvas, Private collection

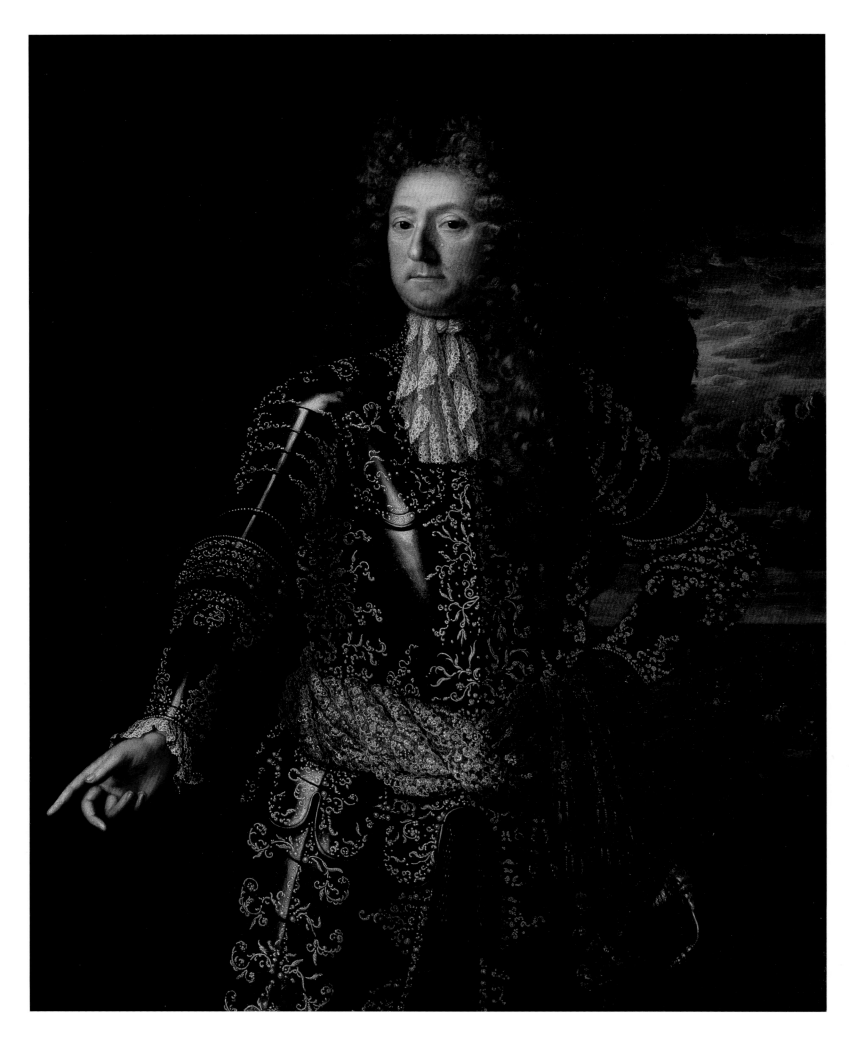

what assistants Morphy employed. Given the range of quality in his work, he must have employed some apprentices. Thomas Bate (*fl.* 1692) has been suggested[63] as one of these in the 1680s. Bate's hand may be seen in the detailed and delicately painted landscape and foreground in the painting of a member of the Bellew family now known as *Lord Bellew*.

Thomas Bate is only known by one very fine portrait, *Lord Coningsby in Roman dress*, signed and dated 'T Bate 1692' (Fig. 21). Vertue records him as 'Thomas Bates famous for that kind of Painting from the life. in Ireland. where he livd mostly Several whole lenghts painted by him & heads are done'. Vertue also mentions that Bate worked on glass.[64] As in a Morphy, Coningsby is relaxing under a tree with his hounds in a romanticized landscape with Hampton Court, Herefordshire, in the background. Coningsby had an Irish career from the Boyne onwards and was granted a large estate. He was one of the Lords Justice, Paymaster General in Ireland, and he is included in the Kilmainham series of portraits as a Governor of the Royal Hospital. The figure is more stylized than in a Morphy, but the landscape and the foreground details seem to relate to Morphy, and possibly Smitz for the flowered still-life. However, the portrait obviously summons up, with its embattled house, spear and bow and arrows, all the romantic medieval fantasy world for which Coningsby was famed, despite the fact that he is in classical dress, a commonplace conceit of this period.[65] The problem of Bate is complicated by the fact that an artist of that name died in Ireland in 1677. Sir George Rawdon, writing to Lord Conway on 18 July 1677, mentions a Thomas Bate 'grown a famous painter … was buried four days since'.[66] He may have been our artist's father and no work is known by him. Thomas Bate Jr also worked in the field of pure topography, as can be seen in the landscape *View of Dublin from the Phoenix Park*[67] (Fig. 22) which dates from around 1699 and which we will discuss later, under landscapes.

There must, even at this late date, have been a number of itinerant 'face painters'. It is unusual to be able to attach a name to paintings in a house where they have always been. Joachim Croger or Crocker (d. 1699) was one of these 'face painters'. He is recorded by Strickland as painting Joseph Toplis, a cutler who was a prominent member of the Guild of St Luke. Toby Barnard records Samuel Waring of Waringstown, who had travelled in England and continental Europe, returning to his old house and fashionably restoring it. An inventory of 12 October 1704 records the colours of the rooms with their curtains and bed hangings. Until recently, a magnificent pair of embroidered curtains from the late seventeenth century hung in one of these panelled rooms. Family portraits are mentioned in letters between Samuel and his father William, including one dated 31 October 1699, when the price of £3 each is mentioned. The artist was Joachim Croger or Crocker, who was probably German and had been in Dublin and 'was much

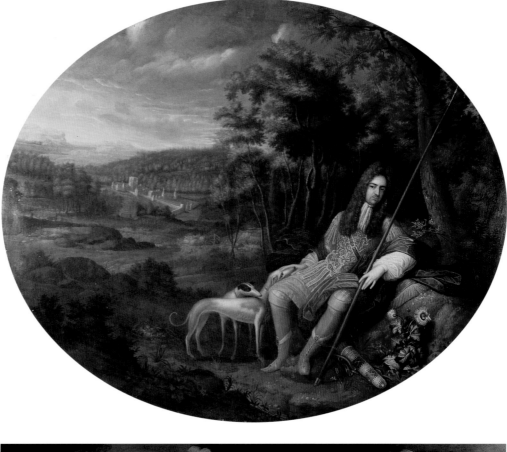

employed about Portadown and was like to have much employment in this country'. Waring's neighbour, Arthur Brownlow of Lurgan, after dinner at Waringstown, said that the pictures 'were the best drawn to the like that ever he saw'. This remark was passed on to Samuel by his father on 8 March 1698. Waring is recorded as collecting various recipes for varnishes and cleaning pictures and concerned himself with having frames made for the portraits. These activities were curtailed by Croger's death in Dublin around November 1699.[68]

21 Thomas Bate, *Lord Coningsby*, oil on canvas, Ulster Museum

22 Thomas Bate, *Dublin from the Phoenix Park*, oil on canvas, on loan to the Bath Preservation Trust

facing page
20 Garret Morphy, *Brigadier General William Wolseley*, oil on canvas, Private collection

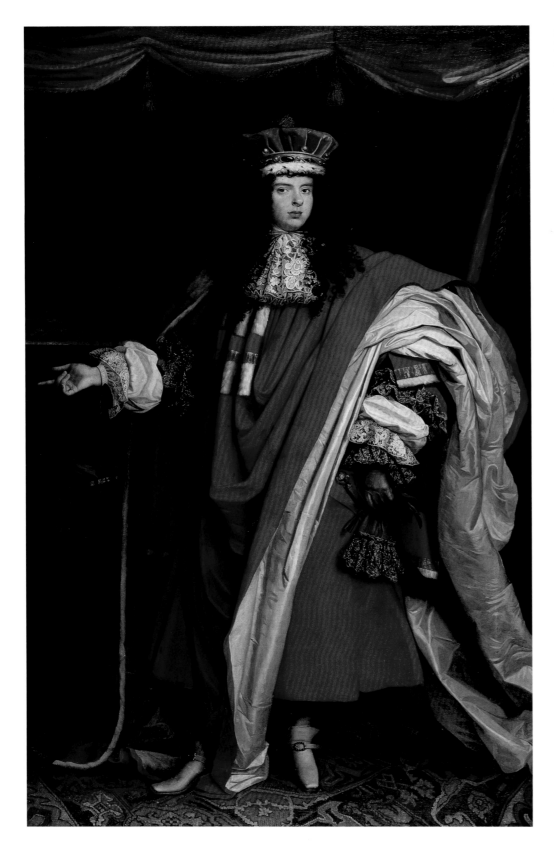

nephew of the well-known portrait painter, John Michael Wright (1617–1690/1700), as on another occasion Vertue says that he did not go to Ireland until after the death of his uncle, which would mean he could not have known Smitz, who had died in 1688. This quote must therefore refer to John Michael Wright himself, who was in Dublin in 1679, probably as a refugee after the anti-Catholic legislation passed by the London parliament as a result of the Titus Oates plot, and stayed in Ireland for three or four years. He had a number of commissions here, painting two portraits for the Ormondes, one of the Duke's mother, Lady Thurles, in mourning and one of his sister, Lady Clancarty. *Lady Thurles* still hangs in the Long Gallery in Kilkenny Castle. Others were commissioned by the King family of Boyle, and include the first *Lord Kingston* in armour and his son, the second *Lord Kingston* (Fig. 23), showing the subject resplendent in his coronet and voluminous baron's robes, which seem to epitomize the pride of the new Irish aristocracy. He also painted members of the Hill family of Hillsborough, Co. Down as well as the third and fourth Earls of Tyrone.

His exquisite double portrait of *Catherine and Charlotte, the daughters of Colonel Richard Talbot*, afterwards Earl and titular Duke of Tyrconnell (Fig. 24) bore an inscription on the back of the canvas, before relining, which read 'James Mich Wright a Londre, pictor Regini pinxit, Dublin Anno 1679'. On the same visit he must have painted Tyrconnell's relative, Sir Neal O'Neill, in the costume of an Irish chieftain, of which two versions exist, one now in Tate Britain and one which belonged to the Ormondes. They also owned two versions of Wright's portrait of a Highland chieftain and it is through one of their inventories that he has been identified as Mungo Murray.[70] The *Sir Neal O'Neill* (Fig. 25) is far and away the most important portrait of an Irishman painted in the seventeenth century, perhaps not surprisingly, as, due to his visits to Rome, Wright had more contacts with European artists than any other British artist. The portrait of *Catherine and Charlotte Talbot* exhibits his superlative fabric painting at its best and can compare with his *Vyner family* (NPG) which Waterhouse described as 'very frenchified'[71] and the most ambitious of his later works.

The portraits of the nephew, mentioned by Vertue as 'young Wright learnt painting of his Uncle after whose death he went to Ireland and settled there & was living many years afterwards',[72] have not yet been identified, though we think it possible that a few rather coarse portraits in the Wright manner which we have seen in private collections may be by him.[73]

Since our early research in *The Painters of Ireland* in 1978, when we knew only one work by William Gandy, the son of James Gandy, whom we mentioned earlier, much work has been done on William's painting. His Irish *œuvre* has been reconstructed recently.[74] He must have been introduced to painting by his father, James, but is said by Vertue[75] to have studied

23 John Michael Wright, *Robert, second Baron Kingston* (1657–93), c.1676, oil on canvas, Ulster Museum

facing page
24 John Michael Wright, *Lady Catherine and Lady Charlotte Talbot*, oil on canvas, National Gallery of Ireland, Dublin

The state of painting in Ireland at this period was summed up by Vertue: 'Mr Michael Wright painter was in Ireland several years where was in great esteem at the same time there was Magdalen Smith [Gaspar Smitz] & Mr Pooley painters. Wright is said in his first year of comming there he gain'd nine hundred pounds. He had ten pounds a head – Smith and he were always at strife which was the best painter.'[69] The Michael Wright who appears on the list cannot have been the

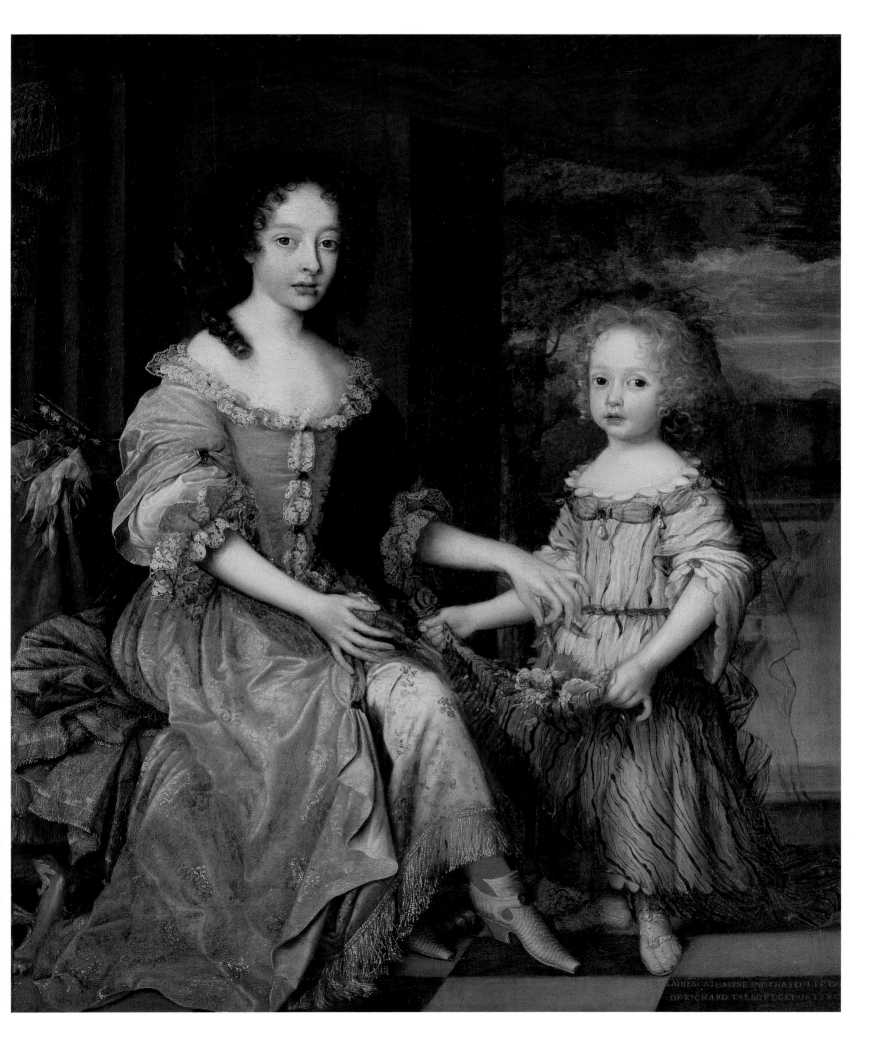

25 John Michael Wright, *Sir Neal O'Neill*, oil on canvas, Tate Britain, London

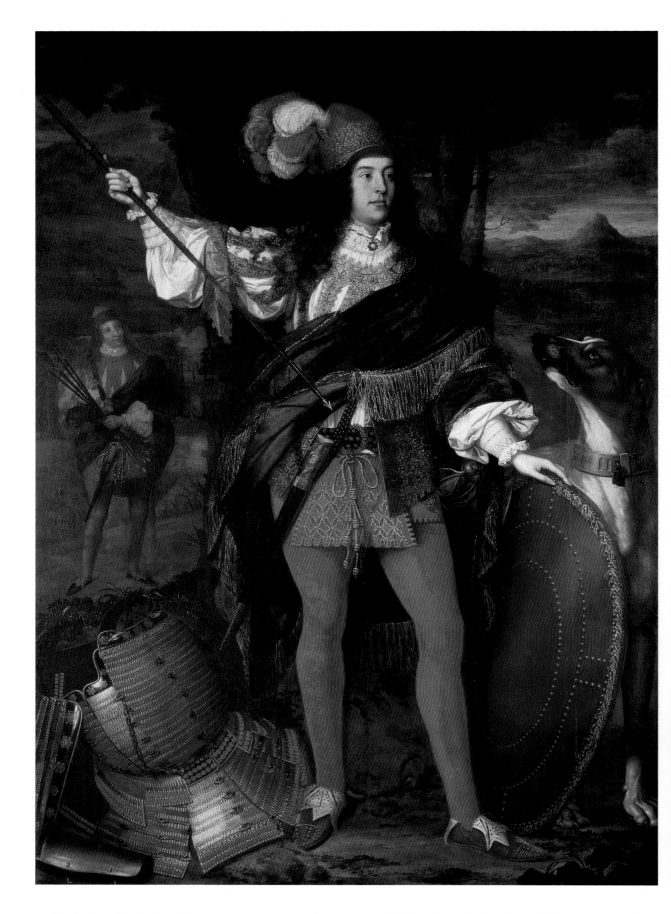

under Smitz when in London, presumably some time in the 1670s. However, we have no definite birthdate, though Northcote, in his *Life of Reynolds*, suggests a date of around 1655.[76] In which case, he was probably born near or in Exeter and came to Ireland as a very young child with his father in 1662. Apart from his stay in London with Smitz, William seems to have been in Ireland certainly from the mid-1680s until about 1700, as all his known works in that period are of Irish sitters. As might be expected from the Ormonde connection of his father, the earliest dated work is a portrait of the *Second Duke of Ormonde* when

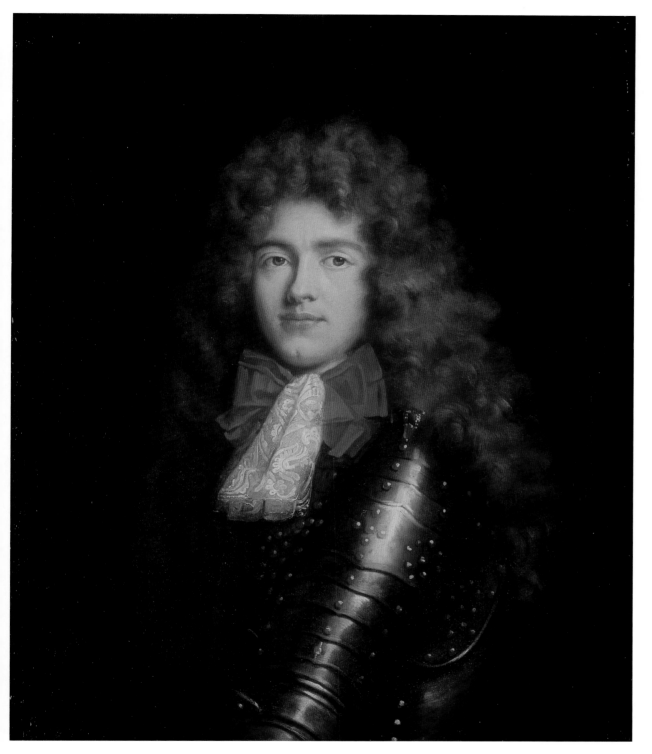

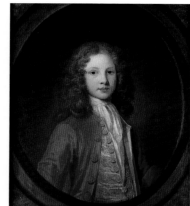

26 William Gandy, *James Butler, Earl of Ossory*, oil on canvas, National Maritime Museum, London

27 William Gandy, *Richard Parsons, later Earl of Rosse*, oil on canvas, Private collection

Lord Ossory (Fig. 26). He was painted on his return from France in 1685 and his costume with its cravat and multiple red bows and armour in the latest French fashion can be closely compared with a similar and contemporary portrait of the *Duke of York, later James II* by Largillière.[77] Gandy was paid for a portrait by the earl's secretary, John Ellis, on 17 January 1686/7,[78] and we assume that this was for the Ossory picture. William's style does not change much in the following years, except for one whole-length portrait, of *Kendrick Fownes*, son of a Dublin civic magnate, which is taken directly from a mezzotint after William Wissing (1656–87) of Lord Burleigh by John

Smith, published in 1686. From the age of Kendrick, it probably dates to about 1692, and it is much harder in execution. A more attractive portrait is the youthful *Richard Parsons, first Earl of Rosse* of the first creation (Fig. 27). His clear, innocent face belies his later 'hell-fire' irregularities. Gandy had a real talent for children's portraits, and young *Henry Stewart of Killymoon*, painted about 1700 has the same freshness as his finest portrait of *Master Willcocks* (Fig. 28), painted after his return to England around 1700, which also owes its pose to Wissing. This is a signed but not dated picture, and certainly the best of his mostly inferior English *œuvre*. As Reynolds thought

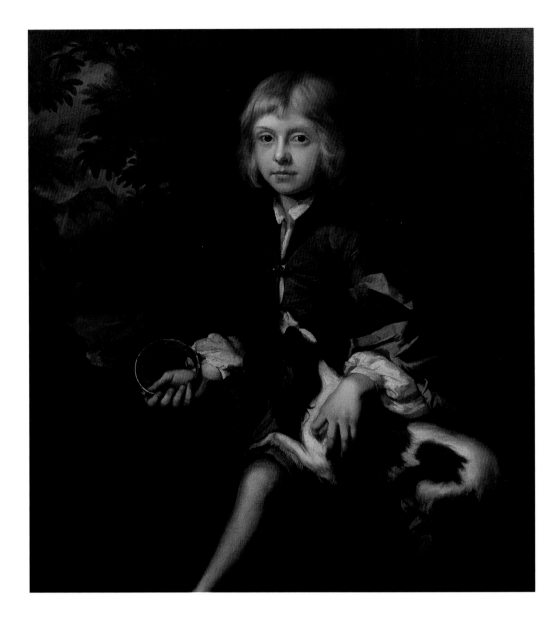

James Gandy's van Dyckian *Henrietta Maria* there, which the young William Gandy must have known well, did influence him. The sensitive, fluid painting, the uncertain expression on his children's faces and the beautifully painted hands are all features that he could have taken from van Dyck. It is a great pity that we know so little about this fine painter.

Apart from the mural decorations which are known to have existed in Kilkenny Castle, there is only one other mural known to us from this period. One room, perhaps dating from the 1680s, in County Wicklow has a most interesting series of horsemen in poses taken from prints on horsemanship, probably those by Abraham van Diepenbeeck (1596–1675) made for the Duke of Newcastle. They alternate with three allegorical groups, all including horses. One horseman is identifiable as Charles II and the background view is of London, taken from a Hollar engraving. The other two riders are Ormonde and General Monck, later Duke of Albemarle.[80] Like Charles, they are in armour, holding field marshals' batons, and are also set against landscape backgrounds. The allegories include a barebosomed Minerva (?) holding Pegasus by a rein in one hand and a book in the other. The other two groups are based on the poses of the Dioscuri on the Quirinale Hill, one of the men being clearly a brawny, country Hercules, while the other, as yet unidentified, grips a drawn sword as he controls his fiery steed. They are apparently painted on floorboards and, if the artist lacks finesse, the series is notably ambitious in scope and lively in execution.

Looking back over the scrappy remains of the artistic scene of the seventeenth century in Ireland, one is struck by its sparsity in comparison with Scotland, a country whose population and isolation from the main currents of European and English influence might be deemed similar. However, no other area of the Stuarts' kingdoms suffered the repetitive upheavals of sectarian and political wars, settlements and resettlements to such a devastating degree as Ireland. The submergence and the emigration of the greater part of the native Catholic aristocracy and their replacement by a new settler class, more interested in the acquisition of land than works of art, delayed the establishment of a culture by the best part of a century. From this point of view, it is surprising that so much is coming to light, though mostly in the form of archival information rather than the objects themselves.

28 William Gandy, *Master Willcocks*, oil on canvas, Private collection

highly of Gandy, whose works he knew in his own Devonshire youth, Gandy's English portraits must have suffered through cleaning or other ill treatment and many must now be lost or unrecognized. One signed work by William Gandy, of *Sir Richard Pyne*, probably of 1708, shows he used an elaborate background of classical ruins in this small whole-length.[79] Gandy's father, as we have mentioned, was said to have been influenced by van Dyck. This is rarely discernible in the few known remaining attributed works. However, the van Dycks at Kilkenny, and

3

Portrait Painting in the First Half of the Eighteenth Century

The economic and social stagnation that characterized much of the first two decades of the eighteenth century is reflected in the dimness of the surviving portraits. There are a great many, but unfortunately they are usually unidentifiable, either because they are hung in conditions too dark to see or they have become so encrusted with peat smoke as to be nearly invisible. This peat smoke has always been a snare to the English restorer and many an Irish picture has been skinned because of their treatment of this unfamiliar tarlike surface.

Morphy died in 1716 and Pooley in 1723 as old men. The remaining resident artists included Ralph Holland, who was working in the 1720s. Two works by him are definitely known, portraits of Archbishop King (TCD), dated 1725/6[1] and of Sir Richard Levinge (Newbridge House) which are mediocre portrayals. Another, now unknown, was recorded in Strickland, a full-length of George I which hung in the hall of the Painter–Steyners. An equally weak portraitist was James Stewart (*fl. c.*1750), whose hand is almost identical to that of Ralph Holland. Stewart's[2] work is identified in the Cobbe papers as the painter of Archbishop Charles Cobbe who built Newbridge House. Another painter was Thomas Carlton (*fl.* 1670–d. 1730), who had been at work since the 1670s, when he became a member of the council of the Painter–Stayners and Warden of the Guild of St Luke in 1680. He did not die until 1730, and is today only represented certainly by his portrait of John Stearne, Bishop of Clogher (Clogher Cathedral) which was identified by Thomas Beard's mezzotint of about 1728. This hardly whets one's appetite for further research. However, it is probable that he painted a full-length portrait of Sir Audley Mervyn, who had been speaker of the Irish House of Commons during the reign of Charles I and the Cromwellian period, and whom we have already mentioned. There are two versions of this portrait, one of which has 'Thos C' written on the back, and the second a copy by Stephen Catterson Smith, records this inscription. The odd depiction of the costume, which includes some very old-fashioned items and others quite up to date, also suggests that Carlton was not familiar with his subject.

Michael Mitchell (*fl.* 1711–50) is known by his primitive, if formidable, portrait of *Grizel Steevens* (Fig. 29), the foundress of Steevens Hospital. She is holding a plan and elevation of the building, which was financed through the will of her brother Richard. Mitchell also worked for Trinity College and his copy after Kneller's coronation portrait of George I survives there, for which he was paid £20 on 16 July 1738.[3] Mitchell's pupil Michael Ford (d. 1765) is another virtually lost artist. He studied in France, Italy and London and was better known as a mezzotint scraper than painter. His paintings including one of *Lord Chief Justice Singleton* in judicial robes (1747), are now only known through his engravings. He worked as a dealer and picture restorer as well as a teacher of drawing and painting after his return to Dublin in 1742. He engraved a competently painted portrait of the fourth Earl of Barrymore after Otway, about whom nothing is known except the survival of this picture with its companion of his wife, Lady Barrymore. They were briefly on loan to the Crawford Art Gallery, Cork a decade ago.

A most intriguing painter was John Flynn (*c.*1690–1747). According to Strickland he practised and died in Galway but we think he also lived in Cork. There are two portraits of a dwarf, Master Chuffe (Fig. 31), and a jester still at Ballymaloe, Co. Cork, one of which is described by Charles Smith in his *History of Cork* in 1750.[4] One is signed by Flin and inscribed to the effect that they were painted at Shanagarry on 25 December 1709. There is a satirical poem on the dwarf with a dog and pigeon. In another poem, written as Flin's epitaph, he says he often painted saints, an unusual reference to religious painting. His work which has great gusto, is pure folk art, strangely enough, very rarely found in Ireland.

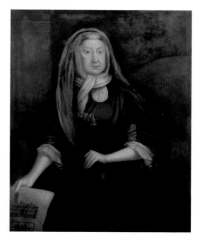

29 Michael Mitchell, *Grizel Steevens with the plans of Steevens Hospital*, oil on canvas, Eastern Health Board of Ireland

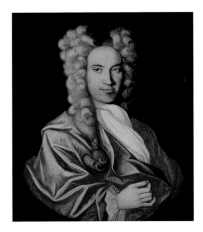

30 Anonymous, *Knight of Kerry*, oil on canvas, Private collection

31 John Flynn, *Master Chuffe*, oil on canvas, Ballymaloe Hotel

32 Anonymous, *Master George Quin of Adare with a black dog*, oil on canvas, Private collection

There are a few more competent portraits, but they are all unattributable and indicate that a number of other painters were at work during the first quarter of the new century. Among the better examples are a group of stylized, but vigorous likenesses of the FitzGeralds, Knights of Glin and Knights of Kerry (Fig. 30), which are markedly influenced by the work of the Scottish artist Sir John Medina (1659–1710). Tantalizingly, a portrait by the same hand which belonged to the Creagh family of Cahirbane, Co. Clare is signed indistinctly 'AP' or 'AT', but no names in the list of 'Painters Steyners' connect. Two members of the Westropp family of Limerick were also painted by him, the wife holding an elaborate riding whip. Another series, but by a different artist, is of Valentine Quin of Adare, Co. Limerick and his family, the most charming of which is *Master George Quin* out shooting with his black dog (Fig. 32). It is by a more primitive hand but less stylized. The black dog links this anonymous painter with the delightful picture of the *Black dog with the Franciscan Friary of Adare in the background* (Fig. 33).

Several foreigners following in the wake of the itinerant painter Joachim Croger (d. 1699) are known to have been at work. One of the d'Agars, Jacques or Charles, painted portraits of the Clanbrassil family which bear the inscription 'Dogar'. Numerous other works, looking like sub-Michael Dahls, of ladies in low-cut dresses, may well be attributed to them. Vertue records that a nephew of the fresco painter

Antonio Bellouchi worked in Ireland 'and in some years stay there clear'd about 2,000 pounds'.[5] Works by him have been identified in Scotland, but no certain attribution can yet be made in Ireland. Another, a landscape painter, Isaac Vogelsang (1688–1753), also mentioned by Vertue, worked in Ireland as well as in Scotland. He painted small pictures with farm animals and horses against Italianate backgrounds.[6]

The first of the family of Stoppelaer, Charles (*fl.* 1703–45) was also in Ireland at this time and is recorded as painting still lives as well as portraits. There is a signed and dated London work in the NGI (Fig. 34). Strickland mentions a still life which hung in the Hall of the Guild of St Luke. He became a 'quarter-brother' of the Guild in 1703 and was admitted to its freedom in 1708. This was probably because he was a Protestant and therefore came under an Act of 1662 'to encourage strangers and others to inhabit … Ireland'. He may well also have worked as an actor. In the 1730s he left for London, where he died in 1745. Two other members of the family, who Strickland thinks were not Charles's sons, were Herbert (d. 1772) and Michael (*fl.* 1730–75). They were both born in Ireland, but made their careers in England, where Michael also worked in the theatre. Herbert was a more interesting painter, working, according to Waterhouse,[7] primarily in Norfolk, but his most ambitious recorded picture is a family group of *Roger Bolas*, Mayor of Shrewsbury of 1765, with his wife and daughter all dressed in their Sunday best.[8] Herbert Stoppelaer went to London with Thomas Frye, whom we will discuss shortly. In a piece on Frye in the *Hibernian Magazine* for January 1789, taken from an article of the previous year in the *European Magazine* for December 1788, a Stoppelaer, probably Herbert, is

mentioned as Frye's companion and 'of this man many whimsical and ridiculous stories are in circulation'.[9] It adds that Stoppelaer could 'just keep his head above water, by painting' so he gave up the stage. In fact, he painted at least one picture, *Shylock and Tubal*, from the *Merchant of Venice* which is now in the British Art Center, Yale.

Another possible artist visitor is Hans Hysing (1678–1753), who came from Sweden. Works by Hysing survive in the Perceval collection and others of Sir John Perceval are recorded by mezzotints. It is interesting that a pair of paintings still in Dromoland, of *Sir Edward O'Brien* (Fig. 35) and his mother *Catherine Keightly*, by Hysing, cost £29.8.0. The case and two frames were sent to Dublin in 1732 for £6.18.0. The bills survive in the Inchiquin manuscripts[10] and were sent to Andrew Crotty, who was an agent for Lord Burlington in Lismore and was also in touch with Henry Boyle, later first Earl of Shannon. However, all these pictures may have been painted in England.

Not only foreign artists visited Ireland, but foreign paintings were being imported for sale.[11] From about 1681, when the first specialist auctioneer appears, and certainly from around 1700, chattels of every kind were being auctioned in Dublin. This does not, however, appear to apply to pictures. For instance, an advertisement in the Postscript to the *Dublin Gazette* for 22 July 1707 reads:

> A Choice Collection of fine Original Pictures, fit for Halls, Stair- Cases and Closets, lately brought over from Holland; As also a Collection of Limning, Indian and Painted Screens, Prints and Maps; Screwtores and Chests of Drawers; a large Looking-Glass and fine Glass Sconces, will be sold by way of Auction (or who bids most) in Lucas's-Coffee-House-Yard, on Cork Hill.

The explanation of the meaning of the word 'auction' seems to indicate that picture buyers had little experience of them.

The habit of gentlemen travelling abroad persisted and for the first time we learn of artists being lured to Rome for their education. The artistic climate of these times is best described in Bishop Berkeley's words to Sir John Perceval, later first Earl of Egmont (d. 1749), who was one of the most cultivated Irishmen of his day. Berkeley wrote on 22 September 1709:

> Dear Sir, I am sorry to hear from Dan Dering that you have lost your statues, medals, etc. that you had coming from Italy; though on second thoughts I almost doubt whether it may be reckoned a loss. Nobody purchases a cabinet of rarities to please himself with the continued light of them, nothing in it being of any farther use to the owner than as it entertains his friends; but I question if your neighbours in the county of Cork would relish that sort of entertainment. To feed their eyes with the sight

of rusty medals and antique statues would (if I mistake not) seem to them something odd and insipid. The finest collection is not worth a groat where there is no one to admire and set a value on it, and our country seems to me the place in the world which is least furnished with virtuosi.[12]

One member by marriage of the Dering family, Henriette de Beaulieu,[13] a Huguenot refugee (*c.*1674–1729), worked as a pastellist, drawing portraits of her husband's relations, the Perceval family and their connections between 1703 and 1705 (Fig. 36). In the latter year, her Dering husband having

33 Anonymous, *Black dog at Adare*, oil on canvas, Private collection

34 Charles Stoppelaer, *Portrait of a Gentleman*, oil on canvas, National Gallery of Ireland, Dublin

35 Hans Hysing, *Sir Edward O'Brien of Dromoland*, oil on canvas, Dromoland Castle Hotel

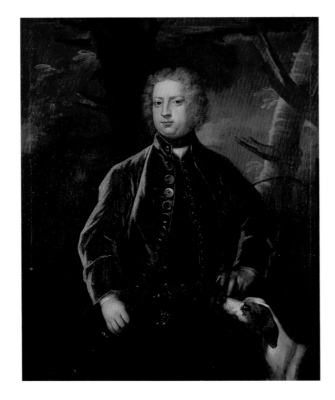

died, she married a clergyman, the Revd Gideon Johnston. They left Ireland in 1708, settling in the colony at Charleston, South Carolina, where she helped to support her husband by continuing her art. She was the first recorded woman artist in North America. She may have been taught by Simon Digby, the Bishop of Elphin (*fl.* 1668–1720), who was an established miniaturist and whose family were also painters. Another pastellist who may have worked in Ireland is Edward Lutterel (*fl.* 1673–1724), who worked on copper[14] (examples in the NGI). These artists are part of the groundswell of interest in the fine arts which developed rather hesitantly in Ireland in the first years of the eighteenth century, at the beginning of the period of lasting peace and stability in the now Protestant establishment.

The education of three young Irish artists in Italy was of little benefit to Ireland, as the result of their travels seems to have encouraged them to forget their birthplace and settle in the more congenial and cultivated society that Italy or the English capital afforded. Henry Trench[15] (d. 1726), a member of that extensive Galway family who spread throughout Ireland, was in Rome certainly by 1704 but possibly earlier and studied under Guiseppe Chiari, a pupil of Maratta. He had considerable success as a student in the Accademia di San Luca in Rome,[16] where his surviving drawings show him to have been a very fine draughtsman (Fig. 37). He knew his fellow Irish artists, Hugh Howard and Charles Jervas, as well as Perceval, Lord Burlington and William Kent. Trench was brought to the attention of Lord Shaftesbury and was employed by him to illustrate the second edition of Shaftesbury's *Characteristics*.[17] He returned briefly to England in the early

1720s, where he was commissioned to paint a ceiling in a temple at Shireoaks Hall, Nottinghamshire, which does not survive and may possibly not have been painted, as Trench was ill.[18] After a second visit to Rome,[19] where he worked under Solimena, he returned to London and died young, in 1726, of the pox.[20] As far as we know he never returned to Ireland.

Hugh Howard (1675–1738), who was born in Dublin, son of an eminent doctor, and whose brother Robert became a bishop and father of the first Viscount Wicklow, went to the Low Countries with Thomas, Earl of Pembroke in 1696 and from there to Rome, where he studied under Carlo Maratta, becoming a favourite pupil. Howard's drawing of his master is finely delineated and may have been touched up by Maratta himself as Lord Egmont (previously referred to as Sir John Perceval) says that 'he [Maratta] corrected his works and finished them sometimes with his own pencil'.[21] During his rather brief stay in Rome, Howard studied, in the words of Egmont, 'what the Italians call *la virtu*, and we a taste and insight in building, statuary, music, medals and ancient history'.[22] He was back in Ireland by 1700, though he travelled to and from England. In 1710, he was in Dublin after his father's death and stayed certainly until the next year, when his mother records, in a letter of 8 March 1711, that he 'hase done severall pickturs for the Collidg'.[23] Only one work, a portrait of Bishop Peter Brown in Trinity College, is signed, though others can be attributed from it. One is of Archbishop Marsh, of which there are two other versions; one, whole-length, in the Royal Hospital, Kilmainham and another three-quarter-length in his library adjacent to St Patrick's Cathedral, known today as Marsh's Library. His work is competent, robust, but unexciting and in no way influenced by his Italian sojourn. His most interesting pictures are the several he painted of the composer Corelli,[24] one of which (Fig. 38) has a novel composition of a painted surround of musical scores of work by Corelli, and musical instruments. Waterhouse[25] linked Howard's style with that of J. B. Closterman, using *Sir Justinian Isham* as an example. The letters of Bishop Robert Howard of Elphin to his brother have an amusing superlative when he foresees Hugh Howard as 'an Irish Raphael or Angelo'.[26] Other letters discuss buying pictures, architecture and sculpture.

A prudent marriage in 1714 relieved him from working for a living and he became a notable collector and dilettante. In the same year as his marriage, he secured, through the Duke of Devonshire's patronage, the post of Keeper and Register of the Papers and Records of State and in 1726 became Paymaster of the Royal Palaces, dying a rich man in 1738.

A most interesting aspect of his career is his work as a dealer, in which he was assisted by Trench, though in Ireland this side of his work was limited to his family and friends in Dublin. Barnard[27] summarizes these activities and quotes correspondence between himself and his brother, the Bishop of Elphin, and his

sister, widow of Anthony Dopping, also a bishop who was Vice-Chancellor of Trinity College between 1682 and his death in 1697. For instance, the bishop, his brother, writes asking him to send a mixed batch of paintings to Dublin, 'you know I have an eye to furniture in them', while protesting 'not that it is my taste but there are no judges here'. The bishop requested, 'if you meet with delightful landscapes or views of buildings, or other pictures cheap and well framed ... buy a few'. His sister asked for three paintings, 'not exceeding dear, such kind of pictures as you sent to my brother last', and specifies the dimensions and that

the frames be true gilt.[28] Howard despatched what he considered good versions after Guido Reni, Luca Giordano, Andrea del Sarto, Gaspar Poussin and Pellegrini. In England, he was working at a higher level, helping the tenth Duke of Devonshire and the famous Dr Meade make their great collections especially of drawings but also discussing acquiring Titian and Veronese. Howard's personal collection, which was considerable, came to Ireland to his nephew and heir, Ralph Howard, later the first Viscount Wicklow. This young exquisite as an undergraduate had renovated and decorated his rooms at Trinity College with

37 Henry Trench, *Reclining female figure*, signed & dated 1705, drawing, Academy of St Luke, Rome

38 Hugh Howard, *Arcangelo Corelli*, c.1699, oil on canvas, National Gallery of Ireland, Dublin

a collection of at least fourteen pictures, two of which had carved and gilded pear-wood frames.[29] Another important Irish family of collectors and dealers operating in Italy were Thomas and Dr James Tyrrell.[30] The latter seems to have taken over after Howard's death in helping Lord Wicklow with his furnishings and picture collecting. Sadly, like most Irish collections, those at the Wicklow seat, Shelton Abbey, have all been dispersed.

Charles Jervas (c.1675–1739) was the most important of the trio, but clearly left himself open to satire, as no other Irish artist has been so commented upon. He came from Shinrone in Co. Offaly and was a member of a gentry family. Of the three, he is the most closely associated with Ireland. Born there about 1675, he studied under Kneller c.1694–5, and started a lifelong interest in copying Old Masters about 1698, when he made copies of Raphael's cartoons for Dr George Clarke of All Souls, Oxford. Two of his copies were used by the French artist Audran for his engravings of the cartoons. Clarke had links with Ireland going back to the period of the Williamite wars. He was connected with the architectural world of Dublin at the time.[31] Clarke and other friends lent Jervas some money to go to Italy in 1698. Another source of finance was the death of his father. His will was proved early in 1698, and from newly found letters Jervas was in Paris by May 1698.[32]

Vertue notes that he was called 'Carlo Jervasi' and continues, 'he haveing learnt the art of painting at the wrong end was 30 years old, when att Rome, & Esteemd as good, engenious painter. he began then to learn to draw as if he had never learnt before'.[33] Many of the copies after Carlo Maratta and other Italian painters which were included in the sale of his collection[34] after his death must have been drawn at this

time, though many were done in England later. He returned to England in 1709 and then, as Vertue says, 'by his talk and boasting manner he had a great run of business when he first came from Italy but it would not do, what he did answerd not expectation'.[35] Despite Vertue's cattiness, Steele could say of him: 'The last great Painter Italy has sent us, Mr Jervase'[36] and goes on to note that he painted 'a lady, as a shepherdess, and another as a country girl'. He moved in the highest circles of the literary and social world and became an intimate of the poet Alexander Pope, to whom he gave drawing lessons about 1713. He was also a friend of Swift, whose portrait he painted several times,[37] the most famous in 1724, showing the satirist seated in an armchair in his study (NPG).

Unlike most other absentee Irish painters, Jervas regularly visited Ireland. The first recorded visit of 1715 is mentioned in a letter from Pope to Jervas, dated 9 July 1716, when he writes:

> Your Acquaintance on this side the Sea are under terrible Apprehensions, from your long stay in Ireland … Everybody Here has great need of you. Many Faces have died forever from want of your Pencil, and blooming Ladies have wither'd in expecting your return… Come then, and having peopled Ireland with a World of beautiful shadows come to us.[38]

Jervas was in Ireland till December 1716, and again from June 1717 to September 1721, though he may have paid short visits to London in between. Two later recorded visits were in 1729 and 1734. However, the number of Jervases in Ireland is not as great as might

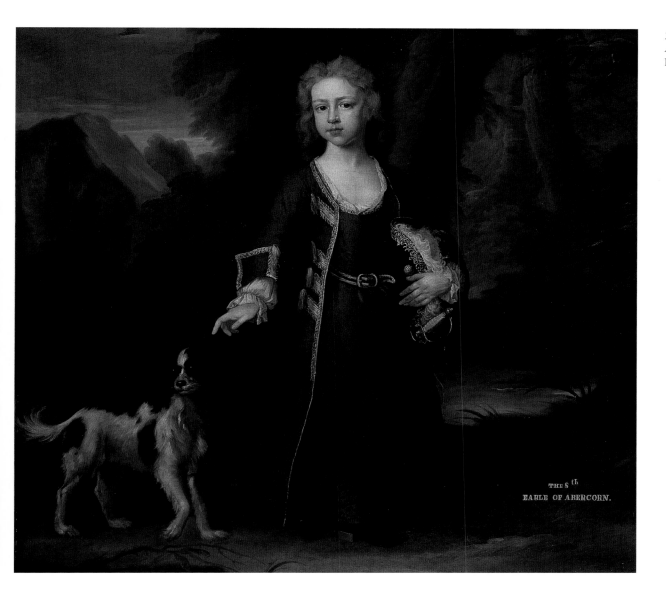

39 Charles Jervas, *The eighth Earl of Abercorn as a child*, oil on canvas, Private collection

be expected. He painted Speaker Conolly, and his wife and great-niece (both at Castletown House, Co. Kildare); he worked for the Cosbys at Stradbally; he painted a charming whole-length of the youthful John, Lord Boyle, later fifth Earl of Cork; a handsome three-quarter-length of *Col. William Forward*,[39] whose daughter married the first Viscount Wicklow, and a large number of other sitters. One of the finest male portraits is of Alexander Pope (Bodleian, Oxford) and his masterpiece is the double portrait of Martha and Teresa Blount at Mapledurham – two girls who were closely associated with Pope. Unusually, the Blount girls do not languish as so many of his insipid females appear to do. Vertue noted this when he said: 'his works rather appear to me like. fan painting fine silks. fair flesh white & red. of beautifull colours but no blood in them or natural heat or warmness. much a manerist …'[40] Lady Mary Wortley Montague, whom he painted frequently, amusingly and aptly, felt when she visited the Ladies' Baths at Adrianople that to 'Tell you the Truth, I had the unkindness to wish secretly that Mr. Jervas had been there invisible. I fancy, it would have much improved his art to see so many fine women naked, in different postures'.[41]

The Reclining Lady, *Jane Seymour Conway* in the NGI is a good example with fine fluidly painted drapery. Another pair of unusual pictures in his *œuvre* are the still lives he painted for Sir Robert Walpole[42] at Houghton, now known only in engravings. He is notable for his paintings of children, either singly or in groups, such as the family of Lord Townshend, who are 'bird nesting'. Mostly they are quite young and he achieves the appealing softness of childhood with great skill, as in the portrait of James Hamilton, later eighth Earl of Abercorn (Fig. 39). The sitter is young enough to wear girl's clothes and is walking in a mountainous and wooded landscape with his spaniel, clutching his braided tricorne hat with an ostrich feather. Waterhouse noted that he studied van Dyck for drapery but also for his poses. He has a few of these frequently repeated, sometimes back to front so that his works tend to look alike. Waterhouse admired the flowing quality of his silks and satins and amusingly considered that his women 'all look astonishingly alike and resemble a robin or one of the birds of the finch tribe'.[43] At the end of his life, he was much patronized by Walpole, whose nephew Horace had no opinion of him, and described his paintings as 'wretched daub-

40 Francis Bindon, *Dean Swift*, oil on
canvas, The Deanery of St Patrick's
Cathedral

drawings, briskly described by Vertue as 'so much
trash'.[48] His reputation quickly evaporated and
Reynolds's sister remarked that 'she had heard so
much of Charles Jervas … and had seen so little of
them', Reynolds replied 'My dear, you will find they
are all removed to the attic'.[49]

Mezzotints can be a most useful method of identifying
Irish portraits, as the artist's name is frequently given.
For instance, at Kilrush, Co. Kilkenny, several por-
traits of the St George family have hanging beneath
them mezzotints from which they can be attributed to
Francis Bindon (*c*.1690–1765), who was a gentleman
amateur and the only Irish artist, other than Jervas, to
study under Kneller. He made a tour to Italy in 1716,
where he is mentioned in Padua with his cousin,
Samuel Burton.[50] He developed into a reasonable archi-
tect and his paintings, though stiff and awkward, have
a masculine directness in their handling. Bindon's ear-
liest known work is a probable self-portrait (NGI)
which shows the influence of Kneller but is less solid
than his later work. He excelled himself in his full-
length portraits of Swift, who, with Dean Delany and
Thomas Sheridan, were his intimates. The finest of his
Swifts, all four painted between 1735 and 1740, is the
one at Howth Castle which commemorates Swift's
patriotic campaign over Wood's Halfpence. Swift
derided, correctly, Bindon's quality and wrote to the
Revd Thomas Sheridan in 1735, 'I have been fool
enough to sit for my picture at full length by Mr
Bindon for my Ld Howth, I have just sate two hours
and a half'.[51] A posthumous portrait, formerly in the
Shannon Collection of the third Lord Burlington, is
mentioned in a letter of 1 April 1732 to Henry Boyle of
Castlemartyr, asking whether he is prepared to take
possession of a portrait, not a distinguished work, of
the late Lord Burlington, 'as Mr Bindon must soon set
out for England'.[52] He painted the Lord Lieutenant,
the Duke of Dorset, in 1733 and no doubt due to his
family connections was one of the rare artists to have
a government pension of £100 a year.[53]

 Bindon's full-length portrait of Archbishop Boulter
surrounded by suppliants begging, painted during the
famine of 1740–1, was originally hung in the Dublin
Workhouse but has been in the Provost's House of
Trinity College since the middle of the last century. It
has a superbly carved contemporary frame, probably
by John Houghton (*fl*. 1731–61), whom Bindon had
employed to frame his *Swift*[54] in the Deanery at St
Patrick's Cathedral (Fig. 40). The frame of the Boulter
portrait contains symbols of charity and religion.
 Charles Exshaw[55] (*fl*. 1747–71), a pupil of Francis
Bindon, went on in 1747 to study in France. He trav-
elled extensively over the years 1747 to 1755 returning
to Dublin 1755–7. He then set out for a second tour to
Paris, Amsterdam and Italy, staying for some time in
Rome. In Paris, he worked under Carle van Loo
(1705–65) and in 1757 he made mezzotint portraits of
two of van Loo's sons. *The Dublin Courant*, No. 498, of

ings'.[44] Kneller felt the same, when he heard that Jervas
had acquired a carriage and four remarking 'Ah, Mein
Gott if his horses do not draw better that he does, he
will never get to his journey's end'!*[45]

 However, Jervas was appointed Principal Painter to
George I on 23 October 1723, an indication of his con-
temporary standing. Later, in 1738, he visited Italy
again to buy pictures for the king, but he died shortly
after his return, saying, according to Pope, 'Life itself
[was] not worth a Day's Journey at the expense of
parting from one's friends'.[46] No doubt assisted by the
financial benefit of an advantageous marriage (to an
heiress reputed to have fifteen or twenty thousand
pounds), he became a great collector. The size of his
collection is witnessed by the fact that the sale of his
works of art after his death in March 1740 took thirty-
four days and included 2,275 lots.[47] It included many

14 February 1789, says that he was awarded a medal[56] while in Paris, presumably from the Académie Royale. When in Italy,[57] he etched 'from the life' Carlo Maratta's model, and drew a fine study of a *Bearded Old Man* in 1758. A portrait of a gentleman holding a book (NGI) is signed and dated 1760. He has a remarkably haughty expression.

He was a successful dealer, making collections on his tours which he sold at auction sales in Dublin in 1755 and 1762. These were held in a well-known venue for auctions, Geminiani's Rooms. His known oil portraits all date from his return to Ireland in the 1760s and are inferior to his prints and drawings, which show the marked influence of Rembrandt. In 1764, Exshaw moved to England, where he exhibited portraits and landscapes at the Free Society of Artists and the Society of Artists.

In his early days, Bindon may well have been patronized to some extent *faute de mieux*, as certainly in the 1720s his only resident competitors were men like Anthony Lee and Justin Pope Stevens (d. 1771), discussed later. An Englishman, Stephen Slaughter (1697–1765), a pupil of Kneller's academy in 1712, spent much of his career in Ireland. According to Vertue, in the 1720s he was abroad in Paris and Flanders, and indeed worked there for some seventeen years,[58] and first appears in Ireland in 1734 when he painted the Lord Mayor of Dublin, Nathaniel Kane. This visit seems to have been short, for his other signed and dated works from 1735 to the early 1740s appear to be of English sitters. But there are numerous portraits of Irish sitters from 1741 to 1748 still in Ireland. A superb portrait of John Rogerson (NGI), dated 1741, shows marked French influence, as does his lively and well-conceived rococo study of Mrs Malone. A long visit is likely in view of his influence on Irish painters, but he must have returned to England, if only briefly, for Vertue in 1744–5 says that 'this painter has lately been in Ireland at Dublin. where has done many portraits & has had there great busines'.[59] He had become Keeper and Surveyor of the King's Pictures in 1744 which also suggests that he was in England in that year, though several Irish portraits are dated then, including that of Archbishop Hoadley and Elizabeth Brownlow, wife of the first Lord Knapton. Slaughter is at his best as a costume painter, showing great skill in the episcopal splendour of lawn sleeves, the magnificence of gold braid, lace and embroidery and in the rococo frills and flowers beloved of his female sitters. His backgrounds tend to be backcloths, but his ladies, usually artificially posed, look sprightly against their pastoral and sylvan props, such as *Miss Henrietta O'Brien* (Dromoland Castle Hotel) in the guise of a shepherdess.

Of a number of his portraits, notably that of that great racing man Sir Edward O'Brien, Bt, the remarks of Bishop Berkeley in *The Querist* concerning the over-elaboration of dress of the Irish gentry are singularly apt.[60] O'Brien's sporting intimate, *Windham Quin of*

Adare (Fig. 41), is shown similarly attired in extravagant quantities of silver lace, especially on the enormous cuff on his velvet coat, though in another portrait[61] he is seated simply dressed, out shooting with his gun-dog and game.[62] Vertue makes a significant comment that Slaughter 'is always happy in his Designs – and finishes the whole with his own Hands – not common'.[63] We have no evidence of how an Irish studio was run or if Irish painters employed assistants and drapery painters, though we assume that some of them must have done so.

Slaughter's closest Irish imitator was Anthony Lee (d. 1769), whose work we know from 1722, when he signed and dated a portrait of Sir Isaac Newton aged eighty.[64] This was almost certainly a copy; Lee was an excellent copyist. In turn, a copy of Lee's work by Angelica Kauffmann of *Joseph Damer* shows him painting a remarkable French baroque composition, in itself almost certainly based on an engraving. On his own, he varies from a naïve transcription of Slaughter to the

41 Stephen Slaughter, *Windham Quin of Adare*, oil on canvas, Private collection

42 Anthony Lee, *Richard Wingfield, first Viscount Powerscourt*, oil on canvas, Private collection

strutting pose of his *Lord Milltown* of 1735 (NGI), whom he painted more successfully in an attributed small whole-length in a country-house setting.[65]

There are a number of paintings of the Molesworths, the Leesons, Earls of Milltown,[66] the Brabazons, Earls of Meath, the Maxwells, later Lords Farnham, and a fine portrait of Earl Grandison sitting in his library. One of his best works is his three-quarter-length of the first *Viscount Powerscourt* (Fig. 42) with the Powerscourt waterfall in the background,

a picturesque feature which the viscount promoted as an attraction for Dubliners. The rocky wooded scenery of the Dargle was also on his property and this whole area was the perfect example of wild nature in easy reach of Dublin artists. His second *Viscount Southwell* (d. 1766) in peers robes (Fig. 43), also has a topical background of the Irish Parliament House with its original dome, making the picture an important icon of Ireland's colonial ruling class in the mid-century. Another, representing a different world in

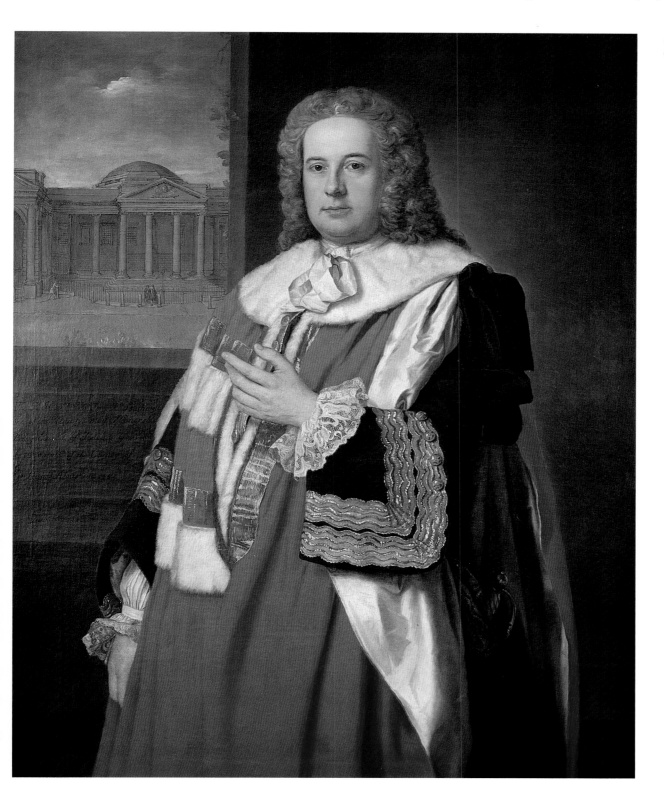

Irish society, which is not his best as a painting, is also deeply interesting historically. It shows a member of the Devereux family, who were 'Wild Geese'.[67] Their Irish property was Dungulph Castle, Co. Wexford, and this forms the background to the owner with his horses and hounds. Though Lee is a pedestrian painter, it is these occasional sidelights into the life and times of the sitters that make him of interest.[68]

A soft-edge imitator of Lee is Jeremiah Barrett (d. 1770), who was the son of a Dublin silversmith and painted in the west of Ireland. Nothing is known of his life, but a number of works are known, including

Henry L'Estrange of Moystown, a signed and dated picture of 1753, and *Master Daly* (NGI), dated 1765. Another example is in Westport House, the signed and dated *Anne Gore, Countess of Altamont* in her peeress's robes 1763, and a further example is the head-and-shoulders of *Colonel Dominick Browne of Castle MacGarrett*, Co. Mayo as a young man. Also from Castle MacGarrett is another portrait of a Browne, three-quarter-length in a blue coat with a pudgy-looking dog, perhaps Dominick when older and very like Henry L'Estrange. The portrait of John Stacpoole of Cragbrien Castle was engraved by James Watson in

44 James Latham, *Christopher Butler, Catholic Archbishop of Cashel*, c.1714–20, oil on canvas, University College, Dublin

45 James Latham, called *General Wade*, 1730–5, oil on canvas, National Gallery of Ireland, Dublin

46 James Latham, *Unknown man*, oil on canvas, Private collection

facing page
47 James Latham, *Pole Cosby and his daughter Sarah*, c.1742, oil on canvas, Private collection

mezzotint. It was probably one of Jeremiah Barrett's last works and, either through the talent of the scraper or because the paint was still intact, it is a creditable work. Most, if not all, of his surviving pictures have suffered badly at the hands of restorers.

By a long way, the most distinguished painter in the first half of the eighteenth century, and the only Irish portrait painter who transcends the parochial picture of Irish art at this time, is James Latham (1696–1747). Pasquin, who provides us with almost all the known facts about his life, tells us that he came from Tipperary. There was a landed family of Lathams at Meldrum and Ballysheehan near Cashel, but unfortunately the genealogy of this family in the National Library does not include any James and a search of the Registry of Deeds also yields no clues. However, a James Latham of Thurles, Co. Tipperary appears in a document of 1706, possessing property in Cashel which was witnessed by Oliver Latham of Meldrum, so he was almost certainly a member of this family, which included some with the name of James.[69] His will,[70] dated 1 January 1746, known to Strickland, gave his wife's name as Joan and said he had one son, James, and four daughters.

Though we know nothing of Latham's early training, Ireland was less of an artistic desert in the first years of the eighteenth century than has often been indicated. Garret Morphy did not die until 1716 and the young Latham may well have known him in Ireland's small artistic coterie, though there is no evidence of influence until quite late in Latham's career. Hugh Howard and Charles Jervas were visitors, the latter for long periods, and they must have brought over the latest London artistic gossip and ideas. A rather younger contemporary was Nicholas Blakey (*fl.* 1747–78), who lived for years in Paris and whom we discuss later in this chapter.

A significant family connection is that Oliver Latham of Meldrum, was appointed in 1695 by the second Duke of Ormonde as Commissioner of Oaths[71] of the County Palatine of Tipperary. This leads us on to the earliest identifiable portraits by Latham, which are of the Duke's cousins, *James Butler of Kilcash and Ballyricken* and *Christopher, Catholic Archbishop of Cashel* both of which must date to c.1718–20 (Fig. 44).[72] The Butlers were, despite the penal laws, one of the most prestigious families in Ireland. As we have indicated, we know nothing about Latham's training, but the portrait of Thomas Butler in armour is a similar composition to Nicholas de Largillière's portraits, for instance, of Frederick Augustus, Elector of Saxony. This might suggest that he had been in France; one must remember that Catholic and Huguenot circles in Ireland (Latham painted several Huguenots) all had close connections with France and, for a boy in Tipperary, Paris would have been as easy an attraction as London. He would have known that great collection of pictures in Kilkenny Castle made by the first Duke of Ormonde and his duchess, particularly the portraits by van Dyck and Lely, not to mention those by John Michael Wright

and William Wissing. In this way, he had a similar background to English portrait painters. There were also pictures at Kilkenny by the great Italians and Flemings. Unfortunately, this collection was largely dismembered by 1718–19, but this is not too early for the young Latham to have been acquainted with it. Other early portraits by Latham were also of Catholic aristocratic families; as a young Protestant, he must have accepted the commissions on social grounds and indeed they must have made his name.

The first certain record of him is of his visit to Antwerp, where he is mentioned in the lists[73] of the Antwerp Guild of St Luke. It is recorded there that 'Jacobus Latham, schilder [painter]' became a master of the guild between 18 September 1724 and 18 September 1725. He paid the sum of twelve florins, 'op Rekening' that is, on terms: this sum probably paying for one term, the other two not being recorded. The other new members paid thirty-six florins, which apparently was the full fee to be paid, so another interpretation is that he left without paying his full fees or only stayed one term.

Our assumption that he had his artistic training before he went to Antwerp is based on the fact that he was twenty-eight in 1724 and must have started to paint many years earlier. It is fair to assume that he travelled to or from Antwerp via Paris, though we are inclined to think he was there earlier. Pasquin says that he returned to Dublin in 1725.

A visit to England must have taken place, though precisely when is speculative, as Vertue never mentions him. Waterhouse[74] suggests the 1740s, but Latham was a fully fledged artist by that date and indeed died in 1747, so a visit to London is possible but would not have made much stylistic difference. There was little enough to interest him in London in the

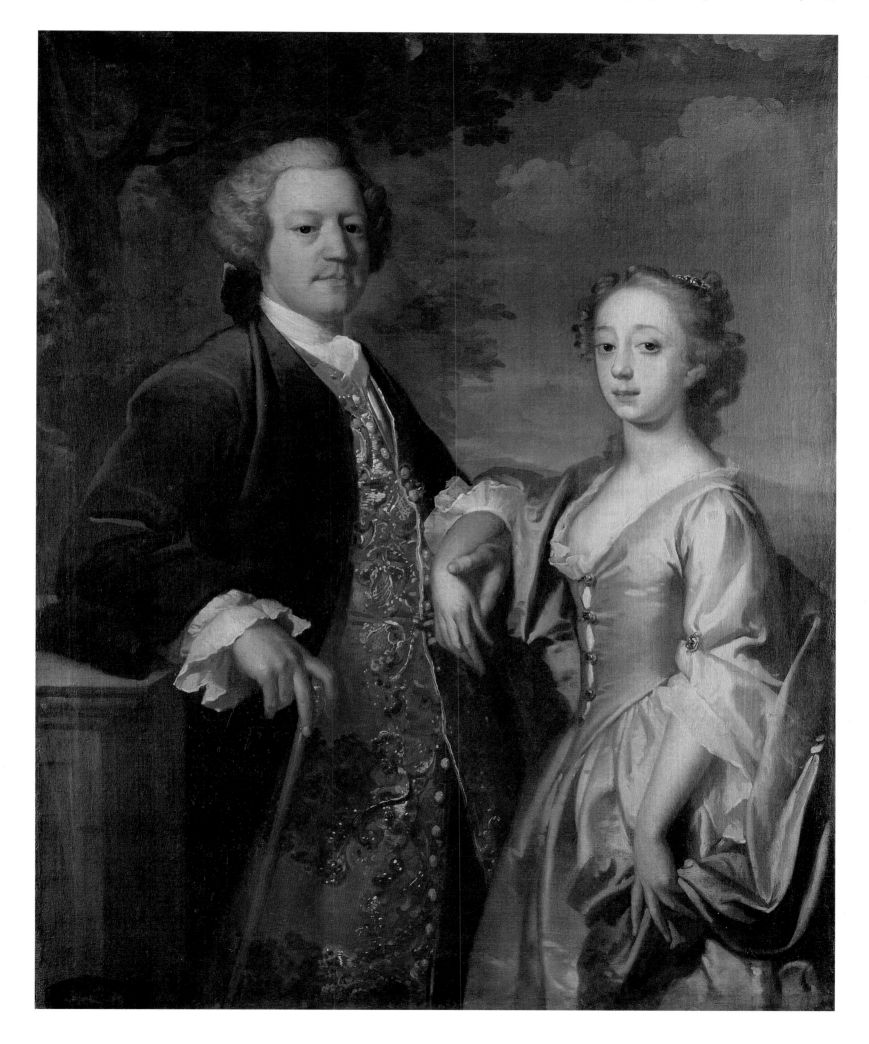

48 James Latham, *George Berkeley, the younger*, oil on canvas, Private collection

1720s except the English portraitist Joseph Highmore (1692–1780); Frans (*c.*1719–83) and Herman van der Myn (1684–1741), with whom he may also have been in contact in Flanders; and the Swedish artist Hans Hysing (1678–1753), who may, as we have mentioned, have visited Ireland, for he painted several members of the Perceval family. A portrait signed by Hysing sold as a Latham in 1998.[75] One cannot help noticing how similar Latham is sometimes to Allan Ramsay (1713–84), Hysing's pupil, but the dating of Ramsay's career and pictures do not coincide with Latham's work. Highmore painted several portraits such as the three-quarter-length *Girl with her Pug* dated 1738 (Sheffield City Art Gallery) which links with Latham, but mostly they are dated quite late in Latham's career. Hogarth, with whom his portraits are even to this day confused, was not painting life-size portraits until the 1730s, by which time Latham was established in Dublin. There is, however, a small bust portrait until recently attributed to Hogarth in the NGI but now recognized as being by Latham (Fig. 45). It was also called a portrait of *Field Marshal Sir George Wade*, an identification which is now contested.[76] It is of very high quality and one of Latham's masterpieces, with its flickering highlights and delicate handling.

The problem of influences and similarities is discussed by Brian Allen, who quotes a Frenchman, Abbé Le Blanc, who was critical of the sameness of British portraiture at this date, the late 1730s. He says, 'at some distance one might easily mistake a dozen of their portraits for a dozen of the same original …'.[77] Identification of Latham's work is based on the *Bishop Berkeley* in TCD, which was engraved, but not dated, by J. Brooks. The subsequent discovery of another engraved work of *Eaton Stannard* (NGI), which shows the sitter as Recorder of Dublin, an office he held from 1733, confirmed numerous attributions such as the *Charles Tottenham*[78] in the NGI. A work identified through an early nineteenth-century inscription is the *Colonel Charles Janvre de la Bouchetière* (UM), a Huguenot officer, which must date from before his death in 1731. It shows how much more sophisticated Latham became after his Antwerp visit. The sitter wears a breastplate under his beautifully embroidered coat. He points with his right hand in a gesture which can also be matched in French painting. The grandeur of his bearing is achieved with no props and he is perfectly placed within the canvas, unlike Thomas Butler, who is too low in the picture space. Close in style and probably in date is the *William, fourth Earl of Inchiquin*[79] (Dromoland Hotel), who is wearing the Order of the Bath, which was reinstituted in 1725; the portrait may therefore have been painted to commemorate this event. It has the same silvery tonality as the *de la Bouchetière* and the *Unknown Man* (Fig. 46) and they introduce us to Latham's superb handling of embroidery which blossoms in the 1740s. Another probable early work is the *Richard Wesley, later first Lord Mornington*,[80] which has all the vigorous painting that is apparent in a series of gentlemen's portraits

of the Pakenham, Cosby, Leslie and Nugent families. Apart from the *Colonel de la Bouchetière*, there are two other notable portraits of military men, one known only in engraving, *Sir John Ligonier*, who, like *Lord Inchiquin* is wearing the ribbon of the Order of the Bath, and *General Thomas Bligh*. The latter is one of Latham's most memorable paintings, almost French in feeling with its vivid colour and its animation and strength.

Pasquin recounts a story about the dissatisfaction of one of Latham's female clients which was probably founded on fact, as his handling of female sitters is markedly inferior, with their frog eyes and bored expressions. Notable exceptions to this are the Cosby ladies in the magnificent series of three-quarter-length pictures of Pole Cosby, his wife and children, painted in the 1730s and 1740s. One of these is the portrait of his wife and their toddler son Dudley, which, with its pair, the group of *Pole Cosby and his daughter, Sarah* (Fig. 47), display vivid characterization and fine modelling together with strong brush strokes. They contrast with the theatrical, rococo elegance, culled perhaps from a knowledge of Watteau, of the youthful *Dudley Cosby*, probably painted some six or seven years later, which has unfortunately been cut from its original three-quarter or whole-length. Sarah, of whom there are two portraits besides that with her father, was painted as a child, as a teenager with her father, and two years later, after her marriage to Arthur Upton of Castle Upton, Co. Antrim, when she is seen in a superb pink dress, offering cherries to her parrot. The Cosby pictures, which must span at least ten years in Latham's career, are extremely important for his development and show his love and understanding of children which appears also in his portraits of the Lambert children of Waringstown, Co. Down and of Bishop Berkeley's young son, *George* (Fig. 48).

A very few whole-length portraits by Latham survive, of which *The Duchess of Norfolk* (Fig. 49), wife of the eighth duke, is extremely fine. It brings up the problem of a possible visit later in his life by Latham to England, as there seems to be no evidence that the duchess visited Ireland. However, the portrait was in an Irish Catholic collection, and she came from a Catholic family from Lancashire, so a family friendship or connection may have existed. One of the features of the portrait is a superbly painted pot of carnations. Flowers are always very well painted in Latham's works, notably in the later examples such as *Master Dudley Cosby* or *Lady Tullamore with her cousin and heir John Coghill*, who is playing a drum, painted *c.*1737/8, probably on her marriage to John, Lord Tullamore, later first Earl of Charleville, in 1737. This picture, and its companion of Lord Tullamore, is a whole-length.

Besides the Cosby groups and the painting of Lady Tullamore and her cousin, Latham is notable for a number of double portraits, *Bishop Clayton and his Wife*[81] (NGI), *Two Ladies of the Leslie Family at the Harpsichord* and a family group said to be of *Two Ladies*

49 James Latham, *Duchess of Norfolk, wife of the ninth Duke*, oil on canvas, Private collection

of the Chardin Family with a Baby (Wood Collection, University of Limerick). In the Leslie ladies, one can detect the influence of Morphy, especially in the standing figure. It is worth remembering that Latham was twenty when Morphy died and that the latter was

the only good painter in Ireland in Latham's youth. He may well have influenced him and suggested the Antwerp training in view of his own knowledge of Netherlandish art. In the 1740s, several three-quarter lengths indicate a connection between Latham and

50 James Latham, *Sir James Cotter*, c.1740, oil on canvas, Private collection

Slaughter. The costume painting of Latham's *Sir Capel Molyneux* (1740, Tate Britain) and his *Sir James Cotter* (Fig. 50) and Slaughter's *John S. Rogerson* of 1741 (NGI) makes this very plain. Cotter's wife was a Rogerson, so there may be some close family connection.

Until the early nineteenth century, Latham remained a well-known name, for Warburton, Whitelaw and Walsh mention Latham in an entry, mostly plagiarized from Pasquin, saying 'some of his pictures would do honour to a modern [that is, regency] painter for colour, breadth, familiarity of execution and good drawing'[82] and it was a strange fate that resulted in his total eclipse until recent times. The emphasis it lays on his painterly qualities is a fair estimate, as it is for the beautiful brushwork, with its contrasting delicacy and breadth, varying from sparkling braids to the soft density of a powdered wig that lifts him above the level of his humdrum fellow artists. Thomas Campbell in 1777 noticed this, saying: 'I have seen very good portraits here, those of Latham are admirable and far superior to those of Mr. Jervaise …'.[83] Pasquin's comment was that 'His portraits … were painted in so pure a stile, as to procure him the title of the Irish Vandyke' and also tells us that 'he painted history, but not with equal success'.

It must be said that Latham was a very busy man and did not always keep his standards as high as he should. He may well have employed assistants, but one must remember that his range of pose and expression is wider than the numerous surviving bust-length portraits might make one think. He moves from the dignity of *Lord Inchiquin* and *de la Bouchetière* to the loving and cultivated Cosbys, the lively and thoughtful Bishops (of which a newly discovered example in the Armagh Musuem is a splendid addition), to the men-about-town who were, without doubt, among his favourites.

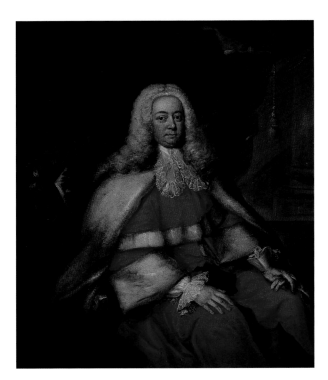

51 Philip Hussey, *Judge Blennerhassett*, oil on canvas, Private collection

There is a half-length, said to be, without any documentary evidence, a self-portrait, hands hugging his waistcoat, with a marvellous, proud and arrogant face – maybe it is him (NGI). There is nothing sour-faced about Latham. He puts on his paint with direct firm strokes, he enjoys colour when it comes his way and tonal quality when it doesn't; he has a strong feeling for form and all his sitters are alive and vigorous, but the details are often applied with unexpected delicacy. A few of Latham's ladies, apart from the lovely Sarah Cosby, are delicate and young, like the unknown lady, known as *Stella*, in the NGI. Many of his ladies are middle-aged and treated with sympathy and charm. There are few portraits of children, but these include the delightful *Ralph Lambert* and young *George Berkeley*. The manner in which Latham paints their frilled collars and ribbons with his touches of colour reminds one of Chardin. Despite his dates, Latham shows little evidence, except in colour and in the portrait of Dudley Cosby, of the rococo. He is much too interested in solid form and character, and it is this sympathy with people that makes his portraits still a fascination when their likenesses are no longer a concern.

Philip Hussey (1713–83) owned a self-portrait by Latham which, according to Pasquin, 'was exceedingly valued by the possessor', so they must have been close friends. At times, their work can be disconcertingly similar, to the extent that we consider the twin portraits of Lord and Lady Carlow to have been painted by Latham and Hussey respectively. *Judge Blennerhasset of Riddlestown* (Fig. 51), a small three-quarter-length, is a very minutely painted work which also has considerable similarities to Latham and also to Slaughter. As they were all in a tiny circle in Dublin, this is not surprising, but it frequently makes attributions difficult.

Hussey came from Cork and began his career as a sailor. Pasquin goes on: 'He was ship-wrecked five times – he evinced his disposition for the Polite arts, by drawing the figures from the sterns of vessels.' Strickland, who clearly had some undisclosed source, says that: 'he twice visited England and improved himself by the study of the old masters. He made several copies of a head of Cromwell by Lely, which he disposed of advantangeously in Ireland. On his second visit to England he was introduced to the Prince of Wales.' Hussey was a protégé of Lord Chancellor Bowes, whose portrait he painted in his robes; his head is finely detailed and is amongst his best character studies, as he shows the judge in quizzical mood.[84] There is a signed and dated Hussey of 1754 of Sir William Yorke, Chief Justice of the Common Pleas, whose face is sharply delineated. The Bowes is clearly by the same hand. It is an unusual work, in that Hussey had to paint elaborate gold lace and raised embroidery in the purse. His male costumes tend normally to be fairly simple, perhaps because he had no drapery painter. Hussey can be easily mistaken for Slaughter, to whom the Bowes portrait has been

attributed. Slaughter painted magnificent costumes, as we have already noticed.

Hussey is at his best with female portraits, and enjoyed the trappings of baskets of flowers, necklets and pearls and the light cascades of lace on the sleeves so much that the portraits of many of his ladies and young girls are densely decorated with them. Examples include *Mrs Sophia Tipping and her daughter, Wilhelmina Salisbury*,[85] *Lady Elizabeth Tynte and her son* (Fig. 52), *The Countess of Brandon* and *A Lady of the Smyth family* of Ballinagall, Co. Westmeath. His early male portraits can be markedly baroque, with props such as drapery curtains. *Master Edward O'Brien*, a signed and dated (1746) work (Dromoland Hotel), is an excellent example, as is *Sir Compton Domville*, with his plans for his formal garden at Templeogue,[86] with its rustic arch and waterfall in the background. Another early example is somewhat different. This is the fine bust portrait of David La Touche[87] of Bellevue (Bank of Ireland) which is dated 'Aug.ᵗ 1746'. It is simple, clear-cut and with Hussey's typical porcelain flesh tones. His eyes and their surrounds are always closely pencilled in and his faces rarely show any great character. Other signed portraits include *Captain and Mrs Prendergast*. Four charming children are two young Hamiltons from Portglenone and a girl of the Bland family in her mob cap, holding her pug dog (Fig. 53), and a teenage girl, *Miss Anne O'Brien*. *Mr and Mrs Matthew Lynch* of Galway have the same doll-like quality as his children and strong, vibrant colours. The repetition of a basket or bunch of flowers makes one speculate on whether he painted flower-pieces as well. Pasquin mentions that 'He was a botanist and florist', which makes it all the more likely.

Hussey's male portraits are incredibly alike and fairly dull and stiff. Later works include *Sir Edward Leslie*[88] and *Edmund FitzGerald, Knight of Glin*. These are good examples, though neither of them is signed. He is also influenced by the early work of Robert Hunter (*c*.1715/20–*c*.1803), particularly in his portrait of *Lady Meredyth*[89] of 1764, who is seen seated with her spectacles and a book, and in such a late work as the *Revd William Lodge* (Armagh Museum), seated with his books as a student in Trinity College, Dublin, where he obtained his BA in 1777. This picture also shows the clear 'enamel' finish of the face and a much smoother textured and less fussy treatment of clothes and details than in his earlier work. As his tendency was to sign on the back of the canvas, lining must have obliterated a great many signatures. All six portraits of a set of the Hodder family of Fountainstown, Co. Cork are signed with a monogram 'PHofsey' and dated 1739 to 1740 on their reverse.

Hussey lived long enough to become the centre of the Dublin artistic circle. Pasquin, who knew him personally, said:

His house, on every Sunday morning, was the rendezvous of the literati and painters of Dublin, who there sat in judgement on the relative occurrences

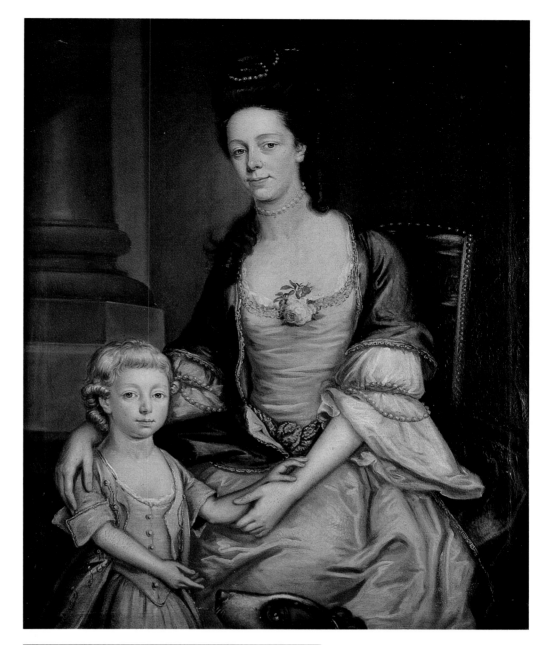

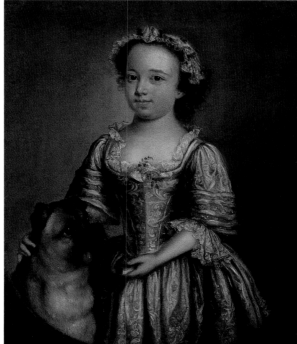

52 Philip Hussey, *Lady Elizabeth Tynte with her son James*, oil on canvas, Private collection

53 Philip Hussey, *Miss Bland*, oil on canvas, Private collection

54 Nicholas Blakey, *J.T.B. Marwood*, signed and dated 1755, oil on canvas, Private collection

55 John Lewis, *The Judgement of Midas*, signed and dated 1737, oil on canvas, Private collection

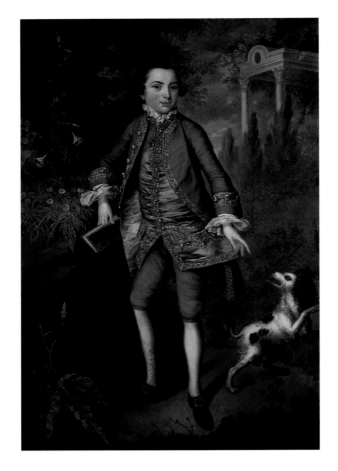

A painter of a small three-quarter-length was James Curry (*fl.* 1738–9), whose portrait of the third Viscount Mountjoy, Grandmaster of the Irish Freemasons 1738–9, has been identified from a mezzotint by John Brooks of 1741. This competently handled work shows Mountjoy in his masonic regalia and indicates that other unknown hands, like Curry, were about at the time.

Nicholas Blakey (*fl.* 1747–78) is almost as little known, except that he worked in England illustrating books, including one with Hayman. Many of these engravings are in the Fine Art Museums in San Francisco, as well as the BL.[93] *The Connoisseurs*, a plate for Pope's *Essay on Taste*, shows the influence of both Watteau and de la Joue. It has been suggested that Blakey was educated in England but, given the obvious links with Hussey which can certainly be seen in one of his works discussed later, an early Irish education is quite possible. It may be that he was a Catholic and found Ireland uncongenial. As early as 1748, he is described, surprisingly, as 'an eminent painter' in the *Universal Magazine*. He had only recently returned from France, where he spent much of his life, and, according to Strickland, died there. Most of his surviving portraits were carried out in France, such as the Scottish Field Marshal *Lord Keith* (1759), which is an accomplished Largillière-type baroque portrait. Engravings of a portrait of Louis XV and of the Abbé Pluché exist, as well as a fine early work done of a young English boy, *James Thomas Benedictus Marwood of Abishays, Somerset* (Fig. 54),[94] signed and dated 1755. It is a somewhat stylized essay, probably composed from a mezzotint, but spritely, well coloured and the garden background with its temple, birds, convolvulus and leaping dog adds to the pleasant youthfulness of the sitter. This is the picture we feel has similarities to Hussey. Another child portrait[95] of Master Blacker (1740–1826) aged ten

of the week ... I have passed many evenings with him in his kitchen; where he has informed me by his discourses, and improved me by his manners ... He was also a musician.

There is evidence that, apart from painting pictures, Hussey worked as a dealer, frame-maker and copyist. Between 1756 and 1759 he was involved with the Edgeworth family of Edgeworthstown, Co. Longford, framing for £2.5.6*d.* a half-length portrait he had painted of Mr Edgeworth for £11.16.2*d.* The latter sum included repairs of Edgeworth's parents' pictures and altering a case. Then he organized the purchase and framing of a print of the Prince of Wales and was paid two lots of 6.6*d.* for subscribing to the copperplate, but the full amount is not given. In 1758, Edgeworth was paying for Hussey to travel from Edgeworthstown to Lissard, also in Co. Longford, to copy family portraits there, and three of these cost £ 2.5.6*d.*[90] Some of these copies and portraits are now in the NGI and are in their original enriched, bolection moulded frames. Hussey was in Co. Antrim in 1763, when he was involved in the sale of Henry O'Hara's pictures at Portglenone. The portraits of the Hamilton children, who were O'Hara's nephew and niece, may well have been painted by Hussey at this time. Working for the auctioneering trade was much better paid than painting. He earned some £35.9.2*d.* for the sale.[91] Hussey's will survives. He left his servant Ann Hynds £25 a year and other members of her family also received bequests.[92]

is also like Hussey. It is based on a mezzotint after Wissing of Lord Burghley. It is in poor condition but is interesting as the child is from a well-known Northern Irish family.

Unusually for a scene painter, John Lewis (*fl.* 1737–69 or 1776) also painted portraits. He is not mentioned by Pasquin, perhaps because he was English. It is possible that he was a tenant of Lord Egmont, the head of the Irish Perceval family in London between 1739 and 1745.[96] He was certainly painting by 1737, when he signed and dated *The Judgement of Midas* (Fig. 55).[97] This small mythological picture is competently painted, using somewhat Venetian colouring, and is totally unlike most of his work, including his much later mythological subject, dated 1758, of *Cimon and Iphigenia* from Boccaccio's *Decameron* (Fig. 56).[98] This subject was popular in Northern Europe during the seventeenth century and was turned into an operetta, put on by Garrick, in 1768. It is a much more fluid and assured painting than the *Midas* and the figures have an almost flickering, rococo liveliness. A landscape, very similar to it, was on the art market recently.[99] Whether Lewis was ever in Paris, where he could have seen more continental work and old masters, is pure speculation, but his brother-in-law, Stephen

Slaughter, spent seventeen years in Paris and Flanders, not returning to England until 1732–3.

Turning to Lewis's portraits, a group of six of these, signed and dated 1744 and 1745, are of the Vaughan/Lloyd family of Derwydd and Cwrt Derllys, Carmarthenshire and show that his female portraits at this date are conventional and stiff. The most charming is of a young girl of the Lloyd family holding a bunch of grapes.[100] Lewis's connection with Ireland may have come through Slaughter, the brother of Lewis's wife, Judith Slaughter (*fl.* 1755–6), the painter of riding scenes.[101] Though there are several dated portraits in the 1740s, these may not have been produced in Ireland, where he is first securely met with in 1750, when he started work with Thomas Sheridan at the Smock Alley Theatre, Dublin. The first dated portrait of 1740, *A Boy in Blue*,[102] is strongly but sketchily painted, showing his scene-painter's technique. A change in style seems to occur in the 1740s as a number of his slightly later portraits are painted with a minute and highly finished method, notably two, now only known to us from photographs, of a woman and a girl,[103] formerly in the Stirling Collection, Hampshire, which were signed and dated 1748, and a charmingly pretty portrait of a lady of the Bowen-Miller family of Milford, Co. Mayo, which is an attribution. This neat

56 John Lewis, *Cimon and Iphigenia*, signed and dated 1758, oil on canvas, Private collection

57 John Lewis, *Miss de Winton*,
signed and dated 1765, oil on canvas,
Private collection

neath [Strickland says on the east wall] four portraits in large medallions of Milton, Shakespeare, Swift and old Dr Sheridan. These were supported by allegorical figures, and set-off by draperies, and a goodly sized sphinx or two, for the corners.' Strickland adds that the room had flowers, probably as swags, and given Lewis's interest and talent in flower painting, this seems likely. There were other panels by him in the house, one at least representing Italian landscape. Sheridan's pose was repeated in the portrait of Henry Brooke, author of the *Fool of Quality*, which is dated 1755. All these are more broadly painted than his ladies and have a relaxed informality. The portraits of Stella and Vanessa, Dean Swift's loves, in the NGI which used to be attributed to Lewis are either not by him or are of other ladies, as they had died in 1728 and 1723 respectively.

Though he left Smock Alley in 1757, Lewis seems to have stayed in Ireland for some years. In 1757, he is recorded as working in a theatre in Dublin and *Faulkner's Dublin Journal* of 16th–20th August 1757 says he 'has executed a noble Design for the sounding Board, Ceiling, Lattices etc. in the New Taste, and there would be a Variety of new Scenes by the same Hand'. *Faulkner's Dublin Journal* said on 15 October 1757 that at a reception including the Viceroy and the Duchess of Bedford 'the Audience ... all expressed the utmost satisfaction at the beautiful Manner in which the Theatre is decorated by Mr Lewis and in Point of Taste, Elegance of Design and Masterly Execution is allowed by the Connoisseur not to be inferior to any in Europe'. However, a different point of view was expressed in an anti-Sheridan pamphlet called *The Case of the Stage in Ireland*, published by Saunders in the High Street in 1758. Though this pamphleteer suggests that the Dublin Society Schools had trained many artists who could do the work, the most important feature is the writer's distaste for a painted drop curtain which he feels is an outrage when 'the Theatres in London are content with plain green Curtains'. He calls Lewis's curtain 'a Depravity or total Deficiency of Taste as an Affectation of Paltry and unnecessary Ornaments', and he rants on.[108]

Two sets of portraits painted in Ireland by Lewis were of the Saundersons of Castle Saunderson, and the Dobbyns, merchants of Waterford. The four Saunderson paintings, signed and dated 1753, are decorative with bright colours, baskets of flowers and plenty of lace. There are three of the ladies and children of the family, one a conversation piece, and only one gentleman, Alexander Saunderson, who is shown with a partially ruined Castle Saunderson in the background. But their soft and pleasing tones of grey, pink and silver make them appealing groups, though they retain a certain flatness and expressionless naïvety in their faces. Another pair depicts the Revd Guy Atkinson, who is seen in a three-quarter-length in an interior with the son of his first marriage, done in the early 1750s. The companion piece of his second wife, Jane Wray, with two children must have been painted considerably

manner is rarely met with. A portrait signed and dated 1751 (last digit unclear) was probably done in Ireland. It is of Elizabeth, Countess of Moira with her pet dog, a rather primitive work with his usual interest in costume.[104]

As we might expect, he painted a number of theatrical personalities, including Peg Woffington in 1753, done during one of her Smock Alley seasons, of which there are several versions. It must have inspired Roger O'More's Latin 'verses to be placed under the picture of the celebrated Mrs Woffington'.[105] A less attractive picture is his operatic performer, *Signora Majendi with her Lute*,[106] signed and dated 1769. His portrait of *Thomas Sheridan* (NGI) is also dated 1753, and shows the sitter in his study in an informal pose. Lewis was a close friend of Sheridan and painted murals at Quilca, Sheridan's house in Cavan, probably after his marriage in 1747. These are sadly lost, but an account of them survives[107] and they are described as follows: 'The room had a coved ceiling – over this canvas was spread, and Lewis ... painted sky and cloud scenery, and under-

later, perhaps in the 1760s. The five Dobbyn portraits, dated 1759, show a solid burgher family with some of the props seen in the Saunderson portraits, but all display poorly and flatly painted hands and faces. Anne Dobbyn is made more interesting by a painted asymmetrical rococo frame surrounding her charming young features. In nearly all his portraits, the sitters have pronounced eyebrows and large, lustrous eyes.

Lewis achieved his best subjects in two English works, dated 1765 and signed 'Jn Lewis', of children[109] of the de Winton family from Wallsworth Hall, Gloucestershire (Fig. 57). They are as assured as the Stirling ladies and the drapery is still painted in great detail. They show a delicacy which one does not always see in his Irish work. The landscape backgrounds with their trees are fluidly handled, as in his *Cimon and Iphigenia*, and are probably the reason why the Dobbyn portraits, set in interiors, are less attractive.

He seems to have returned to England about 1762, when he again exhibited at the English Society of Artists, of which he became a founder member. Because Lewis's landscapes do not connect with his portraits, it is sometimes thought that there were two

artists of the same name, but a close examination of the subject pictures, such as the *Cimon and Iphigenia* which we have mentioned, and which are set in landscapes, convinces us that the two men are in fact one and the same. Edward Edwards says Lewis was a friend of Thomas Smith of Derby,[110] and Grant[111] gives a lengthy account in which he appears to accept the two John Lewises as one, though Waterhouse[112] lists them as separate, giving the landscape painter's death date as 1776. However, the last certain date for Lewis in Ireland is 1759 and the first date given for the English master is 1762, which fits, as we think they are the same person. It is also improbable that a scene painter would not have painted landscapes and those he painted in Devon, such as the panoramic views of Totnes taken from the nearby hills and Sharpham Barton Farm (Fig. 58), have a delightful sense of peace and life in the countryside. A very similar view of what we think could be an Irish village,[113] showing men reaping and a horse and cattle in the foreground, is very close in style and execution to these Devon views and indicates that he might have painted panoramic views in Ireland.

58 John Lewis, *Panoramic view of Totnes, Devon, from Sharpham Barton Farm*, oil on canvas, Private collection

59 Anonymous, *View of Enniskillen*, dated between 1754 and 1764, oil on canvas, National Trust for Northern Ireland, Florencecourt

60 Anonymous, *Devenish Island*, dated between 1754 and 1764, oil on canvas, National Trust for Northern Ireland, Florencecourt

61 Anonymous, *Devenish Island*, detail of funeral, oil on canvas, National Trust for Northern Ireland, Florencecourt

About this period, there are two sets of very striking Irish topographical landscapes, all unidentified. Four large views of the Enniskillen area, the *Town of Enniskillen* (Fig. 59); *Devenish Island* (Figs 60, 61); *The Falls of Ballyshannon* and *Old Crom Castle*, were painted in the late 1750s to decorate Florencecourt, Co. Fermanagh, which was being rebuilt. Three are still in Florencecourt, though one is in Crom Castle, and they may represent the painting of an unknown scene painter who worked with Lewis. Some of the rococo figures in the Florencecourt views, particularly the one of Enniskillen, echo those in the *Cimon and Iphigenia*, and the cattle in the Crom picture are similar to those in the Devon pictures. However, there are differences, especially the notable use of reflections in the water and the dramatic use of trees. The paintings are full of fascinating details and must be the work of an artist of greater landscape ability than Lewis. They are the most decorative landscapes executed in Ireland in the mid-century. Another set of four views of Glenarm (Fig. 62), dating from its rebuilding by Alexander, fifth Earl of Antrim, from 1756, also owe a debt to Lewis, though they are by a different and less competent hand than the Enniskillen views. They are more straightforwardly topographical, and have a certain baldness which reflects the treeless condition of the Antrim Glens in the mid- and late eighteenth century, though new plantations are in evidence.

Another importation who painted a rather different stratum of society was James Worsdale (*c*.1692–1767).

He is more interesting as a recorder of social life than for his merit as a painter. A pupil of Kneller, he was dismissed after secretly marrying Lady Kneller's niece and afterwards claiming to be Kneller's natural son. He came to Ireland about 1735 and in 1736 was in Mallow, Co. Cork according to numerous mentions of him in the memoirs of Mrs Laetitia Pilkington,[114] Swift's rather troublesome admirer. In 1738 Swift wrote 'we thank your Good City [London] for the Present it sent us of a Brace of Monsters called Blasters or Blasphemers or Bachanalians (as they are here called in Print) where of Worsdale the painter and one Lints [Lens] (a painter too, as I hear) are the Leaders'.[115] This refers to the establishment of the Dublin Hell Fire Club at the Eagle Tavern on Cork Hill about 1735. Worsdale painted a group of its members seated at a table drinking, now in the NGI, for the fourth Lord Santry. Another picture by him, painted for Edward Croker of Ballinagarde, shows the *Limerick Hell Fire Club* (also NGI), which is said to have met in the old house in Askeaton Castle, Co. Limerick. It was painted before his sojourn in Dublin and shows a group of Limerick squires and their alleged only lady member, Mrs Blennerhassett, to whom a poem is dedicated by Daniel Hayes. Published later in 1769, it describes the revels:

But if in endless Drinking you delight
Croker will ply you till you sink outright
Croker for swilling Floods of Wine renowned

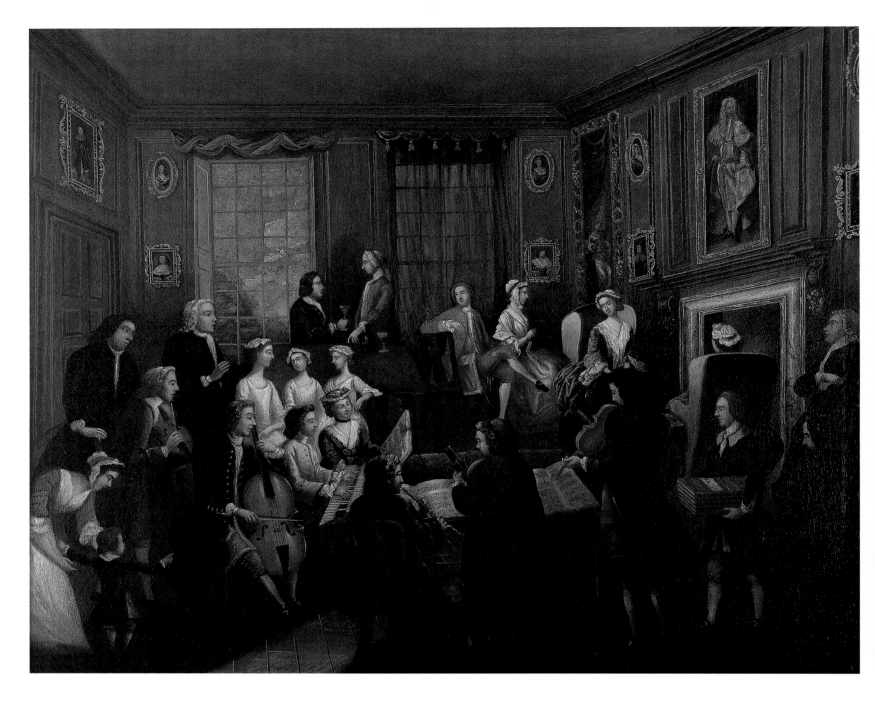

63 James Worsdale, *Musical Party*,
oil on canvas, Private collection

Whose matchless Board with various plenty
 crowned
Eternal Scenes of Riot, Mirth and Noise
With all the thunder of the Nenagh Boys
We laugh we roar, the ceaseless Bumpers fly
Till the sun purples o'er the Morning sky
And if unruly Passions chance to rise
A willing Wench the Firgrove still supplies.[116]

Its main interest today is that it is the earliest picture
in Ireland showing an interior with figures drinking
and smoking, with interesting provincial furniture
and a wine cooler with carved masks on the sides.
Another similar work of a musical party in a panelled
room which came from an Irish house, is clearly by him
and shows his lively, if naïve, manner (Fig. 63).

Worsdale also painted portraits, in Dublin, of the
Lord Lieutenant, the fourth Duke of Devonshire for

the Royal Hospital and one for Mrs Conolly of
Castletown. Pasquin says, accurately, that 'he met
with more success as an artist than he deserved; but
his poignant table chat and conviviality begat him
many admirers'. He wrote poetry and a ballad opera or
two. He was a notorious womanizer. In 1741, he was
appointed Deputy Master of Revels to the Viceregal
court and was active on the Dublin and London stage.
Vertue described him in 1744, when he was back in
London, as 'a little cringing creature' and says that by
'many artful wayes [he] pushd himself into a numer-
ous acquaintance ... we that have known this painter
– & have detected his barefacd mountebank lyes. are
not surprizd at his Meeting encouragement in this
age.'[117] Later, Pasquin tells us he was appointed Master
Painter to the Board of Ordnance, through the influ-
ence of Sir Edward Walpole, 'who had been accused of
a detestable crime; but Worsdale discovered the con-

spiracy against his patron's honor; and by great address and incessant pains brought the delinquents to justice. To effect this, he lodged on Saffron-Hill, as a haymaker, from Munster; and in the Mint, Southwark, as the widow of a recruiting sergeant from Sligo.' A great deal of information about this scandalous character and his relationship with Laetitia Pilkington appears in the newly annotated edition of her memoirs.[118] Worsdale died in 1767.

Alexander de Lanauze (1704–67) signed his portraits as 'A deL' and the two surviving examples are of *Bishop Synge*, which is signed but not dated (Fig. 64), and *Lady Shelburne*. The former is a robust and honest likeness of a divine, now so well known to us for his fascinating letters to his daughter.[119] De Lanauze, who was a teacher, was in the west of Ireland in 1739, when he was instructing the Cuffe family at Elm Hall in Co. Mayo. He was asked by James Cuffe to sketch Croagh Patrick and Nephin, 'exactly as those mountains appear from my windows'. He was too old to climb these peaks, Cuffe confided, and went on to say 'my curiosity is satisfied in bringing it [Croagh Patrick] to terminate a beautiful vista to my windows in the form of the greatest Egyptian pyramids',[120] a fascinating comment on landscapes by an improving landlord. Another portrait painter was one C. Brown, who worked in the mid-century, and the single known example of his work is identified by an engraving of Oliver Grace[121] of Gracefield, Co. Laois; it shows him to have been very much in the Bindon manner, heavily and fleshily painted.

We have left Thomas Frye[122] (1710–62) to the end of the chapter as he spent most of his career in England, where he became particularly famous as the founder manager of the Bow porcelain factory in 1744 and as the creator of perhaps the most original series of mezzotint studies of the eighteenth century in the British Isles. His origins are relatively obscure, but it is now accepted that he was a member of the Fry family, then of Edenderry, Co. Offaly, and more recently of Frybrook, Co. Roscommon, where there were two portraits by the artist. Nothing is known of his training, except that his earliest signed and dated work of 1732 seems to have silvery echoes of James Latham, as well as in the firm stance of the figure. Other early works show a real understanding of the painting of lace. The first dated work shows a young boy standing, a column on his left and a landscape view of a hill and lake to the right. It may even have been painted before Frye left Ireland, apparently in the early 1730s with Henry Stoppelaer, the painter and actor, whom we have mentioned earlier. Strickland quotes from the *Hibernian Magazine* of January 1789, which says Frye had a master who was 'neither eminent nor skillful'. This might have been Herbert Stoppelaer; however, he could only have taught him the technique of painting while Frye was inspired by the silvery and sophisticated style of Latham.

Frye was certainly in London by 1736, by which date he must have achieved a high reputation, as in

64 Alexander De Lanauze, *Archbishop Synge*, oil on canvas, Private collection

65 Thomas Frye, *Mr Crispe of Quex Park*, signed and dated 1796, oil on canvas, Private collection

that year he was commissioned to paint a formal portrait of Frederick, Prince of Wales, for the Saddlers' Company. This is now destroyed and known only through a mezzotint. A slightly later half-length version survives (Royal Collection), with smooth painting of the pudgy face and hands and beady eyes typical of Frye's early work. An unusual portrait of an unknown man dated 1742, painted as a sculpted bust after an artist like Roubiliac, and is very freely handled. Frye's large full-lengths, like the *John Allen* (NGI) 1739, are somewhat stiffly posed, with baroque trappings. His half- and three-quarter-lengths are

66 Thomas Frye, *Miss Elizabeth Major, later Duchess of Chandos*, oil on canvas, Private collection

of *c*.1761 was largely painted by assistants, as by this time Frye was dying.

Frye's female portraits are as fine as his male and can be extremely charming, as in the case of the full-length *Duchess of Chandos* of 1752, made before her marriage, when she was Miss Elizabeth Major (Fig. 66). This rococo figure, gliding across the room in a shimmering sack back and panniered dress with a corsage of flowers and bedecked with bows, is curiously like a porcelain statuette.

Frye is known to have painted miniatures and pastels. Michael Wynne discusses the possibility of Frye being influenced by Rosalba Carriera who, Pasquin states, visited Ireland. However, his use of this medium, which was to become a feature of later eighteenth-century Irish painting, is not particularly unusual, having been used in Ireland since the time of Edward Lutterel and Henrietta Dering. There is a charming but dry pair of pastels of two young boys, signed and dated 1734. Whether they were drawn in Ireland or England is uncertain. Most of Frye's drawings were for his memorable sets of mezzotints, all of which date from the 1760s, and which have sometimes been attributed to Piazzetta. Indeed, he is the principal influence on Frye's engraved work, with its mysterious chiaroscuro and frequently Gothic intensity, such as in *The Boy with a Candle*.[123] In an advertisement in *The London Chronicle* for 3–5 June 1760, Frye deliberately points out his inspiration by Piazzetta. His presumed self-portrait shows him in contemplative mood, whereas the *Man Wearing a Turban* stares out at the spectator with a sinister, brooding expression. Apart from the supposed self-portrait, those of George III and his wife and some others, the mezzotints, even though single figures, are fancy subjects. It has been correctly pointed out by Benedict Nicolson that Wright of Derby was much influenced by these, especially in his candle-light subjects. Other chalk drawings, not made for engravings, are coming to light, such as the *Girl Holding a Kitten* (BM) and two studies of an elderly man with a staff. They are probably among his last works.[124] Waterhouse, who usually shows little enthusiasm for Irish painting, nevertheless in most complimentary fashion considered Frye 'one of the most original and least standardized portrait painters of his generation'.[125] The extraordinary fact remains that none of the eighteenth-century writers such as Horace Walpole and Pasquin bothered to mention him at all.

often his best, as the fine pair of *Mr and Mrs Benjamin Day* of 1751 attest. His style evolves in the 1740s into a much more realistic and psychological portrayal of his sitters. This is particularly shown in the case of his highly sensitive study of the musician and actor, Richard Leveridge, of 1760. An earlier and grandiloquent work is *Mr Crispe of Quex Park* (Fig. 65), dated 1746. His weak portrait of the young Jeremy Bentham

4

Patronage and Dealing from the Eighteenth Century

Collecting was of great importance for improving the general level of taste and knowledge, encouraging patronage as well as supplying examples of great works for study. In every sense, it was vital to the remarkable upturn in the number of artists. The subject of patronage and dealing in Ireland in the eighteenth century is one of considerable interest, as artists were always influenced by what they saw, and this is why we interpose this chapter at this point. Many Irish artists closely studied the collections which were available to them in Ireland and this must have encouraged them to travel abroad. A number of our finest landscape painters saw Dutch and Flemish works in Irish private collections and auctions rather than Italian, though of course they were all familiar with Claude. The few landscape painters that travelled on the Continent were much admired, but the three best, George Barret, Thomas Roberts and William Ashford, never went beyond England, though poor Roberts died in Portugal. Their knowledge was culled at home or in England. Barret,[1] in an undated letter written to an unnamed artist working near Holker Hall, Cumbria, the house of the Cavendishes, wrote:

> pay a visit to the pictures at Holker Hall … there is a Rubens in his possession, a landscape, and a Hobbima, which I particularly recommend to your consideration – there are also many other pictures of great merit like Claude etc, from which you may learn much – At Lowther's there are many fine pictures as well as beautiful scenery for your consideration. Paint from nature not forgetting art at the same time – study effects as much or more than mere outlines. Do not be engrossed by any one master, so as to become a mimic but think of all who have been excellent and endeavour to see nature with eyes.
>
> This was the practice of Sir Joshua, Gainsborough and Wilson – this is all the advice I can give you …'

This is also part of the reason why there were so few naïves among Irish painters and those there were came from the west, where there were very few collections. In the case of John Ryan of Galway, he used Italian engravings of well-known masters such as Pietro da Cortona as the basis of his decorative works (see chapter 11), but they remain very crude as he had not seen originals.

As in England, the 'cabinets' of the nobility and gentry were accessible to anyone with 'genteel' manners. An interesting remembrance of house visiting in the eighteenth century is the silver ticket of about 1780–90 which, below Lord Ely's coronet on one side, is inscribed 'this. ticket/to. be. left. at/ the. porters/ lodge', and on the reverse 'this. ticket/admits. four/ persons. to. see/ rathfarnham/ on. tuesdays/only' (Figs 67, 68).[2] Another surviving ticket is that given by The Society of Artists of Ireland to the 100 noblemen and gentlemen who each subscribed 3 guineas to the fund for building it in 1765.[3] The new exhibition room in William Street with its octagonal domed room which still stands, is now used by the Civic Museum. It was the first custom-built exhibition space in Dublin and the site had been bought by Richard Cranfield (1731–1809), the well-known carver, and Simon Vierpyl (c.1725–1810), the sculptor and builder, who was much patronized by Lord Charlemont. The two may well have designed and built the rooms themselves and one might speculate that Vierpyl struck the medal. The Society's first exhibition in William Street was opened on 10 March 1766 and the surviving ticket (see title page), emblematic of the arts, bears the name of one of the original subscribers, Blaney Townley Balfour (1705–88).[4]

We soon find the Society petitioning parliament for an outstanding debt of £380 so that the building could be completed. The committee added that the proposed academy was 'of the greatest Advantage to the Arts and Manufactures of this Kingdom, particularly to Painting, Sculpture, Architecture, Engraving, Carving, Pattern Drawing, Upholsterers, Coach-Makers, Silver-Smiths, Weavers, Carpet-Makers, Stucco Workers,

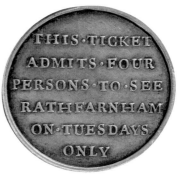

67, 68 A silver ticket to Rathfarnham Castle, obverse and reverse, Private collection

Embroiderers, Carpenters, Smiths etc'.[5] This statement of intent appears to rival the Dublin Society Drawing Schools, but there is no evidence that an academy actually functioned there.

Returning to country-house visiting in Ireland, this was a popular pastime for the upper realms of society and everybody must remember the visit to Pemberley in *Pride and Prejudice*. Another brilliant novelist, Anthony Trollope, takes up the trail in his memorable Irish novel *The Kellys and the O'Kellys*, of 1848. He describes the Earl of Cashel's fictional family mansion as very dull and with good, plain furniture and a gallery of indifferent pictures. He continues, saying that the park is open every day and 'the house on Tuesday and Fridays between the hours of eleven and four'. The author thinks it extraordinarily strange that many people 'frequently pay half-a crown to the housekeeper for the privilege of being dragged through every room in the mansion'. A familiar feeling, perhaps?

A number of Irish tourists and visitors left accounts of their tours, including Bishop Pococke,[6] Judge Edward Willes,[7] Richard Twiss,[8] Arthur Young,[9] Daniel Augustus Beaufort[10] and his children,[11] Judge Day,[12] Robert Graham,[13] and the German Prince Pückler-Muskau,[14] who made his peregrinations round Ireland in 1829. He was refused access at Kilruddery because of the 'unpretending appearance' of his friend and himself: they were 'most discourteously denied admittance'.[15] In England, this was common enough, but rare in Ireland. Some of these travellers remarked on the pictures they saw, as did Pückler-Muskau. He visited Castle Howard, Co. Wicklow, where he 'found the castle buried in sleep; but a servant in his shirt showed him the pictures'.[16] At Shelton Abbey, another Irish Howard house belonging to the Earl of Wicklow, head of the family, the prince found the house deserted, but 'a negro gardener' showed him the rooms and the very interesting collection of pictures made by Hugh Howard and James Tyrrell in the first half of the eighteenth century which we mention in chapter 3. He especially commented on the early Reynolds caricature of Ralph Howard with his coach on the Grand Tour. The less exalted Beaufort family left accounts of many houses all over Ireland, but their visit to Downhill in 1807 is perhaps the most important from the collecting point of view.[17] The house built by the fourth Earl of Bristol and Bishop of Derry was full of the collection of fine pictures and sculptures he had made on his visits to Italy.

Artists must also have noticed the pictures now being imported in quantity into the country and sold by dealers and auctioneers. The first picture auction that we have noted is dated 22 July 1707, printed as a postscript in the *Dublin Gazette* which we have mentioned in chapter 3. This newspaper was published by Edwin Sandys (d. 1708), the first engraver of any importance in Ireland. There seems to be a gap between this advertisement and a rather similar one of 13 November 1723, published in the *Dublin Intelligence* by George Felster, who is selling 'all sorts of Pictures, fit for Stair-cases, Chimneypieces and Overdoors and large prospect Pieces for gardens painted in Antwerp, also all sorts of prints and lately imported from beyond the sea' and these were sold at auction at his warerooms on Cork Hill near Dublin Castle. Felster may have been the auctioneer in 1707, as he is advertised as an 'Upholder' on Cork Hill on 7 June 1709. On 1–5 November 1743, in *Faulkner's Dublin Journal*, an advertisement put in by Felster's widow indicates that she had moved to Marlborough Street after her husband died. It mentions a collection of paintings, 'most of them by eminent hands', prints, furniture and an enormous variety of *objets d'art* and arms, textiles and even Dutch tiles. Mrs Felster had imported more stock by 21–24 April 1744, including landscape, history and sea pieces. Her warehouse was still being used on 30 November–3 December 1751, when oriental china was being sold in it and Henry Delamain, the delft manufacturer, was involved.

From this time onwards, auctions were irregularly advertised until the 1760s. There were six in *Faulkner's Dublin Journal* in 1760 at Geminiani's in Spring Gardens, Dame St. After 1760, several were usually held every year, the numbers increasing until the end of the century. Charles Topham Bowden, in his *Irish Tour*,[18] says:

> Auctions are frequent in Dublin. I was handed an auction bill in which some curious paintings were advertised for sale … I went to see the paintings which certainly were the productions of capital pencils. A Mr. Wilson was the auctioneer, and maybe called the Christie of Dublin. He pointed out the beauties of each piece with the most accurate discernment, and displayed a perfect knowledge of the fine arts. If I except Mr. Christie, the gentleman and the auctioneer are happier blended in Wilson than in any other man of his profession, perhaps in the world. He possesses the talent of encouraging the sale in a familiar voice and language – judiciously avoiding those blustering climaxes and vulgar repetitions, which adorn the *orations* of other auctioneers.

Bowden visited a number of Dublin collections, and Russborough, where he pointed out that Lord Milltown used to take the visitors around his collection himself.

The Customs started recording the importation of pictures in 1764.[19] They list many pictures coming from England, but this was a transit trade, most of the pictures coming via England from the continent. The dues from 1764 to 1823 vary enormously, from £2,313 in 1764 to as low as £591.7.2 in 1773. The Napoleonic blockade appears to have been very successful, as nothing came through from around 1798 except the odd pound's worth. Imports resumed in 1815, when £929.6.7 was exacted.

Most imported pictures came originally from the Low Countries, but on 20–1 November 1739, Mr Langford, probably the London auctioneer, was advertised in *Faulkner's Dublin Journal* as 'selling at Mr. Esdall's the sadler in Dame Street, a collection formed by Mr Samuel Paris in Italy and France etc. consisting of the works of the most eminent Italian, French, Flemish and Spanish masters'. Advertisements do not, unfortunately, cover the auction scene entirely; in some cases, an advertisement cannot be found, although the catalogue survives. For instance, a Dutchman, Gaspar Erck in one of the earliest surviving catalogues, dated 4 March 1754,[20] sells 'in the Musick-Hall in Crow-Street' a collection of original pictures 'lately imported by Him'. They are mostly from the Low Countries, but a sprinkling of Italians and French are included. Erck was a member of the Merchant's Guild of Dublin and served on the City Grand Jury in 1749. Another catalogue of one of his sales is in Lord Grandison's papers from Dromana, Co. Waterford,[21] and he must have been at work in Dublin some time before 1754.

It is impossible to resist at this juncture mentioning the greatest of Irish collectors, Sir Daniel Arthur, whose collection was never in Ireland. He was a 'Wild Goose' from a Limerick burgher family, who obtained his knighthood from James II in 1690. As a refugee, Arthur made his home in Paris, where he became immensely rich as the banker, not only for James II, but also for other 'Wild Geese' (Wild geese were Catholics, mostly soldiers who left Ireland after the Treaty of Limerick in 1691. They settled all over Europe from Russia to Spain. Most were mercenaries, but many others were merchants, bankers, and politicians). Arthur travelled a lot to Spain and, confusingly, had four sons all called Daniel. However, in 1723, Sir John Perceval, later first Earl of Egmont, wrote in his diary,[22] 'I would not omit that this morning Mr Bagnall shewed me a great number of very fine original paintings which he got by marriage with the Lady Arthur, widow of Sir Daniel Arthur, a rich Irish merchant who died in Spain'. Arthur, though undoubtedly a collector, may have in some cases been forced to accept pictures as securities for loans to James II and other, even more debt-laden, 'Wild Geese'. Perceval proceeded to list the pictures, which included a van Dyck for which he asks £400, 'it is of Diana and Endymion'. Then he mentions a work described as Rubens, but now given to van Dyck, which is in the Royal Collection at Windsor, *St Martin and the Beggar*. The list continues with 'pictures by Savery, divers of the Breughels, some pieces of Italian masters, as Michelangelo, Caravaggio, Tintoret, Paul Bassan, Veronese and a head by Titian …' The work now in the Royal Collection was bought by Frederick, Prince of Wales, from the sale held on the death of Arthur's widow and her second husband, Mr Bagnall, he also purchased a Murillo self-portrait.

One must remember that at the same time gentlemen on their Grand Tours were making collections for themselves, employing artists like Hugh Howard as agents and intermediaries, as we have already indicated in chapter 3. In Ireland, William Flower of Castle Durrow, Co. Laois and his neighbour Mr Thomas Vesey of Abbeyleix were starting to collect landscapes and animal pieces as well as portraits and Mr Flower bought a picture of St John the Baptist's head. They both record Mr Seeman[23] as copying portraits and this is presumably either Isaac or his brother Enoch Seeman. Irish subjects by both of them exist. The portraits of Mr and Mrs Flower, later first Lord and Lady Castle Durrow, were painted by Enoch Seeman and are still in the possession of the family. Further afield, Robert ffrench of Monivea, Co. Galway bought pictures.[24] He was an improving squire, a descendant of Bishop Digby, the miniature painter, and closely connected with Francis Bindon, who painted his and his wife's portrait in 1750 for £18.4.0 (hers for free). Bindon redesigned his house and ffrench bought furniture, as well as pictures, to decorate it. He also made an interesting tour of England in 1751, when he inspected a number of celebrated collections, particularly Lord Pomfret's at Easton Neston, Lord Pembroke's at Wilton and in Northumberland House in London, where he noticed Titian's portrait group of the Cornaro family. He purchased a painting of *Vertumnus and Pomona* and a number of landscapes are also listed in his papers. It is encouraging to see that interest in the fine arts was spreading all over the country.

Owners were beginning to make collections sufficient for individual sales to be held, for instance, Sir Robert Echlin's fine paintings and prints were sold in his house in Queen Street, Dublin on 6 November 1759. The sale of the collection of James Digges LaTouche,[25] the Huguenot banker, occurred on 16 May 1764 in Geminiani's rooms in Dame Street. James Chapman (*fl.* 1762–92) was in charge of the sale, which included ninety-eight Netherlandish pictures, eleven Italian, ten French, six English, three Irish and one Spanish. Chapman was a dealer, a cleaner of pictures employed by, among others, Trinity College, a landscape painter and, later in his life, an auctioneer of books and prints[26] as well as pictures. As we will discuss under the landscape painter John Butts (*c.*1728–65), he was also a faker of pictures.

The trade in pictures must have been considerable as early as the 1750s. A 'dramatick satyr' by Beaumont Brenan entitled *The Painter's Breakfast* was published in Dublin in 1756 (Fig. 69), and indicates how important and how crooked picture collecting had become. Scene 1 begins with Pallat, the painter, saying: 'an inundation of ill pictures, imported by Knaves with design to impose on the Tasteless and Unwary, has quite sap'd the Foundation of our Art. We Painters, who us'd to live comfortably on the income of our Professions have no more to do, than Whores in Time of a Pestilance, or Lawyers in a Summer Vacation: And if something is not done soon to stop the progress of this growing

69 Title page to *The Painter's Breakfast* by Beaumont Brenan, Dublin, 1756

70 James Latham, *Bishop Berkeley*, oil on canvas, Trinity College, Dublin

vouchsafe to look upon the paltry daubings. Indeed, if I had resource to the dealers' arts, and made use of the Spaltham pot, and gave it out that they were executed by Signor Someboldini, all the connoisseurs in town would flock about them, examin them attentively with their glasses, and cry out with rapture – 'What striking attitudes! What warm colouring! What masses of light and shade! What a rich foreground! Did you ever see any more *riant*?'

The visitor goes to Carver's house and sees that this was no empty boast and he was 'pained to see so much merit under admired and unrewarded'. This sketch makes *The Painter's Breakfast* all the more telling and supports the fact that Butts had to fake pictures with the restorer Chapman to make a living (see chapter 9).

Undoubtedly the best pictures were bought by the nobility and country gentlemen on their Grand Tours. Bishop Berkeley (Fig. 70) made a fine collection, probably not when in Italy (where he went in 1713–14, later travelling all round Sicily, 1717–20), as he would not have had the money then to do so, but obviously it schooled his eyes for the future when he was able to collect. His travel diaries and letters written in Italy show his keen interest in architecture and his love of paintings which he saw in the Farnese Palace, the Borghese Gallery, etc., which he said were reckoned to number 1,700, and he mentions all the great renaissance artists from Perugino to Titian and of course he visited the Vatican and most of the great churches. He was also in Florence, Venice and Padua. He later housed his collection of pictures in the Palace in Cloyne, Co. Cork[28] and Charles Smith, in his well-known description of 1750,[29] records that:

> His present lordship [when Bishop of Cloyne] successfully transplanted the polite arts, which heretofore flourished only in a warmer soil, to this northern climate. Painting and music are no longer strangers to Ireland, nor confined to Italy. In the episcopal palace at Cloyne the eye is entertained with a great variety of good paintings as well as the ear with concerts of excellent musick. There are here some pieces of the best masters, as a Magdalen of Sir Peter Paul Rubens, some heads by Van Dyck and Kneller, besides several good paintings performed in the house, an example so happy that it has diffused itself into the adjacent gentleman's houses, and there is at present a pleasing emulation raised in this country, to vie with each other in these kind of performances.

Berkeley wrote nostalgically to Lady Burlington from Cloyne of being 'haunted with a taste for good company and fine arts that I got at Burlington House, the worst preparative in the world for a retreat to Cloyne'.[30]

Another divine, Bishop Clayton, was in Italy[31] between 1725 and 1728. His collection was kept in his

evil, we must perish incontinently.' In fact, he has been reduced to faking pictures for, among others, Sir Bubble Buyall who is buying 'For his Museum [which] is compos'd of all the patch'd, exploded, dear, unauthentick pieces, that have these many years been imported into this kingdom. He is the very soul of Auctions.' Other characters include Lady Squeeze 'who haunts auctions for bargains' and various connoisseurs, including Formal: 'He is extremely well read in the rust and mildews of antiquity: and can tell to a month, how many hundred years ago such a picture was painted, though perhaps, it only came out of the fabricators hands yesterday. I have prepared three of the right sort for him; dark looking things you can make nothing of, and which were cut out of one tatter'd picture taken from a nobleman's staircase.' He also pillories importers and dealers, one of whom 'Buys the refuse and trash of all auctions abroad; which he sets up here for jewels stolen out of the Cabinets of foreign Princes …' Mention is made of paintings from famous Italian collections from which, of course, those on view had not come and many of the greatest painters' names are bandied about. However, Lord Frolic is looking for pornography and horse pictures, knowing an immense amount about the pedigrees of famous Arabians but nothing about painting.

In Gilbert's *History of the City of Dublin*,[27] he quotes a pamphlet of 1769 which bewails that Irish painters received so little patronage. Replying to the question from a visitor, the artist Robert Carver says that few Irish pictures are bought [as the sale rooms indicate]. He says:

> I have some pieces at home which would be no disgrace to a gentleman's dining-room, but then they would be known to be mine, and no one would

two successive Dublin town houses in Stephen's Green and Mrs Delany describes his magnificent furnishings, which included 'virtues, and busts and pictures that the Bishop brought with him from Italy'.[32] The well-known quote from Lord Orrery, when Clayton was Bishop of Cork in 1737, is worth repeating:

> We have a Bishop, who, as He has travel'd beyond the Alps, has brought home with him, to the amazement of our mercantile Fraternity, the Arts and Sciences that are the Ornament of Italy and the Admiration of the European World. He eats, drinks and sleeps in Taste. He has Pictures by Carlo Marat, Music by Corelli, Castles in the air by Vitruvius; and on High-Days and Holidays We have the Honour of Catching Cold at a Venetian door.[33]

He had been assisted in purchasing two Correggios by the architect Alessandro Galilei. Later, on discovering that they were copies of two works in the royal collection and the Duke of Orleans collection in Paris, he wrote to Galilei on 5 June 1726, informing him, and added 'however, as your good intentions were not wanting to serve me, I have bought you one of the best Microscopes which I could possibly find'[34] – a brilliant piece of subtle criticism.

The Revd Samuel Madden, famous for his connection with the Dublin Society, made a fine collection which may have been bought at sales in Ireland as we do not know of him going abroad. His house at Manor Waterhouse, Co. Fermanagh, is described in 1739 as having two parlours 'covered with fine pieces of painting several of which are originals, done by the names that have been most famous over Europe'.[35] In his will of 1761, proved in 1766, he left Trinity College twenty pictures to be chosen by the college. Only seventeen of these survive and show that the college preferred religious and subject pictures and, unusually, Italian rather than northern works. They also show how important copies of famous pictures were in the days before photography, and all collections must have included a number of copies of the owner's favourite works. The one Flemish picture in the Madden collection in TCD is *Coriolanus receiving the Embassy* by Peter Lastman, executed when Rembrandt was in his studio (Fig. 71).

Mrs Delany hardly mentions any pictures other than those for her own copying, including those she borrowed from friends like Mr Alexander Stewart of Mount Stewart, Co. Down, who lent her a Carlo Maratta to copy, adding that 'she must hurry up to borrow it as the gentleman is whimsical and may change his mind'.[36] The one instance when she does mention them is when she visits Bishop Bernard, Bishop of Derry, on 10 December 1750. The bishop had a collection of over 200 paintings in his Dublin house, 'not many Italian, but the greatest variety of pictures I ever saw in one collection … and besides a

71 Pieter Lastman, *Coriolanus Receiving the Embassy*, signed and dated 1625, oil on canvas, Trinity College, Dublin

72 Francesco Trevisiani, *Lord Clanbrassil*, oil on canvas, Private collection

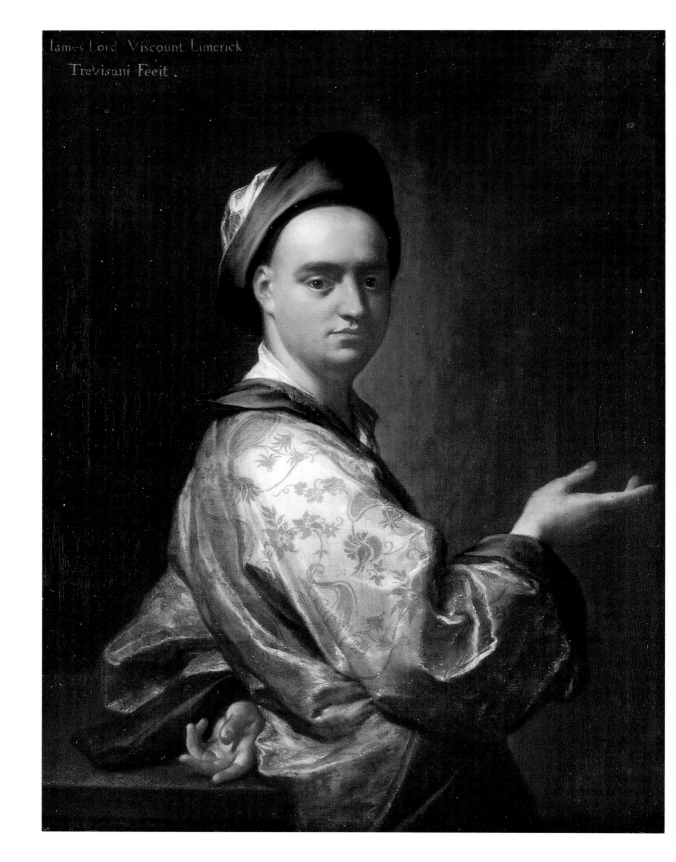

library well furnished with portfolios of fine drawings and prints'.[37] Another great Dublin collection was in Lady Moira's house, where an inventory taken on her death by Zachary Foxall in 1800 mentions as many as twenty-eight pictures in the study, and many paintings in other rooms, including family portraits.[38] In the elder Luke Gardiner's house, 10 Henrietta St, in an inventory of 1772 we find thirty-five pictures including one of Powerscourt Waterfall, flower pieces, many

Dutch pictures and whole-length portraits, and the inventory gives a room-by-room account of the pictures, their gilt frames and sometimes their position as overdoors.[39]

James Hamilton, Earl of Clanbrassil, made an important collection in the early part of the eighteenth century, including works by Trevisiani (Fig. 72), who painted his portrait, and Amigoni. Much later, Hamilton and his wife were painted by Liotard

73 Jean-Etienne Liotard, *Trompe L'Oeil*, oil on canvas, The Frick Collection, New York

74 Page from the printed catalogue of Tollymore Park

and the collection also included an exquisite *trompe l'oeil* by Liotard of 1771 of rococo plaques and drawings hanging on a board (Fig. 73). It is now in the Frick Collection, New York, and was in the 1840s, in Tollymore Park, Co. Down. A catalogue of this period is of particular interest as each room is shown with the 'hang' of the pictures on all the walls, with numbers identifying the paintings in the text of the catalogue (Fig. 74).

For all the chicanery that went on in Rome, it still remained the best way to pick up capital pictures. A great many Irish were among the earliest patrons of Pompeo Batoni,[40] the Leesons in particular. The earliest extant portrait commissioned from Batoni by a British subject was dated 1744 and was of Joseph Leeson, later first Earl of Milltown, who accumulated an important collection of works of art for his new Palladian house at Russborough, Co. Wicklow. Other Batoni portraits of the early 1750s were of Lord Charlemont and Joseph Henry of Straffan, a cousin of Leeson's, who was a notable connoisseur as well as collector.[41] The list of Irish sitters is long: it includes Ralph Howard, later first Viscount Wicklow; Robert Clements, later first Earl of Leitrim; Robert ffrench; James Stewart of Killymoon; Valentine Quin of Adare, one of the finest portraits of them all (Fig. 75); Thomas Dawson, Lord Cremorne; Otway Cuffe, later first Earl of Desart; Arthur Gore, later Earl of Arran; Frederick Hervey, Bishop of Derry and later fourth Earl of Bristol; Thomas Taylour, later Marquess of

Headfort; Edmund Pery, first Earl of Limerick; Sir John Parnell Bt; Alexander Stewart of Ards, Co. Down; John Staples of Lissan, Co. Tyrone. Several collectors were painted by Anton Maron (Fig. 76), including the Provost of Trinity College, Francis Andrews, and his crony Robert FitzGerald, later Knight of Kerry. Tom Conolly of Castletown and Robert Stewart, later first Lord Londonderry sat to Anton Mengs.[42] Most of these made considerable, and some notable, collections of pictures which hung partly in their Dublin houses as well as in the country. Arthur Young and Richard Twiss remark appreciatively upon the collections of Lord Charlemont, Robert FitzGerald, Valentine Quin of Adare and Dominic Trant of Dunkettle, Co. Cork. These grand collectors had more Italian works and Lord

75 Pompeo Batoni, *Valentine Richard Quin, later first Earl of Dunraven*, signed and dated 1773, oil on canvas, Private collection

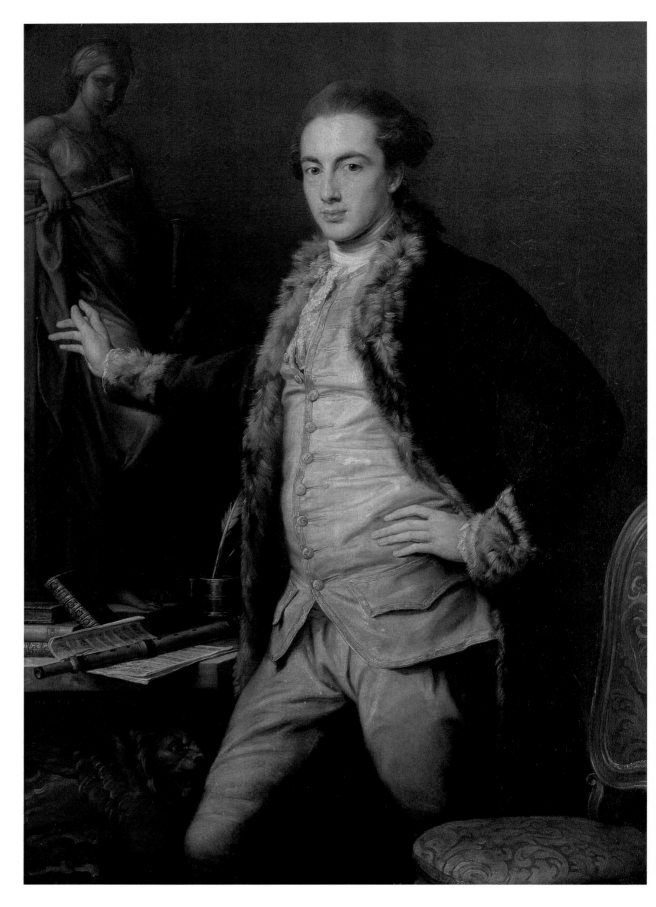

Charlemont was famous for his Hogarths including *The Lady's Last Stake* (Fig. 77). Some of his collection is recorded by John Loughman, who discusses *The Repentent Judas* of 1629 by Rembrandt and a Gerald van Honthorst, a *Musical party* (NGI), which was then attributed to Caravaggio.[43]

The strong interest in northern, Dutch or Flemish pictures is shown in our study of nine auctions[44] held in Dublin between 1829 and 1839, all of which would have largely been made in the eighteenth century. From these, 61 per cent were northern; 22 per cent Italian; 9 per cent English; 1 per cent Spanish and 6 per

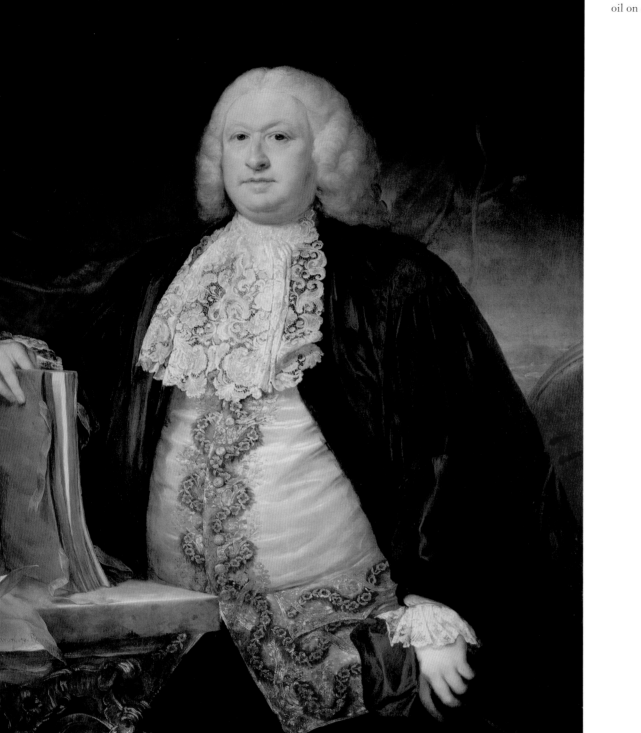

cent Irish. The Irish pictures were probably not all sold, as people would have kept family portraits and views taken on their estates. The collections were frequently enormous and came from varying strata of society: for example, from George Meade (1755–1835), the son of a ribbon weaver, who worked as a clerk to a brewer and in his leisure time studied painting. He took up collecting and at the end of his career became a full-time painter. He sold 258 named lots. Robert Murphy sold 400 paintings; Boyd, a barrister from Donegal a mere 92; Lord Listowel 100, while Sir Charles Coote had 401 in Baggot St; A. B. Maziere, 73,

Caldwell (d. 1808), who had a large collection himself, was left more prints and drawings by his friend Alexander Mangin. When they were sold after Caldwell's death, he suggested in his will that they might be too expensive for an Irish market and that they should be offered in England. They were mostly drawings by old masters, especially northern artists, and the catalogue is a critique of them. The Italian drawings include Piranesi, Zucchero and some Venetian work. There were only three Irish works, Mullins, Barret and a Barrelet. Caldwell had a large library and a collection of pictures in his house in Rutland Square. He never went to Italy, but visited the Low Countries in 1773 and relied on his large circle of friends and relations to look out for likely purchases. After his death, Caldwell's collection was sold by Thomas Jones on 1 and 2 March 1809 in Caldwell's house in Dublin. They include three pictures from the Orleans collection and contemporary works by Reynolds as well as Mengs, Kauffmann and many earlier northern paintings. The Caldwell papers[45] are very interesting; this lawyer knew the Dublin art world very well and had many English contacts. He was in touch with English artists and visited Bath, Harrogate, London and no doubt other English resorts.

Another notable collector was John Sweetman, a brewer who leased the Leeson brewery in Stephen's Green, who made a collection which he sold in 1798, when he was exiled abroad for his involvement with the 1798 rebellion and was unable to return to Ireland until 1820. The 1798 catalogue was by James Valence of Eustace Street, one of the major auctioneers. The pictures are very fully described, some most eloquently, and many must have been originals, as the pair of Paninis were signed and dated 1737. A number of the pictures had been purchased from the Londonderry collection and there were altogether some seventy-two pictures. He had a few Irish paintings and under Thomas Roberts's *The Salmon Leap at Ballyshannon*, the catalogue entry remarks that in Roberts's 'premature death our Country has to deplore the loss of a superior Genius'. Another *Moonlight* in the style of Vernet is given to Barret, with the figures by Hunter. This seems unlikely to us and more probably it was a Forrester. A collection of paintings sold by his son in 1817 fetched high prices and included a Guido Reni, a Le Brun, Wouvermans, and the highest price, 180 guineas, went to *Le Solitude* by Poussin from the collection of the Marquis de Hauterive, which was bought by one Marrable, who acquired eight pictures at the sale. This picture is now in the Royal Palace in Yugoslavia.[46] As Sweetman *père* was then living in Paris, it is possible he made this collection. Both contain first-class pictures, in many cases far better than the norm.[47]

Though the sales mentioned mostly took place on the death of the owners, the considerable withdrawal of fashionable life from the capital after the Act of Union of 1801 was another reason for the dispersal of

77 William Hogarth, *The Lady's Last Stake*, 1759, oil on canvas, Albright Knox Art Gallery, Buffalo

78 Francesco Barbieri known as Guercino, *St John the Baptist in the Desert*, oil on canvas, Private collection

and John Whaley, 132 in his great house, 86 St Stephen's Green, now known as Newman House. These were only the oil paintings. They all sold lots of drawings and prints in their sales. The Harrington Gallery had 1500 lots of prints and drawings – all multiple lots, adding up to some 20,000 items in all. Collections of prints and drawings were not uncommon and the collector and connoisseur, Andrew

the contents of these great Dublin town houses. Financially, Dublin was no longer rich and the great houses were lived in now by the professional classes, who, though interested in art, lacked the money to collect.

Contemporary lists of paintings in the early nineteenth century for Dublin and the country appear in George Wright's *Historical Guide to ancient and modern Dublin*[48] and in Neale's[49] *Views of Seats*. Though these only whet the appetite with short lists, the great collections they name, over and above those we have already mentioned, were those of the Earl of Farnham (including Tintorettos and a Guercino which were only sold in the twentieth century; Fig. 78); The Marquess of Waterford in Tyrone House, later moved to Curraghmore, Co. Waterford; and Francis Johnston's huge collection, sold on 3 March 1835, taking eighteen days to sell. Many of the paintings were hung in the rotunda at the back of his house. Johnston included some seventy-seven Irish pictures among the 455 lots of paintings. They included works by Roberts, Ashford (Fig. 79), Barret, Sadler, Nairn, Richard Carver, Grogan, Butts and E.H. Murphy. Littledale in his introduction acknowledges the help of John Gernon and he exclaims 'with the exception of the great sale at Strawberry Hill [Horace Walpole], there never was a catalogue published, or a collection offered for sale containing the same number of rare and precious articles of Vertu – of Original Paintings, Oriental China, Carvings in Ivory and Wood, Matchless Cabinets, Bronzes, Statues, Vases, Sculptures, Antique Furniture …' This may be something of an exaggeration. Littledale also mentions that Mr and Mrs Johnston had bought from the Downhill collection, the collection of Dr Bernard, Bishop of Derry, and more recently from the Marquess of Ely, the Countess of Milltown, Lord Powerscourt and many others. John Gernon, who came from another family of auctioneers, dealers and picture restorers held his father's sale on 20–1 January 1834 in Littledale's rooms. It included three van der Hagens, a Butts, a Carver, a Coy, a de Gree, and two Barrets. Some of the collection had been bought from Lady Eleanor Butler's sale at Llangollen.

Other Dublin collections named by Wright were Major Sirr, Alderman Cash, Lady Harriet Daly, the Earl of Moira, and Lady St George, whose collection was inherited by the second Duke of Leinster in 1775. It had been formed in Italy in the 1760s, when she and her husband were on their Grand Tour.[50] This collection formed the major part of the pictures in a gallery built in Leinster House by Richard Castle (d. 1751) in 1745 but not completed or used until the St George pictures arrived, at which time, 1775, the gallery was decorated by James Wyatt.[51] James Malton describes the picture gallery and its contents in 1795, mentioning Rembrandt, Claude, Giordano, two Rubens, a Barret, etc.[52] After the sale of Leinster House in 1815, the pictures went to Carton and Kilkea. A list from

79 William Ashford, *Opening of the Ringsend Docks*, 1796, oil on canvas, National Gallery of Ireland, Dublin

1885 of these survives.[53] As usual, it was a predominantly Netherlandish collection with a few Italian works, Irish landscapes by Roberts and Ashford and of course the family portraits.[54]

In the country, there was the Wicklow collection at Shelton Abbey,[55] and the Earl Bishop of Derry's remarkable gallery of pictures at Downhill, some originally hung in Ballyscullion. It had quite a strong Italian bias and quite early Renaissance works.[56] In a letter of 1792 to his daughter, Lady Erne, the Bishop wrote: 'my own collection is forming from Cimabue thro' Raphael and delicious Guido down to Pompeo Batoni, the last of the Italian School and in Germany from Albert Durer's master down to Angelica [Kauffmann]'. The Earl Bishop had intended to arrange 'to illustrate "the Progress of Painting" open to "young Geniusses who can not afford to travel to Italy".'[57] Unfortunately, the large part of his extensive purchasing left in Italy was sequestered by the French in 1798 and sold to the public. A list has recently been found showing that about 350 works never reached Ireland.[58]

An outstanding collection of works of art was made by the second Earl of Bantry, who travelled on the continent in the 1820s and 30s where, among other treasures like Boucher tapestries (still in Bantry House), he bought a series of paintings on subjects taken from Tasso's *Gerusalemme Liberata* by Gian Antonio Guardi assisted by his brother Francesco (Fig. 80), which he used as ceiling decorations. They were discovered to be wall panels when sold in 1956.[59] Two are now in the National Gallery in Washington. The Smith Barrys of Fota, Co. Cork included a splendid picture by Guercino of a dog and they had a number of Spanish pictures in their collection.

80 Gian Antonio and Francesco Guardi, *Erminia and the Shepherds*, 1750/55, oil on canvas, National Gallery of Art, Washington

81 Photograph of the Drawing Room at Newbridge House, *c*.1890, Cobbe Foundation

One of the most important and better recorded collections of paintings was at Newbridge, Co. Dublin, the seat of the Cobbe family.[60] Matthew Pilkington, a clergyman who was satirized in *The Painter's Breakfast* as the Revd Mr Busy and was married to the infamous Laetitia, became the rector of Donabate, close to Newbridge House, and was commissioned to make a collection for Thomas Cobbe (1733–1814).[61]

Pilkington was writing his *Dictionary of Artists*, the first in English, which he published in 1770.[62] This must have been composed to a large extent from pictures he saw in Dublin, either in private collections or the sale rooms. There is no real evidence of his travelling, but Frances Power Cobbe,[63] writing in the nineteenth century recalls from family lore that Pilkington was sent to Holland and Italy to collect pictures for Newbridge. Though it is quite probable that he went to the Low Countries, a trip to Italy seems unlikely as he bought very few Italian works. The great Drawing Room at Newbridge (Fig. 81) with its splendid rococo ceiling was complete by 1764 and was intended for the new pictures, of which, according to the catalogue written by Frances Power Cobbe in 1868, there were still fifty-three hanging despite sales earlier in the century. The sales of the major Hobbema (National Gallery of Art, Washington, USA) and the Gaspar Poussin for £1,500 in 1839 were to finance stone and slated houses for Charles Cobbe's tenants in the Dublin mountains. The best Italian picture was a Guercino, but of the Dutch there were a Ruisdael, van de Velde, Decker and numerous minor masters, and portraits by van Dyck and Gainsborough. There were a few Irish pictures, such as four small but very beautiful early Italianate Barrets. The room must have been one of the most splendid of its date in Ireland and today, with its early nineteenth-century wallpaper, curtains and carpet, it survives as a great backdrop for the surviving pictures of this collection.

Pilkington assisted in forming other collections for example Robert Bonham's, which states on the front of the catalogue that it 'was formed under the advice and Judgement of the Revd Mr Pilkington, Compiler of the Dictionary of Painters'. The pictures were sent to London for sale at Christie's on 16 February 1811, but did not fetch high prices. Another picture collection sent to London to be sold by Phillips Son and Neale on 18 January 1887 was the Anketill Grove collection, from Co. Monaghan, made by William Anketill, the great-grandfather, of the vendor, who had died in 1756. There were 185 lots, many of them selling at prices up to 400 guineas. What all this collecting seems to indicate is that Dublin in the eighteenth century was a cultivated city, deeply interested in pictures.

The study of the Irish Art Trade is in its infancy, but the number of loan exhibitions[64] in Dublin, Cork and Limerick to which the nobility and gentry were very willing to lend was remarkable. Apart from the relatively small exhibitions held regularly by artistic bodies such as the Royal Irish Institution and The Cork Society for Promoting the Fine Arts, large exhibitions promoting industry as well as the arts, emulating the Great Crystal Palace exhibition of 1851, were followed up by Cork and Dublin in the early 1850s. William Dargan, the Irish railway king, financed a major show, the Irish Industrial Exhibition of 1853 on Leinster Lawn, which included a major section devoted to the fine arts.[65] There were 328 old masters

and many later-eighteenth-century works. The moderns brought the number of paintings up to 1,023. The exhibition can be clearly seen in Mahoney's remarkable watercolours (NGI). The fourth Earl of Portarlington was a major lender and had a very large collection.[66] There was another enormous exhibition in Dublin in 1865 and several others later. The artist Thomas Bridgeford left notes[67] of the various houses he visited for the selection for the 1872 exhibition in Dublin. They included Emo Court, Curraghmore, Bessborough, Castle Bernard, which was burnt with all its pictures in 1922,[68] and many others.

The sheer quantity and quality of the country-house collections which were added to throughout the nineteenth century was to be seen in the 1920s, when so many estates were sold and the collections were to be found among the dealers and auctioneers on the quays in Dublin, of which perhaps the most famous was Bennetts of Upper Ormonde Quay. Thomas Bodkin bought a remarkable personal collection, including a Rembrandt, and another connoisseur, Judge James Murnaghan, who walking back from the Four Courts every evening, also found some incredible treasures. Eighteen of these are now in the Walters Art Gallery in Baltimore and include Terbrugghen, Snyders, Vasari and an early Italian work of the first years of the fourteenth century.[69] Two works are illustrated here, one by Abraham Bloemart of the *Parable of the Tares* (Fig. 82) and a portrait of a gentleman with his horse and groom by Adrian van Nieulandt (Fig. 83).

82 Abraham Bloemart, *The Parable of the Tares*, oil on canvas, The Walters Art Museum, Baltimore

83 Adrian van Nieulandt, *Gentleman with Groom and Horse*, oil on canvas, The Walters Art Museum, Baltimore

A German tourist, Gottfried Küttner, noted in the early 1780s in his *Briefe über Irland*, published in Leipzig in 1785, that most of the cabinet pictures which he saw on his travels were Dutch, and this remained true in the 1920s. The greatest collector of the first quarter of the twentieth century was Sir Hugh Lane, whom we discuss in chapter 17. The exhibitions which he arranged included many fine old masters from Irish houses. It had been stated that 'there are no pictures in Ireland' and Lane hoped that his exhibitions would rebut this frequent claim. It was a common point of view, and most people still think that there was very little painting of importance executed in this country before about 1900 and that nobody bought pictures, Irish or foreign. This chapter proves that there was a great interest in pictures and the development of dealing and auctioneering was an eighteenth-century phenomenon.

Today, we are lucky that a new generation of collectors has grown up in a more prosperous Ireland and they are bringing back Irish pictures to this country, pictures which in many cases left in the early part of the twentieth century. The collecting of continental and English works is not so common, whether old masters or modern. The academic study of Irish art has never been so enthusiastically followed, partly as a result of the sale rooms which often bring to light many a newly discovered work. We are indeed indebted to the group of new collectors who have given us all great encouragment.

5

Landscape in the First Half of the Eighteenth Century

In the seventeenth century, landscape painting was represented by a number of topographical views by visitors who were either engravers, map-makers or travellers. Only two oil paintings survive which have claims to be of seventeenth-century date and they will be discussed below. The map-makers were associated with the English conquest and settlement of Ireland. The earliest known are the familiar woodcuts by John Derricke,[1] published in 1581 in his *Image of Ireland*. They include many illustrations and are memorable for their representation of the dying Gaelic world which he views with the superiority of a conqueror's eye. Others were associated with the plantation of Ulster, including Richard Bartlett, Francis Jobson and Thomas Raven.[2] They all worked in watercolour. Bartlett's map of Dungannon (NLI) of about 1600 is a splendid example of their work. It shows woods, cottages, the moated castle itself, a crannóg, all in a landscape setting showing the fighting. It is particularly interesting as it depicts the O'Neill ceremonial stone chair. The great painter of Virginia, John White (c.1540–1606), settled in Ireland after leaving Roanoke in 1590 and is generally considered to be the author of the Mogeely estate map (NLI), produced for Raleigh in 1598. It is regrettable that no other Irish works are known, and that we do not have the marvellous record of Ireland which he so brilliantly made of the American colony of Virginia.

Of the oil paintings, the earlier is a half-map, half-landscape in Trinity College of the *Battle of Kinsale*, 1601, connected with the engraving in *Pacata Hibernica* of 1633. It is known that views, probably of Kinsale, where the English army defeated the Spanish and Irish force in 1601, were made. It is recorded in the Venetian State Papers that in 1620 the entourage of the Spanish ambassador destroyed some paintings in one of the royal palaces in London, including one 'representing some valorous action of the English in Ireland against the Spaniards'.[3] In the King's Weston inventory of 1695,[4] number ten is 'A View of the Taking and Siege of Kinsale by the Lord Mountjoy 1601, copied by young van Diest from an excellent original now belonging to the Earl of Scarborough'. This copy cost £15. Whether it is possible to connect one of these with the Trinity College picture is pure speculation. It is very difficult to date this painting, because there is so much conflicting evidence contained within it. For instance, the surrounds to the labels are composed with elaborate strapwork decoration, which would suggest an early seventeenth-century date, and the inscriptions are different from those on the engraved map, but the painting of the woods, hills and the battlemented walls and towers of Kinsale itself appear to be early eighteenth century. It may therefore be a copy of an older picture. It was bought in London by the eighteenth-century antiquarian, map-maker and engineer, Colonel Vallancey, and given to the college in 1784, its previous history being regrettably unknown.[5]

The second surviving oil landscape of the century has already been mentioned in chapter 2 (Fig. 22). It is the *View of Dublin*[6] which can be dated 1699 from a study of the architecture included, and is by Thomas Bate, according to an old label on the back. The architecture shows the Royal Hospital with its uncompleted tower and the horizon full of Dublin city churches. It is not a particularly interesting prospect, but none the less a real landscape – the forerunner of many. A recently identified work which we attribute to Thomas Bate is a view of Blessington,[7] where Archbishop Boyle's formal garden with its radiating avenues and alignment with the church and the house is notable. It must date from the first decade of the eighteenth century and it is the earliest known painting of an Irish formal layout. Several more competent landscapes of Irish scenes were painted about this time and are connected with the Williamite campaign. They were done as battle pieces, such as the sketch made by Dirk or Theodor Maas of the Battle of the Boyne mentioned in chapter 2, which was also used by Jan Wyck as the basis of his Battle of the Boyne paintings.

Two Dutch engravers are connected with Ireland. One was Wencelaus Hollar, who executed a map of Inishowen, Co. Donegal, and a view of shipping with a coast and castle-topped promontory, possibly Culmore Fort, Co. Donegal, entitled *Louving in Ireland*. This would appear to be after a drawing by Bonaventure Peeters. The map is possibly linked with the work of the great scientist, surveyor and entrepreneur Sir William Petty (1623–87), who was engaged in a major mapping undertaking known as the Down Survey. The other Dutch artist who was actually in Ireland was Gasper Huberti (*fl.* 1645), the first man to engrave a print in this country. He was brought back to Ireland by Thomas Preston, Viscount Tara, the commander of the confederate Catholics in Leinster, and his map of the siege of Duncannon fort was engraved at Kilkenny in 1645.[8]

One of the earliest topographical draughtsmen was Thomas Phillips, an engineer who was instructed in 1684 'to take an exact view of the several forts, castles and garrisons of the said kingdom'[9] for the Lord Lieutenant, the Duke of Ormonde. This resulted in a number of watercolour views of Irish towns and forts, now in the National Library of Ireland and the British Library. We show a view of Charles Fort in Kinsale, Co. Cork (Fig. 84). These are the earliest views with a sense of atmosphere and climate, not to mention social and architectural interest. They show the influence of the Dutch landscape painters at work in England at this time. Thomas Dineley[10] in 1681 had illustrated his *Observations* with thumbnail sketches which are not always strictly accurate, but have considerable topographical value and naïve charm, showing, as they do, towns, churches, abbeys, monuments and tower houses. Neither of these artists approaches the craftsmanship of Francis Place (1647–1728), a traveller and antiquarian from the north of England, who arrived in Drogheda in 1698 and journeyed thence to Dublin and on, via Castledermot and Kilkenny, to Waterford in 1699.[11] His views are not only topographically accurate but have a clarity of vision and virtuosity which is not found again for several decades. Not only is he interested in buildings, but also their surroundings. For instance, in the *View of Kilkenny Castle* (Fig. 85), he minutely observes the orchards, plantations, gardens and cottages which make up the splendid panorama surrounding the Ormond castle. He was a pupil of Hollar. His concern with light and shade on the profile of a castle, and the homely detail of a country road with the wind blowing, gives his work an immediacy which carries one along with him on his travels.

No native school emerged from these beginnings. The few locally painted landscapes are still without pretensions to knowledge of perspective or recession, splendid naïve statements which evoke the increasing pride obviously felt by the Irish nobility and gentry in their seats, outbuildings and newly created garden layouts. An early eighteenth-century example, signed by a practically unknown artist, Peter Burke,[12] is one of these. It is a very badly damaged view of the Blackwater and the walled town of Youghal (Youghal Urban District Council), painted before 1737, and from it can be attributed two paintings in better condition of the Smyth estate of Ballinatray, a few miles up-river. It shows the estate only partially planted; the relatively small house with its Dutch gabling has a huge range of offices and stables and a walled garden. Mr Smyth's barge, with his liveried boatmen and a huge, emblazoned flag, is being rowed down between

87 Anonymous, *View of Stradbally House and garden*, oil on canvas, Private collection

87A *Mr Cosby's carriage*, detail of *View of Stradbally House and garden*

two sailing boats. In the second example (Fig. 86), more attention is paid to the house. A similarly naïve example, but without an author, is the view of Mount Ievers, Co. Clare, painted on plaster as an overmantel. The house was finished in the 1730s, and the red brick north front is shown. It is surrounded on one side by the stable courtyard and on the other by a walled garden. On the south side is a large formal layout with allées, a pond, a pigeon house, and an obelisk; in the right foreground, there is a stepped waterfall leading to a canal which passes under the bridge in front of the main entrance with its tall gate piers. Much of this layout survives today.

In contrast, there is the huge bird's-eye view of Stradbally Hall, Co. Laois, possibly by the same hand, which may date as late as the 1740s (Fig. 87). It illustrates the house, an interesting sequence of architectural styles in itself, from a tower house to a brand new Palladian pile, which may, in fact, never have been built. Its elaborate Dutch gardens are filled with statues, temples, a grotto, espaliered walled potagers and a gazebo. The owner, Mr Cosby, is arriving in his coach and six horses (Fig. 87A) and other gentry stroll by the canals and glades. The O'Mores' castle on the Rock of Dunamase dominates the horizon, and the village, with its fine manufacturer's dwelling and a

market house, is shown in detail, not to mention in the far left quarter a 'necessary house' (a latrine), standing astride a stream. The gabled manufacturer's house was largely built out of the stone taken from the abbey, the remains of which can be seen. Two bird's-eye views, very much in the same tradition, but showing clearer understanding of landscape, are the otherwise unknown George Moore's *Views of Westport House*, Co. *Mayo* with Croagh Patrick and Clew Bay in the background, which were painted as late as 1760 (Fig. 88). A delightful scene of sheep-shearing and branding in front of Knocklofty, Co. Tipperary is another example of a painting which, by the costumes, dates from the 1760s but at first glance looks fifty

Corporation and in St Michan's Church, Dublin to have been William. However, there is cause for even more confusion as the van der Hagens were a large family[14] and in the Low Countries the name is very common. At least two families of this name lived in London, one of which married into the van de Velde family, famous as marine painters.[15] There is a Joris van der Hagen, a marine painter in the van der Velde manner, who has been thought to have come to Ireland, and yet another Joris, who worked in the style of the Konincks in the seventeenth century. The William we chronicle, who was probably English, was in Ireland for over twenty years.[16] William van der Hagen's first signed oil is of Gunwade ferry, Northamptonshire and is signed 'Wm van der Hagen'.

Engravings of other topographical views, such as Gawthorpe in Yorkshire, are dated variously in the very early 1720s and are signed 'Wm van der Hagen'. This difficult matter, with further English attributions, has been discussed by John Harris.[17] Pasquin enlightens us no further as he gives no Christian name and says van der Hagen was 'a painter of landscape and shipping in Dublin and other towns in Ireland'. He remarks on William's eccentricity and says, incorrectly, that he died *c*.1760. William may have worked elsewhere in England and abroad, specializing in harbour views such as Portsmouth, Falmouth, Plymouth, Gibraltar, of which there are several versions, and even as far afield as Messina. However, some of these may have been painted using drawings by other artists. They have many figures and shipping and where they are dated, it is to the very early 1720s. He is first recorded in Ireland as 'Mr Vanderhegan lately arrived from London' in 1722, as painting sets in the Theatre Royal, Dublin,[18] and he is then noted in 1724 when he is commissioned to paint an altarpiece for the Protestant church of St Michan's, for which he was paid in two instalments the considerable sum of £18 in 1725 and 1726.[19] He had to restore this altarpiece in 1728.[20] Sadly, this has disappeared, as has the other altarpiece he is recorded as painting for St Patrick's Church in Waterford, described by Charles Smith as 'a painted Glory of Vander-Egan's well performed'.[21] A unique portrayal of an Irish church interior done at this period is the Dutch-inspired view of Christchurch, Waterford, with all its elaborate fittings, including the bishop's grandiose throne (Fig. 89). A companion piece depicts the external view of the cathedral and this suggests that other foreign painters were at work in Ireland at this time.

In 1728, van der Hagen was commissioned by the upholsterer and tapestry-maker Robert Baillie of Abbey Street, Dublin, to 'take prospects' of the places to be depicted in the six tapestries for the newly built House of Lords. These were to be of *The Defence and Relief of Londonderry*; *The Landing of King William and his Army at Carrickfergus*; *The Battle of the Boyne*; *The Entry of King William into Dublin*; *The Battle of Aughrim* and lastly, *The Attacking of Cork and Kinsale by the Duke*

88 George Moore, *View of Westport House*, 1760, oil on canvas, Private collection

89 Anonymous, *Interior of Christchurch, Waterford*, oil on canvas, Waterford Treasures Museum

years earlier. The most amusing of these views is a panel painting of Kilruddery, Co. Wicklow, where the houses, formal gardens and mountainous background showing the Sugarloaf, have been pasted over with a lively hunting scene. Several of the animals have fallen off and the fox is now a blue, ghostly patch.

The first important name we have in landscape painting is William (Willem) van der Hagen (d. 1745). He came to Ireland in the early 1720s.[13] Considerable confusion has arisen over his Christian name, given in Strickland as Johann but proved now from recorded payments in the minute books of Waterford

of Marlborough. Only two were ordered as tapestries, and these still hang in the House of Lords. They correspond with only one oil by van der Hagen of the city of Derry (Fig. 90), and it is difficult to ascertain whether he painted any of the others. The Carrickfergus scene (UM), a shipping piece despite the decorative elements such as the dolphins and the scroll at the top, does not resemble the tapestry in the House of Lords, though the subject, *The Landing of William III*, is the same; it may represent an unexecuted design. The man o' war is very close to another in the background of a *capriccio* signed 'W. Van der Hagen', now in an English private collection. The Derry view, with the artist in the foreground, is, as well as being extremely competently painted, a landscape with considerable atmosphere and close in appearance and detail to the background of the tapestry. There was a watercolour of the Derry view, but both have disappeared in the last twenty years.

Van der Hagen's *View of Waterford*, for which he was paid £20 in 1736 by the corporation,[22] is particularly interesting, as it is taken from the same spot as Francis Place had drawn from in 1699 and shows the considerable growth of the town outside the walls along the waterfront in the intervening period, giving a graphic indication of the newly flourishing economy of the city. By a comparison with these works, it is possible to attribute to van der Hagen a bird's-eye *View of Carton, Co. Kildare*, showing the house as it was before its rebuilding by Richard Castle in 1739, with its elaborate formal gardens and radiating avenues. A very similar view of *Howth Castle*, which is set in as an overmantel and still in the house today, may also be attributable to van der Hagen. A great deal of life is going on, with people walking, chatting, riding and the details of the gardens are particularly fascinating. He also painted straight landscapes, which are naturally in the Dutch manner (Fig. 91).

Among his best and most decorative works are his *capriccios*, which vary from imaginary views in Ireland and the much more charming compositions of shepherds amid classical ruins, watermills, and mountainous scenery, clearly influenced by painters of the seventeenth-century Dutch–Italian tradition such as Nicholaes Berchem, Jan Weenix and Jan Both. Some of these *capriccios* are signed 'W v Hagen'. One in the NGI is dated 1732 and another larger overmantel picture, in a carved rococo frame, from Kilsharvan, Co. Meath (Fig. 92), is signed 'Wm v Hagen 1736',[23] the same date as the dryly painted *View of Waterford*. The figures of shepherds and a dog surprising a swan are delicately painted and unlike his often rather elongated and sometimes cursory figures. The classical ruins which peep out from behind the trees are not accentuated and the whole landscape, with its lake and distant mountains, is sunlit, light and airy. The painting shows a rococo virtuosity never before seen in Irish painting.

Apart from landscape and *capriccios* he was well known as a decorative artist. His most elaborate

recorded scheme was at Curraghmore, Co. Waterford, where he painted an entire downstairs room with landscapes and on the staircase painted 'columns, festoons, etc. between which are several landscapes' while the ceiling was 'painted in perspective and represents a Dome, the columns seeming to rise, though on a flat surface'.[24] All this has disappeared, as has the work done by van der Hagen for the Christmas family at Whitfieldstown, Co. Waterford, where again, according to Smith, there were 'some well executed landscapes of the late Van der Egan, and other good pieces, particularly a picture of St. John Baptist. The hall is painted in

90 William van der Hagen, *View of Derry*, oil on canvas, formerly Derry City Hall

91 William van der Hagen, *Landscape*, signed, oil on canvas, Private collection

Clara Oscura, with several of the heathen deities, and in it stands two statues of Neptune and Amphitrite.'[25] There was once a grisaille decoration of classical mythological figures in the dining-room of Mount Congreve nearby, which was probably by van der Hagen, though it is not mentioned in Smith. Possibly they had been moved from nearby Whitfieldstown. The series has recently reemerged and were sold in London.[26] These simulated statues of classical gods and goddesses are naïve and indicate that he had not been trained as a classical figure painter. A similar type of decoration of monochrome mythological figures painted on panels between the Ionic pilasters in the hall survives at Seafield House, Co. Dublin, though no certain attribution to van der Hagen can be or ever has been hazarded. According to another eighteenth-century source, Austin Cooper, van der Hagen painted the ceiling roundel in the drawing-room at Beaulieu, Co. Louth. He said 'some paintings on the ceilings I suppose to have been done by Van der Egan who painted many houses in this Kingdom'.[27] This still survives, but one at Howth in a similar roundel has disappeared. The overmantel in the hall at Beaulieu, a view of Drogheda, is also by van der Hagen. It shows the town walls and red-brick houses painted with considerable freedom and accuracy. Strangely, there are no figures as in the Waterford and Derry views.

Another decorative painting recorded by Smith in his 1756 *History of County Kerry* must be interpolated here as it is the only other painting in this genre which we know of at this period. It was at Lixnaw, Co. Kerry, where the chapel was 'painted in fresco by a foreigner called John Souillard, being copies of the celebrated cartoons of Raphael at Hampton Court ... The figures are as large as the life; ... and over the door, between festoons and other decorations are the heads of Homer, Virgil, Milton, and Pope all in claro obscuro by the same hand.'[28] These would seem curious bedfellows to be found in a chapel.

Van der Hagen also worked as a scene painter at the theatre at Smock Alley, where in 1733 he painted the scenery for *Cephalus and Procris*, 'finer painted than any ever seen in this Kingdom'.[29] A view of the *Duke of Dorset's State Ball in Dublin Castle* (Fig. 93), which took place in November 1731, had figures which compare with the genre figure of a boy coursing and others playing with a kite in the foreground of the Waterford view, and it is tempting to attribute the picture to him. The ball was described by Mrs Delany when she wrote to her sister:

On Monday at eight o'clock went to the Castle. The room where the ball was to be ordered by Capt. Pierce [Sir Edward Lovett Pearce] finely adorned with paintings and obelisks, and made as light as a summer's day. I never saw more company on one place; abundance of finery, and indeed many pretty women. There were two rooms for dancing. The whole apartment of the Castle was open, which consists of several very good rooms; in one there was a supper ordered after the manner of that at the masquerade, where everybody went at what hour they liked best, and vast profusion of meat and drink, which you may be sure has *gained the hearts* of all guzzlers! The Duke and Duchess broke through their reserved way and were very obliging; indeed it was very handsome the whole entertainment, but attended with great crowding and confusion... The ball was in the old beef-eaters hall, a room that holds seven hundred people seated, it was well it did, for never did I behold a greater crowd. We were placed in rows, one above another, so much raised that the last row almost *touched the ceiling!* The gentlemen say we looked very handsome, and compared us to Cupid's Paradise in the puppet-show. At eleven o'clock minuets were finished, and the Duchess went to the basset table.[30]

The central figures are performing a minuet. They are similar to illustrations in the manual by Pierre Rameau entitled *Le Maître à Danser*, published in Paris in 1725.[31] Some of these decorations have recently been found hung up in the attics at Knole, the Duke of Dorset's seat, and it is possible that van der Hagen may have executed them to Sir Edward Lovett Pearce's design. A very complete description of a ball held in the castle, clearly reusing the decorations, appeared in the *Dublin Evening-Post* for 30 October–3 November 1733. It stated that it was

the most magnificent that has been seen in this kingdom ... The Great Hall below Stairs was fitted up for the Ball in a most Magnificent manner, the Sides were covered with Hangings painted in perspective; at the Entrance stood two obelisks, on which were Coronets, and other devices in Candles, the Seats were rais'd on each side ... with Pillars between stuck full of Candles, and placed at such proper distances as to Deceive the Sight, and make the Hall much longer than it was. The lights are very numerous, and placed with great Taste and Order.

The extract goes on to describe the arrangements for wine cisterns and piping wine into the castle yard where much company was assembled, and this extract clearly shows van der Hagen's picture to be very accurate.[32]

Van der Hagen's last recorded work is a landscape of Powerscourt waterfall engraved by J. Brooks in 1745 as by 'the late ingenius Van der Egan'. This, with its picturesque subject, takes us from the portrayal of formal topography to the appreciation of the romantic landscape, and it is a measure of van der Hagen's importance for Irish painting that he spans the two.

He had a number of accomplished followers, Joseph Tudor and Anthony Chearnley being the most important, though most landscapes of this period show his influence. Joseph Tudor (?1695–1759) had a career curiously linked with that of van der Hagen. He

facing page

92 William van der Hagen, *Capriccio Landscape with Shepherds beside Ruins in a Mountain Valley*, signed and dated 1736, oil on canvas, Private collection

93 William van der Hagen, *State Ball at Dublin Castle*, 1739, oil on canvas, Private collection

worked in Dublin Castle and Smock Alley, in each case a few years after van der Hagen, and his landscape manner is also stylistically close, but whether this indicates that he was a pupil is uncertain. Tudor is first heard of working in Smock Alley in 1739, painting the scenery for *The Harlot's Progress*; in 1748, he worked there again on Woodward's *Fairy Friendship*, or the *Triumphs of Hibernia*. An engraving after him of 1749 records his *Perspective View of the illuminations and firework machines in St Stephen's Green* which celebrated the Peace of Aix la Chapelle in 1748, and he is recorded in November 1753 as working on decorations outside in the courtyard and inside Dublin Castle for the king's birthday. These were apparently designed by the Surveyor General's Office but executed by Tudor and a description of them in *Faulkner's Dublin Journal* says they 'Adorned in imitation of an Egyptian Saloon ... at the far end the Temple of Comus finished in a

most delightful manner ... Round three sides of the Temple ran an arcade of azure pillars, gilt, in imitation of lapis lazuli, an exquisite enchantment.'[33] One further piece of documentary evidence indicates that Tudor may have worked in England, as an artist called Tudor painted the Gothic wallpaper for the hall and stairs of Strawberry Hill for Horace Walpole in 1753.[34]

Tudor had a successful career as a landscape painter, winning premiums for landscapes from the newly founded Dublin Society in 1740, 1742, 1743[35] and 1746. None of these can be identified, but two paintings exist which are clearly by him, as they correspond with an engraving after Tudor by John Brooks, dated 1746, of the *Obelisk in memory of the Battle of the Boyne* on the site of the battle. Both engraving and paintings are enlivened by figures, though these differ, and the composition, which in one version includes the artist painting, and colouring undoubtedly reflects the influ-

ence of van der Hagen. The larger version has the same date and is dedicated to the Lord Lieutenant, the first Duke of Dorset, with his arms on a swan-pedimented memorial plaque in the foreground. The smaller version was painted for the daughter of William's General Ginkel, later Earl of Athlone. The Dorset picture is particularly interesting as it shows in the left foreground three gentlemen discussing what looks like a dolmen and must therefore count as a very early example of antiquarian interest in Ireland.

A landscape in the overmantel of the hall at Castletown, Co. Kildare, of Leixlip Castle and the Salmon Leap, may correspond with an engraving by John Brooks, dated 1745, after Tudor's *A View of Leixlip and Waterfall* mentioned by Strickland, but not known to us. The Castletown painting is stylistically close to the Boyne obelisk though strangely without any figures. A delightful small picture which is now given to Tudor shows *Leixlip Castle* (Fig. 94)[36] with its surrounding village and church, with two milkmaids and two young men lolling in the foreground. An engraving of this picture, but without its letterpress, exists, so the attribution to Tudor is purely on stylistic grounds. Its small scale makes the handling of the picture much more sympathetic than his other oils, but it is close to his watercolour style. The architecture in this pastoral scene is well handled and the colours are brighter than the green landscape of the *Boyne Obelisk*.

Four of the drawings for his six engraved views of Dublin published in 1753 exist and are freely painted in grey wash. The Parliament House drawing shows the gabled Dutch billies in Dame Street and two rows of horse-drawn cabs. A recently discovered work, which we attribute to Tudor, is a large panoramic view of *Dublin from the Phoenix Park* (Fig. 95) which has a lively group of musicians and dancers and the picture is based on Claude's *The Mill* (NG). Tudor's figures are usually an important and charming element in his compositions. Tudor's painting of Dublin relates to his watercolour and the engraved view of Dublin from the Phoenix Park and is the most important mid-century depiction of Dublin, with all its churches, bridges, brick houses and even Killiney with the Mapas obelisk in the far distance. This was built in the famine years of 1740–1, which gives the earliest possible date for the picture.

Another engraved work is of Archbishop Boyle's palace at Blessington, Co. Wicklow, where the foreground is enlivened with a group of horsemen returning from a hunt. *Faulkner's Dublin Journal* for 9–13 April 1745 informs us that on that day John Brooks published engravings of Tudor's *Leixlip with a waterfall*, for which he was given twenty guineas by the owner, William Conolly. Also published was the Blessington prospect by the owner Lord Viscount Mountjoy, while Brooks received ten guineas for ten prints from the Duke of Dorset for the Boyne obelisk. Other subscriptions came from the Lord Mayor and Aldermen, and

from members of the Boyne Club, who erected the obelisk. Arthur Dobbs, the Surveyor-General and the Club's President, subscribed £40. This comprehensive advertisement indicates that Brooks made more than one engraving of some of Tudor's pictures. Tudor is recorded, again like van der Hagen, as painting an altarpiece, *A Heavenly Vision*,[37] for Waterford Cathedral in 1750, which unfortunately has not survived.

A painter of similar interests was an Englishman, Thomas Mitchell (1735–90), who visited Ireland in 1757. His painting of the Boyne obelisk (Fig. 96) is an elaborate composition incorporating Grinling Gibbons's equestrian statue of William III which in reality stood on College Green, Dublin. It has been

94 Joseph Tudor, *View of Leixlip and waterfall*, oil on canvas, National Gallery of Ireland, Dublin

95 Joseph Tudor, *View of Dublin from the Phoenix Park*, oil on canvas, Private collection

96 Thomas Mitchell, *The Boyne Obelisk*, signed and dated 1757, oil on canvas, Ulster Museum

97 Anthony Chearnley, *View of Kinsale*, oil on canvas, Private collection

suggested that the painting was commissioned by the fourth Duke of Devonshire, who was Lord Lieutenant between 1755 and 1757, as a celebration of his connection with Ireland.[38] Mitchell's painting is signed and dated 1757. From the handling of the trees and the general composition a painting of Kilkenny (NGI) is attributed to him and both have a very distinctive orange ground. There is a portrait group of Sir John Freke, his wife and Mr Jeffreys of Blarney by a lake, also dated 1757. The Frekes lived in west Cork, and

Mitchell is also significantly recorded as being at the lakes of Killarney with Bishop Berkeley and his son and a musician called Dubois at roughly the same time. It is probable that he was employed by Berkeley to paint the lakes, though sadly no picture survives. Mitchell was a marine painter and shipwright to the Admiralty and held an important position in the dockyard at Chatham.[39] He may have travelled, as there is a *View of Rome* signed by him which shows the Colosseum[40] and the trees in this picture are close to those in his views of Kilkenny.

The only certain oil by Anthony Chearnley (*fl.* 1740–85) is a *View of Kinsale* (Fig. 97) which can be identified from an engraving by Thomas Chambers for Smith's *History of Cork*, published in 1750.[41] But another view of Kinsale harbour with shipping is probably by him[42] and Strickland mentions a portrait which he only knew as an engraving. For the same publication, and for Smith's *History of Waterford*, paintings of Cork, Youghal, Lismore and other southern towns were also engraved after Chearnley, though the originals are not known. The *Kinsale* gives a pleasing panorama of the harbour and the town and, like van der Hagen, Chearnley places the main subject in the middle distance and includes the artist painting. The group of doll-like ladies and gentlemen in the foreground, talking to the artist, stresses that Chearnley wished to be seen as a gentleman. Indeed, some of his engravings, including that of Kinsale, are signed 'Antho Chearnly, Gen. Burnt Court, Delin'. In one of his views engraved in Grose's *Antiquities of Ireland* 1791–5, he portrays the neat residence he built for himself within the walls and under the shadow of the ruins of the early seventeenth-century gabled Castle of Burnt Court, Co. Tipperary.

Grose is the source of all our meagre information about him, mentioning that he 'deserves to be remembered for cultivating the art of design, when few pursued it, in 1740, in Ireland … He had a large collection of views from ancient remains, which probably lie in private hands, and well deserve to be made public'.[43] Included in Grose is a view of *Ardfinnan* (RIA), dated 1744, by Chearnley, which is in a neat topographical style.[44] An example of cut paper work, showing a bust statue on pedestal of Marcus Tullius Cicero, including arabesques and floral forms mingled with human heads, birds, a cornucopia, etc., is signed 'Anton Chearnley 1744'. Chearnley's output seems to have been small but varied, perhaps because he was an amateur, but its quality, judging by the Kinsale picture, is reasonable and lively enough.

Samuel Chearnley (d. 1746) of Birr, Co. Offaly, Anthony's brother,[45] was an amateur architect who worked for his cousin, Sir Lawrence Parsons, and whose drawings of bizarre garden buildings and follies are amongst the most entertaining projects of their time, very much in the style of Thomas Wright of Durham (1711–86). Another antiquarian topographer was Jonas Blaymire, or Blaymires, who was employed

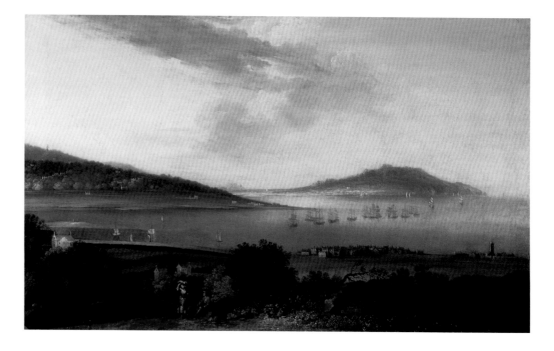

by Walter Harris to illustrate a new edition of Ware's *Works*. Strickland records an amusing letter from him and Barnard states that the Bishop of Killaloe was angered by Blaymire because the engraving did not do justice to his cathedral. Blaymire retorted: 'Is it possible that I can draw a Venus from a broomstick'.[46]

Unlike Chearnley, who worked outside Dublin, with William Jones (*fl.* 1738–d. 1747) we turn to the popular beauty spots in the vicinity of Dublin which in the 1740s seem to have been limited, with Dublin Bay, Powerscourt waterfall, the Dargle, and the Salmon Leap at Leixlip cropping up with ever-increasing frequency. All these are known in the engravings after Jones by Giles King. His oils include two identified from engravings of Dublin Bay looking towards the Hill of Howth (Fig. 98), which is topographically fantastical, as is his other view from Blackrock across to Bray Head and the Sugar Loaf Mountain. From the engravings, his rock and water painting seems to have been very mannered, but his figures are engaging puppets, some of which are seated and include the now standard artist sketching. Two other attributable views of Kilkenny and Leixlip with his same, very personal, figures are far superior to his Dublin coastal scenes. The Kilkenny view used to be attributed to Butts.[47] Grant illustrates *A View of Ardfinnan*[48] with its castle and bridge and, given the handling of the trees and architecture, it is probably correctly attributed to Jones. From studying his landscape style, he is unlikely to be the painter of a primitive view of Adare House, which is signed 'WJ'.[49] He was also a portrait painter, as the engraving by Andrew Miller of Charles Lucas, dated 1747, informs us.

His early career appears to have been in England, where he fully signed and dated 1738 one of a set of four overdoors at Kimbolton Castle which include a view of the castle; the figures are very similar to those in the Irish pictures. Elizabeth Einberg has connected

98 William Jones, *View of Dublin Bay*, oil on canvas, Private collection

99 William Jones, *The Fortune Teller*,
oil on canvas, Private collection

100 William Jones, *Girl showing her
bottom*, oil on canvas, Private
collection

these with two pictures in Tate Britain,[50] two scenes from Colley Cibber's *Damon and Phillida*. These show the marked influence of Hogarth and ultimately of Watteau, showing that Jones probably stayed some years in England. In fact, we do not know whether he was English or Irish. The Tate pictures lead us on to a most interesting fortune-telling scene (Fig. 99),[51] where the figures are seated round a table, one bare-breasted with the red-coated fortune teller pointing at her teacup. Another fortune-telling scene with the same sitters appeared in a Christie's sale[52] and a very saucy picture on copper of a woman baring her bottom (Fig. 100), acquired on the Dublin art market in the 1960s, is almost certainly by him. The last informa-tion we have of this varied artist is that Samuel Dixon held a sale at his shop in Capel Street, Dublin in February 1747, of landscape and history paintings done 'by the late ingenious Mr Jones'.

A fellow premium winner in 1740 with Joseph Tudor, sharing with him the palm of being the earliest premium-winning landscape painter in Ireland, was Susannah Drury (*fl.* 1733–70). She came from an artis-tic family related in some way to the French miniatur-ist Jean Petitot, and her brother, Franklin, was also a miniature painter. Her first known work was a water-colour, *London from Greenwich Park*, dating from 1733 and recorded in Strickland, but she is now only known by her premium-winning views of the Giant's Causeway which reflect the minute observation of a miniature

painter (Fig. 101). Two pairs of these gouaches on vellum (one in the Ulster Museum) are known and engravings in various editions after them are common-place. The technique of gouache on vellum is similar to the work of Joseph Goupy, the fan painter, with whom she might have studied when in London. Apart from their unusual technique, they are exceptional for their subject-matter and for the sophistication of the drawing of their figures. If she was an amateur, she was remarkably capable, and it is unfortunate that no more is known about her other products or her training. Mrs Delany said that she spent some three months living in the cold and uncomfortable Causeway area while she was working on her pictures.[53]

Less competent but still of absorbing interest is the work of Mrs Delany (1700–88) herself,[54] an English lady who married as her second husband Swift's inti-mate, Dean Delany. Besides being one of the most lively letter writers of her time, she was a gardener, a creator of collages and a noted exponent of shell dec-oration, both in friezes in her own house at Delville, Co. Dublin and in her friends' grottos. She was an enthusiastic copyist, but in her surviving sketchbook in the NGI she appears as a naïve but keen portrayer of Irish landscapes from Derry to Dublin and Killarney to the Causeway between 1749 and 1767. Her abilities were no match for Miss Drury and she could not cope with the grandeur of the extraordinary rocks at the Causeway, but the loving care with which she recorded

the view from Delville and her garden there is most memorable. The range of her travels and the scope of her interests is only equalled by the work of the antiquarians of a generation later. Her friend Letty Bushe was also a landscape painter, who travelled from Killarney to the North of Ireland, making drawings and watercolours and teaching several members of the aristocracy. Through a very bad engraving, her view of the lakes of Killarney is now the earliest view in existence of that famous picturesque beauty spot.[55]

The most famous of these antiquarians was probably Gabriel Beranger (1729–1817), who was of Dutch Huguenot origin, coming to Ireland in 1750 aged twenty-one and earning a living as a print-seller and framer, a teacher of drawing and a painter of pastel portraits, silhouettes, flowers and birds. He even decorated table tops and marblized furniture.[56] He started to make drawings of antiquities soon after his arrival. His draughtsmanship and antiquarian tastes were noticed and used by General Vallancey, the scholar and map-maker of the Board of Ordnance, and the great patron of the arts and architecture, William Burton Conyngham. They, with scholars such as Charles O'Conor and Edward Ledwich, formed a circle who encouraged and employed a vast number of painters and amateurs who produced a corpus of watercolours of Irish antiquities. Many late eighteenth-century artists and architects, such as Angelo Bigari, Thomas Roberts, Jonathan Fisher and William Ashford, worked on these projects, of which Francis Grose's *Antiquities of Ireland* is the most famous. Angelo Bigari is recorded as having painted a large oil of Westport and Clew Bay for Lord Altamont in 1779, though it

does not survive.[57] Though all this work[58] is only peripheral to landscape painting, it was the spirit of enquiry in which it was undertaken that led to much travelling all over Ireland and to a new interest in natural scenery. This becomes very marked in the second half of the century, when Irish landscapes, much influenced by the compositions of Claude, Gaspar Poussin, Salvator Rosa and the numerous Dutch masters, incorporating round towers and abbeys, superceded the formal topography of the first half of the century.

Another foreign landscape painter whose work must be mentioned is Gabrielli Ricciardelli (*fl.* 1745–82), a Neapolitan artist who painted many views of his home town and its surroundings. He had a considerable success in Ireland, though he may have gone to and from England, where he is recorded as exhibiting in 1777. He arrived in Dublin in 1753 and apparently painted portraits, though none are now identifiable, as well as landscapes. According to Strickland, he advertised himself in the following terms: he 'was at liberty to paint any gentleman that think him deserving of his countenance'. He may have been encouraged to come to Ireland by Ralph Howard, later first Viscount Wicklow, for whom he painted four pictures, views of Naples for which he charged £56.17.6 according to a receipt dated 3 December 1755.[59] He may also have been a decorative artist, as he was involved, according to Strickland, in negotiations, which were not successfully concluded, with Cipriani in connection with Dr Mosse's proposed ceiling paintings for the Rotunda Hospital Chapel. However, it is as a landscape painter that he is known today. He had

101 Susannah Drury, *East Prospect of the Giant's Causeway*, 1740, gouache, Ulster Museum

102 Gabrielli Ricciardelli, *View of Dublin*, oil on canvas, Private collection

103 Gabrielli Ricciardelli, *View of Dublin*, detail including the Parliament House dome, oil on canvas, Private collection

been trained by J. F. van Bloemen, called Orizonte, and Nicolo Bonito, and Italian landscapes and *capriccios* with classical statuary and ruins by him are sometimes met with. He was employed either by Philip Tisdall or Lord Allen, or by both, to paint landscapes of Stillorgan House and Obelisk which had been let in 1754, the year after Ricciardelli's arrival, by Allen to Tisdall. Two versions of each picture survive, coming from descendants of both families, the larger versions with Lord Allen's descendants, the Probys. These paintings have the sharp contours and low horizons which typify his work. From these Stillorgan pictures it is possible to attribute several other works, including two views of Dublin also in the Proby collection. The latter must be the originals for the engraved views advertised in *Faulkner's Dublin Journal* of 7–11 March 1758, though no prints are known. They were entitled views of Dublin from the sea and from the Phoenix Park. They could be seen at Mr Henderson's seed shop at the corner of Capel Street. Though Dublin appears in the distance in both paintings, so sharp is Ricciardelli's focus that the buildings can easily be identified and the pair are the most descriptive views of the city of Dublin in the mid-eighteenth century (Figs 102, 103).

Another view of the port of Dublin (NGI) in somewhat rubbed condition, which has been incorrectly attributed to Tudor, seems to us to be by Ricciardelli. He appears to have travelled north, as two views of Drogheda, the building of the Mausoleum at Dawson's Grove, Co. Cavan and a view of Ballyshannon are certainly by him. The Drogheda views must date to at least 1782, as the three-arched bridge on the right hand side of one of them was not built until that year. The other picture is particularly excellent in showing the red-brick Dutch gabled houses and the formal garden down by the river. The *Mausoleum* was

engraved by Walker and Angus in 1784 and wrongly inscribed by 'P. Sandby, R.A. Pinxit', a typical example of the annexation of an Irish picture by an English artist who in fact never visited Ireland. The Ballyshannon view shows fishermen angling from rowing boats, as well as a two-masted brig anchored in the river. As one might expect, the rigging is shown in great detail, as are the houses of the town.

We finish this chapter, perhaps incongruously, with racing pictures, which are in many cases a variety of landscape and the only Irish still-life painters we know of. An example of such a painter is Charles Collins (*c.*1700–44). His Irishness is based on a report on the auction of pictures from the collection of Gustavus Hume, a doctor and property developer. In the *Dublin Evening Post* of 4 May 1786, it stated that 'there are also two pictures most admirably executed; one of live fowl; the other a dead hare, dead birds etc. by an Irish master [Collins] which is allowed by the first judges in point of elegance and performance, to be inferior to none'. Admittedly, 1786 is some forty years after his death. Strickland, giving no authority, says that 'he appears to have followed his profession sometime in Ireland'. Vertue mentions him twice, saying that he died in 1744 and that he was aged between forty and fifty.[60] He said he was a bird painter and Walpole adds the fact that he painted 'all sorts of fowl and game ... [and] his own portrait in a hat'.[61] For many years, it was not recognized that the oil painter of hunting still-lives was the same man as the watercolourist of birds and animals. Recently, there has been an attempt to identify him as Charles Collins of Chichester, who was born in 1680. To us, this seems impossible. One other Irish link is that a painting of a pheasant by Collins was included in the J. D. La Touche sale at Geminiani's sale rooms on 16 May 1764. All these auctioned works must have been oils. Other examples by Collins turn up in

Ireland, some of overdoor shape, and there was one oil, dated 1733, of *Dead Game and Fowling-Piece* in the Duke of Leinster's collection at Carton.[62]

The chief influence on his work was Dutch, especially Jan Weenix. It is entirely possible that Collins went to the Low Countries to study, though works by him were turning up in sales in both London and Dublin. The content of Collins's[63] still lives were hares, rabbits, game birds and all the panoply of a shooting day's bag, as they include guns, flasks and satchels with Italianate landscapes in the background (Fig. 104). He is as good as any Dutch master in his technical skill in painting textures: fur, feathers, leather and metal. One of his most delectable works is his *Lobster on a Delft Dish* of 1738 (Tate Britain). Its quality lies in its simplicity and its impressive scale. There are a number of other rather crowded still-lives of fruit and other domestic details on tables. Apart from the Dutch influence, his work sometimes has French overtones from Oudry and Desportes, especially in the hunting compositions. He signs most of his works and the earliest date we have is on an oil of 1729.

Later in his career, he was involved in illustrating H. Fletcher and J. Mynde's ornithological books, published in 1736. For these, he made large watercolours and John Murdoch[64] suggests that he was influenced by the Bolognese naturalist Ulisi Aldrovandi (1522–1605), whose book on ornithology was reprinted throughout the seventeenth century and to which Collins would therefore have had access. Two different watercolours, one of 1737, depicting a heron over a pool, and the second of a bittern, dated 1735, are very close in pose to Paul de Vos's *Wading Birds in a Landscape*.[65] Iolo Williams was a great admirer of his watercolours and says of one that it is a 'masterly drawing of a heron, a wonderfully satisfactory thing for the quality of the plumage, the bold pattern of the pose'.[66]

Though we have not seen any watercolours other than birds, Collins apparently was involved in illustrating other animals, including exotic beasts from the New World, Africa and the East, as well as fishes, crocodiles and fungi. Hundreds were listed in the Taylor White sale at Sotheby's.[67] Many of these are now in McGill University, Montreal.

While discussing this genre, we must mention Ireland's best-known flower and bird painter, Samuel Dixon[68] (*fl.* 1748–69), whose brother, John Dixon the mezzotint scraper, went to the Dublin Society Schools. Samuel may also have done so before the schools were fully established. He was involved in the trade of printed fabrics, as was the great fabric designer, William Kilburn (1745–1818). The techniques employed were one of the great innovations of Irish manufacturers in the eighteenth century. The two influences on Dixon were G. D. Ehret and George Edwards, whose book *The Natural History of Uncommon Birds* was published in London between 1743 and 1751. Dixon's work is highly decorative; he invented an embossed technique, what he called a 'basso relievo',

104 Charles Collins, *Still Life, a Hunting Piece*, signed and dated 1741, oil on canvas, Private collection

for his series of birds and fruit and flower pieces between 1750 and 1755, when his method was being plagiarized by others.

Turning to other animals, we are amazed at the very few horse paintings of Irish origin from the eighteenth century which are now known. There must have been many, as the Irish gentry were known for their horses and horsemanship and the paintings must now be hiding under English names. The only Irish sporting artist that we know about in this period was Daniel Quigley. His dates are uncertain, though an attributed, but virtually certain, work inscribed '*Irish Hero 1778*' is known. He was a primitive painter, working closely in the Seymour tradition, setting his horses, figures and carriages in a friezelike composition in front of nearly treeless landscapes. Quigley's painting *The Match between Mr Walpole's 'Paoli' and Mr O'Neill's 'Hero' on the Curragh* is dated 1764,[69] but an earlier work, known in various versions, is *The Famous Carriage Match Between Lord March and Lord Eglinton against Theobald Taafe and Andrew Sprowle [both Irishmen] for 1000 gns* which took place in 1750. This is a version of a Seymour, now in the British Art Center, Yale. He also copied other English masters' paintings, such as David Morier's famous icon, *The Godolphin Arabian* which he painted on several occasions. Two more attributable Quigleys were in Adare Manor,[70] where the fact that they hung with a Wootton and two Seymours showed up the derivative nature of his work. One of them shows the ruins of Kildare Cathedral with its round tower in the far distant background of the Curragh (NGI). An interesting example is his picture of the grey stallion *Flyar*, because it shows

with Croagh Patrick and Clew Bay in the background was on the London art market in 1984.

Another work in the Seymour manner is signed 'R. Roper pinxt 1757' and is entitled *Ground Ivy, the property of Jn° Knox Esq*. Known as 'Diamond' Knox (1728–74), he came from Castlerea near Killala, Co. Mayo. Roper (*fl.* 1749–65)[72] must be the same as the artist noted by Edward Edwards as exhibiting in London in 1761 and 1762. Edwards remarked that 'his powers as an artist were not considerable, yet sufficient to satisfy the gentlemen of the turf and stable'.[73] His famous screen painted for 'Diamond' Knox shows many of the most famous race horses of the day (Fig. 106).

Windham Quin of Adare's great crony on the turf was the horse-mad Sir Edward O'Brien of Dromoland. A series of pictures of his horses and other famous sires such as *The Bloody Shouldered Arabian* and the *Godolphin Arabian* hung there until 1962. One of these was signed by Thomas Spencer and dated 1753, so he may also have been working in Ireland at this period. Some of them were very close to Quigley and as they were all copying from each other, this is not surprising. A very interesting inventory[74] of O'Brien's pictures for 1751 has survived and indicates that he had an enormous number of horse paintings.

By far the finest sporting painting of the 1730s was Windham Quin's *Race on the Curragh*, with the round tower of Kildare in the background (Fig. 107). This used to be attributed to John Wootton but it has recently been suggested[75] that it is by James Ross[76] senior (*fl.* 1729–38), who mostly worked in the west and south-west of England. Like many of his pictures, it includes carriages and horsemen galloping across the turf. A tradition in the family suggests that Mr Quin in his blue silks won the race. As yet, no other Irish work by Ross has been firmly identified and we are on very shaky grounds, for the Curragh painting is clearly based on James Seymour's *A Race over the Beacon Course at Newmarket*.[77] The Newmarket buildings have been changed for the Curragh, so it is quite unclear whether it was painted by Ross or Seymour. *The First Lord Carbery and His Hounds*,[78] painted on a panel and dated from about 1740, is a charming picture which might be by Ross, though it is impossible to identify the artists of any of these pictures with any certainty. The largest Irish hunting scene of this period shows horses and hounds in a lush, green landscape incorporating many ruins. This used to hang in Castle Hyde in County Cork.

Judith Lewis (*fl.* mid-1750s–1781), the sister of Stephen Slaughter, married John Lewis and was probably in Ireland while he was here in the 1750s, probably on and off until 1759, when, as we have already said, he painted portraits of the Dobbyn family in Waterford. Only two signed works by her exist, dated 1755 and 1756,[79] which show groups of men and women on horseback with dogs by a river. To some extent, the figures reflect both Slaughter and John Lewis. They are well painted and may, from their dates, have been

105 Daniel Quigley, *'Flyar', a grey stallion on the Curragh*, oil on canvas, Private collection

106 Richard Roper, *The Knox Sporting Screen*, signed and dated 1759, oil on canvas, Private collection

the grandstand on the Curragh behind the winning post (Fig. 105),[71] and gives a full description, as was not unusual, of the winners, their owners and their pedigrees, between 1772 and 1773. He appears also to have painted other animals, as a splendid study of a hound

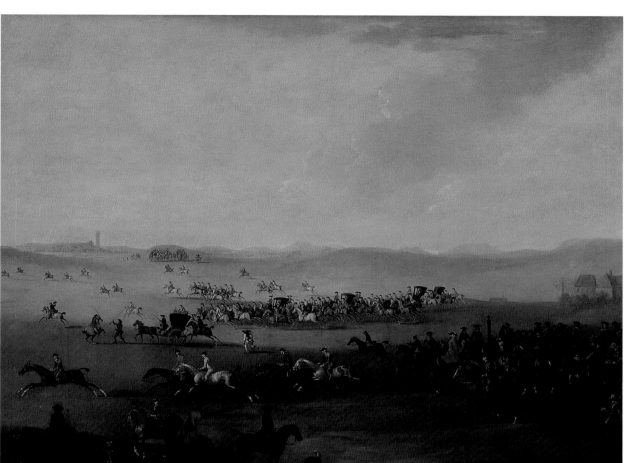

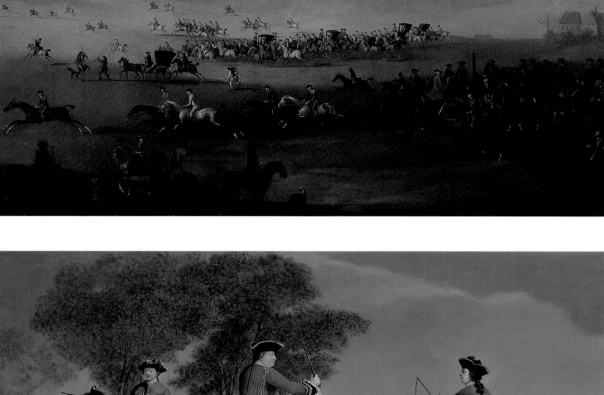

107 Anonymous, *Race on the Curragh*, oil on canvas, Private collection

108 Judith Lewis, *Riding party with the Duke of Cumberland*, oil on canvas, Private collection

done in Ireland. Waterhouse thinks they show the influence of Wootton.[80] A third, of another riding party, has been attributed to her and shows the Duke of Cumberland, who was a passionate horseman and owner of a stud (Fig. 108).[81] A problematic portrait group of extremely high quality signed 'JL' in a monogram is attributed to her. It depicts the *Hon. Herbert Hickman Windsor dressed as a hussar and his sister, Charlotte*

worked together and until we have more evidence, we cannot be sure. After John's death, the date of which is not certain, she lived with her brothers and sisters in Kensington and some of her pictures appeared in the sale of Stephen Slaughter's household effects on 3 and 4 March 1764.[82] In a note by Elizabeth Einberg[83] she suggests that Judith was the Mrs Lewis who was an honorary exhibitor of crayons, miniatures and needle-work pictures at the Society of Artists in London and that she was the same person that Horace Walpole praised for her imitation bronze bas-reliefs. Some of these appeared in Slaughter's sale.

The pastels of Robert Healy are discussed in chapter 6. He has to be mentioned here, however, as he was a horse painter and the finest practitioner in this genre in Ireland in the eighteenth century. His contemporary, John O'Keeffe, wrote that 'his chief forte was horses, which he delineated so admirably, that he got plenty of employment from those who had favourite hunters, racers or ladies' palfreys'.[84] His set of pictures done in 1768 for the Conollys of Castletown, Co. Kildare include one of Tom Conolly out hunting and several smaller works of the Conollys riding. These are the only certain surviving pictures of horses by him. However, he may have known the work of George Stubbs, who was patronized by Lady Louisa Conolly's brother, the third Duke of Richmond, and had painted a scene including Lady Louisa riding at Goodwood, Sussex. It is possible that Healy was introduced by her to Stubbs and these pastels have qualities, as Judy Egerton suggests, which indicate a knowledge of Stubbs. She notes that 'in the stuffed-leather appearances of horses and hounds, the sharp fall of light on horses's flanks, the elongation of the figures and their frieze like grouping',[85] Healy had links with Stubbs's style. But as no oil by Healy survives, she feels that she cannot attribute *The Death of the Hare* (British Art Center, Yale) to him. However, its attribution remains uncertain and there is some evidence that Healy did paint in oil, as John Wesley[86] saw murals by Healy when visiting Moira House in Dublin, which could not have been in pastel.

More of such works must have been painted in Ireland, despite their extreme rarity today. This is all the more curious, as the Irish nobility and gentry were rarely out of the saddle and it might be expected that of all types of painting, the sporting picture would have been the most popular. It is very surprising that so few survive today.

109 Attributed to Judith Lewis, *The Windsor children*, oil on canvas, Private collection

Jane, later Countess of Bute, with a dog and other pet animals in a landscape (Fig. 109). It links with John Lewis, whose initials are, confusingly, the same, so that one cannot be certain which of them painted it. On the other hand, it is of higher quality than John ever achieved. There is one other portrait of a highly fashionable, powdered Ramsay-like lady, which has the finesse of the Windsor group and might be attributable to Judith. However, they may sometimes have

6

The Dublin Society Schools and their Influence

The 1730s were a period of considerable change in the arts in Ireland. Patronage and an interest in architecture and painting were developing. This was partly due to the founding of the Dublin Society in 1731. The membership was made up of public-spirited gentlemen, some of whom, including Bishop Berkeley (1685–1753) and Samuel Madden (1686–1765; Fig. 110), were interested in the fine arts and themselves collected pictures. They were behind the founding of an academy.

Bishop Berkeley, the philosopher, in *The Querist* of 1735 enquired 'Whether when a room was once prepared, and models in plaister of Paris, the annual expense of such an academy, need stand the public in above £200 a year?'[1] He clearly had in mind drawing from the antique, which was the universal method of instruction. On the 24 August 1736, in the *Daily Advertiser*, John Esdall proposed opening a drawing school, stating that 'Drawing is the Mistress of all the manual Arts and Masonary, Carving, Stucco-forming, jewellry, Furniture and Damask Weaving …' Another plea for greater interest in the arts came from Samuel Madden. In 1738, he wrote his seminal pamphlet, *Reflections and Resolutions proper for the Gentlemen of Ireland, as to their Conduct for the Service of their Country*,[2] in which he encouraged the nobility and gentry to devote themselves to embellishing their estates and houses rather than becoming absentees. But he was a patriotic Irishman and concerned, like his friend Thomas Prior (1681–1751), with Ireland's economic development. Charles Smith, in his *History of Cork*, 1750, describes the bishop in a most significant paragraph and we have quoted this passage about his collecting of pictures in chapter 4, but Smith continues sketching out the view of Berkeley, Madden and Prior, saying, 'The great usefulness of Design, in the manufacturers of stuffs, silks, diapers, damasks, tapestry, embroidery, earthen ware, sculpture, architecture, cabinet work, and an infinite number of such arts, is sufficiently evident.'[3] This sentence, with its emphasis on 'design', brings us to the establishment of the Dublin Society Schools, undoubtedly the brainchild of this intelligent patriotic coterie. Their ideas were in the mainstream of the European Enlightenment and Prior and Madden saw the schools as providing the artists and artisans needed to develop their country's infrastructure which had suffered so much in the wars of the seventeenth century.

From 1740, Madden had been giving £100 per annum to the Dublin Society to found a system of annual premiums. These were to include agriculture, which encompassed tree planting, as well as the arts, including landscape painting, an unusual branch of art to encourage at that date. Vertue noted this new scheme and wrote that it would 'bring forth some eminent Artists – which will eclipse our London proficients of Art [it] may supply and rival the English who want a school or foundation – or some propper encouragement'.[4] The art school started a little later. In 1746,[5] Thomas Prior had an audience with the Lord Lieutenant, Lord Chesterfield, and spoke of the proceedings and plans of the Dublin Society in connection with establishing a regular school or academy of art. Strickland quotes the minutes of the society for 18 May 1746, saying that 'It is intended to erect a little academy or school of drawing and painting',[6] and this happened quite soon after. According to Carey, who records this audience, Lord Chesterfield replied to Prior, 'The genius of Irishmen is capable of excellence in every art and science, if encouraged. Get masters from the Continent to instruct you. You will soon have painters and sculptors of your own.'[7]

The first master of this school, Robert West (d. 1770), one of the most important figures in the development of Irish art, remains maddeningly elusive. All we know is that he was the son of a Waterford alderman and married the daughter of another, Thomas Smith. His importance was recognized very early, as even Warburton, Whitelaw and Walsh say that 'He is con-

110 Richard Purcell, after Robert Hunter, *Samuel Madden*, 1755, engraving, Private collection

111 Attributed to Robert West, *Speaker Boyle*, drawing, Private collection

sweetness and without a tincture of that celebrated draughtsman's mannered squareness'.

Even a well-known English engraver, William Wynne Ryland, knew about his Paris training. In the interesting *Diary of a Visit to England in 1775* by the Irish clergyman Revd Dr Thomas Campbell, which was not published till 1854, he remarks that 'The best of the English don't think as ill of the Irish as I expected'.[12] He continues, 'Let me not forget to set down what Ryland told me ... what indeed I had always heard in Ireland, that old West was the best drawer in red chalks at Paris, of his time, and that for drawing in general he was the best scholar of VenLoo [*sic*]'. He then goes on to mention the many Irish mezzotint engravers who were at West's academy and who dominated 'scraping' in England in the eighteenth century.

We have found no reference to West in any French lists of the Académie de St Luc or the Académie Royale, but these are by no means exhaustive. Boucher, who was only '*agrée*' in the Académie Royale in 1734, was, however, appointed an assistant in 1735, in which year Charles van Loo was professor and his son, J. B. van Loo, was also an assistant. This date, 1735, would fit well for a student period for West, as he set up his drawing school in Dublin in the late 1730s. This French background fits in well, too, with Chesterfield's remarks cited earlier.

Writing in 1841 in *The Citizen*, an anonymous author, 'M', identifiable as Thomas James Mulvany (see chapter 13) stated in a memoir of West's son, Francis Robert (*c*.1749–1809), that Robert West's chalk drawings from the living model (termed academy figures) 'have never been surpassed and perhaps but rarely equalled ... They are infallible models for study and have produced more good draughtsmen, and have impressed finer notions of the human form, than have the works of any other artist in the last century.'[13] Sadly, none of these has survived, though a list of packing cases probably belonging to his grandson, Robert Lucius West (1774–1850), tantalizingly containing many drawings by himself, his father, Francis Robert, and grandfather, Robert West, are included, but the cases are lost. The titles include chalk drawings of *Venus and Doves*; *Heads of Christ and saints*; *Academy figures* and *Various Heads of old men*, etc.[14] The collections include two oil portraits of Robert West by an artist called Foster, probably Thomas Foster, a pupil of Robert Lucius West, and another by Robert Hunter (*c.* 1720–1803).

We attribute a most striking portrait of Speaker Boyle to Robert West (Fig. 111), though there is absolutely no proof. It is a grisaille chalk study which, on first appearance, one would associate with one of West's better pupils, Robert Healy, whom we will discuss later. Henry Boyle, born in 1682, was Speaker of the Irish House of Commons between 1733 and 1756, when he was created Earl of Shannon. These dates eliminate Healy, who was still a child when Boyle retired from the speakership. Healy only became a

sidered as the parent of the Arts in Dublin'.[8] A stiff conversation piece in the Dandridge, Gawen Hamilton manner of Thomas Smith and his family, now at Upton House, Northampton (National Trust), was signed 'R West fecit 1735'.[9] But despite the signature and the sitter's name, we believe, after careful investigation, that this picture has nothing whatsoever to do with our Robert West. In addition, the style of picture does not coincide with Pasquin's assertion that he had 'studied in Paris under Van Loo and Boucher'. His French background is also mentioned by O'Keeffe in his *Recollections*,[10] published as late as 1826, though O'Keeffe was a student at the Schools in about 1755. William Carey says that West won the first prize for drawing in the French Academy under Carle van Loo[11] and added that 'West, with all Van Loo's prowess in chalks, drew in a purer style, with more truth and

student of the Schools in 1765 and Boyle is shown here with his long Speaker's wig; such a very realistic study is unlikely to be a posthumous portrait. Indeed, the sitter looks like a man in his sixties, in which case the picture would have to have been drawn in the 1740s, when West was starting the Schools and had not yet trained any pastellists. The portrait reflects West's French training and in its quality lives up to the eulogies we have quoted. It is very softly drawn, with great care taken in representing the subtle anatomy of the face and the beautiful fluidity of his wig, not to mention his intelligent and benign character. Robert Walpole described Boyle as the 'King of the Irish Commons'.[15]

The only possible contemporary reference is in an undated letter from a Robert West to Sir Hans Sloane. It starts: 'Having a work in hand which I intend to Publish by Subscription, I was ambitious of having a Man of Worth at the Head of my List, and was not long before I fixt on Sir Hans Sloane ... I therefore take the Liberty to wait on you ... and exhibit the Drawings ...'[16] Sloane was Irish and in touch with Trinity College in 1696, when he presented his book on the catalogue of the plants of Jamaica, and later gave the college a version of one of his portraits, so a letter from West is plausible.

Strickland says that in the later 1730s West opened a school in George's Lane, Dublin, and that about 1740 the Dublin Society, which had been founded as recently as 1731, arranged to send him twelve boys to teach. In fact, this was probably in the mid-1740s, as it is not until the minutes of 18 May 1746 that an entry appears which we have already partially quoted and which reads: 'Since a good spirit shows itself for drawing and designing, which is the groundwork of painting and so useful in manufactures, it is intended to erect a little academy or school of drawing and painting, from whence some geniuses may arise to the benefit and honour of this Kingdom; and it is hoped that gentlemen of taste will encourage and support so useful a design.' The first boys, according to J. C. Walker, writing in 1803,[17] were admitted in 1744, though the first fees to West are paid from 1746 and he was not paid a salary until 1750,[18] when the Schools moved to a new building in Shaw's Court.

The following advertisement appeared in *Faulkner's Dublin Journal* of 27–30 October 1750:

> We have the Pleasure of informing the Publick, that there has been lately opened an Academy for Drawing and Design, erected in Shaw's Court in Dame street, at the Expence of the Dublin Society, which is furnished with several fine Modells in Plaster, imported from Paris, &c. in which Academy the Pupils have already made a very considerable Progress both in drawing from the Round, and also from the Life, a Design which, we hope, must soon shew itself in the Forms and Elegancy of several of our Manufactures. The Academy was Yesterday visited by several Members of the Society, who expressed great Satisfaction on seeing the several Drawings and Performances of the Pupils, which hang up in the Room.

A contemporary account of the school exists in John O'Keeffe's *Recollections* which must reflect practice in the late 1750s, when he was a student. He says:

> We were early familiarized to the antique in sculpture, and in painting, to the style and manner of the great Italian and French masters. We also studied anatomy; and, indeed, the students there turned their minds to most of the sciences.
>
> We had upon the large table in the Academy, a figure three feet high, called the anatomy figure; the skin off to show the muscles: on each muscle was a little paper with a figure of reference to a description of it, and its uses. We had also a living figure, to stand or sit; he was consequently a fine person; his pay was four shillings an hour. Mr. West himself always *posed* the figure, as the phrase is, and the students took their views round the table where he was fixed. To make it certain that his attitude was the same each time we took our study, Mr. West with a chalk marked upon the table the exact spot where his foot, or his elbow, or his hand came. We had a large round iron stove nearly in the centre of the school, but the fire was not seen; an iron tube conveyed the smoke through the wall. On the flat top of this stove, we used to lay our pencils of black and white chalk to harden them. The room was very lofty: it had only three windows; they were high up in the wall, and so contrived as to make the light descend: the centre window was arched, and near the top of the ceiling. At each end of this room was a row of presses with glass doors; in which were kept the statues cast from the real antique, each upon a pedestal about two feet high, and drawn out into the room as they were wanted to be studied from: — but the busts were placed, when required, on the table. The stools we sat upon were square portable boxes, very strong and solid, with a hole in the form of an S on each side to put in the hand and move them. Each student had a mahogany drawing-board of his own: this was a square of three feet by four; at one end was a St. Andrew's cross, fastened with hinges, which answered for a foot; and on the other end of the board, a ledge to lay our port-crayons upon. When we rose from our seats, we laid this board flat upon the ground, with the drawing we were then doing upon it.
>
> We had a clever civil little fellow for our porter, to run about and buy our oranges and apples, and pencils, and crayons, and move our busts and statues for us ... We had some students who studied statuary alone, and they modelled in clay ...

The members of the Dublin Society, composed of

the Lord Lieutenant and most of the nobility, and others, frequently visited our academy to see our goings on: and some of the lads were occasionally sent to Rome, to study the Italian masters.[19]

The students, who were very young, often under fourteen at the time of admittance (O'Keeffe says he was six, though Strickland doubts this), not only attended classes but were examined for premiums, the first of which were awarded on 17 May 1746. Exhibitions were held annually at first, in rooms in the House of Lords. In 1747, sixteen boys exhibited and in 1748, twenty-eight. The Society was paternal in its approach and assisted students not only by admitting them for free but by encouraging them, paying for their apprenticeships, occasionally sending them to Italy and even paying, in the case of one sculpture student, Patrick Cunningham (d. 1774), for 'his Bed and Bed clothes'.[20] It is evident that Dubliners were extremely proud of their school. The following information appears in a pamphlet which, though unsigned, was written by the Revd Dr Thomas Campbell, whom we have quoted from before. The author uses some of his material again in his *Philosophical Survey of the South of Ireland*, 1778. He writes:

> Nor let it be objected that the nature of our provincial government excludes excellence here, as it does in Literature. *Ireland* gave *England* the hint of a Drawing Academy. Some of the greatest Artists have been bred here. In Landskips, we have no competitors. *Mr West* has sent out scholars of the greatest promise, now abroad. But, before that great Master presided in our Academy, we have had Painters the best in these islands at least. *Jervais* I would not mention, but that he is so celebrated by *Mr. Pope … Frye, Fisher, McArdel*, and many of the capital Engravers, were ours.[21]

Later developments included the establishment of a School of Design where James Mannin (d. 1779), possibly of either French or Italian birth, was the master. He was apparently a friend of West's and, though first mentioned as coming to Ireland in 1753, was probably teaching informally earlier than this. A third School, of Architecture, was founded about 1765, and a School of Modelling in 1811. However, whatever their intended careers, whether in the fine or applied arts, or even as in the case presumably of two members of the great banking family, La Touche, who must never have intended to become professionals, all students were initially taught together and with no payment. The School was not just for fine artists but also gave freehand, mechanical and pattern drawing. In 1764, the Society said that:

> The Dublin Society having established schools for Figures and Ornament Drawing, this is to give Notice, that all Painters, Carvers, Chasers, Goldsmiths, Carpet-Weavers, Linen and Paper Stainers, Damask and Diaper Weavers, their Journeymen and Apprentices, and others whose Profession depends upon Design, may have free Admission to view the Drawings of said Schools, in Shaw's Court, Dame Street, having first obtained Tickets from the Society.[22]

Strickland adds to this list cabinet-makers, silversmiths, calico printers, seal engravers, builders and surveyors. In 1842, Isaac Weld, Secretary of the Society, said that he had worked out from the Admission Registers that in the last hundred years no fewer than ten thousand pupils had passed through the schools.[23] In none of the early accounts is there any evidence that oil painting was taught. Campbell makes a very definite point of this when he says: 'The Academy has produced many excellent in Chalks, and more it could not do, for more it did not teach. To

expect Painters from mere Workers in Chalk, would be to expect Philosophers from a Grammar-school.'[24]

Strickland mentions that after its publication in 1748, the School used Robert Dodsley's *The Preceptor*, a manual on practical subjects which was particularly useful for the numerous students who went into the artistic trades.[25] As O'Keeffe has noted, the School employed models, and their plaster casts were mostly chosen by Lord Charlemont when he was in Rome and, again according to O'Keeffe, they arrived about 1751.[26] The School must also have had a collection of engravings, some of which may well have been brought from France by both West and Mannin. There must also have been a large collection of Old-Master drawings, a few of which survive in the NGI, one a copy after Charles Le Brun, others by Natoire, Jeaurat and Boucher. O'Keeffe was drawn in black-and-white chalks by West in the 'Guido style'. The close links between French designs and the applied ornament that appears in Irish rococo plasterwork, in silver chasing and on furniture carving is partly the result of these teaching tools. In 1764, one Joseph Fenn, described as 'heretofore Professor of Philosophy in the University of Nantes', proposed a number of measures to improve the teaching which were largely intended to increase the mathematical content of the course. His elaborately decorated book, entitled *Instructions given in the Drawing School established by the Dublin Society ...* came out in 1769. Fenn was really intending to provide for military and naval-commissioned recruits, but this innovation did not take place until later in the century.

Besides the Dublin Society Schools, various other private establishments came and went. The interesting feature of these is that the masters often informed the public that they had recently returned from Paris, or were French, as was William Bertrand who had been a fellow pupil with West and who opened his school in 1765.

Another Frenchman, Lesac, mentioned thus in Strickland, is noted in the *Old Dublin Intelligencer* of 28 April 1730: 'A fine Portrait of Monsieur Lalauze, the French Dancer, a full length in a Comick Dress, has been made here by Mons Lesac, a young Gentleman bred in the academy in Paris and come over within these few months, and is reckon'd by several curious persons to be a Better Painted more lively and correct piece than has been done by any Artist in this Kingdom for many years Past.' Strickland adds another piece of information, that he was 'the greatest artist since Gervaise [Jervas]'. No other information on Lesac has come down to us, but it is possible that he was the same man as the Pierre Mondale Lesat who advertised some years later in the *Dublin Daily Advertiser* of 25 November 1736 as 'Painter and Medalist, member of the Royal Academy of Paris, bred by Monsieur le Bouteux, Painter to the King of France, having come hither from Lisbon where he was employed by his Portuguese Majesty and intending to settle in this Honorable City,

113 Rupert Barber, *Jonathan Swift*, pastel, Bryn Mawr College

hereby advertises the Nobility and Gentry that he will teach Pupils ... He will also Draw from Nature, copy Curious Pieces ... at the easiest rates'.

During West's mental illness between 1763 and 1770, Jacob Ennis (1728–70) took his place teaching in the Figure School and it is noted in the Dublin Society Minutes for 31 May 1764 that his salary was to be increased to £80 per annum. He had been a pupil in the Schools, winning several premiums, and completed his studies in Italy. He had been sent there about 1754 by Arthur Jones Nevill, then Surveyor General. In Rome he lived with Robert Crone (q.v.) and James Forrester (q.v.) and studied in the Accademia di San Luca and the Accademia del Nudo, in both of which he won prizes and was taught by Rafael Mengs and Pompeo Batoni. He also made drawings of famous statues and on his return from Rome he decorated the cove of Nevill's drawing room in No. 14 Rutland Square after Pietro da Cortona's figures of Vulcan, Diana, and Mercury (NGI) in the Palazzo Pitti. This was a somewhat out-of-date model, full baroque, at this time. We illustrate *Vulcan ends the manufacture of arms* (Fig. 112). No other decorative work is recorded by him, though Strickland knew a number of portraits and subject pictures, and it is known that he painted portraits in Gibraltar on his way back to Ireland from Italy in 1757.[27]

Few works are now known by Ennis, but the National Gallery of Ireland has recently identified and attributed a portrait of Speaker John Ponsonby to him, on the basis of an engraving. It was formerly attributed to George Gaven (*fl.* 1750–75).[28]

The stress laid by the Dublin Society on the need for drawing skills in manufacturers is reflected in at least two publications of this period. The Revd Dr Thomas Campbell most pertinently remarked in 1767 that:

114 Matthew William Peters, *Self Portrait with Robert West*, oil on canvas, National Portrait Gallery, London

Silks, Tapestries, Velvets, Carpets, Carving, Gilding, Gardening, Architecture owe the greatest part of their price to one branch or other of *design*. Nay it gives value even to toys. We see what sums the *French* extract from this article. Now tho' few would excel as liberal Artists, yet they might influence the form and, fashion in some of the above works. He that might not rise to History, might yet paint a Landskip. And he that could not be a *Claude Lorrain* or a *Barret*, might yet paint coaches or porcelain ware. If the young Engraver could not be a *Strange* or a *Fry*. he might grave Arms on Plate, and be excellent in chased Works.[29]

These views are again aired later in the century in a drawing manual published in 1789 by William Allen, a Dublin man and print-seller. An engraving survives, showing his busy shop front. The manual is entitled *The Student's Treasure, a new drawing book consisting in a variety of etchings and engravings executed by Irish artists.* In the preface, it points out that 'The Advantages which accrue to the Community from the Study of Design, are not confined to the superior Ranks of Life, they are diffused through a Variety of Ingenious branches of Manufacture, in which a taste and a knowledge of Drawing is indispensably necessary, for their attaining perfection'.[30]

This stress on drawing and the French bias of the teachers, together with the establishment of what

amounted to an official School of Art are no doubt the reason for the high quality of much Irish eighteenth-century craftsmanship, mezzotint scraping, surveying and, above all, pastel drawing, which we have already begun to chronicle with the work of Edward Luttrell and Henrietta Dering Johnston in chapter 3. Thomas Frye used pastel in 1734 and the miniaturist Rupert Barber[31] (*fl.* 1736–72), whose mother Mary was the poetess *protegée* of Swift, also worked in this medium. Barber had trained in Bath before his return to Dublin in 1743, where he lived at the end of Mrs Delany's garden at Delville.[32] His medallion pastel of Swift (Fig. 113), of which the head is like his engraved portraits of the satirist dating from 1752,[33] is a fine example, with its decorative still life, and represents a complete contrast to the type of pastel associated with West and the Dublin Society School.

Rosalba Carriera, the great Venetian pastellist who popularized the medium in Europe through the charm and vivacity of her heads and half-lengths and through her extensive travels, was claimed by Pasquin to have practised in Ireland. Whether she did or not, her works must have been known here quite early, as they were included in collections such as those made in the 1740s by Lord Milltown, then Joseph Leeson. However, if West was in Paris in 1735–6, he could have seen her work there. West, according to Pasquin, 'principally excelled in his drawing of the human figure in chalk

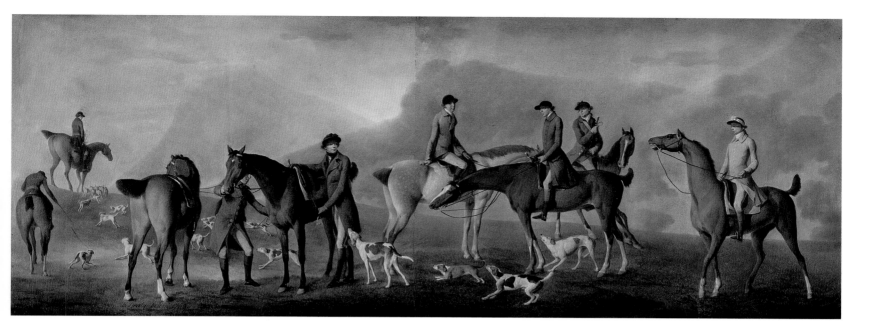

and crayons'. The high standard achieved in the School can be gauged to some degree by the beautiful chalk drawing by Matthew William Peters (1741–1814), drawn in 1758 when he was sixteen, of himself being drawn by West (Fig. 114).[34] It is possible that West assisted Peters, especially in his own portrait, which has stylistic links with the portrait drawing of Speaker Boyle which we have discussed. Unfortunately, as we have already noted, no certain drawings by West have come to light, though Strickland records a mezzotint after a portrait by him. In the list of the contents of a number of cases of drawings which we have already mentioned it is clear that examples survived into the nineteenth century.[35]

Hugh Douglas Hamilton (1739–1808) had exhibited a chiaroscuro subject picture at the Society of Arts in London in 1764 and this use of grisaille was clearly popular in the Society's Schools. Thomas Hickey's first recorded portraits, near life-size busts in black-and-white chalk of *Charles Lucas* and *Sir Fielding Ould* (both NGI), signed and dated 1758 and 1759 respectively, are other examples. Hickey (1741–1824), a fellow pupil in the Schools with Hamilton between 1753 and 1756, turned, however, to oils quite early in his career, though a number of chalk drawings dating into the 1770s exist. Hickey's portrait of *Charles Lucas* is stylistically close to Robert Healy's work, which is also in grisaille. His miniature of the medallist Henry Mossop, carried out as an illustration for *Exshaw's Magazine*, February 1775, is another grisaille. But the *Bernard Smith Ward*, signed and dated 1760, is closer to Hugh Douglas Hamilton. Healy had a very short career between *c*.1765, when he was a student, and his untimely death in 1771. He has left some of the most original works created in Ireland in the eighteenth century. However, the influence of Thomas Frye's mezzotints on Healy's bust portraits (several in NGI) has been noted by Michael Wynne and indeed in reproduction they do look extraordinarily alike.[36]

Healy is best known for the superb series of studies, discussed in the last chapter, of the Conollys and their friends at Castletown, hunting (Fig. 115), skating, walking and shooting. These were painted in February 1768, when they were recorded in a letter by Lady Louisa Conolly to her sister, Lady Sarah Napier:

> Lord Townshend return'd at night in order this morning but they [*sic*] is so bad that they can't stir out, Lord and Lady Gore are here, and many more gentlemen, there is a man in the House, who draws very good likeness's in black and white Chalk, we have made him draw some of the Company which is good entertainment this Bad Day.[37]

Accounts have survived for pictures Healy painted for the Conollys, but they do not indicate what he got for an individual picture. Tom Conolly paid him the large sum of £182.0.0 between 2 November 1767 and 16 November 1769.[38] This indicates that he did a great deal of work for the Conollys which has not survived.

Pasquin sums up his style perfectly when he says his pictures 'are proverbial for their exquisite softness: they look like fine proof prints of the most capital mezzotinto engravings'. More commonly met with are his small, whole-length works, such as Mrs Cradock, Miss Cunningham, Richard Townshend and Anne, Countess of Mornington, feeding her peacocks in Dangan Park. Recently found works include two delightful portraits of the Misses Stapleton seated in interiors, one with a book and one with her embroidery (Fig. 116), signed and dated 1769. They are in their original oval carved and gilt ribbon frames. Another is a whole-length portrait of Henry Hope-Vere, Lieutenant-Governor of Canada outside his tent with his gun and drum, signed and dated 1770. Healy's self-portrait in the NGI, and the finely characterized head and shoulders of an unknown lady, show the variety of his manner. The self-portrait was drawn while he was a student and therefore studying the antique. He leans

115 Robert Healy, *Tom Conolly with his hounds*, oil on canvas, Yale Center for British Art

116 Robert Healy, *Miss Stapleton*, oil on canvas, Private collection

117 Francis Robert West, *Miss Mathew, Lady Knapton and Miss Piggott playing cards*, crayon, Private collection

on a classical female bust. It is a strictly academic, idealized study, whereas the lady is a closely observed portrait. His pastels are full of tension and when there is a landscape background it is clearly observed and has subtle atmospheric distances. One grisaille pastel (NGI) by his brother William Healy,[39] (*fl. c.*1770) is known, and a few other rather poor studies in his brother's manner can be attributed to him.

Charles Forrest (*fl.* 1765–80) was a fellow pupil with Healy in 1765 in the Schools. Between 1771 and 1774, he exhibited portraits in chalks and miniatures with the Society of Artists in London and made his final appearance at the Society of Artists in Dublin in 1780. No precise dates are known for him. He exhibited portraits which included horses and dogs, and he drew a series of actors, now in the NGI. A fine family group of the Fishes of Castle Fish is now known only through a photograph.[40] One of the best and most typical pictures is his portrait of Surgeon-General Cunningham, in which, as is customary in his work, the sitter is seen in a chair fitted with its holland cover. Forrest also worked as a topographer for the antiquarians and there is a watercolour by him of Dunbrody Abbey, Co. Wexford in the Royal Irish Academy. His figures have charm but lack the artistic brilliance of Healy.

Francis Robert West (*c.*1749–1809), the son of Robert West, succeeded his father in 1777 as Master of the Figure School. From an extensive account in *The Citizen* for October 1841, again signed by 'M' (Mulvany), it appears that he was a particularly fine teacher and inspired immense affection in his students. He was apparently a good art historian as a result of his intimate knowledge of engravings, though he only travelled to England once and was never on the Continent. 'M' states that Francis Robert West was capable of much more inventive work than his father and mentions his many illustrations for books including the Bible and Fenelon's *Telemachus* and likens his reputation to an Irish Stothard.[41] Strickland mentions an illustration in *The Hibernian Magazine* for 1789, *Science issuing from the College and presenting Genius to the Royal Irish Academy* (of which no copy now seems to survive). His chalk drawings, in the manner of Hamilton and Healy, show considerable charm, particularly the study, *A Man in a Library*,[42] dated 1771, which is in the Pierpont Morgan Library. There are two ovals, probably illustrations, formerly in Malahide Castle, *A Group of persons at a Masked Ball in van Dyck costume* and *A Lady being Pushed on a Sleigh by a Russian Officer*. They are close to mid-eighteenth-century French engravings. By far the most exciting works we

118 Francis Robert West, *Viscountess Northland with the Hon. Lady Staples taking tea*, crayon, Private collection

119 William Watson, *Lady Caroline Hamilton*, 1762, oil on canvas, Private collection

know by him are a set of nine oval conversation pieces done probably in the late 1770s. They are of fashionable families seen playing billiards, sewing, reading, coming in from the garden after picking flowers, three ladies in Turkish dress, volunteer officers looking at a map of Ireland, children playing the then popular board game of goose, Miss Mathew, Lady Knapton and Miss Piggott playing cards (Fig. 117) and Viscountess Northland with the Hon. Lady Staples, taking tea (Fig. 118). Francis Robert was the father of Robert Lucius West (1774–1850), whom we discuss in a later chapter. He also became Master of the Figure School in 1809 until 1845. Thus the three Wests taught in the School from about 1740 until 1845 and between them educated virtually every Irish artist for over a century.

After James Mannin's death, the ornament and landscape school was taken over by William Waldron (*fl.* 1762–1801), who had studied under Mannin and won a premium in 1762. He is an example of the paternalism of the Schools as in 1768 and 1769 they gave him grants to clothe himself. He specialized in flower pieces, exhibiting them in the Society of Artists in Ireland between 1770 and 1774. Later, he exhibited theatrical subjects, which we do not know. However, there is an altarpiece of the Resurrection which he painted for the Blue Coat School, now known as King's

Hospital. He was paid £22. 15s. for it. The picture is signed and dated 1783 and, though not a masterpiece, it is important as one of two surviving altarpieces of the eighteenth century.

Of the minor men working in pastel, George Lawrence (*c.*1758–1802) is an example. He entered the Society's Schools in 1771 and, basing his style on that of Hamilton, he clearly did not overestimate his powers, as he advertised himself as taking likenesses 'in Crayons, and in Miniatures at one guinea each. The same size of the crayons, in oil at one guinea and a half'.[43] Another notice, presumably of a later date, mentions a price of two guineas. One life-size oil by George Lawrence, dated 1791, survives and he also made life-size pastels, such as his portrait of Richard Bibby.

A more colourful painter was William Watson (d. 1760). He signed two pastels, from which others can be attributed, including the *Lady Anne Dawson*. The signed works are *Viscountess Sudley* (NGI) and *Lady Caroline Hamilton*, dated 1762 (Fig. 119).[44] He did not attend the Schools, though another student of the same name who went in 1772 confuses the issue. He shows a slightly different trend in pastel portraiture, much closer to the work of Francis Cotes. Cotes, who came of a Galway family, may have maintained contacts in Ireland and Watson's work is almost certainly

120 John James Barralet, *Speaker Foster with his family*, watercolour, Private collection

apprenticed as a herald painter and 'knew every great family in Ireland, their servants at least',[46] was another pastellist outside the Schools. His cut profile heads on black backgrounds are done in pastel and he was also a competent draughtsman. His real fame, however, lies with his exquisite cut paper work, such as the arms of the fifth Earl of Orrery. John Cullen (1761–1825/30), after studying at the Schools in the mid-1770s, worked with Hamilton, presumably in London, and developed a style very close to his master, as in his *Mr Tighe* in the NGI. He practised in Dublin and doubtless drew a large number of works now given to Hamilton. Works by William Lawrensen (*fl.* 1760–88), John Bloomfield (d. 1808) and Bartholomew Stoker (1763–88), of whose work there is an example in the NGI, also survive with a great number of unidentified pastels, many of which are of good quality.

Matthew William Peters (1741–1814), whose pastel of himself and West we have already mentioned, was born of Irish parents. His father was a landscape gardener associated with Stowe. He came to Ireland, working for Lord Charlemont at Marino. There is uncertainty whether Peters was born in Dublin[47] or the Isle of Wight.[48] He was a student at the Schools, which accounts for the fact that half of his early exhibited works were in crayons, though very few of these are now known. We deal with his later career in chapter 7.

Another pupil of the Schools, this time of James Mannin, was John James Barralet (*c.*1747–1815), who worked in watercolour rather than crayon or pastel, producing fashionably populated town and country views. The liveliness of his groups is well exemplified by the two watercolours painted for the Duchess of Rutland when Vicereine in 1785, one of which shows her driving her cabriolet, and in another of Speaker Foster and his family at Oriel Temple, Co. Louth (Fig. 120).[49] Though he spent some years in London in the 1770s, where he set up a drawing academy, he was back in Dublin by 1779 and taught briefly in the Schools during the illness of James Mannin. He drew his *King William Giving Orders to Sir Albert Conyngham, at the Head of the Enniskilleners* and exhibited it at the Society of Artists in Ireland in 1780. He also worked for the topographical engravers and in 1795 he went to America, dying in Philadelphia in 1815.[50]

We have not mentioned their most famous pupil, Hugh Douglas Hamilton, whose career is not easily divided into early pastels and late oils. We shall discuss him in the next chapter.

being attributed to him now. He also painted in oils and a charming painting of a lady (NGI), signed and dated 1759, shows her with an open copy of Homer's *Iliad*.[45]

Nathaniel Bermingham (*fl.* 1770–4), who had been

Portraiture and Subject Painting
in the Second Half of the Eighteenth Century

Continuing in the tradition of portraiture established in Dublin by Latham and Hussey, the latter of whom was still working until 1783, the confusing family of the Popes and Pope-Stevenses also appear on the horizon. They rarely signed their works and cover three-quarters of the eighteenth century and into the nineteenth, with Alexander Pope, whom we will consider in chapter 12. In the Registry of Deeds, there are a number of references to the property dealings of this family, who owned land in Cabragh (now Cabra) and other places on the outskirts of Dublin.[1] According to Strickland, the founder of the family was Stevens Pope of Cabragh, who married a daughter of Henry Stevens. They had two sons, Thomas Pope (*fl.* 1764–82), a miniaturist and copyist, the father of four artists, and Justin Pope-Stevens, whose portraits are known only through mezzotints. Examples of these are the solicitor Daniel MacKercher[2] in profile (Fig. 121) pleading in court, scraped by John Brooks in 1744, and a fine whole-length of the MP Charles Tottenham outside the Parliament House by Andrew Miller, dated 1749. This should not be confused with Latham's portrait of the same man also standing outside the Parliament House (NGI). Both the mezzotints have great dignity and realism and if a painting of his ever appears, Justin Pope-Stevens may prove to be an artist of some distinction. A third portrait by him, of Lord Chancellor Jocelyn, dated 1747, was also scraped by Andrew Miller (*fl.* 1737–63). Another of the same sitter, showing Jocelyn standing holding a scroll, derives from a painting by J. B. van Loo of Robert Walpole of 1739. It may also be by Justin Pope-Stevens. It is interesting to note that the sitter's son, Robert, later first Lord Roden, wrote on 31 December 1744 about the full-length portrait which he did not like and complained about in detail, saying that when he wrote to the English Lord Chancellor he would 'let him know how ill provided we are in Ireland with painters, but that this was executed by the best there'.[3] A fifth mezzotint of the Hon. James Annesley

is another scraped by Brooks after Justin Pope-Stevens. No certain oil painting is known.

Justin's four nephews included Justin II (*fl.* 1764–1808), who worked as a carver and gilder, and Somerville (*fl.* 1764–1818), who painted landscape and flowers and fruit pieces. Pasquin says he studied under his father and Thomas Roberts, who was his contemporary. Pasquin adds that he 'principally copied Vernet'. No definite work is known by him but a charmingly amateurish landscape of Lucan House, with fashionable, elongated figures might be attributed to him. His master, Roberts, had painted a set of four exquisite views of the house and demesne (NGI). According to Strickland, after Somerville inherited the family property in Cabragh in 1771, he became too grand a gentleman to be more than an amateur. He was High Sheriff of the County of Dublin in 1783.

A number of portraits can now be grouped together for the other two nephews, Thomas (*fl.* 1764–80) and Alexander (1763–1835), whom we discuss in a later chapter. Like his brothers, Thomas attended the Dublin Society Schools, first in 1764, and he was exhibiting in the Society of Artists in Ireland from 1765. Only four signed works survive: one is a fine whole-length of a Lord Mayor of Dublin (Fig. 122), allegedly Sir Thomas Fetherston, second Bt,[4] who in fact never was Lord Mayor, and it was more likely John Daragh, who was Lord Mayor in 1781–2. It is signed and dated 'T Pope Stevens pinxit 1782'. The picture is a fine, drily painted, highly detailed full-length of considerable competence. Another is a pair of the Browne family of Riverstown House, Co. Cork. One of these is signed 'T S Pope 1775'.[5] Captain David Ross[6] and his wife are the last pair, one signed 'Stevens', the other 'Pope-Stevens', and neither of them are dated. A pair of old attributions fit with the Ross pair and are of Thomas Reilly of Scarvagh (UM) and his wife Jane Lushington. They were married in 1773 and it seems likely that they are a marriage pair. All are good, plain portraits with the detail of dress and accessories

121 Justin Pope Stevens, (mezzotint by John Brooks), *Daniel MacKercher*, 1744, Private collection

122 Thomas Pope Stevens, *John Daragh*, oil on canvas, Private collection

Mount Alexander, full length with her Montgomery son (Fig. 123), standing beside an urn and trees, which may be a little earlier than the Reillys; Catherine McDonnell of New Hall, Co. Clare, and one of her young sons in van Dyck costume with detailing of pearls and lace, (they are almost identical with young George Montgomery); a group of four children, one flying a kite and another blowing bubbles, and an anonymous group of a mother with four children. This picture includes an urn, a kite and a deer and was also once attributed to Hickey. All the children in these pictures are extremely alike and have a toylike naïvety. Finally, there are the two teenage children of Charles Birch of Birch Grove, Co. Wexford, John and Sarah Birch, who have an elaborate wreath, an urn and a pet deer, also crowned with flowers, a composition taken from Kneller. Another pair of pictures of Robert Birch, MP of Turvey, Co. Dublin (Fig. 124) and his wife Elizabeth Bland of Blandsfort, Co. Laois, have brass plaques labelled Pope Stevens which is another indication that all these pictures are by Thomas Pope Stevens. The props and furniture are all meticulously handled in Robert Birch's portrait.

A group of female portraits all painted in the 1760s may, we feel, be Justin's work. The families they came from include the Aldworths and Floods, the Wallers of Castletown Waller and the Jervoises of Brook Hall. Many of them have small headpieces of feathers, flowers or jewels and usually flowers tucked into their bodices and some hold lilies of the valley and in one case a dove. With their clear outlined faces, these ladies are in fashionable costumes and hair arrangements well known from the portraits of Allan Ramsay. The handling of the faces, with their strong characters and careful delineation, connect with the signed examples we have mentioned and they are totally unlike the work of other contemporary Irish painters. However, we know the attributions are speculative.

A pupil of Justin Pope Senior was Robert Hunter (*c*.1720–1803),[9] a competent if eclectic figure, who bridges the gap between the mid- and late century. Pasquin, writing in 1796, within Hunter's lifetime, informs us of this and that 'he was born in Ulster; studied principally under Mr Pope Senior'; and apart from this, nothing is known of his early career, not even his date of birth. However, William Carey, a Cork critic of reliability, when discussing the foundation of the Dublin Society, quotes Hunter a great deal and says that he 'was intimate with Madden and Prior'.[10] Prior died in 1751, and so, if Carey is correct, Hunter must have been an adult by the mid-1740s and therefore born *c*.1715/20. This would mean that he did not go to the Dublin Society Schools or to Robert West, who did not return to Ireland from France till the late 1730s and this supports the theory of Pope teaching Hunter.

The earliest dated picture is of 1753, when Hunter was commissioned to paint a large, baroque, full-length portrait of the Lord Mayor of Dublin, Sir

brought out with great precision. Jane is particularly charming, as she holds her crayon and in the other hand proudly displays her album of studies, children's heads and a landscape.[7] Due to its similarity, we are inclined to think a picture we once attributed to Hickey,[8] of the first Earl of Mount Cashel and his family, is by Thomas Pope Stevens and, if so, it is the most ambitious conversation piece we have yet come across by him.

From this, we lead on to five other conversation pieces clearly by the same hand as the Mount Cashels and all with very similar children. They are: Lady

Charles Burton, so by that date he must have been admired. It is now only known by the mezzotint by James McArdell (1728 or 1729–65). In 1755, his portrait in TCD of Samuel Madden was issued as a mezzotint by Richard Purcell (*fl.* 1746–66; see Fig. 110), with some minor alterations to make it appropriate for the public. In the painting, Madden is shown without a wig and in a cap, while in the mezzotint he is wearing a wig;[11] otherwise, they are much the same. It is a particularly sympathetic study of a man of great stature, patriotism and love of the arts, which is re-emphasized by the oval picture in the background depicting a winged figure blowing a trumpet, probably emblematic of fame. As we have already mentioned in chapter 4, Madden was a collector, and some of his pictures are still in TCD.[12] He was also an important founder member of the Dublin Society and inventor of premiums for the arts and manufactures (see chapter 6).

Rather earlier, and painted probably about 1748, are six portraits of the King family. They are datable from their ages and the fact that Sir Robert King was created Baron Kingsborough in 1748 but is not called by that title in the picture. They are attributed by tradition to Hunter and stylistically they are close to the portraits of Madden and Burton. They are remarkable for their liveliness, depth of colour and overall complexity of composition. They must have made a considerable impact on a Dublin then lacking a major painter such as Latham. Unlike the Slaughters, on

which they may be based, the figures are integrated into their backgrounds. In fact, they must have been the young artist's show-pieces, from which he aimed at acquiring more sitters. Presumably they were hung in the Kings' Dublin house in Henrietta St.

Hunter was much influenced by English artists, probably through engravings, though there is some evidence that he visited England latish in his life, when he made a drawing of the head of Queen Charlotte after Gainsborough's portrait exhibited in 1781 at the Royal Academy. In 1760, he used a Thomas Hudson of *Mrs John Faber*, engraved *c.*1756, as the basis of his portrait of an *Unknown Old Lady*.[13] Later, he used Reynolds as a model, an example being *Lady Margaret Butler*, later Countess of Belmore (lent to NTNI, Castlecoole), whom he painted as Diana after Reynolds's portrait of her neighbour, Lady Anne Dawson of Dawson's Grove, Co. Monaghan. The Butler portrait is probably one and the same as the *Lady in the character of Diana* which he exhibited in 1769 in the Irish Society of Artists. Other English artists who influenced him and provided him with models are Devis and Cotes.

He painted a number of small half- and whole-lengths, of which the *Tom Conolly in van Dyck costume*, signed and dated 1771, is a good example and comparable to the Devis at Stoneleigh of the *Duke of Chandos*. Other small whole-lengths, usually attributed incorrectly to Devis, are portraits of the second Lord Longford in naval uniform and his brother-in-law, Lord Langford,[14] in a wooded landscape. There are payments in the Pakenham archives to Robert Hunter which are thought to be for this pair.[15] A sporting picture by Hunter is the portrait of Peter La Touche of Bellevue[16] (Fig. 125) a signed and dated painting of 1775 which is life-size and one of his finest works. It is based on a Pompeo Batoni of Sir Humphrey Morice,[17] dated 1762. Another work, a portrait, is alleged to be of Charles Cameron,[18] Catherine the Great's architect. This is very unlikely. It is a small whole-length and the fur and silk of the fancy-dress costume (not Russian) is superbly handled. It was painted some years before Cameron went to Russia in 1777. There may be two versions, as the picture's date has been read as 1771 or 1773,[19] but, as it came from the Townshend Collection and Lord Townshend was Lord Lieutenant, resident in Dublin between 1767 and 1772, the earlier date seems more likely. However, the painting, of which the authors have a photograph, is dated 1773. In it, Cameron is holding an illustration from his book, *Baths of the Romans*, published in 1772. So either date fits quite well. On the reverse of the picture there is a note in pencil saying that it is of 'Lord Bulte's [Bute?] agent',[20] which seems doubtful.

Another unusual picture is Hunter's small whole-length of Sir Robert Waller, Bt, with his son, rummaging in his library (NGI), of which there is a second version. It is a strange work because of the odd proportion of the child. This may be due to the fact that the picture was cut down in size during some restora-

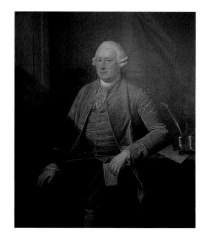

124 Thomas Pope Stevens, *Robert Birch of Turvey, MP for Belturbet*, oil on canvas, Private collection

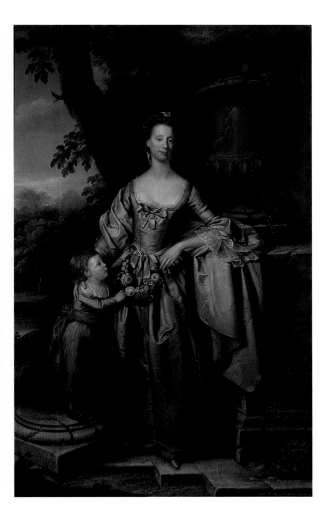

123 Attributed to Thomas Pope Stevens, *Lady Mount Alexander and her son, George Montgomery*, oil on canvas, Private collection

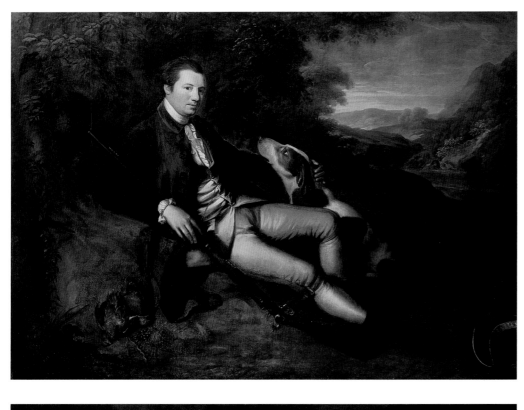

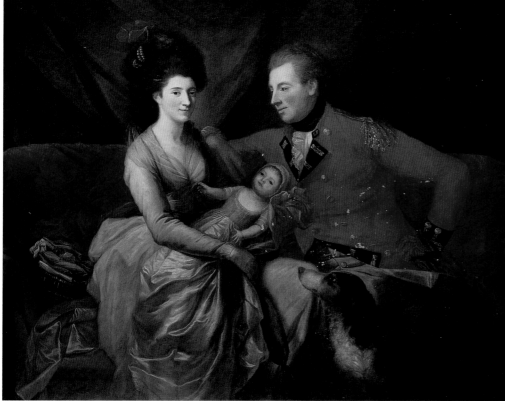

125 Robert Hunter, *Peter Latouche of Bellevue*, 1775, oil on canvas, National Gallery of Ireland, Dublin

126 Robert Hunter, *Earl and Countess of Belvedere with a baby*, oil on canvas, Private collection

facing page
127 Robert Hunter, *Lord Newbottle*, 1762, oil on canvas, Private collection

tion.[21] Hunter was good at child portraiture, an example being the Hon. Christopher O'Brien with his pet dog (Dromoland Hotel). He painted a number of double portraits three-quarter length, and this size was his most favoured. His *Second Earl of Belvedere with his wife and infant* is a good example painted *c.*1775/6 (Fig. 126).

In 1765 Hunter was commissioned by a Mr Buttress to paint John Wesley on his visit to Ireland in that year. The picture was given to Wesley's chapel in City Road, London, where it still is. Wesley records in his journal[22] that Hunter painted his face alone between ten o'clock and a little after one, producing 'a most striking likeness'. Whether this was Hunter's usual practice to paint the head and all but finish it first, we don't know, but if it was, it suggests that he used an assistant drapery painter. This might account for his prolific *œuvre* and its great variety of quality.

His masterpiece was *Lord Newbottle, later fifth Marquess of Lothian* (Fig. 127), of which there are two versions, painted when the sitter came to Ireland in 1762 to visit his future wife, Elizabeth Fortescue of Dromisken, Co. Louth. He is dressed in uniform. Other examples are *The First Earl of Belmore*, *c.*1771, that was painted later than his wife's portrait, which we have already mentioned. Another example of Hunter's borrowings is his *Admiral McBride*[23] of 1783, which is extremely close to Tilly Kettle, who, significantly, was in Dublin during that very year. Another whole-length worth recording is the *Twelfth Lord Clanricarde in the robes of the Knights of St Patrick* of 1783, now at Harewood, Yorkshire. Of his half-lengths, a fine example is the *First Earl Harcourt*, now in the NGI, of which a number of versions exist.

Hunter's contemporary, Pasquin, said that the arrival of Robert Home in 1780 'eclipsed his renown', but it seems more likely that old age was creeping on. There are few works known after 1785, though he had an exhibition and sale of his paintings in 1792, a very unusual event at this time, perhaps suggested by the Nathaniel Hone exhibition which we discuss later. Other artists who came to Ireland about this time included Gilbert Stuart (in Ireland 1779–89) and Hugh Douglas Hamilton, who returned home to Dublin in 1791. Hunter was still alive in 1803 when for the last time his name appears in the *Dublin Directory* where he first advertised himself in 1789. Hunter's contemporaries justly had a high opinion of him but, like Latham, his fame has been hidden because he lived exclusively in Ireland. As early as 12 March 1763, *Sleator's Gazetteer* printed overblown verses on him, including the couplets:

> Thy Picture speaks the language of each eye,
> Shall damp detraction, and its force defy;
> The parts compose one energetic whole,
> Which seems to think, and breathe a living soul,
> Could Hogarth, Reynolds, view the bold design,
> They'd gladly wave their richest wreaths with
> thine ...

William Carey, writing in 1826, describes Hunter as 'a walking chronicle of everything relative to the Irish artists and arts'[24] and W. B. Sarsfield Taylor said he had 'a large and profitable practice' and that 'he had collected many old pictures, some of which were very fine; upon these he formed his style of colouring: hence it happened that his works, though sometimes low and dingy in tone, are never raw or crude'. He added that Hunter 'was a mild amiable man, liberal in

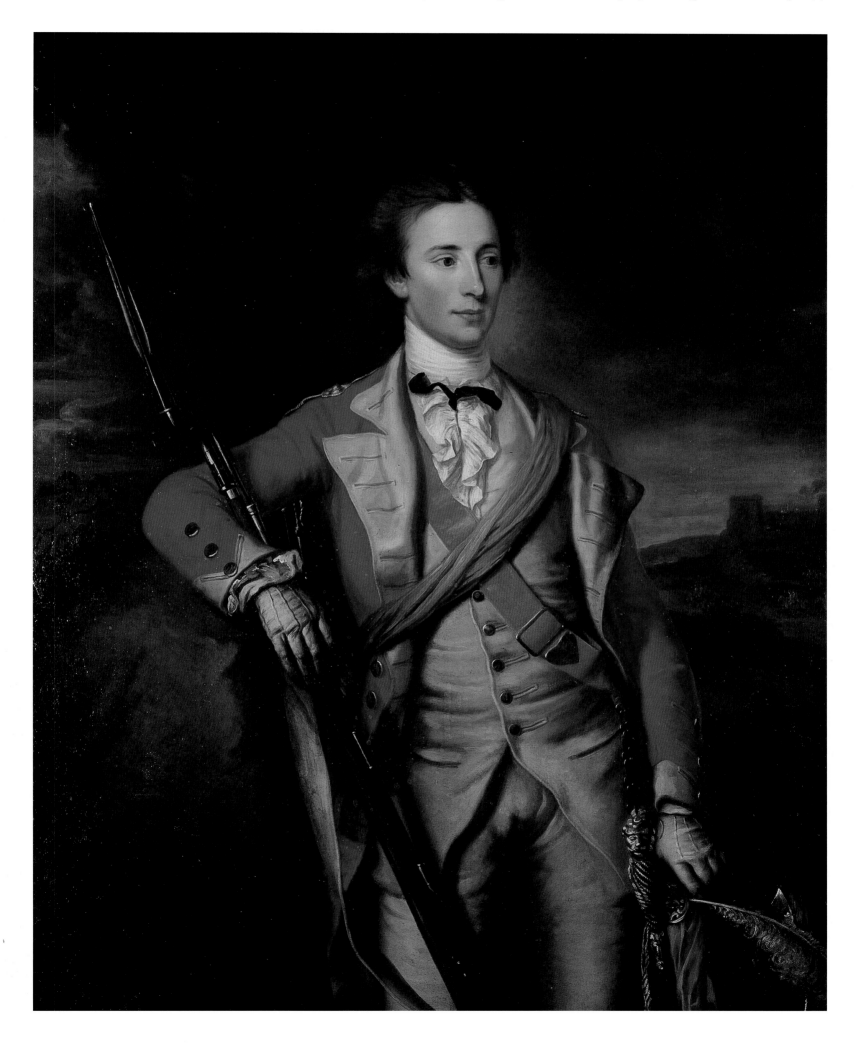

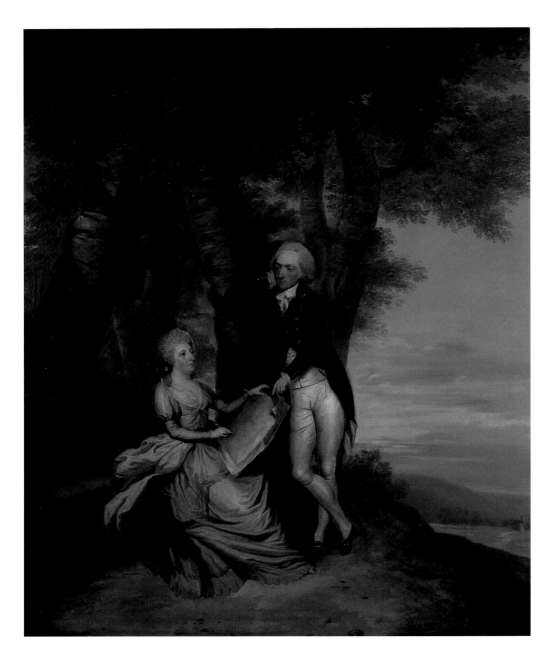

patriot, who was then in Italy. He was secretary to the leader of the Corsican rebels, General Paoli, whose portrait, according to an inscription on the back of the picture, has been cut out. The two other faces are of major officials of the Corsican nation.[28] Strickland quotes the *Hibernian Journal* in 1800, remarking that Trotter was renowned for his drawings when in Italy.

He was back in Dublin in 1773 when he painted the *Group of Gentlemen* for the Blue Coat School in whose possession it still is. This is an uninspiring composition in poor condition and not as successful as his medium- and small-sized full-length groups of the Barker (Fig. 128) and Staples families, one of which is signed by Trotter in 1784. In the Staples double-portrait, both heads were reworked later by Gilbert Stuart. These show the influence of Wheatley, who was in Ireland at this time. He must have attended some of the Volunteer reviews and conventions as a number of his small whole-length portraits show officers in Irish Volunteer uniform with encampments behind them. His landscape backgrounds are always picturesquely portrayed and often Italianate in feeling. The three finest of the Volunteer portraits are *Captain John Alston*[29] and an unidentified officer standing with his dog by an urn, with a church in the background.[30] Trotter has a strange mannerism of reducing the size of the leg from the knee downwards, which gives a stilted effect and is well illustrated in the officer's portrait. The third is *The Hon. John Rawdon Hastings*[31] which was mysteriously inscribed as being by Fagan, dated 1776 when the latter was nine years old. Among his most charming female portraits are Mrs Pollock with her spectacular hat at her writing table (Fig. 129) and John Rawdon's sister, Lady Anne

128 John Trotter, *Sir Robert and Lady Staples*, oil on canvas, Private collection

129 John Trotter, *Mrs Pollock*, oil on canvas, Private collection

communicating what he knew, and generous in estimating the works of his brother artists'.[25] He was for thirty years the most important painter of the Irish establishment.

Hunter's daughter Mary Anne, who also painted, married another artist, John Trotter (d. 1792), who went to the Dublin Society Schools in 1755, where he won three premiums. He was sent to Italy *c.*1759 by his father, who was agent for the Southwells in Downpatrick. He said of his son, 'Tis said he has a Genius that way and is liked by many of the Dublin Society, and that I must send him in about two years to Italy', where he hopes he may meet Southwell.[26] Some three years later misfortune befell him in Rome as he was taken prisoner and carried off to Spain in 1762.[27] He was back in Rome again in 1764, where he lived in the same house as Solomon Delane, the landscape painter. Only one work produced in Italy is known, recently discovered, painted in 1772 of Padre Maestro Bonfiglio Guelfucci a notable Corsican

Elizabeth,[32] inscribed and dated 1776 by a later hand as by John Trotter and his wife Mary Anne. Apart from a small plaster portrait relief, this is the only work known to be by her. John Trotter's most decorative composition is a group of the O'Neill children playing with a small chariot in the grounds of Shane's Castle, Co. Antrim (Fig. 130). Due to the fact that Trotter was almost unknown until recently, a number of other groups formerly attributed to Hickey can now stylistically be attributed to him.[33] A few small portraits in oil on copper, signed by him, have also been seen. He had a colourful palette and his dogs are lively and vigorously painted.[34]

Unlike Hunter, Nathaniel Hone (1718–84) lived most of his career in London, only very occasionally returning to Ireland. He was born in 1718, the son of a merchant of Dutch descent who lived on Wood Quay. We do not know any facts about his education, but the existence of pastels, some in the Exeter Collection, Burghley House, indicate that his early training may have been with Robert West when he was teaching on his own in the late 1730s. He was in England by 1742, when he married, in York, Mary Earle (sometimes called Ann), the natural daughter or cast-off mistress of a nobleman, who brought some money with her. He established himself in London soon afterwards, painting both life-size oils and miniatures, specializing in enamels. Indeed, the earliest recorded oil portrait, dated 1741, of George Gostling,[35] is a curious mixture of an old-fashioned stiff portrait, likened by Waterhouse[36] to Richardson, with the face modelled in strong chiaroscuro and brilliantly painted eyes, reflecting his enamel miniaturist technique. Enamel portraits were extremely popular at this time on both sides of the Irish Sea. Christian Friedrich Zincke, the most famous practitioner of this medium, was in Ireland in 1732, so Hone could have been familiar with his work from an early date, and Rupert Barber was studying in Bath from 1736 but was back in Ireland painting enamels certainly by 1743. Hone became very successful, especially after Zincke's poor eyesight forced him to retire from practice. However, Hone was never able to charge more than ten guineas, as opposed to Zincke's twenty to thirty guineas.[37] The early oils are correctly described by Hilary Pyle as 'competent but anonymous'.[38] He developed his own manner later.

From a study of Hone's diaries,[39] Pyle discovered that Nathaniel Hone is unlikely ever to have gone to Italy, but that it was his brother Samuel, also a painter, who was there and who must have been the Hone mentioned and amusingly caricatured by Reynolds. The friendship between Hone and Reynolds which this implies is totally out of keeping with the later hostile relations between Nathaniel Hone and Reynolds. It was Samuel who, a member himself, arranged for his brother Nathaniel, then in London, to become a member of the Florentine Academy.[40]

Hone's fashionable patronage, as early as 1752,

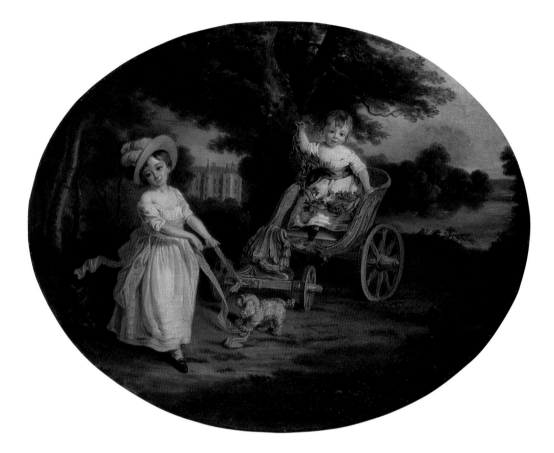

130 Attributed to John Trotter, *The O'Neill children*, oil on canvas, National Trust

included the Prince and Princess of Wales, and he lists in his appointments and accounts nearly sixty commissions.[41] He turns more to life-size oil painting after 1760, when, in his own words, he 'gave up his leisure-hours from that time to painting in oil'.[42] He was a devoted father to a very large family and perhaps painting their portraits helped him to become the great child portrait painter that he was. *A Piping Boy* of 1769 (NGI) shows his own son, John Camillus, and is an early example of a 'fancy' picture. It is based on the Giorgione at Hampton Court. Another portrait of one of his sons sketching with a riverscape and bridge in the background (UM) is more Dutch-inspired, as are the children with garlands of flowers, like Master Muspratt Williams. Another portrait, his son Horace drawing after the antique (NGI), is superbly composed, with the figure admirably foreshortened, a feature he often fails to achieve elsewhere. The mawkish portrait of Miss Julie Metcalf with her dog is a case in point. Miss Metcalf,[43] with her brilliantly highlighted, beady eyes is a forerunner of the sentimental child portraiture of Lawrence. Hone was in Paris in August 1753 and could well have seen the work of Greuze during his visit; there is a decided similarity between the sentimentality of the two artists in this genre of child portraiture. A conversation piece of three of the Whitford children[44] is an ambitious work in a finely delineated woodland setting. Another child who catches the eye is young Kenneth Mackenzie, later Earl of Seaforth, with his benevolent tutor, Dr Mackenzie.[45] This must have been painted before the child went abroad in 1752 and represents an early

example of Hone's ability to depict character. The boy lives up to Robert Adam's description of him as he had never seen 'a little creature of more spirit, sense and sweetness as this little milord, as they call him, who speaks all languages with equal facility'.[46] One of Hone's masterpieces is his conversation piece of *James Kirkpatrick with his sons James and George* (Fig. 131). The children are playing with the hat and sword of their father, who had just returned from India.

Hone was closely connected with the foundation of the Society of Incorporated Artists and was one of its first directors in 1766. However, he seceded from that body in 1768 when he became a founder member of the RA. His famous battles with the Academy, probably caused by his jealousy of Reynolds, started in 1770 with his sending for exhibition his portrait group of *Francis Grose and Theophilus Forest as Capuchin Friars*, one squeezing a lemon and the other stirring the punch with a crucifix. The latter had to be altered to a ladle for exhibition purposes, though later he put the crucifix back. In 1774, Hone attacked Reynolds personally by proposing Gainsborough as President of the RA. It was in the following year that he exhibited his now most famous painting, *The Conjuror* (Fig. 132), where Reynolds' work is satirized subtly and cleverly by the inclusion of engravings used in his compositions and by the fact that Reynolds's favourite model, 'Old

George White' the paviour, sat for the conjuror himself.[47] The background scene refers to the fruitless efforts of Reynolds, Barry and other artists, including Angelica Kauffmann, to paint the dome of St Paul's. Kauffmann objected to a likeness to herself in one of the nudes later painted out, though a figure of this type is still visible in the sketch version in the Tate. The Academy ultimately refused to exhibit the picture, even in its altered form, and Hone went off in a huff and held the first one-man show in the British Isles[48] at No. 70, St Martin's Lane, opposite Old Slaughters Coffee House. Hone exhibited not only oil portraits but a number of enamels, some landscapes and subject pictures, of which he had painted very few. The exhibition included works which had been exhibited elsewhere and was really a retrospective; for instance, two which he had shown in the Society of Artists were *The Brickdust Man* of 1760 and *Diogenes looking for an Honest Man* of 1768.

Hone's attack on Reynolds's method, and his compositions using antique, Renaissance and seicento sources, was some indication of Hone's opposing style, which is based on Dutch examples. It was, more importantly, as Waterhouse points out, one of the first indications of a change of taste leading to the romantic stress on 'originality'.[49] Hone's series of self-portraits are among his best works and in both their handling and numbers they

132 Nathaniel Hone, *The Conjuror*, 1775, oil on canvas, National Gallery of Ireland, Dublin

indicate a considerable knowledge of Rembrandt. The example in the NPG is particularly striking (Fig. 133). However, it would be wrong to assume that classical elements do not occur in his work; for example, one of his self-portraits in the NGI shows him with the Temple of Vesta at Tivoli in the background, and his magnificent portrait, dated 1778, of the Hon. Lady Curzon,[50] of which there are two versions, shows her leaning on a pedestal with classical enrichments on which stands a fluted incense burner. An earlier double portrait of the Misses Knight, dated 1775, is a roundel and shows Hone in a more sympathetic pensive mood, in which his real feeling for character is well portrayed. This could also be said of the charming, contemplative portrait of an unknown girl. He painted a number of full lengths, of which *Edward Finch Hatton*[51] charging his gun in a lake landscape is a good example. *Captain the Hon. Robert Boyle Walsingham* (Fig. 134),[52] signed and dated very boldly 1760, has a view of Louisburg, Canada, in the background and is a typical work with considerable borrowing from Reynolds, especially his *Admiral Keppel* (National Maritime Museum). The double portrait *General Sherard and Captain Tiffin at the battle of Bruckenmühle* in the Seven Years War is one of his finer and most original compositions.

Hone's clientele was not entirely fashionable, for he painted a number of theatrical personalities, such as the spirited portraits of the actor and singer *Charles Lewis* and the dancer *Madame Zamperini*.[53] This is painted with a far greater clarity and interest in colour than is normal in his work, where chiaroscuro is very marked. Some of his lesser works take on a heavy, oily consistency, which may account for the dislike of many contemporary critics, including Pasquin, who was particularly disparaging. Hone made a remarkable collection of old masters and drawings, which were stamped with his mark of an eye. His particular *coup* was the acquisition of a volume of drawings by Fra Bartolommeo, which are now in the British Museum and which he bought in England. He was a mezzotint scraper and also collected prints. On one occasion, he tried to appease Nollekens by the gift of some fine prints, but without success.[54] His rather notorious image was not improved by the fact that, according to Smith, he 'kept a famous black woman … as his model' when he was living in 'Pall Mall in Jervas's old house'.[55] However, he continued to exhibit at the RA until his death. Hone's career, overshadowed by that of Reynolds and Gainsborough and by the gossip caused by his hot-headed temperament, deserves a considerable place in the history of British painting. One oddity in his *œuvre* was his painting of a horse, *Jason, a grey racehorse*,[56] belonging to Sir Nathaniel Curzon Bt, signed and dated 1755. Presumably it was done because

133 Nathaniel Hone, *Self Portrait*, 1760, oil on canvas, National Portrait Gallery, London

134 Nathaniel Hone, *Captain the Hon.
Robert Boyle Walsingham*, *M.P.*, 1760,
oil on canvas, Private collection

the Curzons were one of his important patrons. His links with Ireland, which he is known to have visited, are artistically slight. He influenced no Irish artist. However, he was of great importance as the ancestor of two of Ireland's most famous nineteenth- and twentieth-century painters, Nathaniel and Evie Hone.

A much younger artist, whose adventurous career took him to Portugal and India, was Thomas Hickey (1741–1824), the son of a Dublin confectioner, Noah Hickey, who was born in Capel Street, Dublin in 1741. He was educated at the Dublin Society Schools between 1753 and 1756 and like all its pupils became a fine pastellist, as a contemporary anonymous writer noted: 'Mr. Hickey, much noticed when a boy for his amazing likenesses in chalk'.[57]

He paid a visit to Italy in 1761–7, arriving in Rome in April 1762. These travels seem to have left virtually no imprint on his style. He came into contact with Gainsborough's work early on his return, for there is a replica by him in the Mansion House, Dublin, of Gainsborough's full-length portrait in TCD of the *Duke of Bedford*, dated 1768. Hickey was very much influenced by Gainsborough, attempting his light, feathery virtuosity, but without much success. The portrait of two children, probably his own two daughters, dated 1769, in the NGI is a feeble pastiche of Gainsborough's exquisite *The Artist's Daughters Chasing a Butterfly*,[58] which he presumably saw in England. He also painted Lord Townshend, the Viceroy (Mansion House, Dublin) at this time.

Three years in Dublin, where he exhibited with the Society of Artists and where presumably little work was to be found, forced him to take the artist's usual path to London, where he exhibited at the RA between 1772 and 1775. He was reasonably successful, gaining some important commissions like the whole-length of the Chief Cashier of the Bank of England, *Daniel Race*, signed and dated 1773 (Bank of England), where he is clearly trying to ape the grandiloquent trappings of a Reynolds. More successful was his double portrait of *Edmund Burke and Charles James Fox*[59] (NGI) which is a medium-sized whole-length. It is unfortunate that Hickey did not rise to greater heights. In 1776, he went to Bath, possibly thinking that, as Gainsborough had left for London in 1774, he might find work there. His contemporaries were fair judges of his ability, as, in an unidentified newspaper cutting of 1775, the critic wrote, 'If we may judge of the rest of these pieces, from the very great likeness preserved in the first, we must pronounce them so far good portraits; but there is a stiffness, and a want of confirmation of character, in most of Mr Hickey's performances, which very much obscure the rest of his merit'.[60]

Probably before he set sail for India he was in Ireland, as his most amusing fancy picture is a group portrait of Colonel William Southwell, in Totenkopf Hussaren uniform, and his wife Juliana of Glen Southwell outside Dublin, with their daughters,

Frances and Lucy (Fig. 135). On their left there is a memorial to the colonel's father. It is a curiously primitive but striking image.

Hickey set sail for India in 1780. He was not the first Irish artist to do so, as a letter of January 1705 from Mrs Bonnell, speaking of a Mrs Hewetson, goes on to say 'that in the yeare 1700 her son John Hewtetson entered his name in the East Indye Company book in London as a painter and then bound himself … as a soldier for five years, and sailed to Bombay'. She goes on to say that he was in favour with 'his Excellency in those parts who had sent for him to paint their pictures after which nothing more was heard of him'.[61] However, we know nothing of his work. Hickey had the misfortune to be on a ship captured *en route* by the French and Spanish fleets and was released in Cadiz. William Hickey, the diarist, who was in no way related, was living in Lisbon and states that Hickey, having obtained permission from the Spanish Government to return to England, had gone from Cadiz to Lisbon by land, in order to proceed from the latter place in a packet, but on his reaching Lisbon he had so much employment that he had remained there to very good account, had painted most of the English ladies and gentlemen and was then engaged upon the portraits of several Portuguese of rank.[62]

Some of Hickey's finest work was done in Lisbon, including the charming *Girl leaning against a Piano*, now in Tate Britain and datable because she holds a sheet of music of a song brought out in 1780, entitled *Mallbrook s'en va-t-en guerre*. Another Portuguese work of decorative charm is *The Actor between Comedy and Tragedy* (NGI), signed and dated 1781, the composition of which is based on Reynolds's *Garrick between Comedy and Tragedy*. Hickey finally arrived in Calcutta in 1784 and his Indian works are among his best. They include his masterpiece, *An Indian Lady* (NGI), and his

135 Thomas Hickey, *Colonel William Southwell and family*, signed and dated 1780, oil on canvas, Private collection

136 Thomas Hickey, *The MacGregor family*, 1785–6, oil on canvas, Private collection

137 Hugh Douglas Hamilton, *Sir Rowland and Lady Winn in the Library at Nostell Priory*, 1770, oil on canvas, National Trust, Nostell Priory

a *History of Ancient Painting and Sculpture*. He was back in London in 1792 and went with his fellow Irishman, Lord Macartney, on the embassy to China as the official portrait painter, though in fact all but one of the surviving drawings are by his colleague, William Alexander. Hickey's seated whole-length of Macartney was engraved as the frontispiece to the second volume of Macartney's *Embassy to China* in 1796. He visited Dublin on his return, and two years later, left for Madras where, except for the years between 1807 and 1812, he lived till his death in 1824. Between 1807 and 1812, he was in Calcutta and took a house 'in Ranny-Moody-Gully commodiously suited to that purpose'.[63] At this stage, he was charging £250 for a whole-length portrait.[64]

Interestingly enough, some of his surviving works in India are in the collection of the Duke of Wellington and show that he reverted to his youthful training, as they are in chalk and charcoal. This is true also of those portrait studies now in the Darya Daulat Bagh, Seringapatam.[65] These were a series of sixteen portraits he painted and drew of Tippoo's sons and officials of the new Rajah when visiting Mysore. All these studies he made for a projected, but never completed, set of seven paintings on the fourth Mysore war and they include very free sketches of the major generals and other officers, like Captain Goodlad, who were involved. *The Madras Government Gazette* of 17 June 1824 recorded that 'this venerable artist preserved his faculties to the last moment; indeed we have heard it with confidence asserted that the portraits he had finished only a few days prior to his dissolution bore every appearance of his wonted vigour, genius and skill'.[66]

Most of our information on Herbert Pugh (*fl.* 1758–88) is based on anecdotes by the turn-of-the-century writer, Edward Edwards. Pugh came to England from his native Ireland around 1758, and between 1760 and 1776 exhibited mostly landscapes at the Society of Artists, one of which, a rather dull view with cattle, is in the NGI. A more ambitious work is his view of *Sunbury on the Thames*, dated 1767, which shows the influence of Richard Wilson. However, as Edwards says, 'He also painted two or three pictures in a manner which he called an imitation of Hogarth, which are nothing but mean representations of vulgar debauchery.'[67] The first part of the description certainly fits the titles of the works he exhibited in the London Society of Artists in 1769, 1770, 1772 and 1775. Edwards states that he died 'between the years 1770 and 1780'. The quality of his *George, fifth Earl of Granard having his Wig powdered*, identified by an engraving of 1771, is competent in a crudely vulgar way. The NGI also owns one of his bawdy scenes, and there is another, a wig-powdering picture said to be of Lord Granard again.[68]

groups of British Army officers and officials, scholars and functionaries with their Indian servants, where his treatment of the Indians is often more sympathetic and telling than that of the Europeans. The most ambitious European group is his conversation piece of eight of the MacGregor family celebrating the birth of their only son, Evan, which dates to 1785–6 (Fig. 136).

Despite a considerable practice, he found time to write and publish in 1788 the first and only volume of

One of the early pupils in the Dublin Society Schools was Hugh Douglas Hamilton (1739/40–1808), who became one of the finest painters ever to come out

of Ireland.[69] He was the son of a Dublin peruke-maker and joined the Schools in 1750, when he was ten or eleven. As a student, he won several prizes and O'Keeffe in his *Recollections* says that Hamilton, who was a fellow student, 'was remarkable for choosing, when drawing the human figure, the most foreshortened view, consequently the most difficult'.[70] Hamilton was not allowed to receive a prize for pattern designing on 9 December 1756 because he was over sixteen, but though he could not receive the prize, he was given £4 in this competition 'for the best Design and Inventions of Pattern Drawing and Ornamental foliages …'[71] This incident indicates that he must have studied in the School of Ornament founded in May 1756 when James Mannin was officially appointed to teach in the Schools. However, design had been taught earlier, even if informally, as premiums for damask and linen designs were given from 1746 and Mannin was certainly in Dublin from 1753.[72] Indeed, Hamilton's earliest known work today is a remarkable architectural composition of a triumphal arch very much in the French classical manner, signed by him, which appears on the title page of a *Survey of Kilkea* made by John Roque in 1760 for the Earl of Kildare. Another dated 1760 is an album of sixty-seven fascinating figure drawings, entitled *The Cries of Dublin*, which vary from studies of a piper, a cobbler, a shoe boy, a fish woman, funerals, and even Papist criminals being taken to execution. We reproduce some of these as endpapers and they are the most lively and brilliantly observed drawings of Dublin life in existence. The rococo cartouche around the title suggests, as Joe McDonnell has said, that Hamilton may have decorated a number of Roque's estate maps. These both show the breadth of teaching in the Schools and are an aspect of Hamilton's work only recently discovered.[73]

After Hamilton left the Schools in 1756, he seems to have concentrated on drawing oval pastel portraits which very soon made him famous. Frequently they are very slight in execution, 'laid in with very few colours, the prevailing tone of which was grey, and then finished with red and black chalk. They were marked with great skill and truth, the features, particularly the eyes, were expressed with great feeling; but as pictures, they were not sustained by those depths either of colour or of shadow which alone confer pictorial effect. They had all the appearance of having been hurried rather than neglected.' These criticisms were written by 'M' (Mulvany) in 1842.[74] They are a fair estimate of Hamilton's early works, though, to modern eyes, their charm impedes our criticism. An example of this early manner, though done when he was in London, is the portrait of Queen Charlotte dated 1771 (Royal Collection). It was one of several versions, as the queen in a letter to Lord Harcourt dated 23 March 1770 refers to a portrait of herself by Hamilton: 'however, this delay is fully repaired in the Drawing, as think it even better than the Originall one you saw in the Sumer last'.[75]

Hamilton left for London about 1764 and he stayed there until the late 1770s. In 1764, he exhibited in the Society of Artists a grisaille of *Priam and Hercules lamenting over the Corpse of Hector*, which won him a premium; in the following year, 1765, he had a £60 prize for an oil of *Boadicea and her Daughters in Distress*. He won another prize in 1769. None of these works seems to have survived. He also exhibited in the Free Society of Artists and in 1769 he sent two small wholelengths to the Society of Artists in Ireland, giving the address of 8 Bond Street, London.

An important new addition to his *œuvre* is the discovery of a bill from Hugh Douglas Hamilton, covering the years 1767 to 1769, to Sir Roland Winn of Nostell Priory. Amongst pictures which vary from a marmoset and a morning riot in Covent Garden to interiors and a farmyard are 'two small whole length Portraits on one Canvass which cost £32'[76] which Alastair Laing identifies as *Sir Roland and Lady Winn in the Library at Nostell Priory* (Fig. 137). This conversation piece shows the couple in an Adam interior, discussing a bust of the Venus de Medici, which is also mentioned, with its two packing cases, in the bill. The head of Sir Roland foreshadows Hamilton's later work. Another charming early group is of children playing with dolls. The latter is mentioned in an inventory taken in 1769 of the fourth Earl of Stamford's pictures at Dunham Massey (NT) and listed as '*Honble. Mr Grey and Miss Grey (Now Lord Grey and Lady Henrietta) with the figures of a nurse, a dog, etc. Hamilton 1767*' (Fig. 138).[77]

Most of Hamilton's exhibited works at this time were portraits in pastel. Mulvany says about his early London years: 'He could scarcely execute all the orders that came in upon him and the writer has heard him

138 Hugh Douglas Hamilton, *The Grey children*, oil on canvas, National Trust, Dunham Massey

declare, that in the evening of each day, a part of his occupation was picking and gathering up the guineas from amongst the bran and broken crayons, in the several crayon boxes into which, in the hurry of the day, he had thrown them.'[78] Mulvany also says that he obtained nine guineas for a likeness. This cannot always have been the case as Sir Watkin Williams Wynn was charged six guineas for portrait drawings and two copies of him and his wife on a bill dated 30 October 1772.[79] Most of the London drawings were still in the oval shape, such as a young child holding a dog, and usually head-and-shoulders, but Hamilton began to make larger pastels where the figure is three-quarter-length in a setting. An example of this is *Mary, Marchioness of Rockingham*, where she is shown with her embroidery, wearing a pretty silk dress and a very high headdress. A few were whole-lengths, like those sent to Ireland, including the charming portrait of a child of the Leslie family with his catapult, battledore and shuttlecock and two friends peeping in through the window.[80] A splendid pair of portraits of the second Duke of Leinster and his duchess, which must date from after their marriage in 1775, shows the duke proudly studying his estate maps. Another charming character study, also a whole-length, was of one of the duke's elderly servants, Joe Foster. A very rococo pastel, entirely different from those just mentioned, is of the *Muse Erato*. It is another whole-length, probably done before Hamilton's visit to Italy. More groups have survived, such as the second Earl of Halifax and his secretaries (NPG), the Rose family[81] and a few mother-and-daughter and father-and-son portraits. These were sometimes placed in a setting, while the early ovals are not. They are sometimes rectangular in shape or considerably larger ovals and not necessarily upright. Hamilton's London years were very successful, but at the height of his popularity, around 1781, and presumably after making enough money, he took the adventurous step of setting out for Italy with his wife and daughter. He is recorded in Rome from early in 1782.[82]

His success went with him, as he drew the exiled Stuarts, Prince Charles Edward, Cardinal York, Louise de Stolberg and the Duchess of Albany, and made a remarkable series of pastel and oil portraits of English and Irish men and women on the grand tour. The *Self Portrait* in the NGI dating from about 1791 echoes James Irvine's comment that Hamilton 'was a good plain sort of man' and adds that his chalk portraits were 'very Clever'.[83] Indeed, his pastels are of the highest quality. He was in Italy for some nine or ten years and visited Florence, where he studied the statues in the Medici collection and was elected to the Accademia del Disegno in 1784. He also visited Venice, Naples and Sicily, as drawings survive of the harbour at Syracuse and of one of the Temples at Agrigentum.[84] One of this series is a direct copy after a gouache by Xaverio de la Gatta, signed and dated 1783,[85] which was one of several bought by Jonas Brooke, whom Hamilton knew and painted in Venice. It makes one wonder if he travelled all around Sicily or whether more of these may have been copies. They are not typical works, nor are they drawings of high quality.

It was in Italy that Hamilton achieved his greatest brilliance as a pastellist, but he was concurrently working in oils. The theory that it was Flaxman who suggested that he use oils is incorrect, though he may have encouraged him to do so. There are oils of Prince Charles Edward and the Duke of York as well as pastels. *George Cockburn, later General Sir George Cockburn,*[86] painted in Rome in 1783, is an oil. In the same year he painted the one subject picture which has survived from his Italian years, *Diana and Endymion*, also an oil. Both figures are inspired by reliefs in the Capitoline Museum: the Endymion is a very close transcript of a Hellenistic marble of Endymion and the Diana is less close but clearly relates to a Diana in a fourth-century marble sarcophagus.[87] Another oil is the three-quarter-length of Elizabeth Bridgetta Stepney, Mrs Gulston,[88] who was painted in Rome in 1784. It is a very sombre, contemplative essay in browns, and forms a particular contrast to his *Portrait of a Young Gentleman in Rome* (NGI),[89] which is a small whole-length. He is standing with the Forum and the Basilica of Maxentius in the background, in the usual grand-tourist manner, fashionably and elegantly clad. The stone fragments and sarcophagi around him are probably from the Palace of Tiberius.[90] The beautiful tree with its delicate foliage makes the interesting point of how his landscape style may be compared and contrasted with that of his fellow artist, Jacob More, in Rome at the same time. There is no date for this portrait, but it is very similar in handling and colouring to Hamilton's superb series of pastels, which we will discuss shortly.

An unusual oil is his very striking triple study of *Emma, Lady Hamilton* of *c.*1789–90, done during his visit to Naples in that year (Fig. 139). The three portraits on one canvas represent the three original muses of dance, mime and poetry, Terpsichore, Polyhymnia and Calliope. It has been suggested that the 'small and intimate scale and informality of this jewel-like cabinet picture shows clearly that it was a work for private contemplation rather than public consumption and display'.[91] Her husband, Sir William Hamilton, was also painted in oil to accompany it. Both sitters were also drawn in pastel, Lady Hamilton reclining on a sofa. Another Neapolitan lady playing with her child was painted lying on a sofa with a view of Vesuvius and the Bay of Naples in the background. This pastel was very large, 39 inches (97.5 cm) in length.[92]

Undoubtedly the most exciting of Hamilton's Italian oils is his large full-length of *Frederick Augustus Hervey, Bishop of Derry and fourth Earl of Bristol with his grand-daughter Lady Caroline Crichton* (Fig. 140). The eccentric earl bishop was well known for his collecting and building of Downhill and Ballyscullion in Northern Ireland and later of Ickworth, near Cambridge. The figures are seen in the grounds of the Villa Borghese in Rome, with the lake in the back-

139 Hugh Douglas Hamilton, *Lady Hamilton as the Three Muses*, 1789–90, oil on canvas, Private collection

ground and beside it the Temple of Aesculapius, built in 1787.[93] The portrait dates from *c.*1790–1. The spritely Lady Caroline is pointing out the relief on the Altar of the Twelve Gods which was then part of the Villa Borghese collection; later sold to Napoleon, it is now in the Louvre. The ravishing landscape in the background indicates how well landscape painting was taught in the Dublin Society Schools. Two other conversation pieces of Lady Caroline with her mother, the Countess of Erne, exist, both with finely painted landscapes, and are tender essays in maternal affection. In one, the countess, wearing a big straw hat, is holding a mandolin, while her daughter is showing her a drawing from a portfolio. They were both done at this time while they were in Rome, as was a pastel of the bishop (NT, Ickworth) seated on the Pincian Hill,[94] with a view of the roofs of Rome in the background. It is a remarkably informal portrait. One other newly attributed oil portrait of the earl at Ickworth, erroneously thought to be by Angelica Kauffmann, shows him soberly dressed, but also informal in pose leaning against a wall.[95] It features a painting of Derry cathedral, showing the spire, which appears in Pompeo Batoni's portrait of the bishop, but was taken down in 1802. The earl bishop's wife Elizabeth was also painted in Rome by Anton von Maron and has the Giant's Causeway in the background, which reflects the earl bishop's geological interests.

Though Hamilton continued to paint small oval pastel portraits, while in Italy he developed a larger scale of this genre, as seen in another very sympathetic study of *Lady Erne* (NT, Ickworth) and one, similar in format, of *Lady Cowper* (Firle Place, Sussex), wearing a turban. But the real gems of his whole career are the large pastels, sometimes nearly a metre in height, of elegant young grand tourists. In one notable example, the eighteen-year-old John David La Touche[96] insisted on having the theatre at Taormina and Mount Etna in the background, despite the fact that the picture was drawn in Rome in 1790. Others[97] include a portrait of a young member of the Hill family, Marquesses of Downshire, impatiently waiting for the tackle of his Berlin or travelling carriage to be repaired; to ensure that we know the mishap took place in Italy, there is an aqueduct behind the trees. Then there are the memorial portrait of Jonas Langford Brooke, who died in Venice; James Dawkins reclining on two pieces of an antique frieze, probably on the floor of the Capitoline Museum;[98] the sad young man in a red coat who has just dismounted from his horse and is looking hot and tired, and *William Milbank with the Temple of Vespasian* (NGI). The two masterpieces of this group are *Frederick North, later fifth Earl of Guilford* (Fig. 141) and *Henry Tresham and Antonio Canova looking at Canova's Cupid and Psyche* (Fig. 142).[99] The former shows North standing in the Forum with

the Basilica of Maxentius and the Colosseum in the background. As Margaret Morgan Graselli says:

> This particular portrait, which measures almost a metre in height, is a gorgeous *tour-de-force* and a great tribute to Hamilton's complete mastery of his medium. Particularly admirable here is his wonderful use of color – the rich, bright blues of North's coat contrasting with the bright white of his vest, for example; the orange-red band inside the black beaver hat; the great variety of tones and textures of the masonry and bricks; and the wonderful use of blended and unblended pastels to define both the figure and the setting. Most marvelous of all, though, is the crumpled kid glove that evokes so perfectly the look and feel of crushed leather.[100]

There are two versions of the majestic *Tresham and Canova* (V & A, Fig. 142), one of which the artist sent home to the RA in 1791. It must have been painted before Tresham left Rome in 1789 and the difference between the carving of *Cupid and Psyche* in reality and the modello in the picture is probably because the work was drawn before it was completed. The second version remains in private hands. As in the portraits of the young grand tourists, Hamilton succeeds in showing the character and mood of both sitters. Tresham is deeply immersed in studying the sculpture, while the romantically handsome Canova is anticipating Tresham's reaction. As always, the details are beautifully drawn and the simplicity of the setting and gravity of the composition shows that Rome, its antiquities and its contemporary neo-classical artists had all profoundly affected the development of Hamilton's art. The other great neo-classical artist who became an intimate was Flaxman. In the Flaxman papers, there are references to expeditions, such as one to the hot baths of Acqua Santa, and Mrs Flaxman describes Hugh and his daughter as their 'best friends in Rome'.[101] Miss Hamilton was an artist and blue stocking and finished some of her father's paintings after his death.

Hamilton and his daughter (his wife had died in Rome) arrived in Dublin in 1792. Many of Hamilton's Irish friends in Rome continued to support him in Ireland, particularly the La Touche family, so well known for their artistic and charitable interests. Among his late Irish pastels were two of *William George Digges La Touche of San Souci and his wife Grace* (Bank of Ireland). These quite large pastels are brightly and firmly delineated and *William George*, in particular, has the delicacy of pastel with the authority of an oil. *David La Touche of Marlay*, 1772–1817, (NGI) was painted twice in oils. A full-length seated in a red armchair was exhibited in an exhibition held in Hawkins Street in 1804. In the same exhibition there was a very similar portrait of Lord Moira, later Marquess of Hastings,[102] seated in uniform in a library with his arms crossed and a sleeping spaniel at his feet. The second portrait of David La Touche (NGI), possibly

painted after Hamilton had officially given up work in 1804, is a head-and-shoulders and shows him as an older man.[103] Peter La Touche of Bellevue may have commissioned a picture of Dean Kirwan preaching to the orphans at the Female Orphan House in Dublin, which was exhibited in 1800, from Hamilton. The orphans are posed around the pulpit to attract the sympathy of the fashionable congregation who are kept behind a colonnade. The picture is now known by a mezzotint of 1806 by William Ward.

Hamilton was very busy on his return and Mulvany, writing in 1842, says that his studio in the large house in the corner of Merrion Square and Clare Street was 'crowded with pictures, most of which were large whole lengths and half lengths. We have never seen in

141 Hugh Douglas Hamilton, *The Fifth Earl of Guilford*, pastel, National Gallery of Art, Washington

facing page
140 Hugh Douglas Hamilton, *Frederick Augustus Hervey, Earl of Bristol and Bishop of Derry with his granddaughter*, oil on canvas, National Gallery of Ireland, Dublin

142 Hugh Douglas Hamilton,
*Tresham and Canova looking at a study for
Canova's Cupid and Psyche*, c.1788–9,
pastel, Victoria and Albert Museum,
London

any of the London portrait painters rooms so many
works in actual progress.'[104]

One or two of his portraits still have Italianate over-
tones, for example Lord Boyle was in Rome just after
the Hamiltons left. He did not return until late in
1792, when presumably his whole-length portrait in a
black cloak was painted. The Vatican and a sphinx are
the grand-tourist props for this sombre and undra-
matic study. The trees and plants, including a poppy,
are finely and accurately painted. Another portrait
with an imaginary gallery of sculpture behind the
standing figure of Colonel Hugh O'Donnell is presum-
ably a reference to O'Donnell's artistic and collecting
interests. He and his brother may have travelled in
Italy and they were both also painted by Hamilton in
oval bust portraits now in the Ulster Museum. It is
likely that they all date from the 1790s.

Hamilton's bust portraits are very honest portray-
als and concentrate on the sitter's face, paying little
attention to clothes and setting. In this respect, they
are unlike Reynolds, but the intensity of expression
may well show a debt to that great master. They

include a large proportion of the Dublin world at this
date, varying from the young Robert Stewart, Chief
Secretary of Ireland, later second Marquess of
Londonderry,[105] who is depicted in a haunting portrait
as an anxious politician, to the marvellous study of
benevolent old age in a nobleman in militia uniform
(Fig. 143). Richard Lovell Edgeworth, the inventor
and writer, has an intelligent, frank face, while the
Knight of Kerry looks questioning and sly and the
great lawyer John Philpot Curran, who so nobly
defended the rebels of the United Irishmen uprising of
1798, looks sad and reflective. His hair is casual and
this is a mark of a number of Hamilton's portraits,
such as the three-quarter-length of Lord Edward
FitzGerald painted in 1796 or 1797, a year before his
death, as a United Irishman. Hamilton painted a
number of versions of this portrait in bust size. There
is a miniature by Horace Hone, painted in 1796, on
which the Hamiltons may be based.[106]

Hamilton's female bust portraits can be outstanding
but tend to have less character, though he uses the
brown shades just as effectively as he does with men.

There are several very informal pictures, in one of which Jane Monck-Mason sits on a low ledge. In their white muslin empire dresses, these ladies are very naturalistic. Selina, Countess of Granard, is teaching her two young children to read; Mrs Tighe concentrates on her sewing, and Lady Mount Charles, later the well-known mistress of the Prince Regent, is carrying her child piggyback in wild countryside. It is sad that it was destroyed in the Slane Castle fire. The latter is based on a portrait by Hoppner of Mrs Richard Brinsley Sheridan. Though Hamilton's work has parallels with English painting of the period, his neo-classicism owes more to France. It is exemplified in his striking whole-length of the Countess of Aldborough as Hebe with her ewer.[107] She leans against Jove's throne, on which lie his thunderbolts, and is accompanied by his eagle.

In his correspondence with Canova, Hamilton mentions that there was nobody to talk to about the fine arts in Ireland and that he was worn out with painting portraits, but that to relieve his tedium he did a few sketches of heroic subjects.[108] 'M' (Mulvany) mentions a splendid head of Medusa,[109] but the only surviving subject picture is a *Cupid and Psyche* in the NGI. This was exhibited in Dublin in 1801 and was enormously admired. 'M' said: 'Angels need not have turned away from beholding it! This is art, worthy of all honour, and the nation which cherisheth it not, can, at best, be rated but as semi-barbarous.'[110] The fine handling of the background landscape makes one speculate what a magnificent landscape painter Hamilton might have been. The subject as treated is perhaps too coy in manner for modern taste, but the characterization of Cupid's eager whispered words and Psyche's hesistant acceptance is very reminiscent of similar feeling in the contemporary work of Girodet. It is more sensual than his *Diana and Endymion*, perhaps because it is based on a fresco in Herculaneum of a lecherous satyr. This was identified by Fintan Cullen and was illustrated in *Le Antichità di Ercolano*, a volume of which was owned by Hamilton.[111] Cullen also thinks the head of Cupid is derived from the Fillipino Lippi fresco in the Brancacci chapel in Florence, which was then becoming a place many artists visited.

'M' (Mulvany) goes into raptures over three portraits which he describes as historical.[112] They were Arthur O'Connor[113] dressed in a toga, orating – 'the whole air of the man is that of Brutus'; the second was of Lady Frances Beresford mourning at her husband's tomb, and the third of *Colonel Mansergh St George* (NGI)[114] mourning by his wife's tomb, which is depicted as a classical sarcophagus in a cypress grove, clearly reminiscent of Italy. It was exhibited in 1801 and the *Freeman's Journal* said: 'We have not amongst the best works of the British School a finer picture'.[115] The Unknown Diarist, whose diary of 1801–2 has survived (RIA) and who was very interested in art, would have agreed, as he thought Hamilton 'decidedly the best exhibitor this year' and enjoyed seeing the St George portrait again, having noted it some years pre-

viously in Hamilton's studio. It filled him with 'most melancholy sensations' when he considered that the sitter himself had died at the 'hands of assassins'.[116] The picture was painted around 1795 or 1796, after the death of Anne St George in 1792, and may not have been finished when the unfortunate St George died at the hands of rebels in January 1798, 'hacked to pieces by a rusty scythe'.

The 1798 rebellion was caused by the effect of the revolutionary wars in America, when, as we have said, many Irish people of all social groups found themselves supporting the American cause, and of course the French revolution. From a theoretical point of view, liberty and fraternity were seen as aims by large numbers of people: Presbyterians in Belfast, peasantry everywhere and in Wexford all classes from gentry to labourers were prepared to fight and die. The various groups had little or no contact with each other and hence they were disastrously disorganized and easily defeated. The fighting, especially in Wexford, led to dreadful, savage losses. The English government were seriously worried, as they were at war with the French

143 Hugh Douglas Hamilton, *Portrait of a nobleman in militia uniform*, oil on canvas, Private collection

St George, who was clearly overwhelmed with grief at his wife's death, wrote a raving letter to Fuseli in which he states that the portrait was not only a memorial to his wife but was to be locked in a specially built room so that his sons would not see it till they had reached mature years, so that 'this dreadful and strange apparition may be a sudden and powerful impulse'. As Fintan Cullen points out, St George was a victim of the Gothic novel and though there is no evidence that Fuseli painted anything, he would have been a far more suitable artist than Hamilton, who was too classically restrained to fulfil the patron's black horror.[117] However, Hamilton rose nobly, if not hysterically, to the occasion and painted an extraordinary image which represents grief and melancholy with deep feeling.

All this is made the sadder as St George was unpredictable but had a great sense of the comic and published a number of highly amusing caricatures, including *The City Rout*, showing the denizens of a London party in the 1770s (Walpole Library, Farmington, Connecticut). Another superb, haunting portrait study shows St George in a turban (Fig. 144). It is on panel and has an immediacy which gives it dramatic life. It is very French in feeling and was attributed to François Xavier Fabre in a recent London sale.

Hamilton retired in about 1804 with bad health, and turned to the study of chemistry, especially the nature and permanence of pigments. He died on 10 February 1808, when, according to Mulvany probably inaccurately, he was nearly eighty. He said that Hamilton's 'manners were those of the perfect gentleman; full of information, entertaining an affectionate regard for the talent of members of his profession, and always willing to make the most unreserved communication of his knowledge a practice to all who sought it'.[118] His collection of pictures was sold at Christie's on 15 May 1811 and included various old masters, but consisted chiefly of books, maps and a large number of prints, many of them of Italian antiquities bought when he was in Italy.

Frederick Prussia Plowman (1773–1820) has only recently come to light with one sparklingly painted portrait of a fashionable young lady, Mary Logan Henderson (Fig. 145). It shows the influence of Hugh Douglas Hamilton. Plowman went to the Schools in 1774–7 and exhibited in the Academy of Artists, Dublin, a splinter group of the Society of Artists of Ireland. He showed heads after Rosalba and four chalk portraits. Miss Henderson is in oils on a mahogany panel and is very well painted, and its discovery shows how weak our knowledge of Irish painting still is. He was better known as a miniaturist, but may have given up painting early.[119]

144 Hugh Douglas Hamilton, *Colonel St George as an old man*, oil on canvas, Private collection

and knew the latter were helping the insurgents. A sea battle at Bantry Bay was defeated by the weather, but the French forces later landed at Killala and, though joined by many locals, they were defeated and the peasantry were treated with great cruelty. Finally, the French fleet landed at Lough Swilly, where one of the Irish leaders, Wolfe Tone, was captured and imprisoned in Dublin. He and Lord Edward FitzGerald, another prominent leader, both died.

The outcome of the rebellion was the Act of Union of 1801, when the Irish Parliament was suppressed, and though Irish MPs sat in the Parliament in Westminster, Ireland was governed from London until the 1920s. An ineffectual rising in 1803 and another in 1848 were followed by considerable agrarian unrest and, with the potato famine of 1845–50 and the ensuing emigration, the whole nineteenth century was an uneasy period. These dramatic events led to a decline of patronage and many estates were being sold up and their contents auctioned off. However, artists only rarely depicted these sad events.

To return to Hamilton's group of Canova, the artist talking to the sculptor, Henry Tresham (1751–1814), was a Dublin-born painter of history subjects. He studied under Francis Robert West and Jacob Ennis in the Dublin Society Schools from 1765 and distin-

guished himself, winning premiums in 1770 for a chalk portrait and in 1773 for his *Adam and Eve*, which Pasquin says was bought by Lord Powerscourt. From 1768, he exhibited with the Society of Artists and, even at that youthful age, two of the three drawings he showed were of subjects connected with Greek mythology, which he continued to favour. However, Strickland states that he maintained himself with small portrait drawings, some of which were small whole-lengths, like his portrait of the actor Shagg Wilks as Jessamy in the comic opera *Leone and Clarissa*, which is dated 1778. It looks like a Healy or a Forrest. He had gone to England in 1775 and seems almost at once to have become friendly with John Campbell, later first Lord Cawdor, who was to become a major patron. Tresham went to Italy in 1775 and presumably was financed by his aunt's husband, Sir Clifton Wintringham, Bt, who gave him an allowance of £200 a year till the Earl Bishop of Derry, according to Pasquin, 'believing him not to be sufficiently industrious', wrote to Wintringham 'to withdraw his pension in order to excite his zeal'. This seems quixotic, as by 1780 Tresham had already painted *Brutus Sentencing his two Sons to Death* for the bishop and in February 1782 had begun *The Death of Julius Caesar*.[120] These were presumably commissioned by the bishop on his third trip to Italy 1777–9. Tresham, however, seems to have found some method of subsistence, probably dealing, as is implied in the mention of him in the dealer Thomas Jones's diary and in a letter of 1778 from Henry Tresham in Rome sent to 'il Sigr Pery' [first Lord Limerick] in Naples.[121] He remained in Rome for fourteen years, studying antiquities, and in 1784 he produced his extremely interesting book *Le Avventure di Saffo*. These sixteen aquatints, which he drew and engraved, are very delicately coloured and show his close stylistic links with Fuseli, Romney and Italians such as Appiani and Camuccini. Pasquin says that 'he seemed to imitate Mr W Hamilton's manner, more than the presentation of nature – his intelligence is superior to his mechanism, and his colouring so ordered, that I am betrayed into the notion that I see his pictures through a mist'. The stylistic links with William Hamilton, a Scottish artist, were interesting and indeed close. While in Italy he also painted watercolour landscapes of which *The Ascent of Vesuvius* (British Art Center, Yale) and *The Bay of Naples* are examples. He went to Naples after the eruption of Vesuvius in 1781 and Sicily after the earthquake at Messina in 1784. Campbell was his companion then and on his return to England. Other excellent examples of his drawings are *Indians from the Coast of Malabar Manufacturing Textiles*, done in Malta, and a study[122] of an archaeological dig where statues of Apollo and the Muses are being disinterred in the Villa di Cassio near Tivoli (Vatican). He also painted some large oils, of which the *Venus and Cupid*,[123] formerly in the Malahide collection, is so close to his aquatint of *The Dying Sappho* in his *Saffo* that it must be an Italian

work. There is in this a certain unattractive, overblown quality to his human figures, but the landscape and details are finely portrayed. In many ways, his watercolours are more attractive, such as those produced for John Campbell in Sicily (BM).

On his return to London in 1789, he started to exhibit at the RA, becoming an ARA in 1791, an RA in 1799 and Professor of Painting in 1807. His subjects were usually classical, such as his diploma work for the RA, *The Death of Virginia* (Fig. 146), or biblical, and, not surprisingly, he was asked to contribute three pictures to the Boydell Shakespeare Gallery, illustrating *Anthony and Cleopatra*. Tresham also worked for Robert Bowyer's *Historic Gallery*, of which the picture of *The Earl of Warwick's Vow previous to the battle of Towton, 1461*[124] (Manchester City Art Gallery) is an example. It was engraved for *Hume's History of England*. He also contributed to *Macklin's Bible*.

He sustained his links with Ireland, painting an altarpiece at Maynooth College in 1807. In 1773, before he left Ireland in 1775, he had done transparencies as

145 Frederick Prussia Plowman, *Mary Logan Henderson*, oil on canvas, Private collection

146 Henry Tresham, *Death of Virginia*, *c*.1799, oil on canvas, Royal Academy, London

part of the ball decorations of the Fishamble Street Music Hall. In London, he did decorative work in the Pantheon in Oxford Street. There he 'filled the tympanum with a profusion of figures, displaying the sciences, of which performance he was not a little proud', remarking one day to an artist friend, 'well, Mr Fuseli, how do you like my pedimental colouring'.[125]

Tresham made a close study of Italian art and was considered one of the ablest critics and art historians of his day. His knowledge was put to the test on his return to England, when he became a picture dealer, opening a gallery in Lower Brook Street, and by the fact that he proved to be as good if not a better judge of Greek vase painting than Thomas Hope, whose rejects he bought and sold with great profit to Samuel Rogers and Lord Carlisle. He was much admired also for his poetry and, in a panegyric written after his death, much comment was made on his sense of humour, liveliness of character and the patience with which he bore a 'spasmodic affliction'.[126] As Raimbach in his *Memoirs and Recollections* says, 'In 1803, when threats of invasion called the whole nation to arms, Tresham was a member of the Committee of Artists who assembled to form a Volunteer Corps. It was observed on seeing his name at the top of the list "that when the peaceful arts themselves took the field, led on by Tresham, the great Bonaparte would surely panic in his attempt".'[127]

One of the few Irish artists who painted more subject pictures than portraits is Henry Brooke (1738–1806), the nephew of another Henry Brooke, the author of *The Fool of Quality*, and the son of Robert Brooke, a journeyman painter, mostly of portraits about whom we know nothing. A sketchbook[128] by our Henry survives in the NGI and is important as the only known

sketchbook by an Irishman which shows the advantage for artists of the practice of noting down portraits and paintings from engravings as well as originals for their poses. For instance, he copies the portrait of Thomas Sheridan (NGI) by John Lewis who had painted the author Henry Brooke, whom he probably knew. This type of sketchbook would be valuable throughout their careers as a memory bank. It also includes studies of statues and wall paintings and an ill-conceived sketch of an archer on a prancing horse which suggests some mythological idea.

He exhibited at the Society of Artists in Ireland in 1770, 1771, 1772 and 1773 and then in 1780. He always describes himself as a Drawing Master. Most of his works were religious, biblical scenes; it has been suggested that they were for altarpieces though none has survived. In 1772, he exhibited his only oil painting now known. The subject, *The Continence of Scipio*[129] (Fig. 147) was popular and this work is very large, making one think that it was intended for a specific place. Stylistically, it is dependent on French seventeenth-century painting, especially Le Brun. Benjamin West had exhibited his version in the Free Society of Artists in London in 1766, when Brooke was in London. The central figures are well conceived. Brooke spent most of his life in Ireland but exhibited when in England from 1761 to 1767, where apparently he sold a number of subject pictures. He also won prizes in both England and Ireland.

Also resident in London was Matthew William Peters (1741–1814), whose education in the Dublin Society Schools we have already noted in connection with his pastel portrait group of himself with Robert West in chapter 6. After he left the Schools, he went to London, where he became a pupil of Hudson, probably at the

same time as Cosway, in the later 1750s, and won a premium at the Society of Arts in 1759. However, it was the Dublin Society who paid, through the generosity of the second Earl of Lanesborough, for his visit to Italy in 1761–5,[130] where he studied in the Accademia del Nudo and under Batoni, and copied Rubens and Titian. Whitley quotes a letter from Peters in Rome to William Oram, dated 6 May 1762, 'I am under the direction of Pompeo Battoni from whom I shall hope to get some furtherance in drawing: but shall look after the Old Masters for those things that require most study'.[131] He returned to Dublin in 1765, exhibiting in the Society of Artists of Ireland in 1768 from London. He went back to Italy in 1771, staying until 1776 and visiting Parma, Perugia and Venice as well as Rome and Florence. He made a study of Correggio and Barocci.[132] On his way home he stopped in Paris and particularly liked the work of Fragonard and Greuze.

He had not got enough business when he returned to Dublin in 1765 so from 1766 he settled in London and subscribed in that year, with Hone, to the Roll Declaration of the Society of Incorporated Artists of Great Britain. After his second Italian trip, he was back in London in 1776 and it was at this period that he painted his slightly salacious ladies. Whitley quotes from a poem, 'The dewy lip, the swimming eye, the

slackened breast, the naked thigh, these ... are your glories'. Whitley also cites newspapers of 1777 as saying that his *Woman in Bed* shown in the RA was 'fit for a bagnio' and that 'in its present position it seems to prevent the pictures around it from being so much seen and admired ... for every man who has either his wife or his daughter with him must for decency's sake hurry them away from that corner of the room'.[133]

This was probably the pair to the *Sylvia, a courtesan*, 1778, in the NGI.[134] In the opinion of Waterhouse, they represent the influence of Greuze, though 'the moral overtones and the yearning glances are given no cover by being made to appear to be motivated by a dead sparrow or an attitude of prayer'.[135]

Peters became a clergyman in 1781, but did not immediately give up painting, even travelling to Paris at the request of the Duke of Rutland, one of his principal patrons, to copy Charles Le Brun. Here, according to R. R. M. See, he became friendly with Vestier and the younger Boilly, who was clearly an influence on his genre work.[136] He had become an RA in 1777, but resigned in 1788. However, he took part in the Boydell Shakespeare scheme, and, although he virtually gave up painting, produced some portraits and religious subjects. He is about the only eighteenth-century Irish painter who can be described as a colourist. In his

147 Henry Brooke, *The Continence of Scipio*, 1792, oil on canvas, National Gallery of Ireland, Dublin

148 Matthew William Peters, *The Gamesters*, oil on canvas, OPW/Dublin Castle

149 Matthew William Peters, *The Flageolot Players*, oil on canvas, Huntington Museum and Art Gallery

portraits and genre scenes, he has a tremendous sparkling quality and it is a pity that he is now so underestimated and only remembered for his mild eroticism. A striking work is the *Three Children Dressing Up* in the Bearsted Collection, National Trust. It is a spirited work in the Reynolds manner. *The Two Children*, his diploma work of 1777, exists in two versions, one in the RA and one a finished study in Dublin Castle, where there is also an excellent subject picture, *The Gamesters*, dated c.1785, where a fresh-faced youth is being fleeced by card sharpers (Fig. 148). The artist, presumably anxious after he became a clergyman to restore his moral reputation, had the following warning inscribed on the mezzotint scraped by William Ward in 1786:

> Vice, whatever sex or form it may assume, leadeth to destruction; woe to the unwary youth who hath been seduced into the acquaintance. To the young nobility of England this plate is most humbly inscribed[137]

It is a traditional subject, popularized by Caravaggio and many others. A particularly attractive conversation piece, again traditional in subject-matter, is *The Flageolot Players* (Fig. 149), showing a group of itinerant musicians.

Peters and Solomon Williams were the only Irish artists who took part in the Irish Shakespeare Gallery, a short-lived and unsuccessful exhibition advertised on 7–9 June 1792 in *Faulkner's Dublin Journal*. It opened on 1 May 1793 in Whistler's Great Room in Exchequer Street.[138] It was promoted by Mr Woodmason, who lost a considerable amount of money over it. Though he aimed to produce an exhibition on the lines of the Boydell Shakespeare, only seven artists were involved and only twenty-three pictures were shown, a few at a time, and four more were added when it went to London. The seven were Fuseli, Northcote, Wheatley, William Hamilton, Opie, Peters and Solomon Williams. Peters contributed in Dublin *The Shipwreck* from *The Tempest*, *Charmion and the Soothsayer* from *Anthony and Cleopatra*, *Mother Jourdain's Cave* from *Henry VI*, and *Juliet Stabbing Herself* from *Romeo and Juliet*. All the pictures were to be engraved to illustrate an edition of Shakespeare which was never produced, though the *Juliet* and two others were engraved. Robin Hamlyn writes that '*Anthologica Hibernica* commented upon the sense of deep regret with which "every person of refined and cultivated taste" regarded the depressed state of the Fine Arts in Ireland. The advent of this Shakespeare Gallery ... was hailed as "the dawn of a happier day" and as a step toward the laying of "the foundation of a *School of Painting*"'.[139] The exhibition's lack of impact justified their remarks as, except for Hunter's one-man show, there had not been an exhibition in Dublin since 1780 and indeed no other exhibition took place until 1800. It must have seemed that Dublin had few painters.

150 Robert Fagan, *Self Portrait with his second wife*, *Anna Maria Ferri*, oil on canvas, Hunt Museum, Limerick

The second Irish artist, Solomon Williams (1756–1824), who painted a scene from *Titus Andronicus*, had attended the Dublin Society Schools from 1771 and later went to the RA School in 1781. In the RDS there is his portrait of the philanthropist Thomas Pleasants and another of Vallancey, rather weak paintings. He exhibited some seals in the Society of Artists in Ireland in 1777 and 1780 but did not continue in this vein. He painted a number of religious works and subject pictures as well as portraits, which were exhibited in Dublin mostly at the Society of Artists after 1809. He also showed in London, at the RA and the British Institution. Two copies by him after Kneller and Gainsborough survive in the Mansion House, Dublin. The latter is a portrait of the Marquess of Buckingham when Lord Lieutenant in 1787–90. In his youth, he spent six years in Italy visiting Rome, Florence and Bologna, where he became a member of the Accademia Clementina. He worked mainly as a copyist and a travelling companion, Henry Quin, the doctor, who was with him in Bologna, wrote, 'He seems to have a great deal of Enthusiasm apparently mingled with a degree of chagrin that the world don't think as highly of his works as himself.'[140] There is a sketchbook in the NGI of slight interest. It contains drawings after antique sculpture and a Tintoretto in Venice. We cannot make any assessment of his work as most of it is now unknown.

Reynolds's influence is marked in the two pictures known by William Palmer (1763–90), a very short-lived artist from Limerick. He was a product of the Dublin Society Schools before becoming a student of Reynolds in London, winning prizes at the English Society of Artists in 1784 and 1788. He returned in that year to Limerick and died of consumption in 1790. His portrait of Amos Simon Cottle (NPG)[141] is painted with great delicacy and distinction, but his self-portrait (University of Limerick) is cursory. He was a good miniature painter.

An Irishman whose links with this country are minimal was Robert Fagan (1761–1816).[142] As he was neither born nor educated in Ireland, and did not live there at any time, his importance in the history of the mainstream of Irish art should not be exaggerated. His father was in the bakery business in Long Acre in London and was said to have come from Cork. Fagan called himself Irish later in his life and was certainly a Catholic. He had an enormously interesting career which reads like a picaresque novel. In 1781, aged twenty, he was admitted to the RA Schools. His father had died in the same year, presumably leaving him financially independent, and he was able to go to Italy via Paris in 1783, reaching Rome in January 1784. He remained in Italy for the rest of his career, marrying twice, on both occasions Italian girls of considerable beauty. He worked as a portraitist of fashionable grand tourists; as a dealer in antiquities and paintings, one of his greatest *coups* being the smuggling of the Altieri Claudes to William Beckford; as an archaeologist, whose work in Ostia and later in Sicily was among the pio-

151 Robert Fagan, *Portrait of Margaret Simpson as Hibernia*, first decade of the nineteenth century, oil on canvas, Private collection

neering ventures in this field; as the friend and confidant of that distraught drug addict, Queen Marie Carolina of Naples; and finally, in 1809, after considerable angling with Nelson and Sir William Hamilton and through the influence of his new son-in-law, William Baker of Bayfordsbury, he was appointed Consul General for Sicily and Malta. In 1815, Fagan journeyed to England and painted murals based on classical themes and frequently copies of classical sculpture at Attingham Park for Lord Berwick, whom he had met in Naples. It has recently been found that he did not finish all the work and that Barret's son George, with presumably another son, William, completed the commission.[143] Owing to a combination of ill health and financial reversals, Fagan committed suicide, throwing himself out of a window in Rome in 1816.

His pictures are of outstanding quality and are truly continental in style and inspiration. If the nearest parallel to his earlier portraits of Lady Mainwaring and Lady Webster[144] of 1793 is the work of Fabre, his later portraits, such as the famous obsessional *Self-portrait with his second wife* 'à la Grecque', is in the style of the Italian Appiani (Fig. 150). The second wife is painted again, more modestly, in a profile half-length which echoes French painters, such as Prud'hon and David. But perhaps *Margaret Simpson as Hibernia* is his patriotic masterpiece (Fig. 151), showing her at an early date for such symbolism, with a wolfhound and a partly unstrung harp, a shamrock border to her green mantel and a scroll bearing the Gaelic words '*Eireann go Bragh*' (Ireland for ever). The epitome of the English in Rome is his full-length of his archaelogically minded friend, *Sir Corbet Corbet, his Wife and Dogs* in 1797. His final portraits, done in Sicily, deteriorate in quality considerably. Fagan was however one of the most dramatic characters associated with Irish painting.

The Genius of James Barry

James Barry (1741–1806) is a difficult artist to place in a history of Irish painting as he was such a unique and extraordinary character and had enormous talent as an artist. He was a painter of mythology, history and biblical scenes, working very much in the public eye and on the grand scale, while the average Irish painter was content to work on a more prosaic level. His background was similar to that of many other Irish artists. His father was a Cork builder who went into the shipping business between England and Ireland and later owned a pub on the quays. James had some difficulty in persuading his father to allow him to become an artist. However, his family cannot have been without some interest in the arts, as, according to Strickland, they had engravings in the house of the Raphael cartoons, which the young Barry constantly copied.

Farington records that Edmund Garvey (d. 1808) told him in 1805 that he had gone with his master Robert Carver (fl. 1750–91)[1] to visit Cork in 1762 'where Barry was at that time, & considered to be a very eccentric young man'[2] and added the facts of his early Cork years. It is interesting that Barry's character was the same in his youth as in his age. It is worth mentioning that by tradition his mother Juliana Reardon came from a decayed Catholic gentry family and his father was a Protestant. He was therefore as much Catholic as Protestant, a situation he shared with his great friend and patron Edmund Burke.

Barry seems to have worked on historic subject-matter from the beginning[3] and had the good luck to become a friend of an ex-schoolmate of Edmund Burke, Dr Fenn Sleigh. The doctor was clearly a highly cultivated and travelled man, who had once visited the Orleans collection in Paris in the company of 'Athenian' Stuart,[4] for whom Barry was later to work. Barry was also a student of John Butts (see chapter 9), whom he greatly admired, writing after his death to Dr Sleigh, his 'example and works were my first guide, and was what enamoured me with the art itself'.[5] It is worth noting that in these early years Barry even painted landscapes, one of which, a view in the Wicklow mountains, was in the sale held after his death,[6] and a small pen-and-ink sketch of a river and weir with a classical temple in the background (Pierpoint Morgan Library), signed and dated 1762, reflects Butts's work but with more stress on outline.[7] In his letters to Burke when on the continent, there are frequent mentions of sketching landscapes, both *en route* to Rome and when visiting places like Naples. He also learned how to etch in Cork, for apparently he made illustrations and helped to etch them for a publication of 'fables, emblems or tales'.[8]

Before he left Cork, Barry had painted several pictures, mostly on biblical themes, but there was also an *Aeneas Escaping with his Family from the Flames of Troy*[9] and *The Baptism by St Patrick of the King of Cashel*.[10] He brought this latter picture, with its uniquely patriotic subject for the date, to Dublin in 1763 and exhibited it at the Dublin Society. The records of the society are confusing[11] and indicate that he may have attended the figure school about 1760 and that he won a premium in 1763, presumably for *The Baptism by St Patrick of the King of Cashel*. The picture attracted much notice and, no doubt because of the subject, was very popular. It was long thought to have been destroyed in the fire in the Irish House of Commons in 1794, but it seems likely that it is the very damaged work which is now owned by the school, Terenure College.[12] It is particularly interesting in its use of such classical details as the king's armour, which relates to the costumes in his much later *King Lear*. It is simpler in composition than the later work. It is fascinating, as it was the first effort to paint a nationalist Irish subject and antedates the nationalist fervour of the late 1770s and 1780s by a number of years. It has one precursor that we know of, a huge equestrian portrait of Brian Boru still in Dromoland Castle, once the home of the O'Brien family, who were naturally very proud of their descent from this national hero. The picture was mentioned in an inventory of 1751 and it may have been painted

quite early in the century. The picture is a naïve version of two similar engravings of *Donatus O'Brien, second Earl of Thomond* by P. van den Berge and is clearly intended to tell the onlooker that the O'Briens had claims to the Irish monarchy.[13]

Once in Dublin, Barry stayed for some seven or eight months, apparently studying in the Dublin Society Schools, where the figure school was under the direction of Jacob Ennis. He was already planning a trip to the continent and no doubt Ennis, who had studied in Italy, encouraged him. Dr Sleigh recommended Barry to Edmund Burke, who visited Dublin in 1763 and whose essay *A Philosophical Enquiry into the Origin of our Ideas of the Sublime and Beautiful* Barry had already absorbed. In the following year, he accompanied Richard Burke,[14] Edmund's brother, to London, where Burke got him a job copying 'Athenian' Stuart's drawings of Greek antiquities in oils.[15] He was introduced to Barret and to Reynolds, who took immense pains in advising him and maintained a continued interest in his career, even writing to him later, in Italy.[16] Barry's actual departure for the continent seems to have occurred at very short notice and he left in October 1765, staying in Paris for nearly a year. While there, he painted a copy of a lost Le Sueur, *Alexander Drinking the Potion*, which he describes as 'incomparably the first picture I ever saw in my life'.[17] He also admired some Nicolas Poussins. There is a small panel of a copy after Poussin in the NGI.[18] But he did not like the late landscapes. Of the moderns he preferred Greuze. He mentions, too, that he attended the life classes at the Académie de St Luc every night.[19] He finally reached Rome in November 1766, from where, on 8 April 1769, he wrote, 'I am forming myself for a History painter'.[20] Apart from a brief visit to Naples in the company of John Runciman in late 1768,[21] he remained in Rome until April 1770. Throughout his travels, he was financed by Burke and his brother. In one letter from Rome, he estimates that he could manage there on £45 a year.[22]

Barry's aggressive temperament showed itself almost at once and he seems to have fought not only with other Irish artists in Rome, but also with the dealers whose trickery he objected to,[23] particularly as it was ridiculing the English as patrons. He seems to have even found it impossible to be deferential to the 'Milordi Inglesi', for nearly every letter that Burke sent him included temperate advice to try and get on with his fellow men, as did Reynolds's letter, but all to little avail. Poor Barry was disconcerted to find that Sir Watkin Williams Wynn had heard that he was 'a troublesome fellow, who made a great disturbance in the place',[24] and Barry even tried unsuccessfully writing a conciliatory letter to him to attract the baronet to his studio. In Rome, as he wrote to Dr Sleigh in November 1767, his 'objects of study, since my coming abroad, are purity of design, beauty, elegance, and sublimity of expression, you will not wonder at my preferring the antique to all things, next Raffael and Michel Angelo, Guido for some things, Le Sueur, Poussin, Le Brun, and Domenichino; these are the artists my heart warms towards, and I have ranged them, I think, just in the order I love them'.[25] Among the moderns, he praised Gavin Hamilton and his Homeric pictures, but it is interesting that one of the independent pictures he painted in Rome was *The Temptation of Adam* (NGI),[26] which, when he engraved it, he subtitled with a reference to Milton. He exhibited it in the RA in 1771 and it appeared on the centre wall, hung on the line in Charles Brandoin's watercolour (Huntingdon Library and Art Gallery) which was engraved by Richard Earlom. The exaggerated, overlarge figures of the Adam and Eve, with their generalized anatomy, are completely antique in inspiration. His enormous interest in the antique prefigures his faith in the classical republicanism of Rome which was to echo through his political ideals throughout his life.[27] After visiting Herculaneum, he said that 'The moderns, with all their vapouring, have invented nothing, have improved nothing, not even in the most trifling articles of convenient household utensils; ... is there anything new in the world!'[28] Obviously, when faced with the antique, Barry must have felt much as his fellow-countryman, Daniel Webb, had done before *The Horse-tamers*. We know that Barry had read Webb's *An Enquiry into the Beauties of Painting*, of 1760, in which Webb said of antique sculpture:

a great part of the pleasure we receive in the contemplation of such Colossal figures, arises from a comparison of their proportions with our own. The mind, in these moments, grows ambitious; and feels itself aspiring to greater powers, and superior functions: These noble and exalted feelings diffuse a kind of rapture through the soul; and raise in it conceptions and aims above the limits of humanity.[29]

Recently, a number of beautiful sketches[30] of views of Rome, and of the scenery between Rome and Naples, done with a very gentle touch, have been identified as being by Barry (Fig. 152). They are attributed to him from a known drawing of Lake Avernus in the British Art Center, Yale. Barry wrote to Burke that he intended to make sketches on his Naples trip and these are clearly the result. As Pressly says, referring to early drawings but equally true of the Roman drawings, they have 'fragile delicacy' and are 'thinly drawn'.[31]

On his return journey, Barry much admired Cimabue, Giotto and Masaccio in Florence, as well as Parmigianino, mentioning a *Madonna and Child* in the Pitti as having 'elegance, carried a little too far',[32] but Parmigianino's sibyls in the *Madonna della Steccata* in Parma he felt were in the true Greek taste.[33] His fascination for mannerism is also evinced by his comment on *The Raising of Lazarus* by Sebastiano del Piombo (National Gallery, London), then in the Orleans Gallery, which he said was 'in truth one of the greatest works of painting in the world'.[34] Throughout his letters from Rome and, later, in his *Observations on different Works of Art ...*,[35] it appears that Barry made an incredibly detailed critical assessment of the sculpture and Old Masters that he saw in France and Italy. It is therefore not surprising that his borrowings are extraordinarily varied. He was also very well read and these facts imbue his art with an intellectualism rare anywhere and unprecedented in an Irish artist.

During his stay in Bologna, he became a member of the Accademia Clementina, for which he painted his *Philoctetes*, in 1770. As Irwin rightly points out, this sombre and disagreeable work is important as the earliest of his classical pictures to survive and also shows the literary basis of his art, as it is inspired by Lessing's *Laocoön*, where Sophocles' account of Philoctetes is analysed.[36] The emphasis on suffering is underlined by a comment on the preparatory drawing and portrays Barry's romantic tendencies, already fully developed. The figure derives from a variety of sources, such as classical sculpture and Irwin also suggests the mannerist, Tibaldi.[37]

In 1771, Barry returned to England, where he spent the rest of his career and met with much success, being made ARA in 1772 and an RA in 1773. A contemporary, one K, said his lectures were very good and he made unsuccessful efforts to make a collection of pictures for the use of the academy students.[38] In the next few years, he exhibited in the RA a wide variety

of classical subjects taken from Greek mythology and Roman history, including an early version of *Jupiter and Juno* and *Pandora*, of which only the later versions are now known. In 1774, he exhibited his first version of *King Lear Weeping over the Body of Cordelia*, which, unlike the eighteenth-century acted versions, illustrates the Shakespearean text. This was something of a shock to contemporaries though the use of the pose for the dead Cordelia of the Dead Christ from Annibale Carracci's late *Mourning over the Body of the Dead Christ* would have been familiar to them. But if the public found this great painting too difficult to enjoy, artists were fascinated by it and it influenced, probably via engravings, John Mortimer, Girodet and others.[39] A magnificent neo-classical portrait group, which he exhibited in 1776, was of himself and Burke in the characters of *Ulysses and his companions escaping from Polyphemus* (Fig. 153) as related in Homer's *Odyssey*.[40] As well as its obvious subject, it almost certainly has a hidden agenda. Both Burke and Barry

153 James Barry, *Burke and Barry as Ulysses and his Companions escaping from Polyphemus*, oil on canvas, Crawford Art Gallery, Cork

Since his Roman days, Barry had painted occasional portraits, such as his portrayal of himself with the English architect, James Paine, and the French artist, Dominique Lefevre, *c.*1767 (NPG). At this time, his portraits were always of personal friends, like *Edmund Burke* (TCD) and his in-laws, including *Christopher Nugent*, 1772 (Fig. 154), one of his noblest pictures. It is a beautiful profile and the curls and the delicate hand touching his chin all add to its quality. The sitter is reading and deeply involved in thought, contemplating and concentrating on his book.[42]

Barry made one essay in painting contemporary history, a field much popularized by Benjamin West, and indeed, Barry's *Death of General Wolfe* of 1776 is clearly in competition with West's own picture of the subject dating from 1771. Though Barry is historically more accurate, his picture was not admired, probably because it lacked the idealization to which the public was accustomed.[43] In fact it is an unsatisfactory essay and possibly Barry's least successful picture.

The central point in Barry's career is his mural painting for the Great Room of the Society of Arts, Adelphi, London. The history of this project begins with the fruitless collaborative efforts by several artists, including Barry, to complete the Thornhill decorations in the dome of St Paul's in 1773 and to decorate the Great Room of the Society of Arts in the Adelphi in 1774. Barry's feelings about these abortive schemes prompted his article entitled 'An Inquiry into the Real and Imaginary Obstructions to the Acquisition of the Arts in England', published in 1775. He made his own eagerly accepted offer to decorate the room single-handedly and unpaid in 1777, to prove his theory that the British were capable of grand historical works. It was completed by about 1784. The overall subject is *The Progress of Human Culture*, in Barry's words 'to illustrate one great maxim of moral truth, viz. that the obtaining of happiness, as well individual as public, depends on cultivating the human faculties'.[44] The pictures themselves are entitled: *The Story of Orpheus*; *a Grecian Harvest Home, or Thanksgiving to Ceres and Bacchus*; *the Victors at Olympia*; *Navigation, or the Triumph of the Thames*; *the Distribution of Premiums in the Society of Arts*; *Elizium, or the state of final retribution.*

Barry's intention to rival Raphael can only be described as a failure, because the literary and philosophical content dominates the paintings. Nevertheless, the series includes some individually magnificent painted sections; Orpheus is depicted encouraging the early inhabitants of Greece to rise out of their savage state by industry and religious rites, which are depicted in the second picture of the *Grecian Harvest Home*. This is a celebration of simple, agricultural life and rural pleasures. *The Victors at Olympia* (Fig. 155), the last classical scene, is a triumph of the learning, philosophy and the arts of the Greeks, as well as of their physical prowess. It is the best individual scene, unfolding like a great classical bas-relief of a triumph across the full length of the wall.

154 James Barry, *Christopher Nugent M.D. (1715–75)*, 1772, oil on canvas, Victoria Art Gallery, Bath and North East Somerset Council

opposed English policy in America and Washington's armies were followed with great enthusiasm by many of Ireland's nationalist and Volunteer leaders. Ireland also wanted free trade and legislative independence for itself. It has been suggested that Polyphemus is counting his sheep and that the picture is an allusion to England's control over the Irish wool trade, much to Ireland's detriment. This economic control over Ireland since the days of Swift was a bone of enormous contention until free trade was finally granted in 1779, so it was a very topical issue.[41] No doubt Burke has a finger to his mouth counselling caution to Barry and this may be a comment on their deteriorating relationship. Burke would not have liked being in a subject painting which, because of the deformity of the Cyclops, could hardly be called 'sublime', despite its terrifying aspect. He did not approve of Barry's radical thinking, which led him later to be friendly with Richard Price, Joseph Priestley and William Godwin. Barry supported their thoughts on democratic republicanism, freedom of African slaves and the rights of women.

The modern scenes starting with *The Triumph of the Thames* are, by analogy, placing modern England as the successor of the Greeks. Included are portraits of historic figures, both dead and alive, such as Raleigh, Drake, Cook and, somewhat incongruously, Dr Charles Burney, the musicologist, whose portrait in the company of several nereids occasioned the following comment from a lady, who observed, 'That she was by no means pleased with Mr. Barry, for representing the Doctor in company with a party of naked girls dabbling in a horse-pond'.[45] The *Distribution of Premiums* in the Society of Arts, which follows, includes a host of portraits for which Barry obtained sittings, some of which form the basis of his later individual portraits (Fig. 156). It is a better-composed group, with sufficient incident to prevent too static a composition. The final scene, *Elizium*, which is on the entrance wall, is also composed of a host of likenesses which Barry endeavoured to make historically accurate by borrowing old portraits. The more effective section is on the right of Tartarus, where a fiend can

be seen dragging a damned man down by the hair.

The influences seen on these pictures are numerous. To look at the *Grecian Harvest Home* alone shows firstly a knowledge of Poussin, particularly the group of dancing figures in *The Dance to the Music of Time* (Wallace Collection) or *The Golden Calf* (National Gallery, London), then in the collection of Lord Radnor, on which Barry's dancers are modelled;[46] secondly, as Croft-Murray notes, the dancers are reminiscent of Reynolds's *Three Graces Adorning a Term of Hymen* (National Gallery, London) exhibited at the RA in 1774. Croft-Murray also notes the general influence of the subject pictures of Benjamin West and the mannerism of Henry Fuseli.[47]

During the seven years Barry was working at the Society of Arts, he survived largely due to the prints he made in the evenings, and he eventually made a powerful series for the Adelphi room itself, as well as issuing a booklet which explains the scenes in minute detail. The fact that such a booklet was needed is an indication of the failure of their visual impact.

155 James Barry, *Crowning of the Victors at Olympia*, detail, oil on canvas, Royal Society of Arts

156 James Barry, *Distribution of the Premiums*, oil on canvas, Royal Society of Arts

157 James Barry, *The Act of Union*, engraving, British Museum, London

However, such was their fame that in 1782 Barry was asked, and refused, to go to America, to paint the exploits of George Washington.[48] This was surprising, perhaps as the new republicanism of America was close to his heart, because he saw it as a re-enactment of the republicanism of Greece and Rome.

In 1782, Barry was appointed Professor of Painting at the RA and continued in that position until he was expelled in 1799, after a fierce controversy with his fellow Academicians. Earlier, he had alienated Reynolds and had even at one time broken off with Burke.[49] His last years were spent in considerable poverty, as a proud recluse, never resorting to work for money-making projects such as fashionable portrait painting. The background to much of his rancour may have been his strong religious and political idealism. Like many other Irishmen, he probably supported the Act of Union of 1801 because he thought it would be followed by Catholic Emancipation. His noble portrait of the Prince of Wales (Crawford Art Gallery, Cork) was no doubt painted with these expectations as at the time it was felt that the prince with his liberal coterie, including Charles James Fox, would support such a move.

Though Barry never seems to have returned to Ireland, his patriotic feelings for his country can be deduced from several subtle details. For instance, in *Elyzium*, Ossian is given an Irish harp, as he considered Ossian as an Irish,[50] not a Scottish, bard, and in 1776 he issued a print entitled *The Phoenix or the Resurrection*

of Freedom, in which he shows his personal sympathy for the American revolution. His two wash drawings on *The Union of Great Britain and Ireland* (Fig. 157), of 1801 make it very plain that he sees Hibernia and Britannia as equals and the scales of justice which come down from Heaven are equally balanced. Therefore, as we have said, he favoured the Act of Union. However, the success of the Union in those terms was undoubtedly not the intention of the British Government. He introduces in the BM drawing various Irish emblems such as harps, a claddagh ring and, in the scribes who record the Union, he hints at ancient Irish manuscript illuminators. The Ashmolean drawing, which is thought to be the earlier of the two, is somewhat cluttered and may include a portrait of Pitt, who engineered the Union and was thought at the time to be in favour of Catholic emancipation. He had hoped that a painting of the subject would hang in the Adelphi and he made unsuccessful efforts to achieve this.

Barry again took up the theme of *St Patrick and the King of Cashel* (NGI),[51] which had been his first surviving work. This second picture, a sketch, is notable for its delicacy and fluid painting, particularly of the handmaidens and the grey helmeted figures in the background. It dates from about 1800, the period when Barry was especially interested in Irish politics and the question of the Act of Union. It shows Patrick accidentally putting his crozier through the king's foot. The king with great heroism and virtue displays no feeling. Behind, on a hill, is a dolmen recalling a period of primitive grandeur and on the side of the hill are two trilithons showing an architectural advance; in the foreground, a Doric temple symbolizes the virtues of the ancient Greeks which were also part of early Christianity.[52]

In many ways, Barry's genius improved with age. His magnificent picture, *Jupiter beguiled by Juno* (Fig. 158), of 1777 shows the interlocking figures more

158 James Barry, *Jupiter and Juno*, oil on canvas, Graves Art Gallery, Sheffield

159 James Barry, *Iachimo and Imogen*,
1786–7, oil on canvas, Royal Dublin
Society

compactly composed than in the early version of 1773.
His *Lear and Cordelia* in the Tate Britain, a considerable
enlargement of his earlier work, was made for the
Boydell Shakespeare Gallery in 1786–8 and is a most
impressive picture. Apparently its greatness was rec-
ognized when it was first exhibited, but the public was
bewildered by Barry's occasional use of non-realistic
colouring. The Stonehenge architecture, aiming at his-
torical accuracy, has been reorganized to compete with
Greek temples, though the costumes still look classi-
cal and the splendid demented head of Lear is in star-
tling contrast to the rather mannered soldiers and
other characters. The *Lear* is described by Albert
Boime as a 'Nordic Colossus' while a near contempo-
rary, Humphrey Repton, the landscape gardener, saw
it as made of alabaster.[53] But whatever criticism can be
made, it remains a superb representation of grief and
death. It is treated with passionate intensity and is

altogether a more successful picture than such 'pretty'
subjects as he had painted earlier, like his *Venus Rising
from the Waves*, *c*.1772 (Hugh Lane Gallery) and *Mercury
Inventing the Lyre*, 1774 (NT, Petworth). Wark considers
that Barry was much influenced by Burke's theory of
the beautiful. 'Small, their contours smooth and gently
undulating, continually flowing, with hardly percepti-
ble beginning, end or interruptions' is a description
which fits both the *Venus* and the *Mercury*, whereas the
Lear is clearly based on Burke's 'Sublime'. This Wark
paraphrases as being 'Sublime objects ... are vast in
their dimensions, solid and massive. Straight lines and
angular accents predominate ... wrapped in gloom, or
seen by sudden, intense illumination and accompanied
by a flash of lightning'.[54]

Barry's second Boydell Shakespeare picture was the
Imogen and Iachimo (Fig. 159) from *Cymbeline*, 1786–7.
The study for this picture is in the NGI. This

bizarrely foreshortened interior, painted in hallucinatory blue-greens and browns, has peeping in through the window a Wright of Derby moon which illuminates the sensual form of Imogen and highlights the evil expression of Iachimo. David Bindman sums it up thus: 'This peculiar painting is hard to reconcile with Barry's relatively staid treatment of mythological and literary subjects, but if one sees it as a study of the malevolent desire of base men to destroy Beauty and Virtue, then it chimes in with the Paranoia of his writings and lectures to the Royal Academy.' Bindman considers it to be one of the most important paintings executed in Britain in the eighteenth century.[55] It is influenced by Fuseli, whose impact on Barry is best seen in such prints as *Satan Calling up his Legions*, 1792–4, and *Satan, Sin and Death*, 1792–5. They are ultimately based on Michelangelo and are quite terrifying in their dramatic intensity and expression.

One of his last pictures, *The Creation of Pandora* (City Art Gallery, Manchester), is again in competition with Raphael, in particular with the *Council of Gods* in the *Cupid and Psyche* series in the Farnesina, some spandrels of which Barry had copied when he was in Rome.[56] However, it is handled with a heavy, dramatic chiaroscuro alien from the brilliant decoration of Raphael. This interest in sharp contrasts of light probably stems from his knowledge of Rembrandt, shown also in some of his self-portraits, both in oil and in pen and ink.

It is as a creator of the neo-classic style and as the most important subject-picture painter in England in the latter half of the eighteenth century that Barry is most famous. But it is the distillation of his grand manner, born in his subject pictures into the simpler, more condensed genre of portrait painting, that makes the latter one of his greatest achievements. In discussing his full-length portrait of *Hugh, first Duke of Northumberland*, where the pose and treatment of the Garter robes are almost identical to those used for the figure of the Prince of Wales in the Society of Arts picture, Waterhouse states that it shows 'a kind of solemnity which was denied Reynolds'.[57] As Barry considered portraiture beneath him, only a handful of portraits exist, of which the unfinished head of *Samuel Johnson* (Fig. 160) is a powerful character study.

His masterpiece is his arresting self-portrait of 1803 (Fig. 161)[58] where his eyes stare out at the spectator unlike the disillusioned and deeply mournful portraits in pen and ink (Royal Society of Arts) and mezzotint (BM) which date from 1802. The close connection between the Dublin oil portrait and the self-portrait of the artist as Timanthes, which is included in his *Victors at Olympia* (Royal Society of Arts), was noticed by Wark.[59] He publishes a very interesting letter from Barry to the Society of Arts, in which the artist replies to a request for a self-portrait to be used as the basis of the engraving to be included in the volume of the society's transactions of 1804. Barry wrote:

The only portrait Mr Barry has of himself is the head which he painted many years since and copied at the time into his picture of the Olympic victors. Notwithstanding the wear and tear on such a fragile thing as the human countenance, yet as Mr Barry's friends thought it still like without in the least touching the head, finished the rest of the picture sometime last summer by painting in the hands, drapery, cyclops, etc.[60]

Again, as Wark comments, there does not appear to be a radical change in style between the head and the remainder of the work, and one can only surmise that, in fact, Barry did touch up the head, so that the changes in style between his work, around 1780 and that of 1803 do not appear. He is holding his own painting of *The Cyclops and the Satyrs*, based on the work of Timanthes as described by Pliny, and above his head is depicted the base of a statue of Hercules crushing the snake of envy, which also appears in the mural. Wark suggests that this was also conceived by the artist as a personal allusion, and goes on to say, 'certainly as far as wealth and worldly position were concerned, he had just cause to envy the fashionable portraitists of his day. But he was not shaken from his resolve to devote himself to what he considered that loftiest (if least remunerative) branch of his art, "history" painting.'[61] However, Pressly suggests that it may be the other way round, Barry taking the moral high ground, and it may represent the envy others who were unable to paint such magnificent portraits or subject pictures felt for Barry. Pressly sees the pose of the satyrs slightly altered to represent those of Burke and Barry in the double portrait of *Ulysses and his Companions*, considering it an allusion to Burke's leadership in the exploration of the sublime.[62] Whatever the interpretation, this is surely one of the greatest portraits of the period.

161 James Barry, *Self Portrait as Timanthes*, National Gallery of Ireland, Dublin

The anonymous K[63], writing in 1801, surprisingly says that the artist was 'Cheerful, communicative and it is almost superfluous to add interesting in conversation'. However, there is more evidence that Barry's last few years were ones of poverty, depression and pathetic feelings of melancholia. He lived alone and refused to accept any charity. One of his last friends, to whom he was introduced in 1800, was Francis Douce, who collected many of Barry's prints. Barry made two portrait drawings of Douce, one in 1803 in pen and brown ink with grey wash (Ashmolean Museum). The other (Bodleian) has written on the back by Douce, 'Scarcely a particle of resemblance'. However, the one in the Ashmolean was a success and is a splendid example of his draftsmanship.[64] The Dublin Society proposed to send him money in 1805, and efforts were made by Lord Buchan to raise an annuity for him, but it came too late and he died before receiving the first payment. Typically of the hypocrisy of the age, he was given a solemn funeral and was, ironically, laid to rest next to his old enemy, Sir Joshua Reynolds, in the crypt of St Paul's Cathedral.

Mid-Eighteenth-Century Painters and the Irish in Rome

The importance of the antiquarians and van der Hagen[1] for the expansion of landscape painting in mid-eighteenth-century Ireland is seminal. It seems to have occurred in a number of centres at the same time, artists coming from Cork and Waterford as much as from Dublin. It took place alongside a strong predilection for collecting Dutch cabinet pictures. The Dublin sale catalogues frequently included such names as Brill, Breughel, Cuyp, Ruysdael and Orizonte. This was also noted by a German traveller, Gottfried Küttner, in his *Briefe über Irland*, published in Leipzig in 1785.[2] As we mentioned in chapter 4, an example of such a largely Dutch collection which survived until recently is that formed for a local landowner, Charles Cobbe,[3] by Matthew Pilkington, the rector of Donabate and, later, the author of *A Dictionary of Artists*.[4] This *Dictionary* was the first of its kind in English, but unfortunately it mentions only a few artists who were Irish or worked in Ireland, Gaspar Smitz, Charles Jervas, James Gandy and James Worsdale. Pilkington's promiscuous wife was closely involved with the latter.[5] Others, such as George Barret, were introduced in later editions after their deaths. This taste in Ireland for Dutch and Flemish art was reflected in Irish landscape painting, though naturally there were exceptions, and Italian influence can be seen in a number of works, especially in the productions of the artist scene painters and those who studied for some years in Italy.

A Waterford family of landscape painters were the Carvers, father and son. The elder, Richard, died in 1754. He had practised in Dublin as a landscape painter, but also painted an altarpiece for his native town. A landscape of gentlemen fishing and shooting (Fig. 162), probably dating into the 1740s and signed 'R. Carver' is no doubt by this Richard and is an amalgam of undigested influences – Dutch, Flemish and Italian. Its interest lies in the fact that it is not topographical and yet not wholly ideal, for it is peopled with contemporary sportsmen, who seem interlopers in this romantic scenery. Elrington Ball, in his history of Howth Castle,[6] noted overdoors by Richard Carver in the drawing-room, which are no longer there. His son, Robert Carver (*c*.1730–91),[7] studied under his father and under Robert West at the Dublin Society Schools. He had a distinguished career as a scene painter in Dublin, more in Crow Street than in Smock Alley, where he succeeded John Lewis in 1757.

One of his famous sets was for *A Trip to the Dargle*, produced first in Crow Street in 1762 and again with a newly painted set in 1768. Carver painted an 'Astonishing Effect of the Representation of the Waterfall at Powerscourt'[8] which had become a major tourist attraction. For instance Emily, Countess of Kildare wrote in 1762 that 'the stage set of the waterfall was the prettiest thing I ever saw, much beyond that at the opera and so like that at Powerscourt, that you actually fancy yourself in the very place'.[9] Later, around 1769, Carver went to London at the invitation of Garrick and worked for him and Spranger Barry at Drury Lane and Covent Garden. His 'Dublin Drop'[10] for Drury Lane was, according to Edward Dayes,

> a representation of a storm on a coast, with a fine piece of water dashing against some rocks, and forming a sheet of foam truly terrific; this with the barren appearance of the surrounding country, and an old leafless tree or two, were the materials that composed a picture which would have done honour to the first artist, and will be remembered as the finest painting which ever decorated a theatre.[11]

From the description, it appears like a Vernet pastiche, and elsewhere Dayes described 'His style of landscape ... like G. Poussin's grand, with great beauty of touch ... His colouring is warm'.[12]

Many of the works now attributed to Robert Carver are signed only with initials, 'R. C.', and full signatures are rare. The initialled paintings are mostly dated to the year 1754, early in his career; presumably,

162 Richard Carver, *Landscape with figures*, Ulster Museum

163 Robert Carver, *Pastoral Scene*, signed and dated 1754, oil on canvas, Private collection

George Lambert. Carver could easily have seen the French and Italian painters in Dublin collections, if not in originals, certainly in copies. His *Arcadian Landscape with Travellers and Herdsmen in the Distance*, signed 'RC' and dated 1764, is a Claudean essay with a humid atmosphere.[14]

Before he went to London, from 1765 he exhibited at the Free Society's exhibitions there and seemed already to have been thinking of moving, which he did about 1769. Eventually, he became the Free Society's President in 1777. By then, it had been superseded in importance by the RA, where he also exhibited. He may have worked in Vauxhall Gardens, as his name appears on an engraving of Peter Monamy's *Sweet William's Farewel to Black Eyed Susan* which decorated one of the supper-boxes. But if Carver was employed there, it was probably only in a minor capacity.

His similarity to Butts is quite noticeable in some landscapes, as in *The Lake Landscape with Pyramidal Mausoleum*[15] and in others he comes close to Thomas Roberts. He had several Irish pupils, two noted as scene painters, Henry Hodgins (*fl.* 1762–96) and Samuel Whitmore (1770–1819), who succeeded Carver at Covent Garden, and James B. Coy (*fl.* 1769–80), whose works are rarely seen but who painted mostly in Co. Wicklow. He must have promised well as a scene painter, as Strickland says Carver asked him to go to London with him but he refused. Coy who attended the landscape and ornament School about 1768, won a Dublin Society premium in 1770, and besides studying under Carver, he also worked under George Mullins, from whose house in 1769 he sent a landscape to the Society of Artists, where he exhibited between 1769–74. His work resembles Thomas Roberts quite closely, as can be seen in *An Irish Riverside Landscape*, 1774 (Fig. 164). Another dated 1776, shows a romantic Irish landscape with a ruined church, a castle by a lake and a horse by a rutted road.[16] He died from a chill caught when working for Lord Altamont at Westport, Co. Mayo, where he had been painting new mills developed by his patron.[17]

John Butts (*c.*1728–65), who came from Cork and was the pupil of an otherwise unknown painter, Rogers. Butts came to Dublin in 1757, where he worked as a scene painter in both Crow Street and Smock Alley. It is perhaps not surprising that it has been difficult to identify him, as apparently he worked as a forger. Pasquin says:

as he became more occupied in the theatre, he had less time to paint easel pictures. The landscape in the NGI[13] is a typical product, rather drily painted and without much atmospheric quality. He attempted purely Claudean landscapes, such as *A Pastoral Landscape with Classical Ruins and Figures* of 1754 (Fig. 163). None of his easel pictures show the suggested verve of his scene painting, but they have one advantage: once seen, easily recognized. One can see the influence of Gaspar Poussin and the English painter

he became acquainted with Chapman the picture cleaner … These inconsiderate associates occupied the same roof, but had a partition, which bisected the garret into two separate apartments; and an aperture was made in it through which a tankard or jug could pass. Butts sat on one side, producing gems of art, while Chapman, to please an ignorant employer, was mutilating, by rubbing and daubing, the productions of the best masters, on the other. The jug or pot was handed incessantly through the

hole to each while any liquor remained; and, when that failed, they jointly quitted their labours.

James Barry, who was taught by Butts, saw him in a different light. He wrote, on hearing of his death, to a friend in Cork, Dr Sleigh,

> I am indeed sensibly touched with the fate of poor Butts ... who with all his merit never met with anything but cares and misery, which I may say hunted him into the very grave ... His being bred in Cork excluded him from many advantages; this he made evident by the surprising change of his manner on his going to Dublin; his fancy, which was luxuriant, he confined to its just bounds, his tone of colouring grew more variegated and concordant, and his penciling, which was always spirited, assumed a tenderness and vivacity[18]

Apparently, apart from landscapes, Butts painted alehouse and genre scenes, coach panels and inn signs. Despite his various occupations, he died in great poverty in 1765. The only drawing now known by him is a beautifully smudgy, soft chalk study of trees (NGI), very poetic and Claudean in character, and it echoes Barry's words. We suggest that he may have worked for Delamain's delftware factory in Dublin, where such elegant landscapes sometimes formed the decoration of plates. A few are signed 'J. B.'.[19] Until recently, many of his works were misattributed but enough can now be identified by signatures, usually on the back of the canvas, and one by a copy. The latter, a panorama of the city of Cork (on loan, Crawford Art Gallery, Cork; Fig. 165) was attributed to Grogan until a copy of a drawing signed by Butts, now lost, identified it.[20] It was dated 1760 and entitled *Butts' View of Cork from Audley Place*. It is close in execution to van der Hagen but topographically like Chearnley's panorama of Cork in Smith's *History of Cork* of 1750. A view of the *Harbour at Kinsale* (NGI) with carefully delineated houses and shipping, which like the *View of Cork*, used to be attributed to Grogan, is clearly another Butts.[21] A tree, painted with Butts's sometimes bobbly leaves, forms the left side.

Other pictures include a signed landscape dated 1760 (Fig. 166). The signature appears in Latin on a tomb and, translated, reads as follows: '*Into the hands of the shades, John Butts of Cork in Ireland, painter, designed and made this in Dublin in the year 1760 on the ides of April, aged 32*. The landscape has buildings and ruins on the right, and in the foreground there are four figures, two dressed only in loincloths by another tomb and two, a man and a woman, pointing with staves towards the sky. The buildings, which perch on the edge of rocks, are very similar to another signed work of less interest, which is a pure landscape with fishermen and has the same stepping-up Italianate ruins. The rocks are a typical feature in Butts's work: they have striated cracks and are lumpish looking, as though pieces were about to break off. It appears that Barry was incorrect

in saying that Butts's earlier work is the more 'luxuriant'; though this painting has lighter and more feathery trees, other later works return to lushness.

The final certain work is a rocky landscape with a label on the back saying that it is the last work by Butts. It has beautifully delineated trees, but they are not feathery and it is similar in feeling to his drawing. It has two plump figures on the ground, Dutch in character, which are very close to a number of other works, particularly his finest attributed work, *The Poachers* (Tate Britain). This is a view inspired by the Dargle gorge, with two fat figures in the foreground wearing felt hats. They are poaching fish and hiding behind rocks, watching a gentleman shooting. It was originally attributed to Barret and it would seem highly likely that they would have known each other in the small artistic coterie of Dublin in the mid-century.

164 James Coy, *Riverside Landscape*, signed and dated 1774, oil on canvas, Private collection

165 John Butts, *View of the city of Cork*, oil on canvas, on loan to the Crawford Art Gallery, Cork

166 John Butts, *Into the hands of the shades*, oil on canvas, Private collection

167 George Barret, *Landscape with rocky arch*, before 1763, oil on canvas, Royal Dublin Society

The rocks are painted in Butts's very individual manner and the figures, as we have said, are also typical and in no way like the work of Barret.

Another painting attributed to Butts is illustrated in Grant[22] (Dúchas, Emo Court, Co. Laois) and dated 1761. This is peopled with the same type of fat figures with round felt hats. In both pictures, the foliage is luxuriant and the rocks in the Dargle are in his usual blockish manner. The Grant picture has great variety in its foliage and is reminiscent of the treatment of woods in early seventeenth-century Flemish landscapes. A smaller variant of this picture is in the NGI. A number of other attributed works show Butts's concern with rock work. One possible case, another picture previously attributed to Barret,[23] includes the rock arch used by Barret and taken by both from Claude's *Perseus and the Medusa, the Origin of Coral* which is based on Claude's love of the Neapolitan coastline. They will have known this work through engravings or copies, either drawings or in oils.

By far the best-known Irish landscape painter was George Barret, whose birth date is variously reported as 1728 and 1732. He died in 1784. Barret used to be designated as a poor follower of Richard Wilson who, it is said, described his rival's foliage as 'Eggs and Spinnage'.[24] This attitude is partly the result of a lack of knowledge of Barret's early Irish work, which establishes that he was already a completely developed painter before he came to London. Barret was not intended originally to be an artist. He was apprenticed to a stay-maker and later coloured prints before going to the Dublin Society's Schools under Robert West, winning a first prize in 1747. In that year, he signed and dated a stiff wooded landscape which gives little indication of his later manner. Other examples of the unexpected variety of styles he used in his youth are the series of panels and overdoors from Russborough, Co. Wicklow, depicting Italianate landscapes and Roman ruins, now mostly in the NGI.[25] Michael Wynne[26] has discovered that three of them are direct, enlarged copies of gouaches by a minor Italian called Giovanni Battista Busiri, bought by Joseph Leeson on his first Italian trip in 1744. Some Roman views may be inspired by the four Paninis bought by Leeson on his second trip to Rome in 1752. Other versions of famous works of art made by Barret in these early years were two paintings after Claude, one of *Tivoli* and one known as *The Mill*, of shepherds dancing.[27] These belonged to Samuel Madden, one of the founders of the Dublin Society Schools where Robert West, the headmaster, kept a large number of drawings and engravings. These Barret 'Claudes' are of remarkable quality and have a verve which is unusual in copies. But the palette is unlike Claude and indicates that they were made from engravings. Sometimes he merely quotes from Claude as in the view of the rocky arch near Naples (Fig. 167) which has always been in the Society's collection and must

168 George Barret, *Italianate wooded river landscape*, signed and dated 1755, oil on canvas, National Gallery of Ireland, on loan to Farmleigh

therefore be an early work. More surprising is a painting of superlative quality, dated 1755, showing him painting in the Zucarelli style, with enchanting peasants walking in a sunlit landscape (Fig. 168). Another of the same type dated into the 1750s, the last figure being unreadable, has a lake and waterfall and in the foreground a couple resting. However, the airy rococo quality seen in both these works changed long before he went to London in 1763 and Strickland is probably right in saying that he came under the influence of Edmund Burke, while the latter was an undergraduate at TCD.

Burke would have noticed Barret's prize-winning work when it was exhibited in the Parliament House, just across the way from Trinity College and, though not published till 1757, his essay, *A Philosophical Enquiry into the Origin of our Ideas of the Sublime and Beautiful*, was largely written while he was a student and it certainly influenced the young Barret considerably. Some of the ideas expressed in it appear in Burke's letters to his schoolfriend, Richard Shackleton; for instance, his reaction to the Liffey flood of 1746, when his father's house was under water to the first floor, shows a clear disposition in favour of the sublime and the terrible. Burke says: 'It gives me pleasure to see nature in those great though terrible scenes. It fills the mind with grand ideas, and turns the soul in upon herself.'[28] These ideas would obviously have encouraged an artist to paint romantic scenery, and it is also said that Burke introduced Barret to the second Viscount Powerscourt. Whether this is so or

not, Barret was working early in his career in the Powerscourt demesne, which includes some of the most romantic reaches of the Dargle Valley and the famous waterfall itself. The *View of Powerscourt House under the Sugar Loaf Mountain* (British Art Center, Yale) is in its lower half a purely topographical portrait, while the upper half is a highly romanticized view of the Sugar Loaf Mountain. Barret's *Powerscourt Waterfall*, of which there are a number of versions probably all painted before 1763 (one in the NGI, a second in the Limerick Art Gallery, the third in the UM, a fourth in the Walker Art Gallery, Liverpool and a fifth in a private collection; Fig. 169), is comparable to Wilson's *Lydford Waterfall* of 1771–2[29] (National Museum of Wales), which may well be influenced by it, as a Barret of *Powerscourt Waterfall* was exhibited in the Society of Artists in London in 1764. This picture may well be the last example we listed as it may have been inspired by an article in *Faulkner's Dublin Journal* of 13 July 1762, which gives a very accurate description of the thatched octagon room, the kitchen with all its accoutrements nearby and the bridge over the stream, and a detailed description of the waterfall, the trees and rocks, also mentioning the lower part of the Dargle river which Barret painted and also engraved (BM). The hexagonal pavilion in the Dargle view is also roofed with straw. The anonymous author of this detailed and poetic account ends with a clarion call 'where is the Author who can describe, or the pencil,

or the colours that can paint them?' Barret seems to have taken up this challenge.[30] Barret's foliage in these pictures is heavy and becomes heavier in his dramatic view of the Dargle gorge (Fig. 170). In this, a red-coated gentleman forms a centre point to the setting sun through the trees and its reflection on the rocks. In Matthew Pilkington's *Dictionary of Painters*, first published in 1770, he notices in a later edition that Barret 'had two decided manners of painting, both as regard to colour and touch; the first was rather heavy in both, his latter much lighter'.[31] These pictures of the Dargle gorge and the Powerscourt waterfall are two of Barret's finest works. They are early paintings, probably commissioned by Lord Powerscourt, who was the waterfall's owner. A brilliant summary of the Powerscourt scenery with the south front of the house far away in a sunlit background (Telfair Academy of Arts and Sciences, Savannah, Georgia), gives an unusual panoramic vision of the sublime Wicklow scenery and is an early appreciation of nature. Another set of three Irish scenes were painted for the second Marquess of Rockingham, to whom Burke was secretary. Until recently, they were at Coolatin, Co. Wicklow, Rockingham's Irish seat. These views have a similar panoramic quality, with beautiful sunset effects and heavily delineated trees. In one of these, a ruined tower house, heavy with ivy, is included; he had been employed to draw these early remains, as a copy after him of Killtimon Castle, Co. Wicklow survives in

the Royal Irish Academy. Another early landscape, *A Mountainous View with a Waterfall* has a group of ruins with an Irish round tower in the background, a choice of scene which becomes typical later in the century with Thomas Roberts. It has a beautiful atmospheric effect with a fine tree silhouetted against the evening sky. A further view, *A Lake Landscape with Figures*, which is based on Wicklow scenery, may well have been painted in England, as Wicklow was always in the forefront of his memory.[32]

Besides the *View of Powerscourt House*, he painted a number of straight topographical scenes such as Beaupark and Ballygarth Castle, both in Co. Meath; CastleRoche, Co. Louth; and Castletown, Co. Kildare, which Lady Kildare mentions in a letter of 7 December 1762. She writes to her husband from Castletown, 'Lord Powerscourt, Mr. Marley and Barret, a landscape painter, have been here; the latter is painting views of this place, which by the by, is too flat ever to make a pretty picture'.[33] The painting still survives and in comparison to the Wicklow scenery shows the artist 's inspiration was not engaged. Barret was never at his best in house views.

Strickland suggests that Barret left for England after the failure of his attempt to issue a set of engravings of his Dargle views, which he advertised in 1762 and which were never published as a set, though one which we have just mentioned remains in the British Museum.[34] In fact, he left in 1763, as, on 19 February of that year, he is described as 'of the city of Dublin, Landskip painter'[35] in a document giving power of attorney in connection with some Dublin property.[36] His next few years are well documented in Barry's *Works*, where Barry quotes from their correspondence. In one letter he wrote to Barret in 1765, he urged him to visit Paris, as it would be no more expensive than going to North Wales,[37] indicating that Barret was already a regular visitor there. Barry also mentions a view of Snowdon he knew before he left England in October 1765.[38] Barry had seen Barret's premium-winning landscape at the Free Society's exhibition in London, in 1764, and had said of it that he had 'seen nothing to match it', compared Claude to it unfavourably because he preferred Barret's skies and continued:

> Barret presents you with such a glorious assemblage, as I have sometimes seen amongst high mountains rising into unusual agreeable appearances, while the early beams of the sun sport themselves ... through the vast arcades and sometimes glances on a ... great lake whose ascending vapours spread themselves like a vale over the distance.[39]

This description could well apply to a number of North Welsh views by Barret, but particularly to the *Llanberis with the Early Morning Mists Dispersing*. Its loneliness and sublimity are accentuated by the fact that no human figure appears, only a couple of Welsh mountain goats. He varied the atmosphere in these scenes so that, in direct contrast to this almost oppressively brooding study, he shows nearly the same view with a brilliant sunrise in a landscape (1777, Castle Museum and Art Gallery, Nottingham) and a thunderstorm in another. The Nottingham landscape includes sportsmen with their horses waiting for a ferry, painted by his collaborator Sawrey Gilpin. It is an airy view, as opposed to the tumultuous clouds and lighting in the thunderstorm. Barret's understanding of North Wales must be due to his early appreciation of similar Irish landscape and he is therefore in the forefront of the discovery of the Welsh picturesque view. For instance, Paul Sandby only visited the area for the first time in 1770 and, apart from Richard Wilson, a Welshman, who was painting Wales with an Italianate eye, Irish painters such as Barret painted it much earlier than Sandby, (who is sometimes regarded as a pioneer in this romantic genre), because it was where they landed on their way to London.[40] Wilson's famous *Snowdon from Llyn Nantlle* (Walker Art Gallery, Liverpool), probably of 1766, makes an interesting comparison with Barret's *Llanberis*. Both, with very different approaches, achieve the similar atmosphere of remoteness and they must date from much the same period.

Writing to Barry, Edmund Burke said in 1767 that 'Barret is fallen into the painting of views. It is the most called for; and the most lucrative part of his business. He is a wonderful observer of the accidents of nature'.[41] Though this resulted in some humdrum paintings, such as the park at Welbeck, Nottinghamshire, with its

170 George Barret, *The Dargle river*, oil on canvas, Private collection

extraordinary oaks, in 1765–6 and the Burton Constable, Yorkshire, views of 1777, his commissions from Lord Dalkeith, later fourth Duke of Buccleuch, in 1769 were more fruitful. This set includes several of mountain scenery in Dalkeith Park, with its rocky river and charming thatched cottages. Barret's ability to paint water is notable in the river view and can also be seen in two of the three Coolatin landscapes previously mentioned as commissioned by Lord Rockingham. The lowlands of Scotland and the Lake District must again have reminded Barret of his native scenery and brought out the best in his work. The views of the lakes include some of his most appealing oils and gouaches. The picture of *Windermere Lake, Early Morning*, 1781 (Fig. 171) is notable for its beautiful cloud formations and the mists hovering over the lake being dispersed by the early morning sun, as Barry had mentioned in his letter to Burke of some sixteen years earlier. Another large canvas (Eagle Star Offices, London) is an evening view with fishermen in which the reflections shimmer in the water. The sun forms an arch which the clouds are slowly enveloping. In a gouache of Ullswater, also dated 1781, a charming detail is the picnickers with their horse and tent. The gouaches have strong blue tones highlighted with white and are often as much genre subjects as landscapes. For instance, the two in the NGI show haymaking and carting timber. The rococo figures and animals in these scenes make it strange that Barret should have found it necessary so often to collaborate with Sawrey Gilpin, Reinagle and Cipriani.

Burke, in his letter to Barry, says that Barret 'does not even look at the pictures of any of the great masters, either Italian or Dutch',[42] but this was not true. At least one storm scene attributed to Barret (NGI) exists, which is said variously to be after

Salvator Rosa, Marc Antonio Sardi and Orizonte and at any rate suggests the common eclecticism of the period.[43] In an undated letter which we have already quoted in chapter 4, Barret is clearly writting to a young artist friend in the Lake District. Barret recommends looking at a Rubens landscape, a Hobbema and a Claude and keeps reminding his friend: 'paint from nature not forgetting art at the same time – study effects as much or more than mere outlines. Do not be engrossed by any one master so as to become a mimic'.[44] His debt to other artists is plain to us, including a knowledge of Netherlandish painters such as Ruisdael and Wynants. One beautiful, typically Dutch landscape shows a sandy path in the foreground, where an exquisite Gainsborough-like milkmaid in a straw hat is being ogled by a gentleman while she collects her charges. Yet another of a rustic bridge over a rocky river (National Trust, Anglesey Abbey) is in the Pillement manner. It is a dramatic composition and, with its ruins, one of the finest pair of paintings executed by Barret.

Among Barret's patrons was Sir Peter Byrne, an Irish baronet and the father of the famous collector, the first Lord de Tabley. It is recorded that Sir Peter entertained both Wilson and Barret under his 'hospitable roof'.[45] Clearly, Barret was well patronized, but he seems to have been unbusinesslike and was frequently in financial trouble. It is very difficult to get at the truth, as the accounts of the money he earned are so conflicting. Dayes states that 'it was reported that at the time he failed, he was in receipt of two thousand pounds a year; though at the same time, poor Wilson could hardly get a buyer',[46] and William Sandby mentions that he was paid £1,500[47] for three pictures painted for Lord Dalkeith. The latter sounds

like idle gossip and is probably the figure paid for all the Dalkeith Barrets, which number fifteen, though four are by his son, George Barret Jr. The Portland accounts show that he was paid £724 between 1765 and 1773, the most expensive bill being £168 for a pair of general views of Welbeck Park.[48] The Burton Constable views seem at first to be cheap, at three pictures for £50, though some of these were sketches and he had £63 expenses for the journey from London.[49] But this money was 'on account' and as other views were painted for which no bills survive, it may not be the total sum. In a letter from Barret, dated 8 July 1775, he quotes for 'a half-length 35 guineas, the other 2ft 5ins is known as a threequarter. Which is 15 guineas, I have painted Pictures from 10ft down to 5ins.'[50] Burke, in 1767, mentions that he had a 'little country house. His business still holds on ... However he has had the ill luck to quarrel with almost all his acquaintance amongst the artists, with Stubbs, Wright, and Hamilton [presumably Hugh Douglas Hamilton]; they are all at mortal war, and I fancy he does not stand very well even with West'.[51]

None the less, in 1768 Barret became a founder member of the Royal Academy, with the establishment of which he was intimately involved. But, according to Edward Edwards,[52] he was bankrupt when he was commissioned around 1780 to paint a room at Norbury Park, Surrey (Fig. 172), for William Locke. Though this may be incorrect as, according to Farington, Locke paid his debts before he moved to Paddington about 1772.[53] Locke may have been involved with Barret in some other transactions at this time connected with houses in Dublin on 24 November 1772, when his Dublin property was bringing in £70 a year.[54] The room at Norbury Park was considered by all as his masterpiece and shows a panorama of the Lake District. A watercolour study for this is in the Courtauld Gallery. Even Farington, the pupil of Barret's rival, Wilson, admired it, saying, 'the lake scene (an evening) is very ingeniously executed, much

172 George Barret, *Room in Norbury Park*, oil on canvas, Private collection

superior to the other parts',[55] but because of the over-furnishing of the room, the murals were difficult to see. As usual, it was a collaborative effort, as Sawrey Gilpin contributed the cattle, Cipriani the figures and statuary, and Benedetto Pastorini the sky.[56] The landscape is seen as if from a pergola summerhouse, with painted garden statues between the windows, which open on to a magnificent roll of country which carries outside the spatial effect of Barret's interior. It is an early example of such a painted landscape room and long predates Sandby's Drakelowe room of the Lakes of Killarney (V & A) of 1793.

On his appointment as Paymaster General in 1782, Edmund Burke began his association with the Chelsea Royal Hospital. He came to Barret's rescue by making him its official painter, but the artist's capabilities in this relatively humble sinecure were not tested, for he died in 1784.[57] Barret was also an etcher, and his plates, according to Edward Edwards, were bought by Paul Sandby and never published.[58] His watercolours have considerable delicacy and were justly praised by Martin Hardie, who said that they had 'a fine sense of drawing combined with fluency and quiet, graceful colour'.[59] Two watercolours are in the V & A and another, which links with his oil paintings of a *River Bank with High Rocks*, is in the collection of the British Art Center, Yale. There are sketchbooks in the V & A which indicate how well he could draw animals and his self-portrait drawing in the Soane Museum, which shows him seated painting. Also in the Soane Museum is a beautiful study of a garden where the individuality of the varied trees is remarkably handled. His son, George Barret Jr, was a noted watercolour painter, but his career belongs exclusively to the history of English painting, as do those of his elder son, James, and his daughter, Mary, who were also painters.

One of the problems in assessing Barret's work is the quantity of very poor pictures attributed to him. Some may very well be by him as, if he earned £2,000 annually, he must have painted an enormous number of pot-boilers. There are, for instance, many Claudean scenes which bear his name and are usually less interesting. From the unquestionable pictures, it would appear that the dense green foliage and autumn tints (Wilson's 'eggs and spinnage') typify his earlier style. A newspaper cutting of 1775, referring to an unspecified picture, rightly points out that his strength was in painting water, when the author says, 'The Water Fall amongst the rocks in this piece, has a very sublime effect, in opposition to the gloom which surrounds it'.[60] Another contemporary, Joseph Pott, remarks that 'every tree he paints is distinctly characterised'[61] and Luke Herrmann points out that Barret's landscapes are topographically and botanically more accurate than Richard Wilson's.[62] Farington records a conversation with Edmund Garvey on 14 February 1804, when Garvey said that 'the popularity of Barret's pictures caused Wilson to change His manner in some degree for a *vivid and gay colouring*'. Farington did not agree.[63]

But there may well have been influence in both directions. In Barret's late works, he thins out the trees, which become much more wispy, as though he felt the need to compete with Wilson in the Italian manner. Otherwise, his work is essentially devoted to British and Irish scenery and weather, unlike Wilson, whose English or Welsh paintings are often confusedly Italianate. As he said of himself, he was a 'Landscape Painter, who wishes to exhibit the sublime parts of Nature'.[64] However, it must be stated quite unequivocally that, though Barret has a very important position as one of the forerunners of romantic landscape painting, he is no match for Wilson at his best, whose genius far outstrips him. Wilson was only half right in foretelling that 'depend upon it you will live to see my pictures rise in esteem and price – when Barret's are forgotten'.[65] The latter are once again beginning to be justly recognized.

Barret never went to Italy, but none the less, in the mid-century and after, there was a considerable Irish coterie in Rome, composed of sculptors, painters, antiquarians and dealers. Their names include John Crawley, sculptor, who lived there from 1750 to around 1759; Robert Crone, from 1755 to 1767; James Forrester, from 1755 to 1776; Matthew Nulty, the antiquarian, from 1758 until his death in 1778; Solomon Delane, from 1764 to the late 1770s; Christopher Hewetson, the sculptor, from 1765; James Barry from 1766 to 1770; Edmund Garvey mid 1760s and again in 1792–3; Matthew William Peters, from 1762 to 1764 and 1771 to 1775; and Thomas Hickey, from 1762 to 1767. A fascinating passage in James Martin's manuscript journal[66] of his grand tour, 1763–5, for 10 July 1764 states that 'Mr Crone, Mr Delane and Mr Forrester the only persons from our Part of the World who practise Landskip Painting are All Irish'. They were joined later by Hugh Primrose Dean and, seven years later, Father Thorpe, in a letter of 6 November 1771, says that 'Mr Dean, Delany and others here have their admirers and each a considerable share of merit in the landscape way and perhaps superior to any of the three or four Italians who have excellencies in the same branch'.[67] It is worth noting that Martin's three Irishmen were all, like Barret, products of the Dublin Society Schools, which was obviously as successful in teaching landscape drawing as it was with pastel and produced this remarkable early flowering of landscape painting in the mid-century. However, Dean, Delane and Forrester were censured by Philip Hackert 'for slavishly aping the styles of Gaspard Poussin and Claude instead of referring directly to nature'.[68]

Robert Crone (c.1718–79), a pupil of West, Hunter and Hussey, to whom he was related and who sent him to Italy in the mid-1750s, is recorded in Rome by Hayward[69] in 1755. In 1758, when he was living with Matthew Nulty,[70] his age is given as forty in an entry in the Stato delle Anime.[71] Details of his years in Rome are given in Ingamells,[72] where it appears that he col-

lected prints, drawings and pictures for other grand tourists. He studied in Rome under Wilson for about a year and various Wilson drawings are now attributed to him, examples being a landscape in the British Museum and one in the Ford Collection. These have been reattributed to Crone because of their stylistic similarity with *The Good Samaritan*, a drawing signed 'RC' which was in the Iolo Williams collection. There are several studies for this picture and an oil painting of it is in the art gallery in Dundee, but it is in poor condition. The earliest painting we know is a *View of the Forum*,[73] signed and dated in Rome[73] in 1759, which is a composite view of Roman ruins in the typical grand-tourist manner. A drawing of the same subject with the Arch of Constantine on the left is also known. His drawings, according to Edward Edwards, are often in black-and-white chalk on blue-grey paper[74] and though we know none in this medium, the drawings we know remain his most attractive works.

Edward Edwards says that he suffered from epilepsy and had a seizure when up scaffolding, copying in the Barberini Palace,[75] and he was described as 'the little crooked Irishman' mentioned in a letter from Richard Dalton to Lord Bute in March 1759[76] and said to be a promising landscapist. He apparently left Italy in 1767, where he had painted views of well-known places in and about Rome. He had completed two pictures for James Grant of Castle Grant which had been begun by John Plimmer but were left unfinished at his death.[77] Crone had collaborated with Plimmer during his lifetime, as a *View of the Bay of Baia* is signed by both artists and is part of a set by Jacob More dated 1783 and 1784, commissioned by Jonas Brooke (originally at Mere Hall in Cheshire).[78] Crone's drawings are similar to Plimmer's, who was also a pupil of Wilson. Crone sent two landscapes to the Society of Artists in London in 1768, and in 1770 he sent 'landscape and figures' to the Society of Artists in Ireland, all from a London address. He also exhibited some twenty-six landscapes in the Royal Academy. They were usually described as Claudean and were mostly of Italian subjects. The only picture of a London subject now known is in the Iveagh Bequest, Kenwood, and is a view of London from Highgate of around 1777.[79] The left half of the picture is devoted to cottages and laundry being hung out to dry. The picture originally belonged to Benjamin Booth, a major patron of Wilson, to whom the picture has long been attributed, but has been given to Crone by David Solkin. If we accept as autograph *A Lake in Italy*, illustrated in Grant,[80] this reattribution seems wholly plausible. In another entry in Martin's journal, for 6 July 1764, he mentions visiting Crone's studio and seeing two pictures which were 'bespoke by Mr Dalton' for the King, though they are no longer in the Royal Collection. One was of '*The Bay of Baia with Vesuvius in the Perspective*'. Martin sums him up thus:

Mr Crone is very clever in his Profession and must have great natural Genius … He has chiefly studied Claude Lorrain and I believe is reckoned to have a good Deal of his Manner. His chief Defects are, a too great Niceness in the small Parts of his Works as the Leaves etc; and somewhat a little unnatural in the Colouring; He is a most excellent Drawer of Landskip of which he has done several for the King [Presumably the one in Windsor is the sole survivor of these]. They have a remarkable soft mellowness in them whch. is very pleasing. He is Irish and does Honour to his Country not only as a fine Painter but as a very honest Man.[81]

The second of the three Irishmen was Solomon Delane (*c.* 1727–1812), also known as Delaney or Delany. In Strickland's own copy of his *Dictionary* (NLI), there is a long letter giving particulars of the Delane family which states that the artist's father was a clergyman from Co. Tipperary. Probably the clergyman was his grandfather and his father was a Dublin clothier.[82] He was educated at the Dublin Society Schools under West, winning a premium in 1750. His only known early work is, surprisingly, a portrait of the comedian Isaac Sparks, which he etched in 1752. Nearly all his later work appears to be in landscape. He was in Rome from August 1755, when his arrival is mentioned by Hayward. Ingamells records intermittent encounters in Rome, Vicenza and Leghorn. He was in London in 1763 when he was elected a Fellow of the Society of Artists, where he continued to exhibit until 1776. He also showed in Dublin, sending *A Land Storm* to the Dublin Society of Artists 1766 exhibition. He was in Rome again in 1764. In 1763 he had sold four views of Tivoli to Lord Hope.[83] He also visited Sicily and possibly even Athens, as there is an undated engraving called *Athens in its Present State of Ruin*, and a picture with the same title was exhibited in the Society of Artists in London in 1773. This is presumably identical to one of the same title used as an overdoor in the library of Ralph Willett, the bibliophile, at Merly in Dorset, where Wilson and Charles Reuben Ryley also worked.[84] All these decorations have disappeared. Delane was still in Italy in early 1769, when mentioned by Barry.[85] In 1770, Father John Thorpe compares him with Forrester, saying that Delane 'contends with him for excellence and … is much more expeditious in his work. I know of no one in Rome who is equal to either in this kind of painting.'[86] On 15 May 1771, Father Thorpe remarks that 'Delany talks of going soon to England', but wonders if he will have 'resolution enough to abandon the charms of Rome'. A cool Claudean landscape signed and dated 1777 (NGI)[87] is a typical work.[88] It shows his distinctive clear, linear style and one would agree with James Irvine, who in February 1781 found his colouring 'a little too cold' and thought he painted 'rather in the manner of Poussin'.[89] He was apparently still in Rome 1778, when 'Delany in Rome' sold two pictures at Christie's.[90] According to Strickland, he was in Augsburg in 1780 and in 1782 sent two views of the Alps to the RA, where he exhibited between 1771 and

1784. He returned to London in 1782. Contemporary
sources tell us a lot about his pictures (Fig. 173); for
instance, James Martin[91] lists a *Dido and Aeneas in the
Storm* for Lord Ossory, a *Lake Albano* for Mr Bouverie,
and, in the sale at Christie's in 1778, he sold *The
Coliseum by Moonlight* and *The Campagna with Aqueduct of
Quartus Sixtus*, both of which may have been bought by
Lord Buckingham.[92]

Four splendid landscapes done for the fourth Duke of
Rutland, when Lord Lieutenant in Ireland from 1784
until his death in 1787, indicate that Delane was back in
Ireland at this time. From a manuscript account book,
the artist was paid £68 5s. 0d. in 1787 for two of them,
a *View of Dublin from the Magazine*, a fine panorama, and
a *View of the Phoenix Park from the Royal Hospital*.[93] Two
further Dublin views complete the set. He exhibited
very rarely after this date. In the Parliament House
exhibition in 1802, he showed a *Thunder Storm* and a *View
of the Arno*, and in 1812 in the exhibition in Hawkins
Street he showed a *View of Tivoli*. Other landscapes
appear occasionally in the London sale rooms and there
is one in Aston Hall, Warwickshire. These are usually
Claudean Italian views with a golden light, but James
Byres is recorded as having *A Landscape with Macbeth and
the Witches on the Heath* in his collection.[94] There are a
number of references to him in John David La Touche of
Marlay's Dublin diary[95] between 1794 and 1796. They
were apparently close friends, dining and walking
together. Delane is a painter of considerable interest,
but still too few pictures by him are known.

Martin's third Irishman was James Forrester
(c.1730–76), who is listed by Hayward as working in
Rome by 1755, and in 1758 he is noted in the Stato delle
Anime as living in the same house as Louis Gabriel
Blanchet and Carlo Mariotti.[96] He had been trained in
the Dublin Society Schools, where he won premiums
and, in 1752, first prize for drawing. The Ulster
Museum's drawing of *Powerscourt Waterfall*[97] must date
from before 1755 and be an early work. When he went to
Rome, he worked not only as a painter of Claudean
views but also as an etcher, signing in 1760 the fron-
tispiece to Peter Stephens's *150 Views of Italy*, published
in 1761. Among his patrons were the Duke of
Gloucester,[98] Lord Arundel,[99] Lord Shelburne[100] and
Lord Bute.[101] He specialized in painting moonlights and
mornings and two huge examples of these, dated 1766,
bought in Rome by the fourth Earl Fitzwilliam in 1767,
survive. They show his great skill in handling unusual
light effects. The first of the pair, entitled *Landscape with
monks by Lake Nemi* (Fig. 174), shows the moon reflected
in the lake with the cowled Capuchin monks and classi-
cal portico catching the moonbeams with a haunting
effect. The second of the pair is entitled *Figures by a
torrent in a stormy wooded landscape* (Fig. 175) and shows
lightning snapping a limb off a tree while others are
thrashed by the wind. Of three figures in the fore-
ground, one appears to be injured or dead and two are
horrified by the incident. The picture has borrowed
much from Wilson's *The Destruction of the Children of
Niobe* and Poussin's *Landscape of Pyramus and Thisbe*.[102]

174 James Forrester, *Moonlit landscape with monks by Lake Nemi*, oil on canvas, Private collection

175 James Forrester, *A stormy wooded river landscape*, oil on canvas, Private collection

Another peaceful view in Italy with a sarcophagus and three contemplative Capuchin monks in the foreground has a receding view from a lake to mountains in the extreme distance and is signed and dated 1772. Forrester's work is by far the most original of the Irish Roman landscape painters and we agree with Father Thorpe's view that 'His [Forrester's] excellency principally lies in grave and solemn scenes of nature'.[103]

Two recently attributed drawings executed in Italy of a waterfall and a hermit in a forest scene have an unusual intensity. The trees and staffage are complicated and yet brilliantly and precisely handled,

176 Hugh Primrose Dean, *Rest on the Flight into Egypt*, oil on copper, Private collection

making us think of German landscape painting. There are two drawings by him in the V & A; one, *The Waterfall at Terni*, which makes an interesting comparison with his earlier and less assured *Powerscourt Waterfall*. Another drawing, *Ariccia*, in the Ford collection, links with a virtually identical painting illustrated by Grant[104] as by Peter Stephens. However, judging from the photograph, it could just as well be by Forrester. Grant also illustrates another view which he attributes to Forrester, *The Ponte Sisto*, Rome.[105] All the drawings are finely composed in Indian ink and bistre washes, heightened with white on buff or grey paper; the three drawings in the V & A and the Ford collection all come from the amateur artist, the first Earl of Portarlington, who was an important Irish patron. Forrester worked as a dealer and is recorded as teaching Sir Watkin Williams Wynn to draw.[106] He was a friend of Timothy Collopy (*fl.* 1777–1810),[107] a Limerick painter who was also in Rome at this time. An altarpiece by him of the *Ascension* survives with the Augustinian Fathers in Limerick. It is too badly damaged and overpainted to be assessed.[108] An enormous amount of information exists about Forrester in the letters of Father Thorpe, with whom he was living when he died, late in 1776. On his memorial stone in Santa Maria del Popolo (now disappeared), the translation of the Latin inscription read: 'James Forrester from Dublin / eminent in the skills of painting pleasant things / here lies'.[109] It is a pity so few works survive.

Another close follower of Wilson, according to Colonel Grant, was Hugh Primrose Dean (*fl.* 1758–84), by whom there was a pair of pictures, *Morning* and *Evening on Lake Albano* in Christie's in 1922.[110] Grant illustrates another view of Lake Albano dated 1778.[111] All these are on a small scale and are all clearly Claudean. Another small roundel on copper, signed and dated 1770, shows *The Flight into Egypt* with the Campagna in the background (Fig. 176).[112] A dramatic oil with classical buildings behind and an obelisk strikingly illuminated by the storm and entitled *The Tempest*[113] is on a larger scale and seems to us to be much closer to the colouring and excitement of Forrester than what we know of Dean. This underlines the close companionship of the Irish group in Rome. A fine, delicate chalk drawing of the Colosseum (NGS) is an addition to his *œuvre* and two engravings of *Vallombrosa, near Florence* and *The Sepulchre erected to the Memory of the Horatii and Curiatii* have the same precision.

A northerner from Co. Down, Dean was later in Cork, where he married and may have studied, possibly under Butts. He was in London by 1765 and exhibited there in the Society of Artists between 1766 and 1768. From London, he appears to have travelled along the Elbe and Danube, as well as to Italy, where he was sent by his patron, the second Viscount Palmerston. He arrived, according to Father Thorpe, in Rome in 1770, after visiting Naples.[114] He was commissioned to copy the Altieri Claudes for Mr Walters in 1771[115] and a great deal of information about this work is in Father Thorpe's letters, where he is described, on 15 January 1774, as being 'mad in his prices; if not less so in his conduct; knocks off pictures as fast almost as a carpenter does a jointstool … his pictures are rather pleasing than fine, they always present fair weather … He cannot paint figures, they are always put into his pictures by another hand.' He achieved some distinction in Italy, as he became a member of the Florentine Academy in 1776. He painted a number of pictures of Naples and of Vesuvius erupting and made a transparency of the latter, which Edward Edwards saw in 1780 exhibited in a large room in Covent Garden.[116] Thomas Jones, who gives an extremely amusing description of Dean's life and career, finishes his account, mentioning the transparency thus:

> This, like the lambent flame of an expiring Taper, preceded the immediate extinction of his character as an Artist – After that, I heard, he commenced itinerant Preacher, And the last account I had of him was, that he sunk into the Oblivious, but useful Situation of a Mechanick in one of Our English Dockyards.[117]

The influence of Claude, Gaspar Poussin and Wilson dominates the work of these Irish landscapists, of whom Forrester stands out as the most interesting and least derivative of the group. It is an occasion for celebration that these painters are slightly better known now and other works may well come to the fore.

Landscapes, 1760–1826

Returning to the artists resident in Ireland, we find a number of landscape painters who enjoyed sufficient patronage there in the mid-century. Though they did not travel to the continent, most of them visited England from time to time. One of these was George Mullins (*fl.* 1763–75), who was educated, according to Pasquin, by Mannin at the Dublin Society Schools from 1756. After he left, he went to Waterford and, as Pasquin reports, 'worked at Mr Wise's manufactory at Waterford; and painted snuff-boxes and waiters in imitation of the Birmingham ware'. Two primitive conversation pieces of the Wyse family, painted on copper (Waterford Treasures Exhibition), with elongated figures, may have been executed later by Mullins for them. They are of particular interest as portraying a print room in one, neo-classical decoration in the other and the furnishings of the period in both. They must date from the 1770s.[1] The Wyse family had a copper mine and the paintings show Francis, John and Marianne Wyse in one painting and John by himself in his study in the other.

On his return to Dublin, it is recorded by Pasquin that he married the owner of the alehouse, The Horseshoe and Magpie at Temple Bar. In 1763, he was awarded a premium for landscape by the Dublin Society and in 1768 a second premium for a history piece. Between 1765 and 1769, he was also exhibiting with the Society of Artists in Dublin, not only landscapes but religious themes and two literary subjects, including *Cymon and Iphigène* after the story in Boccacio, a subject which had been used by Lewis nine years earlier (see chapter 3). In 1768, he painted four upright Italianate, decorative and delicately painted landscapes for the Earl of Charlemont's house at Marino (Fig. 177). Another similar work is in the NGI.[2] Later, in 1770, he sent to the RA a *View from the Gothic Temple at Morina [sic], the seat of the Earl of Charlemont in Ireland, in which is introduced the story of Diana and Actaeon*. In the Marino landscapes, which are signed works, he introduces a number of figures and

animals rather different from the genre elements which are a feature of his work, as, for instance, in the signed and dated *Fishing Party* of 1772 (Fig. 178), and in *The Bathers*. *The Fishing Party* is almost certainly the work he exhibited in the RA in 1772 as *A Cataract, a rude scene illustrative of a passage from Thompson's Seasons,*[3] *Summer*, verse 585. Walpole rightly notes his links with Poelenburgh in a comment on two works exhibited at the RA in 1771,[4] and he bought a Mullins from that exhibition.[5] However, his debt to his contemporaries Wilson, Barret and Carver is also great, not to mention the overall influence of Claude. Two charming oval landscapes by Mullins include a group of ladies bathing (Fig. 179). Mullins consistently includes nudes, male and female, in his landscapes, a trick he clearly took from Poelenburgh and which is very rarely seen in any other Irish landscape painter. The other oval shows a genre scene with his able handling of animals and the usual Claudean glow. These ovals, with other landscapes, belonged to 'Premium' Madden.

Mullins had gone to London in 1770 and stayed with Robert Carver. He continued to exhibit at the RA until his death in 1775 and apparently worked in North Wales, as he exhibited two views of Llangollen, one of which may show a view of Sir Watkin William Wynn's seat, Wynnstay, in the background.[6] A work signed and dated 1773, showing peasant figures and cattle with a mountain and a country house in the background, might be one of these. A picture of a probable North Welsh view with peasants and horses and two elegant figures beneath a wooded hill, with a particularly delicate handling of trees done with dark, cool colours, is a typical example of his work. It is signed but not dated, though it would appear to us to be a late work.

Mullins also exhibited a few portraits and was clearly good at animals; apart from the excellent cows in Lord Charlemont's four pictures, he showed a *Spaniel Dog* at the RA in 1772 which was engraved in that year.

177 George Mullins, *Italianate landscape painted for Lord Charlemont* (one of a set of four), oil on canvas, Dúchas, the Heritage Service

178 George Mullins, *Fishing party*, oil on canvas, Ashmolean Museum, Oxford

An artist possibly called 'Mullins' in 1773 painted the grisaille panels which are set into the ceiling of the saloon at Chirk Castle, Denbyshire for Richard Myddleton. Their subjects are mythological or classical. Croft-Murray suggests that they are by George Mullins, but we feel they are a little crude for him, and that the name may have been misread. He introduces a

light and airy atmosphere into his canvases not found so often in Barret. Though he painted in North Wales, he is not particularly interested in the 'sublime'. His early death put an end to a promising and varied career.

Robert Carver had one pupil who achieved some prominence, Edmund Garvey (d. 1808),[7] who came from Kilkenny and spent most of his career in England. He was educated in Italy, where he studied in the mid-1760s, and returned there in 1792–3.[8] A number of panoramas of Rome, one dated 1792, and a view of Lake Albano with Castel Gandolfo, dated 1770,[9] are known. The latter must have been painted on his return to England and may be his RA picture of 1771. He worked in Bath for a decade, from 1768 to 1778, where he was a friend of Gainsborough. One of his more attractive works is a panoramic view of the town (Bath Preservation Trust), of which we know two versions.[10] The pastellist John Warren wrote to Andrew Caldwell, Lord Bessborough's agent, from Bath on 14 March 1776: 'Mr Garvey I find a very sensible, friendly fellow, and I can assure you that he has great Merit, he seems to me to be very knowing in Effect as he principally attends to it in all his Pictures, he has now in his House five or six which might be hung up anywhere'.[11]

Though a few Irish landscapes, from the Giant's Causeway to Killarney, indicate that he must have returned from time to time to Ireland and travelled extensively, according to Strickland only two certain visits to Ireland are known, in 1784 and in 1796.[12] There was a view of Trim Castle[13] in the Hugh Lane collection which has his often-used trick of silhouetting cattle in the foreground. There are two panoramas of Kilkenny and one of Waterford (Fig. 180).[14] The Kilkenny picture shows the castle, rows of little houses and St Canice's in some considerable detail. Another view portrays the New Bridge with St Canice's in the background, but the architecture is not very well drawn. He was an intimate of Farington, who mentions him frequently in his *Diaries*. Garvey, when talking to Farington, said that he first came from Ireland to England before Barret had arrived and it must therefore have been about 1762–3. At that time he added 'Marlow and Wilson were very popular *among artists*' and that he was captivated by Marlow more than Wilson, though he had now changed his mind.[15]

He had considerable success in England, exhibiting 126 paintings, many of the continent, in the RA, and becoming its secretary during a particularly turbulent period. Two good examples of his work are at Saltram, *Views of the Crabtree Lime Kilns* (NT, Saltram House, Devon). Perhaps the best picture known to us is his *Smugglers in Portland Island*, exhibited in 1808 in the RA. This study of cliffs and rocks was, tellingly, once considered to be by Marlow.[16] He was a somewhat dreary painter, summed up by William Sandby as 'working in the Wilson style in a neat, dry manner'.[17] Strickland quotes Pasquin, writing in a source we do not know, as saying about Garvey that he was 'a Royal

Academician whose qualifications are, if possible, more doubtful than any of his compeers'. We would agree with both these estimates.

Irish painting in the eighteenth century reached its high point in the landscapes of Thomas Roberts and William Ashford, whose works were, to a large extent, exhibited at the Society of Artists in William Street, Dublin from 1765 to 1780. Their quality was underlined by the condescending traveller, Richard Twiss, who remarked about the exhibition of 1775, 'I saw an exhibition of pictures in Dublin, by Irish artists; excepting those (chiefly landscapes) by Mr Roberts and Mr Ashford, almost all the rest were detestable'.[18]

Thomas Roberts (1748–78), the most brilliant and shortest-lived Irish landscape painter of the second half of the eighteenth century, was connected with Mannin, Mullins and Butts, as he was taught by all three. He entered the Dublin Society Schools as a boy in 1763, when he would have been taught by Mannin, and in the same year he also obtained a prize. He was given premiums on several other occasions, in 1768, 1772 and 1777. Presumably after he left the Schools, he went on to work under Mullins as an apprentice, a natural choice, as Mullins was then working in Roberts's home town of Waterford. He followed Mullins to Dublin when the latter married and he gave Mullins's address when he exhibited in 1766–8. Mullins was then running his wife's pub and Pasquin states that while he studied under Mullins, he [Roberts] acquired his pocket money 'by painting the black eyes of those persons who had been fighting and bruising each other in his master's tap-room on the preceding evening'.

A pair of pictures seems to have been painted by Mullins and Roberts together; one of the Dargle at Bray by Mullins; its pair, of Enniskerry, also near Bray, by the young Roberts (NGI). Despite Roberts's youth, the latter picture is much softer and more delicate in treatment and altogether more competent than the Mullins, which is more cursory. There are, of course, many simarlarities between them. The Sugar Loaf scene includes a white horse, which becomes something of a trade mark in Roberts's work. Pasquin adds to the remarks we have already quoted that 'he was improved by Butts', though no details are given and we cannot tell how this came about. Pasquin thought that Roberts 'gained more reputation as a landscape painter than any other Irishman'. At this early stage, he worked for the Antiquarians, as a very poor drawing after him of the Castle of Dunmow exists in the RIA, and there are two drawings after him of Slane Castle, one by Beranger, one from the Austin Cooper Collection. There is, too, a drawing after Roberts of Ballyshannon[19] and this may have been commissioned by William Burton Conyngham of Slane, who made an important collection of antiquarian drawings. Roberts's oil of Slane Castle, seen at some distance from the River Boyne, is a more con-

179 George Mullins, *Oval landscape with women bathing*, oil on canvas, Private collection

180 Edward Garvey, *View of the Quay at Waterford*, oil on canvas, Private collection

ventional topographical view. It forms a contrast to his more romantic and picturesque landscape of Beauparc just up the river from Slane. This shows Roberts's portrayal of trees and rocks at their finest.[20]

By 1766, Roberts was exhibiting at the Society of Artists and seems to have made a name almost at once. Between 1766 and 1773, he exhibited some fifty-six works and continued to exhibit until 1777, though after 1773 the numbers decline greatly and it is obvious that his terminal consumption was already taking its toll. In 1776, Roberts is recorded in Bristol and Bath where he went to improve his health. The

181 Thomas Roberts, *View of Rathfarnham*, oil on canvas, Private collection

182 Thomas Roberts, *Bold Sir William (a Barb) and an East Indian black*, 1772, oil on canvas, Private collection

works, though placing the castle in the middle distance is typical. But unlike his later interest in half-lights, it shows a sunny day and the genre scene in the foreground is unusual. The thatched cottages, slipe (two solid wheeled cart), cart and geese, together with the women washing in the river Dodder, make a superb little rustic vignette, forming a contrast to the great castle standing grandly in its secluded wooded park.

In the 1770 and 1771 exhibitions, there are rather dry views of Ballyshannon and Belleek (NGI) which are topographical townscapes and do not suit his talents: one wonders if a pupil was involved. We have mentioned the drawing of Ballyshannon. In the same exhibitions, he showed a number of pure landscapes, where his main interest lay. He clearly looked at Dutch pictures and at Vernet, for one of the exhibited works, *A Seastorm*, is entirely in the Vernet manner. In these same years, he showed two horse paintings: in 1771, no. 48 is described as *A Landscape from Nature, in which is introduced the portrait of a Mare.&*., and in 1772 he showed the *Portrait of bold Sir William (a Barb)*, *an East Indian black, and a French dog, in the possession of Gerald Fitzgerald Esq.* (Fig. 182). The latter has recently been identified[23] as the painting from the Carton collection which has been called, from the label on the frame, *Lord Edward FitzGerald's negro servant, Tony and his white pony*. If the latter subject was correct, then the picture would have to date from after Roberts's death and it has therefore been attributed to his brother, Thomas Sautell Roberts. The attribution to Thomas Roberts seems most likely because of the high quality of the work both in the landscape and in the treatment of the horse, which is close to that in other certain pictures by the elder brother. It is our opinion that the picture is not of Lord Edward's Tony.

This picture indicates that Thomas Roberts must have been a very fine horse painter and animal painter in general, confirmed by two pictures of a horse, cattle and sheep in the British Art Center, Yale collection formerly attributed to Charles Towne. They are a cleverly contrived pair, with convoluted trees and rocks forming a frame to the landscape. Another group of mares and a foal similar in style is signed and dated 1773.

It is not possible from the existing known works by Thomas Roberts, roughly forty in number, to deduce much stylistic development, though some of his paintings have a hazier or lighter touch, perhaps due to overcleaning. Roberts's paint surface is incredibly delicate, his foliage handled almost as though he were a miniaturist, and this agrees with the description of his character given by Pasquin, when he says 'there was an elegance and a gentleness in the manners of Mr Roberts'. He also tells us that Roberts had 'a pulmonary complaint' as a result of what is commonly termed 'good fellowship'. In 1778, he went to Lisbon for his health and died there the same year.

His patrons included the Duke of Leinster, Viscount Cremorne, the Earl of Ross, Earl Harcourt when he was Lord Lieutenant between 1772 and 1777

pastellist John Warren, whom we have already mentioned, writing from Bath to Andrew Caldwell on 22 July 1776, says that 'On hearing through my Father that Roberts was come to Bristol I went there to find him so emaciated that he shocked me severely but have great pleasure in acquainting you that he has already rec'd great benefit' and goes on in detail to discuss his illness and cure and concludes that among all the painters of landscapes that he has seen in the British Isles, he thought that 'Roberts exceeds any'. This is indeed considerable praise.[21]

Roberts's earliest surviving exhibited works are a view of *Rathfarnham* (Fig. 181)[22] of 1769, and a *Frost Piece* of the same date, which we will discuss later. *Rathfarnham* has many features not seen in his later

and the Veseys of Lucan.[24] Roberts frequently painted series of views, such as the brilliant sets of Carton Park, the lake at Dartry, and the exquisite series of the house and grounds by the Liffey at Lucan (NGI).[25] These show Roberts's love of half-lights, figures taking an evening walk by the river with the long shadows indicating the approaching darkness. They also show water painted with great skill, both the turbulent effect of a weir and the quiet beauty of the still flowing stream in other areas. The topography of the old Gothic house, soon to be replaced by the late eighteenth-century Palladian villa, the tower house, the cottages and bridge are minutely observed; it is the best handled of his architectural views. Two paintings commissioned by Harcourt, one with a romantic castle dominating a luxuriant valley, which are of exceptional quality, still belong to one of his descendants and the earl may have introduced Roberts to English patronage. Certainly, in 1775 Roberts was paid by Sir Watkin Williams Wynn for two pictures for the staircase of his new Adam house in St James's Square. The pictures are still *in situ*, inset into upright panels. He was paid £52 10s. 0d. for the pair and described in the bill as 'Mr Roberts of Dublin'.[26] However, he might as easily have been introduced by Mullins, who, having painted around Wynnstay, presumably knew Sir Watkins Williams Wynn. One of these two uprights, an unusual form for Roberts, includes the remains of the abbey of Castle Dermot, with a ruined church and round tower in the background, which is also a feature of one of the Harcourt pictures. The other Wynn picture shows a waterfall on a windy day, with a man walking up the hill clapping his hand to his tricorn hat, which is typical of Roberts's lively observation of nature, and his figures have the enthusiasm of the *Post Chaise Companion* – the most popular guidebook of the period.

Some Bellisle views of Lough Erne show the admiration evoked by an Irish natural and landscaped demesne by its dramatic lakeside setting (Fig. 183). There were four scenes exhibited in the Irish Society of Artists in 1770 and 1771, of which three show a hunting scene and one has two yachts and a tent by the lake with two elegant figures taking a walk. The long horizontal landscapes with low horizons are remarkably similar to the work of Joris van der Hagen,[27] a seventeenth-century Dutch painter working in the style of Koninck (see chapter 5). The colouring and composition of Joris are strikingly similar to this series by Roberts, and he must have seen his work.

Roberts's appreciation of the blue distances, the soft changing light and tree-begirt castles and mountains of Ireland, together with the now fashionable antiquarianism of the period, make his paintings some of the most nostalgic and evocative ever painted of the country. The Harcourt pictures admirably sum up these moods, as does the large, mountainous landscape in the NGI. The minute, crisp technique which he employs for his trees is aptly described by W. B. Sarsfield Taylor, who says, 'He pencilled in his foliage beautifully'[28] and it contrasts with the softer warmth of his rocks. His depiction of water, in a very marked degree, gives to his pictures the vaporous atmosphere typical of Ireland. A large painting, signed and dated 1774,[39] *A Windstorm*, shows a tumultous waterfall with peasants on a road and rustic bridge (Fig. 184). Another *Landstorm* was exhibited in 1769 and could be the one we illustrate. The tremendous force of the wind thrashing the trees dominates this picture. It forms a brilliant contrast with a recently discovered, totally still frost scene (Fig. 185), most probably the one exhibited in 1769 in the Society of Artists of Ireland. William van der Hagen had painted a winter landscape which has similarities

183 Thomas Roberts, *Belleisle, a hunting scene*, 1770/1, oil on canvas, Private collection

184 Thomas Roberts, *Landscape with waterfall and rustic bridge*, oil on canvas, Private collection

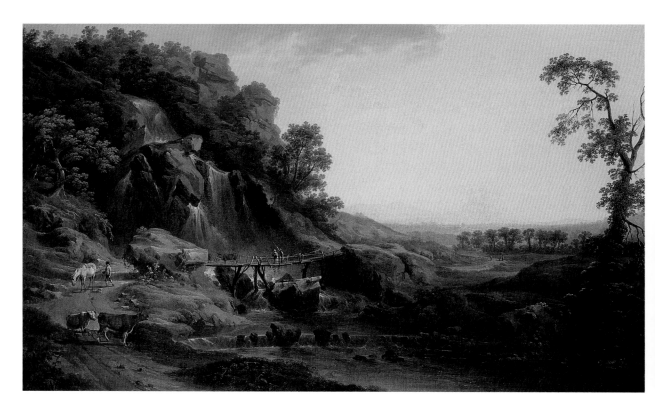

with Roberts's work.[30] Roberts's picture sums up the freezing atmosphere of the dead winter landscape. A group of cottages, with icicles hanging from the thatch, form the background for a gentleman out shooting with his dogs and servant and a cart driven by a man with a flock of sheep. A bearded, hatted, elderly hermitlike figure walks off to the left. The sportsman is frozen stiff, clasping his arms in the cold, and even the dog's breath is carefully painted. It shows considerable Dutch influence, but is an Irish masterpiece.

A late series are the four views of Carton, three of which were exhibited in the Society of Artists between 1775 and 1777. They show the pride of the Leinsters in their landscape gardening with *The Bridge over the Rye Water*, designed by Isaac Ware. This, and the one of the Leinsters about to cross the river in a boat (Fig. 186), are the two best of the set. It is fascinating to see the changes they had made to the formal layout depicted by van der Hagen and also to see the small, newly planted trees and shrubs which have today reached their maturity. The view of the bridge shows a group of horsemen in the middle distance and nothing interrupts the composition of this Elysium. The Leinsters are prominent in the foreground of one of the others and two gardeners sweat away rolling the gravel paths, giving us a close-up of the park. It is tragic to realize that Roberts was dying when he painted these landscapes, and he was a major loss to Irish painting.

Reviewing Roberts's *œuvre*, one cannot but be impressed by the variety of his work, from stormy drama to quiet, pellucid lake and river scenes with Irish ruins in the background. His figures and animals, his delicate trees, his shafts of sunlight and his storm clouds are all brilliantly portrayed. He is unfortu-

nately virtually unknown outside Ireland, though he should figure prominently in the annals of European landscape painting.

Roberts's work was engraved by John Milton, who used two of his pictures in his *Collection of Select Views from the Different Seats of the Nobility and Gentry in the Kingdom of Ireland*. Milton came to Ireland in 1783 and between then and his departure for London in 1786, he issued a number of plates. The remainder date from 1786 to 1793 and were issued in London on his return. William Bell Scott in his *Autobiographical Notes*[31] says that 'Milton had a unique power for distinguishing the foliage of trees and the texture of all bodies, especially water, as it never had been done before, and never will be done again'. A glance at his engraving of Roberts's *View of Beauparc from the river Boyne* illustrates his remarkable ability to maintain the character of an artist's work. These plates were the most important advertisement of the splendours of the Irish landscape and not only propagated the knowledge of a number of Irish artists, but also immortalized Francis Wheatley's stay in this country.

Another artist who contributed a number of plates to Milton's work was William Ashford. In fact, Ashford, Wheatley and Barralet were probably the only landscape painters of merit resident in Ireland that Milton could have employed, as Thomas Roberts had died in 1778, Barret lived in England from the early 1760s, Carver went there in 1769, Mullins died in 1775, the young Thomas Sautell Roberts was a mere beginner, and Jonathan Fisher was publishing his own sets of aquatints from 1770 and was therefore working in direct competition.

187 William Ashford, *A Flower Piece*, 1770/71, oil on canvas, National Gallery of Ireland, Dublin

Ashford (1746–1824) was to become the leading landscape painter working in Ireland in the late eighteenth century. He was born in Birmingham and despite his long Irish residence, some sixty years from 1764, his straightforward topographical views, with their suggestions of lush, well-cared-for farmlands and parks, retain a distinctly English quality when compared with the much more romantic subjects chosen by his Irish-born contemporaries. He rarely tackled the waterfalls and mountain scenery, the lakes or the romantic, misty distances that were the stock in trade of most Irish landscape painters. He was happiest as the painter of the country house, its surroundings, its owners and their civilized pastimes. Even when he attempted the wilder aspects of nature, he tamed them into something approaching ordered neatness. One exception is his painting of *A Thunderstorm*, 1780 (Birmingham City Art Gallery), a favourite eighteenth-century theme which was used later as an illustration to one of the Dublin schoolmaster Samuel Whyte's poems, published in 1795.

Precisely why he went to Ireland aged eighteen to become Clerk to the Comptroller of the Laboratory section of the Ordnance is not known, though he was presumably acquainted with Ralph Ward, the newly appointed (1763) Surveyor General of the Ordnance. The Marquess of Kildare, later first Duke of Leinster, had been appointed Master of the Ordnance in 1761 and it was he who appointed Ward and was to become one of Ashford's important patrons. Pasquin says that 'he was appointed to a lucrative situation in the ord-

nance office'. It was perhaps hardly 'lucrative', as he was paid, according to the *House of Commons Journal*, £40 per year as a clerk.[32] It was presumably not a full-time post, as a fellow employee, Thomas Ivory, who earned £60 as Clerk to the Surveyor General, was at the same time in charge of the Architectural School at the Dublin Society and a practising architect. Ashford seems to have continued to be employed in the Laboratory division until about 1788. His name was not included in the list of Ordnance employees in February 1789, when his post was left unfilled.[33] His work involved going round Ireland, inspecting the armaments stored at the various barracks and forts. His expenses in the year 1765 survive in the *House of Commons Journal*,[34] the largest amount recorded being in March, when Ashford was paid £38 'travelling Expenses … to examine the Arms of the Army at the different Parts of this Kingdom'. This was quite good training for a landscape painter at a time when travel was not that common. A number of lively, sketchy, pencil drawings, some with wash additions clearly made when touring, are known, depicting places in West Cork and Limerick. In the sale of his pictures after his death, 'Field Studies' are mentioned, so many others may one day appear. In the Aldborough papers mention is made of him sketching Stratford and Baltinglass 'for painting from'.[35] It seems probable that once he had established himself as a painter he may well have paid an assistant to do the routine work in checking armaments, a common enough practice in the eighteenth century.

When he went to Ireland, Ashford appears to have been untrained as an artist, and it was not until 1772, eight years later, that he was first heard of as a landscape painter. He had started exhibiting in the Society of Artists in Dublin in 1767, but as a flower painter (Fig. 187), and in 1770 and 1771 he exhibited pictures of fruit and dead game. Four of his early flower pieces are known (one in the NGI).[36] They are very attractive and delicate paintings with the main bulk of the flowers broken up with trails of jasmine and honeysuckle receiving the attentions of butterflies, snails and insects in a thoroughly Dutch manner. The student quality of the works is easily seen in the very weak painting of the vases. Though Ashford was never a pupil at the Schools, he may well have attended some evenings as the Duke of Leinster was a patron of the Schools and would certainly have encouraged him.

As we have suggested, Ashford's interest in landscape may well have been aroused by his work in the Ordnance and, like other artists, he no doubt copied engravings and the works of other artists. One example is known. A painting of Gibraltar by Ashford was painted for Sir John Irwin, C in C, Ireland, 1775–82, from a sketch by the cartographer and antiquarian, Colonel Vallancey, a senior officer of the Ordnance Office in Dublin.[37] By the late 1770s, Ashford was an extremely competent landscape painter, with an admirable feeling for trees, though his

distances are still not very effective. When he first exhibited a landscape in 1772, he won the second premium from the Dublin Society, and in 1773 he won the first. There is a comment on his landscape exhibited in the RA in 1775 which indicates that his promise was recognized early. It says: 'We don't remember this artist's name before in any exhibition; notwithstanding this, he is so far from being a novice in his profession, that if he is young and attentive, he may well expect to reach the first form in this department of painting.'[38] He had aspirations to be a history painter, since one of his works, dated 1777, was entitled *A Rocky Coast with Mercury and Argus*. He tried subject-picture landscapes again later, but they clearly did not sell, as both his *Jacques Contemplating the Wounded Stag* (Fig. 188), (first exhibited in the London Society of Artists in 1790), *Celia and Orlando* (first shown in the RA, 1795) and *Cephalus and Procris* were exhibited by him more than once in his lifetime.[39] His only painting of a topical event is a genre scene of the *Opening of Ringsend Docks*, of 1796 (NGI, Fig. 79),[40] where the boats both large and small fill the water by the dockside where the Lord Lieutenant is just discernible amid a throng of onlookers, knighting the Chairman of the Court of Directors of the Grand Canal Company, John Macartney.

Ashford's imaginary landscapes were much appreciated, for the writer of *A Critical Review of the First Annual Exhibition of Paintings … of the Works of Irish Artists*, held in June 1800 in Dublin, said, when commenting on such a composition of a sea coast:

> The picture is grandly designed; the parts are few, ample and dashed in with all the fire of a broad, certain and rapid pencil. The front grounds and catching lights are not rich in colour … but the want of greater warmth is sufficiently attoned for by a Ruysdael-like beauty and solemnity in the general keeping, and by the Artist's fancy and hand appearing to flie together in the creation of this truly capital performance.[41]

This impassioned praise gives some idea of the esteem in which Dublin held him at this time, and accounts for the remarkable fact that he should have been elected the first President of the RHA in 1823. It was a signal honour for a landscape painter at a time when landscape was still regarded as the Cinderella of painting. This is especially true since so much of his work was unassumingly topographical and made little or no attempt at the grand manner. The exalted position of portraiture is underlined in the unpublished diary in the RIA.[42] An anonymous author, when writing about the 1801 exhibition on 6 July 1801, said that it consisted 'almost entirely of portraits; in fact had the artists practising in Ireland, inclination, ability and sale for compositions, portraiture is at present so much the rage, that they have not leisure for any other branch of study'.

188 William Ashford, *Jacques and the wounded stag*, 1786, oil on canvas, Private collection

189 William Ashford, *View of Killarney with the passage to the upper lake*, oil on canvas, Tryon Palace, New Bern, N.C.

190 William Ashford, *Dargle Valley*, oil on canvas, Royal Hibernian Academy

Wales, as he exhibited five north Welsh views in the Society of Artists in London that year, as well as a landscape of Henley-on-Thames. Strickland says that, when in London, Ashford held an exhibition with Dominic Serres. No catalogue for such a show exists, but on 22 and 23 April 1790, Dominic Serres's son, J. T. Serres, sold a number of his own pictures and paintings which belonged to him, before he went to Italy. To these were added works by 'some of the most admired and esteemed Masters', including Ashford. The catalogue[44] is of great Irish interest as, besides those by Ashford, works by Barret, Roberts and Carver were included, and it is evident from it that J. T. Serres had made a tour in Ireland, for he included landscape views in both Dublin[45] and Waterford and two morning and evening views of Dublin Bay from Blackrock looking across to the Hill of Howth, of which there are various versions. These have fishermen dragging up boats and nets, which are almost identical to figures found in Ashford's, such as his *Shane's Castle*. These motifs were the stock in trade of Joseph Vernet. Ashford included five pictures in this sale, and general views of scenery in Killarney (Fig. 189) and Wicklow – not his usual country houses, which must normally have been commissioned. A surprising title for Ashford was lot 98, *Lions and Leopards in a Landscape*, suggesting that he was attempting to emulate Stubbs.

Not many sea pieces by Ashford are known today, but from the titles he exhibited, they were among his popular subjects, especially later in his life. The critic in 1801, when commenting about one sea-coast scene of *Conway Castle*, says that 'it is injured by an equality of tone in the skies, grounds and distances, and by the general predominance of a grey tint'[46] and describing a view of Dublin Bay, he repeats, that it 'is rendered unpleasant by a predominant, grey tone'.[47] These remarks could well apply to the NGI's *The Royal Charter School, Clontarf, Co. Dublin*[48] This is too grey in tone and not even the usual figures in the roadway enliven it enough. There is no doubt that Ashford's real skill lay in trees. The Charter School itself is handled adequately, though in his earlier works he had found buildings a problem. His ruins at Maynooth, for instance, painted in 1780, are not really convincing and look more like a stage backcloth. In his early landscapes, the figures are usually stock rural herdsmen and shepherdesses, taken directly from Dutch examples, as in the earliest surviving landscape, dated 1777, but later he introduces real genre elements into his scenes with great success, enlivening them with carriages, carts, beggars, fishermen, gardeners, haymakers and all the figures which he must have seen around him in the vicinity of Dublin. A fine example is further afield, *View in Co. Sligo, with Cummin House in the background*,[49] signed and dated 1784, and another, a *Group of Tourists visiting the Ruins of Cloghoughter Castle* (on loan, Wood collection, University of Limerick), shows the popular enthusiasm for antiquarianism of the time.

Ashford probably visited England several times during his career. In 1777, he gave both a Dublin and a London address when he sent pictures to the Society of Artists, and he gave English addresses to the RA in 1789, 1804, 1805 and 1811. He seems to have spent most of 1789 and 1790 in England, after he left his Ordnance appointment. According to a letter he wrote on 3 March 1785, he was proposing to go to England in that year. Interestingly, he mentions Milton the engraver, regarding arrangements for transporting pictures.[43] He must have travelled through north

For his principal patrons, the landowners, he

usually seems to have made a series of pictures, as he did for the seventh Viscount Fitzwilliam of his estate at Mount Merrion near Dublin, now in the Fitzwilliam Museum, Cambridge; for the first Earl of Charleville, of the grounds, river and the Gothic dairy at Charleville Forest; and for the second Duke of Leinster, of Carton, Maynooth and Frascati, to name only a few which are still known. The unknown diarist[50] saw the Charleville series, one of which is in the NGI, at the exhibition of 1801.[51] The diarist noted on 6 July that 'There is here abundant scope for an exertion of the artist's genius in the delineation of foliage. The articulation is perfect and the colouring so beautifully rich, and various, that I could with pleasure have spent hours viewing them.' This quote would also apply to his masterly painting of the Dargle which follows in Barret's footsteps (Fig. 190).

Ashford painted all over Ireland: there are views of Shane's Castle, Co. Antrim; Castleward, Co. Down; Kilkea, Belan (the seat of his friend Lord Aldborough) and Moore Abbey in Co. Kildare; Muckross Abbey in Co. Kerry; and other Killarney views, one with tourists stepping out of a boat. None the less, the majority of his work is from the Dublin area (Fig. 191). There are several versions of his views of Dublin from the Phoenix Park, including the large pair in the NGI,[52] which were commissioned for Earl Camden, Lord Lieutenant from 1794 to 1798. They were justly popular.[53] Though the Charleville series are dated, and some of the Mount Merrion pictures are as late as 1804, it is possible that there was a slowing off in the

commissions after the Act of Union of 1801. W. B. Sarsfield Taylor says that from 1801 'until his decease (1824) ... he had received but one order, and that was from a Mr Hodges, for two pictures'.[54] This is certainly a great exaggeration, but there may have been a slackening of trade and several of the pictures he exhibited at the British Institution in 1806, 1808 and 1809 seem to have been painted earlier. Unfortunately, the catalogue does not exist, if there was one, for the one-man exhibition he gave in February/March 1819 in the Board Room of the Dublin Society's House in Hawkins Street. He wrote requesting the Society's permission to make 'an exhibition of my own paintings and drawings' on 19 January 1819,[55] but no titles were mentioned. His letter was from his home in Sandymount, just outside Dublin. His house, a small neo-classical villa which still survives, had been built for him around 1792 by his great friend James Gandon, and from it he could see the sea and the Bay of Dublin, looking across to Howth, which naturally became a favourite subject. In 1792, Ashford sold his collection of statues and models to the Dublin Society for eighty guineas. Unfortunately, there is no record in the Society of what became of them. In the same year, he showed his 'moveable room and transparencies' to his friend Lord Aldborough in February.[56]

If he painted less as he got older, the quality of what he painted remained steady. The critic in 1801 summed up the quality of Ashford's paintings: when talking of his view of Tollymore, he said that 'the union of the picture is so perfect, and it is every where

192 Jonathan Fisher, *View of the lakes of Killarney*, oil on canvas, Private collection

finished with so much solidity, judgment, and beauty, that we leave it each time with regret, and return to it with fresh pleasure, as a masterpiece fit to rank with Ruysdael and Waterloo in the cabinet of a Prince'.[57]

One of the more interesting landscape painters in late eighteenth century Ireland was Jonathan Fisher (*fl.* 1763–d. 1809). He is first heard of in 1763, when he was awarded a premium for landscape by the Dublin Society, and he later received another in 1768. He does not seem to have been a student of theirs and Strickland surmises that he was educated in England, though the source of his information is not disclosed, nor do Fisher's works show any particular English influence. However, an attributed drawing of Lymington in Hampshire (BM) indicates a possible English sojourn and he certainly returned there about 1800, as a number of watercolours survive, one dated.

He was employed by the antiquarians, copying a few earlier works for Francis Grose and Austin Cooper. He was probably born in the 1740s, as he is associated with the carver Richard Cranfield and the miniature painters James Reily [Reilly] and Gustavus Hamilton, who both worked for Samuel Dixon of embossed bird fame in property transactions in the suburbs of Dublin from 1769 to 1775.[58] He must, therefore, have been over twenty-one in 1769. Pasquin, writing in 1796, says Fisher was self-educated and originally worked as a woollen draper in the Dublin Liberties. He was patron-

ized by and was a friend of Lord Carlow, later first Earl of Portarlington, who was an amateur artist and belonged to the antiquarian set. He used to stay with Fisher when in Dublin and was a close friend of the artist, and it may have been through his influence that from around 1778 until his death, Fisher held the post of Supervisor of Stamps in the Stamp Office in Eustace Street. It was probably a sinecure. Fisher assisted Lady Portarlington with her painting when staying at Emo.[59]

He painted all over Ireland, not only issuing sets of views of Carlingford and Killarney (Fig. 192), but also making a first attempt, in 1795, at a comprehensive coverage of the scenery of Ireland in some sixty sepia aquatints which are amongst his most attractive productions.[60] He exhibited some fifty-seven landscapes at the Society of Artists in Ireland between 1765 and 1780. He gave his address as Great Ship Street throughout this period. In 1774, he married Martha Price, the daughter of a Cork merchant, but there is no record of any children. Two sketchbooks which he used from 1768 to 1770 are in the NLI. These freely handled annotated drawings relate to the two sets of paintings and engravings of Killarney and Carlingford. But they also include drawings of Cork, Waterford, the suburbs of Dublin and country houses such as Curraghmore and Mount Juliet, several of which were later worked up as oil paintings. The set of oils of Killarney exists in several versions and the engravings for the six were advertised in *Faulkner's Dublin Journal* of 5–8 November

1768. The finest of the oil set is a panoramic view of the lake and its surrounding mountains, including the little town of Killarney, Ross Castle and the great house of Viscount Kenmare, the lord of the soil.[61] The greens and browns of the landscape are punctuated with patches of golden sunlight on the cornfields in the foreground and on the distant mountains; a glimpse of the upper lake and the sky, always one of Fisher's best features, contrast with the pale blues and greys to considerable effect. Another unengraved view shows a different angle of the lower lake with the Tower House of Dunloe Castle in the distance. The foreground is dark with travellers on the road, but the sun illuminates the other side of the lake.

The Carlingford Lough[62] views were sketched in 1770 and were also a set of six engravings. Apart from the town of Carlingford itself, they include Narrow Water castle and the new road near Rostrevor on the opposite bank of the Lough. Other sets include the demesne, house and views of Strangford Lough at Castleward, where they still hang (NT); and another group is of Castle Dillon near Armagh (Armagh Museum). A most interesting set is one of four paintings of the mansion of Belvoir near Belfast (Fig. 193), which includes one view down the Lagan valley past Belfast and the Lough towards Carrickfergus. The red-brick mansion with its portico looks on a canal where a barge is being pulled by three horses (Fig. 194). Newtownbreda Church stands to the left. Another charming detail is a fishing party. In all these views, Fisher's rather knobbly handling of trees and hedges is very distinctive, and the main trees themselves are mannered and rarely naturalistic, but are used for compositional purposes. All the landscapes indicate how recently plantations had been set in the out-of-the-way countryside he favoured. Belvoir is not surrounded by a well laid-out garden and many of the trees are still quite small. It is surprising how many of Fisher's oils have survived and this may indicate an extensive practice. Certainly, he painted more than one version of his most popular views. In many ways, his drawings and aquatints have a more assured sophistication than many of his oils, which can be charmingly naïve. However, a work like the view of the upper lake at Killarney with a single tree in the foreground (NGI),[63] contradicts these remarks and has the assurance of his smaller pencil and engraved work.

Thomas Sautel Roberts (*c.*1760–1827) was the younger brother of Thomas Roberts. Christened Sautel after his Huguenot mother's family, he took, according to a niece writing in 1853, the additional name of Thomas after his brother's early death in 1778.[64] He had originally intended to follow his father, John Roberts's, profession as an architect, and had gone to the Dublin Society Architecture School. He became an apprentice of Thomas Ivory, but extricated himself from his indenture as soon as possible and this fact, plus his change of Christian name, is suggestive

that he hoped to take over his brother's practice. As he was only about eighteen when his brother died, it is probable that to some extent he learned from completing works by his brother, of which there must have been several begun but not finished, as Thomas was ill for at least five years before his death. There are a number of landscapes which indicate that this is the case, such as the *Mares and Donkeys* in the NGI,[65] which may represent this early phase in Thomas Sautel's career, in which he was either copying or finishing his brother's pictures using his precise touch but with a hard and sometimes crude detailing. There are at least two versions of this work and the animals are not of

193 Jonathan Fisher, *View of Cave Hill and Belfast Lough*, oil on canvas, Private collection

194 Jonathan Fisher, *Belvoir House with a canal in the foreground*, oil on canvas, Private collection

195 Thomas Sautel Roberts, *The Windstorm*, oil on canvas, Private collection

196 Thomas Sautel Roberts, *Landscape with violent river*, oil on canvas, Private collection

the standard associated with the elder brother or his own later career, as indicated by contemporary critics. The unknown diarist, writing in July 1802,[66] describes him as 'a very eminent artist in the portraiture of horses, dogs etc. they are generally of a small size but very beautifully finished and the anatomy (I am told) perfect'. Not one of these horse portraits has yet been identified, though they figure in numbers in his exhibited paintings. Another aspect of his work which has disappeared even more completely is his handling of

architecture in his paintings. This is remarked on by 'M' (Mulvany), in a memoir on Thomas Sautel in *The Citizen* of November 1841, where he says that Roberts' knowledge of architecture, 'although he did not like the pursuit, was of immense value to him as a painter, enabling him, whenever he introduced buildings, to give to them a proportion, and a grandeur, very imposing'.[67] Not a single architectural work survives.

Pasquin says that 'he practised in London for several years' and this is confirmed by his niece and by the titles of paintings like *Ambleside* and *The Falls of Ladore* in the Lake District, and *Watford* (near London) exhibited in the British Institution in 1816. Strickland notes that he was in London until 1799, but it seems more likely that he travelled regularly to and fro. He exhibited Irish views frequently at the RA between 1789 and 1811 and again in 1818. A signed and dated work of 1791 shows some changes in his style. The leaves on the trees are more broadly treated, as is the background mountain which closes the landscape, preventing the long misty views so loved by his brother. The foreground figures relate to another painting, a rather weak genre scene in gouache, a signed though not dated work which is clearly influenced by George Morland, then a popular painter in London.

Thomas Sautel was patronized by Lord Hardwicke, Lord Lieutenant between 1801 and 1806. On 18 December 1801, Roberts was petitioning Hardwicke[68] to allow him to exhibit drawings which he had made of Irish scenery for his *Illustrations of the Chief Sites, Rivers and Picturesque Scenery of the Kingdom of Ireland*. The exhibition of forty works took place in the Parliament House in 1802. He had issued twelve aquatints in connection with this projected folio between 1795 and 1799, but it was never completed. These exhibited views were all painted in watercolour, which seems to have been his principal medium at this time. He collaborated with John Comerford in painting the landscape for a portrait of Lord Hardwicke in the valley of Glencree in 1802. The unknown diarist described this early one-man show at length and as it is an excellent account of his watercolour styles, a subject we are ignorant of for lack of material, it seems worth quoting in full:

> This painter has two manners very widely different from each other and both faulty – one appears to be an imitation of the effect of oil, dashing careless touches, bright colours, dark shades and frequent & prominent lights, the pieces which are executed in this style, please at the first view but on a longer observance convey the idea of having been scraped and the paper by that means making its appearance – his other manner is just the reverse – softness nearly fuzzy, dead colouring, and always autumnal, browns, reds, dusky yellows and sickly olives.[69]

The latter part of this quotation also applies to the illustrated work for *The Windstorm*, (Fig. 195) which is an attribution.

A further type of watercolour is represented by his large, blue views of Irish scenery, which include a series of Lord Meath's Park at Kilruddery, Co. Wicklow one of Curraghmore, Co. Waterford and another of Celbridge Abbey, Co. Kildare, which may have faded but do not tally with the above descriptions, which in many ways relate to his oil paintings. A later critic in 1814 mentions 'the undeviating hardness of Roberts' pencil. His trees all resemble the stone fretwork of a Gothic Cathedral.'[70] This must refer to his oils as well and is an excellent description of one of his storm scenes, where the trees bent by the wind present a flowing pattern across the sky. The strong contrasts in the deep shadows and the brilliance, presumably from lightning, seem to echo the critic's words.

The critic of 1801, when speaking of a landscape, however, says that 'there might be a greater solidity in some parts, but the picture is painted with a clever Gainsborough-like sketchiness; the verdure is in a warmer tone ... the pencil is light and flowing, the leafing playing in the wind and the aerial perspective excellent'.[71] This would lead one to believe that certain lightly pencilled and hazy sylvan landscapes some-times attributed to his brother are in reality by Thomas Sautell.

Like all other Dublin landscape painters, Thomas Sautell Roberts was fascinated by 'the close scenery, such as the Dargle'[72] and 'M' adds that 'No painter ever expressed with more skill or truth the rushing of a mountain river'.[73] Two paintings, probably part of a set of five, exhibited at the RA between 1800 and 1818, show his later, freer, sparkling understanding of water (Fig. 196). One of these is in the NGI. It was, according to 'M', his love of nature which induced him to give up watercolour and turn exclusively to oil painting. Another facet can be found in an attributed picture of a night storm scene of Slane Castle, a deeply Gothic essay, which leads into the romanticism of James Arthur O'Connor and Francis Danby.

Roberts's position in Dublin artistic circles was high and, when the RHA was about to be incorporated, it was Ashford, William Cuming (1769–1852) and Roberts who were nominated as the selection committee for the first Academicians. He sent eight oils and two watercolours to the first exhibition in 1826. Unfortunately, he had been injured in a coaching accident when travelling from London in 1818 and became incapacitated before his suicide in 1826, shortly after the Academy's foundation and before the opening of the first exhibition.

A provincial painter who combined landscape, genre and decorative work, Nathaniel Grogan (c.1740–1807) came from Cork, and was the most interesting late eighteenth-century painter working outside Dublin. He was the son of a turner and block-maker. Daniel Beaufort, in his journal of 1788, notes him as 'a young painter of merit here, bred a carver – has much fancy they say'.[74] He met with so much opposition to his

artistic leanings that he enlisted and travelled to America and the West Indies in the army, returning to Ireland, according to Pasquin, towards the end of the American war. While in Philadelphia, presumably having left the army, he advertised himself in the *Pennsylvania Ledger* 31 December 1777, for 'Sign and ornamental painting, with pencil work in general'.[75] Pasquin says that 'His early aspirations had been encouraged by Butts' and he adds that 'his forte consists in an apt delineation of humorous subjects; in which he correctly represents the manners and customs of the Irish peasantry. I had seen pictures from his pencil, not inferior to Egbert Heemskirk – he has published some aqua tinter views of the suburbs of Cork, which possess great truth.'[76] Pasquin, who was patronized by the seventh Earl of Barrymore, may have come into contact with Grogan through the earl. A lively Grogan exists of Lord Barrymore driving his carriage and pair out of the North Gate of Cork.[77]

A romantic picture filled with incident, probably a fair scene, showing peasants drinking and dancing outside an inn, with a riot scene and a castle in the background, may be an early work and shows both the influence of Butts and the Dutch seventeenth century. The handling of the figures is already extremely competent. The twelve oval views of the environs of Cork mentioned by Pasquin were advertised in the *New Cork Evening Post* in 1796. They again show his interest in peasants at work. His pure landscape views in water-colour, mostly of ruins, are very romantically and freely handled, with well-delineated trees and vegetation. Some of the animals and figures in the Cork views link them with a set of four small oils[78] in a private collection in Cork. These show *The Entrance Gate*; *The Gothick Temple at Tivoli on the East Bank of the Lee*; a *View looking across the River from old Blackrock Castle*; and *The Gothick Ruin in the Grounds of Vernon Mount*. In

197 Nathaniel Grogan, *Children playing at Tivoli*, oil on canvas, Crawford Art Gallery, Cork

198 Nathaniel Grogan, *Boats on the Lee near Tivoli*, oil on canvas, National Gallery of Ireland, Dublin

the Tivoli view (Fig. 197), he treats the children playing in front of the Gothick Temple with as much sympathy as he does his peasants, and the night scene of the entrance to Tivoli, with its Temple of Vesta in the background, shows a knowledge of Dutch night pieces. His masterpiece, *Boats in the River Lee below Tivoli, Co. Cork* (Fig. 198),[79] depicts in reverse some of the architectural features of the night scene, and some of the figure groups, especially that of a straw-hatted lady riding in her solid-wheeled cart, are repeated in both. But in the NGI painting, he has mastered the placing and organization of his figure groups, the balance of his composition, and the figures themselves are remarkably well drawn. They link with the work of the English artist Henry Walton, though it is unlikely that they knew each other's work. Occasionally there are touches of Morland, but it is more in the subject-matter than in his style, which has a much broader landscape backgound to his figure groups. Strickland suggests that he was in England in 1782 when he sent four landscapes to the exhibition of the Free Society of Artists. A visit to England is possible, if the English influences we mention are accurate.

There are several straight landscapes of the environs of Cork, one of the best of which is of *Kilcrenagh at Healy's Bridge near Blarney on the River Lee* (Crawford Art Gallery), otherwise known as *Woodside*. It is signed and dated 1792; its delicately painted trees owe much to Butts, and the architecture and delightful labourers

with horses in the foreground are very well conceived. The colouring is pleasantly sunny.

The peasant scenes, for which Grogan was well known, have practically all disappeared since Strickland's day. The two principal survivors, from the Earl of Listowel's collection, both painted on panels, may be identical with, or variants of, two listed by Strickland, *The Itinerant Preacher* and *The Wake* (Figs 199, 200). Both are dated 1783 and are satires of Irish country life and full of vivid portrayals of country folk, with their dark, thatched rooms filled with little figures; their debt to Dutch seventeenth-century peasant interiors is obvious. The two oils must be the most important paintings of Irish life of the period in existence. The liveliness of the preacher gesticulating and prating away while his audience laughs, chats and sleeps – one even picks his nose – and the children play, is highly amusing. The other shows the corpse laid out with candles around the tester bed in the background and in the foreground children play games while the oldies gossip around the huge hearth. The mezzotint of *The Country Schoolmaster* is another example of this genre, as is *The Bantry Bard*.

From loan exhibitions, it becomes clear that Grogan painted a great variety of subject pictures, including two illustrations to Fielding's *Tom Jones*, a drawing possibly for a Shakespearean subject, and a curious *Allegory of Desire*.[80] None of these show him at his best, while illustrative work, such as the frontispiece to R.

199 Nathaniel Grogan, *The Itinerant Preacher*, oil on canvas, Private collection

200 Nathaniel Grogan, *The Wake*, oil on canvas, Private collection

201 Nathaniel Grogan, Ceiling painting of *Minerva at Vernon Mount*, oil on canvas, Private collection

A. Milliken's *The Riverside*, *A Poem*, published in Cork in 1807, shows a masterful rustic composition with a woodcutter, a sportsman shooting, a mill and romantic ruins in the background.

A decorative scheme in Vernon Mount, done for the notorious Sir Henry Hayes of abduction fame, was, as far as we know, Grogan's only essay in mural painting. In the upstairs lobby there are simulated niches containing *trompe-l'œil* gods alternating with urns, no doubt influenced by the work of de Gree, whom we discuss in the next chapter, and van der Hagen. The ceiling in the drawing-room depicts *Minerva throwing away the spears of war* (Fig. 201). Her other hand points to the rainbow, symbolic of hope, being painted by one of the many attendant putti. This decorative attempt[81] shows the painter struggling with the problems of *sotto in su* perspective.

A *risqué*, crudely painted small oil on copper, *The Sausage Maker*, is an essay in alehouse humour. This type of picture was probably done by one of Grogan's sons, Nathaniel or Joseph, who both worked as artists. Another, which may have been begun by the father, of *Whipping the Herring out of Town, a Scene in Cork*, is a particularly interesting genre scene with many figures portraying this unusual Cork Easter custom commemorating the end of Lent.[82] Little is known about the sons, but one of them taught art in Cork and visited country houses nearby as a teacher.[83] Strickland suggests that they copied their father's popular subjects, though *The Sausage Maker* is certainly not an edifying example for their young pupils.

A group of landscape painters in watercolour should be mentioned at this point, though we make no effort here to chart this large and interesting subject in any detail. Thomas Walmsley[84] (1763–1806) was born in Dublin, the son of an English army officer, and he earned his living as a scene painter both in London and in Dublin at Crow Street. Most of his life was spent in England, where he painted his *Carisbrooke Castle*, but he returned to Ireland in search of picturesque material from time to time. He published aquatint views of Killarney, Co. Kerry from 1795 onwards and overbright gouaches of Irish scenery are common. James George Oben[85] (*fl.* 1779–1819), whose real name was O'Brien, was a product of the Dublin Society Schools, gaining a medal for landscape in 1779. Though he visited England in 1798, he was back by 1801. The Unknown Diarist wrote on 6 July when he saw Oben's work in the exhibition held in the Parliament House in that year:

> This artist though long much esteemed in Dublin, was not at the opening of the exhibition recollected by any one. The pieces of O'Brien had often been admired, but Oben had never been heard of, at length it was discovered that the idea of foreign workmanship being preferred in the London market, had induced him to Germanize his ci-devant appellation.[86]

In 1809, he held a one-man show in Dublin, exhibiting seventy landscapes. A watercolour of the *Rock of Fennor on the Boyne* (RA 1811), in the Ulster Museum, shows his minutely detailed style. He left for London soon after the exhibition and sent works to the RA from 1810 to 1816.

John Nixon[87] (*c.*1750–1818) may not have been Irish, but he worked as an Irish factor and merchant in London and paid many visits to this country, working for Francis Grose on his *Antiquities of Ireland*. He was a friend of Rowlandson, and Nixon's caricatures and figures owe much to him and Isaac Cruikshank. A splendid *View of the Cove, Cork*, 1794 (V & A) shows all the busy activity of the port during the French wars. These painters are very valuable from the point of view of the life and surroundings of ordinary Irish people who lived in the landscapes we have been discussing. As many of the views are of estates, they show a somewhat idyllic view of Ireland.

Visitors, Decorators and History Painters

Throughout the eighteenth century, foreign painters, mainly Englishmen, the 'straggling adventurers of the brush' as one critic called them,[1] visited Ireland with a view to making their fortunes. In some cases, surprisingly, they did. The mid-century saw brief visits by Benjamin Wilson (1721–88) in 1746 and again from 1748 to 1750, and by the rococo artists Philippe Mercier (c.1689–1760) in 1747 and Barthélémy du Pan about 1750.

The only two pictures definitely known to us by Wilson are in Trinity College, Dublin: a full-length of Archbishop Price, ruined later by fire, overpainting and bituminous varnish, and a portrait of Bryan Robinson, the professor of physics who was Wilson's friend and with whom he collaborated on scientific investigations and wrote a treatise on electricity. Martin ffolkes, the President of the Royal Society, had encouraged his scientific experiments but suggested that he went to Ireland for two years so 'that early works painted there would not appear against him in this country [England], and that so he would start here with fuller mastery of his pencil and better chances of success'. This is a telling example of the attitude of the English to Irish painting at this time.[2] Other portraits by Wilson, known now in engraved form, are those of the great Irish beauty Maria Gunning and an etching of Jonathan Swift made from a chalk drawing by Rupert Barber.[3] This was produced as the frontispiece for Lord Orrery's book *Remarks on Swift*.[4]

Philippe Mercier's visit was even briefer. He was in Dublin in 1747, according to Vertue,[5] when he painted a number of portraits, though only two certain Irish works by him are now known: Henriette, wife of William Le Fanu, which is signed, and the family of the first Viscount Dungannon of Belvoir, Co. Down, with an obelisk in the background. Barthélémy du Pan painted Lord Harrington, the Viceroy; a portrait of Lord Shannon; and a pair of Frederick, Prince of Wales and his consort which came from Rockingham, Co. Roscommon and are now in the Ulster Museum.

Yet another visitor was Joseph Blackburn (*fl.* 1752–78), who is first recorded in Bermuda in 1752 and later in New England, where there is a large portrait group of the Winslow family in the Boston Museum. Ellis Waterhouse thought he was educated in England.[6] He was in London certainly in 1764 and 1769, when he exhibited in the Free Society of Artists. Later, he showed at the Royal Academy. He was in Dublin in 1767, when he painted a charming portrait of a child holding a Dublin Lottery ticket (Fig. 202). He was probably also in Dublin in 1766, when he painted portraits of the architect Henry Keene, who was involved in the building of the West Front of Trinity College and possibly also the interior of the Provost's House. In 1766, Keene left Ireland with his wife Anne who was also painted by Blackburn (both in TCD). All three of these portraits include very minutely observed details: Mrs Keene holds a miniature of her husband, he has a fly prominently sitting on his hand, and the child holds up the lottery ticket.

Another American was Matthew Pratt (1734–1805) from Philadelphia, who was briefly in Ireland in 1770, in connection with an inheritance of his wife, in company with an Archibald McColloch. While here, he painted some portraits and one of Archdeacon Isaac Mann.[7] Unfortunately, we know none of these.

An extremely colourful character was John Astley (1724–87),[8] who came to Ireland around 1756. In the three years he spent in the country, he is said to have made some £3,000 by his painting.[9] He had been a pupil of Thomas Hudson and visited Italy around 1748–52, at the same time as Reynolds, and painted Sir Horace Mann (W. S. Lewis Foundation, Farmington, Connecticut) in 1751. Astley's Irish pictures are frequently confused with those of Reynolds, though in fact the brilliant, flickery highlights which enliven his work and make his embroidery vibrate, and the accentuated noses and other mannerisms, are totally unlike Reynolds's more dignified style. As his income suggests, his works are commonly found, though only the

202 Joseph Blackburn, *Girl with a Lottery Ticket*, oil on canvas, National Gallery of Ireland, Dublin

203 John Astley, *The Molyneux Family*, 1758, oil on canvas, Ulster Museum

204 John Astley, *Countess of Antrim*, oil on canvas, Private collection

length portraits. Of these, the *Sarah Fownes*, the *Richard and Henrietta Moore of Barne*, the *Earl and Countess of Bective* and members of the *Antrim family of Glenarm*, two of which are full-lengths, are representative (Fig. 204). There are several of the Rowleys and the O'Haras of Annaghmore which are particularly striking. A lady of the Armstrong family of Kilsharvan, Co. Meath is typical, with her sharp nose and the strong highlights on the costume.[11] Astley is still confused with Reynolds. In the latest *catalogue raisonné* of the portraits of Reynolds, the first Earl Masserene and second Earl of Rosse are attributed to Reynolds but are clearly Irish Astleys.[12]

Like many of his contemporaries, Astley used the compositions of other painters as models; examples include works by his master, Hudson, and Rubens's *Chapeau de Paille*. There is a particularly pretty bust portrait of one of the McDonnell ladies, with flowers in her hair and a garland around her *décolletage*. While in Ireland, he married a 'suitable Irish girl', who died before he left the country. Pasquin gives a most entertaining account of Astley:

He thought that every advantage in civil society was compounded in women and wine: and, acting up to this principle of bliss, he gave his body to Euphrosyne, and his intellects to madness. He was as ostentatious as the peacock, and as amorous as the Persian Sophi; he would never stir abroad without his bag and his sword; and, when the beauties of Ierne sat to him for their portraits, he would affect to neglect the necessary implements of his art, and use his naked sword as a moll-stick ... He had a harem and a bath at the top of his house, replete with every enticement and blandishment to awaken desire; and he thus lived, jocund and thoughtless, until his nerves were unstrung by age; when his spirits decayed with his animal powers, and he sighed and drooped into eternity!

On his way back from Ireland to England, in 1759, Astley married, secondly, Lady Dukinfield Daniel, a rich widow. After this, he painted very little, but 'the dashing, reckless, conceited, clever, out-of-elbows'[13] individual was constantly in debt and is said to have spent £150,000.[14]

Astley's style changed considerably between his pre-Italian works, such as *George and John Osborne*, dated 1746, and his later style which we have been discussing, where he showed much greater freedom of brushwork. *A Biographical History of Astley* of 1789, cited by Edward Edwards,[15] is untraced, but from an account in William Betham's *Baronetage*,[16] it is obvious that this merely reprints the lengthy obituary notice, 'Account of the late John Astley, Esq.' in the *European Magazine* of December 1787.[17]

A more famous name to whom a vast amount of work, both decorative and otherwise, is incorrectly attributed is Angelica Kauffmann (1741–1807). Before

large group of the Molyneux family from Castle Dillon, now in the Ulster Museum, dated 1758, is signed (Fig. 203). However, from this it is possible to attribute to Astley the very large group of eleven figures of the Earl and Countess of Tyrone and their family also in van Dyck-style costumes,[10] as well as a considerable number of single bust and three-quarter-

206 Martin Ferdinand Quadal, *Mrs Caldwell*, oil on canvas, Private collection

205 Angelica Kauffmann, *The Townshend Family*, oil on canvas, Private collection

her Irish visit, she had copied a portrait by Anthony Lee (1674–1768) painted in Ireland in 1720 of John Damer, Esq. (Travellers Club, London). William Carey[18] states that Kauffmann was brought over by Colonel Madden, the son of Samuel Madden, and Judge Hellen, with the intention of purchasing some of her pictures as models for the students in the Dublin Society Schools. Lady Victoria Manners,[19] says she was in Ireland in 1771 for some six months, staying with Mrs Clayton, the widow of Bishop Clayton, in her St Stephen's Green house; with the Tisdalls at Stillorgan Park; with the Elys at Rathfarnham Castle, where she is said to have decorated the ceiling designed by 'Athenian' Stuart; and was also at Emo Park, for John Dawson, later first Earl of Portarlington. She painted pictures and groups of most of these families, and was particularly intimate with the Damers, who later intermarried with the Dawsons. She painted a self-portrait which she gave to Lady Caroline Damer. The large group of the Elys is now in the NGI and the Tisdall family portrait is in a private collection. By far the most interesting portrait group conceived in Ireland is that of the Lord Lieutenant, Lord Townshend, and his children, four sons and a daughter, all dressed in mourning due to the recent death of the Marchioness in Dublin in 1770 (Fig. 205). They are seen in a dark interior conversation piece. Townshend is shown with his back to the viewer, looking into a mirror. The whole composition

is a psychological and introspective study of Lord Townshend, who is strikingly self-effacing for a man who was usually known for his 'pride, insolence and proflicacy [*sic*]'.[20] Though Kauffmann may have found time for a very small amount of decorative work as well as for her portrait commissions, most of the many hopeful attributions are undoubtedly copies after engravings of her work.

Another artist whose works were in fact bought by the Dublin Society for use in the Schools (now in the NGI) was the animal painter Martin Ferdinand Quadal (1736–93) from Moravia.[21] He was in Dublin in 1779 and painted portraits, though only two Irish examples are known, a very sympathetic study of Mrs Elizabeth Caldwell (née Heywood; Fig. 206) and her husband, Andrew, the collector. Caldwell makes a witty comment in a letter of 25 January 1808 to his nephew, 'It has been my fate to sit for five Pictures, and of all the shocking waste of time and dull drudgery it is the foremost'. *Mrs Elizabeth Caldwell* is a sensitive and contemplative study of an older woman painted with a beautiful cap on her white hair. Her nephew, George Cockburn, wrote on 30 November 1835 about this picture, 'I am glad to find there is at least one of the Family anxious to preserve a most *Capital Likeness* of one of the best of women that I now in my old age, & remembering from almost infancy, declare to be in my opinion almost unequalled for every good quality possible to human nature'.[22] Quadal is better known for his

207 Francis Wheatley, *The Earl of Aldborough reviewing Volunteers at Belan House, Co. Kildare*, 1782, oil on canvas, National Trust, Waddesdon Manor

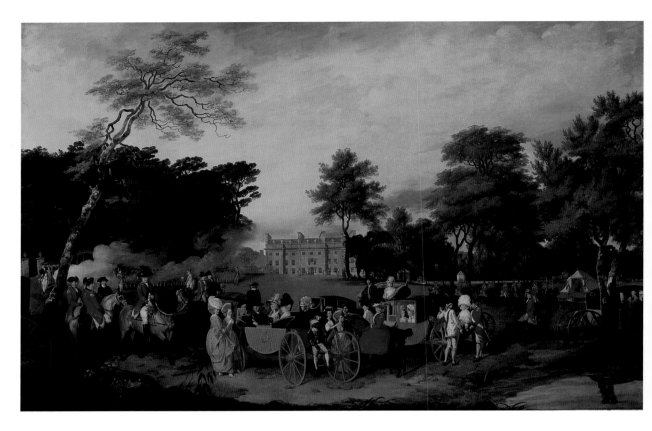

animal pictures. Later, he went to Russia, where he became master of the Academy in St Petersburg.

An even briefer visit was paid around 1783 by Tilly Kettle (1735–86), who, as we have already noted, influenced Robert Hunter. He sought asylum in Ireland from his London debts. The only known Irish work by him is the portrait of his friend James Gandon (NGI),[23] the architect, which he left unfinished, only painting the head and probably sketching in the figure. The remainder, (i.e. the costume and the background of the Four Courts, the Custom House and the Rotunda Hospital) was impressively completed later by William Cuming whom we discuss in the next chapter. Kettle had been in India before he came to Ireland and was returning there when he died.

Robert Home (1752–1834), who went to India after his Irish visit, stayed in Ireland much longer. Home was here for some ten years, between 1779 and 1789. He had studied under Angelica Kauffmann who had encouraged his Roman visit between 1773 and 1779.[24] This had but little impact on his style and Pasquin is right when he says that if Hunter was driven out of business by Home, it was because Home's 'better fortune, more than his superior merits, eclipsed his renown'. Home painted full-length portraits, mostly posthumous, for the Public Theatre in Trinity College, Dublin, and their yardage seems to have overwhelmed his talents. He is known to have been in Northern Ireland, in Newry and Belfast, in 1786–7, as there are several mentions of him in the Drennan letters.[25] They mention that his cheapest price was £5, and that he was regarded as a good artist but a very poor miniature painter. Drennan had already visited

him in Dublin in his studio and recognized most of the faces in the pictures. Home painted Drennan himself and apparently did not send the picture promptly because he said he received 'more credit by it than any [other]'. However, even his smaller works in Ireland, such as his *Captain Waddell Cunningham* (UM), are of little enough merit and his true worth can only be seen in some of his splendid and colourful Indian subjects, such as *Lord Cornwallis Receiving Tipu Sultan's Sons as Hostages at Seringapatum*, 1792. The evidence for his large practice in Dublin is no longer to be seen, as only a few Irish paintings have been found. The most distinguished of these are two attributed portraits of the second Lord Langford and a group of his nieces and another female relation, which was probably painted shortly after he arrived. It is known that he made copies for the Lord Lieutenant, Lord Hardwicke (1785–7), though the works have not survived.[26] However, Strickland maintains, as Pasquin did, that 'he had … a monopoly of the best practice in Dublin, but he grew careless in his work, his practice lessened, and finally, on the arrival of Gilbert Stuart he found his studio deserted'. But before dealing with Stuart, another fascinating visitor enters the Irish scene.

Francis Wheatley[27] (1747–1801) painted some of the best pictures of his career during his Irish sojourn, coming to Ireland about 1779, also in flight from his creditors. He was accompanied by Mrs Gresse with whom he had, in Edward Edwards's phrase, 'the folly to engage in an intrigue'.[28] The discovery of her imposture and further debts hastened his return to England early in 1783. This period saw the height of

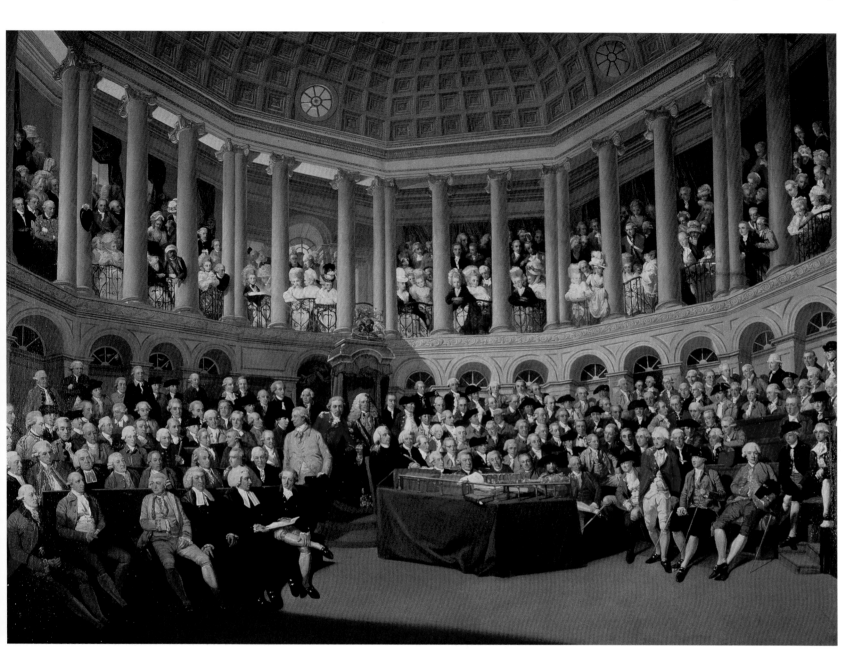

excitement over the Irish Volunteer Movement and Wheatley was therefore able to obtain many important fashionable commissions. The great picture now in the NGI, *The Dublin Volunteers Meeting on College Green*,[29] was the first of his major Volunteer groups. The Volunteers were an organization founded by the great patriot Lord Charlemont as a defence against the French when the English army was absent from Ireland, fighting in North America. Quite soon the movement took on a nationalist flavour, emulating the desire for free trade and legislative independence of their American compatriots. The painting was announced to be disposed of by raffle in 1781, but it was finally bought by the Duke of Leinster. It contains many portraits of members of the Dublin Volunteers, including the Duke of Leinster, Sir Edward Newenham, Luke Gardiner and Napper Tandy. The details of ladies and gentlemen, including, it is said, Princess Daschkoff, leaning out of the windows of the Dame Street houses, are fantastically evocative of the

period. Another Volunteer group is *Lord Aldborough on Pomposo Reviewing Volunteers in Belan Park* (Fig. 207). One of Wheatley's finest pictures, it sums up the glamour and glitter of those Volunteer days. *Sir John Irwin reviewing Troops in the Phoenix Park* (NPG) may be equated with the picture exhibited in the London Society of Artists, 1783, *Review of Irish Volunteers in the Phoenix Park* of 1783. Wheatley's most famous Irish picture is his *Irish House of Commons* (Fig. 208) which depicts the apogée of the Irish patriotic movement by showing Henry Grattan making his famous speech of 19 April 1780 on the Repeal of Poynings Law: 'That the people of Ireland are of right an independent nation and ought only to be bound by laws made by the King, Lords and Commons of Ireland'. This painting brought Wheatley into contact with a large number of the Irish nobility and gentry, though, due to the shortness of his stay, he painted relatively few portraits. Of these, his small full-lengths set in landscapes such as the *Macartney Family* (Art Gallery,

208 Francis Wheatley, *Irish House of Commons*, 1780, oil on canvas, Leeds Museums and Galleries (Lotherton Hall)

209 Francis Wheatley, *The Marquess and Marchioness of Antrim*, oil on canvas, Private collection

210 Francis Wheatley, *View of Tarbert*, oil on canvas, Private collection

Wheatley must have toured widely in Ireland, as many delicately painted watercolours and oils of buildings and scenery around the Dublin district exist, of which some of Glendalough are particularly sensitive and romantic.[30] One of the most charming is the *Salmon Leap at Leixlip with Nymphs Bathing* (British Art Center, Yale). He must have been along the Shannon estuary, for a ravishing little sketch, *Tarbert from the Clare Bank with Sailors Dancing*, exists in two versions (Fig. 210). One is identical to the engraving that was published by Thomas Milton in his *Views* of 1793. We assume that the artist may have been on his way to Killarney. Apart from topography, Wheatley's Irish work is especially interesting for a number of genre subjects in the Wouverman manner of Irish fairs, fisherfolk and gipsy encampments. As James Kelly has written, these genre subjects 'provide one of the most rewarding and appealing vistas on to the daily life of the common people of late eighteenth-century Ireland'.[31] Wheatley's paintings capture the late eighteenth-century Irish scene better than most artists because of their fluency, clarity and gaiety.

Like Wheatley, Gilbert Stuart (1755–1828), the American artist, came to Ireland in 1787 after a somewhat hectic London period, again to escape his debts. His instantaneous success made him send for his family the following year, and he remained the most sought-after portrait painter in Dublin until he left in 1793, also as a result of financial embarrassment, for he was an extravagant and flamboyant character. His patronage was largely connected with the Irish House of Commons and he apparently spent the summers finishing the work started during the winter parliamentary sessions. Perhaps his most famous Irish portrait is the noble full-length of *The Lord Chancellor, John Fitzgibbon, later Earl of Clare*, of which there are several versions, both large and small, the best of which is in the Cleveland Museum of Art (Fig. 211). It is interesting that Andrew Caldwell, writing to George Cockburn at Hanover on 13 October 1788, comments that 'Stuart the Painter has resolved to go directly to London the Death of poor Gainsborough leaves such a prospect open, that Stuart's Head is fairly turn'd with the Expectation, I can't get a sight of him, he is always in the Country, I want to get home your Picture'.[32] There is no evidence that Stuart tried his luck in London at this time.

His other noted Irish paintings include those of Sir William and Lady Barker, *c.*1790,[33] who are very well characterized. The sitters are seated by windows through which one sees the ruins of Kilcooley Abbey, Co. Tipperary, and with Lady Barker there is a lake landscape with a Gothic folly (Fig. 212). She is embroidering on a tambour frame and looks straight out at us, raising her eyes as though surprised to be interrupted. These portraits should not be confused with the small full-lengths by John Trotter (d. 1792), where the Barkers and their relatives, the Staples, are seen in landscape settings, discussed in chapter 7. The heads of Sir

Ontario) and the Maxwell children are good examples. The best, however, is *The Earl and first Marquess of Antrim and his Wife Driving their Phaeton* (Fig. 209) accompanied by two grooms, in the deer park above Glenarm, Co. Antrim, looking down towards the house. His extraordinary treatment of Lady Antrim's costume and hat is a *tour de force* of tone as well as drawing. Wheatley is a total realist, as he depicts even the dust raised by the feet of the horses and the wheels of the phaeton.

Robert and Lady Staples were reworked by Gilbert Stuart. It is probable that Stuart visited Kilcooley and George Cockburn wrote to Andrew Caldwell on the 24 November 1788: 'I hope Stuart will undertake your picture, as you promised it, he must certain finish his engagements before he quits Dublin', which suggests he travelled in the country.[34] Caldwell's letter quoted above also gives this impression.

Another ravishing picture is his group of young Miss Dick and her cousin, Miss Forster, seated sewing, which is now in a private collection in the United States. A portrait of George Thomas Nugent, later eighth Earl of Westmeath, with a large Newfoundland dog, is a charming picture. Dorinda Evans[35] interprets the portrait in a novel way, as the artist has signed the fawning dog's collar, and she suggests that the dog represents Stuart's position as a flatterer of the sitter. However, this appears to us a cynical idea, as Stuart, in true American Republican style, had no respect for titled rank. There are innumerable head-and-shoulder portraits and three-quarter-lengths, usually of robust quality. The portraits of Judge George Hamilton and his wife (William A. Farnsworth Library and Art Museum, Rockland, Maine) have a rich, hot colouring, unlike the usual silvery touch with the palest pink cheeks which can be seen in his *Lady Cremorne* and in many others. Other fine head-and-shoulder portraits of the Ponsonbys and the Staples survive. A number of portraits begun by Stuart were finished by his assistant, John Dowling Herbert, the author of *Irish Varieties*. This work contains many entertaining stories about Stuart's sojourn in Dublin, including the amusing conversation at the artist's Dublin dinner on St Luke's Day[36] and his imprisonment for debt in the Marshalsea in 1789. His sitters poured in to the prison to order portraits, as Dunlap says, 'the Irish lordships and gentry imprisoned in effigy',[37] referring to the pictures Stuart left behind in jail.

John Dowling Herbert (1762/3–1837) mostly painted watercolour drawings of no great quality and was also an actor, scene painter and writer, particularly as a chronicler of the Dublin art world and especially the Schools. He devotes a short chapter in his *Irish Varieties* to Robert Home. Charles Merrill Mount[38] states that other pictures by Stuart were completed by Robert Woodburn (d. 1803), who, like Herbert, had been an assistant of Robert Home, who was also his teacher. Woodburn was a more interesting painter than Herbert, and his portrait of the learned MP, Andrew Caldwell,[39] is in the NGI, signed and dated 1793.[40] It is in the Stuart manner. He also painted Peter Walsh of Belline, Co. Waterford, and a charming topographical landscape showing the octagonal gate lodges at Belline with the house in the background (Fig. 213). It includes elegant figures, a peasant on horseback, another on a donkey and two children playing behind a coach on which Woodburn has signed his name and the date, 1800. He exhibited it in Dublin a year later.

211 Gilbert Stuart, *Lord Fitzgibbon*, 1789, oil on Irish linen, The Cleveland Museum of Art

212 Gilbert Stuart, *Lady Barker*, oil on canvas, Private collection

Two charming bust portraits of Thomas (Fig. 214) and William Barton of 1801 are known. It seems unlikely that Thomas Hickey, who Mount also claimed as a finisher of Stuarts, worked in this way as he was only briefly in Dublin in 1796[41] after his journey to China

213 Robert Woodburn, *The Gates of Belline*, signed and dated 1800, oil on canvas, Private collection

214 Robert Woodburn, *Thomas Barton*, 1801, oil on canvas, Private collection

and before his return to India. Although Stuart had a certain amount of influence on Irish painting, a study of him really belongs to the history of art in America.

Another English visitor who had East Indian connections, and who spent most of his career after he left Ireland in India and Macao, was George Chinnery[42] (1774–1852), who came to Ireland around 1795 after studying at the RA Schools. He had already attracted the attention of Pasquin, who noted in his *Liberal Critique on the Exhibition for 1794*, in London that 'he had adopted a new style of painting, somewhat after

the manner of Cosway'.[43] The reason for his Irish visit is not known, but there were Chinnerys in Co. Cork and he painted a portrait of Sir Broderick Chinnery, so there may have been some family connection. He seems to have been accepted rapidly in Dublin as he was teaching in the Life class of the Dublin Society Drawing Schools from 1796, and, as Secretary, organized an exhibition for the Society of Artists in Ireland in 1800. A silver palette presented to Chinnery in 1801 by the Artists of Dublin is inscribed: *In testimony of his Exertion in promoting the Fine Arts in Ireland.*[44] He married his landlord's daughter, Marianne Vigne, in 1799 but after the birth of two daughters the marriage seems to have broken up, though she followed him to India fifteen years later. In 1802, he returned to London, leaving for Madras in the same year. The Irish works, though rare, are of consistent quality. They include the more conservative and realistically painted *Mrs Eustace*, his wife's grandmother (NGI), and the two Misses Vigne: the one in the NGI, his wife, is sitting reading and that in the RDS is his sister-in-law (Fig. 215). Painted with marked effects of light and shade and deep colouring, they are forerunners of romantic portraiture, though they are very stylized. The RDS picture especially seems to have hints of Fuseli. A contemporary critic said of it, when exhibited in the Society of Artists in 1801 as *Attention*, that it was 'A picture in which the most difficult attitudes and the greatest variety of drapery has, like the motley penmanship of a Christmas piece, been assembled to display the powers of the artist'. The same critic earlier remarked that 'it appears to be his wish to paint everything in an uncommon manner'.[45] In Ireland, Chinnery painted landscapes as well as miniatures, especially of theatrical people. His Irish drawings, of which not many are known, are among his best works.[46] The drawing of his wife, dated 1800, with her penetrating black eyes and soft cross-hatchings in the costume, is an assured and arresting study (Hong Kong and Shanghai Bank). He also painted small full-lengths in oils, such as the *Portrait of a Young Man Thought to be the Earl of Limerick.*[47] The background landscape and sky is painted very fluidly and anticipates his eastern work.

Apart from decorative and portrait painters, Ireland, with its picturesque scenery, attracted many topographical painters. There is evidence from catalogues and surviving works that J. T. Serres, Nicholas Pocock, Cornelius Varley, Samuel Heywood, Agostino d'Aglio, John Laporte and others worked in Ireland.[48] The Maltons, father and son, are in rather a different category, as they lived in Ireland for some time, and their views of Dublin are justly famous. The elder, Thomas (1726–1801), came to Dublin in 1785 and earned a living teaching perspective and working as an engraver. His son, James (1766–1803), accompanied his father, working as a draughtsman in James Gandon's office while the latter was building the Custom House. His first exhibited works, *A View of*

Heywood and *A View of Castle Durrow*, were sent to London, to the Society of Artists, in 1790. Both are now in the V & A. His series of drawings of Dublin, completed in 1791, continued Wheatley's superb standard of watercolour draughtsmanship. They were followed by many other issues which were published between 1792 and 1799. Malton exhibited at the RA, from 1792 but he did not leave Ireland until 1798. He died in London in 1803.

Three portrait painters, English in origin, were associated with the north of Ireland during the latter part of the eighteenth and the early years of the nineteenth century. The oldest of these, Strickland Lowry (1737–*c*.85), was born at Whitehaven in Cumberland.[49] He was a portrait and landscape painter who worked mainly as a provincial artist in Staffordshire and Shropshire and later in Dublin as well as in Northern Ireland. He finally settled in Worcester, where he died. Details of Lowry's career in Ireland are fragmentary, but pictures by him occur in and around Dublin and in the east of Ireland as far north as Co. Down. In the Ulster Museum, there is a portrait of an officer in Volunteer uniform wearing a cross-belt plate inscribed 'Lurgan Volunteers 1780' with a shamrock in the centre, which refers to Lurgan in Co. Armagh. The portrait has as its pair a lady holding a lap-dog, which is very similar to a portrait of Mrs Sarah Holmes, née Jellett, a signed work of 1780. Other paintings attributed to Lowry can be seen in Castleward, Co. Down.

A splendid example, signed and dated 1777, of *Mrs Jonathan Raine* (Fig. 216), has a quizzical and alert expression full of character, unlike his usual bland style. She is wearing a magnificent costume trimmed with lace, which is an elaborate piece of painting, and these details are close to those found in his Bateson family and the conversation piece in the NGI, both of which we shall discuss shortly. The surprising fact is that he remained very poor. In a letter from Lady Moira to her daughter Lady Granard of 11 July 1782, she says, 'Lowry is dying with illness and want at Newry. I am bringing him over when he can move, and have sent him some relief. When he is here, if you think of having any doors painted in ornaments of landscapes of shades of one colour (as Lord Scarsdale has some in green) I could after the plan was settled have the doors made and he paint them here'.[50] This shows he did decorative work as well as portraits.

Mention is made of Lowry in Lady Betty Cobbe's manuscript account-book at Newbridge, Co. Dublin,[51] where the following entries occur for 4 April 1765: 'To Lowry for ye pictures of the children £9.2.0' and for 18 January 1765, 'To Lowry the painter £4.11.0'. The picture of the two children shows them as small full-lengths, grouped by a tree, the boy holding a dog and the girl a dove (Fig. 217). The figures and faces of these children are very close to the remarkable conversation piece of the Bateson children (Fig. 218) which we used to think was by Hussey but is given to Lowry in a catalogue of the paintings at Belvoir Park

215 George Chinnery, *Miss Vigne*, oil on canvas, Royal Dublin Society

216 Strickland Lowry, *Mrs Jonathan Raine*, signed and dated 1777, oil on canvas, Private collection

(1865), and in a *Belfast Newsletter* account of 19 September 1828. If this is correct, Lowry must have gone to Belfast about 1762, the date which appears on the harpsichord in the Bateson picture.[52] This is not its date, however, as it is an earlier instrument. It is a view in the hall at Orangefield, the Batesons' home before they moved to Belvoir, and the house is shown in one of the paintings hanging on the panelling above the highly carved Irish red mahogany side-table and the chairs beside it. The detail of the clothing is minutely observed and is early 1760s in date, but the faces of the

217 Strickland Lowry, *The Cobbe Children*, oil on canvas, Private collection

218 Strickland Lowry, *The Bateson Children*, 1762, oil on canvas, Ulster Museum

children have the somewhat lifeless and flat expressions typical of Lowry's work.

A most interesting picture also formerly attributed to Hussey, is a conversation piece of a family (NGI)[53] dating to about 1770, later than the Bateson family. They are posed in their superbly papered drawing-room, complete with its regimented chairs and a fireplace of a typically Irish type. This has now been tentatively given to Strickland Lowry. Despite the large scale of the Bateson picture in contrast to the relatively small size of the NGI conversation piece, which at first glance makes the two look as though they are by separate hands, we think that this attribution is correct because differing techniques are used to cope with the large and small sizes of the two pictures. The NGI conversation piece came from the Corbally family of Rathbeale Hall, Co. Dublin. As the Corbally family did not live there till 1805, it may have belonged to the Gorges Meredyth family, who sold the house and its contents to the Corballys. The pillar-and-arch wallpaper is found in colonial America but was manufactured in England between 1760 and c.1810. It is also found at Temple Newsom House, Leeds and, as Nicola Figgis and Brendan Rooney remark, the interior is closer to a town house than a country house in its proportions and window spacing. The use in both this and the Ulster Museum picture of the regimented Georgian interior with a set of chairs round the walls and other meticulous interior detailing is quite unknown in any other Irish pictures of this date.

Whether Lowry was in Ireland continuously between 1762 and 1782 is doubtful. He probably went to and fro, as in 1779 he published a set of engravings for the *History and Antiquities of Shrewsbury*. Lowry's style resembles that of the Belfast painter Joseph Wilson (*fl. c.*1766–93), who was working in the 1770s, and it is worth noting that Lowry painted a portrait of Mrs Wilson and named his son after the artist, who in turn named his son Joseph Wilson Lowry. There seems to be some close connection, as yet untraced, between the two painters. Wilson Lowry became well known as an engraver and worked for James Malton, among others.[54] A further complication is the existence of three *trompe-l'œil* paintings, one after the engraving of Reynolds's portrait of the Duke of Leinster and two in the NGI,[55] depicting engravings pinned to boards. One of these is entitled *Lowry* and another *The Spartan Boy, after a picture by Nathaniel Hone*. Perhaps they are by Lowry and include a self-portrait. Another *trompe-l'œil*, now in the Hunt Collection, Limerick (Fig. 219), may also be attributable to Lowry. It depicts a board with ribbons attached, holding a necklace, a peacock feather, a quill, a bracelet, a letter inscribed 'To Mrs Grady, Elton' and in the centre a watercolour portrait of a sportsman with his dog carrying a hare. The watercolour is stuck on the board with sealing wax and it is very much in the tradition of Samuel van Hoogstraten (1627–98) and can be compared to his 'Letter-rack' in the Karlsruhe, Staatliche Kunsthalle. The Gradys (O'Gradys) of Elton were a well-known East Limerick family. As Lowry is known to have painted a still life,[56] signed and dated 1776, including the music of a favourite hunting song and a violin and flute, it fits in with the Hunt *trompe-l'œil*. Such paintings are extremely rare in Ireland. He may well have been familiar with the little Liotard *trompe-l'œil* in the Clanbrassil collection at Tollymore Park, Co. Down (see chapter 4).

As can be seen, the career of this artist has by no means been elucidated; in the earlier edition of this book, the Bateson and another large conversation piece of the Greg[57] milling family also from Belfast were attributed to Hussey, but must now be given to Lowry. Lowry was certainly dead by August 1785, when his widow was looking for a domestic situation in Belfast; she was given a pension by Lord Moira, whose family, as we have seen, patronized the artist .

The second artist, Joseph Wilson (*fl.* 1779–93), whose links with Lowry we have mentioned, is nearly as enigmatic a figure. His birth and training are unknown and practically no facts on his life have come to light except some advertisements in the *Belfast Newsletter*. His wife died in Dublin and it may have been he who exhibited three portraits at the Society of Artists in William Street in 1777, giving no Christian name but the address 'Mary's Abbey Dublin'. Strickland gives a list of portraits by him. We are of the opinion that he may have attended the Dungannon Volunteer Convention of 1782, as a number of Volunteer portraits by him survive. Interestingly the Volunteer portraits are close in style to early American portraits such as those by Ralph Earl and Rembrandt Peale, and we wonder if it is more than a coincidence that Peale, who painted many portraits of Washington between 1772 and 1795, had a nephew, Charles Peale Polk, who painted a portrait of George Washington, inscribed on the reverse 'General Washington/ before the battle of Trenton/ painted by Polk/ for the Earl of Bristol [then Bishop of Derry] who was then in Rome and was/ sold by the painter to Robert Moore/ of Molenan, [Co. Antrim] …' Polk[58] is said to have delivered the portrait in person, but

finding the bishop away, sold it to Moore instead. Polk may have had relatives in Ulster, as President Polk came from a house near Raphoe in Co. Donegal and Polk is a well-known Scots-Irish name.

Wilson's masterpiece, *John Bateman FitzGerald, 24th Knight of Glin, in Volunteer uniform* (Fig. 220), has the clarity and linear quality and design of a banner. Of his two portraits of the sixth Earl of Antrim, also in Volunteer uniform, one is a small full-length and the other a small three-quarter-length, which is signed and dated 1784. Both show him wearing the ribbon and star of the Order of the Bath. These are the key works on the basis of which his other Volunteer portraits are attributable. His *Lieutenant Hyndman* (UM) is a more ambitious three-quarter-length, showing the sitter seated with his clay pipe. Hyndman's granddaughter, a charming small head-and-shoulders, is signed 'Joseph Wilson 1782'.[59] There is an attributable small full-length of a Volunteer member of the Burgh family of Burt, Co. Kildare, who is leaning on his cannon holding a telescope.

That Wilson was living in Belfast is proven by a series of mentions in Belfast papers. In the *Belfast Newsletter* of the 28 June 1782 his painting *Daniel interpreting for Belshazzar the Writing on the Wall* was to be balloted for on 9 July of that year. In addition to life-size portraits, a number of small oval wood panels[60] have been attributed to Wilson, including some in the County Museum, Armagh, and those of three members of the Magee family in the Ulster Museum. The following notice of Wilson's death appeared in the *Belfast Newsletter* on 15 March 1793: 'Died on Wednesday 13th inst. at Echlinville, Co. Down, Mr. Joseph Wilson, long a Portrait and Landscape Painter in this town; and a very worthy honest man'. A series

219 Strickland Lowry, *Trompe l'oeil*, oil on canvas, Hunt Museum, Limerick

220 Joseph Wilson, *Colonel John FitzGerald, twenty-third Knight of Glin*, 1782, oil on canvas, Private collection

of portraits of the Andrews family of Comber, Co. Down,[61] are also almost certainly by him but no landscapes have been identified. Wilson represents a remarkable example of a provincial portrait painter who worked mainly in Ulster at this time.

The biographer John Williams (alias Anthony Pasquin), who is the principal artistic source for the eighteenth century in Ireland and from whom we have quoted so much in this book, was also an itinerant painter. He was in Ireland in 1783, when the Irish actor John Bernard met him in Northern Ireland and he painted a portrait of the Adelphi Club, a Belfast literary society, where 'Pasquin's conversational talents rendered him a general favourite' (Fig. 221). After he had been invited to a meeting, Bernard goes on to say that Williams painted a large portrait group of the club to hang over 'our mantlepiece, but it was very inferior as a specimen of art'. This is an odd comment as it is a charming conversation piece with an interesting still life of a jug, glasses, decanters and books on a tripod table. An artist with his palette and mahlstick appears on the right-hand side and a smiling face behind him could be Williams if it is compared with the watercolour portrait by Martin Archer Shee.[62] This, or a version of it, has recently come to light and, though we might agree with Bernard's remarks that Williams 'was a much better writer than a painter',[63]

the picture is signed surprisingly by 'J Wilson' and the painting looks like his *Lieutenant Hyndman*. It is possible that Williams sketched the scene, but it is now definitely thought that Wilson painted the group.[64]

The third artist was Thomas Robinson (*fl.* 1770–1810).[65] He was born in Windermere sometime before 1770 and came to Dublin in 1790, after serving an apprenticeship to George Romney in London. A portrait of Sir Richard Jebb, 'the face painted by George Romney Esq.', was exhibited in the Society of Artists of Ireland in Dublin in 1810. The rest was finished by Thomas Robinson, so he must have retained his connection with Romney. Robinson advertised in the *Dublin Chronicle* on 21 August 1790: 'twenty guineas full length, ten guineas half length, four guineas the head'. It used to be assumed that he was the same 'T. Robinson' who signed and dated a portrait of Barry Yelverton, later second Viscount Avonmore in 1792, now in the City Art Museum, St Louis, Missouri. This is signed uncharacteristically 'T. Robinson'. The normal signature is 'T. Robinson of Windermere' and the Yelverton is an infinitely finer painting than any other work we know of his. It is smoother and more coldly neo-classical. A version of this picture, traditionally identified as the second Earl of Enniskillen, is in Florence court, Co. Fermanagh (NTNI), and is unsigned. There are two

222 Thomas Robinson, *A Gothic Scene*, signed and dated 1793, oil on canvas, Private collection

pictures of Queen Sofia Albertina, one of which is signed and dated 'Roma 1793', which are in Skokloster and Rosenburg in Sweden. These might possibly be by the Yelverton Robinson, as the rather hard-edged draperies are similar and the faces are close. As there is no evidence that the Robinson who worked in Ireland was ever in Rome and all the pictures attributable to him are far more naïve, and some quite close in style to Romney, we think there are two artists, causing a great deal of confusion. A slight piece of evidence that might

support our view is that there was a student, Thomas Robinson, in the Dublin Society Schools in 1788 and there was someone of the same name, not a student, who won a prize in 1793, who could be the second artist.

For some years, our Robinson was a protegé of Bishop Percy of Dromore, the author of *Percy's Reliques*, who was at the centre of an interesting literary circle. Robinson painted *A Group at Dromore*, 1807, which is now in Castleward, Co. Down (NTNI). It is in poor condition, as Robinson used bitumen. The

223 Thomas Robinson, *Mrs Emilia Montgomery*, oil on canvas, Private collection

224 Peter de Gree, murals in 52 Saint Stephen's Green, Dublin, Dúchas, the Heritage Service

influence of Benjamin West's *Death of General Wolfe* is self-evident. The curiously elongated figures and the general composition, with its sinking church tower, shows him unable to handle such a grandiloquent history piece.

His practice was as a portrait painter of northern nobility, gentry and merchants, and a number of these portraits survive. A notable group are of the Montgomerys of Grey Abbey, Co. Down, particularly the very Romneyesque Emilia (Fig. 223), who married the Revd Hugh Montgomery in 1782. Robinson painted a few landscapes. One of the Giant's Causeway was disposed of by a raffle, presumably after being exhibited at the Society of Artists in Dublin in 1809, where he also exhibited a number of portraits. A charming small painting of a race meeting at Downpatrick shows the horse Spanker with his jockey and owner in discussion; it is signed and dated 1802. His portrait of his son, Thomas Romney Robinson, later Astronomer Royal for Ireland, shows the boy laying flowers by a classical monument to Romney. The small whole-length of William Ritchie, the founder of the Belfast shipyards, is an interesting example of symbolism, with Ritchie leaning against the pedestal of a statue of Neptune and his shipyards seen in the background. Robinson had settled in Belfast in 1801 and painted his most striking work there. Strangely, this was first painted as *A Review of the Belfast Volunteers and Yeomanry by the Earl of Hardwicke, Lord Lieutenant* in 1804, but Robinson was unable to dispose of it, so he changed it to *A Procession in Honour of Lord Nelson* (Belfast Harbour Office) by adding a statue of the armless admiral in the centre.[69] His debt here to Francis Wheatley's *The Dublin Volunteers Meeting on College Green* is considerable.

Robinson's obvious eclecticism in no way detracts from his vigorous, though awkward, provincial style. He is described by Martha McTier in a letter to her brother William Drennan in March 1807 as an 'interesting, sensible man, of great simplicity, and *very poor*'.[70] He returned to Dublin in 1808 and this was heralded by a letter from Bishop Percy to General Cockburn which states in the postscript, 'To so good a judge of painting as Mr Caldwell [Andrew] the Bishop of Dromore has great pleasure in announcing that Mr Robinson of Windermere whose Portraits have been formerly much approved by Mr Caldwell intends soon to settle in Dublin, and he is so much improved in his Art, that he will deserve every encouragement from persons of taste, and found superior to any other Artist who has endeavoured to succeed the late Mr Hamilton ...'.[71] Two signed and dated oval crayon drawings of 1782 of Dr James Traill, Bishop of Down and Connor and his wife Mary are close to Hamilton.

Another branch of painting favoured by foreign artists in Ireland, following in the footsteps of van der Hagen, was decorative work. Peter de Gree (d. 1789), who arrived in Ireland in 1785, falls into this category.

picture (Fig. 222) which appears in the background of this painting has now reappeared;[66] it shows a dramatic medieval scene of a friar and a lady silencing a visitor while a knight in armour is praying at a tomb, where a recumbent figure of a woman lies and an angel is also seated, presumably awaiting her death. It is signed and dated 1793 and includes the word 'Wynandermere'. Robinson was also involved in Percy's landscape gardening, even painting an obelisk and urns in the scenographic tradition to decorate Percy's walks and groves.[67] His best-known work was painted while at Lisburn, *The Battle of Ballinahinch*,[68] signed and dated 1798 (NGI), which is like a journalist's account of incidents in the battle, though the

225 Vincent Waldré, *Minerva in an allegory of the arts*, oil on panel, Private collection

He was invited to come to Ireland due to contacts he had made in his native Antwerp with David La Touche of Marlay, Co. Dublin and through the recommendation of Sir Joshua Reynolds, who had employed de Gree as an agent to buy pictures for himself and the Duke of Rutland.[72] He was also invited by William Burton Conyngham. When Rutland became Lord Lieutenant, and was considering establishing various artistic institutions, including a National Gallery for Old-Master paintings in Dublin, he asked de Gree to become its first keeper. The death of the duke and the complications that ensued due to other ideas being put forward by Lord Charlemont, and finally, by the death of de Gree himself, meant that the scheme, despite Speaker John Foster's efforts, came to nothing.

De Gree was a pupil of Gheeraerts and worked in his manner and that of Jacob de Wit, painting what was described by Reynolds as 'in chiaro-oscuro in imitation of basso-relievos'.[73] He goes on to say 'that he paints likewise portraits in oil and in crayons extremely well'. Only one of these portraits has been met with and is a *basso-relievo* in profile of Esther Crookshank, the wife of a judge in Dublin. De Gree's splendid simulated '*basso-relievos*', still adorn several Irish houses such as Curraghmore, Co. Waterford; Abbeyleix, Co. Laois; and Newtownmountkennedy, Co. Wicklow, where they are all inserted into Wyatt-designed plasterwork. The most important sets are the large works in No. 52, St Stephen's Green (Fig. 224), originally David La Touche's Dublin house, where the grisailles are placed in an elaborate decorative scheme with trophies, urns and an antique tripod over the chimney-piece;[74] a set now in Dublin Castle; and a group at Luttrellstown Co. Dublin, originally at Oriel Temple and done for Speaker Foster, which includes an allegory of Britannia

introducing Arts and Commerce to Hibernia. De Gree died of ill health caused, as his friend Pasquin thought, 'from breathing an atmosphere poisoned with the fumes of lead, which brought on those violent bilious attacks to which he died a martyr'. Whatever the cause, the illness was clearly of long duration, as Daniel Augustus Beaufort had noted when in 1788 he visited the Oriel Temple, the 'beautiful room where de Gree is painting – poor man seems in bad health'.[75] At the time of his death a year later, he was in the process of finishing a series of four '*basso-relievos*' of the seasons for the Marquess of Buckingham as overdoors in the Presence Chamber in Dublin Castle.

The main decorator of Dublin Castle was another visitor, an Italian variously described as coming from Faenza or Vicenza, Vincent Waldré (1742–1814), who was first brought over from Stowe in 1787 by the Marquess of Buckingham, the Lord Lieutenant. However, Waldré did not settle permanently in Ireland until the early 1790s.[76] He worked as a painter of decorations, easel paintings and panels, including a painted lunette, possibly an overdoor, showing *Minerva in an allegory of the arts* (Fig. 225). He also created stage sets and was an architect. He became chief architect to the Board of Works through Buckingham's influence, and later, in 1802, Inspector General of Barracks, though no architecture by him is now known in Ireland.

He is remembered today by his three great canvases for the ceiling of St Patrick's Hall, Dublin Castle, the *bozzetto* (Fig. 226) for which is set as a table top in the Council Chamber of the RDS. The circular central panel depicts George III accompanied by Liberty and Justice and symbolizes the Act of Union of 1800. The two flanking rectangular panels show scenes from Irish history, *St Patrick Lighting the Pascal Fire on the Hill of*

226 Vincent Waldré, *St Patrick's Hall
scene*, modello, 1790s, Royal Dublin
Society

Slane and *King Henry II Meeting the Irish Leaders*. In contrast to the central panel, these are executed without any baroque flying figures and with a neo-classical feeling for relief and silhouette. The *St Patrick* was exhibited in 1801 and the *Henry II* in 1802, according to the unknown diarist critic,[77] who noted the paleness of the colours which may indicate that they were exhibited unfinished. Certainly the ceiling and the coved decoration were not completed by the time of Waldré's death in 1814.

The history of the ceiling and cove is very complex and has not yet been clearly elucidated. The most recent work, *Dublin Castle Art* by Róisín Kennedy of 1999,[78] lists most of the literature on the subject and illustrates the works very well. The artist's widow, Mary Waldré, indicated that the slowness of his progress over the ceiling was due to the numerous commissions he received for 'transient occupations though always connected with the Elegance and Splendour of the Viceregal Court during Seasons of unusual magnificence'.[79] These 'transient occupations' were decor for such events as balls and state occasions, and included some splendid transparencies for a banquet in the year 1789.

Faulkner's Dublin Journal gives a series of descriptions of the work being carried out at the Castle in 1788.[80] On 20 September, the paper reports that St Patrick's Hall is being decorated 'with a number of excellent paintings characteristic of the place, particularly a representation of the sacred mission of the Irish Apostle and Patron, St Patrick: portraits of all the present knights of the illustrious order that bears his name, and a number of other elegant decorations executed by an ingenious artist, M. Waldrea [*sic*]'. In the previous paper of 18–20 September, they said that by the winter the Castle would be 'the rendezvous and meridian of the Bon Ton' and that the Marquess who was paying for the alterations, wanted the rooms to be 'of superior elegance'. They add 'the ballroom alone it is said will cost more than one thousand guineas'. In the 4–7 October 1788 edition, the paper talks of 'St Patricks Hall, at the Castle is now undergoing so thorough a reformation that when finished it will vie for taste and magnificence with any room in Europe ... and in the designs of Waldrea [*sic*] there is a light taste which has a beautiful affect. With every exertion the whole will not be completed before the meeting of Parliament.' They were quite right; it was not finished even in 1814. On 18 October 1788, the *Journal* says that Lord Buckingham visited 'the glasshouse on North Strand and ordered a set of magnificent lustres for St Patrick's Hall and the new rooms of the Castle'.

The only other decorative work probably by Waldré is the set of four painted oval panels on the lord mayor's coach which was finished in 1791 and described in detail in 1793 in *Anthologica Hibernica*.[81] The subjects are *Apollo instructs the Muses to sing the Praises of Hibernia; A Personification of the City of Dublin offering a Prize Medal as an Encouragement of the Arts;*

Minerva directs the Corporation of Dublin past the Temple of Virtue on the road to Fame and Honour; and *Commerce recommending the Manufactures of Ireland to the Lord Mayor of Dublin.*

Apart from St Patrick's Hall, the most famous painted interior in Ireland is the Long Gallery at Castletown (Fig. 227), the work of Charles Reuben Ryley (1752–98) and Thomas Ryder (1746–1810), though his part in the work is unclear. Ryley, an Englishman and pupil of J. H. Mortimer, came to Ireland sometime before 1775 at the invitation of Thomas Conolly, who had come across him working for his brother-in-law, the Duke of Richmond, at Goodwood, Sussex. Ryley's career in Ireland is well documented in the letters of Emily, Duchess of Leinster, where he is described in 1775 by Lady Sarah Bunbury, her sister, as 'little Ryley'. She later adds that 'his taste, his execution, his diligence [and] his price are really a treasure, and will not be met with again'.[82] According to Ann Keller,[83] Ryley probably painted the frieze panels and niches in the Long Gallery, while Ryder did the grotesques flanking the doors and the muse panels in the manner of Raphael. The attribution to Cipriani[84] of the lunette of Aurora after Guido Reni, though of long standing, is not borne out by its quality and it is impossible to be certain of its authorship or even if it dates from the 1770s.[85] Ryley's handling of the decoration in the niches is particularly delicate and it is not surprising that he went on to work for Emily, Duchess of Leinster, at Frascati, Blackrock (now demolished) where he painted in the dining- and drawing-rooms and the circular room, being paid altogether £220 for his decoration and for stucco work.

227 Ryley and Ryder, *Long Gallery at Castletown*, mid-1770s, oil on canvas, Castletown House

228 J. Ryan, *Interior of Belleview, Co. Galway*, mural, from a photograph of *c.* 1860

229 J. Ryan, *Arthur French St George*, oil on canvas, Private collection

The lunette after Guido can be paralleled with the lunettes by Jacob Ennis (1728–70) after Pietro da Cortona's decorations in the Palazzo Pitti in Florence mentioned in chapter 6. This was a surprisingly baroque prototype for a mid-eighteenth-century decorative scheme. The fashion for painted interiors was probably reasonably common at this time. For instance, the second Earl of Aldborough employed the totally unknown Filippo Zafforini (*fl.* 1798–1811), a scene painter and miniaturist, to paint an elaborate series of grisaille wall and ceiling paintings on the staircase, the ballroom, anteroom and library of Aldborough House,[86] Dublin for 30 guineas in June–July 1798. The agreement was dated 12 June and the subjects included the *Lords St Vincent and Duncan on the Great Stairs* and classical subjects like *Achilles' triumph over Hector*. An otherwise unknown artist, Mr Meares, painted a series of famous men including Achilles, Alexander, Caesar, Cromwell, William III, Marlborough and Lord Cornwallis. He appears, from Lord Aldborough's diary, to have been working from March 1798.[87] As the interior of Aldborough House was largely destroyed by fire in 1916, none of this is now evident, but an amusing description survives in a letter by the Countess of Hardwicke, wife of the Lord Lieutenant, who wrote:

> Dublin, 1801. – The Chancellor of the Exchequer carried us lately to see the Dowager Lady Aldborough's house. It is newly finished. '*Otium cum dignitate*' is the motto displayed on the front, and when you enter the *porte-cochère*, another motto tells you to look around and you will find nothing but

beauties. The staircase is richly adorned with paintings. Let one be in your idea a model for the rest. Imagine a large panel occupied by the 'Triumph of Amphitrite', personated by Lady Aldborough in a riding-habit, with Minerva's helmet, sitting on the knee of Lord Aldborough in a complete suit of regimentals, Neptune having politely resigned his seat in the car to his Lordship, and contenting himself with the office of coachman to the six well-fed tritons. The whole corps of sea-nymphs attend the car in the dress of – nereids! But each, instead of vocal shell, bears in her hand a medallion with the picture (the head and shoulders as large as life) of an admiral – wigs, baldheads, crops, etc. Think of a whole mansion decorated in this way! But the unhappy Amphitrite, now in weeds for her lord, has promised at the end of the wretched period of her woe to mount again the triumphal car of Hymen, seated on the knee of the late Lord Mayor of Dublin.[88]

An intriguing naïve provincial decorator was John Ryan (*fl.* 1784–96), who Strickland records as painting on the end wall of the hall of Bellevue, Lisreaghan, Co. Galway a *View of General de Burgh inspecting the Bellevue or Lawrencetown Volunteers at Birr 30 September 1784*. This was signed and dated 'I Ryan inv and pinx 1796'. It included at least thirteen figures and no longer survives, as the house has since been demolished, but an album of old photographs, including views of the interior exists.[89] It must have been one of the most elaborately ornamented houses in Ireland. Colonel Walter Lawrence, the owner of the house, collected many sculptures, including one by Canova, as additional

works of art to display there; he was an early patron of Canova. Apparently Bellevue was also decorated, presumably by Ryan, with other murals after famous Italian compositions, such as the *Rape of the Sabines* by Pietro de Cortona, *Aurora* by Guido Reni, *Romulus and Remus* after Rubens and other mythological subjects (Fig. 228),[90] echoing the work of Ennis. Indeed, one of the grandest rooms was called the Hall of Aurora.

Not far away, in Lisdonagh, near Headford, Co. Galway, there survives a series of crudely painted cardinal virtues in grisaille seated in niches between ionic columns. A similar figure of Temperance is also seen in Bellevue. These are obviously by Ryan, as they are closely related to the Bellevue work and two portraits of members of the St George and Bingham families (on loan, Castletown House; Fig. 229), one of which has an old attribution to John Ryan of 1780.[91] These portraits are amongst the most notable naïves which we have seen. Ryan has two rather distinct manners, one exaggeratedly linear, the other more precise. Another portrait by him which has come to light recently is of Dr Niall, Bishop of Kilfenora, seated at a table in a library with an open book[92] showing an illustration of the Crucifixion. Owing to the penal laws, portraits of the Catholic hierarchy and the priesthood are rare enough in Ireland in the eighteenth century. We should remember, however, Latham's portraits of the Archbishops of Cashel and Dublin, painted at the height of the anti-Catholic legislation.

A far more professional note is struck by the beautiful work of Gaspar Gabrielli at Lyons, Co. Kildare. Gabrielli (*fl.* 1803–*c*.33), probably a Roman, was brought by the second Lord Cloncurry to Ireland in 1805 at the time when Cloncurry was constructing and decorating Lyons at great expense. Gabrielli remained in Ireland for fourteen years, marrying Lady Cloncurry's maid, and during this period served as an important eyewitness at the great 'criminal conversation' proceedings that took place in 1807 between Cloncurry and his wife's lover, Sir John Piers.[93] He painted and exhibited numerous landscapes in Dublin between 1809 and 1814. Some of these are beginning to surface and indicate that he was a fine painter in the Claudean manner on his arrival in Ireland, as seen in his *View of the Campagna*, dated 1805. But he developed a more romantic style, with strong dark atmospheric contrasts, as seen in his *Poulaphouca* in the Graves Art Gallery, Sheffield.

Though some of the Lyons decoration has been painted over, recently a major restoration on the west drawing-room has revealed the ceiling and circular overdoors, showing local beauty spots such as the Salmon Leap at Leixlip, the waterfall at Poulaphouca and the Powerscourt Waterfall. The hall was decorated

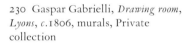

230 Gaspar Gabrielli, *Drawing room, Lyons*, *c*.1806, murals, Private collection

231 Gaspar Gabrielli, *Drawing room, Lyons*, detail, mural, Private collection

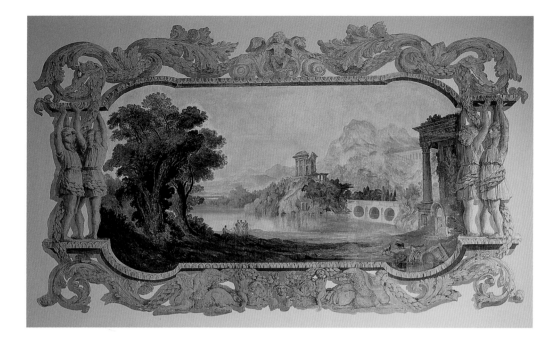

232 Anonymous, detail of mural in a house in Fitzwilliam Square, Dublin, *c*.1830

Tanderagee, Co. Armagh,[95] destroyed as long ago as 1836. Though he had become very much part of the Dublin artistic scene, being Vice President of the Dublin Society of Artists in 1811, he was sent back to Italy in 1819 by Lord Cloncurry to collect works of art and never returned because of his health. He worked in Rome as a dealer and agent for the architect of Lyons, Richard Morrison, sending back chimney-pieces and ornaments for his Irish clients,[96] and he continued to exhibit in England and Ireland and showed views of Killarney to a visitor to Rome in 1819.

The habit of decorating interiors was not unusual in Dublin town houses at this period and a number survive, particularly in the Merrion Square and Fitzwilliam Square area. As late as the 1830s, a very fine scheme, still surviving and recently fully restored, was carried out in Fitzwilliam Square where Italianate landscapes were surrounded by elaborate frames with supporting Atlantes (Fig. 232).[97]

An unusual architectural set of views of the newly recreated baronial Johnstown Castle, Co. Wexford, was done in 1847 for a room in the castle by Edmund Thomas Parris[98] (1793–1873), an Englishman. These survive in a private collection in England and show four views of the castle peopled with figures in Tudor or Caroline costume. This brief description of decorative painting in Ireland may only be an indication that the technique was used quite often. By nature, this art form is ephemeral and is frequently painted out. The fact that it was painted at all suggests that many a patron found it cheaper than collecting and hanging paintings and it formed a dramatic and grand background for rooms of parade.

in monochrome, with a trophy of classical shields and weapons over the chimney-piece[94] and candelabra backed by cross standards set into panels of simulated porphyry. The east drawing-room has exquisite ideal full-length murals signed by Gabrielli and dated 1806, one a direct copy after Claude (Figs 230, 231). Other schemes at Lyons include dancing nymphs and a trellis ceiling above overdoors of the waterfalls. In the dining-room, now obliterated, there were once views, facing each other, of Dublin and Naples Bay.

Decorative work by Gabrielli used to exist in North Great George's Street in Dublin and there was more at

12

After the Act of Union

In 1801, Dublin ceased to be the seat of Parliament and union with Britain was finally brought about. This obviously led to a change in Dublin society, as a great number of the nobility and gentry now regarded London as the seat of power and society. Before 1800, 269 peers and 300 members of Parliament had Dublin houses, but by 1821 there were only thirty-four peers, thirteen baronets and five members.[1] New people were at the Vice-Regal Court and Dublin dropped back into a kind of provincial torpor, kept alive by a thriving professional class. Many of the nobility and gentry retired in disgust to the country and some built themselves splendid houses, partly as a result of receiving liberal compensation from the government for their rotten boroughs and partly because of the buoyant economy, with rising rents due to the need for Irish agricultural produce during the Napoleonic wars. This came to an abrupt halt after Waterloo, 1815. A watercolour caricature entitled *Society 1801* by Caroline Hamilton of Hamwood shows a Dublin card party with everyone yawning their heads off with boredom in a reception room hung with many canvases (Fig. 233). Elsewhere, great houses and great demesnes were starting to decay as their owners settled in England and spent their rents there on London seasons. Auction rooms such as the Gernon family's, Mr Herbert's and John Littledale's were awash with sales of Old Masters and a few modern pictures (see chapter 4), though families usually kept their portraits and views of their houses. Maria Edgeworth paints a picture of these times in her novel *Ennui* (1809). Having described Lord Glenthorn's surprised reaction to the magnificence of the Shelbourne Hotel, once Kerry House, in St Stephen's Green, before the ill-fated union, she continues:

'Ah! sir,' said an Irish gentleman, who found me in admiration upon the staircase, 'this is all very good, very fine, but it is too good and too fine to last; come here again in two years, and I am afraid you will see all this going to rack and ruin. This is too often the case with us in Ireland; we can project, but we can't calculate; we must have every thing upon too large a scale. We mistake a grand beginning for a good beginning. We begin like princes, and we end like beggars.'[2]

This marked lack of optimism contrasts with the brilliant enthusiasm of the 1780s, the period of Grattan's Parliament and the Volunteers. The new middle classes, though they frequently admired pictures, rarely bought them. However, this era saw great impetus given to art exhibitions from 1800 and in 1802 the Dublin Society's new exhibition rooms in Hawkins Street were opened, which were very impressively described by the unknown diarist:

Strangers are brought into a fine Gallery, of great length principly intended for sculpture and furnished with a large number of casts from the most celebrated Busts and Statues The pupils of the figure academy are at work in this Gallery sketching from the sculpture, ... beyond the museums a superb apartment of great extent and very judicious contrivance is finishing for the annual exhibition of the arts.[3]

New art societies formed and reformed themselves with bewildering monotony; for instance, the Society of Artists of Ireland, founded in 1800, divided in 1812 into the Irish Society of Artists and the Society of Artists of the City of Dublin, later to amalgamate in 1814 into the Hibernian Society of Artists, only to disagree and divide in 1815 into the Artists of Ireland and the Hibernian Society. In 1816, there was a coalition which held until 1819, after which no exhibitions occurred until the first RHA show in 1826. Exhibitions were, however, held annually from 1800 to 1819, except between 1805 and 1808.[4] The Royal Hibernian Academy was preceded by the Royal Irish Institution, which aimed at forming an academy. Like

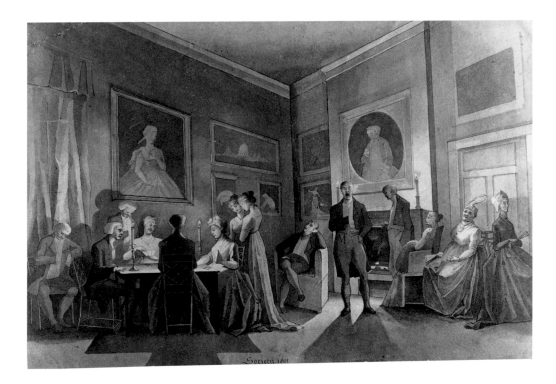

233 Caroline Hamilton, *Society*, 1801, watercolour, Private collection

234 Royal Irish Institution, engraving

the British Institution, it exhibited Old-Master loans in a series of annual exhibitions from 1814 to 1818, but had a long lapse until 1829 because the Hawkins Street gallery was closed. No suitable premises could be found until a fine neo-classical exhibition room in College Street was built. This was demolished when the Munster and Leinster Bank built its grandiose Banking Halls in the 1860s. A view of one of the Institution's exhibitions shows the room,[5] lit by a lantern, to have been quite small, and the print illustrates a number of people copying the old masters as well as viewing them (Fig. 234). Subscriptions were liberal, from the Prince Regent's £200 to various

Lords Lieutenant who gave £100, and a large number of peers and gentlemen giving anything from £56.17.6 to the usual contribution of £11.7.6. As far as one can judge, all Ireland's *cognoscenti* contributed and exhibited, and by 1832 the preface to the catalogue remarked that they were surprised that 'Ireland possessed a much greater number of the true and genuine works of the great masters of the art of painting than was generally believed'. This exhibition of Old Masters was a new departure which was maintained later in the century by the great exhibitions held in Dublin and in Cork from 1853 onwards. The Institution faded away in the 1830s and was dealt a death blow by the establishment of the Royal Irish Art Union in 1840. The habit of holding a one-man show was growing – Robert Hunter had held one in 1792, Thomas Sautell Roberts in 1802 and William Ashford in 1819. The Cork Society for the Promoting of the Fine Arts was founded in 1816 as a result of the first art exhibition entitled *The First Munster Exhibition* which had been held the year before, 1815; in emulation of the Dublin 1814 exhibition, it included old masters as well as modern works. Through the good offices of Lord Listowel, a friend of the Prince Regent, the Cork Society acquired from George IV a fine collection of antique casts (Crawford Art Gallery, Cork) given by the pope to George III. Gradually, a School of Art developed out of this fine teaching tool.

The Royal Hibernian Academy,[6] which was to have an extremely stormy history, was granted a charter in principle in 1821 but, due to lack of funds, this could not be drawn up until 5 August 1823, when the Royal Irish Institution came to the rescue and paid the necessary £300 to enable it to be incorporated. The first President was William Ashford; Martin Cregan was the Secretary; Francis Johnston, the architect, was Treasurer. There were to be fourteen members and ten associates. Of the first members, Martin Cregan, William Cuming, John George Mulvany, Thomas James Mulvany, Joseph Peacock, Thomas Sautell Roberts, Thomas Clement Thompson, Robert Lucius West and Solomon Williams were the painters. The first exhibition was held in 1826 and RHA annual exhibitions continue to the present day. Though most of the pictures exhibited were by Irish artists, some were by Englishmen. As a result, in 1842 some patriotic figures founded the Society of Irish Artists, who only showed native and resident talent. Its last exhibition was held in 1847 and the Society came to an end two years later.[7]

The Royal Hibernian Academy's first Secretary, Martin Cregan (1788–1870) had a romantic start in life. He was born in Co. Meath and brought up by foster parents whose name, Creggan, he adopted, later altering it to Cregan. He entered the service of the Stewarts of Killymoon, Co. Tyrone, who recognized his talents and sent him to the Dublin Society Schools, where he won medals in 1806 and 1807. He was sent to

London, still financed by the Stewarts, and became the only pupil of Martin Archer Shee. Cregan exhibited at the RA from 1812 to 1821 and while in London, according to Strickland, became a friend of Constable, Hayter and the young Landseer. He returned to Dublin in 1823 and contributed twenty-six portraits to the first RHA Exhibition in 1826. He was an immensely successful and prolific portrait painter, who exhibited no less than 334 pictures in the RHA, of which he was President between 1832 and 1856. His retirement was by no means total and he continued to paint until the end of his life and, according to Strickland, was working on an altarpiece at the time of his death. To our eyes, he was a workmanlike painter whose male portraits are often tedious, while his females are bright and fashionable, although frequently rather sloppily painted and sometimes boneless. His three-quarter-length portrait of Isaac Weld (RDS)[8] holding an engraving from one of his travel books shows Cregan at his competent best. Weld was honorary secretary of the Royal Dublin Society between 1828–49 and Vice President until his death in 1856. Cregan's small-scale family group of Francis Johnston, his wife and two nephews (Fig. 235) was exhibited in 1827 and, like his small whole-length of the landscape gardener at Shane's Castle, John Sutherland (Fig. 236),[9] painted in 1822, is among his most successful works. Two small drawings of children of the Pakenham family show his considerable abilities as a draughtsman. However, his anatomy is weak (see, for example, his portrait of General Sir Edward Michael Pakenham of New Orleans fame). A much finer example is his three-quarter-length of Hugh Percy, third Duke of Northumberland, Lord Lieutenant in 1829–30, wearing the Order of St Patrick and its ribbon (Dublin Castle).[10]

A better painter was William Cuming (1769–1852). Although he held no office in 1823, he was President of the RHA from 1829 until his retirement in 1832. His interest in art was aroused as a child by visits to the workshops of coach- and herald-painters near Moore Street, where he lived. He went to the Dublin Society Schools in 1785, at a time when his earliest biographer, writing in the *Hibernian Magazine* in 1811, said 'the reputation of Stuart, De Gray [*sic*], and Hamilton, was, at that time in its full vigor'.[11] Strickland thinks that he was the Cummins who exhibited 'bas reliefs in the style of de Gree at Ellis's 'Museum' in Mary Street in 1792. A year later, he was commissioned by the corporation to paint the late Lord Mayor, Alderman Sankey and soon after had a number of commissions to paint such figures as Lord Charlemont. He also completed the portrait of James Gandon, the head of which by Tilly Kettle we have already mentioned.[12] This cannot have been completed until the 1790s, as it shows Gandon holding a drawing for the Four Courts, not commissioned until 1785, and has the completed Four Courts and Customs House in the background. By 1800, when his work was first exhibited, Strickland says that he was acclaimed 'as a very rising genius'. One of his exhibited pictures was a portrait of the artist, Vincent Waldré (NGI),[13] which is painted with considerable bravura and clearly shows the influence of Chinnery, who was in Dublin at this time. The hot colouring is particularly close to Chinnery's portrait of Colonel Vallancey in the RIA. One of his finest known works is a whole-length of a Dublin lord mayor, now in the Chicago Art Institute.[14] It is a formal and authoritative work, with his chain of office and mace lying on a cushion and his sword leaning against the pedestal of

235 Martin Cregan, *Francis Johnston, his wife and two nephews*, c.1827, oil on canvas, Private collection

236 Martin Cregan, *John Sutherland*, oil on canvas, Private collection

237 William Cumming, *Duke of Richmond*, oil on canvas, Mansion House, Dublin

238 William Cumming, *Mrs Reeves*, oil on canvas, Private collection

the figure of Justice that appears to the right in the City of Dublin's arms. It is uncertain which lord mayor it represents, but the most likely is Charles Thorpe, the well-known stuccadore, lord mayor 1800–1, whose portrait he exhibited in 1802 in the Society of Artists exhibition. He exhibited another portrait of Thorpe two years later in 1804, also in the Society of Artists. This shows Thorpe standing by a gilt table on which the mace lies while various books and papers are leaning on the table leg and scattered about. It is a less regimented portrait than the other. His full-length picture of the Duke of Richmond, the Viceroy, in the Mansion House is another spendidly pompous state portrait (Fig. 237), fluently handled, showing him in his peer's robes and ducal coronet. It is signed and dated 1813 and includes an Irish harp with its Hibernia fully breasted. He had painted the Duke of Richmond some years earlier for Dublin Castle, a three-quarter-length, equally strong and honestly conceived.[15] A previously unattributed work in the NGI, of Sir Neal O'Donnel and three of his grandchildren, must be the painting exhibited at the Society of Artists in 1811. It is a charming and affectionate whole-length conversation piece. Earlier, Cuming had attempted subject pictures, showing a *Brutus after the Battle of Philippi* in London and again in Dublin in 1801 and a *Christ and the Children of Zebedee* which was engraved for Macklin's *Bible* in 1798. He also seems to have painted at least one panorama of the encampment on the Curragh of Kildare with portraits of Lord

Hardwicke and the general officers, though it is not certain if it was completed or even wholly executed by Cuming. He did, however, exhibit an allegorical transparency 'at the Royal Exchange, at the celebration of the late Jubilee' of George III in 1810.[16]

An old attribution to Cuming of a portrait of a Mrs Reeves shows him in a more intimate mood, painting a sympathetic elderly lady (Fig. 238). Again, it is a picture much influenced by Chinnery. In 1811, he became President of the short lived Society of Artists and his fashionable career was crowned by his presidency of the RHA. He was not a prolific painter and by no means sustained high quality throughout his *œuvre*. Many pieces are pot-boilers, such as the dismal array in the Common Room of Trinity College. His retirement from painting in 1832 seems to have been complete, though he did not die for another twenty years. Cuming had a small private income and after his retirement he visited a brother who had plantations in the West Indies. He also, according to Strickland, visited the continent quite frequently and had a brother who lived in Versailles.

Cuming had one very distinquished student, Charles Cromwell Ingham (1796–1863), who spent four years with him after he left the Schools, where he was admitted in 1809, winning prizes in 1810 and 1811. While with Cuming, he exhibited portraits and subject pictures in the Hawkins Street Gallery, including *The Death of Cleopatra*, for which he won £34.2.6. from the Irish Institution and which he took with him when he went to America. In 1816, his family emigrated to New York, where he made his career, becoming a founder member of the National Academy of Design in 1826, and exhibiting his *Cleopatra* in its first show. His highly finished style was particularly successful

239 Charles Cromwell Ingham,
Amelia Palmer, *c.*1829, oil on canvas,
The Metropolitan Museum of Art,
New York

with fashionable ladies and with children. Alfred
Gardner notes that Ingham's style was quite different
from most American portrait painters and that it con-
sisted of 'laborious glazings and minute attention to
textiles and details ... his paintings of flesh often look
hard, like polished ivory and his colour schemes some-
times got out of hand'.[17] Gardner continues in a purple
passage noticing 'their wardrobes of Parisian splen-
dour; their elaborate coiffeurs, their rich shawls and
silks, their snowy, domed brows, their limpid orbs,
their rosy cheeks, the sweet, subtle, melting plumpti-

tude of their arms, wrists, throats, and bosoms; ... the
grave flowerlike innocence of childhood; all these
things tempted Ingham's brush and kept him steadily
at work, happily chained to his easel, for almost fifty
years'. He exhibited over 250 paintings in New York
between 1816 and 1863.

Unlike some authorities, we do not consider that
his work looked like Sir Thomas Lawrence, but with
its very clear outlines, it has quite a strong look of
Ingres. Notable portraits include *Amelia Palmer* (Fig.
239) holding a bonnet full of flowers, stepping out of a

240 Charles Cromwell Ingham, *The Great Adirondack Pass*, oil on canvas, Adirondack Museum, Blue Mountain Lake, New York

241 Sir Martin Archer Shee, *W. T. Lewis as the Marquis in 'The Midnight Hour'*, oil on canvas, The National Gallery, London

beautiful landscape. Some of his subject pictures were done on a scale close to miniature[18] and he sometimes painted landscapes such as his attributed *Great Adirondack Pass*, 1837 (Fig. 240). Ingham's surviving sketchbook in the National Academy of Design, New York, dating from between 1820 and 1836, includes drawings in memory of Robert Emmet and architectural and landscape sketches, including one of a famous hotel in the Catskill Mountains. His *Warrior of the Last Judgement*[19] (New York Historical Society) was a remarkable watercolour and it is not surprising that he was a founder member and first President of the Artists' Sketch Club 1829 and of the Century Association, 1847, New York's most famous intellectual and learned gentleman's club, which still flourishes. He did not forget his home country and exhibited twice in the RHA, in 1828, sending a portrait of R. Cuming, and in 1842, *A Portrait of a Lady*.

The son of an impecunious Catholic county family, Martin Archer Shee (1769–1850) was brought up near Bray by an aunt, his mother having died when he was twenty-two months old, and his father, a merchant, having gone blind when Martin was fourteen. In his early boyhood, according to his son's biography, he saw some Dutch tiles in a fireplace illustrating the scriptures.[20] Copying these from memory aroused a passion for drawing. He went to the Dublin Society Schools when he was fourteen to be taught by Francis Robert West. He won many prizes, and by the age of sixteen was well known for his portraits in crayon, though he started painting in oil before he left Dublin. After he left the Schools in 1786, the Dublin Society presented him with a miniature silver palette which bore an inscription expressing their admiration for his draughtsman-

ship.[21] Urged by his many friends, including Gilbert Stuart, he went to London in 1788 with letters of introduction to Reynolds and Barry. Barry treated him with his usual lack of interest, Reynolds with perfunctory politeness. Burke reintroduced him when Reynolds advised attendance, somewhat to Shee's surprise, at the RA Schools, which he entered in 1790. The influence of both Reynolds and Stuart is strong in his early work, especially in his self-portrait of 1794–5 and in *Captain William Moore*, which dates from between 1794 and 1798. An even earlier portrait also shows the same influence of Reynolds and Stuart, though he had also seen and learned from the young Lawrence. It is a full-length of the actor William Thomas Lewis, and the painting is entitled *Mr Lewis as the Marquis in the 'Midnight Hour'* (Fig. 241).[22] Shee painted it for himself, as he was fascinated by the theatre and painted many actors and actresses. It was exhibited at the RA in 1792 with six other works when the artist was aged only twenty-two. In his charming group of the Annesley children (NT, Bearsted Collection), he seems to have been looking at Matthew William Peters's *Two children with a Jay in a Cage*.[23] *The Upset Cart* (Fig. 242), recently on the London art market, is a charming portrayal of a two-year old and has hints of Copley. In fact, Shee was a first-class painter of children, including his own family.

Shee was a friend of Hoppner, whose portrait style his own sometimes approaches. Farington refers to

time. He painted with a pleasing, although sometimes redundant, glow of colour; but his works are deficient in depth and force, and lack variety of expression and treatment.[26]

His list of sitters in Strickland is enormously long and includes a number of Irish people in the glittering roll-call of the British aristocracy. Shee's career was crowned in 1830 when he succeeded Lawrence as President of the Royal Academy. Though he does not seem to have practised latterly in Ireland, he always retained an interest in his home country and was involved in the negotiations which preceded the founding in 1823 of the RHA where he exhibited on several occasions.[27] He was the author of a number of books of poetry and art criticism and suffered as much as he gained by the prolixity of the two-volumed hagiography written by his son. He was, however, honoured by Byron, who described him as 'The Poet's Rival, but the Painters Friend'.[28]

242 Sir Martin Archer Shee, *The Upset Cart*, oil on canvas, Private collection

243 Sir Martin Archer Shee, *Self Portrait with Andrew Ellis Ellis*, 1816, oil on canvas, Private collection

Turner speaking of 'the inferiority of Shee's portraits of women', calling them 'flimsy' in comparison to the 'vigour' of his men.[24] Shee certainly gives his male sitters a solid presence, as in his *First Marquess of Exeter*, for which he charged £53.11s. 0d. in 1802.[25]

He exhibited in the RA from 1789 and in fact made rapid progress, becoming an ARA in 1798 and an RA in 1800. Although nowadays considered only as a portrait painter, like most other artists he painted a number of subject pictures on Shakespearean, biblical and classical themes, like his *Ariadne deserted by Theseus*, 1834 (Glasgow Art Gallery). His RA diploma work was afterwards damaged and he substituted *Belisarius* for it in 1808. The head is a striking study, but the rest is weak. A portrait of a countrywoman, taken from a character in Thompson's *Seasons*, *Lavinia*, which he exhibited in the RA in 1808, is a simple and realistic study and a contrast to his sometimes portentious aristocratic sitters. *Lord Monteagle*, 1833 (Limerick Chamber of Commerce) is a typical example. However, the composition of his grand portraits – and he was especially good on a large scale – is always well sustained and he handles the columns, drapery and impressionistic landscape backgrounds with a panache that is very akin to Lawrence. The 1816 double portrait of himself talking to a city man, *Mr Ellis Ellis* (Fig. 243), is one of his finest compositions, and his highland portrait of James Munro Macnabb shows him at his proud best. William Sandby sums him up extremely well when he says:

His figures have an air of ease and nature, combined with refinement; but there is a deficiency of intellectual expression and character in them, although his pencil has undoubtedly preserved to us the best portraits of the most eminent personages of his

244 Thomas Clement Thompson, *Self Portrait*, c.1820, oil on canvas, Private collection

245 John Comerford, *Mrs Dobbyn*, oil on canvas, National Gallery of Ireland, Dublin

246 Henry Kirchhoffer, *Mrs Francis Johnston's garden in Eccles Street, Dublin*, oil on canvas, Private collection

An extraordinarily prolific painter was Thomas Clement Thompson (*c*.1780–1857), who was from Belfast, though he was educated in the Dublin Society Schools, entering in 1796. He started work as a miniature painter in the manner of Comerford, showing in the various Dublin exhibitions. After 1809, however, he turned entirely to oils and after 1817 made his home in London and later Cheltenham. He exhibited regularly in the RA, the British Institution and the RHA, of which he was a founder member. His subjects include everybody from Catholic bishops to Church of Ireland parsons to actresses such as *Elizabeth O'Neill*, later Lady Wrixon Becher (NGI), to many members of the Irish and English peerage and gentry. For the most part, they are solid, though uninspired, portraits and many are influenced by Lawrence. His self-portrait (Fig. 244) is one of his most striking studies and shows him painting George IV. Two large pictures of the *Arrival of the Monarch at Howth* and another enormous study of the *King leaving Kingstown*, both from 1821, are ambitious if not entirely successful compositions. His subject and religious pictures are rarely met with and from the only example we know, *Our Lord in the House of Martha and Mary*, are painfully sentimental and poorly drawn.

According to 'B', Cuming had a fellow student at the Dublin Society's Schools, John Comerford.[29] His training was in the Schools (1789–91), where he won a medal in 1790. Caffrey[30] suggests that it was after he returned to Kilkenny that he painted in Kilkenny Castle, making

a number of copies of Ormond portraits. He put an advertisement into the *Leinster Journal* for 29 June 1793, when he announced his arrival in Kilkenny from Dublin as a 'portrait painter in oils' and he advertised himself again in 1797 as he had once again been visiting Dublin. He was influenced early in his career by Gilbert Stuart, who left Ireland in 1793, but his portrait of Thomas Braughall (RDS) is based directly on Reynolds's portrait of Joseph Baretti squinting at a book close up to his eyes. Comerford's sitter, who was intimately involved in the Dublin Society and its Schools, is attempting to read a book concerned with them. In 1800, Comerford sent two miniatures to the Society of Artists of Ireland exhibition at Allen's in Dame Street, which were his first works seen in Dublin. He settled there in 1802, at the persuasion of George Chinnery, whom he had met in 1795. The influence of Chinnery, particularly his *Mrs Eustace*, is seen in Comerford's portrait of *Mrs Dobbyn* in the NGI (Fig. 245). He was always particularly good at portraits of old ladies; as early as 1794, he had painted a vivid likeness of his relative, *Miss Jane Langton* of High Street, Kilkenny.[31] Early in the nineteenth century, he foresook life-size painting for miniatures, but was enormously successful, as Mulvany says:

> although of sufficiently prudent turn of mind to amass a very handsome fortune, having left, it is said, £16,000 after him, [he] still enjoyed the fruits of fortune during his life, and, as easy circumstances rendered too great devotion to his profession unnecessary, he delighted to relax in the society of his friends, among whom were included all the distinguished artists of the day[32]

He was violently opposed to the foundation of the RHA, of which therefore he did not become a member.

In 1822, however, he painted a memorable miniature of William Ashford, its first President (NGI).[33]

Another miniaturist who turned later to oils was Henry Kirchhoffer[34] (1781–1860), whose works are very rare. He was born in Ireland but descended from a Swiss family. His father was a cabinet-maker in Dublin, and the family were in the timber trade. He trained in the Dublin Society Schools and became the first Secretary of the RHA, between 1826 and 1830. From the subjects of his exhibited works, it seems he travelled widely in the south of Ireland and by 1815 seems to have spent some time in Scotland and Wales. A *View of Edinburgh* is known, and a Vernet pastiche of Martello in Corsica with shipping and a rising moon is signed and dated 1829. This is probably the painting entitled *Coast scene, smugglers* (Dublin Castle) exhibited in the RHA in that year.[35] Kirchhoffer also travelled in the south of England, having gone to live in London in 1835. His exhibited portraits are noted as watercolours and were presumably miniatures, one surviving signed example (V & A) shows the influence of Frederick Buck of Cork. His *View of Mrs Francis Johnston's Garden in Eccles Street from her Dining Room*, exhibited in 1832, shows considerable charm and ability (Fig. 246). A very detailed drawing for this also exists. He is mentioned by the Unknown Diarist in 1801–2 (RIA), whose miniature portrait Kirchhoffer painted. The diarist also took lessons from the artist and records his methods.

Small whole-length portraits in pencil, crayons and watercolour became very popular in the early nineteenth century. Most of the practitioners were also miniaturists and the leading Irish painters of this genre were Adam Buck, brother of the above-mentioned Frederick, and Alexander Pope. Buck (1759–1833), the son of a Cork silversmith, seems to have practised in Dublin, mostly as a miniature painter, before he went to London in 1795. From this period, we are only familiar with the delightful oval group portraits of the Edgeworth and Kingston families, the former of which is dated 1787,[36] and both prove his excellence in painting profiles in watercolour and pencil. Richard Edgeworth, writing to Lady Granard in 1787, wrote perspicaciously about the picture:

> We have lately had a man of genius in the art of painting upon a visit in this country. I should rather say, in the art of taking portraits, which can scarcely be called the art of painting. He has taken a group of my family (nine children) in Swiss crayons which admit of no erasure or alteration, and has given most striking likenesses of every one of them. Your Ladyship perceives that, if it were a single head or perhaps two, he might throw aside one attempt and make another. But where so many are united, the difficulty increases[37]

From 1795 on, he had a very successful career in England and only once exhibited in Dublin in 1802, though a number of Irish sitters are recorded. In 1812,

he worked on a book, which was never published, on Greek vase painting from examples collected by Thomas Hope of Deepdene. Some 157 pen, ink and wash drawings for the project were made (TCD manuscript library) and thirty-four etchings made from them. A number were signed 'Drawn, etched, and published, March 31st, 1812, by Adam Buck' and a prospectus had been issued in 1811, but the complete book never saw the light of day. This interest in Greek vases pervades his whole work and can even be seen in the Edgeworth and Kingston family groups, with their figures silhouetted against a black background. In most of his works, he eliminates background detail, as far as possible, and the neo-classical costume of the Regency period, combined with such articles as 'klismos' chairs, helps to maintain the 'antique' illusion. His self-portrait with his family, dated 1813, is his masterpiece (Fig. 247).[38] He was also well known for his sentimental genre engravings, which are derivative of Flaxman. Their sentimental titles bring us into the new century; *Mama, let me not beg in vain!*; *My dear little Shock, you must have a dip!*; *Have I not learned my book, Mama?*; and *Come father's hope, come, mother's glory, and listen to a pretty story*. He was also engaged in fashion drawing and was much influenced by Thomas Hope's *Costume of the Ancients* of 1809 and *Designs of Modern Costume* in 1812.

247 Adam Buck, *Self Portrait with family*, watercolour, Yale Center for British Art

Adam Buck's brother, Frederick (1771–1840), worked as a miniaturist in Cork, a good trade during the Napoleonic wars as so many officers left Cobh and sent their miniatures back as a memento to their loved ones. Robert Gibbs was a contemporary, recorded in Patrick Street in Cork in 1810. He painted small whole-length portraits in oil. One, a particularly charming likeness of a seated lady in a straw hat (NGI), is signed and dated 1818. Others can be attributed from this. A painting of a totally different nature is a group of horrified onlookers watching a shipwreck. His drawings of Kilkenny and Tipperary antiquities were done for the architect William Robertson, who intended to publish them.[39]

More eighteenth-century works survive by Alexander Pope (1763–1835) than by his almost exact contemporary, Buck. Pope's development can, therefore, be more easily traced from the typical Dublin Society pastel portrait to watercolours of the Buck neo-classical type. He was the youngest member of the Pope-Stevens clan (see chapter 6) and studied at the Dublin Society Schools, entering in 1776, and was later a pupil of Hugh Douglas Hamilton, presumably in London. His earliest surviving productions, two crayon portraits of an officer and his wife, are signed and dated 1781, the year he went to Cork, where he charged an Irish guinea (£1 2s 9d) for taking a likeness. These works are imitations of Hugh Douglas Hamilton and vary very much in quality. His rather

later pair of *Mrs Siddons* and *Mr Kemble* (Royal Collection) date,[40] presumably, from 1785, when he sent a *Mrs Siddons* to the Royal Academy. These are much more accomplished and show the figures half-length. By this date, Pope was already acting himself, mostly on the London stage, but he continued to paint pictures, frequently of theatrical sitters. His style changed completely in the early nineteenth century, when he turned to the small whole-lengths in watercolour in the Buck manner. His *Lady Frances Ducie* is a good example, showing his greater interest in architectural settings. He was a *bon viveur* and a hospitable man who entertained and encouraged the young Martin Archer Shee[41] when he first went to London.

Robert Lucius West (1774–1850),[42] the third and last of the West teaching dynasty, was also a painter of small whole-lengths both in oils and in crayon. There are four portraits by him in the NGI, two copies after Reynolds. Though said to be less distinguished than the rest of the family, his bravura oil portrait of *Commander Urmston*, signed and dated Dublin 1817, is a fine example of this type of work, with a fluidly handled coast scene in the background. Another is probably of William Hume MP, which appears to be later but has the same informality, if not the bravura, and is very elegantly posed in a landscape (Fig. 248). A large full-length of *Alderman Richard Manders*, Lord Mayor of Dublin 1801–2, which is in the Mansion House in Dublin is listed in the Corporation Records as by 'West'. It is totally in the Hamilton manner and may represent a logical Hamilton stage in Robert West's development, though at the moment no other work is known to us to support the attribution. The similarities between West and Cuming's official portraits, both heavily dependent on Hamilton, make the attributing of these pictures rather uncertain. A superior version of this Manders picture has been on the London art market and is now in an Irish collection. It is very close to Hamilton. From the RHA catalogues, it appears that in his later career West painted many landscapes in various parts of Ireland and in Scotland. Of greater interest is the quantity of religious pictures in several cases identified as 'for altarpieces', which he exhibited. In 1826, there was a *Christ upon the Cross*, and a *Crucifixion* and three other *Crucifixions* in the ensuing three years. All just predate Catholic emancipation, when many churches were being planned and built. Other religious subjects are also mentioned but, as with the landscapes, none of these are known to us as yet. A genre picture of *A Dispute over cards*, signed 'R West', is known. It is drily and competently painted in the obviously Dutch mode.[43]

A pupil of West, Thomas Foster (1798–1826) educated at the Schools from 1811, winning a premium in 1812, and another from the Irish Institution for £34 2s. 6d. None of his subject pictures or religious works survive but a number of portraits are known of the Earls of Rosse and their family. He charged a surpris-

ingly large sum of £100 for a whole-length, £50 for a Bishop's half-length and £20 for a Kit-Kat. The interest of this artist is due to a recently found album of biographical material which adds greatly to our knowledge of the artistic world of his period. He sadly committed suicide for love of an actress.[44]

George Grattan (1787–1819), who contended unsuccessfully with West for the mastership in the Schools in 1809, is best treated here. He was one of the Society's most promising pupils, winning prizes regularly for a variety of skills, including landscape painting and modelling. He is also known to have drawn crayon portraits and topographical views for the engravers. Two watercolours in the NGI, *A Country Dance*, in the Morland manner, and *A Pilgrim Kneeling in front of a Crucifix and a Pile of Bones*, in the style of Salvator, show considerable competence. An oil genre scene of *A Labourer's Return* shows the daughter unlacing his leggings, a motive directly borrowed from Morland. Another watercolour dependent on Morland, called *Feeding Pigeons*, is a signed work.[45] But his best-known painting is a large oil, *The Blind Beggarwoman and Child* of 1807 which was bought by the RDS for £105 (Fig. 249). It is a broadly handled, realist work which promised well for his chosen career as a subject-picture painter. He visited London and exhibited there in the RA and British Institution, but poor health brought him to an early death in 1819. His brother, William Grattan (c.1792–c.1821),[46] is only known to us by one very fine watercolour of a labourer. A visiting artist who worked very much in the manner of Buck and Pope, but in oils, was Maria Taylor (1777–c.1823), the daughter of the English engraver, Jonathan Spilsbury. She came to Ireland sometime after her marriage to one John Taylor in 1809. However, she may have visited Ireland in her teens in 1795. In that year, her uncle, John 'Inigo' Spilsbury who was also an engraver, and had taught at Harrow School, was engaged by the Tighes of Rosanna, Co. Wicklow (Mrs Tighe was the heiress to Woodstock, Co. Kilkenny) to teach their family, including Caroline Hamilton, at the very generous salary of £300 a year. Maria had exhibited at the RA between 1792 and 1794 and again in 1799–1808; this gap between 1794 and 1799 may well indicate that she was in Ireland with her uncle. Later, she exhibited at the British Institution, from 1806 to 1813. Her engraved works, like Buck's, were thematic, *Going to School*, *Reading*, *Singing* and a series of four prints showing the abduction and return of a child taken by gipsies. In Ireland, she exhibited at the Hibernian Society in 1813 and 1814 and was responsible for a number of small portrait groups and single small figures in oils. These, which are met with frequently, include the group of the Tighe children in the panelled drawing-room at Rosanna; a group of the Trench children with their grandmother and one of the Hervey family where the children are gathering apples. Her portrait of *Mrs Henry Grattan* (NGI), of

249 George Grattan, *Blind beggar woman with child*, oil on canvas, Royal Dublin Society

which there are several versions, and of *Francis Synge of Glanmore*, a neighbour of the Tighes, are typical of the small whole-lengths. Synge is seated in his study where an oil painting of his new baronial castle is proudly displayed above him. His portrait of the younger *Henry Grattan* in his Gothic library is strangely elongated. But usually her portraits are delicately handled, with great interest in the interiors and furniture and curtains.

She exhibited a number of religious works, the only one known to us, in reproduction only, is a vision of *The Ascension of the Innocents* where the sky is filled with music-making angels welcoming the babies above an imaginary view of, presumably, Bethlehem. However, Maria Taylor's most exciting works are her genre pictures, such as her masterpiece, *The Harvest*

250 Maria Spilsbury Taylor, *Harvest Dance at Rosanna*, oil on canvas, Private collection

251 Maria Spilsbury Taylor, *Pattern at Glendalough, Co. Wicklow*, oil on canvas, Private collection

families playing has considerable charm. Other excellent examples of this type of work are her three versions of *The Pattern at Glendalough* (Fig. 251),[47] one of which she exhibited in Dublin in 1816. She leaves out the more unpleasant features of this religious folk festival such as the faction fighting which Joseph Peacock puts in his version of the scene (Fig. 252). But her versions include many charming vignettes: a lady painting, possibly a self-portrait; boys playing dice on a grave slab while elderly mourners visit graves, making a contrast of youth and age suitable for a graveyard; rows of pilgrims and some elegant figures giving alms. The Irish Folklore Commission version emphasizes the round tower and concentrates on the tented stalls and booths of the fair. At times, Taylor's work looks like a genteel version of George Morland's pictures of rustic life, but her *Schoolmistress* shows children of more polite circles. Her interest in everyday people developed while she is in Ireland.

A number of recently discovered sketchbooks by Maria (NGI) are of enormous social interest and included sketches for the Glendalough and Rosanna paintings as well as detailed interior backgounds of Rosanna and Woodstock. There are also numerous studies of a beggarman, estate workers and household staff, as well as gentry. She even portrays a survivor of the 1798 rebellion who had attempted to murder Mr Tighe. There are landscapes of parks, *cottages ornées*, villages and of children being taught to make lace, as well as the Pestolozzian school established by John Synge of Glanmore. This school also exists as a finished drawing.[48] The studies are all treated with a sincere immediacy and quick observation, which make these sketchbooks stand out as being a most valuable pictorial record of country life in Ireland during the first decades of the nineteenth century.

Another notable genre painter, was Joseph Peacock (c.1783–1837) who described himself as a 'Familiar Life and Animal Painter'. We know no horse paintings by him. Strickland said he was a copyist and much influenced by Dutch art, particularly work by Teniers, which is supported by his exhibits to various Dublin exhibitions between 1809 and 1835 and by a fine copy after Reynolds's portrait of *Provost Hely Hutchinson* (TCD). We have no knowledge of where he was trained, but he was a founder member of the RHA. One small whole-length of *Alderman John Alley, Lord Mayor of Dublin 1817–18* is known and was exhibited posthumously in the RHA in 1826. It shows the sitter standing in an imaginary grandiose architectural background, with an opening on the right showing the statue of George II on St Stephen's Green. Peacock's real importance lies in three paintings, all of contemporary events. His *Palmerston Fair*, exhibited in 1811 at the Society of Artists of Ireland, is in the tradition initiated by Francis Wheatley. In the words of *The Freeman's Journal*, 15 April 1811, it includes 'by at least one thousand figures all the incidents to be met with in such scenes of variety and merriment'. The second,

Dance at Rosanna (Fig. 250). Here, a group of musicians and an uileann piper are playing for dancers dressed in sheaves of corn while the estate tenants look on and the gentry gather at the Venetian window of the house to enjoy the revelry. A view of the interior of the Rossanagh Drawing Room with the Tighe and Kelly

which is a major *tour de force*, is *The Pattern at Glendalough* (Fig. 252), exhibited in 1813. The landscape background overshadows the tiny figures and the round tower has achieved gigantic stature. These pictures show Peacock's extremely sharply observed, miniaturelike technique and are a mine of information on all the folk artefacts they portray.[49] These include a hardware dealer selling pottery, cooper's ware, kettles and candlesticks; nearby is a toy stall; hats are being sold; and, of course, a blind fiddler plays for a singer selling broadsheets. In the background is a vigorous faction fight in full swing, a piece of realism evidently not to the taste of Maria Taylor. The rumbustious behaviour at fairs and patterns led to their suppression, and the Glendalough pattern was abolished in 1862 by the hierarchy. The third example moves us to the realm of high life with the *Installation of a Knight of St Patrick in St Patrick's Cathedral, 1819*.[50] The knight is Lord Sligo and Peacock handles the Gothic architecture and the robes and fashionable audience both in the choir stalls and in the galleries with a miniaturist's technique. Peacock also painted religious and history pictures. It is amazing that the artists of this period all painted religious pictures but virtually none of them have yet come to light. In view of the extensive lists of exhibited pictures still extant, we at least know they once existed.

The genre of the small whole- and half-length was continued into the Victorian period in watercolour by a highly proficient artist, Edward Hayes (1797–1864), who came from Co. Tipperary. A product of the Dublin Society Schools, he was also a student of Joseph Alpenny. Starting work as a miniature painter, he described himself in *Saunders' Newsletter* of 12 September 1831, as 'Late Professor of Drawing at the Abbeyleix Institute, the College of Kilkenny and the Ursuline Convent, Waterford'. He exhibited at the RHA between 1830 and 1864, becoming an ARHA in 1856 and then RHA in 1861. His watercolours vary from a great many military portraits and illustrative genre subjects, landscapes like *The Old Bridge at Milltown* (NGI) or a gentleman's seat, *Clonearl, Co. Westmeath*, to his charming 'keepsake' style of fashionable ladies and their children, in the manner of A. E. Chalon. *The Babes in the Wood*[51] is a good example of what we think is his late manner and shows a vortexlike composition surrounding the pathetic infants.

A foreigner, whose small-scale portraits and conversation pieces in crayons are found all over the country, though most frequently in the North, is Felice Piccione (*fl.* 1830–42) and another who worked in this vein was Robert Richard Scanlon[52] (*fl.* 1826–76), though he used watercolours. We touch on Scanlon again in chapter 13.

252 Joseph Peacock, *The Pattern at Glendalough, Co. Wicklow*, 1813, oil on canvas, Ulster Museum

253 Samuel Lover, *The Kelp Gatherers*, oil on canvas, Department of Irish Folklore, University College, Dublin

The oil portraits by William Brocas (*c*.1794–1868), which are frequently small whole-lengths set in landscapes, parallel Hayes's style and we shall be discussing them in the next chapter. Samuel Lover, who was predominantly a miniaturist, also painted some fine small oil portraits, including his wife and doll-like daughter, Meta (NGI). His finest surviving genre work is *The Kelp Gatherers* (Fig. 253) which shows him as one of the earliest painters of Connemara. It is dated 1835, the year it was exhibited in the RHA. His romantic self-portrait is life-size and freely handled and rises above the usual monotony of the male portrait at this time.[53]

The fashion for smaller pictures, including silhouettes, became prevalent in the early nineteenth century. The decorated drawing-rooms with their deeply coloured wallpaper and Regency swagged curtains were an ideal background for a myriad of tiny and medium-sized gilt-framed pictures and black-framed silhouettes. This helped to create the sumptuous but heavy effect which led on to the ponderous décor and cluttered interiors of the Victorian era.

Genre, Landscape and Seascape in the First Half of the Nineteenth Century

The tradition of small figural groups extends itself into landscape/genre compositions in the work of a number of painters during the early nineteenth century. The best known are the Sadler family, of whom the father, William Sadler I, died as early as 1788. He is now remembered by his mezzotints and a single chalk drawing of J. B. Kemble in van Dyck costume (NGI) in the manner typical of the Dublin Society Schools, where he had studied. His son, William Sadler II (*c.*1782–1839), is the painter of some of the great number of pictures attributed to him; the rest were surely painted by a studio or perhaps by his son, William Sadler III. He was not born until 1808, and may have continued in this tradition until well on into the second half of the century. There is an enormous difference in quality between the best and the worst of these productions. None of the Sadlers usually signed their work, but William Laffan states[1] that he knows only one 'correctly signed work by William Sadler II', which is 'a fine *View of a church interior*' in the manner of Saenredam.

William Sadler II's pictures are normally small, but a few of 20 × 30 inches exist. Recently, his masterpiece of the *Battle of Waterloo* (Fig. 254) measuring 32 × 69 inches has been discovered and it changes our whole concept of his paintings.[2] They are often painted on mahogany and sometimes on copper, and frequently depict scenes in Dublin and its vicinity. Sometimes they are of journalistic interest, such as the *Burning of the Royal Arcade in College Green* (*c.*1837, NGI), or of Irish topical or historic themes, which include scenes of the 1798 revenue raids, shipwrecks, a staghunt and the like. His pictures are very valuable for the social historian. A few straight copies after Dutch seventeenth-century painters, such as van Goyen, survive and there are many other Irish views closely based on seventeenth-century Dutch painting, such as the Saenredam we have just mentioned. At their best, the Sadlers are lively and amusing, but topographically they are very poor and the buildings are often rather

ineptly constructed. However, there are examples where this is not true, such as his charming *View of the Deputy Master's House at Kilmainham Hospital*. His painting is dry, with considerable use of lumps of impasto; a typical example is his *Stag Hunt at Killarney*. His set of views of the park at Killua, Co. Westmeath, showing the house with its lake and follies, are particularly pastoral and idyllic scenes (Fig. 255).[3] Many of these landscapes of gentleman's parks are by unknown artists often of considerable merit. For instance, a view with the King's house at Charlestown, County Roscommon, in the background has elegantly painted figures walking by the river and a man fishing from a boat (Fig. 256).

Sadler's picture of *Tiger Hunting in India* must be based on a print and is of high quality and very lively. Despite the oriental setting, it recalls his Irish journalistic pictures. It leads us to his *Battle of Waterloo*, which is an amalgam of a number of well-known incidents in this famous engagement. These have been recorded in numerous accounts, particularly George Cruikshank's *Historical Account of the Battle of Waterloo*, written with plans, maps and engraved views of the battle and published in 1817. Sadler must have studied these accounts carefully; he produced an extraordinarily detailed work based on them, showing the battle about 1.30 in the afternoon. We do not know for whom this work was painted, but it has been suggested that it was for a regimental officers' mess in Dublin.[4] Fascinated as he was by conflagrations, which occur in many of his pictures, Sadler naturally was interested in painting battle scenes, including the Boyne, the Siege of Derry, Navarino, the Bombardment of Algiers and the Battle of Copenhagen.

The only work which has been attributed in the past to William Sadler III is a workmanlike, straightforward, panoramic view of the town of Fermoy, Co. Cork, with its vast barracks in the background and with none of the figure painting usually associated with the Sadler family (Fig. 257). There are two ver-

254 William Sadler II, *Battle of Waterloo*, oil on canvas, Private collection

255 William Sadler II, *Killua Park, lake and follies*, oil on canvas, Private collection

sions of this picture; one showing the church without a steeple, which had been taken down by 1837, is inscribed on the back 'part of the town of Fermoy painted by William Sadler III' (UCC). The second version has no inscription and it is close to the work of a talented army officer, Captain Thomas de Rienzi from Co. Carlow, who was posted to Fermoy in 1822. It shows the spire which, according to a local history,

certainly existed in 1826. The picture has a strong resemblance in its simplicity and feeling for space to a watercolour by de Rienzi of the barracks at Fermoy, taken from one of his sketchbooks.[5] What the link is between the two views of Fermoy town is uncertain and they are topographically and even stylistically very similar. They may both be by William Sadler III, though he is said to have been in America in his youth,

256 Anonymous, *The King House at Charlestown, Co. Roscommon*, oil on canvas, Private collection

257 William Sadler III, *Panoramic View of Fermoy, Co. Cork*, oil on canvas, University College Cork

which would have been in the early 1820s. Perhaps he knew de Rienzi. Certainly the two pictures are among the more graphic portrayals of an Irish town in the first half of the nineteenth century.

Michaelangelo Hayes (1820–77), the son of Edward Hayes, was a horse painter who specialized in military subjects. He is, however, best remembered for his six engravings, *Car Driving in the South of Ireland*, 1836, which commemorate Bianconi's famous cars. Working both as a watercolourist and an oil painter, he was taught by his father and at the RHA schools. He was a lifelong exhibitor at the RHA and heavily involved in its mid-century disputes.

258 Michaelangelo Hayes, *Military Parade at Dublin Castle*, oil on canvas, OPW/Dublin Castle

259 Lieutenant Napier, *His room in Belfast Barracks*, oil on canvas, Private collection

subjects, with a particular emphasis on cavalry regiments; he orchestrated the horses in his battle scenes with extraordinary reality. His *St Patrick's Day Military Parade at Dublin Castle*, 1844 (Fig. 258),[6] a large watercolour, is a good example. A second version of this picture is known. He studied horses in motion and in 1876 read a paper to the Royal Dublin Society on this topic. In this, he appears to come to the same conclusions as Muybridge and other photographers did a little later, in rejecting the flying gallop which he had used in his early works.[7] He is one of the most notable and neglected artists of the mid-Victorian period.

A small but fascinating picture of military life by a Lieutenant Napier depicts 'My Barrack room at Belfast with a likeness of Lt Lacy, 46th Rgt Oct 3 1835' (Fig. 259). It shows an intimate side of army life as opposed to Hayes's Cavalry Charges or Military Parades.

After the Napoleonic wars, the patronage of Irish artists was becoming steadily worse. William Grattan in 1818 wrote a pamphlet called *Patronage Analysed*, already noted in chapter 12, which he addressed to the Royal Irish Institution, for the encouragement of the fine arts in Ireland. After discussing the restlessness of habit and difficult temperament of artists and their quarrels, he went on to say that 'the painters of this country owing to the great want of patronage, are obliged to desert the higher walks of the profession for whatever employment in the arts the fleeting taste of the moment may offer'. The controversies of the RHA in the mid-century are given in detail by Strickland and are of little interest today, but the state of the arts in early to mid-nineteenth-century Ireland should be touched upon.

Thomas J. Mulvany, a painter of some quality who, with Gandon's son, James, Jr, was editor of the *Life of Gandon*, wrote articles in *The Citizen* on a number of Irish painters under the pseudonym 'M', which we have already quoted from. His letters to his eldest son, William T. Mulvany, between 1825 and 1845,[8] provide an interesting insight into the financial aspects of Irish painters at this time. He regarded 6 guineas a week[9] as a sizeable income when he first got married in the early years of the century, and remarks on 24 July 1840 that he was 'meditating a little tour of some three weeks or so in the direction of Sligo, Ballyshannon and Enniskillen and returning by Boyle. I must do something to put me in possession of popular scenery in the hope of selling something in London or elsewhere during the winter or next spring something of the kind I must do, for my present professional prospects are certainly chillingly dispiriting.'[10] He adds that he has just sold three oil paintings to Daniel O'Connell's solicitor, Pierce Mahony: 'for these three I am to get but £45 – including Francs!'. He continues: 'By the bye, painting with the high feelings necessary to sustain it and the low remuneration given for it renders the pursuit a trying one'.[11] In 1822 the novelist John Banim wrote to Mulvany from England, saying: 'You can have a comfortable home

His watercolour views of Dublin were engraved and he sometimes painted in this medium on a very large scale. Among his large watercolours are several battle scenes, including *The 16th Queen's Lancers breaking the Square at the Battle of Aliwal in the Sikh Mutiny, India, 28 Jan 1846*. This spirited work was exhibited in London 1852 and in the RHA a year later. It sold for £388, an enormous sum at the time. A year earlier, in 1845, his oil of *The Last Stand of the 44th at Kabul* was purchased by the Royal Irish Art Union. The lists of his works include numerous other battles, reviews and military

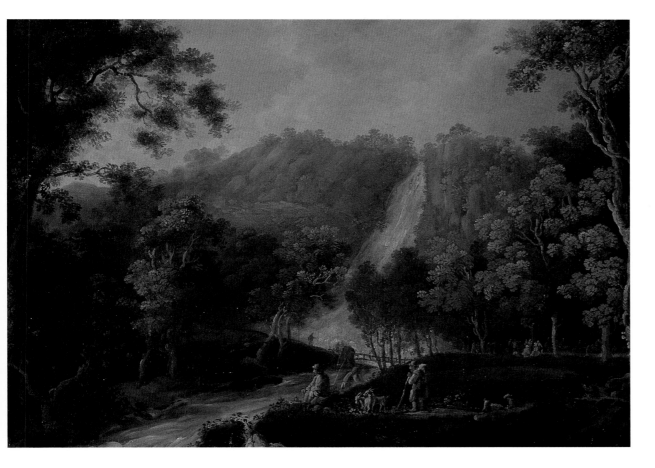

260 John Henry Campbell,
Powerscourt Waterfall, oil on canvas,
Private collection

here in the country where all the landscape men live for £35 a year, everything is cheap … Forswear Ireland and all would be well'.[12]

In fact, Mulvany was lucky to sell three pictures, however little he got for them, as Strickland recounts that for four years (1835–8) only £1 10s. 0d. worth of pictures (two watercolours) were sold at the RHA and in 1839 they could not hold an exhibition. The Royal Irish Art Union was formed in 1839 as a result of this indifference, in order to encourage the purchase of the work of Irish living artists and counteract the general apathy with regard to the fine arts at this period. The situation had not improved much by the time Michelangelo Hayes was working, and he submitted a number of comments on the state of the arts in Ireland to the Select Committee on Art Union laws in 1866.[13] His principal theme was the now familiar truism that the Irish artist only achieved fame if he went abroad, no doubt thinking of Maclise and the sculptor Foley. The upper classes, in the main, bought old masters. Hayes backed this up by pointing out that in the great Dublin Exhibition of 1853, out of the 1,023 paintings loaned, only a mere handful were by Irishmen. Haverty exhibited a number of pictures; other artists included James Arthur O'Connor, R. B. Beechey, E. Murphy, James B. Brenan, George Nairn, Edward Hayes, William Guy Wall and Sir George Hodson. One does have to remember that the Great Famine was only just over in 1853 and the economic situation in Ireland was dire, both before and after its peak. As this chapter full of minor artists proves, the best were all working in England.

An artistic family at this period were the Campbells and Nairns. John Henry Campbell (1757–1828) came from Herefordshire, settling in Dublin, according to Strickland, as a partner with the king's printer, Graisbery. He attended the Dublin Society Schools and by 1800 was sending landscapes to Dublin exhibitions, continuing to do so till his death in 1828. From the catalogues, it can be seen that many of his subjects were taken from the romantic scenery of Co. Wicklow, though he went as far north as Counties Down and Fermanagh and sometimes painted imaginary views of enchanted castles in the style of Claude. He did a number of moonlit scenes. His watercolours, straightforward topographical views, have long been known, but his oils have only recently been identified; rather sombre in tone, they prefigure the romanticism of James Arthur O'Connor. Among his best are views of *Powerscourt Waterfall* (Fig. 260) and a downstream view of the Dargle. His foliage, though inspired by Barret, is weak and rather nobbly. His talented daughter, Cecilia Margaret (1791–1857), married the painter George Nairn in 1826. Taught by her father, she had been exhibiting landscapes in Dublin exhibitions from 1809. Later, she showed in the RHA till 1847. Again, her watercolours tend to be better known, but her oil paintings show her to be a competent, if pedestrian, performer.

Her husband, George Nairn (1799–1850), was a portrait, landscape and animal painter who even ventured into the field of the nostalgic antiquarianism of the period, as can be seen from an evocative oil of the

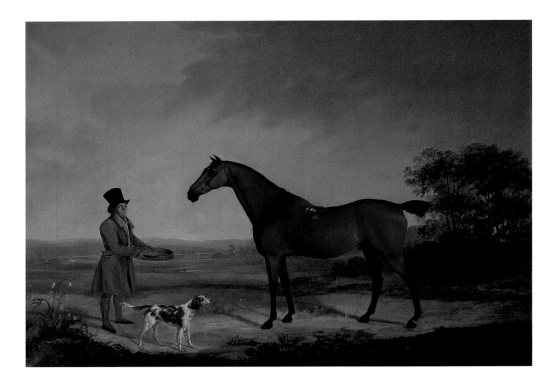

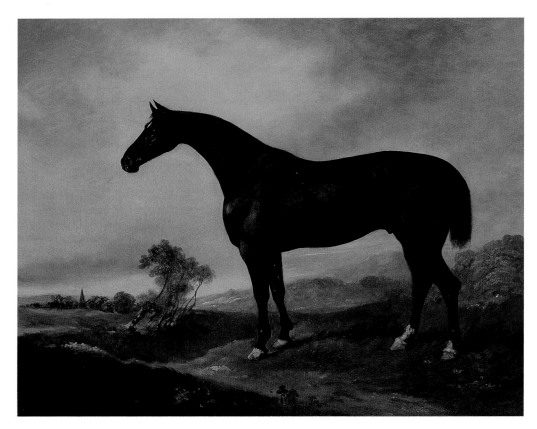

261 George Nairn, *Willsgrove*, oil on canvas, Private collection

262 John Henry Brocas, *Study of a horse*, 1835, oil on canvas, Private collection

Clonbrock's four in hand waiting for the return of company near the Lake of Killarney, which was exhibited at the RHA in 1829 and is one of the very rare pictures of this type to be found in Ireland. It is interesting how few of Nairn's paintings can now be identified, considering how many pictures of horses and other animals by him were exhibited between 1826 and 1848. Two paintings of a hunter, hound and groom, and a prize black bull with his attendant, which belonged to Colonel Mathew Forde, are fine examples. It is probable that many of his pictures are now masquerading under more famous names. It should be remembered that the great English horse painter, John Ferneley (1782–1860) of Melton Mowbray, had paid four visits to Ireland, the first in 1808, when he had introductions from the fifth Duke of Rutland, whose father had been Lord Lieutenant. Ferneley returned for long visits in 1810, 1811 and 1812. There were therefore a number of his works in Irish houses and he undoubtedly influenced Nairn. However, as Nairn's work can be of very high quality, some may even now be attributed to Ferneley.

A contemporary horse painter was James Henry Brocas (*c.*1790–1846), the eldest son of Henry Brocas the elder (1762–1837), who was the Master of the Ornament and Landscape School in the Dublin Society Schools. James studied under his father and obtained premiums in 1802 and 1803. He was something of a prodigy, being commissioned to illustrate cattle for the Dublin Society's *Statistical Survey of the County Meath* in 1802, when he was about twelve.[14] His drawing style is extremely delicate, whether he is drawing trees or animals, dogs or horses.[15] He settled in Cork, about 1834 where he is known to have done portraits and probably landscapes.

James Henry Brocas turns out be the most talented horse painter of his clever family. During the early nineteenth century, horse painting had become extremely popular in Ireland and Ferneley's visits between 1808 and 1812 were, as we have mentioned, very important. He had a large clientele,[16] including Lord Rossmore, Lord Lismore and the Vaughans of Golden Grove. He must have been a considerable influence on the young Brocas, as on George Nairn – the most prolific Irish horse painter of the period.

A newly discovered J. H. Brocas, signed and dated 1835, *Portrait of a Horse* (Fig. 262), gives us an important document on the basis of which other works can be attributed. From this picture, it is obvious that the receipt dated 1836 for three out of four horse portraits,[17] from a Brocas to James Hans Hamilton of Sheephill, Castleknock, Co. Dublin, later called Abbotstown, was from James Henry and not William as had been thought. These have slightly more elaborate backgrounds of the Sheephill estate, whereas the signed portrait is simpler. However, all the landscapes are autumnal in mood. The glossy sheen and substance of the black stallion, probably a hunter, is a particularly fine study of Irish horse painting.

tower and 'crossing' of the ruined abbey at Muckross, complete with skulls and bones, signed and dated 1829. He also painted other views of Killarney. He produced some of the best horse paintings of this time, a notable example being his splendid portrait of Lord Clonbrock's celebrated hunter *Willsgrove with a Groom and Dog* (Fig. 261), painted in 1828 and exhibited at the RHA the following year. In the same collection there was a large but now damaged canvas, *Lord*

A contemporary, Robert Richard Scanlon (*fl.* 1826–76), who was for a short time (1852–4) Master of the Cork School of Design, was also a horse and sporting painter as well as a portrayer in watercolour of small portrait groups which we have already touched upon. Many of his hunting and sporting scenes were lithographed or engraved; he usually painted horses in motion, sometimes with deliberate comic intent. He worked and exhibited in England and Ireland and, though most of his surviving work is in watercolour, he was also an oil painter and miniaturist.

Nairn's position as a horse portraitist was later taken over by William Osborne (1823–1901) who was educated at the RHA Schools in 1845 and started exhibiting in 1851, continuing to do so till his death. His exhibited works cover two and a half pages in the RHA exhibitors' index. His famous group portrait of the *Ward Union Hunt of 1880* does him little justice, as it is inevitably overcrowded, the figures doll-like and wooden. It was based on a photograph. His individual horse and animal paintings have quality. The pair of whole-length portraits of the popular, convivial and hospitable Thomas Conolly MP and his wife, Sarah Elizabeth (Fig. 263), shown riding on their hunters, are painted with considerable finesse and elegance. The pictures must date from after their marriage in 1868. His paintings of dogs, though given sentimental titles, are as well painted as his excellent horses.

The most prolific and regularly seen horse painter in Ireland is Samuel Spode (*c.*1811–*c.*58) though there is no evidence that he was Irish. However, he must have visited this country frequently. Little is known about him, but two works by him were illustrated in *The Sporting Magazine* in 1825. An Irish example of a grizzled, red-coated member of the Carlow hunt, John Dawson Duckett of Duckett's Grove, is signed and dated 1856. The horse, *The Lad*, is standing still, with four hounds surrounding him. From a racing point of view, Mr W. Disney's *Chestnut Stallion*, *Birdcatcher*, portrayed on the Curragh with the then ruined cathedral and round tower in Kildare in the background, is more important, as this horse was the sire of several first-class thoroughbreds. His finest work is *Coursing on Stonehenge*,[18] which shows much movement and vigour in comparison to his usual static style. Another spirited and lively work is his *Boy riding with two dogs* (Fig. 264). It is said that he may have been a trainer on the Curragh. One portrait of a fashionably crinolined lady is known to us and emphasizes Spode's naïvety.

James Walsham Baldock, an Englishman (1822–98), was in Ireland in the 1850s, when he painted his splendid *Samuel Reynell and his hounds at Archerstown, Co. Westmeath* as well as a charming farmyard scene, dated 1856, of the Rutherfoord family at Mooretown, Co. Louth (Fig. 265). He seems also to have worked in the Co. Meath area, as he painted at Mountainstown and Arch Hall, where he showed *Mrs Garnett and her two sons on horseback* in 1854.[19] A trotting horse and driver at the Cavalry Barracks in the Phoenix Park is signed and

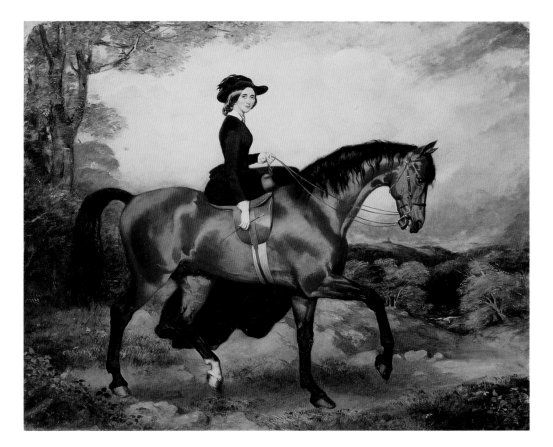

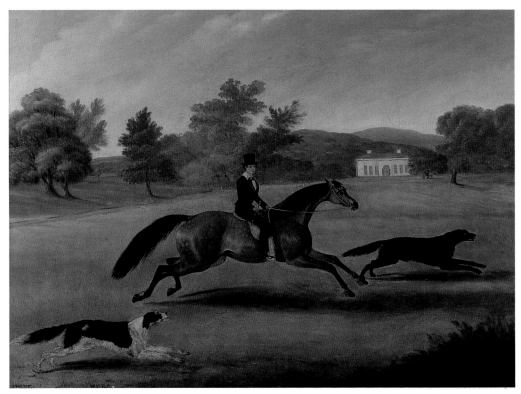

dated 1855. They are all uniformly well painted with considerable finish. Baldock had a lengthy English career, working mostly in the Nottingham and Sheffield areas.

A number of other artists worked in the urban topographical manner we associate with Sadler. In Belfast, there was William Henry Maguire (*fl.* 1820–40),

263 William Osborne, *Mrs Sarah Elizabeth Conolly*, oil on canvas, Private collection

264 Samuel Spode, *Boy riding with two dogs*, oil on canvas, Private collection

265 James Baldock, *Farmyard scene with the Rutherfoord family at Mooretown*, 1856, oil on canvas, Private collection

266 James Black, *View of Armagh*, 1810, oil on canvas, Armagh Museum

whose views of *The Four Corners* and of *The Royal Belfast Academical Institution* are now in the Ulster Museum. *A View of Donegal Square*,[20] with the white Linen Hall on the left, shows he is very similar to a good Sadler. In Dublin, there was Thomas Snagg (1746–1812), whose life history, as related by Strickland, is more amusing than his surviving pictures, which date to his last years. Two of these are *Bathing Huts on Sandymount Strand* and *A View of Dublin Bay from the University Rowing Club* (both NGI). Another landscape and portrait painter was James Black (d. 1829) whose best-known work is his view of Armagh, which was raffled

267 William Turner de Lond, *George IV, entering Dublin*, 1821, oil on canvas, National Gallery of Ireland, Dublin

in 1810 and is now in the Armagh Museum (Fig. 266). This is one of the finest views of an Irish provincial town in the nineteenth century and its slightly primitive quality makes it all the more appealing. It shows a considerable interest in local farming and market gardening. He was also well-known for his inn signs.

An artist who sustained the tradition of journalistic draughtsmanship was James Mahoney[21] (1800–79), whose main career was as an illustrator for English magazines like the *Illustrated London News*, where his contemporary sketches of famine scenes in West Cork (1847) are famous. In Ireland, he is known by a magnificent watercolour panorama of Dublin and by his charming and extremely competent watercolours of the visit of Queen Victoria, Prince Albert and two of their children for the Dublin Exhibition in 1853 (NGI). The watercolour of Queen Victoria's visit to the section of the Exhibition devoted to the Fine Arts is a particularly fascinating record of this vast loan exhibition where the walls are lined with paintings and sculpture is free-standing in the hall.

Another painter of rather similar themes, but on a larger scale and usually in oils, is William Turner de Lond, an Englishman who was in Ireland probably for some two years. Little is known about him in Ireland, except that he exhibited twenty-five pictures in an

exhibition at Limerick in 1821. Mallalieu is inclined to think he is the same William Turner who was born in 1763 and entered the RA schools in 1785, thereafter exhibiting architectural and town views and a few portraits rather infrequently at the RA until 1816.[22] However, the suggestion is not certain. *A View of Barnet Horse Fair*, signed and dated 1864, which was on the London art market,[23] looks to us unlike his earlier work; and the date, 1864, would make the attribution seem impossible. He must have been in Ireland before George IV's visit of 1821, as he recorded his arrival at Kingstown (now Dun Laoghaire), and in another large and handsome picture the king is seen arriving at a triumphal arch outside the Rotunda Hospital (Fig. 267). At least ten of the twenty-five pictures by him exhibited in Limerick were of Irish scenes. The artist was in Edinburgh by 1822, once again painting George IV's visit, and clearly stayed there for some time, as a number of Scottish pictures are known.

His Limerick exhibition included *The Chairing of the Member, Thomas Spring Rice* (Limerick Chamber of Commerce)[24] and *The Entry of George IV into Dublin at the Rotunda* (Fig. 267). Others are known, such as a series of coaching scenes, and all have a lively portrayal of crowds, dress, carriages and a solid painting of the architectural settings. *The View of the Quays with the Four Courts* is an excellent example. He had trav-

268 Attributed to Samuel Frederick
Brocas, *View of an estuary with
fisherman's cottage*, oil on canvas,
Private collection

269 William Brocas, *Going to Market*,
oil on canvas, Private collection

elled on the continent and included several works painted while abroad.[25] His views near London include a fine portrayal of *The Bridge at Richmond*[26] with boats and numerous townspeople out for the day.

The most difficult problem in the first half of the nineteenth century is the Brocas family, of which we have mentioned two, Henry Brocas Senior and James Henry Brocas. There were five in all, who left a mountainous array of sketches and a few finished drawings, largely unsigned, which are now in the National Library of Ireland. They were Henry Senior (1762–1837), the father of the other four: James Henry (c.1790–1846); Samuel Frederick (c.1792–1873);

William (*c*.1794–1868); and Henry Junior (*c*.1798–1873). As far as we can judge, all five of them exhibited in Dublin exhibitions, beginning with Henry Senior at the Society of Artists from 1800 to 1812; even the exhibition lists are not altogether clear. Only Samuel Frederick and William are fairly easily identifiable, Samuel because of his handling of townscapes. His twelve views of Dublin are very well known besides being engraved by his brother Henry and published in 1820. Samuel was extremely talented and is known to have painted oils, but few have been identified. These are of Limerick and its environs, and down the river Shannon, showing a number of country houses and castles, such as Askeaton, Co. Limerick. A sketchbook by an amateur copying his work, which connects with these oils, exists. It is suggested that he had painted an attractive coastal scene in the NGI, using soft colouring and some impasto, as well as a view of Ireland's Eye from the Hill of Howth[27] which also uses impasto, though it is brighter in colour. From this we attribute to Samuel Frederick a panoramic view of an estuary with a fisherman's cottage, figures and nets, fluidly and brightly painted (Fig. 268). He had intended to paint a complete topography of Ireland, which was never finished; many of his views in Co. Limerick and elsewhere may have been intended for this purpose. He was not the only brother to draw architecture, as a drawing of Moira House was etched by William when he was very young after one of his own drawings in 1811.

William's oils are better known than his watercolours. As well as producing landscapes and portraits, he worked as a horse and animal portraitist, though the animals are sometimes rather naïve. A pair signed and dated 1863, set in the park at Santry Court, are good examples. His landscapes, such as *Going to Market* (Fig. 269), usually have a strong genre element, including horses and other animals. The landscape in the NGI is unsigned but it is a well-painted picture and fits in with the other signed works. He tackled portraits not only in oils but also in pencil for engraving by his brother Henry.

Not many of William's oil portraits have been identified, but a set of nine portraits of members of the Westenra family are signed. *The Hon. Ann Westenra* is the most distinguished example of these works (Fig. 270); they are useful in identifying others. There are a number of watercolours and drawings, some highly finished, an example being *The Boy in the Deanery Garden of St. Patrick's*, signed and dated 1836,[28] which closely relates to an oil of a young boy of the Rowley family with Summerhill, his family home, in the background. A great many others are in the National Library of Ireland,[29] including some of country people working, both men and women, as well as fashionable folk. One is his sympathetic oval of the Jesuit, the Revd Thomas Betagh, which was engraved from his pencil work.

James Henry Brocas settled in Cork in 1834 and to him is attributed an oil painting of the Boghera moun-

270 William Brocas, *Hon. Ann Westenra*, 1828, oil on canvas, Private collection

tains, but again without any certainty. A signed caricature exists and a signed landscape drawing of the park at Ballynure, Co. Wicklow, which shows him to have had a very delicate touch distinctive from his brothers. His earlier work includes some very finely executed scenes on the romantic Dargle river.

The two Henrys are even more difficult to disentangle. They both made watercolours of landscapes, caricatures and decorative motives and the elder probably worked in oils; a possible oil by him is of Stackallen House though it has also been given to James Arthur O'Connor.[30] Both of the Henrys, one after the other, became Masters of the Landscape and Ornament School in the (by then, Royal) Dublin Society Schools. Virtually all the finished landscape watercolours in the National Gallery are attributed to Henry Senior, but one is certainly by Samuel Frederick and there is absolutely no reason to accept the old attributions. They all came from the RDS but all the sons were trained there and the two Henrys taught there. None of these drawings are signed and one certainly looks like a copy after an English watercolour. Though it is known that Henry Senior acquired many English watercolours for the students to copy, it is more likely to be by one of his sons than by himself. However, Henry Junior, apart from working as an engraver, is known by one signed watercolour of a garden party given at Crom Castle, Lough Erne, in 1850[31] for a visit by the then Lord Lieutenant, Lord Clarendon. It is a delightful scene, with all the ladies making what speed they may in their crinolines in

order to reach the quayside before the Lord Lieutenant's boat comes alongside. Much work has been attributed to Henry Senior and a sketchbook (NLI) of Irish views from Derry to Co. Waterford is probably by him. The figures date from early in the century, which is a little early for the sons. Fresh colours and lively figures with good topographical backgrounds abound. It includes some watercolour sketches of Carlingford which relate to a finished watercolour in the NGI.

James Hore (*fl.* 1837), a gentleman-amateur, painted views of Dublin, including one of the Four Courts, and another of the Custom House seen through the rigging of ships anchored on the South Quay (Fig. 271).[32] Both of these, with another of Trinity College, were exhibited at the RA in 1837. They are drily but very competently executed. His views of Rome are precise pen-and-ink studies and his work seems to be characterized by meticulously detailed handling.

The other major artistic family of this period are the Mulvanys: John George (*c.* 1766–1838) was the elder brother of Thomas James Mulvany (1779–1845), who was the father of George Francis (1809–69). John George was primarily a landscape painter, best remembered for his large views of *The Medieval Street, Killmallock* (NGI), and *The Dominican Friary outside the Old Walls, Killmallock* (Hunt Museum, Limerick), both exhibited at the RHA in 1830. John George painted numerous landscapes in and near Carlingford between 1826 and 1831 (Fig. 272), when they were seen in the RHA. They are filled with lively incidents, although

the figures are somewhat naïve and boneless.[33] His view of *The Bridge and Castle at Lismore* (exhibited RHA 1827) shows the Blackwater canal with a barge being pulled by three men on the towpath. The castle is shown before its extravagant baronial alterations by Paxton. More interesting today are his rather rare interiors of prosperous middle-class people, like *Children sailing paper boats in an interior*. One, entitled *The Grandmother*, was exhibited in the RHA in 1828 (no. 371)[34] and shows children playing with boats and dolls in a sitting-room with their grandmother, who is sewing; another shows a kitchen (NGI) where the children are teasing their father, who looks the worse for wear, while the mother looks on patiently. These interiors are most unusual and are often of people of the middling class. The one we illustrate is a prosperous peasant kitchen interior (Fig. 273). They give us an idea, as do the landscapes, of Ireland before the famine. They have a soft, smooth surface, and a pink tonality. However, a recently acquired landscape in the NGI suggests that he also painted in the James Arthur O'Connor manner.

We have already discussed Thomas James Mulvany, 'M', earlier in this chapter, but now we must mention something of his painting. From the exhibition catalogues, it is clear that he was often in France, as many of his scenes are of that country and he uses the figure of the negro waving in Géricault's *Raft of the Medusa* in his picture of the *Last Hope of the Castaway*, signed and dated 1842. His work was very varied, from horse portraits to pure English, Irish and French landscape, to subject pictures and genre, of which, sadly, we now

272 John George Mulvany, *View of a street in Carlingford*, oil on canvas, Private collection

273 John George Mulvany, *Cottage Interior*, oil on canvas, Private collection

274 Jeremiah Hodges Mulcahy, *View of Curragh Chase*, oil on canvas, Private collection

know very few. He painted the descent of Thomas Livingston's balloon into the sea at Baldoyle, Co. Dublin in 1822, which we know from an engraving, and a very spirited painting of peasants winnowing corn of 1838, when it was exhibited at the RHA. There is also a Dublin view of the Four Courts, painted with great clarity, the foreground enlivened with groups of drays, officers on horseback and Dubliners by a side car. The quality of these pictures makes one wish one knew more about his considerable *œuvre*.

Thomas's son, George Francis Mulvany, became a run-of-the-mill portrait painter despite his father's praise (in several letters in the collection we mention on p. 198). The best of his portraits appears to us to be his full-length of *Daniel O'Connell* (Limerick Art Gallery), wearing a cloak and gesturing with his left hand. However, he seems to have painted many important Irishmen of the period, including Thomas Moore (NGI). A letter from Moore to Samuel Rogers of 6 January 1836 jokes about a portrait of 'my unworthy self'; he thinks the portrait 'a most excellent likeness' and hopes Rogers will 'speak a good word [for the picture] among your friends'.[35] He painted and exhibited a few landscapes of which the survivor reminds us of Sadler and Campbell. There is a genre work of *Orphans Visiting a Graveyard* of 1856 (NGI), which is remarkably ill-painted, and a scene from *Two Gentlemen of Verona* which is in the Venetian mode. His real claim to fame is that he was the first Director of the National Gallery of Ireland, which opened in 1864. He had been associated with its foundation for some years previously as Secretary to the Board. He purchased some seventy pictures for the gallery, including many baroque masters, notably a superb Jordaens and, surprisingly, several early German panels.

In the provinces, a number of artists were not only painting but setting up schools of art. Jeremiah Hodges Mulcahy (d. 1889) came from Limerick, where he had set up a school of painting in 1842 which continued for twenty years till he left for Dublin. It is recorded that he started teaching 'with the object of developing native talent, hitherto dormant for want of suitable instruction'.[36] He was an ARHA and exhibited at the RHA from 1843–78. (A number of drawings by him are in the NGI). Apart from work engraved for *Hall's Ireland, its Scenery and Character*, he is now known by a number of distinctive landscapes of the west of Ireland including Kerry. Rather blue in tone, they have an enamelled surface and dramatize the mountain scenery, as did all the topographical draughtsmen who worked for the engravers. W. H. Bartlett is a particular example of an English artist who worked in Ireland in a similar manner. Mulcahy, however, had started his career as a painter of gentlemen's parks; his views of Curragh Chase and its park of 1834 (one in the NGI) are fine examples (Fig. 274). Perhaps the park scene with the de Veres and their children is the best, and it is a sympathetic view of domestic life. These scenes display a totally eighteenth-century treatment of trees and foliage. He was also patronized by John Croker of Ballinagarde, and a view of his house, gardens and conservatories survives.[37] The Stafford O'Brien family of Cratloe in Co. Clare were other patrons, and, besides painting Cratloe, Mulcahy was sent to England to paint the park at their English seat, Blatherwycke in Northamptonshire. His most ambitious work is the great panoramic view, *The Shannon Estuary with Glin Castle at Sunset* of 1839, showing that he had seen Turner's work. Another highly picturesque view of *Scattery Island* on a windy day, signed and dated 1844,[38] shows the variety of his painting. *The Limerick Chronicle* of 5 March 1836 remarks that 'his landscapes are exquisite, his style of pencilling bold and free, and his colouring clear and true to nature; every object is well expressed and so animated, that we consider Mr. M as one of the most promising artists of these days'. Mulcahy did not die until 1889, but few of his later works are known, a fine one being a *View near Killarney* of 1866. It is possible that in his youth he signed himself 'J. M. Hodges', as a naïve *Landscape with Leda and the Swan* dated 1824 is probably by him. A recently discovered Italianate view, highly finished and very deep blue in colouring, shows that he also became a remarkable *pasticheur* of early seventeenth-century Flemish painting. A number of Claudean ideal landscapes of considerable quality have also come to light in the last few years. Commissions were scarce in his old age and he painted one or two portraits, saying in a letter to his sons, all working abroad, that he did not wish to beg money off them, but painting portraits kept him going financially.[39]

Another provincial painter was Daniel MacDonald[40] (1821–53) of Cork, who was a landscape and genre painter of naïve quality. He had an interest in people,

as he shows in the group of fashionable ladies and officers listening to the gun rousing the echoes in his *Eagle's Nest, Killarney*. Some animal pictures, including one entitled *Toy Spaniels*, signed and dated Cork, 1843, show him as a more conventional artist. More important are his pictures of Irish life and customs, such as *The Bowling Match at Castle Mary, Cloyne 1847* (Crawford Art Gallery, Cork). This is a game of bowls played along the roadways which is still practised. The figures, particularly the bowlers, are etiolated and this mannerism of the artist is seen in a small whole-length of *General Sir Rowland Smyth in Uniform*, whose figure is stretched out to the point of caricature in a mountainous landscape. This is quite unlike the large, manly figure of *The Irish Patriot*, a signed and dated picture of 1844 which seems to record a faction fight.[41] *The Fairy Blast*, exhibited in 1841, now known by its Irish title, *Sidhe Gaoithe* (Dept of Irish Folklore, UCD), records sudden

wind storms during the harvest caused, according to folk tradition, by fairy forces. His most dramatic picture is the *Discovery of the Potato Blight*[42] (Fig. 275), one of the very few contemporary paintings recording the tragic years of the Great Famine, which shows the scene of despair on the face of the peasants looking at the rotting crop.

Belfast painters of the same perod were Hugh Frazer (*fl.* 1812–61) and John Howard Burgess (1817–90). Frazer was a pupil at the Dublin Society Schools in 1812 and exhibited in the RHA regularly, becoming a member in 1837. He resided in Dromore, where he was born, as well as in Belfast and Dublin. He was the founder President of the Belfast Association of Artists in *c.*1836 and was Professor of Painting in the Royal Hibernian Academy from 1839 to 1853. He is remembered today for his Northern views, not only of Belfast and the Lough but also of Co. Down scenery

275 Daniel MacDonald, *The Discovery of the Potato Blight*, Department of Irish Folklore, University College, Dublin

276 Hugh Frazer, *Waringstown, Co. Down*, 1849, oil on canvas, Ulster Museum

277 Andrew Nicholl, *Flower Piece with Mussenden Temple, Co. Derry*, oil on canvas, Private collection

The Battle of Clontarf, has recently emerged. Burgess painted mostly in watercolour and chalk and, like Mulcahy, contributed twenty-five illustrations to *Hall's Ireland*. He worked for other engravers and contributed to the RHA from 1830. Some of his works show romantic antiquarianism, for instance, his fine *Pilgrims at the High Cross at Arboe*. Like most of his views it is of Northern Ireland, as is his oil of *The Antrim Coast with Fishermen and a view of Garron Point*.[43] This is a spirited picture, with the sea breaking against the rocks. He is a delicate draughtsman in his watercolour of the O'Cahan tomb (UM) and in a carefully drawn series of estate views of Seaforde, Co. Down.

The clear forms and simple washes of the early work of Burgess's contemporary, Andrew Nicholl[44] (1804–86), form a contrast. Nicholl was also a Belfast man, who probably learned from his brother, William, another painter, and was a founder-member of the Belfast Association of Artists. Though his interest in drawing was manifested early, it was not until he had spent seven years apprenticeship in the Letterpress Department of the *Northern Whig* that Andrew Nicholl was able to support himself by his paintings and his teaching. His talent had been noted by Francis Dalzell Finlay, founder of the paper in 1824, and he was much helped by Finlay's publicizing of him in Belfast, Dublin and London. He was sent to London by his chief patron, James Emmerson, later Sir James Emmerson Tennant, MP. He spent a period teaching in the Columbo Academy in Ceylon from 1846 to 1849, when Emmerson Tennant was Colonial Secretary for Ceylon, and there Nicholl became a 'teacher of landscape painting, scientific drawing and design'.[45] He exhibited in the RA and RHA and contributed to *Hall's Ireland* and other publications, including a collaboration with Henry O'Neill over *Fourteen Views of the County of Wicklow* in 1835. Emmerson Tennant really brought him to Ceylon to illustrate his great book on the island, *Ceylon*, 1848.[46] His early, hard-edge style, as seen in his *101 Views of the Antrim Coast* (1828, UM), is modified in his later works, which stress the romantic qualities of the sea beating against the rocks. The principal influence, especially on his technique, was certainly Turner and, to a lesser degree, Peter de Wint and Copley Fielding. There is, too, a similarity between his work and that of John Thomson of Duddingston and William Daniel, whose Scottish watercolours are very similar. Nicholl uses the technique of 'sgraffito', or scraping-out, to considerable effect. In those near-surrealist watercolours of wild flowers, poppies and daisies, with land and seascapes in the background (Fig. 277), there is an originality which makes them among the most haunting, albeit repetitive, Irish paintings of the early nineteenth century. These are his masterpieces.

The only other Irish artist who uses this trick of placing a landscape as a backcloth to his main subject, in this case birds, not flowers, is an amateur water-

like his *View of Waringstown* (Fig. 276). The best collection is in the Belfast Harbour Commission, where his interest in distant views is notable. They usually include architectural features, from country houses to thatched cottages and mills, but his interest in ordinary rural landscape makes him somewhat different from other painters of his time. He was a very prolific painter and from the catalogues of the RHA and Belfast exhibitions it appears that he also painted a few portraits and subject pictures, of which one, entitled

colourist from Cork, Richard Dunscombe Parker. He was descended from two distinguished old Cork families and is now only known for his 170 watercolours of 260 Irish birds,[47] 'drawn the size of life and accurately coloured', now in the Ulster Museum. He exhibited frequently in Cork and was influenced by the double elephant folio *Birds of America* of 1827–38 by Audubon, which he would have seen when staying with his brother, a Glasgow doctor, as there was a copy in the university library. In a newspaper cutting in the Dunscombe Parker volume dating to the period when the British Association was visiting Cork, it was stated that Parker's paintings were 'only second to Mr Gould's of London, and fully equal to Audubons'.

Another gifted amateur, this time a Northerner, James Moore[48] (1819–83), who painted in time spared from his profession as a consultant surgeon, was a prolific watercolour painter. He took lessons from Andrew Nicholl. His spontaneous shorthand sketches, such as his view of *The Gardens at Versailles* of 1845 and *The Coleraine Regatta* of 1847, both in the Ulster Museum, have a freedom which prefigures the twentieth century and was probably only possible for an amateur. He became an Honorary RHA in 1868. He also painted a more finished type of watercolour, like *Slieve Bernagh from the Trassey Bog, Mourne Mountains* (UM), of which Martin Anglesea comments 'the vigorous style of brushwork on heavy, rough wove paper, bears much similarity to the work of the English watercolourist Thomas Collier who carried on the David Cox tradition'.[49]

An artist of very varying subject matter, whom we have already mentioned, was Henry O'Neill (1798–1880), who came from Clonmel and went to the Dublin Society Schools in 1815, exhibiting mostly watercolours in the RHA from 1835 to 1847. The latter part of his career was less concerned with painting than with politics and with his antiquarian interests. He painted portraits and figure subjects, as well as landscapes, working with George Petrie as well as Andrew Nicholl. His views on antiquities, particularly on the pagan origins of Irish round towers, totally differed from Petrie's and he intended to bring out a publication on the subject of which the first part only was completed and published in 1877. In 1844, he had an interesting and unique commission to paint *The Apartments of the Repeal State Prisoners in Richmond Bridewell* and *The Governor's Gardens* (NMI). They make a set of nineteen and are fascinating records of early Victorian interiors.[50] The prisoners included Daniel O'Connell and Charles Gavan Duffy.

John Faulkner (*fl.* 1835–94) was a pupil at the Royal Dublin Society Schools in 1848–52, where he won a premium in 1849, and he exhibited at the RHA from 1852. He also exhibited at the RA. He painted highly finished watercolours and oils, often of wild and empty scenery with mountains and sometimes ruins and stormy sea pieces. His watercolours include more domestic subjects, such as cattle grazing in lush pas-

tures and harvest scenes. All his pictures have an atmospheric quality which highlights the vaporous Irish climate (Fig. 278). The romantic, sweepingly painted oils are usually dramatic, with sombre colouring and brilliantly handled distances. He was elected an RHA in 1861, resigned in 1870, and his later life is shrouded in some mystery as like Danby he was involved with the wife of another artist. He retired for a few years to America about 1869 but was in Ireland again by 1875 and at one time lived in London. He certainly painted in the English countryside, as he sent two pictures of Warwickshire to the RA in 1885. Earlier, he had visited Scotland, and in 1887 he showed a German landscape near Coblenz. He exhibited a view of Lough Gill in the New Watercolour Society in 1890 and died in 1894.

Another oil and watercolour painter who lived for some years in America was William Guy Wall (*fl.* 1792–after 1862), who may be the William Wall who trained in the Dublin Society Schools in 1792–3, though 1792 is given by Strickland as his birth date. He worked in Dublin until 1818, when he left for America, where he had an interesting career, being one of the original members of the National Academy of Design established in New York in 1826. He was in Dublin again in 1832 and exhibited in the RHA. He was back in America from 1856 to 1860, when he returned to Dublin, and his death date is not known.

Today, Wall is remembered for his series of watercolours known as *The Hudson River Portfolio* which were aquatinted between 1820 and 1825 and reprinted in 1828. His work in oils is of exceptional interest, his masterpiece being *Cauterskill Falls on the Catskill Mountains*,

278 John Faulkner, *Dargle Valley*, oil on canvas, Private collection

279 William Guy Wall, *Cauterskill Falls on the Catskill Mountains*, 1826/27, oil on canvas, Honolulu Academy of Arts

280 William Guy Wall, *The River Dargle*, oil on canvas, Private collection

taken from Under the Cavern (Fig. 279). This dates from 1826–7 and was well received by the National Academy of Design exhibition in New York. The famous American painter Thomas Cole also painted the falls from four different viewpoints and John K. Howat comments that they 'remain more impressive to modern eyes because they are so dark and tempestuous – the work of an artist in awe of his subject –

while Wall's rendering, the work of an accomplished topographical draughtsman, seems spritely and pacific providing an attractive record of an inspiring place of resort'.[51] It is revealing to compare this view of the falls with Wall's painting of *The Dargle Valley* (Fig. 280), which was formerly called *Catskill Scenery*. With its autumnal colouring, it is particularly close to the *Cauterskill Falls*, but is also a throwback to the work of Barret and Thomas Sautell Roberts which Wall would have seen in his youth. Wall painted many pictures in the Catskills, another example being *Passaic Falls* of 1843, which, unlike the pictures we have just mentioned, shows glassy, calm water under rocky cliff faces. Between 1840 and 1842, he exhibited views of the Rocky Mountains, Newport, Rhode Island and the source of the Hudson River in Lucerne Mountain.

In Ireland, Wall travelled from Kerry to Leitrim, painting country scenes, ruins and beauty spots. We know very few of these paintings today, though a fine oil of Blarney Castle, signed and dated 1860, was recently on the market.[52] He must have been financially on the rocks when he agreed to paint backgrounds for a child prodigy, 'Master Hubard', who did scissor work and held an undated exhibition in Galway. In America, Wall taught art and was even offered the post of Teacher of Drawing and Painting in the University of Virginia by none other than Thomas Jefferson himself.[53]

A number of other Irish-born artists worked in America, mostly in watercolour, like William Craig (1829–75).[54] Others went out as very young children, a notable example being the great still-life and *trompe-l'œil* artist, William Michael Harnett (1848–92), who came from Clonakilty. We are not dealing with these artists, only with those who received their artistic education in Ireland. Over the border in Canada, Paul Kane (1810–71), the painter of life on the prairie, is a similar case to Harnett, as he left his native Mallow aged eight or nine. In reverse, the American, Alexander Helwig Wyant (1836–92) visited Ireland and painted a number of memorable pictures in the Killarney area including his panoramic view of the lakes (Fig. 281).

In Canada, a number of Irish artists flourished, mostly in the medium of watercolour. By far the most interesting of these were William Armstrong and Robert Hood who, despite their medium, deserve mention here.

Armstrong (1822–1914)[55] went to the Dublin Society architecture school and worked on the English and Irish railways. In 1850, he emigrated to Toronto, where he carried on his engineering practice, which included working on the Canadian Pacific railway; later, he taught drawing in Toronto for twenty-six years. His watercolours are of a very high standard and give a brilliant picture of early Canadian life, from aqueducts, sailing and laying watermains, to Indian encampments in the Rockies. He also worked in pastel, though rarely in oils. There is a magic view of *Silver*

281 Alexander Wyant, *Killarney Lakes*, oil on canvas, Private collection

282 William Armstrong, *Silver Island on Lake Superior*, watercolour, National Archives of Canada

Island, on Lake Superior, which is signed and dated 1869 (Fig. 282). This shows a flight of geese in an icy sky with canoes and figures.

Hood (*c*.1795–1821) was a naval officer who was involved in Arctic exploration. It is not known where he studied, but it was probably in a naval art school in Dublin or Cork. His drawings, of both birds and ships in the Arctic, are superb. The latter are lightly coloured, but the birds' plumage is vibrantly painted in naturalistic vein.[56] George Russell Dartnell

(1798–1878) from Limerick was a surgeon stationed in various posts in Ontario between 1836 and 1843. He is well known for his watercolours.[57] However, a large oil, a *Panoramic View of the City of Toronto*, 1851 (Royal Ontario Museum), was exhibited in 1852 and shows many buildings in the town that had not yet been built![58]

The situation in Australia was much the same, watercolours being preferred by most of the Irish emi-

painted stage scenery in Sydney and a number of religious and historical pictures, none of which survives. He died sometime after 1870.

James Anderson[60] arrived in Melbourne from Belfast in 1852. He had been educated in Dublin and a James Anderson (d. after 1877) was in the Schools in 1814, but this seems early for him. He is thought to have worked as a painter in England and Scotland before emigrating and, though he signed works 'RHA', there is no evidence that he ever exhibited there, still less was a member. The portrait we know, of the Revd John Sheridan, is competent but dull, though Anderson had considerable practice.

William Paul Dowling[61] (*c*.1824–77) went to Australia as a political prisoner but achieved his ticket of leave on arrival. He was a pastellist and watercolourist as well as an oil painter of portraits. He ended his career as a photographer.

One of the best of these *emigrés* was Charles William Duke[62] (1814–53) from Cork, who was an assisted emigrant who worked at many trades before becoming a scene painter and finally a painter of maritime subjects. He worked in Tasmania. His *Offshore Whaling with the 'Aladdin and Jane'* (October 1849; Fig. 283) is a well-conceived marine painting, full of action.

The most striking of this group is Isaac Whitehead (*c*.1819–81), who worked in Ireland as a frame-maker. It has been said that a surviving Irish sketchbook shows the influence of Thomas Sautell Roberts and James Arthur O'Connor.[63] He did not leave Dublin until 1858, when he established himself in Melbourne as a picture-framer. But by 1861 he was exhibiting oil paintings in the Victorian exhibition. His work as a landscape painter is notable for its botanical accuracy and his late romantic style shows 'the bush with serene blue skies, stately tree trunks and cool green forest ground-cover peopling his scenes with small active figures of timber-fellers, prospectors, travellors and sight seers – the first generation of European visitors to such romantic beauty spots as Fernshaw, the Sassafras valley (Fig. 284), Mount Macedon and New Zealand's Milford Sound and Arthur's Pass, all favorite subjects'. Whitehead was obviously greatly influenced by the work of the Swiss artist Louis Buvelot, another emigrant, who also painted highly dramatic landscapes.[64]

By far the most influential Irish painter in Australia was George Frederick Folingsby (1828–91).[65] He left Ireland aged eighteen in 1846, and did not study at the Dublin Society Schools but went via Canada to study at the Academy of Design in New York, where he worked as an illustrator for *Harper's Magazine* and Cassel's *Illustrated Magazine of Art*. After travelling in Europe, he settled in Munich for two years and later studied in Paris under Couture. He then returned to Munich and spent five years studying under Karl von Piloty. In 1862 he went to Belfast, from where he sent two historical works to the RHA, *William of Orange Receiving the Keys from the Governor of Carrickfergus* and *The Relief of Derry*. For the latter, he charged no less

283 William Duke, *Offshore whaling with the 'Aladdin' and 'Jane'*, 1849, oil on canvas, Tasmanian Museum and Art Gallery

284 Isaac Whitehead, *In the Sassafras Valley*, oil on canvas, Art Gallery of South Australia, Adelaide

grants. However, several professional painters emigrated and found work as portrait painters, scene painters and engravers. One of the earliest was Joseph Tracton Dennis,[59] a portrait and scene painter from Cork who reached Sydney in 1838 as a free migrant. Only two portraits by him survive; one, the earliest he painted in Australia, in 1840, of Chief Justice Dowling, shows some talent. He had clearly been trained, possibly in the Cork School of Art. He

than £100 and it was an extremely popular work. Both works were engraved by George Magill of Belfast. A large number of Protestant households were delighted to own these loyal pictures. Folingsby exhibited a few works in the RA in London from 1869 and won a number of medals in Vienna and Philadelphia. In 1879 he left Munich and went to Australia, where he settled in Melbourne. His first painting in Australia was his *Bunyan in Prison*, which was purchased by the National Gallery in Victoria as one of its earliest acquisitions. He specialized in history pictures and succeeded von Guérard as Director of the National Gallery of Victoria and head of the art school there. He was in close contact with Irish Australians such as Charles Gavan Duffy, and his first commissoned portrait was of Sir Redmond Barry. He was a highly academic painter, showing the influence of his years studying in Munich.

Another painter who settled in Australia was James Glen Wilson[66] (1827–63). He is only known by five canvases and a number of excellent drawings and watercolours (BM). They were mostly executed when he was the artist on board the Royal Navy's hydrographic survey ship in the South Seas, HMS *Herald*, which left England in 1852. After this survey was over, he settled in Australia and worked as a watercolourist and photographer, a trade he had also used on the survey, though only one example of this survives. He was born and bred in County Down and was trained in the Belfast School of Design in 1849 and the early 1850s. His oils are in the Belfast Harbour Office and the Ulster Museum and are of very high quality, well constructed and composed without drama. The five oils are entitled *Downpatrick* (1850), the *First Lock at Stranmillis* (1850), *Belfast Quay* (1851; Fig. 285), *Belfast Harbour Ferry Steps* (1851) and the *Emigrant Ship leaving Belfast* (1852). He handled water, shipping, landscape and figures with equal ease and serenity.

Resident Irish painters of seascapes are Matthew Kendrick (*c*.1797–1874), Richard Brydges Beechey (1808–95), Edwin Hayes (1820–1904) and the Atkinson family of Cork.

Matthew Kendrick started life as a seaman in a fishing vessel off Newfoundland. He was one of the finest yachtsmen of his day, taking up painting seriously in 1825, when he attended the Royal Dublin Society Schools. From 1827, he exhibited at the RHA, where he became a Member and the Keeper in 1850. His painting of *Yachts Racing off Dun Laoghaire*, dated 1854 (Fig. 286), is a spirited example. During the 1840s, he lived and exhibited in London, at the RA and elsewhere. His seascapes can be extremely dramatic, though the yachts and steamers are also accurately portrayed. One of his finest works is the *Mail Steamer 'Leinster' off Kingstown*, 1866, in the Royal Irish Yacht Club[67] to which he was the official painter.

Richard Brydges Beechey (1808–1895) was the youngest son of the eighteen children of the well-known English portrait painter, Sir William Beechey. He became a cadet at the Royal Naval College in 1821

and went to sea in 1822, seeing service from Algiers to the Arctic. He was invalided out of active service in 1835, when he joined the Marine Survey of Ireland, in which he worked until 1857. It was at this time that he became a friend of Jeremiah Hodges Mulcahy (q.v.) who owned several sketches by him, one inscribed 'Painted for me by Capt Beechey RN in Limerick 1844'. He was a fully fledged artist by this time, having presumably been taught initially by his father and later at the Naval College by John Christian Schetky, the professor of art. Drawing was an important element in the training of naval and army officers before the introduction of photography and he would have had an excellent grounding in draughtmanship.

285 James Glen Wilson, *Belfast Quay*, 1851, oil on canvas, Ulster Museum

286 Matthew Kendrick, *Yachts racing off Dun Leary*, 1854, oil on canvas, Private collection

287 Richard Brydges Beechey, *Bray Head from Dalkey*, oil on canvas, Private collection

288 Richard Brydges Beechey, *Royal Mail ship entering Kingstown Harbour*, signed and dated 1868, oil on canvas, Private collection

Artists and RHA. Beechey painted extremely well-finished, if conventional, sea-pieces with all the movement considered proper to this genre, as can be seen in his *Yacht Race* in the Royal Irish Yacht Club. His colouring can be effective and he achieved some fine translucent wave effects. He could be very dramatic, as in his *Hookers on the Race off the Blaskets, Running for Dingle* (RHA 1876, No. 68), or threatening as in *Bray Head from Dalkey* (Fig. 287), or quite the reverse, peaceful with a great sense of height and distance, as in his *Slea Head on the North shore of Dingle Bay*.[68]

Beechey's most dramatic pictures are of the islands off the Kerry coast, the Blaskets and the Skellig rocks. He charged between £40 and £80 for a picture. His landscapes of Kerry are also notable, especially *Macgillicuddy's Reeks Taken from Near the Village of Killorglin*, dated 1878, which has a delightful evening glow. Two pictures which may well have been painted as a pair are of the *Royal Mail Boat 'Leinster'*[69] (exhibited 1869; Fig. 288) and her sister ship *The Connaught* (dated 1868). Both are depicted outside Kingstown Harbour (now Dun Laoghaire). The 'Leinster' is shown in a dead-calm sea, with a charming vignette in the foreground, where a prosperous Dublin family in a rowing boat with its sails slackened includes a little girl in profile trailing her model yacht behind the boat.[70] No such detail is possible in *The Connaught* (NGI), which is only just visible above the tumultuous seas, the waves breaking on her decks.

An English visitor and man of science, particularly interested in geology, was Edward William Cooke (1811–80).[71] He visited Valentia Island, Co. Kerry, in 1857 and 1858, where he began his series of pictures showing features of the British coast, in this case the slate rocks which form the cliffs of Valentia. He painted superb pictures of these slate rocks (Fig. 289) and another of *Glanbane Bay, Valentia Harbour* (Bury Art Gallery and Museum). They are photographically minute in their rendering of the details.

Edwin Hayes (1820–1904), the son of a Bristol man who became a Dublin hotelier, studied at the Dublin Society Schools and from the first decided to be a marine painter. He sailed around Dublin Bay and the Irish coast in his own yacht and worked as a steward's boy to America and back in order to achieve a real knowledge of the sea and its moods. He exhibited at the RHA from 1842, but left Ireland in 1852, settling in London, where he showed at the RA and elsewhere. He travelled all round Britain and many places in Europe in search of subject matter. His best-known picture, *The Emigrant Ship, Dublin Bay, Sunset* (Fig. 290), is dated 1853 and its quietness belies its tragic subject, the passage of so many emigrants caused by the recent famine. The smooth, finished surface is not altogether typical. Works like *Shipping Making for Harbour in Rough Sea* in the Graves Art Gallery, Sheffield, suggests an understanding of the motion of the water and its contrast with the sky, which is extremely lifelike, and Hayes seems to have preferred the drama of stormy

All marine painting, with its emphasis on storms, rough seas and billowing sails, has a generic similarity, but we wonder whether he had seen paintings by, or was in contact during his travels with the American painter Thomas Birch. Beechey was clearly influenced also by Matthew Kendrick and, like him, painted coastal scenes and landscapes as well as seascapes. After his retirement, he lived for many years in Monkstown, Co. Dublin, only leaving Ireland in 1877, when he settled in Plymouth, and in 1885 he was promoted to admiral. When he was in the Navy, surveying in the Shannon and off the west coast of Ireland, he painted many seascapes which he exhibited in the RA, the British Institution, the Society of British

289 Edward William Cooke, *Valentia*, oil on canvas, Private collection

290 Edwin Hayes, *An Emigrant Ship, Dublin Bay, sunset*, oil on canvas, National Gallery of Ireand, Dublin

weather. However, a work in the NGI called *Coast Scene*, a study of a rotting boat and broken anchor, is in its silence and stillness a marine *memento mori*. His figures are well drawn and characterized. The *Sunset and Sea from Harlyn Bay, Cornwall* in Tate Britain, one of his later works, eliminates all shipping and can be compared to Courbet and Whistler in its treatment of the power of the lonely waves.

James Richard Marquis (*fl.* 1835–85) was born in Dublin of Scottish parentage, and finally went to live in Edinburgh in 1869 and London in 1873. This may account for the rarity of his work in this country, though he was educated at the Schools in 1847 and exhibited at the RHA from 1853 to 1885. In the early years, many of his works were watercolours. He became an RHA in 1862. He painted a number of sunsets including *Sunset with an Anchored 3–Master off Kingstown*, signed and dated 1864. The charming handling of the crinolined ladies and their dog on the quay shows his delicate brushwork. Others we know include *Carlingford*, 1872,[72] where the sky is exquisitely handled and a purple glow suffuses the scene, as in the *Shipping off Kingstown*. He appears to have travelled on the Continent, as two views of Rotterdam are known and he exhibited views of Norway. He was a prolific painter, exhibiting over two hundred works, of which more were landscapes than seascapes. Few of these have yet surfaced, one is an excellent panoramic view of *Lucan on the Liffey*, composed with Scots pines

framing the distant view of the spire of Lucan church. Another entitled *Sunshine and Showers – a Home in Killarney* (RHA 1882; Fig. 291), was exhibited frequently thereafter and epitomized Ireland's archetypal cottage and mountain scene.[73]

Cobh (then Queenstown) produced a family of artists, of whom the first and best known was George Mounsey Wheatley Atkinson (1806–84), a self-taught artist who started his career as a ship's carpenter before being appointed Government Surveyor of Shipping and Emigrants. He exhibited first in 1841 in the Cork Art Union Exhibition, to which he sent eight pictures, and in the following year in the RHA, where, except for one painting in 1879, he exhibited twenty works between 1842 and 1845. Though his early pictures were somewhat naïve, his technique improved with time and as a contemporary said, 'his ships were faultless in every detail, and his sky and sea faithful to nature in her varied forms of beauty'. However, he continued to exhibit with the Cork Art Union and though his work fetched very little money – John F. Maguire in the *Cork Examiner*,[74] said that in 1844 he only made the 'wretched sum' of £30 – he sold many pictures through lotteries and in August 1849 he held a one-man show to mark the visit of Queen Victoria to Cork. He painted *The Arrival of the Royal Squadron, on 2 August, with display of Blue Lights etc.* and also several pictures of the royal landing. Perhaps his most important picture is his *Departure of the Steamship 'Sirius' from*

292 George Mounsey Wheatley Atkinson, *A boating party in Cork Harbour*, 1840, oil on canvas, Crawford Art Gallery, Cork

293 George Mounsey Wheatley Atkinson, *Frigate off Queenstown*, 1859, oil on canvas, Private collection

Cork, bound for New York, 4 April 1838 (Crawford Art Gallery, Cork). But he also painted more domestic coastal scenes, such as *A Boating Party near Queenstown, Cork*,[75] dated 1840 (Fig. 292), which shows a large family and their dog being helped off their rowing boat at Spike Island. A more typical work is his *Frigate off Queenstown* 1859 (Fig. 293) showing the pink hues of a sunset.

294 William Alexander Coulter, *Dublin with shipping and the Hill of Howth*, 1889, oil on canvas, Private collection

All his five children painted, mostly marine subjects, but none was as competent as the father. His daughter Sarah, later Mrs Dobbs, was also a still-life painter in the Dutch tradition. Indeed, the influence of the van de Veldes and other Dutch seascape painters is obvious in Atkinson's work.

An interesting sea painter from Northern Ireland was William A. Coulter (1849–1936). He left Ireland to go to sea at the age of thirteen, though he had drawn as a child in Glenarm and in the Glens of Antrim. Later in life, he spent two years studying art in Europe before settling in San Francisco. He must have returned to Ireland on a number of occasions, as his Irish subjects are sometimes seen and include such scenes as a waterfall in one of the Glens of Antrim.[76] *A View of the Bull Wall*, Dublin, *with Shipping and the Hill of Howth*, signed and dated 1889, is a lively Dublin harbour scene (Fig. 294).

Petrie, Danby and O'Connor

By far the most interesting landscape painters of the first half of the nineteenth century were three friends, George Petrie, James Arthur O'Connor and Francis Danby, who met as students in Dublin and cemented their friendship by making sketching tours together. This habit had been encouraged by the publishers of books of engraved views which reached the zenith of their popularity in the 1820s, 30s and 40s. The fashion was also common in England, where Turner, for example, made such trips annually. Many of these projects were undertaken not so much out of love of pure landscape but by the eternal appetite of the public to see the country seats of the nobility and gentry. We have touched on this aspect of tourism in chapter 4, and in Ireland this taste is found in the novels of Charles Robert Maturin, Maria Edgeworth and Lady Morgan. One has only to think of those romantic pasteboard baronial castles that people the pages of Neale[1] and Brewer,[2] beetling on the edge of cliffs or ravines – usually highly exaggerated – to see the romantic Gothic spirit of the period. This travelling also developed the late-eighteenth-century antiquarian interest in the ruins of Ireland's past, both early Christian and medieval, along more scientific and comparative lines. It further emphasized the tragedy of Ireland's turbulent history and must have stimulated the romantic imagination of young artists. It was perhaps the most important influence of Ireland on these three young painters, two of whom were to make their careers in England. But one should not forget that while studying in Dublin they must have become familiar with the work of Barret and of the two Roberts, the younger of whom, Thomas Sautell, was still at the peak of his career and whose own love of painting wild scenery may have been transmitted to the younger generation in person.

George Petrie (1790–1866) was the oldest of the three and the son of a Dublin portrait and miniature painter. He had a successful career in the Dublin Society Schools, winning the silver medal when he was

fourteen, in 1805. His first sketching tour was in Wicklow in 1808, when he kept a journal, and his first trip to Wales was in 1810. It was probably about this time that Petrie met Danby and O'Connor, and the three set off to London together in 1813. There, Petrie had introductions to the President of the RA, Benjamin West, who was very kind, but Petrie was summoned home by his father, who sensibly sent him a saleable picture with which to pay the fare.[3] However, later in the year, he seems to have visited Wales again in the company of Danby and O'Connor. In his early years, Petrie concentrated on watercolour landscape painting, travelling as far as Co. Kerry, though most of his work was produced nearer Dublin. It was not until 1821 that he made his first trip to the Aran Islands. As early as 1816, he exhibited two pictures, the only ones he ever sent to the RA, of Glenmalure and Glendalough, which had been painted for the Lord Lieutenant, first Earl Whitworth. Most of these early works were in monochrome and by 1819 many were being produced for the engravers. In that year, for instance, he supplied ninety-six illustrations for *Cromwell's Excursions through Ireland* such as *Slane Castle, Co. Meath*, 1819, (NGI). He also contributed to Wright's *Guides to Wicklow and to Killarney* (1821) and Brewer's *Beauties of Ireland* (1825), as well as to many other publications. He was admitted an ARA in 1826 and made a full member in 1828, the first time a watercolour painter had been so honoured. However, it was understood that he would in future attempt oils, though he never in fact did. In 1829, he became Librarian at the RHA and in 1833 he was put in charge of the Antiquities Section of the Topographical Survey of Ireland, being made by the Ordnance Office, and until this department was disbanded in 1846 had little time to continue painting. He was too much engaged in writing his book, the *Ecclesiastical Architecture of Ireland*,[4] and other publications. He was a devoted member of the Royal Irish Academy all his life, collecting books, manuscripts and antiquities for

295 George Petrie, *The Last Circuit of Pilgrims at Clonmacnoise*, c.1838, watercolour, National Gallery of Ireland, Dublin

296 George du Noyer, *Killiney looking towards Bray*, 1866, watercolour, Private collection

after he left the Ordnance Survey, he painted in full colour, as in his *Pilgrims at Clonmacnoise* (1838, Fig. 295). His masterly handling in broad washes in both small and large watercolours and his real understanding of architectural details, light and distances make some of his work most evocative. As Stokes says, 'the poetry of Wordsworth made a deep impression upon him ... in both we find the same perception of the beautiful, the same dwelling on scenes of simple nature'.[6] In another passage, he says:

It has been already shown how closely related in his mind were the studies of nature, and of those old surviving monuments of the land, which, while they are witnesses of its history, become themselves objects of a peculiar beauty, and give to the reflecting mind a larger enjoyment of the landscape. Hence many of his pictures show the effects of that combination so strangely frequent in Ireland, where the ruin and its surroundings unite in giving a national character to the scene, and so in a large proportion of his works, we have the feeling and skill of the painter in union with knowledge of the antiquarian.[7]

Thackeray admired Petrie's work in 1842[8] when he visited the almost empty RHA.

Petrie's pupils, George du Noyer (1817–59) and William Frederick Wakeman (1822–1900), were, through his influence, employed as draughtsmen in the Ordnance Survey. Du Noyer, like Petrie, was an antiquarian and his drawings of antiquities are very much in his master's manner. He also worked for the engravers, including *Hall's Ireland*, but much of his work is to be found in a large series of watercolours now in the Royal Irish Academy. A very fine topographical view from *Killiney looking towards Bray* (1866; Fig. 296), showing the railway and a number of new villas, is a very good example of his considerable talent. After the Survey collapsed, he had an interesting career as a geologist: his drawings are of outstanding quality. He was also employed in drawings of plants, fruit and flowers, and natural history such as fish and shells. Many of these are in the Natural History Museum, Dublin. His vignettes of everyday life are also highly intriguing.[9] Much of Wakeman's work is also to be found in the RIA. He was a profuse illustrator of antiquarian works and guidebooks of the period, and became art master at Portora Royal School.

it and founding its museum. He was also a notable collector of ancient Irish music.

After 1846, he returned to painting in order to earn his living and in 1857, at the height of the domestic troubles in the RHA, became President briefly but resigned to leave the way free for the government enquiry. Though William Stokes says that 'the pictures of the elder Barret, in Ireland, and of Wilson, in England, were objects of great admiration to the mind of Petrie',[5] his style does not seem to have been influenced by them. The elder Henry Brocas, who would have taught him at the Schools, and possibly Jonathan Fisher, through his many sepia aquatints of Irish scenery, are the most likely influences. In his early years, his near-monochrome technique can be considered somewhat monotonous, but in the 1830s, and

James Arthur O'Connor (c.1792–1841) was the son of a Dublin print-seller and engraver, who may have taught his son, as there is no record of him going to the Dublin Society Schools, and the old story that he was taught by Sadler seems to have no contemporary foundation. He was recorded as 'self taught' by an early critic writing about a series of etchings he published in 1810 which were received favourably.[10] However, other writers, such as Stokes in his *Life of Petrie*[11] and J. D. Herbert in *Irish Varieties*,[12] say that he

went to the Schools, though he is not included in the list of students. He had exhibited at the Dublin Society House and at the Society of Artists of Ireland in 1809 and continued to exhibit at such shows until 1813 when he left Dublin with Petrie and Danby. His hasty return from Bristol, leaving Danby to prosper there alone, was, according to a letter of Danby's written in 1843, because 'O'Connor's poor little sisters who were orphans and depended on him could not be without him'.[13] When he returned to Dublin, he continued to exhibit with the Hibernian Society of Artists and in 1818–19 was working in the west of Ireland painting a series of topographical paintings for such landowners as the Marquesses of Clanricarde and Sligo and for Courtney Kenny of Ballinrobe House, Co. Mayo. These are among his best works and include a panoramic view of Westport (Fig. 297); painted with direct simplicity, they are the heirs of Ashford's landscapes and show little emotional response to the grandeur of the west of Ireland, but rather an interest in the improvements and activities of man. Despite this patronage and his continued exhibition appearances in Dublin, O'Connor did not prosper sufficiently and left for London with his wife, Anastasia, in 1822. Here, he started to exhibit at the RA and the British Institution and, though many of his subjects were still Irish, such as his *View of Irishtown from Sandymount* showing bathers and a wooden hut, 1823,[14] he travelled widely in England, making sketches, as is proved by an existing sketch-book dated 1822 in the NGI. His style developed during the 1820s, away from the eighteenth-century objective view to the more romantic style of painting current in London, the product of

the imagination and intensity of the paintings of Turner, Constable and even Danby.

O'Connor's first trip to the Continent was in 1827, when he went to Brussels, and after his death in 1841 a number of his watercolours of that city were exhibited at the RHA. His charming, but still neat, topographical view of the battlefield of Waterloo must date from this time. His other continental visit was in 1832–3, when he spent eight months in Paris and then a further six travelling in the Rhine Valley. By this date, his style had already developed a feeling for the force and majesty of nature, initially perhaps encouraged by Irish scenery and Irish paintings such as Ashford's *Storm Scene* of 1780 and Thomas Roberts' *Stormy Landscape* (Wood Collection, University of Limerick) on which O'Connor's landscape, formerly in the Widener Collection, Philadelphia,[15] is based. But how far he was influenced by French artists like Georges Michel, whose work may be reflected in several later scenes lit with the French artist's contrasting areas of light, or by such Germans as Caspar David Friedrich, especially in such a scene as *The Monk in a Rocky River Landscape*, it is impossible to say with any certainty. But O'Connor's eclecticism is notable where Dutch painting is concerned and it would be strange if he had not been affected by Dutch and Flemish artists during his visits to those countries. He was apparently appreciated in Paris and painted for Louis-Philippe. One of his finest, if very Ruisdael-like, landscapes had been painted for the king as early as 1826 when he was in England, and it is now in the Nottingham art gallery.[16]

O'Connor paid a number of visits to Ireland, finding inspiration in 'the wild and beautiful scenery

298 James Arthur O'Connor, *Eagle Rock*, *Killarney*, oil on canvas, Private collection

299 Francis Danby, *Landscape near Clifden*, 1822/3, oil on canvas, Yale Center for British Art

some English colleagues, had to raise a subscription for her to purchase a small annuity. Despite the great variety of sources from which he drew, James Arthur O'Connor's style is easily recognizable. Usually small and often on panel, his little landscapes with clumps of trees enclosing the scene in which a couple of small figures walk in solitude, sometimes varied by a rocky or mountainous background, are commonly encountered. But if his earliest drawings and etchings derive from Rembrandt and Teniers,[18] and many of his landscapes from Dutch seventeenth-century landscape painters and occasionally from Claude and even Wilson, the main bulk of his work is broodingly romantic and very personal. His *Eagle's Rock*, *Killarney* (Fig. 298) and *The Frightened Wagoner* (NGI) both show a similar awe in the face of natural effects, as does his large-scale Salvator-like *Glen of the Rocks* of 1830. However, his *Poachers* (NGI), with its beautiful handling of the moonlight and the distance, is serenely calm and it is this quietness which pervades much of his work, early and late, and which gives his *œuvre* its unity.

The third of the trio, Francis Danby (1793–1861), came from a Wexford family who moved to Dublin at the time of the 1798 rising in Co. Wexford. His father died in 1807, when Francis was quite young, and shortly afterwards he started studying in the Dublin Society Schools, where he finished in 1813. Only a few drawings survive in the NGI and the Ulster Museum, which are certain evidence of his Irish training. They are charming, neat little topographical studies of scenes near Dublin, in Co. Wicklow, and one further afield of Castle Archdale in Co. Fermanagh.[19] From the sale after his death, which included a picture entitled *Near the Lakes of Killarney*, it seems that his sketching tours were extensive. One oil is known, clearly an amalgam of Irish scenery loosely based on Ross Castle and the lower lake at Killarney, which is attributed to his early Irish days.[20] Stokes, in his *Life of Petrie*, mentioned a work painted by the three friends, and though this seems unlikely, as Petrie left them in London, it is just possible that O'Connor and Danby collaborated on this view.[21] The three friends had enjoyed a few exciting weeks in London in 1813, seeing, among other things, the RA, where Danby found Turner's *Frosty Morning* particularly memorable.[22] After Petrie left, O'Connor and Danby left too, due to lack of funds, walking to Bristol, where O'Connor set off for Dublin but Danby stayed as he had by chance found local patrons almost at once.

Danby stayed some eleven years in Bristol, until 1824, earning his living by teaching and selling water-colour views, many of the Avon gorge, which were remarkable for their simplicity and gentle, sometimes hazy colouring. They remind one of the watercolours of Thomas Sautell Roberts which were exhibited frequently in Dublin and which Danby must have known. His Bristol oil paintings are local views, with charming genre figures of children playing with boats,

of my native country', as he said in a letter to John Gibbons of August 1830.[17] He continued to exhibit at the RA and other London exhibitions and in 1840 sent three works to the RHA, the first since 1830, the only other occasion he had shown in that institution during his lifetime. But in the late 1830s, his eyesight was failing and his health declining. In January 1841, he died, leaving his unfortunate widow in such penury that a group of Irish artists, headed by Shee, together with

having picnics, etc., enlivening their carefree composi-
tions, and are among his most enchanting subjects
(Fig. 299). Their clarity of light, love of distances and
delicacy of handling separate them from his more
famous work, which he began before he left Bristol but
which was painted for the London public. Eric Adams
suggests that the links Danby formed with local intel-
lectuals and art lovers, especially through the local
drawing club, were influential in his choice of subject-
matter with which to launch his London career, *The
Upas Tree* (V & A).[23] This dramatic subject was shown
in London in 1820 and was the first of his large, dark
canvases in which the forces of nature overwhelmed
the paltry efforts of man. Shown in the British
Institution, it met with universal praise from critics
and from Sir Thomas Lawrence. In the great German
art historian Waagen's words, it was 'a gloomily poetic
conception' with 'a very careful execution of detail'.[24]
One critic noticed the resemblance to John Martin's
apocalyptic style, but we are not certain if Danby
knew Martin's work at this stage in his career.

Danby's *Disappointed Love* (V & A), sent to the RA in
1821, introduces the sentimental note into his work
which ensured its popularity. The story-telling aspect
of the picture is, however, idealized, so that a particu-
lar character is not intended and it is thus isolated
from the normal genre paintings of the period. His
links with English romantic poetry and especially
Coleridge have been well discussed by Adams and
Francis Greenacre.[25]

The years between 1824 and 1829 were the high
point in Danby's career. His *Sunset at Sea after a Storm*
at the RA in 1824 (Fig. 300) was bought by Lawrence,
and in the same year he moved to London. He was
made an ARA in 1825 but he failed to be elected an RA
in 1829 by one vote to Constable. However, he
achieved enormous popularity and fame at this time,
far greater than Constable enjoyed. It is to this period
that most of his famous works belong. His visit to
Norway in 1825 was important in providing him with
even grander, vaster and more empty spaces for his
landscapes than ever before. He used northern scenery
to great effect in a series of canvases which competed
with 'Mad' Martin's apocalyptic paintings although
they were set in realistic landscape as opposed to the
architectural settings which Martin had mostly
favoured to this date. Of these, *The Delivery of Israel
Out of Egypt* of 1825 (Fig. 301) and *The Opening of the
Sixth Seal* (NGI), exhibited at the RA in 1828, are
typical. He also exhibited a wide range of subject-
matter, a Turner/Claude style of landscape, *The
Embarkation of Cleopatra*, and Shakespearean and bibli-
cal subjects. He seems almost to have had the desire to
shock the public into fresh admiration with a new type
of picture for every Academy exhibition.

However, these successful years came to an abrupt
end when he left London in 1830. The exact details of
the domestic crises which culminated in his wife going
to live with the artist Paul Falconer Poole (whom she

married after Danby's death), and his departure for
France with their seven children and his mistress,
Helen Evans, will probably never be known – but cer-
tainly they were at the root of his quarrels with the
RA. His early biographers, by their deliberate eva-
sions and suggested evils, successfully ruined Danby's
reputation for the next hundred years, though not
apparently during his lifetime, as he seems to have
been fully accepted in England when he returned from
France and Switzerland in 1838. He remained in France
in 1830–1 for about twelve months and was then sur-
prisingly unsuccessful. He moved to Switzerland, set-
tling in Geneva from 1832 to 1836, and then returned
to Paris. In Geneva, he seems to have taken up the
hobby of boat-building, which was to occupy a lot of
time and money in his later years, but none the less
paid his way painting large topographical views of the

300 Francis Danby, *Sunset at Sea after
a Storm*, 1824, oil on canvas, Bristol
City Museum and Art Gallery

301 Francis Danby, *The delivery of
Israel out of Egypt*, 1825, oil on canvas,
Harris Museum, Preston

lake scenery (Fig. 302); he never seems to have enjoyed the Alps. In his second stay in Paris, he earned his living copying the Louvre pictures on commission for English patrons, of whom John Gibbons, his lifelong friend, was the most constant help. After a visit to Brittany, he returned to London, where he completed one of his famous and tumultuous works, *The Deluge*, now in Tate Britain. In his letters to Gibbons from Paris, where the picture was begun, he mentioned Poussin's *Deluge* in the following terms: 'It is a most impressive thing; one can never forget it, the tone is awful ... yet I have always felt it is but a poor conception for the Deluge',[26] and this may have sparked off his decision to attempt the subject. In October 1837, he wrote, too, of Gericault's *Raft of the Medusa*: 'It is awfully sublime, yet not an atom deviating from the truth of nature; indeed, its truth is its sublimity'.[27] These and other pictures he saw in Paris impressed him enormously and, coming at a time of great personal sorrow, for several of his children died of illness in Paris in 1837, the tragedy and horror of the theme of the *Deluge* seems to have inspired him to create a picture of monumental grandeur and despair.

His other pictures of this period, *Leinsford Lake* (V & A) and *The Enchanted Castle – Sunset* (V & A), both exhibited at the RA in 1841, are pervaded with the same sadness. *The Deluge* restored his London reputation, though he never returned to full favour with the Academy and never became an RA. In 1840, he probably visited Norway again, and possibly Wales, and in 1844 he began to exhibit at the RHA. He may have been in Ireland that year, and from then on seems to

have kept in touch with Petrie, as the two letters quoted in Stokes's *Life of Petrie* date from 1846 and 1850.[28] O'Connor, with whom he had never lost touch, died in 1841. In 1847, he went to live in Exmouth, and remained there until his death, but continued to exhibit regularly in London, Dublin and Paris.

His most famous late work was *The Evening Gun*, exhibited in 1848 at the RA, and of which only the later and smaller 1857 version survives. This calm, nostalgic seascape was typical of his late work, when seascapes predominate and he had given up apocalyptic subjects. Its poetic qualities and the beauty of its handling of light were the features which critics singled out for praise. It was shown at the International Exhibition in Paris in 1855. Everyone praised it highly, including Theophile Gautier, who said, 'The tranquillity, silence and solitude in this canvas are deeply affecting. No one has better expressed the solemn grandeur of the ocean.'[29] The painter David Roberts said simply that 'Danby's *Evening Gun* was *the* picture in Paris'.[30] The influence of Turner and Claude is paramount at this stage in his career. He always worked in deep tones and by the 1850s this singled him out from the bright colours of English painting of the time and may have been one reason for the French admiration of his work. His sunsets are spectacular throughout his career, particularly in the *Sunset at sea after the storm, 1824* (Fig. 300), and *The Dead calm-sunset, at the Bight of Exmouth, 1855*.[31] His painting declined towards the end of his life, when he lived a lonely existence in Exmouth, dying in 1861. He is certainly one of the most distinguished of Ireland's painters.

Portraits and Subject Pictures
in the Nineteenth Century

Irish nineteenth-century painting was as affected by the international passion for anecdote, sentimental history and genre as that of any other country. It is a little difficult to chart the development as, though we know the titles of so many exhibited works in the RHA and elsewhere, extraordinarily few paintings, with the exception of the well-studied works of Maclise and Mulready, both of whom worked in England, have come to light, and some of the artists died very young. None the less, the subject pictures are an infinitely more alluring topic than the portrait painting, where the standard was often very dull. This is partly the fault of the soberness of male costume and the less numerous female subjects. The general standard of painting is academic and uninspiring and though many painters earned their living by portraits, they nearly all painted some subject pictures.

A typical case is Joseph Patrick Haverty (1794–1854), who came from Galway. His education is unrecorded, but in 1814 he sent a picture to the Hibernian Society of Artists Exhibition in Dublin, where he was living by 1815. In his early years, he seems to have travelled a great deal, presumably in search of commissions, and, according to Strickland, he visited London from time to time throughout his career and exhibited portraits regularly in the RA over the period. On the foundation of the RHA, he was one of the first associates, becoming an RHA in 1829. His whole-length painting of Sir John Power of Kilfane (Rothe House, Kilkenny) is a robust fox-hunting portrait. He also painted Power's brother, who founded the Kilkenny theatre, dressed as Hamlet (Rothe House, Kilkenny).

Many of Haverty's portraits are quietly contemplative and he is often better at domestic compositions, such as the *Dunally Family* and the particularly charming *Reilly Family of Scarvagh* (1823), with one of the boys sitting on a donkey in front of their house in Co. Down. John Lushington Reilly was an artist himself and, according to the Reilly family, had noticed Haverty's talent early, when he was a boy in Galway,

and had assisted in his education. Haverty's well-known pair of aquatints of George IV processing down Sackville Street (now O'Connell Street) on his arrival in Dublin, with cheering crowds and every window and roof filled with spectators, and his departure from Kingstown (now Dun Laoghaire) are full of life and include a myriad of small portraits among the enthusiatic onlookers. They are based on sketches taken on the spot in 1821 by Lushington Reilly himself. Another painting of George IV's arrival at Howth was allegedly not accepted by the king because his carriage was too far in the background. They are all rather static and the figures in the prints are doll-like.

His *Monster Meeting at Clifden* (NGI) is also without movement, though in this case it befits the subject. Daniel O'Connell, the leading figure in the Monster Meeting, was painted on several occasions by Haverty, often in monumental whole-lengths. The most important full-length of O'Connell is in the Reform Club, London (Fig. 303) and shows him romantically as the Gaelic chieftain wearing a great cloak, wolfhound by his side and wild mountains in the background, with what appears to be the ruin of a round tower or castle. Jeanne Sheehy traced the change of Irish cultural life at this time, noting a growing sense of national identity linked to the Celtic past and using symbols and motifs, as originated in the late eighteenth century, to illustrate this newly cultivated nationalism: the harp, the wolfhound, shamrocks and the round tower begin to surround images of O'Connell, for it was he who opened up the possibility of a new identity for Ireland, distinguished from British culture.[1]

Haverty's most charming surviving works are perhaps those which include children. Apart from the Lushington Reilly family, another big family group shows some of the sitters getting into a boat, others sitting playing with a baby against the background, we think, of the Mourne Mountains and Carlingford Lough. Less ambitious pictures possibly by Haverty are of the two Misses Manders and another of the two

303 Joseph Haverty, *Daniel O'Connell*,
oil on canvas, The Reform Club

304 Joseph Haverty, *Christ being nailed
to the Cross*, oil on canvas, Saint
Patrick's College, Maynooth

There are also nationalist overtones in some of his works and occasional religious subjects. His most famous work, lithographs of which are still to be found all over Ireland, is *The Limerick Piper* (Fig. 305)[2] of which two versions are known, one in the University of Limerick, the other in the NGI. This melancholy patriotic theme of the blind piper with, in one example, his attendant child, and in the other a child offering him flowers, playing for a lost Ireland, has considerable pathos, while his painting *Father Mathew receiving a Pledge Breaker* (NGI) has both a social and religious content. Such few works as survive have darkened badly, for instance, the *First Confession* (NGI). He was one of the few Irish artists to paint altarpieces, most of which seem to have disappeared, and he even exhibited an example in 1830 of a series of the Seven Sacraments. Except for a wrecked example, in the Augustinian convent in Limerick, of *The Ascension* by Timothy Collopy (*fl.* 1777–1810), who was a picture restorer as well as an artist, there is one other surviving altarpiece now in Maynooth, by Haverty. It is *Christ nailed to the Cross* (Fig. 304). Apart from these examples, a large number of religious pictures were exhibited in the catalogues of the RHA exhibitions, which have all vanished. It is indeed curious that a country of such deep religious feeling should have patronized so few native painters for religious works nor inspired any artists to paint religious themes, especially during the post-emancipation era, when Catholic church building was at its height. Oleographs and copies of Italian Renaissance and Nazarene works seem to have been preferred.

Another much patronized portrait painter was James Butler Brenan, RHA (1825–89), whose works are commonly found especially in Co. Cork and south-west Ireland. He was a competent but run-of-the-mill artist. His work is usually signed and dated and shows prosperous middle-class ladies and gentlemen and handsome military men. He also exhibited a few religious paintings and genre pieces. He was the son of John Brenan (*c*.1796–1865), a landscape painter from Cork who worked in Donegal as well as in the south-west and even exhibited a view of Hampstead. He exhibited at the RHA from 1826 to 1866 and in Peter Murray's words he was 'competent but uninspiring'.[3]

Charles Grey, RHA (*c*.1808–92), who came from Scotland but made his career in Ireland, was an excellent realist portrait painter, especially of old men like *Captain Alexander Chesney* (UM) and *Whitley Stokes* (TCD), both memorable paintings. He was also a painter of lively shooting and stalking pictures made both in Ireland and in the Scottish highlands, mostly for his patrons the fourth Marquess of Londonderry and his stepson, the seventh Viscount Powerscourt, who owned properties in Scotland. He was the father of several painters and of the prolific landscape and animal painter, Alfred Grey, RHA (1845–1926). Michael J. F. McCarthy writes amusingly, 'Mr Alfred

daughters of John Joseph Blake, a member of a well-known Galway family. There are several others, all somewhat primitive and doll-like in technique, which adds to their charms. Haverty submitted a painting of the *Baptism of Ethelbert* to the committee selecting works of art for the new Houses of Parliament in London without success. Most of his history pieces were on Irish subjects, and many on rural genre themes.

305 Joseph Haverty, *Limerick Piper*, oil on canvas, University of Limerick

Grey's bulls, cows, and sheep look plaintively at us, in March, April and May every year from the walls of the RHA in Abbey Street. They are capital cattle, on misty brae-side, or knee-deep in the placid Tolka. I personally know them all, as if they were old friends, quiet, healthy, contented-looking animals. Mr Grey is as good a cattle artist as Sidney Cooper'.[4] A fine example of his animal painting is *A Warm day, Cattle drinking*.[5] He was patronized by Queen Victoria when she was in Scotland.

A Limerick painter whose talents are of a very low standard, but who has to be mentioned because of his famous sitter, is John Gubbins (*fl.* early nineteenth century). He is known for his portraits of the O'Connell family, which hang in Derrynane House[6] and for a three-quarter-length of Daniel O'Connell in the Mansion House in Dublin. Another provincial artist was John O'Keeffe (*c.*1797–1838), a Cork man who also worked in the Limerick area, where he died. A pair of pompous portraits of the Evans family of

306 George Sharp, *Boy and Bear*,
oil on canvas, National Maternity
Hospital, Dublin

307 William Willes, *The Mock Funeral*,
oil on canvas, Private collection

Knockaderry, Co. Limerick, signed and dated 1836, are competent. He executed a number of altarpieces around the Cork area which are now not known. A 'Sybil' according to Strickland was in the Cork Museum.

An artist who painted a similar type of picture to John George Mulvany, though rather later in the century, was William Heazle (1845–72) of Cork. Strickland records that he copied Etty, but he is known only by three genre scenes of children; one, of a boy posting a letter, painted in 1869, indicates the liveliness of his characters. Another artist of this type of anecdotal work who also painted portraits was Henry MacManus (c.1810–78), who came from being the Head of the Glasgow School of Art to be the first Director of the School of Design created by the Board of Trade out of the Royal Dublin Society Schools in 1849. He exhibited a large number of portraits, subject pictures and landscapes in the RA and RHA, though his *Reading The Nation*[7] (NGI), a slight, humorous genre scene, is the only one known to us. George Sharp (1802–77) was a painter remembered now more

for his teaching than for his painting; he taught privately in Dublin from 1842 until 1868. He adopted the system of Alexandre Dupuis which was used in French government schools and published a lecture based on this method in 1852. He himself had received a remarkable education in Paris under Picot and Couture. Very few of his RHA paintings have survived; two in the NGI, *The Cock that Crew in the Morn* and *Creeping like Snail Unwillingly to School*, were exhibited in 1864 and 1863. A portrait of an old man resting called *Repose* (1867) has a distinctly Daumier-like feel. A newly discovered work of 1847 of colleens talking to a man feeding a bear and attended by a dog (National Maternity Hospital, Dublin), may be the same as the work exhibited by the artist in 1864 at the loan exhibition of arts in Dublin as *Boy and Bear* (Fig. 306). All these works are notable for their broad handling, very vigorous, large brushstrokes and the *Boy and Bear* makes one want to see more of his work.

Genre and subject-picture painting was popular throughout the century and a number of Cork artists, following perhaps in the footsteps of Nathaniel Grogan, were noted for this type of subject. William Willes (*fl.* 1815–51), who became the first Headmaster of the Cork School of Art, was one of these. He was taught by Grogan, though after early medical studies he took up painting seriously in his thirties. Previously Willes was only known for sketches for *Hall's Ireland*, and some nude drawings in the Crawford Art Gallery, until a major work by him surfaced in a London sale room recently. Called *The Mock Funeral* or *The American Wake* (Fig. 307), it depicts the farewell given to emigrants setting out for America, as they were very unlikely ever to see Ireland again. The figures are seated in the foreground, the funeral cortège is in the centre, and high above the clouds is a vision of a castle and distant mountains, perhaps the new, or even heavenly, world. It was exhibited in Cork in 1852, the year after Willes's death, and must have been his masterpiece. The landscape is superbly rendered. It is one of the few pictures which depicts the effect of the famine, and it must have been among the finest genre pictures of the mid-century painted in Ireland. He was noted for portraits, landscapes and genre which he exhibited in London at the RA, and the British Institution, in Dublin at the RHA and in Cork.

A Corkman and exponent of this genre, who was also highly important as an art educator, was James Brenan (1837–1907, not to be confused with the James Butler Brenan previously mentioned). He was something of a child prodigy, going to the figure school at the RDS in 1849, and he worked as an assistant in the Pompeian room at the Crystal Palace for the Great Exhibition in 1851 under Owen Jones and Matthew Digby Wyatt. As a result of the exhibition, by 1855 art schools were developed all over the British Isles which included some earlier institutions like the Cork School of Art. Brenan taught in a number of schools in

England and the RDS and was trained in the famous Marlborough House National Art Training School in London. In 1860, he became headmaster of the Cork School of Art, where he endeavoured to encourage industrial design and was very successful in developing the lace industry, thus helping the inhabitants of impoverished areas.[8] He used old lace as examples, and provided new designs for the convents which were at the centre of this trade. He failed, however, to interest his students in designing for modern factory products.

Brenan, despite his other work, was a prolific artist, exhibiting over a hundred pictures at the RHA between 1861 and 1906. These included some fine landscapes, like *Glenmore Lake, Co. Kerry*, signed and dated 1891. It is a highly finished and well-composed scene and entirely unlike his genre style, which is more robustly handled. His genre topics were often linked to his teaching interests, such as the *Committee of Inspection* (Fig. 308) which was exhibited in the RHA in 1878. This is difficult to interpret as the craft work is not clearly shown and may be knitting (the girl by the door has two needles) and the inspectors appear to be holding pieces of cloth. Peter Murray has suggested that the man and seated woman are buyers from a city department store unsatisfied with these homespun products which could not compete with the cheaper factory materials being imported from England.

One of his most evocative pictures is his *Letter from America* (Fig. 309) where a young girl, the only member of the family who is literate, is reading a letter to her relations from the emigrant family member in America. The old grandfather strains to hear every word and the scene is particularly moving. The simplicity of the cottage setting of both these

308 James Brenan, *Committee of Inspection*, oil on canvas, Crawford Art Gallery, Cork

309 James Brenan, *Letter from America*, oil on canvas, Crawford Art Gallery, Cork

pictures[9] shows a remarkably accurate portrayal of the furnishings of rural Ireland, even to the spoons hanging in the dresser in the *Committee of Inspection*.[10] Brenan was clearly influenced by David Wilkie and Mulready, not to mention the Dutch seventeenth-century work on which they were all based. *The Schoolroom* or *Empty Pockets*[11] (1887) is the picture that really shows the ragged barefoot children whose game of marbles forms a contrast to the torn schoolbook on the floor. Brenan, who appears to aim at accuracy, paints a schoolroom empty of all but desks, benches and maps, but it is clean and well cared for. In 1889, sadly for Cork, he took on the post of headmaster of the Metropolitan School of Art in Dublin, the successor to the Dublin Society Schools, where he continued his good works with lace and design classes. He retired in 1904.

Brenan was succeeded by an Irishman from Kerry, Richard Henry Albert Willis (1853–1905), who trained in Cork under his care. Willis's direct portraits and landscapes are occasionally seen. He was a notable teacher, working in Manchester and in South Kensington. He succeeded Brenan as head of the Dublin Metropolitan School of Art in 1904 for one brief year before he died.

A more lively painter, who died young, is Trevor Thomas Fowler (*fl.* 1830–44). Though his portrait painting is conventional, his *Children Dancing at a Crossroads* (Fig. 310) is painted in pale, bright colours using a white ground. It depicts an Irish rural tradition of using crossroads as a dancing venue, and despite the saccharine sentimentality of the expressions, it is a very well-painted picture. He exhibited at both the RA and the RHA and spent some time in Paris in the 1830s.

Samuel McCloy (1831–1904), a Northern artist who came from Lisburn, Co. Down, painted a number of rather sentimental, small genre scenes, of which the comparatively large *Arrival of Paddy of the Pipes*, signed and dated 1873 (Lisburn Art Gallery), shows two groups of prosperous children and a few adults greeting an itinerant piper. It is a soft evening scene with lengthening shadows, and is an idealized vision of a mythical, rural Ireland. *Hide and Go Seek* (Fig. 311), signed and dated 1869 is a romanticized rural idyll in much the same manner. McCloy became headmaster of the Waterford School of Art for a short time. His watercolours, including *Espalier Apple Blossom* (UM) and *Strickland's Glen near Bangor*, are an indication of his quality as a painter of directly observed nature and are his best work.

A feeling for nature also enlivens the landscape of *Ariccia* (UM) by McCloy's compatriot from Belfast, James Atkins (1799–1833). If this talented view is a fair estimate of his quality, it is sad that so little is known other than his excellent full-size copy of Titian's *Peter Martyr*, now in Queen's University, Belfast. Atkins was a founder pupil of the Belfast Academical Institution in 1814 and in 1819 was sent to study in Italy through the generosity of local patrons, Mrs Batt of Purdysburn and the Marquesses of Downshire and Londonderry. His full-length portrait of the third Marquess of Downshire (UM) in Hussar uniform is a fine swagger piece. Atkins spent thirteen years in Italy, went to Constantinople in 1832 and died of consumption in Malta on the way home. His Italian pictures were sold in Belfast in 1835 after his death.

A striking *Head of a Moor* (NGI) signed by Robert Fox (*fl.* 1835–83) suggests that he, too, may have travelled. Fox is virtually unknown and the head was falsely signed before cleaning and sold as a James Muller, a not very convincing transformation. A similar head of a turbaned Indian has recently appeared. Fox was a product of the Dublin Society Schools and exhibited largely genre, landscape and animal pieces in London and Dublin.

Edward Murphy (*c.*1796–1841) is another nearly vanished artist whose single known work, his *Parroquets* in the NGI, is well worth recording. A painter of still life, flowers and fruit in the seventeenth-century Dutch manner and of landscapes, he exhibited regularly and it is astonishing that such a competent hand should disappear. No doubt he, too, is being sold under other names.

In contrast with these artists, memories of whom are barely tangible, quality rises and colour heightens in the canvases of Richard Rothwell (1800–68) both in character and in style, the epitome of the romantic. His education at the Dublin Society Schools, which he entered in 1814, led to the presentation of a silver palette in 1820. At this stage, he is known to have painted landscapes; an example with a bridge, houses and figures in mountainous scenery is dated 1827. He seems to have developed his rich colour sense well before he went to London in 1829, as, according to Strickland, Landseer remarked to a friend: 'an artist has come from Dublin who paints flesh as well as the Old Masters'. His Venetian technique, with thick impasto, glazes and rich reds, was marred by the excessive use of bitumen, which has ruined so many of his pictures. On his arrival in London, Rothwell studied briefly under Lawrence and at this period his work is extremely close to his master, for example, the unfinished portrait of Miss Lavinia Daintrey (UM). He was much admired by Lawrence, who called him the 'Irish Prodigy', and he inherited much of Lawrence's practice, completing many of his unfinished canvases after his death in 1830. A note on his paintings in the RA exhibition of 1830 says 'Mr Rothwell, it is true, is the fashion and has his door

310 Trevor Thomas Fowler, *Children dancing at a Crossroads*, oil on canvas, National Gallery of Ireland, Dublin

311 Samuel McCloy, *Hide and Go Seek*, signed and dated 1869, oil on canvas, Private collection

beset with carriages, and fashion like folly, knows no reason and his commissions are numberless'.[12]

After his return from his Italian trip of 1831–3, he lost much of his custom. This embittered most of the rest of his career, which was spent in London, America, Italy, Dublin, Belfast and English provincial towns, never settling anywhere for long. None the less, he painted numerous, now largely ruined, portraits, which exhibit his 'speaking' eyes, looming darkly out of pale faces, the whole set against a dark, unencumbered background. One of his best pictures is the *Mother and Child*,[13] which was exhibited in the Art Union of Ireland, where it won a £100 prize, the

312 Richard Rothwell, *The Herbert family*, oil on canvas, National Trust, Powis Castle

313 Richard Rothwell, *Head of a girl*, 1860, oil on canvas, Private collection

subject being 'Either Admiration or Contemplation', from a label on the back. Here we can see the emotional intensity which he creates out of his rich colours and contrasting shadows and the skin which Sir Edwin Landseer admired so much. His male portraits are similarly expressive and his children can sparkle with bubbling humour. It is extremely surprising that his work was very neglected and in part this must have been due to his temperament. His wife came from Belfast and so an unusually large number of his sitters came from the North, including the first Lord Dufferin and his wife, painted in 1828, and a particularly charming family group of Jane Emma, Countess of Antrim and three of her children. Perhaps his best conversation piece is of the Herbert family of Muckross (Fig. 312), exhibited in the RA in 1831 and in the RHA a year later. A profile of a little girl, signed and dated 1860 (Fig. 313) is another example of his understanding of children.

The subject pictures with which we are familiar are frequently extensions of his portrait style – works like his *Novitiate Mendicants*, *The Little Roamer* and *The Very Picture of Idleness* (both V & A), all of which are sentimentalized figures of peasants. Strickland lists a number of landscapes, both Italian and Irish scenes, though none of these are known to us. His *Calisto*, of which there are several versions, one in the NGI, was in his opinion his masterpiece, on which he worked incessantly,[14] but which is too pretentious a study in the Venetian manner to hold modern attention.

An artist with a somewhat similar painterly manner, but using much less bitumen, was Nicholas Joseph Crowley (1819–57), also a pupil at the Royal Dublin Society Schools, where he was admitted at the age of eight and progressed to the RHA School, aged thirteen, in 1832. In the same year, he showed a portrait at the Academy, where he was a constant exhibitor till his death, becoming an RHA in 1837, aged eighteen, the youngest member ever admitted. He spent 1835 and 1836 in Belfast, from where he sent to the RHA his brooding *Self Portrait*, fully illustrating his early precocity. Remarkably few of the enormous list of his portraits that Strickland records are now known, though those few that are, such as *The Longbourne Family*[15] and *The Hon. Mrs James Norton and her Child* are both well composed and painted with distinction. Perhaps his most brilliant group is the portrait of the Irish actor, *Tyrone Power as Connor O'Gorman in the Groves of Blarney*[16] (Fig. 314), signed and dated 1838, which was exhibited in the British Institution in 1840. His exhibited subject pictures were numerous and, from their titles, varied between religious, history and sentimental pieces. Only a few are now known, such as *Guy Fawkes Eve*,[17] which reflects Maclise's *Snap Apple Night*. Another is an enigmatic scene where a young girl is having her pulse taken while her sorrowing parents and gallant fiancé (?) in his regimentals, look on; whether this is *The Eventful Consultation*, his first work exhibited at the RA in 1835, is hard to say. In the same year he exhibited a work called *Consumption* at the RHA, which is another possibility, but, as he signs the pictures as ARHA, it was probably painted in the only year he was an ARHA, 1836.[18] The third is *The Fortune Teller by Cup Tossing*, which won the first prize in the Irish Art Union in 1844.[19] They are lively, well-composed pictures, with strong Dutch, Wilkie and Mulready overtones.

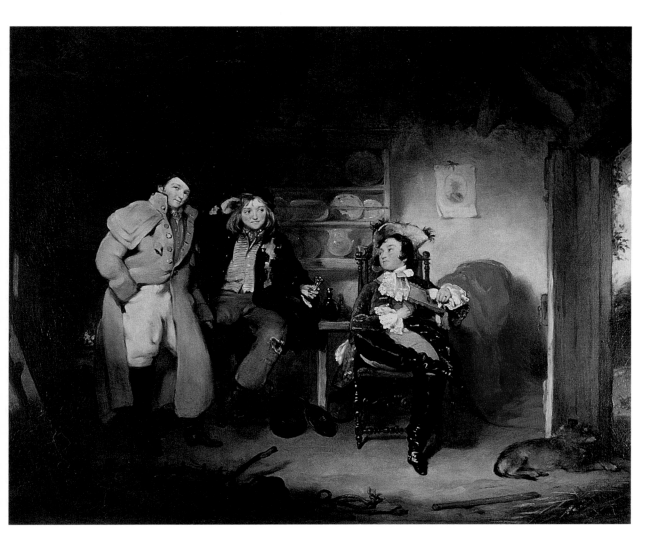

314 Nicholas Crowley, *Tyrone Power in the Groves of Blarney*, oil on canvas, Annaghmakerrig House, Co. Monaghan

One of his famous pictures is *Taking the Veil* (exhibited 1845; Fig. 315), which shows Miss Jane Bellew being received as a nun by the foundress of the Order of the Irish Sisters of Charity, Mother Mary Aikenhead, and Archbishop Murray. A full-length of the archbishop by himself was exhibited in the RA in 1844 and RHA in 1845. He painted some small whole-lengths, one of which is the very spirited sketch of Lord Normanby, the Lord Lieutenant, with his negro page (NGI) of which the large version for the Belfast Academical Institution was exhibited at the RHA in 1837. A delightful female example is Joan, wife of James Power, signed and dated 1850.[20]

The most noted establishment portrait painter of the century was an Englishman, the son of a Yorkshire coach-painter, Stephen Catterson Smith (1806–72). His smooth rise to the Presidency of the RHA in 1859 and the enormous and consistent flow of portraits from his hand form a strange contrast to the mercurial Rothwell. These are extremely competently done, though they have no psychological depth. Perhaps because of the quantity of his output, quality was extremely inconsistent. He came to Ireland after training in the RA Schools and a successful career as a portrait draughtsman in London. There are sixteen of his drawings at the Hoare seat, Stourhead (National

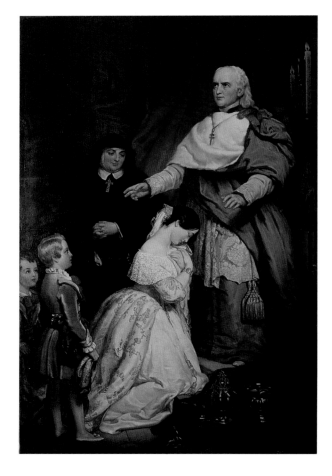

315 Nicholas Crowley, *Taking the veil*, oil on canvas, Saint Vincent's Hospital, Dublin

Trust) where, apart from the family, he drew members of its owner, Colt Hoare's staff, including the game-keeper. The finest drawing is of *Fox Baker, the Ferriter*, dated 1829, seated by his fireside with his dog and holding two ferrets. Smith had been patronized by the royal family and a bright and cheerful picture of the nine-year-old Princess Victoria, painted in 1828 (Fig. 317), is an early example of his considerable talent. He studied in Paris and published a number of lithographs.

He came to Ireland in 1839, aged thirty-three, and settled at first in Derry, only coming to Dublin in 1845, though he became an ARHA in May 1844 and an RHA later in the same year, in September. When he first arrived, he continued his urbane pencil studies, sometimes heightened with white chalk. His self-portrait in chalks (NGI) is closer to the oil style which he soon developed. His best pictures are undoubtedly his female portraits, where his talents as a drapery painter

came to the fore. *Miss Emily Murphy* is a fine example (Fig. 316), with its emphasis on the layers of frilled muslin in the subject's crinoline. His notable painting of costume make his portraits of bishops with their frothy lawn sleeves, such as *Bishop Butcher of Meath* (1872, Fig. 318), impressive. His portrait of the four daughters[21] of Thomas Johnston Barton is a pleasantly informal group and he is at his best when not painting an official portrait. Quick studies, like his *William Smith O'Brien* (NGI), are far more lively than his large, smooth set pieces, but, as he was for thirty years painter to the Lords Lieutenant, the latter are in the majority. However, his seated *First Lord Heytesbury*, 1846, in Dublin Castle is a sincere study, with a faint smile appearing on the sitter's face. It is painted with subdued, rich colouring, which is a noticeable feature of his best work, like the *Richard McDonnell* (1864) in TCD. His whole-lengths are usually unsuccessful as, unlike Shee, he had little talent for composition. However, *The Third Earl of Rosse* (TCD) is a very fine magisterial work. Occasionally, as in the portrait in the RDS of the famous Master of Fox Hounds, *John Watson*, dated 1861, he achieved success by jettisoning baroque trappings and painting his sitter relaxed in home surroundings. He occasionally painted subject pictures, and two studies of children, obviously for one of these, survive, dated 1855 and 1856. They are broadly and sympathetically treated paintings of a schoolboy and an apprentice. From RHA catalogues, it appears that the elder Catterson Smith exhibited genre subjects such as the *Shebeen House, Inishowen* (1844) when he was living in Derry and there were others from later in his career.

Stephen Catterson Smith's son of the same name (1849–1912) succeeded his father as the fashionable

man in Dublin. He is remarkable for having painted one of the three portraits of nurses in Irish hospitals, that of Sara Hampson, who was the first Nightingale nurse to work as matron in the Rotunda Hospital. A very different woman, signed and dated 1887, is a late Victorian lady seated on a settee covered with a sheepskin rug, looking at herself in a mirror with a background of palms; this is a pretty, maudlin piece. His male portrait of *W. J. Fitzgerald* (NGI), however, carries on something of his father's competence, as does *Lord Clonbrock*, exhibited at the RHA in 1892. He painted a number of landscapes in both Ireland and Scotland. Another son (Robert b. 1853–?) was a competent watercolourist and book illustrator.

The elder Smith was succeeded as President of the RHA on his retirement in 1869 by Sir Thomas Alfred Jones (1823–93), also a prolific artist. Strickland, who rarely rises to comparative judgements, is moved, however, as well he might be, to say that Jones's 'art was commonplace, and though his pictures satisfied his sitters as faithful likenesses, they were poorly painted, mechanical in execution, and without any artistic merit'. He was also a painter of sentimental genre works, mostly in watercolours, such as his mother-and-child study entitled *A Prayer for the Absent*, and *The Babes in the Wood* (RHA 1885), *Molly Macree* and *A Galway Girl* (Fig. 319). These are competently painted and, unlike his oils, are quite clear and brilliant in colour. His *Molly Macree*, obviously influenced by Frederick William Burton and the Pre-Raphaelites, is a favourite at the NGI and sums up the changing attitudes to Irish culture, Irishness and nationalism. Margaret MacCurtain, in a study of this picture, links it to the lyrics of James Lyman Molloy, 'The Kerry Dances', ballads like 'The Rose of Tralee'

and the popular operas and plays of the time such as *The Lily of Killarney* and *The Colleen Bawn*. She considers it an icon of the period.[22]

It is as true of the nineteenth as of all other centuries in modern times, that Irish artists flourish, like Irish writers, away from home. So it is not surprising that the two finest Irish-born painters of the mid-century, Maclise and Mulready, should have spent most of their careers in England. Daniel Maclise (1808–70),[23] the son of a shoemaker, had the advantage of being born in Cork, then a very flourishing city, a centre of the provision trade during the Napoleonic Wars and a town with a lively intellectual community. The foundation of the Cork Institute in 1808, followed in 1816 by the Cork Society for Promoting the Fine Arts, gave an impetus to the arts which was greatly assisted in 1818 by the gift of casts from the antique by the Prince Regent (Crawford Art Gallery, Cork, mentioned in chapter 13). From this time on, the institute employed instructors and an art school existed, though little is known about it until the Board of Trade established a School of Design based upon it in 1849. Cork had also produced John Butts, James Barry, Nathaniel Grogan and Adam Buck, artists whose lives must have been an inspiration and whose pictures must have been available for study.

Another young contemporary and friend of Maclise from Cork was Samuel Forde (1805–28), who, like Maclise, had come from a humble background. He did well and became a teacher under J. Chalmers, who ran the school and was a scene painter. Forde painted an altarpiece for the church in Skibbereen, now lost, but his one surviving work in oil was a huge painting, of considerable quality though unfinished, *The Fall of the*

318 Stephen Catterson Smith, *Bishop Butcher of Meath*, oil on canvas, Trinity College, Dublin

319 Thomas Alfred Jones, *A Galway Girl*, oil on canvas, Private collection

Rebel Angels after Milton (Fig. 320). The sketch for it is a fine grisaille, clearly dependent on Michelangelo's *Last Judgment* and possibly Fuseli, who certainly influenced his stunning drawing of *The Veiled Prophet of Kohrassan* (Crawford Art Gallery, Cork). Maclise was a pupil with him and remarked that 'his drawings were as vigorous and correct as Michaelangelo's'. It is a tragedy that he died so young.

Maclise's first fame was as a portrait draughtsman and, in this field, Adam Buck's success, which had taken him to England in 1795, must have been an example. Cork did not lack patrons either; Thomas Crofton Croker, the author and antiquarian, and Richard Sainthill, another antiquarian and numismatist, were Maclise's earliest encouragers, but his own enterprise over his famous early profile drawing of Sir Walter Scott,[24] done in 1825, was the real opening to his career. His practice as a portrait draughtsman, both in Dublin and Cork, was broken by sketching tours in southern Ireland and by drawing book illustrations for Crofton Croker's *Fairy Legends*. In 1827, he went to London and, in the following year, entered the RA School, winning a silver medal in 1829 and a gold medal for history painting in 1831. He continued to maintain himself while at the Academy by his portrait drawings and, later, he turned his skill to good account in his stylized caricature portraits for *Frazer's Magazine*, 1830–6, of which the lolling, dandified Disraeli[25] is one of the most brilliant. However, though he later painted a few oil portraits of friends, like his masterpiece of *Dickens*[26] (Fig. 321) and his fine *Tom Moore* (NGI), he gave up this aspect of art for subject-picture painting early in the 1830s. He continued to work for book illustrators from time to time, especially works connected with Ireland, like Hall's *Ireland, its Scenery and Character*[26] and Moore's *Irish Melodies*.[28] Another link with Tom Moore is *The Origin of the Harp* (1842, City of Manchester Art Galleries), which illustrates Moore's poem of the same name. As the authors of the catalogue of the Maclise exhibition remark, 'the picture presents us with a strangely melancholy and sensual vision of the origin of Ireland's native music'.[29]

In the exhibition at the RA in 1831, he showed his gold-medal-winning picture, *The Choice of Hercules*,[30] with the seductive figure of Vice clinging to him. It is difficult to see why Hercules looks towards Virtue, who appears like a disapproving governess. The whole picture is in the Reynolds tradition, though the total work is Italianate. He continued to paint literary, historical and biblical scenes. His vivid imagination remained with him throughout his life. It had been stimulated by his contact with literary figures from his Cork days and later in London, where his closest friends included Thackeray and Dickens. His romantic, nostalgic view of history had been originally inspired by his feeling for Ireland's tragic past and was fed by his Irish tours, when he drew medieval ruins. Though he rarely visited Ireland, he was in contact with Irishmen in London and with his family all his

life. Occasionally he painted an Irish genre piece such as his brilliantly lively *Snap Apple night* (Fig. 322) or *All Hallow's Eve in Ireland*, 1833. It is painted with assurance and clarity and is full of expression. He included a portrait of Walter Scott in the crowd. It is obviously influenced by Wilkie and perhaps his fellow Corkman, Grogan. William Maginn pronounced *Snap Apple* a 'truly Irish picture' and wrote a ballad praising the painting and describing the high revelry with much drinking and dancing shown in the scene. A few lines will suffice:

323 Daniel Maclise, *The Marriage of Strongbow and Aoife*, oil on canvas, National Gallery of Ireland, Dublin

324 Daniel Maclise, *The Marriage of Strongbow and Aoife*, detail, oil on canvas, National Gallery of Ireland, Dublin

Laughing and quaffing and squalling,
Such romping, and ranting, and mauling,
With whistling, and singing and bawling,
To celebrate All-Hallows-eve ...

For warm looks and warm hearts,
Hot love and hot hands,
Hot speeches, hot heads –
Ireland's land of all lands![31]

Maclise's medieval spirit is best seen in *The Combat of Two Knights*, which he painted for Bulwer Lytton in the 1840s on a theme from Scott's *Marmion*.[32] Another example is the watercolour of Sir Francis Sykes in armour and his wife and two children in medieval costume, associated with the neo-Gothicism of the Eglinton Tournament. He holds an enormous lance and it is perhaps relevant, since Maclise had a notorious affair with Lady Sykes.

The main stylistic influences on his painting were French and German. After a trip to Paris in 1844, he returned much inspired by the scale of French history painting and was particularly impressed by Delaroche. Although he did not visit Germany until 1859, modern German art was extremely important in his development, as he knew it from book illustrations and other engraved sources.[33] From 1843, when he painted

murals for the series of *Scenes from Comus* for Prince Albert's garden pavilion in Buckingham Palace, he was in contact with the Prince Consort, who had consulted the Nazarene artist, Peter Cornelius, over the House of Lords decoration. He also knew William Dyce, who was familiar, from long sojourns in Rome, with Nazarene principles and paintings and their efforts to recreate the monumental art of the quattrocento. Italian Renaissance composition and figure style dominate the other influences which can be discerned in his early frescoes for the House of Lords[34] and such paintings as his *Noah's Sacrifice*[35] of 1847. Despite these monumental sources, he was not immune to the early nineteenth century's rediscovery of Dutch and Flemish art; genre subjects, such as his *Merry Christmas in the Baron's Hall* (NGI), his *Wood Ranger* (RA) and *The Falconer*[36] (Crawford Art Gallery, Cork), do occur and the still-life painting which fills the foreground of many of his works is very Netherlandish in its origin. Another aspect of his work, also found in other mid-century painters, such as the Irishmen Danby and Richard Doyle and the English Dadd and Cruickshank, is the fairy element, which appeared in his illustrations after F. de la Motte's *Undine* of 1843, where the central figures are surrounded as in a book vignette by fairy figures in the foliage.[37]

The scale of his historical compositions was

increased as a result of his work in the House of Lords and the magnificent *Marriage of Strongbow and Aoife* (Figs 323, 324) of *c.*1854 is an example. This painting is full of symbolic historicism (a feature also culled from German precedents), for the Norman Strongbow's invasion of Ireland, at the behest of Dermot McMurrough, King of Leinster, has always been seen as the beginning of the English oppression of Ireland. McMurrough asked for armed assistance from Henry II to aid his internal Irish politics. Strongbow and his knights arrived to help in 1170. This picture was particularly topical as, only a few years before, in 1848, the rebellion of the Young Irelanders had been suppressed. This is all symbolized by the figure of the old harpist whose harp strings are broken and the proud pose of Strongbow, with one foot trampling on a fallen Irish high cross. The harp was a version of 'Brian Boro's' harp in Trinity College, which was in fact a fifteenth-century instrument. But like many symbols in the picture, the dating and provenance of objects was incorrectly known at the time. In fact, many of the 'Irish' figures are dressed in Scandinavian dress. Waterford was a town of Viking origin, so that this was not wholly inappropriate. The picture's emphasis on sacrifice to the Norman invader shows Maclise's nationalism and nostalgia for Celtic Ireland only too well. As in all his history pieces, Maclise took endless pains to get the details of costumes, metalwork, etc. correct and in this he relied on the antiquarian researches of his Irish contemporaries, which, as we have noted, were not particularly accurate at that time, so bronze-age weapons are included. There is an incredible richness in the details, especially in the foreground, which stand out in relief, as though seen through a microscope. Despite the 'errors' in the details, the whole picture conveys the trajedy and grandeur of the scene with great success and the new archeological knowledge, though very interesting, does not take away from the effect of the picture.[38]

His career culminates in the huge murals for the Palace of Westminster carried out between 1858 and 1865, the *Death of Nelson* and *Wellington and Blücher on the Field of Waterloo.*[39] Though the originals have suffered from inadequate technical knowledge and later repairs, the great full-scale cartoons, produced in chalk on paper, survive in good condition. Such contemporary scenes involved even greater accuracy of detail, even down to the tourniquets which the medical staff had applied to the wounded. The scale and the lighting problems added further difficulties to his execution of these huge pictures. Despite the overwhelming quantity of details and incidents, they do not crowd out the main themes. The emphasis on the death and suffering in battle is reflected in Wellington's troubled and exhausted expression and the murals seem to portray the tragedy and futility of war rather than its heroic glory. The critic W. M. Rossetti wrote:

325 Daniel Maclise, *King Cophetua and the Beggarmaid*, oil on canvas, Private collection

Mr Maclise sets an indisputable seal upon all the brilliant promise and vivid aspirations of his career – a career which, where marked by powerful genius and many great pictorial faculties, had hitherto produced little upon which one could look with satisfaction … At length the greatest opportunity of his life has come, and, to his lasting renown, Mr Maclise has been equal to it and superior to himself. He has produced a work which stands without competitor in England, and which no continental masterpiece could possibly put to shame.[40]

Despite the general admiration for his work, the final frescos which had been commissioned from him in the Palace of Westminster were cancelled, and Maclise felt this deeply. He refused several honours, including a knighthood and the Presidency of the Royal Academy, and became a recluse. His health, too, was failing and he succumbed to pneumonia in 1870. His last exhibited works returned to poetic subject-matter and owe a debt to the Pre-Raphaelites. His superb *Madeleine after Prayer*, 1868 (RA),[41] is a fine example from this period and shows that his craftsmanship was not failing. A recently rediscovered work, *King Cophetua and the Beggar Maid* (Fig. 325), was only finished and exhibited in the RA in 1869, a year before he died. It shows no loss of power, and the expressiveness of the courtiers' faces, the modest beauty of the beggar maid in her softly-coloured rags and the transfixed and concentrated expression of the king are done with his usual masterly touch.

In complete contrast to Maclise was the other notable absentee Irishman, William Mulready (1786–1863), whose training and life are almost exclusively English, as he left Ireland at the age of five and had little contact with his native country thereafter. In fact, he concealed his Irish nationality as much as possible and would probably not have been pleased to have

inspect them.[42] These nudes show the amazing dexterity with which he could use shading to create outline, and he perfected his technique by studying at the Kensington Life Academy, a private society meeting three evenings a week at the house of Richard Anstell, the painter. They are sensuous but at the same time chaste,[43] and the charming sketch of the back view of a girl and her child, a study for *The Canon*,[44] shows his ability to introduce flowing movement and character into his drawings.

The sharpness of Mulready's vision is carried over in his painting, which heralds the methods and colour of the Pre-Raphaelites. His detailed handling of stones, plants, costumes, etc. is also very much in their manner. Earlier work, like *The Widow*[45] of 1823, shows a more traditional, Dutch approach to composition, with its minutely observed interior. However, the work that created a great stir when it was first exhibited was *Choosing the Wedding Gown* (1845), depicting a scene from Oliver Goldsmith's *The Vicar of Wakefield*, which Mulready had illustrated. It is filled with symbolic meaning over the worldly aspects of marriage. The details are superb, including the wallpaper, the sconce, the materials the bride is examining and even the items of shopping in the boy's pocket. *The Younger Brother* (Fig. 326) is a late work of 1857, where sentiment, not a story, holds the three figures together, and the splendid aerial view of cliffs in the background reminds one again of similar work by Holman Hunt. Mulready painted slowly and so produced quite a modest *œuvre*, but he was none the less very influential, as he was regarded as a fine teacher by artists as various as Samuel Palmer and the young Pre-Raphaelites. Holman Hunt wrote of his days at the RA Schools:

> We did not always have as instructors the members whose deserved renown made them coveted teachers, but in midsummer on one occasion – regarded as a fortunate one by all the students – Mr Mulready was the visitor. I listened to his criticisms, when my turn came, with much attention, and he continued his instructive remarks so patiently each evening that it seemed he treated me with more than average favour.[46]

He was much admired, too, in France, being given the Légion d'honneur for the nine paintings he sent to the Paris International Exhibition of 1855.

Though the Pre-Raphaelite movement never had any adherents in Ireland, many of their theories and ideals coincided with the opinions of artists in Ireland, so that a number of works, and even artists, are sometimes called erroneously by their name. Of these, by far the most interesting was Frederick William Burton (1816–1900), who is known in England as one of the early Directors of the National Gallery in London. Like his friend George Petrie, who certainly influenced his subject-matter, Burton was a watercolourist and a painter deeply interested in Irish history, legend and

been mentioned in the Limerick exhibition catalogue of 1821 as a man who contributed to the honours of his native city, though this is not strictly true. He came from Ennis, Co. Clare and, after early lessons from the sculptor Thomas Banks and others, he went, in 1800, to the RA Schools. Though he is not remembered now as a landscape painter, his work in this genre developed early under John Varley, whose sister he married in 1803. He continued to study landscape in his drawings and watercolours throughout his career, producing some of his finest watercolours in his skyscapes, now in the NGI. However, it is his anecdotal genre subject-matter for which he is best known. This derives from Dutch prototypes and from the work of contemporaries like Wilkie, though Mulready did not altogether share his sentimentality. From the beginning, he showed great talent for drawing and was an exquisite portrayer of the nude. Despite the efforts of officialdom, Queen Victoria saw his chaste nude studies on exhibition in Gore House in 1853, exclaimed 'What fine works' and had her children brought immediately to

folk life. He was born in Corofin in Co. Clare in 1816, the son of a country gentleman who was an amateur painter. The family came up to Dublin in 1826 for the children's education and Frederick went to the Dublin Society Schools, studying under Robert Lucius West and Henry Brocas. He first exhibited at the RHA in 1832, aged sixteen, with a religious subject, *Abraham on his Journey to Sacrifice Isaac*. He practised as a miniature painter for the first few years of his career, when he was much influenced by Samuel Lover. Lover (1797–1868) had a fantastic career. He was a writer of novels and plays; a songwriter, of both librettos and music; and a music-hall-type performer, as well as a painter. In the 1830s, he was working as a miniaturist[47] with considerable skill and success in Dublin and later in London. Some of his work is on a relatively large scale, such as his *Flow on thou Shining River* (NGI) and this shows the high quality of his craftsmanship, which Burton much admired. A spirited self-portrait of 1840–1 (NGI) shows a bold handling and a less miniaturist approach.

Burton travelled about Ireland, sketching and painting subject pictures, like his *Blind Girl at the Holy Well*, exhibited in 1839. While in Connemara in that year, with Petrie, he assembled material for several pictures, including *The Aran Fisherman's Drowned Child* (NGI). With Petrie he was one of the first artists to visit the Aran islands off the Galway coast and their remoteness made the scene all the more dramatic. Margaret Stokes, who started an unpublished biography of Burton, estimated that there were 'at least fifty preparatory drawings in pen and pencil for the picture of *The Aran Fisherman's Drowned Child*, which show how the subject grew on the painter's brain till he found the true arrangement and grouping by which to concentrate all feeling on the parent's sorrow'.[48] He made landscape studies, too, which reflect his great interest in the changing colours and light effects of the west of Ireland. In 1840, in a letter to Robert Callwell, he rhapsodizes about the 'amethistine glow – that filled the whole atmosphere and tinged the silvery rocks of Maam Turk with ineffable loveliness – with every prismatic colour was visible on the mountains all softened by this violet sort of smile'.[49] On his visit to Scotland in 1848, he made detailed analyses of the colours at every time of day and he did much the same in Ireland.[50]

His portraits in the 1840s were more often watercolours or chalks than miniatures and include several of the actress Helen Faucit, one showing her full-length as *Antigone*,[51] and one of Miss Annie Callwell (NGI), also a full-length, showing her seated in a flowery glade. A superb watercolour of Lady Gore-Booth of Lissadell and her daughters was exhibited in 1845 and has the pyramidal Renaissance composition. Until 1851, most of his work exhibited in the RHA was portraiture, except for a few subject pictures. After that date, landscapes predominate.

Burton was a friend of Thomas Davis and the Young Irelanders. The Young Irelanders were a political movement of the 1840s, eager to establish a cultural identity for Ireland and Davis mistakenly saw Burton as the artist who might realise their dreams on canvas because of his interest in such Irish themes as the Aran fishermen. Burton, however, was not to be persuaded and pointed out to Davis[52] the impossibility of creating a nationalist art, encouraging him to turn his attention to poetry and song. However, he designed the cover of their magazine, *The Spirit of the Nation*. He was always a learned artist and, in a notebook of the period 1839–40, he mentions a wide range of subjects which interested him, from Raphael through German theoretical works to Flaxman's lectures.[53] It is not so surprising, therefore, that he became a frequent visitor to Germany, in 1842 and 1844, eventually staying for seven years from 1851, when he was employed by Maximilian II of Bavaria in connection with the royal painting collection. It was during this visit that his knowledge of art history developed. Few of his German pictures are now known, though they include titles which indicated that peasant subject-matter, whether anecdotal or realist, continued to interest him, as did medieval subjects. On his return from Germany, he lived in London, though he remained in close contact with his Irish friends. In London, he was influenced by Ruskin and became part of the Rossetti circle, though his closest friend was Burne-Jones.

His masterpiece which, with its brilliant colouring, shows the influence of both the Pre-Raphaelites and contemporary German art, is *Hellelil and Hildebrand: the Meeting on the Turret Stairs* of 1864 (Fig. 327).[54] The subject was taken from a Danish ballad, translated for him by an Irish friend, the philologist Whitley Stokes. George Eliot, whose portrait by him (NPG) is so well known, wrote to Burton: 'The subject might have been the most vulgar thing in the world – the Artist has raised it to the highest pitch of refined emotion'.[55] In his later London years, he painted numerous studies of which *Springtime* (British Art Center, Yale) is a typical example. Like many Victorians, he was deeply affected by children and the child in this painting is very like that in *The Child Miranda* from Shakespeare's *Tempest* and *The Fair Conchologist* (Fig. 328). The *Illustrated London News* described her as 'shell bedecked, and holding a nautilus-shell she has perhaps just placed to her ear, sitting listening to "the enchanted noises and sweet airs" of her island home, is as graceful a fancy as it is masterly in execution'.[56] Another example exhibited in 1864, *Recuyer* (V & A) is of a young medieval page holding his master's helmet. *The Dream* (British Art Center, Yale) is the most romantic of these, with glorious colouring. Though Burton did not paint in oil, his later watercolours have the brilliance and depth of oil painting.

It was unfortunate that after 1874, when Burton became Director of the National Gallery in London, he found he had no more time to paint. This is not surprising as, during his time of office, 450 works were

327 Frederick William Burton,
Helellil and Hildebrand, watercolour,
National Gallery of Ireland, Dublin

purchased, including many household names, and he rearranged and classified the whole collection. The critic of *The Times*, whose reviews of his work in the 1860s were always in glowing terms, was right when he said on 25 April 1864:

> Mr Burton is an example of the compatability between intellectual and artistic culture, since he has both in a high degree ... In the quality of refinement, both intellectual and executive, his artistic work is of extraordinary excellence, and it is especially noble and satisfying because we feel the delicacy and culture of the intellect that lies half concealed behind the beautiful veil of colour.

Thomas Bridgeford (1812–78) was another artist whose best surviving work, *Two Lovers in a Landscape* (Fig. 329), possibly that exhibited in the RA of 1837 as *Golden Moments*, can also be described as Pre-Raphaelite, both in its sentiment and execution, though the painting is less precise. His other known works are rather dull portraits, many of fellow artists and academics, and one subject painting, an *Irish Piper* (exhibited RHA, 1842), which was very broadly

328 Frederick William Burton, *The Fair Conchologist*, 1864, watercolour, Private collection

329 Thomas Bridgeford, *Two lovers in a landscape*, oil on canvas, National Gallery of Ireland, Dublin

cessfully as a portrait painter and when he first went to Liverpool he painted figure subjects and still life. A later example, painted about the mid-century and entitled *Gifts* (*c*.1850) shows a young girl in profile and a seated old lady looking at the gift of pheasants and duck. It is an excellent example of his skill at genre painting, as the figures have tremendous character, though it is its realism that is so notable. He turned to landscape, for which he is best known, under the influence of one of his patrons and of a local painter, Robert Tonge, with whom he visited Ireland in 1853. He painted several views in 1857 in the Leixlip area (Fig. 330), and on visits home, other Irish views including an undated scene, *Bringing home the turf*, an evocative Irish landscape (Fig. 331). His biographer, H. C. Marillier, described them as 'painted in a broad, vigorous style', as opposed to his usual 'fine and delicate technique, often amounting to stipple in parts'.[58] They are particularly atmospheric, with their scudding clouds and watery reflections. About 1859, he painted *St Mary's Well, St Asaph* (Fig. 332), probably the picture exhibited at the RA that year. It shows a minutely observed study of stone ruins and the well itself has a masterly observation of moss and lichen.[59] A mother and child in the foreground and a donkey in the corner, the only human elements, are as still as the architecture and ivy-covered trees. The loneliness of a shrimper by a moonlit shore is another example of his marvellous handling of clouds and water and indeed of the solitary labours of man. He was interested in foreground detail and had no taste for grand scenery. His pictures are intimate in their realism.

In the mid-1850s, Davis became closely involved with the Pre-Raphaelites, being much admired by Ford Madox Brown and the two Rossettis, though he was never really appreciated by Ruskin. Davis seems to have had a difficult temperament: on one occasion, when staying with friends in Scotland, the daughter of the house sang 'Home Sweet Home' to him and he immediately walked out and did not come back for two months.[60] He refused to work for dealers, relying on a small group of patrons, painting slowly, never achieving much fame and dying very poor. Ford Madox Brown tried to get Gladstone to put Davis's widow on the Civil List after his death, but failed because the family were Catholic.[61] Like the Pre-Raphaelites, he worked on a white ground and on one occasion he instructed a copyist of one of his landscapes thus: 'Place a little orange here, beside it a little grey, then some dark blue next to that, then a touch of vermilion, now draw the edges of the colours together, so'.[62] This exceptionally advanced attitude to colour, worthy of a Post-Impressionist, was, however, coupled with the deep reverence for nature typical of his time, as he is said to have added, 'there are all these colours in nature if we look for them'. Opaque or transparent glazes were laid on to, and allowed to mix with, a ground of wet white, so that the whole composition 'shines with an inner luminosity'. These comments

330 William Davis, *Near Leixlip on the Liffey*, 1857, oil on canvas, Walker Art Gallery, Liverpool

331 William Davis, *Bringing home the turf*, oil on canvas, Private collection

handled and, like much of his *œuvre*, is now in very poor condition. There are some workmanlike pencil and chalk portraits. He was a product of the Dublin Society Schools and spent ten years (1834–44) in London, when he exhibited at the RA. Returning to Dublin, he later taught at Alexandra College, the famous girls' school in Dublin, and became a full member of the RHA in 1851. It is curious that no other works in any way approaching the quality of the *Two Lovers in a Landscape* have come to light.

William Davis (1813–73) was a further product of the Dublin Society Schools, who left Ireland about 1835. He went first to Sheffield, but made his career from *c*.1837 almost exclusively in Liverpool. There, in 1856, he was appointed Professor of Drawing in the Liverpool Academy.[57] In Dublin, he had worked unsuc-

accompanied his picture *A Sunny Day* when it was sold.[63] Allen Staley sums up his work very well:

> His subjects are always unpretentious scenes of the English [or Irish] countryside. Occasionally they show a freshness of vision and an inventiveness which seems to prefigure aspects of French impressionism and post-impressionism, but he achieved no sustained development.[64]

None the less, he is one of the most interesting artists Ireland has produced and one of its least known and appreciated.

Henry Albert Hartland (1840–93) was another *émigré* to England. Coming from Mallow, Co. Cork and educated in the Cork School of Art, he left Ireland in 1870, coming back for visits only. His Irish landscapes, mostly painted in watercolour, give the impression of vast, empty spaces of bogs, rivers and real isolation. Figures rarely appear in his work. But they have quality and are totally free of the all-pervading nineteenth-century sentimentality. He is a much neglected artist, but during his lifetime, largely spent in Liverpool, he was, unlike Davis, very successful.

Two painters with very short careers were Michael George Brennan (1839–71) and Matthew James Lawless (1837–64). Lawless, the son of a Dublin solicitor, studied art in London, where his father was living. One of his teachers was Henry O'Neill, whose own occasional subject pictures were of a keepsake variety, like his *Beauty, the Enchantress* (Walker Art Gallery, Liverpool). But O'Neill's interest in antiquities and work for the engravers would have been more influential for Lawless, who became a regular contributor to *Once a Week*, *London Society* and other periodicals and books. These illustrations clearly influenced his oils, which were of a type of subject matter common at the RA and less so in the RHA, like *A Cavalier in his Cups* of 1859 and *A Man about Town* of 1861. The quality of his painting, with its needle-sharp detail, its historic and sentimental overtones is best seen in *The Sick Call*, (1863, Fig. 333) with its Flemish setting.

While Lawless's brief career was spent in London, Michael George Brennan spent his life in Italy. He was the son of a shopkeeper in Castlebar, Co. Mayo, but his talent was recognized early and he was sent to the Dublin Society Schools, then to the RHA and finally to London, to the RA Schools. For a short time he drew for *Fun*, a rival magazine to *Punch*, but finally, after an illness, he had to move to Rome and later Capri, from where he sent his pictures to the RA and occasionally to the RHA. An amusing genre scene carried out while in Rome in 1870 was entitled *The Acolyte* (Fig. 334) and shows children playing in the street. His paintings were justly admired, *The Times* critic saying of one: 'Exquisite for quiet truth, its sentiment of repose and its serene diffused light'.[65] His best-known work is *A Vine Pergola at Capri* (NGI), which is seductively nostalgic for the beauty and sunshine of Italy.

A family of artists[66] who contributed greatly to the magazines of mid-Victorian England were the Doyles. The father, John (1797–1868), had been a pupil of the Dublin Society Schools and later worked under Gabrielli and Comerford. He tried to make a living in both Dublin and London, painting horses, hunting scenes and miniatures, but found his true *métier* when he turned to political caricature under the pseudonym 'H-B' in 1827. Of his four sons, two were artists. Henry Edward (1827–92) was an illustrator of some note, exhibited a few paintings in the RHA and became the Director of the NGI in 1869, making a number of notable purchases and founding the portrait collection; and Richard (1824–83) became famous as Dicky Doyle. From the age of twelve, the fertility of his imagination and his humour poured

332 William Davis, *Mary's Well near Saint Asaph*, oil on canvas, Private collection

333 Mathew James Lawless, *The Sick Call*, oil on canvas, National Gallery of Ireland, Dublin

334 Michael George Brennan,
The Acolyte, 1870, oil on canvas,
Private collection

335 Erskine Nicol, *The Tenant,
Castle Rackrent*, oil on canvas, Private
collection

forth a mass of magazine and book illustrations, some-
times satirical, but never caricature. His most famous
work was the cover of *Punch*, finalized in 1849, which
was used until 1956. His penchant for fantasy and
fairy scenes was commonplace at the time, when even
history painters such as Maclise used the form. Many
of his fairy watercolours are now in the NGI. The
youngest son was Charles Altamont Doyle (1832–93),
the father of Sir Arthur Conan Doyle. Charles was in
some ways the most interesting member of the broth-
ers and his *Bank Holiday* (NGI), a watercolour proba-
bly of Donnybrook Fair, is full of wit and a lively,
colourful study of Irish characters.

In complete contrast to the Doyles is the work of
Erskine Nicol (1825–1904), a Scottish artist who lived
and taught in Dublin for five years between 1845 and
1850, through the famine. He visited, indeed lived in,
Ireland frequently later in his career and his scenes of
Irish peasant life, like his *Irish Emigrant's Arrival in
Liverpool* (National Gallery of Scotland) or his *Wayside
Prayer*, have a feeling of reality which sets them apart
from most of his contemporaries. Another example is
his many-figured, cheerful interior of a shebeen at
Donnybrook (1851). He also painted a general view of
Donnybrook Fair (Tate Britain). His landscape set-
tings are finely painted, with a strong Dutch influence.
The costumes are minutely observed and he has a
strong sense of the dramas of climate. However, like

practically every other artist, he made no attempt to
portray the harrowing horror of the famine. Daniel
MacDonald's *Discovery of the Potato Blight* (p. 209, Fig.
275) is, as far as we know, the sole surviving contem-

porary depiction in oils of the disaster. The magazines sent artists to the most depressed areas and it was they who produced the graphic illustrations which accompany their correspondents' reports. It has to be said that pictures of such scenes of starvation would not have been easy sellers. Artists also wished to avoid direct political statements critical of the British government.

Brian Kennedy, writing about Nicol's *An Ejected family* (NGI), which was shown at the RSA in 1854, said that 'it was not interpreted as a political and social statement about evictions because it was disguised as an emotional stage-Irish scene'.[67] Indeed, Nicol is best known today for his scenes of Paddywhackery, with grinning peasants and fair colleens enjoying life, as in *Don't Say Nay* of 1854, which shows Paddy creeping up behind a charming colleen who is drawing water at a spring. However, he could handle tragic subjects with great sincerity and meaning. For instance, his *Notice to Quit*, which could possibly be a Scottish, as well as an Irish, topic, shows the family in deep distress and the grandmother flourishing a crucifix to ward off the evil of the agent in his high-collared coat standing by the doorway. Other, happier scenes of peasant life are graphically shown in his many figured shebeens.

His political interest continues right into the Land Wars, a concerted movement against the landlords in the 1880s, as one of his most thought-provoking pictures, with no sense of satire, is *The Tenant, Castle Rackrent* (Fig. 335), which is signed and dated 1880. Here, the healthy tenant is sitting outside the land-

lord's estate office underneath the map of Castle Rackrent – with all its Edgeworthian connotations. The map shows small holdings and bogs, and beneath it hangs a blunderbuss, immediately behind the tenant's head. This appears to symbolize the landlord O'Rafferty's defence of his estate and one feels that the expression of surly defiance of the man bodes ill for the future. Indeed, the breakup of the old landlord system had already begun by this time and the Land War was in the air. Nicol's sympathy was with the tenant.[68]

An American who lived in Ireland for some ten years in the 1870s and 80s, both in County Galway and in Kinsale, was Howard Helmick (1845–1907). In some of his pictures, notably *News of the Land League* (Fig. 336), signed and dated 1881, he continues in a more direct manner Nicol's comments on Irish political life. The league was founded in 1879 to protect tenants against rackrenting and evictions. Gladstone's Land Act of 1881 went some way to satisfying the claims of the tenants and encouraged the whole process of land purchase. This picture shows a group of customers seated in the garden of a pub reading in the newspaper and inspecting a handbill. The clear pleasure they have is very well, if simply, shown. Helmick's own delight in Irish people and his understanding of their character – he liked them more than the English – is immediately obvious.[69]

There were a few late-Victorian Irish subject-picture painters, though they mostly lived and worked in London. They were represented well in Hugh Lane's exhibition of Irish painters at the Guildhall in 1904, when the startling *The Victory of Faith (Miserere*

337 St George Hare, *Victory of Faith (Miserere Domine)*, 1890, oil on canvas, National Gallery of Victoria, Melbourne

338 St George Hare, *The Gilded Cage*, oil on canvas, National Trust, Stourhead

Domine) (Fig. 337) by the Limerick-born St George Hare[70] (1857–1933), was illustrated in the catalogue. Hare's father, an Englishman, practised as a dentist and lived in No. 2, Pery Square, a house now restored by the Limerick Civic Trust. Hare went to the Limerick School of Art before going to the South Kensington School in London, where he trained and taught for some seven years. He first exhibited in the RHA in 1881 and the RA in 1884. He painted a number of good portraits, of which his studies of children were very sympathetic. Two of the daughters of Richard Stacpoole of Edenvale, not far from Limerick, are a cheerful example. They date from about 1890. His subject pictures, for which he was best known in

his time, vary from keepsake beauties to erotic nudes, with hints of both lesbianism in *The Victory of Faith (Miserere Domine)* (1890)[71] and sado-masochism in *The Gilded Cage: a Female Captive* (1891, Fig. 338), which shows a beautiful girl in gilded handcuffs attached to the wall, looking at three butterflies.[72] Surprisingly, the latter was bought, with a number of others, by his great patron, Sir Henry Hoare, sixth Baronet and his wife Alda, whose portraits still hang at Stourhead (NT). Hare was a fine draughtsman[73] and an illustrator of melodramatic tales. He produced a large number of illustrations for *The Graphic* in the 1890s. His *Gilded Cage* was one of the successes of the Paris Salon in 1892. One of the largest of his pictures at Stourhead is the very striking *The Adieu*, showing an androgynous angel about to kiss a young dark-haired, voluptuous naked girl. It is amusing to recall that the late James Lees Milne remarked in front of this picture that 'the relationship would not bear close inspection'.[74]

James Doyle Penrose's (1862–1932) *The Last Chapter* (1889), depicting the Venerable Bede dictating his Latin history of the English people in the eighth century AD, is sober in its straightforward realism, and was also in Lane's exhibition, but not illustrated. Penrose came from the great Quaker Waterford family who manufactured Waterford glass. He trained as an artist in South Kensington and the Royal Academy Schools, and lived in England for most of his life. He painted a number of fine portraits, including his full-length of the Lord Chief Justice of England, Lord Russell of Killowen 1897 (Royal Courts of Justice, London). The catalogues show that his greatest output was in historical and mythological pictures, of which the most attractive, to our knowledge, is *Iduna's Apples*, RHA 1897. He also showed a few landscapes. To us, it is interesting that his son, Roland, became a friend of Picasso and was a well-known authority and patron of modern art.[75]

One of the more notable of these painters from the Guildhall exhibition was Sir John Leslie, Bt, of Glaslough, Co. Monaghan, an amateur. Born in 1822, he lived to the ripe old age of ninety-three, dying in 1916. He only took up painting in 1850, after he left the Army, and went to study in Düsseldorf in 1851. He was also taught in Italy by the portrait painter Richard Buckner. One of his works exhibited in the RA in 1853 was called *Children – they have nailed Him to the Cross*, a very well-finished and composed painting. Most of his exhibited works were portraits. Occasionally he sent landscapes, illustrations and subject pictures with titles like *Near Rome*, *Beati i poveri*, *il Regino dei cieli e loro* or *Una deserted – Spenser's Faery Queen*. The most marked influence on his career was Italian Renaissance art, but he was well known in English artistic circles as a friend of the Pre-Raphaelites and Leighton. At his home at Glaslough, he worked on a decorative scheme, now much ruined, for a picture gallery, which owes a great deal to Raphael's *Loggia*.[76]

The Influence of Continental Europe and England in the Late Nineteenth Century

The late nineteenth century saw a considerable change in Irish painting, one which reflected the greatly increased continental influence on the training of Irish painters. However, in the second half of the century several Irish artists continued to go to English art schools. The elder John Butler Yeats and William Orpen were two painters of importance to do so, and figures such as Helen Mabel Trevor, Augustus Burke, John Lavery, Harry J. Thaddeus and Sarah C. Harrison also studied for short periods in London. But there was no Irish equivalent to the painting of Burne-Jones, Orchardson or Waterhouse, and there was a steady decline in the quantity of subject-picture painting. But amongst many Irish artists, the similarities lie with the pleinairists, with artists like Clausen and La Thangue, who had also spent years studying abroad. This change seems to have come about in Ireland largely by accident.

Nathaniel Hone (1831–1917)[1] went to Paris in 1853, probably not for any specific reason, but through the chance of a friend's recommendation. Though there was no evidence of a link between his training and those of the other artists who followed his example and went to Antwerp, Paris, Grez or Brittany in the early 1880s, the date of his return from his prolonged French residence, 1872, is significant. His influence, together with that of artists like Augustus Burke, who was in Brittany c.1875–76, and Aloysius O'Kelly, who was there in 1877–8, or even Frank O'Meara, who was living in Paris or Grez from 1873, may have been the cause for the extraordinary number of young Irish students who studied abroad in the 1880s. These included Sarah Purser, Kavanagh, Walter Osborne, Frank O'Meara, Roderic O'Conor, Nathaniel Hill, Richard Thomas Moynan, Henry Allan, Dermod OBrien and John Lavery.

Though Nathaniel Hone was a member of the artistic Hone family and a great-grandnephew of the eighteenth-century Nathaniel Hone, he trained as an engineer in Trinity College, Dublin and actually worked briefly on the Irish railways before he gave up engineering to study painting in Paris in 1853. He worked in the atelier of Adolphe Yvon, a painter of battle pieces, and later, in 1854, in that of Thomas Couture. Couture's romanticism was tinged with a knowledge of Courbet's realism and he was a much esteemed artist, both in Paris and abroad, so many foreigners attended his atelier. Hone studied in the conventional manner, copying in the Louvre and drawing from the model. Couture stressed the importance of a mastery of technique, so that the first impression could be put down with spontaneity. His advice included such statements as 'give three minutes to looking at a thing and one to painting it'.[2] It was not till Hone had finished his training, from c.1856 to 1857, that he turned to landscape painting and settled at Barbizon and, later, around 1863, near Fontainebleau, where he got to know all the Barbizon painters, from Corot and Millet to Harpignies, his principal friend, and even some of the avant-garde, notably Manet. He first exhibited in the RHA in 1862 and sent work to the Salon in Paris from 1865 to 1869. He spent some seventeen years in France, followed by eighteen months in Italy, though he visited home regularly. He settled near Donabate after his marriage in July 1872, and from 1876 exhibited regularly at the RHA, becoming an Academician in 1880. After 1895, he lived at St Doulough's Park, in north Co. Dublin, an estate he inherited in that year. In his Barbizon years, he had travelled in Brittany and Normandy (c.1867) and Italy and the Mediterranean (1870–2). He continued to travel later in his life, visiting Holland, and later in 1891 or 1892 he was in Turkey, Greece and Egypt. Of course, he made return visits to France and many visits to England, where he painted along the south and east coasts as far north as Norfolk. Two of his works were in the Armory Show in New York in 1913.

Despite his training as a figure painter, most of his later works are pure landscapes, enlivened sometimes by animals, but very rarely by figures. His most

339 Nathaniel Hone, *The Boundary Fence*, oil on canvas, National Gallery of Ireland, Dublin

340 Nathaniel Hone, *Rocks at Kilkee*, oil on canvas, Private collection

important early work is his *Boundary Fence, Forest of Fontainebleau* (Fig. 339), in which Courbet's influence can be seen, though the detailed handling is closer to artists like Harpignies. Its emptiness of people links it with his later work, while his other early French pictures, like *Feeding Pigeons, Barbizon* (NGI) still include the common Barbizon peasant subject-matter which soon disappeared completely. His interest in painting the sea, which naturally emerged more when he lived by the sea at Malahide, had its origin too in Courbet and possibly Boudin. He differs, however, from Courbet, as his work is essentially a straightforward

depiction of what he sees and contains no symbolic undertones. Perhaps his closest links are with Corot, whose choice of subject-matter and superb tone values Hone clearly admired. This is well shown in his *Banks of the Seine* (NGI). Though there is little actual development in Hone's style over his very long career, the openness of the north Co. Dublin countryside tends to emphasize his ability to capture distance, sunlight and wind as it hastens the clouds and waves with great sweeping and eddying movements. He painted the dramatic rocky sea coast with its savagely breaking waves around Kilkee in Co. Clare (Fig. 340), which Brian Fallon likens to Courbet's *La Vague*.[3] He also went north to paint in Donegal.

George Moore, in his extremely penetrating introduction to Hone's painting in the Hone/Yeats exhibition catalogue of 1901, criticizes it as 'a little apathetic, the painting of a man who lives in a flat country where life is easy and indolent'. Earlier, he had described Hone's subjects as 'a rainy estuary, some sand-hills, a strip of grey sea with a breaking wave. Our flat east coast calls him and he paints long strips of grass near the sea, where cows are pasturing, and rich skies full of round white clouds that the south wind gathers up from the horizon.'[4] It goes without saying that his sketches are nearly always more exciting than his exhibited pictures. These have a sameness, which is boring, but individually they often sustain his first, fresh vision very well. His occasional treescapes have a soft blobbiness which can be very appealing, and to the end his ability to convey the oppression of an oncoming storm or the quality of twilight is invariably excellent. Though he was interested in painting antique monuments, from the Pont du Gard to the Sphinx, scenes of brilliant hard light are not his most effective work. Later in his career, he became essentially a painter of the changing mood of the Irish climate. Julian Campbell perceptively wrote that Hone was a 'painter of cows and sheep, but not strictly an animal painter. He was a painter of sailing vessels and seascapes, but not a conventional maritime artist. He was interested in archaeological subjects, but not a topographical artist.' Later, he added, 'Hone is a great painter of the elements: land, sea, and sky, light and weather, and the "mood" of nature' (Fig. 341).[5] Hone's life in Ireland was retired, although he was influential both because of his social position and because he was recognized as a leading figure in the small Irish artistic world. From 1894 until his death he was the Professor of Painting at the RHA.

A previous incumbent of this position, between 1879 and 1882, had been Augustus Burke, RHA (1838–91), the brother of the ill-fated Under-Secretary, Thomas Burke.[6] He came from a Galway family and his early artistic training was in London, but he moved to Dublin in 1869 and became an RHA in 1871. He had visited Holland in the early 1870s, but of more importance was his period in Brittany between 1875 and 1877, as one of the earliest Irish artists to visit Pont-Aven.[7] His experiences there almost certainly made him stress the importance of French training to his students, who included Osborne, Hill and Kavanagh. His own paintings are conventional, though technically proficient. They include pure landscape as well as peasant subjects, such as *A Breton Farmyard* (1877), and *On the Apple Tree, Brittany* (1877, Fig. 342). Both of these contrast favourably with his well-known sentimental *A Connemara Girl with Goats* (NGI). His career in Ireland was brought to an abrupt end by the murder of his brother, which meant that he returned to London and then moved to Italy, though he continued to show at the RHA, sending three Venetian views in 1889. He died in Florence in 1891.

341 Nathaniel Hone, *Gathering Seaweed, Malahide*, oil on canvas, Private collection

342 Augustus Burke, *On the Apple Tree, Brittany*, oil on canvas, Private collection

343 Bartholomew Colles Watkin, *Gougane Barra*, oil on canvas, Private collection

344 Frank O'Meara, *Towards Night and Winter*, oil on canvas, Hugh Lane Municipal Gallery of Modern Art

The Keeper of the RHA from 1870 was another landscape painter, Patrick Vincent Duffy (1822–1909), who in his early days painted with Faulkner. His spirited small sketch of *The Needles, Howth*[8] indicates that he should be better known, especially as he exhibited numerous landscapes in the RHA, of which hardly any are now known. A fine large example is *Early Morning at Glendalough*, RHA 1858, where the background mountains are tranquilly handled, with the pinkish morning light contrasting them with the green vegetation of the dappled foreground bushes and trees. A spirited sketch of *Bray Head and the Sugarloaf* shows his versatility when compared with the *Glendalough* or the *Sea and Rocks, Arklow*, RHA 1882. Here, the vigorously painted waves crash on to the black rocks and seethe up the sand.

Another artist who is also neglected today is Bartholomew Colles Watkins, RHA (1833–91). His lake and mountain scenery in Kerry and Connemara is majestically portrayed, with amazing light effects. His *Gougane Barra, Co. Cork* (Fig. 343) and *Lough Fee from Illaunroe, Connemara*[9] are fine examples; they are simply and realistically painted and he was highly popular in his day.

A comparable painter of this generation was William McEvoy (*fl.* 1858–80). He was also a landscape painter of considerable quality, mostly painting in the Dublin and Wicklow area. *A Country Funeral*, signed and dated 1861, and exhibited in the RHA in that year, shows a purple sunset, a ruined church and a peasant funeral cortège with considerable effect. McEvoy went to England, where he spent the latter part of his life.

Frank O'Meara (1853–88) was one of the most interesting painters among those who went to France, early on, in the 1870s, but his short career ended before he had time to return to paint in Ireland or make any impact there. He came from Co. Carlow, the son of a doctor, going to study under Carolus Duran in Paris about 1873. There, his companions included the American painters Sargent who painted his portrait (Century Association, New York) and Will H. Low, whose book *The Chronicle of Friendships* (1908) is a valuable source for information about O'Meara. He seems to have been an attractive and tempestuous character, who did not fit in to the 'thralldom of school work',[10] though his imaginative fantasies never reached the canvas. However, he was clearly happy at the village of Grez-sur-Loing, near Fontainebleau, so beloved by French painters and their American and British students, and he lived there for many years. He developed a style influenced by Jules Bastien-Lepage, using the latter's quiet greys and greens and many of his paintings reflect the still, melancholy atmosphere of the village and river. The author of an obituary[11] notes the influence of Puvis de Chavanne and Cazin. His *Towards Night and Winter* (Fig. 344) is a typical Bastien-Lepage peasant scene. The old woman in his *October* has a gloomy realism which hints at the dark undertones of his imagination. His style is extremely personal and he was among the first to practise *pleinairism* at Grèz – a totally different style and mood from the Barbizon painters. He preferred autumnal and evening light and his figures seen in close-up are silent, melancholy and poetic. One of the finest and largest of his *plein-air* works is *Reverie* (Fig. 345),[12] showing a young girl by a fence on the riverbank, alone, absorbed in thought. It is signed and dated and was exhibited in the Paris Salon in 1882. A year later, he used the same scene in *Twilight*, with an elderly woman standing equally apart, with a setting sun rather than the rising moon.

The titles of his pictures speak for themselves: *Autumnal Sorrows, The Widow, Twilight, October, November* and *Towards Night and Winter*. The latter,

dated 1885, is said by Campbell, correctly, to be 'his best loved and most perfectly realised picture. The grey light and autumnal landscape, and dreamy absorption of the girl in her task, the air of stillness and the poetic symbolism of the title, all add to the lyrical atmosphere that is characteristic of O'Meara.'[13] O'Meara is said to have wanted to form an artist's colony in Ireland, but he died while staying with his father in Co. Carlow, aged only thirty-five, as a result of malaria caught in France. Surely he was one of Ireland's most haunting and individual Irish nineteenth-century painters.

Helen Mabel Trevor[14] (1831–1900), born in Co. Down, was also a French resident. She was only able to take up painting professionally in her late forties, after her father's death. However, she had exhibited in the RHA occasionally from 1854 to 1865. Later, she spent four years at the RA Schools before she went to Paris with her sister, where she studied under Carolus Duran, Jean Jacques Henner and Luc Olivier Merson. She visited Brittany for periods in 1881, 1882 and 1883, before she travelled to Italy, returning in 1889 to make Paris her home till her death. She spent 1895–6 in Concarneau.[15] She exhibited regularly at the Salon from 1889 to 1899, mostly portraits and genre scenes, such as *The Breton Interior* (NGI) and *The Fisherman's Mother* (NGI), which was probably shown at the Salon in 1893. Julian Campbell notes the influence of Josef Israels. The yellowish, mottled skin of the old woman's hands and face are sensitively handled. She also exhibited at the RA and RHA. Her landscapes include the *Woodland Scene* painted in Brittany in 1882, which shows a Breton woman gathering faggots and has a sombre realism. The almost leafless trees are particularly successful.

The choice of Antwerp, rather than Paris, to study was quite normal for Irish students at this period. The man who attracted them, as well as contemporary English students, was Charles Verlat of the Académie Royale des Beaux-Arts, a rather tedious academic painter but clearly a good teacher, a fact noted in an article written in 1893 about painters exhibiting in the New Gallery in London, where the writer states that 'in five cases out of six the English course is succeeded by a visit to the lapidaries of Paris – Bonnat, Boulanger, Carolus Duran, Cabanel, Dagnan-Bouveret, Cormon or another; sometimes it is that fine teacher, the late M. Verlat of Antwerp'.[16] Verlat's training tended to leave his pupils with a tight, controlled style, with paintings finished in the studio from drawings made from the model outside, and with a more or less anecdotal subject-matter. All his Irish students outgrew his influence in due course, though their innate conservatism, except in the case of Roderic O'Conor, was confirmed by Verlat's strictly conventional art. This no doubt made it more difficult for them to appreciate the avant-garde art of the Impressionists when they came into contact with it in France. With the notable exceptions of Nathaniel Hone and Roderic O'Conor, who settled in France, all

the Irish artists who trained abroad, whether in Antwerp or in France (including Lavery), were virtually uninfluenced by the Impressionists but accepted the pleinairism of Jules Bastien-Lepage. If, later on, Osborne and Lavery came to appreciate Manet and Whistler, they were unusual in this. Bastien-Lepage was enormously admired in France, England and Ireland and all over Europe. A. S. Hartrick's telling remarks describe his influence very well:

> In every country the most promising youths were frankly imitating his work, with its ideals of exact representation of nature as seen out of doors, everything being painted on the spot in a grey light, in order that there might be as little change in the effect as possible while the artist was at work.[17]

345 Frank O'Meara, *Reverie*, signed and dated 1882, oil on canvas, Private collection

346 Walter Osborne, *Beneath St Jacques, Antwerp*, oil on canvas, Private collection

347 Walter Osborne, *An October Morning*, 1885, oil on canvas, Guildhall Art Gallery, Corporation of London

This watered-down attitude even to the aims of the discoverers of painting in the open air, the Barbizon painters and Courbet, let alone to the brilliant vision of the Impressionists confronted with the changing effect of light, was a levelling down to cautious standards, which was a very grave mistake. If Bastien-Lepage's Irish followers sometimes produced good pictures and, especially in the case of Osborne and Lavery, they did, it was more by sheer talent than by training or influence. Sometimes the silver-grey tonality and the quiet silence of their work successfully conveys a mood or an emotion, which raises it above the norm, but otherwise it was a period in which the quantity of grey-green canvases must have been very monotonous on the RHA walls.

Of the Antwerp-trained painters, Walter Osborne (1859–1903), the son of the sporting painter, William Osborne, became the best resident late-nineteenth-century Irish artist. He is the only one, except for Sarah Purser and Jack Yeats, to have a recent biography with *catalogue raisonné* devoted to him, though Lavery and Orpen have had a biography.[18] Osborne was educated at the RHA Schools, where he won innumerable prizes, culminating in the Taylor Scholarship, awarded by the RDS, in 1881 and again in 1882. A period of foreign travel ensued, with two sessions spent at the Antwerp Academy in the winter of 1881 and the summer of 1882 and then a further year (1882–3) working in Brittany. After Osborne returned and settled in Ireland, late in 1883, he used to spend long periods on painting expeditions in England. He was there in 1884,[19] visiting London to see exhibitions and staying near Evesham with Nathaniel Hill and Edward Stott, and probably also visiting Lincoln, Southwold and Walberswick. In 1888 and 1889, he paid further visits, working in Berkshire at Uffington and on the Wiltshire Downs. In 1890 and 1891, he was working near Rye and Hastings. In other years, he painted in many areas of Ireland. A particularly fine example is his painting of Roundstone harbour in Co. Galway, which was exhibited in the RA in 1898 as *Life in Connemara, a market day*. A squall is blowing up across the harbour from the mountains in the background and the beautifully portrayed peasants with their animals chat away in the damp atmosphere. It is one of the finest rural scenes painted in the west of Ireland at this time.

During the twenty years of his working life, Osborne exhibited widely in both Dublin and London and exhibited at the RHA from 1877. He was elected an RHA in 1886. He exhibited at the RA from 1886 and in the New English Art Club from time to time from 1887. He became a figure in the Dublin art establishment, helping to run exhibitions of both modern works and old masters, and he was a judge in competitions, such as the Taylor Prize. When visiting London exhibitions, he made sketches in the margins of the

348 Walter Osborne, *A Scene in Phoenix Park*, oil on canvas, National Gallery of Ireland, Dublin

catalogues, which included *The White Girl* by Whistler, whom he much admired. He also added comments, and wrote long, descriptive letters home when travelling in 1895 to Paris, Bordeaux and Madrid, visiting galleries with Sir Walter Armstrong, then Director of the NGI. He was sufficiently an art historian to resign from the committee of the RHA winter exhibition of Old Masters because he disagreed with Hugh Lane over his attributions, saying in a letter to the *Irish Times* that he felt 'unable to accept responsibility for the attribution of some of the pictures'.[20] Walter Strickland also resigned; apparently both of them objected in particular to an attribution of a portrait of Anthony Malone to Reynolds.[21]

Although Osborne's early work and Antwerp paintings are usually tightly and meticulously painted and somewhat laboured in effect, they already show his love of texture and tones, as in his *Beneath St Jacques, Antwerp* (Fig. 346). The composition, and to some extent colour, is directly taken from Pieter de Hooch. His *Porte-Neuve's Mill, Pont-Aven* (1883) shows a developing interest in light and larger brushstrokes than most of his Antwerp work. The influence of Bastien-Lepage is very obvious in such a painting as *Apple Gathering, Quimperlé* of 1883 (NGI) and his *October Morning* of 1885 (Fig. 347), which is one of his masterpieces. This is probably one of his Walberswick paintings and shows how close he was at that time to his English contemporaries – in particular Edward Stott.

He had seen the work of Whistler as early as 1884 in an exhibition held in Molesworth Street by the Dublin Sketching Club, of which he was a member.[22] This made a deep impression, broadening out his technique as well as his horizons.

Works of a near-Impressionist character occur in the early 1890s, such as his scenes done on the south coast of England in Hastings and Rye, and in Galway. His superb painting of *Hastings Railway Station* has great freedom of handling and dashing touches of light; though the steam billows upward, it is too dark to compare with Monet. His development was not, however, steady, as paintings of a much earlier style are also datable to the early 1890s. His atmospheric *St Patrick's Close* (NGI), where he captured Dublin slum life with great skill, is dated 1887, but he continued to paint similar townscapes in the 1890s. His superb *A scene in Phoenix Park* of *c.*1895 (Fig. 348) is a masterpiece of character studies, as Jeanne Sheehy says: 'The tragic woman exhausted and ill holding her splendid baby and her fine son sit beside a middle-aged man and a sleeping pensioner.' The are, in Sheehy's words, 'an allegory to life, from babyhood to old age'.[23] Osborne's figure subjects are marvellously free of sentiment and their character is conveyed as much by his ability to capture light effects as various as the dirty city atmosphere of Dublin on an autumn evening and the sparkle of light through trees, as in his very late works. Brian Fallon draws comparisons with the novels of Gissing or George Moore.[24]

349 Walter Osborne, *Mrs Noel Guinness and her daughter, Margaret*, oil on canvas, Private collection

350 Walter Osborne, *A Children's Party*, oil on canvas, Private collection

bronze medal for Osborne in the Exposition Universelle in Paris in 1900 and being reproduced in one of those splendid volumes, a precursor of the coffee-table book, entitled *Great Pictures in Private Collections*, published in 1904. Another of *Mrs Chadwyck-Healey and Her Daughter* was shown at the RA in 1900[25] and in the RHA in 1902. The virtuosity of the 'cascade' of Mrs Guinness's flowered satin is technically a masterpiece. Osborne was perhaps less successful with his male sitters, as he found the pomposity of 'Presentation Portraits' not to his taste. However, his children's portraits, like *Stephen Gwynn*, and informal paintings, like *J. B. S. MacIlwaine sitting in his Garden with his Dog* (NGI), show him at his best as a most sensitive interpreter of character. MacIlwaine (1857–1945) himself was a landscape painter in the Hone tradition who was born in Dublin but spent much of his life in Ulster, and painted a great deal at Castle Leslie, Co. Monaghan.

Whether Osborne saw French Impressionist pictures when he was in Paris in 1895 it is impossible to say, for, apart from Manet, who hardly counts as an Impressionist, he does not mention them. In a letter written from Paris to Sarah Purser, dated 5 December 1895, he describes his feelings about the Luxembourg as follows:

> The Luxembourg was to me most disappointing, and I thought if you took away Cazin's study of Gambetta's room, pictures by Friant, Besnard and Manet, there was little left to go wild about and certainly the great mass of pictures seemed to be leathery in the extreme. Could anything be much worse than Detaille's huge atrocities, or the work of Lefebvre, Bonnat, Bougereau, Cormon. I really think we have no cause to run down English art.[26]

However, though Renoir and Monet are not mentioned in his correspondence, it is their influence which can be seen in his final works, where even his use of colour was becoming much closer to the French Impressionists and his very free brushstrokes and his technique were closer to Berthe Morisot.[27] His *Children on the Beach* of *c*.1900 is a particularly fine example, as is *The Children's Party* (Fig. 350) of the same date. It is a warm and appealing work and with its Chinese lanterns derives somewhat from Sargent's *Carnation Lily Lily Rose* (Tate Britain), though it is an interior and an evening scene. It has a quality akin to French *intimiste* painting.[28] The dappled effect of light in *Tea in the Garden* of 1902 or *In a Dublin Park* of *c*.1895, or the instantaneous quality of his intimate interiors, like the *Lustre Jug* of 1901, were leading him into a style which, at its best, is close to the domestic pictures of Vuillard and Bonnard. How he would have developed cannot be predicted. He died very suddenly of pneumonia, aged forty-four, in 1903 and the life of one of Ireland's greatest artists was tragically cut short.[29]

He earned his living as a portrait painter and his society ladies and their children are treated with a charming informality and can be quite close in style to William Orchardson. His *Mrs Noel Guinness and her Daughter* (Fig. 349) became a famous work, winning a

Aloysius O'Kelly (1853–*c*.1941) was born in Dublin and probably had his first artistic education from his

351 Aloysius O'Kelly, *The Harem Guard*, oil on canvas, Private collection

uncle, the sculptor John Lawlor.[30] He was brought up in London, which is probably why he did not attend an art school in Dublin but enrolled in 1874 in the École des Beaux-Arts in Paris, studying under Gérôme and also Léon Bonnat. Until recently, little was known of his life and work; indeed, after 1895 he sometimes used the pseudonym 'A. Oakley', which has naturally caused some confusion.[31] His family was deeply involved in Irish nationalism and his brother was one of Parnell's supporters and an MP. O'Kelly attempted unsuccessfully to gain the seat of South Roscommon in 1897. His paintings have little political bias, but the work he did for the *Illustrated London News* is another matter. Naturally, he attempted to give a realistic picture of the dramas of the Land League agitations in 1881 and other notable events. Earlier, he was painting in Pont Aven in 1876 and in Concarneau. He was then in England and Ireland for some years before going to Egypt in 1884, where he worked as a journalist reporting the Holy War of the Mahdi for a magazine, *The Pictorial World*. This was clearly the background which led to his numerous orientalist pictures and one must remember that his teacher, Gérôme, was famous for such work. His masterpiece in this genre was *The Harem Guard* (Fig. 351),[32] which was exhibited at the RHA in 1894. These pictures, painted in a brilliant light, are among his most colourful but, like most of his paintings, lack verve. Technically, O'Kelly is

extremely good, but only a few of his pictures can be described as arresting, like his delicate *plein-air* study of a *Girl in a Meadow*, full of poppies, exhibited in 1889, and *Huckleberry Finn* painted in 1884 for Mark Twain. This remarkable picture brilliantly shows the strength of the sun forcing the boy to half-close his eyes. This picture surprisingly predated O'Kelly's residence in America by some ten years.

Earlier works are genre scenes of Irish peasants in Connemara. As with most other Irish artists, these impoverished persons are represented as looking very well fed and surprisingly clean and neatly dressed. Two examples are *Feeding Hens, West of Ireland* and *Expectation, the West of Ireland*, both essays showing the value of family life. Curiously enough, English painters like Francis William Topham,[33] who visited the west in 1844 and then again in 1862 and 1868, are more realistic in showing wretched cabins rather than these essays in rural industry. Niamh O'Sullivan[34] suggests that O'Kelly's pictures represent an idealized vision of what he hoped to see in Ireland in the future and was not a true picture of contemporary conditions. His other memorable image is *Seaweed Gatherers, Connemara*. This strange painting, with a carefree and perky young man with his donkey carrying panniers of seaweed, followed by an apparently unconnected bowed female figure, heavily overburdened by the overfull creel of seaweed on her back, is extremely well

352 Aloysius O'Kelly, *Head of a Breton of Finistère*, oil on canvas, Private collection

353 Thomas Hovenden, *The Story of the Hunt*, oil on canvas, Private collection

emotion of van Gogh's early sombre style. His Breton portraits, including his truly powerful *Head of a Breton of Finisterre* (Fig. 352), are among his most powerful paintings, and must number amongst the most striking images by an Irish artist of the late nineteenth century.[35]

O'Kelly lived in New York from 1895 to 1935, when he returned to Paris, where he died sometime after 1941, when he is last mentioned. His American pictures do not live up to the standard of his earlier work, though some of the pure landscapes have a lightness of touch, such as *On the Sheepscott River, Maine* with its autumnal colouring, and are Impressionistic in their shimmering light and brushwork, much more so than in his Breton paintings.

An Irish artist usually thought of as American is Thomas Hovenden (1840–95).[36] In fact, he did not go to the States until 1863, when he studied at the National Academy of Design in New York, though his early training was in Cork. He was born in Dunmanway. He seems to have been an orphan of the famine, as he had lost both parents by the age of six and was brought up in an orphanage in Cork. He was apprenticed to a carver and gilder who appreciated his talent and sent him to the Cork School of Art. He was in America from 1863 to 1875, when he returned to Europe, studying with Cabanel in Paris and then spending some time in Pont-Aven, where he probably met O'Kelly and Augustus Burke. He painted history pieces, genre scenes, portraits and landscapes, only returning to America in 1880, where he made a considerable career for himself. The only portrait we know by him is very well painted, with clarity and beautiful free brushwork in the background.[37] Later in his life, he taught at the Pennsylvania Academy and his best-known works were the *Last Moments of John Brown* and *Breaking Home Ties*. A fine genre scene, *The Story of the Hunt* (Fig. 353), was painted in Brittany in 1880.

A fellow student with Osborne at Antwerp was Joseph Malachy Kavanagh (1856–1918),[38] who, having won the Albert Scholarship at the RHA Schools in 1881, went to Antwerp the same year. He stayed longer than Osborne, but while their visits overlapped, their work is extraordinarily close. Kavanagh was still there in 1883, when he went to Brittany, returning there annually till 1886. Kavanagh was much influenced at this time by Dutch art, both seventeenth-century, such as de Hooch, or his own contemporaries, such as Anton Mauve. But he, too, moved on to paint in a less detailed manner when he was in Brittany. His best-known picture is *The Cockle Pickers*,[39] painted on Sandymount Strand after his return to Ireland about 1890, where the lonely expanse of sky and sand is broken only by a distant group of bent old women harvesting cockles. A group of five studies seemingly connected with this work exist, which give evidence of his considerable abilities as a painter when he was able

painted but it vividly emphasizes the appalling and often downtrodden position of women at this period. The influence of Millet and Courbet is quite clear and it forms a stark contrast to the message of the idealized vision of the other two pictures mentioned at the beginning of this paragraph.

O'Kelly spent some time in Brittany in the 1870s and 80s. He is said to have admired van Gogh, but was not influenced by him; although O'Kelly's work remains dark for the most part, it totally lacks the

to concentrate on pure landscape. It is a pity that he devoted so much of his time to more enclosed woodland scenes, where his rather dark colouring is not wholly successful, but in *Children Playing by a Stream*, *Gipsy Encampment on the Curragh* (Fig. 354), and *The Cockle Pickers*, where the scene is open, he achieves his best work. There is a religious element in some of his art, where flocks of sheep with their shepherds are clearly both realistic and symbolic. He was Keeper of the RHA from 1910 and never recovered from the burning of the RHA premises in the 1916 uprising, when he escaped with his life but all the RHA pictures, records and property were destroyed. He died in 1918.

Harry Jones Thaddeus was born in Cork in 1859, the son of a japanner, Thomas Jones. He changed his name by deed poll later in his career, in 1885, for social reasons, taking his second Christian name as his surname and we will call him by this throughout. He enrolled at the Cork School of Art when about ten years old, winning his first award in 1871 and later was appointed an assistant master. He went to Dublin in 1878–9 and shortly afterwards, having won the Taylor Art Prize, went on to London where he entered the well-known Heatherley's School of Art, just a year before Lavery. He only stayed a short time, as winning a second Taylor Prize gave him the money to go to Paris, to the Académie Julian.[40]

In 1881, his work *The Wounded Poacher* (Fig. 355) was accepted at the Salon and actually hung 'on the line', a considerable achievement for one so young. This picture shows the interior of a cottage, with the wife tending her shot husband, both figures well realized but very noticeable for the still-life painting of cabbages and other vegetables in a basket, the dead rabbits by his gun and the glass bottle on the table with its mended leg. The well-painted realism goes down to the loosened laces on the poacher's boots and all the details in the picture. But it does indicate that from the start Thaddeus has a strong social conscience and a sympathy with the sadly oppressed poor. In fact, his second Taylor prize was awarded for a picture called *Renewal of the Lease Refused*. He went on to Concarneau, where he painted a number of fine pictures, including his huge picture *Jour de marché – Finistère* (NGI), shown at the Salon in 1882. Other paintings were of children on the sands, such as one of two ragamuffins smoking on the beach.[41] He spent 1882–3 in Paris, with some months at Moret-sur-Loing near Fontainebleau, and went on to Florence, where he arrived in September 1883. Here, his subject-matter changed substantially, and he rapidly became a society portrait painter for the many European grandees who visited and lived there. A brief visit home to Cork took place at this time, when he taught William Gerard Barry (1864–1941). On his return, Thaddeus began portrait painting in earnest and among his

355 Harry Jones Thaddeus, *The Wounded Poacher*, oil on canvas, National Gallery of Ireland, Dublin

notable sitters were the Duke and Duchess of Teck, the parents of Princess May, later Queen Mary, wife of George V. Later, in Rome, he painted two successive popes, Leo XIII and Pius X, as well as Anthony Maria Anderledy, the head of the Jesuit order (Lady Lever Art Gallery), a dark and positively frightening por-

trait of a contemplative man. He also painted Gladstone and finally returned to London after having 'hobnobbed' with and painted many royal and princely German families.

Thaddeus's London list of sitters is amazingly aristocratic. He was certainly influenced by Frank Holl

and Hubert Herkomer and later by Lavery. But he also painted a number of Irish nationalist portraits: Michael Davitt, William O'Brien, Thomas Sexton and John Redmond.

His great masterpiece, *An Irish Eviction, Co. Galway* (1889, Fig. 356), recalls his early social conscience. The land war of the late 1880s was one of the most dramatic reasons for the fall of Irish landlordism. Some of the landlords and their agents had, as in Scotland, forced emigration and eviction with dire consequences to their unfortunate tenants. Thaddeus's scene shows a family defending their cottage with boiling water, pitchforks, and a ladder against the constabulary who have just caved in the door. The smoky, dark interior is a terrifying image of the emotion engendered by these tragic and ghastly events. The *Liverpool Daily Post* wrote on 16 September 1890 about this picture that it showed 'all the uncompromising details of a desperate struggle for home and liberty'.

Evictions were frequently illustrated by artists such as Aloysius O'Kelly, but never with such a sense of drama as in Thaddeus's picture. It is one of the most powerful artistic, political statements of late-nineteenth-century Irish art. Lady Butler (1846–1933), the great English military artist,[42] married to an Irish Catholic general, carried on this theme and painted two major Irish works. One, the *Connaught Rangers*, is a recruiting scene, and the other is *An Eviction* (Fig. 357) of 1890. It shows the cottage razed to ruins and the lonely tragic figure of the peasant woman, mad with grief, while the rest of the evictors and evictees walk away down the hillside. This is the only other picture of this subject with the same sense of outrage. The amazingly frivolous attitude of the English Prime Minister, Lord Salisbury, was recounted by her when she exhibited the picture in the Royal Academy. In his banquet speech, he remarked on the 'breezy beauty' of the landscape, which almost made him wish that he could take part in an eviction himself. Lady Butler's comment was 'How like a Cecil',[43] suggesting the haughty hypocrisy of that family.

Briefly returning to Thaddeus, over the subsequent two decades, he (and in time, his wife and family) was based in London, and for a time in Wales. He continued to travel, visiting, often for extended periods, such places as France, Italy, Germany, Morocco, Egypt, the United States and Australia.[44] He also made visits to Ireland and kept in contact with the Cork School of Art. He exhibited regularly in Ireland and England, and also showed works in Edinburgh, Liverpool, Cairo and Sydney. Though his reputation was based fundamentally on his portrait painting, he produced works on a variety of subject-matter, ranging from genre paintings to stock Orientalist works, to Arthurian and biblical scenes. In 1907, he emigrated to America with his family and finally settled in California. Around 1916, he and his wife returned to England and settled in the Isle of Wight, where he died.

Despite his Antwerp training, Roderic O'Conor (1860–1940)[45] is unique among his Irish colleagues as the only Irishman who became an artist in the international scene, and was associated with the Post-Impressionists. Because of his hermitlike existence in the last decades of his life, O'Conor's reputation has been relatively slow to emerge, and certainly in Ireland, until thirty years ago, the only works known by him were one or two acquired by Hugh Lane for the Municipal Gallery. He was born in Roscommon to a landowning family who realized some money, as so many Irish county families did, out of the Land

356 Harry Jones Thaddeus, *An Irish Eviction, Co. Galway*, 1889, oil on canvas, Private collection

357 Lady Butler, *Eviction*, oil on canvas, Department of Irish Folklore, University College, Dublin

358 Roderic O'Conor, *Le Cap Canaille (Cassis)*, oil on canvas, Private collection

359 Roderic O'Conor, *Field of Corn, Pont Aven*, 1892, oil on canvas, Ulster Museum

360 Roderic O'Conor, *Romeo and Juliet*, oil on canvas, Private collection

and his influence is discernible in certain landscapes which have parallel 'hatched' brushstrokes, sometimes called his 'striped technique'. This shows in works as early as the Ulster Museum's *Field of Corn, Pont Aven* (1892, Fig. 359) and even earlier, in 1891, in the still life in Tate Britain. There is, too, an interesting connection between O'Conor's *Breton Peasant Knitting* of 1893 and Cézanne's *Old Woman with her Rosary Beads* (NG, London), which is usually dated a few years later.[50]

O'Conor's handling of colour is always compared with that of the Fauves working in the early twentieth century, and this is especially true of the *Cap Canaille* (Cassis) (1913, Fig. 358). His passionate intensity, however, is closer to the German Expressionists and one can compare the fervent embrace of his *Romeo and Juliet* (Fig. 360) with Munch's *Kiss*, though in no way similar in technique. By the turn of the century, his work, especially the *Nude* of about 1900, can be compared with Bonnard and, according to Clive Bell, 'seems to have known … most of the more interesting French painters of his generation – the Nabis for instance'[51]. His coast scenes of the late 1890s are painted with great brio and he uses thick impastos. Although also extremely expressionist in their use of lurid reds and greens, as Sutton points out, they show an awareness of Monet's seascapes.[52] Some nudes in the early twentieth century show how important he must have been for the English painter Matthew Smith,[53] who knew him in Paris and was a great admirer. O'Conor had returned to Paris in 1904. From our point of view, it is the *intimiste* pictures like *A Quiet Read* (NGI) and the gentle and sensuous nude of 1909 with its overtones of the *Rokeby Venus* (NGI) which are amongst his most satisfying later works. A painting of a seated girl bending forwards, putting on her stock-

Purchase Acts,[46] when their property was compulsorily sold out to the tenants. He had a public-school education at Ampleforth in England. He returned to Dublin to go to the Metropolitan School of Art, where he was given a bronze medal in 1882–3, and then studied in Antwerp. He gave an Antwerp address in connection with the Taylor awards at the RDS in 1884. He went on to work under Carolus Duran in Paris sometime in the 1880s, and in 1889–90 he was at Grez-sur-Loing.

By 1887, O'Conor was aware of the Impressionists, especially Sisley, who, according to Denys Sutton,[47] influenced his *River Landscape* of that year. But by the early 1890s he had already developed an advanced Post-Impressionist style, which is closer to van Gogh than to Cézanne or Gauguin. It is uncertain when he got to know van Gogh (if at all), but it was probably in Paris, and it is not clear where or when he first met Gauguin. It is generally assumed that it was after Gauguin's return from Tahiti in 1893, but it could have been earlier, particularly as they were on such intimate terms by 1894–5 that Gauguin not only borrowed O'Conor's Paris studio but also used one of O'Conor's drawings as the basis of a composition.[48] If in the early 1890s O'Conor's use of colour as a psychological expression is closer to Gauguin, his brushwork is much nearer to van Gogh, and lacks the emphasis on flattened forms and dark outlines of the main Pont-Aven group. Either it is a parallel development, or he knew van Gogh's Arles paintings, perhaps through Vincent's brother Theo or the dealer Père Tanguy. His use of pure colour may well have been influenced by Seurat, though he was never a pointillist. He is known to have owned many photographs of Cézanne's works[49]

ings, is another of these quiet, gentle pictures which remind one of Bonnard.

In 1893, O'Conor stayed for a month with Seguin at La Pouldu and worked with him on etchings;[54] though O'Conor did not continue to use this medium, they link closely with his only surviving drawings, which are from this date onwards. His crayon studies of Breton peasants have strong outline and character conveyed with simple lines. His landscapes, which are mostly of trees, almost assume a life of their own, dancing or walking on the page, like the occasional drawing of peasants clumping along a road.

As O'Conor became more introverted, he saw less and less of his fellow painters and yet he was affectionately nicknamed 'Le Père O'Conor' and, according to Clive Bell, they were always very pleased to see him.[55] His fine self-portrait of 1904 is the somewhat gloomy face of 'Le Père O'Conor' (Fig. 361). His remarkable understanding and knowledge of modern painters very much influenced the development of taste in circles such as those which revolved around Clive Bell and Roger Fry. By 1904, O'Conor owned pictures by Gauguin, Bonnard and Rouault,[56] and in the sale after his death, there were pictures by Derain, Segonzac, Vlaminck, prints by Munch, Cézanne, van Gogh, Manet, Redon and Toulouse-Lautrec.[57] He was equally interested in books and *objets d'art* and was very well read. However, this was never apparent in his works, which are in no way literary, and he even criticized Gauguin, complaining that he had 'an artificial literary quality'.[58]

His friendship with Gauguin, if not artistically so important, was the great event of his life, and it is perhaps sad that he never accompanied him on his second visit to Tahiti. His reply to his friend Alden Brooks, when asked why he did not go, was perhaps typical of his gruff personality – he said 'with snuffling indignation, "No, but do you see me going to the South Seas with that character"'.[59] He was never a bohemian and perhaps his reply gives us a hint of the pride of his 'Milesian Irish' background (he came of an Irish royal dynasty).[60] Late in his life, he married a painter, who assuaged his ever-increasing withdrawal from society. Clive Bell wrote, 'I suspect he was a tragic figure, though he kept his tragedy to himself'.[61] As an Irish painter, he was the most outstanding international figure of his time, but, because he lived for so long outside Ireland, it was not until well after his death in France in 1940 that his achievement was fully recognized by his fellow countrymen. It is, too, a sad reflection on his fellow students that he alone emerged from the bywaters to work with vigour in the mainstream of modern European art, leaving them far behind. Perhaps his solitary nature and his financial independence helped him to survey the Parisian scene so intently and so perceptively.

Walter Chetwood Aiken (1866–99), judging by his few known works, was a very fine painter who has only recently been discovered.[62] He came from a landowning family from Woodbrook, Co. Laois, but was born in Bristol and probably studied in London before going to the Académie Julian in Paris in 1890–3, working under Bouguereau where, strangely enough, he was a fellow pupil with Matisse.[63] He went to Concarneau in Brittany between 1895 and 1898, where he picked up the bold outline of Gauguin without the colour. His masterpiece, *A Song of Spring* (Fig. 362),[64] shows seven young women, one with a baby, under a tree laden with apple blossom, their Breton head-dresses and collars helping to form a friezelike composition, for only their heads and shoulders are shown, as in Gauguin's *Vision after a Sermon*, of 1888 (NG Scotland). It has an artnouveau quality which is hardly ever seen in Irish painting. It was exhibited in the RA in 1897. Apart from one landscape, and several drawings in the Bristol

361 Roderic O'Conor, *Self Portrait*, oil on canvas, National Gallery of Ireland, Dublin

362 Walter Chetwood Aiken, *Song of Spring*, oil on canvas, Private collection

Nathaniel Hill (1861–1934) came from Drogheda, Co. Louth, and after studying at the Metropolitan School went on to Verlat in Antwerp between 1881 and 1883. He was a contemporary there with Osborne and Kavanagh, and travelled with them to Pont-Aven. He won the Taylor Scholarship twice in 1883 and 1884, when he returned to Ireland, and again in 1885. In the autumn of 1884, he was painting in England with Osborne and Edward Stott at North Littleton in Worcestershire. Later in the 1880s, he and Osborne were working at Walberswick together. His Taylor prize painting, *Breton Peasants Waiting at a Convent Door* (1884, Fig. 363), is remarkable for its study of the weariness and depression on the faces of the peasants and the detail of clothes, even down to the straw in the clogs of the standing figure doffing his hat.[65] It is typical of an Antwerp student for its social realism and use of dark tones. *The Sunshine, Pont-Aven* is a charming picture of the warmth in the corner of a farmhouse courtyard and the effect of sunlight on the stonework.[66] Some dramatic event in Hill's life stopped him painting in about 1895 and later he went to live in Betws-y-coed in North Wales, where many years later he died.

Henry Allan (1865–1912), born in Dundalk, was trained first in Belfast and Dublin before going to Antwerp from 1884 to 1888. He was a contemporary there of Richard Thomas Moynan and Dermod OBrien, but, unlike them, he returned to Ireland without going on to France. He first exhibited in the RHA in 1889 and, apart from Irish scenes, showed many Dutch and Belgian interiors and landscapes. Joseph Israels was a great influence on his work. He became an RHA in 1901 and in 1909 Treasurer of the Academy. *A Dutch Interior* (NGI) showing an old man studying a silver goblet in an antique shop and *The Rag-pickers* (1884–5, Fig. 364), a striking work of two witchlike black-clothed women, one gesticulating at a group of figures further down the beach, are amongst the few paintings by Allan we know.

Richard Thomas Moynan (1856–1906) is a much better-known artist, who started training as a doctor. He gave this up to study in the Metropolitan School and the RHA School before he went to Antwerp with Roderic O'Conor in 1883. He went on to Paris in 1886, studying under a number of painters, including Bouguereau. He preferred genre scenes, particularly of the urban or village poor, such as *Tired Out*, (RHA 1898),[67] a child with a bandaged leg lying asleep on the ground, or *The Game of Marbles*,[68] where a group of ragged boys are playing in the village street. His large picture, *Military Manœuvres* (RHA 1891, NGI), set in the village of Leixlip, outside Dublin, probably his best known work, is in the same spirit, showing the boys on parade with a soldier of the Royal Irish Dragoon Guards.[69] A really more appealing picture, showing the extreme poverty of an Irish village, is *A Punch and Judy Show* (Fig. 365), which is similar in composition. It was probably exhibited in the RHA in

363 Nathaniel Hill, *Breton peasants waiting at a convent door*, oil on canvas, Private collection

364 Henry Allan, *The Rag Pickers*, oil on canvas, Private collection

Museum and Art Gallery, only one other work is known: *Le Pardon de Sainte-Barbe au Faouet et la fête du Saint Sacrement*, dated 1897–8. This is an upright composition of a procession, where the major emphasis is the colour of a red banner above the priest, who is dressed in robes of yellow and white, forming a strong central element. Both pictures have ornate wooden frames with the titles carved in Breton script, which shows Aiken's fascination with Breton culture. He exhibited some twelve pictures at the Salon and RA and received some appreciative criticism. He was probably a slow worker but sadly he died at the early age of thirty-three.

Of the minor artists who studied in Antwerp and Paris, Nathaniel Hill, Henry Allan, Richard Thomas Moynan and J. J. O'Reilly deserve mention.

1892 as a *Travelling Show*. Landscapes like his *Killiney Sands* (RHA 1894, Allied Irish Bank Collection) are less sentimental. The brilliant sunshine beating on the sands forms a useful foil to the skeletal lobster pots abandoned on the beach. Moynan inevitably painted portraits to make a living. These are occasionally met with, and show him to have been a realist painter of considerable sensitivity.

His *Girls Reading a Newspaper* is a fine example of his work. An unusual picture is his view of a lesson in the Metropolitan School of Art (Fig. 366) which is a fascinating record of art teaching a century ago.[70] *The Death of the Queen* (1902, NGI) is another high striking picture of a newsboy outside Trinity College. It is interesting that he wrote an impassioned letter to the *Irish Builder* in 1896, railing at the neglect of the RHA by the government, mentioning that provincial galleries in England and Scotland saw their corporations exhibiting, sustaining and collecting for their galleries while the government and corporation did little for the RHA.[71] His initially brilliant career was cut short, according to Strickland, by his intemperate habits.

A little-known Co. Cork painter whose few surviving works show him to have been very talented is William Gerard Barry (1864–1941).[72] He was taught initially by Thaddeus, who urged him to study in Paris, which he did, going via London. In 1887, he was in Etaples, where Frank O'Meara was working that year, and he won the Taylor scholarship with a picture he sent to Dublin from there. During his next visit to Ireland, he fought with his father and as a result went to Canada, where, after a wild-west career, he earned enough money to buy paints and then became a portrait painter in the States. Most of his career was spent in America or France, where he died in 1941 in

an accident. In 1888, he exhibited *Times Flies* (Fig. 367) at the RA (Crawford Art Gallery, Cork), a golden autumnal picture set in Etaples with an old lady looking at three children against a background of trees, a river and a church. It is most competently painted, rather in the manner of O'Meara.

Joseph O'Reilly (1865–93) was a Dubliner, who won prizes in the RHA Schools and was encouraged by Osborne to go to Paris, where he studied from 1890 to 1892. He died very young, of tuberculosis, in 1893. His surviving pictures are academic nude studies,

such as his *Head and Shoulders of a Female Model*, delineated with almost cruel realism. There are a few others of a more sympathetic character, of which *A Parisian Girl* is an example.[73]

We have charted the history of Irish watercolours[74] elsewhere, but to rehearse the bare outlines is essential in discussing the history of Irish painting and two of the artists are of sufficient quality to be considered individually. In 1870, a group of ladies living in or near Lismore and Clonmel formed the Irish Amateur Drawing Society and this, through many changes of names and amalgamations with similar groups, finally became the Water Colour Society of Ireland, whose annual exhibitions greatly enhanced the importance of the medium. Of the original group, the two most distinguished were Fanny Currey (1848–1912) and Harriet Keane (d. 1920). The first exhibition was held in 1871 in Lismore. Helen O'Hara (1846–1920) went to live with Fanny Currey in 1898, but had been exhibiting in the RHA for some years in advance. Some of her watercolours are in the top rank.

Other friends included Rose Barton (1856–1929) and Mildred Anne Butler (1858–1941), who had a watercolour bought by the Chantrey bequest in 1896 for the Tate Gallery. Mildred Anne was initially taught by Paul Jacob Naftal by post. She seems to have sent him a portfolio of drawings and watercolours once a month and these were returned annotated with constructive criticism. He thought a great deal of her and after three years felt he could teach her no more.

She went briefly to Frank William Calderon to study animal painting for two summers, 1894 and 1895, she holidayed in Newlyn to study under Norman Garstin, who introduced her to modern French painting. On one occasion, she was accompanied by May Guinness, whom we discuss later. Butler exhibited at the RA and was elected an ARWS in the year 1896. She painted sumptuous garden border pieces, which can be monotonous, but her studies of crows and other animals and birds and the lush Kilkenny countryside often show amazing virtuosity. Sometimes she paints very impressionistically, as in *The Artist Painting* (Fig. 368).

Rose Barton (1865–1929) travelled with her sister and mother on the continent, after the death of her father, and studied in Brussels and later in Paris, in the early 1880s. There, she probably studied under Jacques Emile Blanche's master, Henri Gervex.[75] She developed a genre of Impressionistic water-colour townscapes which is extremely subtle and atmospheric, and she illustrated books on Dublin and London, in both of which cities she lived and worked. Her earliest watercolours, often of her family in garden surroundings, have a singular clarity and contrast with such atmospheric studies as her *Custom House, Dublin* (Fig. 369), which is characteristic of her later style. Both Butler and Barton had very sucessful careers as watercolourists and rank amongst the best of their contemporaries in these islands.

Norman Garstin (1847–1926) came from near Limerick but, though he appears to have seen Ireland

as his home country, exhibiting some thirty-four pictures in the RHA, he never stayed for long in Ireland later in his life. After travelling, not just in Europe but in South Africa, digging for diamonds and working in other occupations, he decided to be an artist and went to train under Verlat in Antwerp around 1880–1, and then became a student in Paris under Carolus Duran until *c*.1883. He went on to Italy, and *c*.1885 painted in Tangier in Morocco. He visited Brittany several times in the early years of the twentieth century, where he may have known Roderic O'Conor. He had settled in Cornwall in 1886, first in Newlyn and later in Penzance, and really belongs more to English than Irish art. He was a fine landscape painter. His pictures usually include figures and there are clear links with Osborne and Leech, the latter of whom will be discussed in chapter 18.

A group of better-known painters whose names were closely linked in Edwardian Dublin were Dermod OBrien, John B. Yeats and Sarah Purser. Dermod OBrien (1865–1945) was rather older than the other Irish artists in Antwerp and only took up painting after he had had a conventional English upper-class education at Harrow and Trinity College, Cambridge. He had travelled to Paris and Rome in 1886, but only began his studies in 1887 in Antwerp, where he stayed some four years, going on to the Académie Julian in Paris. Later, on his return to England, he went to the Slade. Naturally, with this academic background, he painted many nude studies in his early career. He was a friend of Rothenstein, Wilson Steer and Tonks, with whom at one time he shared a house in Cheyne Row. He also knew most of the London art world – artists such as Sargent, Condor, Ricketts and Shannon. OBrien was the grandson of the Fenian leader, William Smith O'Brien, and inherited the family property, Cahirmoyle, Co. Limerick, in 1907. He was a keen farmer, taking part in the co-operative movement, though later in his life he sold the estate. He became an RHA in 1907 and President in 1910. He is best remembered for his landscapes, many of them painted at Cahirmoyle and others close by, such as his *Ruins at Askeaton* (Limerick Art Gallery). His particularly fine picture of his wife and children, painted about 1910, is entitled *The Sandpit* (Fig. 370). They show a calm, pastoral appreciation of the Irish landscape and with their brilliant use of colour, especially in the sky, they appear like modern Constables with a touch of Hone. He had an intimate interest in nature, which is best described in his own words in a letter to his sister, Mary, of 1891, when he said:

> If only one could only get to work to describe one's feelings at seeing the little buds open and the tiny leaves unfold themselves green and gold in a purple mist of twigs and branches like a sort of green snowstorm. Do you know the brave way the horse-chestnut sprouts up with its sticky leaves, so well

369 Rose Barton, *The Custom House, Dublin*, watercolour, Private collection

370 Dermod OBrien, *The Sand Pit*, oil on canvas, Private collection

adapted for pudgy children's noses and how they find out that life is not all beer and skittles and fall down limply like an invalid's hands?[76]

In his youth, he painted a few romantic subject pictures, such as his *Spring*, which he exhibited at the Guildhall in 1904 and which Terence de Vere White described as a naked figure who is 'juggling with six cherubs and has dropped one'.[77] He painted portraits which are conventional enough statements, often more interesting for their sitters than as works of art, though his portrait of *A Lady in Pink*, his cousin Eva Farrer, is spirited and glamorous. OBrien is undoubtedly more successful on the small scale, in his drawings

371 John Butler Yeats, *Mrs Meidie Ashe King*, 1899, oil on canvas, Private collection

372 John Butler Yeats, *Sarah Purser painting*, 1894, drawing, Private collection

and in works such as *The White Dress* (NGI), which shows the influence of his London years and particularly of Sargent and Whistler. His male portraits include the fine *Seventh Earl of Aberdeen*, exhibited at the RHA in 1912, showing him in his full regalia, holding the sword of state. It is a fine and honest character study. He was also a talented still-life painter.

John Butler Yeats[78] (1839–1922), though of an older generation, also took up painting late in his life, having already studied law and been called to the Bar in 1866. In the following year, he went to London and studied at Heatherley's Art School and the RA Schools, and in 1889 visited Holland. While at the RA, he and a group of friends, J. T. Nettleship, George Wilson and Edwin Ellis, tried to form a society for resuscitating the ideals of the Pre-Raphaelite Brotherhood, and a watercolour of 1871, entitled *Pippa Passes* (NGI) after the Browning poem, illustrates this phase and is the most imaginative picture of his career. He turned to portraiture in 1872 and went back to live in Ireland in 1880, exhibiting at the RHA and RA. He was a totally unworldly character, a misfortune for his brilliant children, the poet, the painter and the two daughters who worked in the applied arts. He was an immensely slow worker, as is attested in a Sarah Purser story. Yeats was reproaching a sitter, the poet Katherine Tynan, for having 'cut her fringe, when Sarah Purser came in and observed: "Why, if she hadn't cut her fringe since she has been sitting to you, Mr Yeats, it would be at her feet by now"'.[79]

In an effort to make a living, he returned to London in 1887, living in Bedford Park between 1889 and 1901, and most of this time worked only as an illustrator in black and white. He was the centre of a literary, intellectual and artistic circle, but he was persuaded to return to Ireland in 1901, when Sarah Purser and Edward Martyn organized an exhibition of his work, together with that of Nathaniel Hone, in October and November. This exhibition was a great success for Yeats, as it introduced his work to Hugh Lane, who commissioned him to paint a series of portraits of important Irish literary and intellectual figures, which remain his greatest claim to fame.[80] His broken technique, often called Impressionist, even by himself, has little in common with the French painters, as he had a very sombre palette. He had a great ability to capture character in his sitters (Fig. 371), for instance, the magisterial portrait of the old Fenian, John O'Leary (NGI) and the more intimate and haunting study of the novelist George Moore. He painted portraits of his brilliant family with his usual sensitivity. His pencil portrait studies, done in terms of light and shade roughed in on the page, have a brilliance which exceeds his oils. His charming pencil portrait of *Sarah Purser* (Fig. 372) is typical of this genre. He went to America in 1908 and spent the rest of his life in New York, where he lectured and wrote, as well as painted, and became a well-known and influential figure in artistic circles, especially the Ashcan School.

A member of the Ashcan School, Robert Henri[81] (1865–1929), who had Irish ancestry, had painted John Butler Yeats in the spring of 1913 and later that year, due to Yeats's enthusiastic portrayal of the special qualities of Ireland, Henri and his wife went on a tour of the country and fell in love with Achill, where they found a house to rent which had belonged to the infamous land agent Captain Boycott. They enjoyed Ireland so much that after the war they returned in 1924, bought the house and came for four successive years. Henri painted a considerable number of moving portraits of the local peasantry, their whitewashed cabins and the landscape of Achill. His portraits of children are particularly appealing, cheerful, lively and inquisitive. The children (Fig. 373), though very poor, were quite unlike the poverty-stricken Irish urchins whom he had painted in the slums of New York. He is well known for his use of thick impasto and clear, bright use of colour. Frans Hals was an inspiration for him. A pupil of William Merritt Chase and of Henri was Rockwell Kent (1882–1971),[82] who paid a brief visit to Ireland in 1926 and painted a number of striking landscapes in Donegal. These were very simplified, and he tended to use brilliant colour and strikingly opposed tone values with smooth brushwork. The figures are sculptural and his *Woman lying under a Cromlech* (1926) is a surprising image. His few Irish landscapes are among his finest works.

For Irish twentieth-century painting, the life of Sarah Purser (1848–1943) is more important for the influence she had as a patron, hostess and a collector than for her paintings.[83] She was also a founder of *An Túr Gloine* (The Tower of Glass), the inspirer of Hugh Lane and his Modern Art Gallery and the founder of

that many of her portraits are apparently dull, if not bad, but a portrait of Lily Foley shows her as a direct realist and a highly competent academic artist; *The Slut*, dated 1893, and *The Dublin Urchin*, 1890,[87] are two good examples. Her pastels of children are honest portrayals and her drawings, much influenced by John Butler Yeats, can be lively. In many ways, her portraits of the working classes are better than her fashionable sitters, which include among her earliest and best known the group of Constance and Eva Gore-Booth[88] as children at Lissadel. This resulted in introductions from Lord Lieutenants to English patrons and she remarked later that she 'went through the British aristocracy like the measles'.[89] These portraits were usually exhibited at the RA. She was also a regular exhibitor at the RHA and, with OBrien, picked up Osborne's portrait practice on his death in 1903. Her portrait of a lady with a peacock fan, a crucifix and a skull is an unusual vanitas and shows her lively brushwork (Fig. 374). She also painted landscapes, which are her freshest and least-known works, and are indebted to Nathaniel Hone. She had no time to paint for pleasure till late on in her life.

From 1911, she lived in Mespil House, the great drawing-room of which, with its superb rococo ceiling, was the witness of her famous 'second Tuesdays',[90] where all Dublin's intelligentsia assembled to drink tea and eat sandwiches. Orpen recalled the more informal tea in the dining-room, when the birds used to compete for the bread, butter and cake.[91] Her finest memorial is the stained glass which can be seen in so many Irish churches and which exists by virtue of her administrative and financial work for *An*

the Friends of the National Collections of Ireland. With her cousin, Sir John Purser Griffith, she endowed a Scholarship and Prize in the History of European Painting in 1934, with the aim of providing trained art historians for such jobs as the directorship of the National Gallery of Ireland. This venture led ultimately to the founding of art history departments in Trinity College and University College Dublin.

Purser came of a well-to-do Irish industrial family, two of whom were distinguished academics. She was educated in Switzerland, but, after her father's financial collapse in 1873, battled for some years with considerable poverty, a fact which obviously influenced her later, almost obsessive concern with making money. After studying at the Metropolitan School of Art, she went, with £30 in her bag,[84] to the Académie Julian in Paris, for six months, 1878–9. Some of her best work was produced there or immediately afterwards, such as *Le Petit Déjeuner* or *The Lady with the Rattle*, both in the NGI. A study of the same sitter as seen in the latter, seated on a sofa holding a fan, is a very lively sketch in which great attention has been paid to the folds of her dress and the sofa. It shows very strong French influence. *Le Petit Déjeuner* is identified by John O'Grady as a portrait of an Italian music student and singer, Maria Feller, who shared an apartment in Paris with Purser, and her friend, the Swiss artist Louise Breslau,[85] but its intimate quality is unfortunately not followed up in much of her later work. It is a little reminiscent of Degas and she may well have already been looking at avant-garde works, for, though she was too poor at the time to buy, she later made a collection which included Seurat and Vlaminck.

On her return to Dublin, Purser started a very active career as a portrait painter, making in all, she estimated, £30,000 in fees.[86] The result, of course, is

373 Robert Henri, *The Green Sacque* (*Sissy's Sister Mary*), 1927, oil on canvas, The Nelson-Atkins Museum of Art, Kansas City

374 Sarah Purser, *Woman with a Peacock Feather Fan*, c. 1882, oil on panel, Private collection

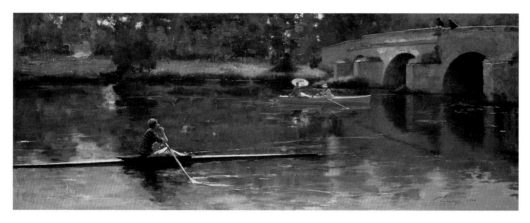

375 Edith Somerville, *Retrospect*, oil on canvas, Private collection

376 John Lavery, *The Bridge at Grèz*, 1883, oil on canvas, Private collection

Túr Gloine, where she employed all the great modern Irish stained-glass artists at one time or another, except Harry Clarke.

A minor painter and great writer, with her cousin Violet Martin, was Edith Somerville (1858–1949) of Drishane, Co. Cork. Her artistic education took in London, Düsseldorf, because her cousin, and later her brother-in-law, Egerton Coghill (1853–1921) was studying there, and finally Paris, where she went to Colarossi's, chaperoned by five members of her family until they faded away, horrified by the Parisian pensions. Edith was made of stouter stuff and returned year after year, leaving Colarossi's for Delacluse's studio in 1899. Egerton had meanwhile gone to Barbizon, 1883–4, and on his return to England became a member of the New English Art Club. He exhibited very little, painting rather monotonous landscapes and some still lives. He returned fairly soon and lived in Castle Townshend for the rest of his life. Edith was more distinguished, particularly for her drawings and illustrations. Her article in the *Art Journal*[92] of 1890 entitled 'Paris Copyists' is both informative and funny, and this vein of her work con-

tinued throughout her life, when she illustrated her and Violet's immortal *Experiences of an Irish RM* [Regional Magistrate]. Two of her early oil paintings, *The Goose Girl* (1888, Crawford Art Gallery) and *Retrospect* (Fig. 375), a study of an old servant at Drishane, are strong statements, showing her French training and her sensitive feeling for the local villagers.[93] Few of her later works, which include many landscapes, live up to these.

The Glasgow School can properly claim the young John Lavery (1856–1941). However, his Belfast origin, which he honoured by a gift of paintings to the Ulster Museum, and his later involvement with Irish politics and interest in the emergent republic, mark out his sympathies for his native land. He was orphaned young and, after a childhood of some hardship, he was apprenticed in Glasgow to a photographer, where he was employed for three years, tinting prints. During this time, he attended evening classes and, after a year's further employment in the photographic colouring trade, he set up an independent studio. Due to the generosity of a client, he found his way to London and attended Heatherley's School for a year. On his return to Glasgow, he had the luck to have his studio burned and went to France in 1882 on the insurance money.

He first studied at the Académie Julian and later in the evenings in Colarossi's, where the models were often in costume. He greatly admired Bouguereau, his first master in the Académie Julian, though the artist commented on his nude studies, 'Mon ami, ça c'est comme bois, cherchez la caractère et les valeurs'.[94] The ascendancy character of Irish students in France is amusingly highlighted by Lavery himself, who recounts that on his arrival at the atelier, he was asked by the *massier* if he was English. He replied 'No, Irish'. 'Are you a landlord?' 'No.' 'How many have you bagged?' Lavery wryly continued, 'I was surprised to find him so well informed'.[95] The training in figure drawing, which was basic to French academic tuition, is shown seductively in Lavery's *Ariadne* of 1887, of which a study and two final paintings exist. Its debt to Bouguereau is obvious, but Walter Shaw Sparrow perceptively points out its links with the Belgian painter, Alfred Stevens.[96] Stevens was much admired in Paris at this period, but it is his costume pieces that are really close to Lavery.

As with most other Irishmen studying in France, the pleinairism of Jules Bastien-Lepage was enormously influential. During his months living at Grèz-sur-Loing, Lavery was able to put into practice the advice given to the students in Paris on the need to crystallize immediate reactions in the sketchbook. The bridge at Grez inspired Lavery to paint it about fourteen times, though many of these pictures were painted on his later visits to the village which he so much enjoyed. One of the early versions done in 1883 shows two girls in a boat and a lone sculler in the fore-

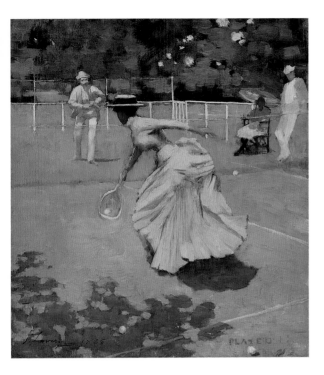

greatly influenced by Velázquez, probably encouraged by Whistler, with whom he was by then on very friendly terms. In 1892, he also travelled in Italy, Germany and Holland with Guthrie and Roche and became a member of the Royal Scottish Academy. His Moroccan seascapes, especially *Moonlight – Tangier*, are superb nocturnes in the Whistler manner, but the beach landscapes with figures are very vivid and sparkling, showing his fluid handling of paint at its best. It was inevitable that this should degenerate into slickness in some of his later works, especially his portraits. In 1904, the magazine *The Studio* found one of Lavery's fashionable female portraits, although marked by fine passages, 'too chic and too empty to be satisfying'.[98] This, however, was not always the case. For instance, his *Japanese Switzerland*[99] of 1913, showing his second wife, Hazel with her daughter, on their honeymoon, is a picture of great charm, due to its extremely simple silhouetted outline, which gives the figures great vivacity. The sumptuous *Green Coat* (1925, Fig. 378), another portrait of Hazel, with whose beauty he was obsessed throughout his married life, shimmers with translucent colour and light reflected in the mirror above the glowing fireplace. The grand-

ground (Fig. 376). His beautiful handling of tone values in the water contrasts with the cheerful communication between the three figures. Another version, now known as *Under the Cherry Tree* (1884, UM), is a very similar subject, with the bridge in the background, showing his use of soft greens in the reflection of the trees and the light in the water, creating a somnolent mood. It has very detailed handling of the sandy earth, weeds and dandelions in the foreground, a piece of virtuoso painting. His languid study of *A Girl in a Hammock* (1884) and another of *A Lady Sitting in a Wicker Chair* (1885) are other intimate studies of this period. It was at about this time that he came to know, admire and be influenced by the work of Whistler, whom he met in 1887. He would not have seen the large exhibition of Whistler's work held in Dublin in 1884, which was the largest held outside London at that time.

On Lavery's return to Glasgow from France, probably in late 1884, he came into contact with Glasgow School figures, such as McGregor, Guthrie, Walton, Crawhall and others. In 1885, he painted his famous and very Whistlerian *Tennis Party*, now in the Aberdeen Art Gallery, which was ill-received when shown at the RA in 1886. We illustrate *Played!* (Fig. 377), a study for the series of tennis matches. But he made his name with the commission from the Glasgow Corporation, in 1888, for the official picture of the state visit of Queen Victoria to Glasgow. The sittings for the various figures in this picture brought him into contact with the fashionable world. He even achieved a sitting with Queen Victoria, against all odds, and went off to Darmstadt to paint Princess Alice.[97]

In 1890, Lavery went to Morocco, where he met R. B. Cunninghame Graham, whose portrait he painted in 1893. He had visited Spain in 1891–2 and been

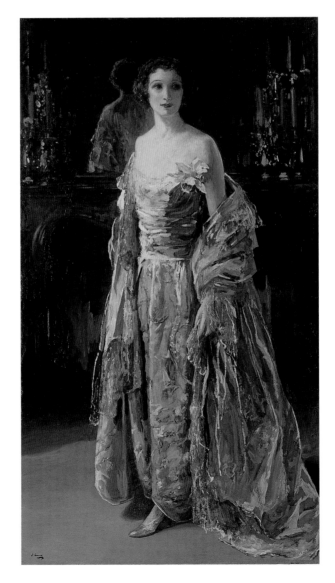

377 John Lavery, *Played!*, 1885, oil on canvas, Private collection

378 John Lavery, *The Green Coat*, 1926, oil on canvas, Ulster Museum

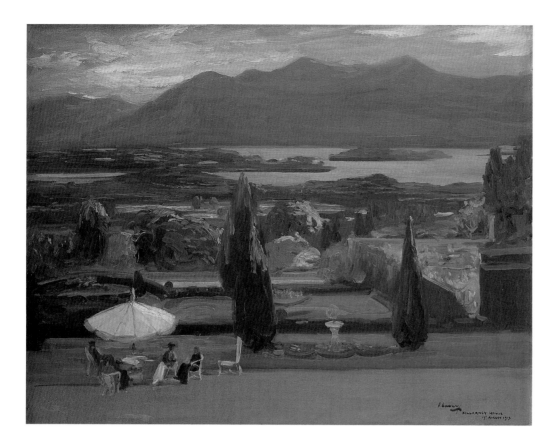

379 John Lavery, *Killarney House*,
1913, oil on canvas, Private collection

most effective and fascinating work was an aerial view, among the first ever painted, of *A Convoy, North Sea, 1918*. Though his work in the 1920s and 30s is sometimes slapdash, when he is painting a conversation piece, such as *Spring in a Riviera Garden*, 1921 or *The Interior with Emerald Cunard and George Moore* of 1925, he is at his best. He can convey the intimate atmosphere of talk extremely well. This was always the case, as one of his most notable Irish studies, showing the Lakes of Killarney painted in 1913 from Killarney House (Fig. 379),[100] achieves intimacy in the foreground group even against the grandeur of the lake and mountains.

Lavery became involved with Irish politics in the early 1920s, through his wife, and painted a record of most of the politicians on both sides, from Carson and Craigavon to Cardinal Logue and the dead Michael Collins. His liberality of spirit was such that one of his best later works is a sparkling *12th of July Orange Procession in Portadown* (UM). He designed the bank notes for the new republic and, until 1976, Hazel Lavery, in the guise of Cathleen ni Houlihan, appeared on every note. She, too, dominates the splendid *Homage to Velázquez* family group with her daughter, Alice, and Lavery's daughter, Eileen, which hangs so grandly in the NGI. His stepdaughter married an Irishman, who lived in Co. Kilkenny. Apart from long visits there, he finally returned from London to Ireland in 1940 and died there in 1941.

This was an exciting period in Irish painting and in recent years so many more pictures have surfaced which have enriched our appreciation. Sale-room prices indicate how much more they are admired and rightfully bring these artists to the notice of a more international audience.

est of these is his Velázquez-like group of his family in the NGI, which is a stunning essay in colour, notably purple. His interior views were among his best paintings, as he had a real feeling for intimacy, both in architecture and its inhabitants.

A different note is struck with his only mural, done for the Banqueting Hall, Municipal Building, Glasgow, where he chose to paint shipbuilding on the Clyde. He became a war artist for the Royal Navy and perhaps his

Orpen and his Shadow

The turn of the twentieth century was a supremely exciting time for the arts in Dublin[1] outside the official realms of the Royal Hibernian Academy, its Life School and the Metropolitan School of Art. These institutions had been slowly slipping downhill since the mid-century and were pilloried in the evidence given with great wit and frankness by Hugh Lane, William Orpen, George Moore, W. B. Yeats and AE (George Russell), among other witnesses to the Parliamentary Commission under the chairmanship of Lord Windsor, whose extensive report was published in 1906. However, these institutions did not wholly sum up the Dublin artistic scene. In fact, it was also a fermenting period for a new national identity, which both fed from and gave inspiration to the arts. It was the great period of Lady Gregory, Sarah Purser, Edward Martyn, George Moore, W. B. Yeats and Hugh Lane. Admittedly, it is for its literary and theatrical contributions that it is world famous, but all these figures were also closely connected with the visual arts; Lady Gregory's son, Robert, was a painter and Hugh Lane was her nephew; Sarah Purser we have discussed; Edward Martyn was in Paris with George Moore[2] in 1886, when he acquired two paintings by Degas and a Monet, now in the NGI. Even more important for Martyn was his later patronage of stained glass and music. W. B. Yeats was the son and brother of painters. His poem on Hugh Lane's Gallery is a pictorial roll call of the group in verse.[3] The great Hugh Lane himself[4] stirred the whole Dublin artistic teacup with a paintbrush.

George Moore, who was painted by both Degas and Manet, had been educated in Paris in the École de Beaux Arts and the Académie Julian. Though a failure as an artist, he quipped, 'I did not go to Oxford or Cambridge but I went to the *Nouvelle Athènes*'[5] – the café where the Impressionists met. He had been introduced to art by his uncle, Jim Browne, who had married his mother's sister. He seems to have been an amateur, though he worked on a large scale, as Moore was highly excited by one of his smaller pictures, four feet by six feet, of a brown satyr chasing a nymph; Moore asked him why it faced the wall and Browne explained that his sisters sometimes visited him.[6] It was he who told Moore to go to Paris to learn to paint. Moore published the first important article on Degas in 1890 and two books, *Impressions and Opinions* (1891) and *Modern Painting* (1893). These are mainly collections of his essays on the more important avant-garde painters in Paris at the time.[7] Moore is also important for his influence on Lane. It was through Lane and his immense energy that the work of converting a suspicious Irish audience to an interest in painting was begun.

There was nothing parochial about any of these figures – they were, as we have seen, aware of foreign and avant-garde movements; they were sufficiently great to fight their smug and conservative Dublin contemporaries; they could see their countrymen's faults and they had the energy to try to enlighten them, and, to a considerable degree, they were successful. Nevertheless, the attitude of their countrymen is well expressed by Orpen, who says of Lane in his otherwise rather maudlin book, *Stories of Old Ireland and Myself*:

Then Hugh Lane appeared with his dreams, genius, and energy, and with these he worked night and day for the foundation of a great European modern art centre in Dublin. Hugh Lane was a force one could not withstand. He used us all like little puppets, and we loved him and worked for him gladly. We who understood him believed in him implicitly, without question or doubt; but most Dubliners thought, and indeed a lot said openly, "What an imposter! Of course he wants our money; but for himself his pictures are worth nothing. He is a dealer; these things he wishes us to subscribe for are the ones he has bought and can't get rid of." So this man, with all his great visions for Dublin, was defeated in his life's passion.[8]

It is still too easy to play down his importance, to remember him only as the man behind the controversial bequest of pictures Dublin saw as its own to the National Gallery in London, a controversy now happily resolved. But Lane was far more than this. He ran a number of important exhibitions in Dublin, including the *Winter Exhibition of Old Masters of the Early English and French Schools*, 1902. In his preface to the exhibition catalogue, he says 'no new project is ever attempted which is not liable to some discouragement, and adverse criticism. It has been stated that "there are no pictures in Ireland, and that if there are such people do not appreciate, or understand them".' He must be referring here to Osborne's resignation from the committee, which we have already mentioned in chapter 16, over the problem of attributions, which seems to have been justified. Lane was also concerned about the likelihood of dealers persuading owners to sell and naïvely thought this unlikely; in fact, most of the works he showed have now left Ireland. Lane gave a great many pictures to the NGI, as well as founding the Municipal Gallery now named after him, and his patriotism led him to try to highlight Irish painters by exhibitions in London.[9] Lane's tragic death on the *Lusitania* in 1915 ended a career of unsurpassed generosity, whether for old masters or modern, or even bibelots for friends. If he begged money, it was only to give it away. It is difficult to realize that, in his first days in London, he lived on ten shillings a week and yet, before his death, he had given away hundreds of thousands of pounds' worth of works of art and died not a wealthy man.[10]

In the 1902–3 exhibition held in the the RHA, all the exhibits were of Old Masters. This exhibition was followed by the great Irish display at the Guildhall in 1904, organized by Hugh Lane, which was somewhat marred by his overenthusiasm for calling a number of English painters Irish. In Dublin in the same year, there was the Staats Forbes exhibition brought over by Lane, which included Irish as well foreign artists, mostly French. The Irish contingent included Osborne, Orpen, O'Conor and Dermod OBrien, while a number of Impressionists and their close associates were included, such as *Les parapluies* by Renoir and works by Pissarro, Monet, Manet, Degas, as well as by earlier painters such as Corot, Courbet, Daumier, Boudin and Daubigny. Other exhibitions followed. George Moore had remained the authority on modern art, ably assisted by Sarah Purser, until the exhibitions held in 1911 and 1912, organized by Ellen Duncan, the Curator of Hugh Lane's Modern Gallery, which were drawn mostly from the Roger Fry exhibitions held in London in 1910 and 1911. In these shows, Dublin saw for the first time pictures by Gauguin, van Gogh, Cézanne, Signac, Vlaminck, Derain, Picasso, Matisse and Rouault, as well as many other French and Dutch

avant-garde artists, and, as in London, they were harshly criticized. Even AE (George Russell), who was interested in promoting external influences, called the exhibition 'not decadent, but merely decrepit'![11] Thomas Bodkin took a more knowledgeable approach, enjoying the Post-Impressionists but not Picasso, or Matisse, whom he described as 'a mere artistic charlatan'.[12] From the point of view of Irish artists, these exhibitions had little or no impact.

Lane worked untiringly for a gallery of modern art. The Corporation of Dublin finally conceded in 1905, and in 1908 the gallery was opened temporarily in Clonmel House in Harcourt Street. However, the parsimony of the corporation was such that they gave the gallery no purchasing grant until the 1970s. The gallery was filled by the generosity of Irish and other, mostly English, patrons. It was because of this that Sarah Purser[13] founded the Friends of the National Collections of Ireland, and she was the main figure in rehousing the Municipal Gallery of Modern Art in Charlemont House.

William Orpen (1878–1931) was the Irish prodigy of the early twentieth century. He was the son of a Dublin solicitor and immensely precocious. He went to the Metropolitan School of Art, aged nearly thirteen, in 1890, studying there until 1897. His own description of the intolerable academic training then practised in the school which added to his morbid concern about his ugliness, was deeply pathetic. Happily, the training did not break either his spirit or his talent, and his years at the Slade under Tonks, 1897–9, were ones of triumph. His drawing of Hugh Lane asleep dates from this period, when they were sharing rooms together. His Slade prize-winning picture of 1899, *The Play Scene from Hamlet*[14] (Fig. 380), an enormous work, shows his assiduous study of old masters and his ability to weld a large number of figures into an easily read composition. Its use of strong chiaroscuro derives, to some extent, from the huge Rembrandt exhibition held at the RA in 1899 and also from Pryde, whom he knew, whose posters and paintings were a considerable influence on London students at this time. Other artists reflected in his work are Hogarth, Watteau, Fragonard, Goya and Rowlandson, and it shows what an unusual knowledge of painters he already had.

Orpen became a friend of Augustus John, with whom he once shared a studio, and got to know the men who later became the London art establishment. They were mostly his fellow students at the Slade, men like Wilson Steer, Ambrose McEvoy, Wyndham Lewis, William Rothenstein and Henry Tonks. He married Rothenstein's wife's sister, Grace Knewstub, in 1901. He exhibited for the first time in 1899 at the New English Art Club, which had been set up to oppose the established artists of the RA. He also exhibited in the RHA regularly. He did not, however, show in the RA – which, although not favoured by artists, was the best

showcase, attracting the fashionable world – until 1908. That year, Charles Wertheimer, the well-known art dealer, of whom he had painted a superlative small whole-length portrait, may have entered that picture for the exhibition without the artist's knowledge. It made Orpen's name. It was shown in the Jewel Room of the RA, where it attracted fantastic attention. It shows Wertheimer standing in the drawing-room of his Mayfair house with a Gainsborough and a Lawrence in the background. The fine furniture, bronzes and a shimmering crystal chandelier show Orpen's prowess as a still-life painter.

His early pictures, with their low tones and deep shadows, are usually interior scenes in the Dutch tradition of Terborch, but they are more realistic and less elegant and are sometimes centred on an 'Arnolfini' convex glass. His first memorable use of it is in his work known as *The Mirror* (Tate Britain) of 1900, and it occurs in a great number of his paintings. In *A Mere Fracture* (1901, Fig. 381), one of Orpen's most important early works, the mirror only reflects the room and not the group who surround the nervous fingers of the doctor as he feels the sullen boy's injured limb. This Dutch influence is equally strong in the portrait of Charles Wertheimer of 1908, and in the following year's portrait of Lewis Tomalin, another dealer, using a black-and-white tiled floor and other furnishings in the Vermeer tradition. Other portraits, like that of Augustus John, show that he had also been looking at

381 William Orpen, *A Mere Fracture*, signed and dated 1901, oil on canvas, Private collection

382 William Orpen, *Midday on the Beach*, 1910, oil on canvas, Private collection

Whistler. A portrait group, *A Bloomsbury Family: the Nicholsons* (1908, Scottish National Gallery of Modern Art), is also in this sombre manner, which highlights his exquisite draughtsmanship, and is one of his best conversation pieces. It may perhaps be surpassed by his *Homage to Manet*, exhibited in the NEAC and then in Birmingham in 1909, and bought by the Manchester City Art Gallery.[15] The *Homage to Manet* is not an Impressionist picture, but shows the influence of the movement on English art. It includes patrons such as Hugh Lane and George Moore, both Irish, Steer and Sickert, the principal English Impressionists, and Tonks and D. S. McColl, the main teachers at the Slade and the Westminster School of Art.[16] This quiet manner is superseded around 1908 by paintings in which light is the dominant factor.

Though Orpen travelled widely in Europe, he never studied abroad and his development of a *plein-air* manner is separate from that of his colleagues who had studied at Grez. It incorporates a brilliance and freedom of colour which reflects his knowledge of Impressionism, especially Monet, no longer regarded as avant-garde. His finest work of this type was painted in a series of idyllic summers spent at Howth, north of Dublin, between 1908 and 1912, whilst he was teaching at the Metropolitan School of Art, Dublin, where he worked part-time between 1902 and 1914. During these pre-war summers, he was inspired by the superb surroundings of the cliffs and pebbly beaches at Howth. His figures are built up in touches of colour, and he rejects outline. They include several of figures lying and sitting at the entrance to a tent, and others of single figures, such as *A Summer Afternoon*, a portrait of his wife, Grace, who stands gazing towards the setting sun, gently silhouetted

against the sea and sky. The masterpiece of this period is *Midday on the Beach* (Fig. 382), exhibited in the New English Art Club of 1910, which epitomizes the *dolce far niente* mood of these years. He may have been influenced by Wilson Steer's beach scene *Knucklebones* of 1888/9.

Throughout his career, he made innumerable exquisite drawings, and at this time (1910) he executed a series of nudes and self-portraits posed at Howth, later reproduced as etchings by the Chenil Galleries, London. Though by date he was part of the Irish renaissance, he did not get on well with the literary set who had created this movement, except George Moore. He was friendly with AE and Sarah Purser and old John Butler Yeats, who was, however, jealous of him. He knew the poet Yeats, but poked fun at his arrogance in his letters, and he never knew Jack Yeats, who was in England for most of the pre-war years. He quarrelled with Dermod OBrien, who became President of the RHA in 1912, over the hanging of a picture in 1915 and only exhibited once more at the RHA in 1917.

His pre-war portraits, despite the pressure of an ever-expanding fashionable portrait practice, included some memorable canvases, not all of the fashionable world. There is a series of very fine robust portraits of *Lottie of Paradise Walk*, who was the Orpens' washerwoman in London from 1904, showing her at work and in other situations. However, his greatest picture does indeed come from the *haute monde*. He had known the St George family from 1908, having been introduced by his mother, and painted a series of portraits of their daughter Gardenia[17] and of both Mrs St George and her husband. Mrs St George was an American, the daughter of a prominent New York banker known as the 'Sphinx of Wall Street'. She had a house in Connemara, but later moved to Clonsilla near Dublin. Orpen's 1912 full-length portrait of *Mrs St George* (Fig. 383)[18] is one of the last great examples of the grand manner, and the subtlety of his depiction of the light and colour of her costume is supremely handled. As Andrew Wilton says in his exhibition catalogue of the *Swagger Portrait*, 'The subdued yet glittering palette was an old addiction of the school of Whistler, but it seems to have been Mrs St George's own idea to eschew primary colours here. The dull golds and greys are used here by Orpen to show off the sumptuousness of the costume and his own skill in coping with a variety of textures, though the paint is dry, not applied in fluid glazes like Whistler's. This dry application is a development from Manet, a hero of Orpen's.'[19] It is interesting that the background of striped curtains was used in another portrait of Mrs St George, entirely in black and with a huge hat. The sitter was one of his greatest patrons and closest friends, his mistress for some ten years and the mother of his daughter, Vivien.

Orpen painted a large number of self-portraits, a fact which is often attributed to the influence of

383 William Orpen, *Mrs St George*, oil
on canvas, Private collection

384 William Orpen, *The Thinker on the Butte de Warlencourt*, signed, oil on canvas, Private collection

Rembrandt's own obsessive self-scrutiny. On 9 December 1925, *Punch*, in a verse accompanying one of Bernard Partridge's caricatures, wrote:

> BILL ORPEN's rapier-thrust is great;
> He'll paint your portrait while you wait;
> But, tho' he doesn't want it known,
> He much prefers to paint his own.

He himself remarked, 'painting your own portrait is a lesson in humility'[20] and a glance at his thoughts on his own physical appearance shows his underlying strain of insecurity and melancholy. James White, in his introduction to the catalogue of the centenary exhibition of Orpen's work, held in the NGI in 1978, wrote truthfully and amusingly of his self-portraits, 'He was the plodding painter with white handkerchief and spectacles on his head, à la Chardin. He was the jockey at the races. He was the man from Aran. He was Pan "gallumping" on the plains of Meath. He was one of the unemployed at Larkin's elbow at Liberty Hall or ladling out soup to the hungry. He was every poor devil who was dropped in the mud of Flanders.'[21] We could add one or two characters: he went shooting and shot a ptarmigan; there is an Impressionistic study in a felt hat now in the Ulster Museum; and several where he is painting and looking in a mirror, one with Cupid and another with Venus. He mocks himself and the rest of the world, as he did in his satirical drawings of his diminutive figure beside the towering hatted frame of Evelyn St George. The world called them 'Jack and the Beanstalk'.

In the First World War, he was a war artist. If few of his war pictures seem to reflect the appalling tragedy and horror of the trenches, this was because he was so moved by the agony of the private soldier, and many of his works show a more contemplative mood such as

The Thinker (Fig. 384) – an infantry man brooding on his dead comrades – with its echoes of Rodin's *Thinker*. He found painting the official portraits of 'the scarlet Majors at the Base'[22] a travesty of his feelings. When faced by the horror of death, he frequently sublimated it. His view of no-man's-land nearly always shows it beautiful under snow, or covered in wild flowers, of which he made a collection,[23] though some of his landscapes include the whitened bones of the slain. On the other hand, the frightening portrait of two shellshocked soldiers and various pictures of the wounded being carried to safety, of half destroyed trenches and dead soldiers in dug-outs, both German and British, show how deeply he was shattered by conditions at the Front and by the appalling death rate. Most of this work is in the Imperial War Museum, though some pictures are in private collections. He found it very difficult to express his emotion and his reaction continued to mount after the war, when he painted scenes of the peace treaty. One of these groups, which started as a portrait of forty statesmen posed in the *Galerie des Glaces* at Versailles, he changed at the last minute, overpainting the figures with a catafalque and two ghostly emaciated soldiers, entitling it *The Unknown British Soldier in France*.[24] He had to remove the soldiers before he could exhibit it.

His feelings for Ireland are depicted in a series of poor, but very interesting, pictures: *The Holy Well* (NGI), *The Western Wedding*[25] and *Sowing the Seed*, which date from around 1913–14 and are composed of snippets of studies made by him and inspired by his student, Sean Keating. They are symbolic and allegorical, rather than realist, and Orpen was unable to handle the complex ideas he introduces into them. His extraordinary, ambivalent feelings for Ireland at the time of its struggle for independence seem to us to be expressed in these, despite their early date.

Throughout his life, he was a masterly portrayer of the nude. One of the greatest of these is his rather androgynous *Reclining Nude* of 1906 (Leeds City Art Gallery), and another is *Early Morning* (1922), of a voluptuous model who was also his mistress, and *Sunlight* (1925), where the dappled light filters through the window on to the model who is pulling on her stockings. Above her hangs his painting by Monet.

After the war, Orpen rarely returned to Ireland. He became a fashionable portrait painter in London, earning fantastic amounts of money, in some years £35,000 and in the last three years of his life £45,000 per annum. Despite his declining health, his professionalism never faltered and the last portraits are as fine as any of his work.

A friend of Orpen's, little remembered today, is William Crampton Gore (1871–1946), who was born in Fermanagh and, after studying medicine at TCD, went to the Slade, working under Tonks. He posed as the doctor in Orpen's *The mere fracture*. Despite living in London, he exhibited in the RHA from 1905 to 1939,

painting genre and landscapes, not portraits. He was influenced more by Osborne than Orpen and French artists like Cazin and Le Sidanier. His *Summer Twilight, West of Ireland, arrival of the evening mail car* of 1927 is a gentle, crepuscular study of considerable sensitivity. It would be good to know more of his work.

Orpen proved a rather overpowering personality as a teacher, and his pupils found it difficult to progress beyond the academic elements in his style. Sean Keating (1889–1977) is the most famous of them, having been the President of the RHA from 1949 to 1962. He studied under Orpen in the Metropolitan School of Art in 1911 and was an assistant to him in 1915, the same year he sent his *Men of the West* (Hugh Lane Gallery) to the RHA. He had gone to the Aran Islands in 1914 and was much affected by their barren scenery. It was Keating who sums up the 'discovery' of the west of Ireland as a source for patriotic, heroic, almost propagandist subject-matter which seems to have been adopted by the independence movement to straightjacket Irish art into nationalist terms. His own painting is the more successful the less message it contains; he is at his best with straightforward narrative works and descriptive realism (Fig. 385). He worked for some years between 1926 and 1929 painting the development of the Shannon Hydroelectric Scheme, of which he composed twenty-six paintings.[26] His aim was to show Ireland's emergence from economic deprivation after its war of independence and civil war, and its progress to a modern state. The most symbolic is *Night's Candles are Burnt Out* (1928–9, Oldham Art Gallery, Lancashire); it sums up these themes, with old Ireland represented by the hanging skeleton and new Ireland by the workmen putting up their concrete dam, and by the businessman contractor looking scornfully at the gunman. He exhibited this at the RA in 1929. It is technically a very fine picture, though he is certainly better in his rugged fishermen, in his excellent Orpen-influenced drawings and his own self-portraits. However, the other paintings of the Shannon Scheme series are nearly abstract, as the few figures are only just discernible. They are his best works, as the machinery rules. *Sight of Powerhouse-Drilling Gang and Steam Shovel at Ardnacrusha* (Fig. 386) are striking pictures, with a magnificent range of tones and strength of forms. Most of the paintings are still owned by the Electricity Supply Board. Keating's son, Justin, sums them up as follows: 'Never again did he attain the combination of realism and optimism, the extraordinary force and verve and energy of the Shannon Scheme paintings and drawings. There were other emotions to be experienced and expressed, but these works represent for him the pinnacle, the last pinnacle, of the twentieth-century confidence and belief in the future.'[27]

In 1939, Keating returned to the theme of the hydroelectric scheme in his huge mural in the main hall of Michael Scott's Irish Pavilion in the New York World's Fair. It shows the dam and tall electricity

pylons with a map of the west of Ireland and the Shannon river. It fitted in brilliantly with Michael Scott's extremely innovative shamrock-shaped building. The whole was a symbol of developing modern Ireland. Keating's nationalism was a failure, in the sense that no other painter attempted to follow in his footsteps in recording Ireland's emergence from her

385 Sean Keating, *Drinking Tea*, oil on canvas, Private collection

386 Sean Keating, *Sight of Powerhouse – Drilling Gang at Ardnacrusha*, oil on canvas, Electricity Supply Board of Ireland

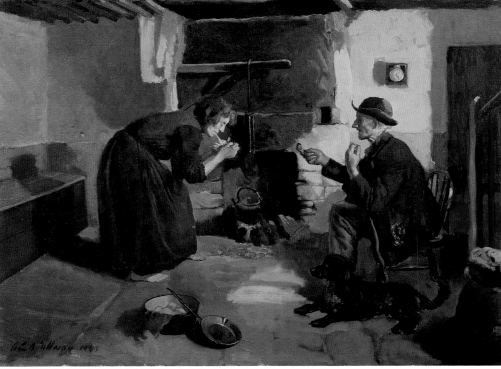

387 Leo Whelan, *Preparing Flowers for Market*, oil on canvas, Private collection

388 Sean O'Sullivan, *The Old Couple*, 1943, oil on canvas, Private collection

He won the Taylor Scholarship in 1916 for *The Doctor*, but his career was really as a portrait painter. His most interesting works are his genre scenes in the early Orpen manner, which are also deeply indebted to seventeenth-century Dutch art, such as *The Kitchen Window* in the Crawford Gallery, Cork, *The Lady Reading* and *Girl at the Piano*, which is a serious study of light and its reflections. His portraits are usually fine academic likenesses, such as his various TCD professors or his splendidly aristocratic fifth Earl of Dunraven, of which the hands are a notable study, but one of Malcolm MacDonald (NPG) is much more loosely handled. A late genre picture of *Preparing Flowers for Market* (Fig. 387) is much more colourful and loosely painted. It is a delightful work which makes one wish that Whelan had relaxed more and painted further works in this mood.

James Sleator (1889–1950) was a pupil from Northern Ireland, coming from Armagh, who studied in the Belfast School of Art before going to the Metropolitan School in 1909. After a period in the Slade and in Paris, he returned to teach at the Metropolitan School in 1915 and was briefly Orpen's assistant. His career was as a portrait painter and he worked in Florence and London, as well as in Dublin, and was again an assistant to Orpen in the last years of his life, finishing some of Orpen's portraits after his death. He returned to Ireland at the beginning of the Second World War, and became President of the RHA from 1945 until shortly before his death in 1950. He tried to breathe some life into the Academy, suffering as it was through the foundation of the Irish Exhibition of Living Art in 1941, but was not very successful with the then moribund institution.

Though not a pupil of Orpen's, Sean O'Sullivan (1906–64) fits into this chapter as he was a portrait painter and contemporary of Whelan and Sleator. He went to the Metropolitan School and then the Central School of Arts and Crafts in London before a period in Paris at La Grand Chaumière and Colarossi's. He worked at first as an illustrator, and exhibited a few landscapes at the RHA, where he showed every year from 1926 to 1964. His cottage interiors are free and fluid (Fig. 388), and it is a pity that few of these and his landscapes can now be seen. However, he is remembered today as a portrait painter, but above all as a portrait draughtsman who painted or drew all the notabilities of the 1930s and 40s (many of these are in the collection of the NGI). Some of them are not only essays in technique but also perceptive studies of character. The oils are straightforwardly academic but sometimes even capture the mood of the sitter.

A fourth Orpen pupil, and the one with most genius, was Patrick Tuohy (1894–1930). He came to the Metropolitan School of Art from St Enda's, a school founded by Padraig Pearse, the leader of the 1916 Rising, famous for its use of the Irish language and its nationalist ethos. He won the Taylor Scholarship twice, in 1912 and 1915. Despite his very

romantic and poverty-stricken past. As Dorothy Walker amusingly quips, 'Keating's paintings of guerrilla fighters in heroic attitudes look like posters for Wild West movies and his women look as if they were posing for paintings of the Madonna'.[28]

Leo Whelan (1892–1956), on the other hand, remained under Orpen's shadow all his life, from the days when he was in the Metropolitan School of Art.

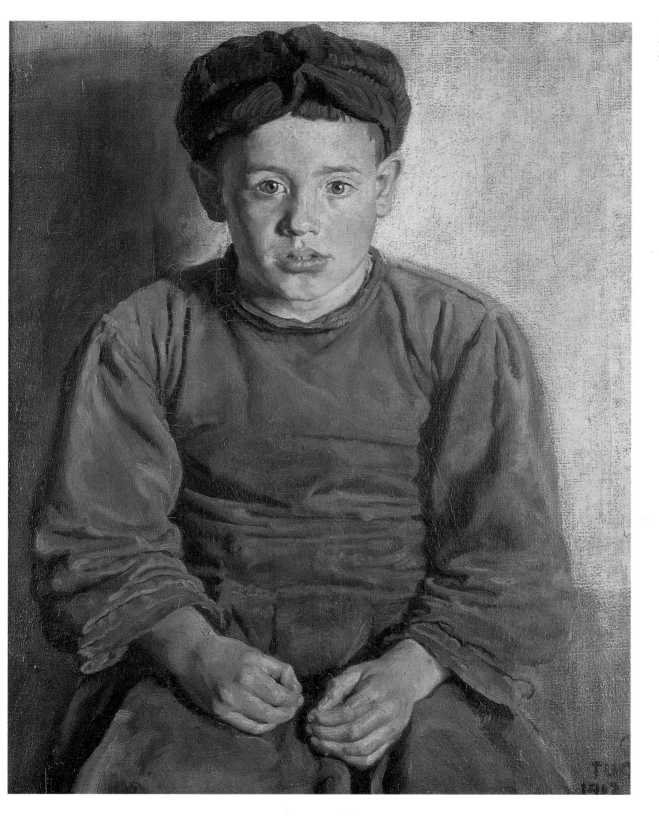

389 Patrick Tuohy, *Mayo Boy*, oil on canvas, Hugh Lane Municipal Gallery of Modern Art

nationalist education, he did not take part in the 1916 Rising, when he would have been of little use as he only had one hand. He did go to Spain in 1916, where he taught, and was much influenced by Zurbaran and Velázquez. He was back in Ireland by 1918, when he started to show at the RHA, his first exhibited work there being a *Mayo Boy* (Fig. 389) which he had painted in 1914. This is a most arresting and precocious work, with a direct honesty transcending the sometimes slick veneer of his master, and seems out of the Orpen canon. It is one of the most powerful pictures painted in Ireland at this time. Tuohy's first commission was in 1913, for a series of paintings on the life of Christ for 'Athenian' Stuart's neo-classical ceiling in the saloon in Rathfarnham Castle. It was at that time owned by the Jesuits, who wanted replacements for paintings then attributed to Angelica Kauffmann and disposed of in the sale held in April 1913. Another work of the same year is his superb watercolour of *The Little Seamstress* (Hugh Lane Gallery)[29] which won the

390 Patrick Tuohy, *John Stanislaus Joyce*, oil on canvas, University Library, Buffalo

391 Eva Hamilton, *Interior, 40 Lower Dominick Street*, oil on canvas, Private collection

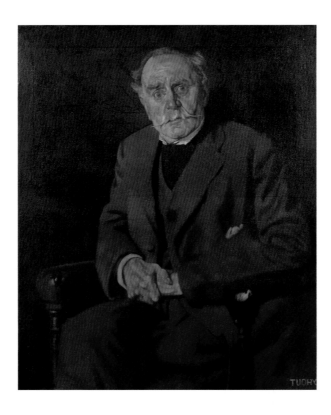

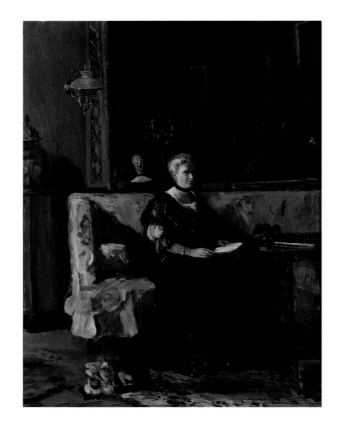

London, 'I suppose there is a lot of dull, heavy work in London, like as if the artist had blisters on his arse for sitting at it and a sore wrist with leaning his hand across a mahl-stick'.[30] Orpen, in *Stories of Old Ireland and Myself*, talked of Tuohy as being the most promising artist in Dublin, but Tuohy could not sell his work there, 'No, the Dubliners preferred a £5 mock J. F. Millet any day'.[31]

During the early 1920s, he went to Italy, and spent long periods in Paris, where he became friendly with James Joyce, who had fifteen sittings with him and also had his family painted. Joyce's unpublished doggerel on him is worth repeating:

> There's a funny facepainter dubbed Tuohy
> Whose bleaklook is rosybud bluey
> For when he feels strong
> He feels your daub's all wrong
> But when he feels weak, he feels wooey.[32]

The picture of Joyce's father (Fig. 390) painted in 1923–4 shows him rigid with fury and is summed up by Rosemarie Mulcahy, 'The nervous hunched up figure with taut hands and puckered face is full of vitality, and is more remarkable – this fixing of an expression of transient querulous irritability – when we consider the slow elaboration of the method adopted and the artist's determination to be unhurried, whether his sitter was raging or not'.[33] In Newman House, Dublin, there hangs a fine wholelength portrait of Archbishop William Walsh, Primate of Ireland. It seems to sum up all the somewhat sinister overtones associated with Mother Church. It prefigures Francis Bacon's popes in its luminous virtuosity. Some of his subject pictures have a compelling presence, with the eyes of the figures having a trancelike stare, similar in their penetration and psychological insight to his portraits.

His dislike of London did not prevent him sending his *Baptism of Christ* (Hugh Lane Gallery) for exhibition at the RA in 1922. It was very well received by the London critics and was one of the few religious works painted in the twentieth century in Ireland not soaked in sentiment. A contemporary British critic, Frank Rutter, said that Tuohy 'has been able to understand Puvis de Chavanne without imitating him'.[34] Following the Renaissance tradition, the artist incorporated portraits of his friends among the figures.

In 1927, Tuohy went to Columbia, South Carolina, later settling in New York, where he died of gas poisoning in 1930. It was a tragic early death for one of the most brilliant young Irish painters.

One of the female pupils of Orpen who achieved distinction was Margaret Crilley, better known by her married name, Margaret Clarke (1888–1961).[35] She came from Northern Ireland and was first taught by Orpen as a seventeen-year-old in the Metropolitan School. She developed a style which is not close to her master. Her self-portrait of 1914 has a forthright, direct manner, whereas her notable later portrait of

Taylor Prize and which seems to prefigure Balthus. Also in the same year, Tuohy painted *The Model* in oils, a remarkably subtle nude study of a prepubescent girl, her head wrapped up in a towel and a rug over her knees, nervously looking out of the picture at the viewer. It has none of the erotic overtones of Orpen's nudes. Tuohy rejected the British school and wrote, without any real knowledge of what went on in

her daughter, *Ann with Cat*, is a pensive study, softer, more linear and with hints of van Gogh in the background. Besides a considerable number of portraits, she painted a number of still-life and flower pieces and exhibited at the RHA, becoming an Academician in 1927. Her husband, Harry Clarke (1889–1931), was the famous, brilliant stained-glass artist who sadly died young, though he has left many an Irish church with stained glass of the greatest quality.[36] His exotic and often macabre *œuvre* is sadly outside the scope of this book, but is of international importance, and is not as familiar as it should be as so many of his works are between the pages of books or in country churches. He illustrated a number of books and poems such as Poe, Keats's *The Eve of St Agnes* and Alexander Pope. His Poe illustrations in watercolour were particularly superb, an example being *Colloquy of Monas and Una* (1923). His draughtsmanship had links with Beardsley and Erté and his imagination was bewilderingly versatile. He ranks among the greatest illustrators of his time.

Two women, both pupils of Orpen, who went to the continent regularly but were hardly influenced by modern trends, were the sisters Eva (1876–1960) and Letitia Hamilton (1878–1964), descendants of the eighteenth-century Caroline Hamilton whom we have discussed. They were cousins of Rose Barton and knew Mildred Anne Butler. Hilary Pyle suggests that these two watercolourists influenced the Hamilton girls' early work. Eva was twenty-nine when she went to the Metropolitan School and Letitia twenty-seven. They both went on to the Slade School, and at some stage, possibly quite a lot later, Letitia was a student of Frank Brangwyn. Eva for some years earned a living copying portraits, including some by Orpen, and then became a portrait painter in her own right, very much in the Orpen manner. One can see this in the two interiors with her mother in No. 40, Lower Dominick Street, Dublin (Fig. 391), where there is a large pier glass reflecting the room and, in one, the back of her mother's head. Though Eva remained a portrait painter, she did a number of small *pleinairist* landscapes; the two styles are combined in the happily sunny picture, *A Summer Day* (1915), showing three Hamilton sisters in deckchairs under parasols.

Letitia concentrated on landscapes and a few interiors. For the most part, she painted rural Ireland, hunts, markets, particularly the *Fair in Castle Pollard*, bogs, coast scenes and donkeys, which all owed something to Paul Henry, whom we discuss in the next chapter. One of her best works, an open-air still life, is *Red Hot Pokers at Ahakista*, a house in West Cork where she frequently painted in the garden. In its brilliant handling and lightness, it reminds one that she went abroad most years, latterly to Venice (Fig. 392). Continental views are also regularly found, and they gave her an opportunity to paint colour, shimmering heat and relaxation, which are reflected in her Irish work. Her *Lago Maggiore*, with its olive-tree foreground, is one of her best. In her late work, she

increasingly uses a thick impasto and puts her paint on with a palette knife, both tricks familiar to her through Brangwyn and which, as Hilary Pyle says, give some of her works 'the energy of van Gogh'.[37]

A close friend and near-contemporary of Orpen, though not actually his student, was Beatrice Elvery (1883–1970). She trained at the Metropolitan School, overlapping with him, but got to know him well when

392 Letitia Hamilton, *Venice*, oil on canvas, Limerick Art Gallery

393 Beatrice Elvery, *Allegorical Scene*, oil on canvas, Private collection

394 Estella Solomons, *Self Portrait*, oil on canvas, Private collection

cards, illustrated children's books, indeed anything which would make her an income. She was urged by Sarah Purser to take up stained glass, which, however, she said she disliked, though she made a number of competent windows. One of her early paintings, *Eire*, was inspired by seeing Maud Gonne as Cathleen ni Houlihan in Yeats's play. Unlike her later work, it is strongly drawn and characterized. The child represents young Ireland on his mother's knee and the supporting cast are Irish saints and scholars.

Orpen encouraged her to go to the Slade in 1910, where she was not a success. She stayed in London until after her marriage in 1912 to an Irish barrister, Gordon Campbell, later Lord Glenavy, only returning to Ireland in 1919, where they had a very trying time during the civil war. The birth and upbringing of her three children kept her busy, though she never completely gave up painting. By 1932, she returned to work seriously, using a somewhat outdated style. Nicola Gordon Bowe wrote of the later work as 'classical tableaux of the chase in a Rex Whistleresque idiom … lovers are reunited, abducted, surprised; they embrace or promenade arm in arm accompanied by blowing zephyrs, leaping centaurs or prancing dogs'.[38] This refers to *The Intruder* and we show another allegorical scene (Fig. 393).

Though only a year older than Beatrice Elvery, her friend Estella Solomons (1882–1968) was taught by both Osborne and Orpen at the Metropolitan School and the RHA schools.[39] Though it is sometimes said that she was taught by Orpen as early as 1899, he was still at the Slade and did not teach in Dublin until 1902. She went on to Colarossi's, but much more important for her development was her visit to the tercentenary exhibition of Rembrandt held in Amsterdam in 1906. His style is important throughout her career and her self-portrait of 1908 (Fig. 394) is by far the most striking of her paintings and clearly Rembrandtesque. She went to Holland on more than one occasion but also worked in landscape throughout Ireland in a colourful and fluid style, occasionally veering towards Impressionism, as in her *Sitting in the Sand Dunes*. Her oeuvre was never academic, but it was not modernist either. Her portraits are for the most part less sucessful than her landscapes. Interestingly, she was one of the very few artists involved in the 1916 Rising, when her studio was a safe house for hiding republicans.

he returned to teach. She was a niece of the great Edinburgh-based but Irish-born arts and crafts artist Phoebe Traquair. Nowadays, Elvery's work is rarely seen, though she worked like a demon, particularly late in her life. Early on, she had difficulty in deciding which branch of art she wished to follow and her earliest pieces are art-nouveau sculptures in bronze or wood, of which a fine example is the bronze lectern in Tullow Church, Carrickmines of 1904. She also designed decorative pieces for Dublin silversmiths,

The Advent of Modernism

This final chapter needs to give a brief review of the end of British rule in Ireland. The tide of nationalist feeling had been rising throughout the nineteenth century, despite English attempts at pacification, such as Catholic emancipation in 1829 and the various Land Acts, which aimed at a fairer distribution of land. The country, though on the surface quiet, was bubbling with a deep determination to achieve a complete break from their English rulers. The first twentieth-century crisis came in 1916, in the middle of the First World War, when, at Easter, the Irish Citizen Army declared the country's freedom and for a week Dublin was the centre of a fierce rebellion. The leaders, such as Padraig Pearse, were executed, and this spread a rapid anti-British feeling throughout the country. After the war, the final struggle against the British led to the foundation of the Irish State, sadly splitting the country in two, with the Northern six counties remaining part of Great Britain. A civil war of great ferocity followed the agreement with the British, which was unacceptable to half the population. Finally, in 1922, this came to an end and the difficult decades of creating a new state followed.

There were a number of artists from the north who were not necessarily trained in Dublin. They included Sarah Cecilia Harrison (*c*.1864–1941), who came from Co. Down and was trained in London, where she worked under Legros at the Slade. After her return to Ireland in the late 1880s, she lived mainly in Dublin and settled down to a career as a portrait painter. Her work is well finished and highly competent. She has a three-dimensional, sculptural manner which commands attention and she has a strong feeling for character. Typical examples of her work are the portrait of her sister (Fig. 395), the double portrait of Mr and Mrs Blaney Balfour of Towneley Hall, exhibited in 1911, and her two somewhat similar portraits of Hugh Lane (one in NGI), with whom she had unfortunately fallen in love.[1] Even her portrait of a child, *Ernest*, shows all his inquisitive innocence very evocatively.

Sensibly, she buried her sorrows in admirable charitable works. Though she did not exhibit them, she painted at least one interior scene, called *The Tea Break*, and landscapes, one unfinished, of a view through the porch of a country house. In its simplicity and subtle range of colour, it is an evocative work.

More obviously striking were two other artists from Belfast, Paul Henry and William Conor. Paul Henry (1876–1958) in his later work is somewhat repetitive and banal; as Brian O'Doherty said, 'At times Paul Henry painted like one of his own followers and imitated himself'.[2] But he was, up to the early 1920s, an artist of great power. His training in Belfast was followed by a period at the Académie Julian in 1898, where his early gods were Millet, Whistler and van Gogh. When Whistler opened his Académie Carmen, Henry transferred and he had the luck there to meet Alphonse Mucha, the great art-nouveau designer.[3] Unfortunately, few of Henry's early works survive, except for some fine Pre-Raphaelite-style drawings and etchings. The few pictures known, which were painted in England, near Guildford, where he was living and where there was still a small bog, supplemented his work as an illustrator. The bog inspired his interest in wind and sky and his pictures of it are mostly in charcoal, a medium he used throughout his career. One, *Water Meadows*, is in the Ulster Museum.

The great influence on Henry's life and work was his discovery of the west of Ireland in 1910,[4] when he went to Achill for a fortnight's holiday with his wife, Grace, also an artist; they finally stayed there for some nine years. To him, the west was a place of poetic beauty and he had a real understanding and sympathy for its small farmers and fisherfolk. The hard life they eked out of the soil is portrayed with objective realism and has none of the sentiment he might have inherited from Millet, though he sometimes used poses taken from the Frenchman.[5] His pictures at this period are usually small, with simple outlined figures and the frequent use of thick impasto as in *The Watcher* (Fig. 396). It is rare

395 Sarah Cecilia Harrison, *Portrait of the artist's sister*, oil on canvas, Private collection

396 Paul Henry, *The Watcher*, oil on canvas, Private collection

397 Paul Henry, *The Lobster Pots, West of Ireland*, oil on canvas, Private collection

for a picture to be dated. The *Potato Diggers*, however, dated 1912 (NGI), is a fine and typical example, with the bending figure reminiscent of Millet. Other famous examples are the *Curragh with Cloud*, the *Launching the Curragh* (NGI), *The Lobster Pots, West of Ireland* (Fig. 397), and *The Potato Harvest* (1918–19). His drawings and some of his paintings summon up the lonely windswept bogs with deep feeling, and in several, the silhouette of the twisted, leafless trees highlights the desolation of this bleak landscape; their convoluted forms have an echo of Arthur Rackham's world. After he moved to Dublin in 1920, Henry's work rarely achieved the same strength and vitality. There are, however, exceptions, such as *Dawn, Killary Harbour* (UM), with its Whistlerian tonal values and its extraordinary sense of distance and solitude which also appears in *The Lake of the Tears of the Sorrowing Women* (Fig. 398). It forms a striking contrast to his charcoal, *Grand Canal Dock, Ringsend* (NGI), an industrial 'nocturne'.

Disaster hit Henry with the use of two of his cottage scenes as railway-carriage and billboard posters. They were enormously popular and he found himself repeating them *ad nauseam*. As S. Brian Kennedy says, 'He ultimately became trapped in his own imagery'.[6] They remain technically well painted and individually are frequently of high quality. Today,

they are icons of an almost vanished rural world. Some, however, have a brooding presence which raises them above the repetitive images, like *Coomsaharan* of 1934–5 (Queen's University Belfast). The work of Grace Henry (1868–1953) in Achill is more simply realistic than her husband's and some of her landscapes have an aerial composition which is very effective. Her masterpiece is probably *The Top of the Hill* of about 1910–13 (Limerick City Gallery). It shows a group of broad-backed 'shawlies' gossiping. Later, after her separation from her husband, she spent a lot of time on the continent and seems to have painted a number of weak flower paintings. But such pictures as *Girl in White* (Fig. 399), a Whistlerian study, show that to the end she had considerable talent.[7]

Though his own work cannot be described as avant-garde, Paul Henry helped to found the Society of Dublin Painters in 1920[8] with Jack B. Yeats, Letitia Hamilton, James Sleator, Mary Swanzy, Clare Marsh (1874–1923) and his wife, Grace Henry. The composition of the group varied considerably over the years, sometimes including Mainie Jellett, James Sleator, E. M. O'Rourke Dickey and others. Artists came and went frequently. It is an indication of the level to which the RHA had sunk that such a group needed to be established.

398 Paul Henry, *The Lake of the Tears of the Sorrowing Women*, oil on canvas, Niland Gallery, Sligo

399 Grace Henry, *The Girl in White*, oil on canvas, Hugh Lane Municipal Gallery of Modern Art

William Conor (1884–1968)[9] was trained at the Belfast School of Art and did not go to Paris until he was twenty-eight, and then only for a visit which left no mark on his style. Nor did his residence in London in the early 1920s show any effect. His great ability was to portray vividly the character of the Belfast mill girl, the 'shawlies', and the street life of the city. To some extent, they remind one of the characters in Sean O'Casey's plays. His early crayon drawings, with their very personal technique, using wax to achieve an uneven texture, develop from his early training as a lithographer and he achieves something of the same effect in his oils. The painting which made his name outside Ulster was *The Lost Child*, which he exhibited in London in 1922, in the Grosvenor Gallery. This pathetic subject, showing two women uncertainly talking to a crying toddler, was unusual in his work, which usually depicts more cheerful subjects such as *The Darlins'*, *Gossiping* or a *Sup of Tea* (Fig. 400). They are among the best social records of the urban poor of this period in the British Isles and, though he continued in the same vein throughout his career, he rarely sustained his original fresh vision.

Two Ulster landscape painters, both regular exhibitors at the RHA and at the Royal Ulster Academy, were James Humbert Craig (1877–1944) and

400 William Conor, *A Sup of Tea*, oil on canvas, Hugh Lane Municipal Gallery of Modern Art

401 James Humbert Craig, *The Donegal Coast*, oil on canvas, Private collection

irises flowering in a bog, form an intimate contrast. McKelvey was a very prolific and somewhat slick practitioner. He was taught in the Belfast College of Art and most of his works are of Ulster scenery. His best landscapes, such as *Caravans on the Donegal Coast* (Fig. 402), are painted with great freshness and competence.

Another pupil of the Belfast School of Art and later of Keating at the Metropolitan school was Charles Lamb (1893–1964). His landscapes are mostly of the west of Ireland and are frequently seascapes. Many of them are of Galway hookers, the traditional sailing boats, by the quay at Carraroe. His colouring is pale and he is not particularly interested in how he depicts the weather. He went to Brittany, but it did not influence him. It is difficult to see anything French in his painting. His best works are his figurative paintings. He did for the Irish peasant what Conor did for the Belfast shawlie. His group of a man and his wife, *A Quaint Couple* (1930, Crawford Gallery, Cork) is a very strong and moving canvas. His painting of *Dancing at the Crossroads* (Fig. 403), painted when he was still a student in 1920, shows an ancient Irish custom still extant, as AE, talking about the lack of amenities in rural Ireland wrote: 'there was no village Hall, no library, no gymnasium, no village choir, no place to dance except the roadside'.[10] It is interesting that, despite the fact that 1920 was the most violent year of the war of independence, Lamb, like most other Irish artists, with the exception of Keating, painted peaceful subjects rather than images of men at war. It is a very striking picture, as is *Hearing the News*, showing one literate peasant reading the newspaper to an attentive group of three.

Lamb was an enormously popular painter, and his idealized views of the west of Ireland and its people which were thought to represent the ancient past were perfect themes for the new state, though Paul Henry's realism showing the poverty of peasants eking out their existence from the soil was far more truthful.[11]

Sleator's successor as President of the RHA was Maurice MacGonigal (1900–79), who had been trained under his uncle, Joshua Clarke, the father of Harry Clarke, in his stained-glass workshops. He joined the republican movement in 1916 and was interned in 1920. He returned to the Clarke studios but went to evening classes at the Metropolitan School, where he was so successful that he earned a three-year scholarship. At this stage, he worked under Keating, Sleator and Tuohy. Though he is usually considered a landscape painter, he was commissioned by the architect Michael Scott in 1939 to paint a multi-figured mural in the Irish pavilion in the New York World's Fair. His powerful picture of *Irish Dock Workers* (Fig. 404) established his ability to give character to figures. Indeed, without knowing, one assumes that they are about to go on strike. He painted portraits, but this was not his genre; he preferred the open air. His landscapes of the west of Ireland have a severity and sometimes a very cool colour range. There are others which have more

Frank McKelvey (1895–1974). The former was virtually self-taught and, though influenced by Paul Henry, never used Henry's blue tonality. His landscapes of Ulster and the glens of Antrim are notable for their skies, their shadows and sense of ever-changing climate. He is rarely sentimental. *Dungloe in the Rosses* (RHA 1941) or *The Donegal Coast* (Fig. 401), though fine examples, are not entirely typical as they are more muted than many of his works where the strong northern wind sweeps by cottage, lake and sea though the colours are rich, offset by deep shadows. His pictures are usually small and his studies, such as one of yellow

404 Maurice MacGonigal, *Dock Workers*, oil on canvas, Hugh Lane Municipal Gallery of Modern Art

402 Frank McKelvey, *Caravans on the Donegal Coast*, oil on canvas, Private collection

403 Charles Lamb, *Dancing at the Crossroads*, oil on canvas, Private collection

405 Harry Kernoff, *The Dublin Cab*, oil on canvas, Private collection

406 John Luke, *A Dancer*, 1947, oil on canvas, Private collection

Harry Kernoff (1900–74)[12] was MacGonigal's assistant in the New York murals and had been a fellow pupil in the Metropolitan Schools. After leaving the Schools, he went to Paris for a few years, where he flirted with cubism, expressionism and surrealism, but in the early 1930s he returned to academic work. Like MacGonigal in his youth, he did stage sets but is best known for his portraits of famous Irish literary figures such as Brendan Behan (NGI), W. B. Yeats (Waterford Municipal Collection) and Joyce (Dublin Writers Museum), and his pictures of Dublin, its people and streets. *Dublin Cab* (Fig. 405) sums up his oblique and purposely naïve vision.

Belfast produced an original artist in John Luke (1906–75).[13] He was educated at the Belfast School of Art, from which he went on to the Slade, working under Tonks. At one point, he shared a room with the sculptor F. E. McWilliam, who was amazed by the care and attention he took with his morning ablutions and his meticulous tidiness. Apparently, McWilliams's 'end of the room was a shambles by comparison'.[14] Luke became obsessed with his tempera technique and his strange, brilliantly coloured, fantastical landscapes and figure subjects (Fig. 406) are always painted in this flat, smooth medium. Due to the slowness of the technique, he rarely managed more than two pictures a year. He painted murals, both in London, where he worked briefly, and in the City Hall, Belfast. It is difficult to categorize him or his work, as though it is apparently realistic, it is almost surrealist and dreamlike. He is a unique artist who has recently received much attention.

William John Leech[15] (1881–1968) studied in the Metropolitan School of Art, and then under Osborne at the RHA Schools before going to the Académie Julian in Paris in 1901. He went to Concarneau in 1903, staying till 1906, and after that paid regular visits until 1910, though he was in Ireland with his family from time to time. He may have seen the Whistler exhibition in Paris in 1905, though he could also have learned of his art through Osborne. Whistler's painting was to affect much of Leech's work, with its muted tones and simple outlines. This is particularly obvious in the snow scenes he painted in Switzerland in 1912, such as *Glion* and his Whistlerian views of Lake Constance (Fig. 408).[16] The influence of Orpen appears in such a painting as his *Scene in a Public House* (1908), but it is of short duration. Leech is a painter of vibrant luminosity, with a strong sense of colour and design, all of which are exemplified in his most famous work, *Convent Garden, Brittany* (Fig. 407). This work was exhibited in the Paris Salon in 1913 and owes much to his master, Osborne's *The Cottage Garden* (NGI) and is also based on his own *The Secret Garden*. In 1910, Dermod OBrien, in a letter to his wife, said that Leech was 'in his studio since luncheon trying to evolve sunlight and reflections'.[17] In this he was brilliantly successful. Leech retained his links with continental painting, exhibit-

realistic colour and a sense of the movement of the grass in the wind, the scudding clouds forming a melody of paint in pictures which create a pattern of stone walls, lazy beds, thatched cottages and distant mountains. There are hints that his knowledge of Cézanne, Picasso and Braque had touched him and, despite his academic qualities, he did appreciate their cubism. A surprising and unfamiliar aspect of his work is his *Man with Hay* (1972), which shows the huge load of hay as the principal part of the picture, with the profile of its carrier emerging from it – a very striking image. He was probably the most influential painter of his time.

407 William John Leech, *A Convent Garden, Brittany*, oil on canvas, National Gallery of Ireland, Dublin

408 William John Leech, *Lake Constance*, 1911, oil on canvas, Private collection

ing in Paris as well as Dublin, at the RHA, in London in 1911, in the Baillie Gallery, and having a one-man show in the Goupil Gallery in 1912. In 1913, he exhibited at the Whitechapel Gallery and in several English provincial galleries. He was a member of the International Society founded by Whistler and Lavery and exhibited with them occasionally. The snow scenes, including one of Killiney Hill, and his portraits done between 1910 and 1920 were much influenced by Lavery. Whistler appears again as a seminal figure in his life in a portrait of May Botterell of 1919, which is signed in Japanese-type characters.

A series of his most striking paintings are his *Aloes* (Fig. 409), painted near Les Martiques in 1918–20. These Provençal landscapes, with their spiky forms silhouetted against shimmering backgrounds, are a contrast as studies of heat to the misty seascapes of Concarneau. *Un Matin* (Hugh Lane Gallery) has a frame probably painted by his wife, which has designs in the Gauguin manner. Leech went to live in London, where his parents had gone in 1910. He continued to spend much time in France, but in 1919 he met May Botterell, who was to become his second wife but was his mistress from about 1920.[18] In order to minimize

409 William John Leech, *Aloes, Les Martique*, oil on canvas, Private collection

days, and later in England, and then almost as a hermit, he had no influence on Irish painting whatsoever.

A much less well-known painter than Leech was E.M. O'Rorke Dickey (1894–1977), a Belfast man like Henry, who, after studying in Cambridge, went to the Westminster School of Art and was much influenced by the London Group, painters such as Gilman, Bevan and Ginner. He was primarily a landscape painter, many of whose best works were done in Italy, but he also worked in the north of Ireland. His panoramic *Errigal* (Fig. 410), with its simplified and stark lines and deep colouring, is, as S. B. Kennedy comments, 'refreshingly free from sentimentality associated with most of his contemporaries'.[20] The Italian works are also geometrically patterned and he enjoys looking down on the blocklike houses of small towns such as *San Vito Romano* (1923, UM). Unfortunately, he gave up painting as a profession in 1924 and became an art teacher in England, and later an inspector of art education. It is a great pity that this very promising young artist was forced to give up painting, but the economic situation all over Ireland was at a very low ebb throughout the 1920s and 30s.

However, some foreign artists settled in Belfast, like Hans Iten (1874–1930), who came to work in damask design and was a fine painter of still lives and landscapes. He was a sympathetic flower painter. There are a number of his works in the Ulster Museum. Like another emigrant, Paul Nietsche (1885–1950), his simple landscapes have a strong foreground and little distant view. Nietsche painted vigorous portraits, including one of the collector Zoltan Lewinter-Frankl (UM). He was also a fine draughtsman and a still-life painter. His *Green Apples* (UM) of 1949 is much influenced by early Cézanne.

A number of women artists emerged during this period – all, as one would expect, from the leisured classes, but by no means amateurs. Few of them had much money, but what little they had was important, as it gave many of them the chance to develop their work in new and exciting ways. They were the artists who brought modernism to Ireland, and pulled her out of the stagnation which followed the wars and civil war of 1922. They lived in Ireland for all that they frequently went abroad to study. They were committed Irishwomen, if not nationalists, and are owed a great debt for their understanding of modern trends.[21]

One of the first, Mary Swanzy (1882–1978),[22] the daughter of a Dublin eye surgeon, was remarkably well educated for her period, both academically and artistically. Before going to the art schools in Dublin she attended classes given by May Manning, a remarkable teacher who gave early tuition to a number of Irish artists in Edwardian Dublin. While there, she had the advantage of lessons from John B. Yeats. She went on to the Metropolitan School where, among other arts, she studied modelling under John Hughes, though she never practised as a sculptor. She studied

embarrassment to the Botterell family, he became very reclusive over the next decades. He did not visit Ireland again, and did not hold an exhibition in London for the rest of his life. He continued to be a faithful exhibitor in the RHA almost every year. In 1945, Leo Smith of the Dawson Gallery, Dublin, persuaded him to hold a one-man show and this was succeeded by a number of others, including one after his death. There is no doubt that his later work is often of inferior quality, but, for instance, the painting of *The Kitchen, Steele's Studios* in the mid-1950s is correctly described by Denise Ferran as being in the 'Bonnard style – [it] vibrates with light'.[19] A number of paintings of railway lines are brilliantly represented by *Railway Track and Telegraph Lines*, which gives a sense of whizzing speed through its diagonals of line and track. Because Leech lived so much in France, in his early

in Paris at Delacluse's studio in 1904–5 and returned in 1906 to study with a number of artists, ending up by going to Colarossi's. The most important fact in her Paris days was that she visited Gertrude Stein on a number of occasions, where she saw very avant-garde work, including Picasso's famous portrait of Miss Stein and the work of Matisse. It was at this time that Sarah Purser became a great friend. Mary Swanzy first exhibited at the RHA in 1905 and for the next few years she showed portraits. The breadth of her handling in such a picture as her *Drawing Room, Mespil House*, painted by her for Sarah Purser, is indicative of her adventurous attitude to paint and colour.

It was not until after her visit to Yugoslavia and Czechoslovakia, doing relief work, that she held a solo show in the Mills Gallery in Dublin in 1919, and possibly showed her first cubist paintings. Her development was not steady, as during her stay with her sister in Samoa in 1923–4 she painted in a straightforward manner and the works were not in any way symbolic, as Gauguin's Tahitian work had been. In 1926, she went to live in London, which she made her headquarters for the rest of her life, and so she did not influence Irish art as much as her quality would have merited. She developed her cubism (Fig. 411), which was influenced by Delaunay and others, and gradually her work took on a strongly surrealist feel, especially from the 1940s. Her art was affected by her wartime experiences, and also one wonders if she knew Edward Burra's work in London. Julian Campbell describes her late work:

> Soldiers are sent to the battlefield, women and children wait in vain outside derelict buildings, dispossessed figures roam the land as beasts. Human figures are often shown, open mouthed, gesticulating, with oafish faces and exaggerated limbs. Paintings contain references to death and destruction, judgement and loss. Mankind is judged. The pictures may be allegories of the troubled twentieth century.[23]

Her final paintings are of a gentler and more lyrical nature and have perhaps been influenced by the dream world of Chagall.

Mainie Jellett (1897–1944) was the daughter of a Dublin barrister and her mother came from a noted family of doctors, the Stokes, who were also seriously interested in the arts.[24] Her great-aunt, Margaret Stokes, was an important scholar of early Christian art in Ireland and the first to consider its links with Europe. Despite being educated solely by governesses, Mainie Jellett's artistic education was not neglected and she had lessons when still a child from May Manning, Sarah Cecilia Harrison and Elizabeth (Lolly) Yeats. She first went to Brittany on a sketching trip in 1913 under Norman Garstin and shortly afterwards, in 1914, she became a full-time student at the Metropolitan School. In 1917–19 she attended the Westminster School of Art in London, as she had been advised to study under Sickert. Her early works are

often portraits of her family on holiday, as well as studio nudes (Fig. 412), etc., and show a soft outline; sometimes she worked very effectively on damp paper. In 1920 she went with her lifelong friend, Evie Hone, of the family of the two Nathaniel Hones whom we have discussed, to study in Paris in André l'Hôte's studio. He was a well-known teacher and there was an immediate change in her style, her landscape showing the influence of Cézanne and her nudes becoming very solid, muscular but only slightly geometric. L'Hôte's teaching was based on natural forms, and under his tuition the women did not become either fully cubist

410 E. M. O'Rorke Dickey, *From the Summit of Errigal*, 1919–23, oil on canvas, Private collection

411 Mary Swanzy, *The Viaduct*, oil on canvas, Private collection

412 Mainie Jellett, *Early Nude*, oil on canvas, Private collection

413 Mainie Jellett, *Abstract*, oil on canvas, Crawford Art Gallery, Cork

or abstract. She and Evie Hone wanted to venture further in these directions and so they asked the reluctant Albert Gleizes to take them on as pupils in 1921 and they stayed with him till 1924. Gleizes had written a theoretical work on cubism with Metzinger in 1912, which developed a totally different style from the cubism of Picasso and Braque. To start with, it involved colour and encouraged abstraction (Fig. 413). The women worked with Gleizes as he developed his ideas on 'translation and rotation'. This theory dominated Jellet's work for over ten years, but not her teaching, and she also continued to produce realist work.

The importance of the two women for the development of modern art in Ireland cannot be stressed too strongly. Their first cubist works were shown at an exhibition of the Society of Dublin Painters in 1923, and naturally met with considerable misunderstanding and dislike. The *Irish Times* described them as 'freak pictures' and AE ranted about 'artistic malaria' and the 'sub human art of Miss Jellett', though later he accepted her work. Throughout her career, she lectured, broadcast and wrote in an effort to make the public understand. In the 1930s, her art becomes more personal and much less theoretical and abstract. In fact, it is quite strongly figurative, as in some of her deeply felt religious art. Some of the secular work is very decorative, for example, the *Achill Horses* and the beautiful muddy-brown *Achill Bog*, which has a hint of Chinese art about it. She had been very impressed when she saw the Chinese exhibition in 1935 at the Royal Academy in London. At times, the circular shapes she uses at this period remind one of the Delaunays.

Both Jellett and Hone retained contacts with the avant-garde in Paris thoughout their careers, and were founder members of the Parisian society Abstraction-Creations, founded in 1932. Evie Hone had been admitted to an Anglican convent in 1925 for about a year, but returned to painting afterwards. She more or less gave up cubism by the late 1920s, and returned to realism in the technique of gouache. This was, however, preparatory to her real *métier*, stained glass, which she first attempted in 1933 and in which she achieved her greatest work. Jellett had never attempted to dictate style to her pupils but encouraged their originality. James White (later a Director of the National Gallery of Ireland) has frequently mentioned Jellett's extraordinary generosity to young people who were receptive to new ideas, and how she helped him personally to become an art critic. Given her avant-garde style, it is a little surprising that she was asked by the conservative Irish government to paint murals in the 1938 Glasgow International exhibition, but from the bucolic subject-matter it is clear that her work for this must have been largely realist. It was her last major work. Perhaps a more influential achievement was the foundation, with Sybil Le Brocquy (the mother of the artist Louis Le Brocquy)

and Norah McGuinness, of the Exhibition of Irish Living Art, which gave a platform to young artists who would not have been considered by the RHA. She was President of the organization, but too ill to attend the first exhibition in 1943. She died in the following year.

An older friend of Evie Hone and Mainie Jellett was the remarkable May Guinness (1863–1955). She had no formal artistic training, but went with Mildred Anne Butler to Newlyn to work under Norman Garstin in 1894 and subsequently visited Florence in 1902–3. She went to Paris from time to time, where she saw the Fauves artists between 1905 and 1907, and she worked briefly under van Dongen and other Fauve painters. She visited Brittany and showed *Breton Pardon* in the RHA in 1911. She exhibited very little at this time. After her remarkable and very brave war career as a French military nurse, she turned to painting more seriously and worked for several years under André l'Hôte, becoming a great admirer of Matisse. She collected a number of fine French pictures, including work by Bonnard, Dufy, Matisse, Rouault and Picasso. From this point until her death, she held several exhibitions and the critics correctly noted her as a decorative artist. Her 1920 exhibition in the Eldar Gallery in London was entitled *Decorative Paintings and Drawings* and its introduction emphasized that she painted 'not to represent but to decorate'.[25] The *Still life with Poppies* (1922–5, Fig. 414) is a well-composed and somewhat cubist work. Colour was what she was best known for.

Lillian Davidson (d. 1954), like May Guinness was a friend of Mainie Jellett and also studied at the Metropolitan School and exhibited at the RHA. She was much influenced by the early work of Jack B. Yeats, rather unusual at that time and this is obvious in her lively interior of an Irish general store probably somewhere in the West, *The Fair Day in Miss O'Dowd's*, 1945 (Fig. 415). She visited France frequently though did not train there. Apart from teaching she was involved in theatre work.

The important history of Irish stained glass,[26] since the eighteenth century does not fall within the parameters of this study, but it would be difficult, while discussing these women artists, not to mention Wilhelmina Geddes (1888–1955), educated at the Belfast College of Art and later under Orpen at the Metropolitan school, before working for twelve years at An Túr Gloine. In 1925, she went to live in London, and devoted her entire career to stained glass, making many memorial windows after the Great War. Her drawings, like her glass, are strong statements; before she left Dublin, she had exhibited drawings and designs at the Arts and Crafts Society of Ireland's exhibitions from 1917. In fact, it was Geddes who gave Evie Hone her first lessons in transferring designs into stained glass,[27] and Hone then went to work at *An Túr Gloine* where she stayed until the death of Sarah Purser broke up the co-operative and she developed a studio for herself in Marlay Grange.

414 May Guinness, *Still life with poppies*, oil on canvas, Hugh Lane Municipal Gallery of Modern Art

415 Lilian Lucy Davidson, *Fair Day in Miss O'Dowd's*, oil on canvas, Private collection

Norah McGuinness (1901–80) came from Derry, and studied at the Metropolitan School under Tuohy, Oswald Reeves and Harry Clarke. Her first work was as an illustrator and she was enormously influenced at the beginning by Clarke's style. After seeing an exhibition of Impressionists in London in 1923 or 1924, she decided she must study outside Ireland and spent a short time working at the Chelsea School of Art. Her best illustrations were done for W. B. Yeats, who remarked in a letter written on 13 March 1928, 'your pictures in *Red Hanrahan* have been a great pleasure to me and are I think exactly right. I like their powerful simplicity.'[28] Yeats dedicated the introductory poem 'Sailing to Byzantium' to Norah. After the breakdown of her marriage to Geoffrey Phibbs, the poet, in 1929, and on the advice of Mainie Jellett, she went to work under André l'Hôte. In the 1930s, she exhibited in Paris and London, where she showed with the Seven and Five group to which Jellett and Hone also belonged, the London Group and at commercial galleries, as well as in Dublin. At this time, she was probably best known for her stage designs for plays by Yeats, Denis Johnston and others. Always having to earn her living, she designed the window displays and interiors of Brown Thomas, the most fashionable shop in Dublin.

Vlaminck was a great influence throughout McGuinness's painting career, though Braque was her favourite painter. Her early views of the Thames were sombre and dense, but her later landscapes, often views near Dun Laoghaire where she lived, included some birds on the mud-flats which are much more alive and spacious. She painted many still lives as well as landscapes, many of her early works being in gouache, such as her surely handled *Four Courts, Dublin*, (1940, UM). The latter is painted with great delicacy and its perspective recedes from the tree-lined quay with skill. Her watercolours are as important as her oils and her style does not change much from the mid-1930s onwards.

Elizabeth Rivers (1903–64) was an Englishwoman who came to Ireland in 1935 and spent most of the rest of her life in the country. She had trained under Sickert and was a fine wood engraver, illustrating a number of books of poetry. After the RA Schools, she had spent three years in Paris, working under l'Hôte and Severini, before she came to Ireland and her paintings showed their influence. *The Ark* (1948), a subject she returned to more than once, is a combination of realism and cubism. Her wood engravings and drawings are strong, yet deftly drawn and concentrate on rural subjects. She spent a lot of time on the Aran Islands.[29]

George Russell (1867–1935),[30] remembered always as 'AE', was much better known to his contemporaries as a writer and editor on social as well as literary subjects, rather than a painter. He had a conventional artistic education at the Metropolitan School and the RHA School and was a prolific painter of topics as varied as straight depictions of children playing, theo-

sophical subjects, with their mythological world, and an occasional conventional landscape, showing considerable talent. His work is purely decorative and reminds one of Charles Condor. He is extraordinarily repetitive in his subject matter. Later in his life, he used pastel to a considerable extent. A set of decorations survive in the house (No.3, Upper Ely Place, Dublin) where he lived for some time in an experimental community, and others from the Irish Agricultural Organization Society are now in the NGI.[31] His importance is not in his work, but as a disseminator of artistic ideas through his much-loved personality. He was also an art critic, usually of a much more liberal view than most of his contemporaries. For instance, he changed his negative view regarding the cubism of Mainie Jellett, as we have already mentioned.

One of the great portraits of the first half of the nineteenth century is of AE in 1929 (Fig. 416). It is by a little-known painter and sculptor, Hilda Roberts (1901–82).[32] She came from a Quaker family and enrolled in the Metropolitan School under Patrick Tuohy. She painted many excellent portraits, but seems to have been inspired by AE, who is shown in front of one of his own mystical pictures. He sits frontally and gazes penetratingly at his audience. It is a portrait which stops you in your tracks, and S. B. Kennedy says of it that the sitter is 'portrayed as a man of ideas, as if about to surge into action'.[33] Roberts also painted genre scenes, including a *Dublin Dinner Party*, which is a very stylish interior, showing a dinner at the United Arts Club. With its art-deco overtones, it is a particularly evocative period piece of 1929. Her watercolours are also notable: *The Goblin Market*, despite the fact that it is a student work, reminds us of Edmund Dulac, but without Dulac's mannerisms.

The AE portrait was among those shown in an exhibition which Tuohy helped to organize in 1930 in New York, at the Hackett Gallery. Apart from Hilda Roberts, he also featured works by Tuohy, Humbert Craig, Paul Henry, Charles Lamb, Frank McKelvey, Estella Solomons, Maurice MacGonigal and Sean Keating.

An unusual Irish painter who does not fit in with any movement or group that we have discussed was Cecil ffrench Salkeld (1904–69). He was the son of a civil servant working in Assam and was born in India. He returned to Ireland after the death of his father and was educated in Ireland and England. He went to the Metropolitan School at the age of fifteen and at seventeen went to the Academy in Kassel, working under Ewald Dulberg, who was noted for his stage design. At this time, Salkeld encountered the eminent artists associated with the Neue Sachlichkeit movement, which included George Grosz and Otto Dix. At the age of eighteen he exhibited at an exhibition in Düsseldorf which included some of the most advanced painters in Europe, including Vlaminck, Boccione, who had died a

facing page
416 Hilda Roberts, *Portrait of George Russell (AE)*, 1929, oil on canvas, Ulster Museum

417 Cecil ffrench Salkeld, *Leda and the Swan*, oil on canvas, Private collection

few years earlier, and Theo van Doesberg. He returned to Dublin, where he expressed his views on painting in an article in a magazine called *Tomorrow* in 1924. In the same year, he had a one-man show and surprisingly returned to the School of Art in 1926, winning the Taylor Prize. He exhibited frequently in Dublin in the 1920s, portraits as well as subject pictures. The latter have strong outlines and a flat surface. The continental influence is strong and the surrealist element extremely unusual in Irish art. In his *Leda and the Swan* (Fig. 417), the pictorial elements float and the whole picture is very stylized. He shows the Trojan war with the wooden horse outside the flaming walls in the background of his painting of Leda because one of the children of the union of Jupiter (the swan) and Leda was Helen of Troy. His best-known works, which happily still exist, are in Davy Byrne's Pub in Dublin. They are a series of Bacchic designs which are extremely lively and nearly surreal. He did a number of exciting

theatre, and especially ballet, designs, with strong Russian influence. Some of these are in the V & A.

The Second World War, known as 'the emergency' in Ireland, brought a group of English painters to this country who became the focus for many Irish artists, and they brought with them a knowledge of surrealism, abstraction and recent trends in continental art. They were known as the White Stag Group and held many exhibitions, with a varying set of artists contributing. The main movers in the group were Basil Rakoczi (1908–79) and Kenneth Hall (1913–46), who were both interested in Creative Psychology. They were much influenced by Herbrand Ingouville-Williams, who came over slightly later and provided financial support for their activities as well as psychological ideas. Rakoczi and Hall initially went to the wilds of Mayo, but returned to Dublin early in 1940. Amusingly, the group was often seen by the authorities as a centre for German spies, but the members, who were mostly young and often up to pranks, found this funny and deliberately led them on. A full chronology of the exhibitions held with the artists who contributed is recorded by S. B. Kennedy.[34]

Most of these English artists left the country in 1945 when the movement was wound up, though by then it had been largely superseded by the foundation of Irish Living Art in 1943. However, it gave a platform for many young artists. Mainie Jellett said in opening the second exhibition of the White Stag group in October 1940 that the exhibitors were aiming 'to interpret the times in which they live' and went on to say that they were not 'hidebound to any particular school or cramped by academic conventionality'.[35] This is so true of Rakoczi, whose work varies from straightforward realism to cubism. The realism has links with work by the English artist Edward Burra, who after the war painted some memorable work in Ireland, including street scenes and landscapes in the west, usually peopled by sinister figures.[36] Hall, like Rakoczi, used very varied styles and called his more abstract work Subjective Art. In Dublin, much of his work contained birds or fishes. One of the young Irishmen who exhibited with them, Patrick Scott (born 1921), has become one of Ireland's most distinguished modern artists and at that time also used birds and animals in a 'nursery world', as Edward Sheehy put it.[37] His later work became abstract, very simple and exquisite in its use of gold on an unprimed canvas.

The artists were much helped by having the backing of Mainie Jellett, but other Irish figures who exhibited with them are Nano Reid, Evie Hone, Ralph Cusack (1912–65), Edward McGuire (1932–86), later a notable portrait painter, and Dairine Vanston (1903–88). The English group included Nick Nichols (1914–91), whose work has an element of Klee in it, and Paul Egestorff (d. 1995), who was much indebted to Mainie Jellett. Nano Reid (1905–81), another pupil of the Metropolitan School of Art who studied in

Yeats had always been fascinated by horses and they reminded him of his youth and the nostalgic freedom of his Sligo childhood. They appear in many of his black-and-white works, his broadsheets and his watercolours, as well as in his oils. The new style was particularly good at conveying motion, so the excitement of galloping horses is particularly well displayed. One need only mention *The Proud Galloper* (1945), *Freedom* (1947) and *The Sport of Kings* (1947). One of the few very large pictures he ever painted, *My Beautiful, My Beautiful* of 1953 (Fig. 424), is a superb but different example of horse painting and is one of his great late masterpieces. In this case, the horse is motionless and the paint is thinly applied in little abstract blobs; the canvas becomes the desert sand around the oasis suggested in the background. The subject is taken from a poem by Caroline Norton, which tells of an Arab who thought he was forced to sell his horse to buy bread, though eventually he was able to keep the animal. It is not only as beautiful as its title suggests, but is emotionally charged, showing the deep grief of the Arab embracing his favourite stead. The horse's head is brilliantly captured.

One of Yeats's most famous paintings is the *Tinker's Encampment, the Blood of Abel,* (1940, NGI). It exempli-

fies Fallon's comment, but, when looked at closely, the figures emerge from the background and the confusion caused by the multiplicity of forms is in fact part of what is happening in the picture, where a murder has been committed at night and the tightly knit community are seen rushing towards the scene of the crime. One must remember that 1940, at the beginning of the Second World War, was a tragic time, and the picture is also symbolic of Yeats's hatred of violence. Such deeply involved pictures are interspersed by more easily read themes, such as *About to Write a Letter,* (1935, Fig. 425) and *A Silence* 1944. Both depict figures deep in thought. A picture full of sadness is *On Through the Silent Lands* (1951, UM), where an old man is walking through a landscape, head bowed, not thinking where he is or is going, too full of grief to care. A very late work of 1955–6, *The Top of the Tide,* is stronger in colour, which gives the two figures who stand in the landscape a more determined and purposeful stance. The colour is very strong, the brushstrokes vigorous, and, despite his age, the artist's abilities were clearly not failing.

Yeats stands isolated in Irish art. He had no followers. His extraordinary popularity, in many cases without deep understanding, can only be attributed to

424 Jack B. Yeats, *My Beautiful, My Beautiful*, oil on canvas, Private collection

425 Jack B. Yeats, *About to write a letter*, oil on canvas, National Gallery of Ireland, Dublin

his seductive colour. It has put him out of proportion in the roll call of Irish painters. Time alone will judge whether the public is right or wrong. Meanwhile, the variety of his work, his marvellous draughtsmanship, his characterization, his colour and his love and understanding of Ireland, from his tiny notebooks to his largest canvases, his illustrated letters and his sense of the comic have given the greatest pleasure.

We can only hope that the gathering-together of such a fragmented tradition in this book will do some-thing substantially to memorialize an until recently neglected and often still unappreciated part of Ireland's intellectual history. Brian O'Doherty, the artist and critic, has described Irish art as 'the gate lodge beside the big house of Irish Writing'.[51] This still remains true, but we hope that we have been able to push the squeaking hinges of the gate a little further open, so that we can see down the avenue with a better vision and notice the masterpieces that exist to tempt the eye further.

Notes

Three books also by Anne Crookshank and the Knight of Glin are referred to as follows: *Irish Portraits* as *Portraits*; *The Painters of Ireland* as *Painters*; *The Watercolours of Ireland* as *Watercolours*. Vertue was published in a number of volumes in The Walpole Society, XVIII, XX, XXII, XXIV, XXVI, XXX. We give only the Vertue numbers.

Introduction

1 J. McDonnell, *Five hundred years of the art of the book in Ireland*, NGI, Dublin and London, 1997, p. 118, illus. cat. 5, *c*.1578 and p. 12, illus. cat. 12, 1640.
2 Information kindly given by Joe McDonnell.
3 John Dunton, quoted by E. P. Shirley and Revd James Graves in the *Journal of the Kilkenny and S.E. of Ireland Archaeological Society*, New Series, vol. IV (1862–3), Dublin, 1864, pp. 14–15. See also Andrew Carpenter (ed.) *The Dublin Scuffle*, Dublin, 2000, pp. 210–12.
4 Jane Fenlon, 'Episodes of Magnificence: The material worlds of the Duke of Ormonde' in Toby Barnard and Jane Fenlon (eds.), *The Dukes of Ormonde, 1610–1745*, Woodbridge, 2000, pp. 137–59, and Jane Fenlon *The Ormonde Picture Collection*, Dublin, 2001. Other works are mentioned in the bibliography.
5 TCD MSS 750, p. 103.
6 *Bath History*, vol, VIII, Bath, 2000, pp. 137–8.
7 William Preston, 'Essay on the natural advantages of Ireland, …' *The transactions of the Royal Irish Academy*, vol. IX, Dublin, 1803, p. 301.
8 'A letter from Joseph Cooper Walker, Esq. to General Vallancey, on promoting the art of painting in Ireland', in *Transactions of the Dublin Society*, vol. III, (for the year 1802), Dublin 1803, Further Communications, pp. 115–34.
9 *Outlines of a plan for promoting the Art of Painting in Ireland … which Walker dedicated to Lord Moira and published as a booklet in Dublin 1790.
10 For further particulars see John T. Gilbert *A History of the city of Dublin*, Dublin 1859, vol III, p. 349 (reprinted with an index, Shannon, 1972).
11 Published in Thomas Davis, *Literary and Historical Essays*, Dublin 1846, pp. 153–62. Between pp. 169 and 172 Davis lists suitable Irish subjects from 'the landing of the Milesians' to 'The Clare Hustings', reminiscent of Cooper Walker.
12 Ibid., pp. 213–15.
13 Adrian Frazier, *George Moore, 1852–1933*, New Haven and London, 2000, p. 350.

1. Beginnings in the Sixteenth and Early Seventeenth centuries

1 Karena Morton, 'A Spectacular Revelation: Medieval Paintings at Ardamullivan', in *Irish Arts Review Yearbook*, vol. 18, (2002), pp. 105–13.

2 D. F. Gleeson, note in *JRSAI*, vol. 66, (1936), p. 193 and fig. opp. p. 191.
3 Information kindly given by Roger Stalley and Joe McDonnell, *Ecclesiastical Art of the Penal Era*, Saint Patrick's College, Maynooth 1995, p. 4, footnote 5, p. 6.
4 Roger Stalley, *The Cistercian Monasteries of Ireland*, London and New Haven, 1987, pp. 214–16, illus. Holycross Abbey, Knockmoy Abbey and Clare island, all hunting scenes; T. J. Westropp, 'Clare Island Survey…', *PRIA*, 31, Section I, 1911, pp. 31–7, illus.
5 Henry Fitzpatrick Berry, *Register of Wills and Inventories in the Dioceses of Dublin, 1457–83*, Dublin 1898, pp. 53, 149, 163.
6 Roger Stalley, 'Solving a Mystery at Cashel. The Romanesque Painting in Cormac's Chapel', in *Irish Arts Review Yearbook*, vol. 18, (2002), pp. 25–9; Mary McGrath, 'The wall paintings in Cormac's Chapel at Cashel', *Studies* (Winter 1975), pp. 327–32.
7 D. Starkey, 'Holbein's Irish Sitter?', *Burlington Magazine* vol. CXXIII, no. 938 (May 1981), pp. 300–3.
8 R. F. Foster, *Oxford Illustrated History of Ireland*, Oxford 1989, opp. p. 113 illus.
9 Sotheby's, 11 July 1984, lot 26.
10 Sotheby's, 30 November 2000, lot 2.
11 Another version given to the Spanish School was in Christie's, 21 May 1997, lot 120.
12 Brian de Breffni, 'An Elizabethan Political Painting', *Irish Arts Review*, vol. 1, no. 1 (1984), pp. 39–41; Hiram Morgan, 'Tom Lee: the posing peacemaker' in B. Bradshaw, A. Hadfield and W. Maley (eds), *Representing Ireland: literature and the origins of conflict, 1534–1660*, Cambridge, 1993, pp. 132–65.
13 Revd. Alexander B. Grosart, *The Lismore Papers*, London 1886–8. His personal financial accounts are mostly in the NLI.
14 Ibid., vol. II, p. 131.
15 Ibid., vol. I, p. 16.
16 Ibid., vol. II, p. 30.
17 Bodleian Library, Carte MSS 55, f. 666.
18 'Sir Hardress Waller's claim after the Rebellion of 1641', MS volume of Co. Limerick depositions, TCD. Publ. in *Journal of the North Munster Archaeological Society*, vol. 1, no. 4, (January 1911), pp. 255–8.
19 Brian O'Dalaigh, 'A Comparative study of the wills of the 1st and 4th Earls of Thomond', *North Munster Antiquarian Journal*, vol.XXXIV, (1992), pp. 48–57.
20 Hector McDonnell, 'Seventeenth century inventory from Dunluce Castle, Co. Antrim', *JRSAI*, vol. 122, (1992), pp. 109–27.
21 For a history of the O'Briens, see Grania Weir, *These my Friends and Forebears*, Ballinakella 1991.
22 Sotheby's 11 July 1984, lot 25. Another portrait, in his peer's robes, dated 1632, on a panel is now at Castletown House, Co. Kildare.
23 Quoted by J. Carty, *Ireland from the Flight of the Earls to Grattan's Parliament*, Dublin 1949, vol. I, p. 39.
24 Jane Fenlon, 'Episodes of Magnificence…' in Toby Barnard and Jane Fenlon (eds), *The Dukes of Ormonde 1610–1745*, Woodbridge 2000, p. 139 and footnote 12.

25 Revd George Hill (ed.), *The Montgomery Manuscripts*, Belfast 1869, p. 309; *Calendar of State Papers, Ireland, 1647–60*, p. 284; and ibid., 1660–2, p.68. We are indebted to Rolf Loeber for this information.

2. Ireland's Restoration Period

1 Rolf Loeber, *A Biographical Dictionary of Architects in Ireland 1600–1720*, London 1981, pp. 75–7.
2 Jane Fenlon, 'The Painter Steyners Companies of Dublin and London, Craftsmen and Artists 1670–1740', in Jane Fenlon, Nicola Figgis and Catherine Marshall (eds), *New Perspectives*, Dublin 1987, pp. 101–8. The initial letter of the guild is illustrated in *Portraits*, p. 10, fig. 1.
3 The Charter is in the National Museum of Ireland and records are in the NLI (MS12,121–3).
4 Jane Fenlon, 'Episodes of Magnificence', in Toby Barnard and Jane Fenlon (eds), *The Dukes of Ormonde, 1610–1745*, Woodbridge 2000, p. 141, and *The Ormonde Picture Collection*, Dublin 2001.
5 Jane Fenlon, 'The Duchess of Ormonde's House at Dunmore, County Kilkenny' in John Kirwan (ed.), *Kilkenny Studies published in honour of Margaret M. Phelan*, published for the Kilkenny Archaeological Society, 1997, pp. 79–87. Also, Fenlon, 'Magnificence' op. cit., p. 141 footnote 26.
6 Jane Fenlon, 'The Ormonde Picture Collection', in *Irish Arts Review Yearbook*, vol. 16 (2000), pp. 143–9.
7 Ibid., pp. 144–5.
8 The best descriptions and discussion of architects are in Jane Fenlon's articles listed under footnotes 4 and 5.
9 The details are graphically described by two visitors to Ireland – Thomas Dineley (NLI MS 392) and John Dunton, who is quoted by E. P. Shirley and the Revd James Graves in the *Journal of the Kilkenny and S.E. of Ireland Archaeological Society*, new series, vol. iv (1862–3), Dublin, 1864, pp. 104–6.
10 Fenlon, 'Magnificence' op. cit., pp. 151 and 156, and Fenlon, 'Her Grace's Closet', in *Bulletin of the Irish Georgian Society*, vol. XXXVI, (1994), p. 45.
11 NLI, Ormonde MS 2503/47.
12 Ibid., NLI, MS 2528/47.
13 Fenlon, 'Ormonde Picture Collection' op. cit., pp. 146–7.
14 B. Tyson, 'Two 17th century Artists in Cumbria', in *Quarto*, Abbot Hall Art Gallery Quarterly Bulletin, vol. XXVII (July 1989), pp. 20–4; and John Harris, *The Artist and the Country House*, London 1979, p. 60, no. 53, illus.
15 According to John Harris, a pupil of Wyck's, Matthew Read, is said to have worked in Ireland before going on to Whitehaven where he was much patronized by the Lowther family. No Irish works have yet been identified by him. Likewise, Robert Griffier, the son of John Griffier, was born in Ireland after a shipwreck, according to Horace Walpole, *Anecdotes of Painting …* (ed. Ralph Wornum), 3 vols, London 1849, vol. III, pp. 9 and 48.
16 Leo van Puyvelde, *The Dutch Drawings in the Collection of H.M. the King at Windsor Castle*, London, 1944, p. 53, no.

620. The inscription reads 'Designé sur le lieu le 1 Juillet 1690 par Thodor Maas paintre du Roy Guillaume'.

17 Revd Matthew Pilkington, *The Gentleman's and Connoisseur's Dictionary of Painters*, London, 1770, pp. 236–7.

18 Sheffield Grace, *Memoirs of the Family of Grace*, London, 1823.

19 The best account of Gandy is in Charles H. Collins Baker, *Lely and the Stuart Portrait Painters …*, 2 vols, London, 1912, vol. II, pp. 56–63.

20 Eileen Black, S. B. Kennedy, W. A. Maguire (eds), catalogue of the exhibition *Dreams and Traditions*, Belfast 1997, no. 1, p. 50.

21 Grace, op. cit.

22 *Annandale* was in the Singer Sale, Christie's, 21 February 1930, lot 2; the picture was signed 'G. Smitz pinxt'; *Yarmouth* in the Erskine Sale, Sotheby's, 5 December 1922, lot 85.

23 See Erna Auerbach and C. Kinglsey Adams, *Paintings and Sculpture at Hatfield House*, London, 1971, where many Smitz are illustrated and all at Hatfield are catalogued.

24 Vertue, vol. IV, p. 120. Vertue's death date of 1707 was incorrect, see footnote 18.

25 Horace Walpole, *Anecdotes of Painting in England*, 3 vols, Strawberry Hill, 1762–3, vol. III, p. 132.

26 Fenlon, *New Perspectives* op. cit., p. 106.

27 A discussion of the problem is in the catalogue of the Ashmolean Museum.

28 HMC, *Egmont Diary*, vol. III, (1739–47), appendix III, p. 365.

29 HMC, *Egmont*, vol. II, pp. 144–5.

30 Rolf Loeber, *Bulletin of the Irish Georgian Society*, vol. XVI (Jan–June 1973), nos. 1 and 2. Frequent mentions of Burton House and two illus.

31 Toby Barnard, 'Art, Architecture, Artefacts and Ascendancy', in *Bullán*, vol. 1, no. 2, (Autumn 1994), p. 23.

32 Toby Barnard, 'The Political, Material and Mental Culture of the Cork Settlers, *c.*1650–1700', in Patrick O'Flanagan and Cornelius G. Buttimer (eds), *Cork History and Society*, Dublin 1993, p. 331.

33 Nicholas Canny, 'Early Modern Ireland', in R. F. Foster (ed.), *The Oxford Illustrated History of Ireland*, Oxford 1989, p. 147.

34 King's Weston inventory 1695, British Art Center, Yale, MS 8, and Jane Fenlon, 'Old Pooley the Painter', (forthcoming).

35 McGill University, Montreal, Osler Library, Osler MS 7612, kindly communicated to us by Toby Barnard.

36 HMC *Egmont Diary*, vol. III, (1739–47) appendix III, p. 366.

37 Samuel W. Singer (ed.), *The Correspondence of Henry Hyde, Earl of Clarendon …*, 2 vols, London, 1828, vol. II, p. 145.

38 HMC *Egmont*, vol. II, p. 181.

39 Quoted from Strickland, who obtained the information from the minute books of the Royal Hospital, Kilmainham.

40 In 1703, there is a reference to 'Mr Pooley' in London, advising which portrait of the recently dead Sir Robert Southwell should be engraved by John Smith (BL Add MS 3763, fol. 1v). Reference kindly given by Toby Barnard.

41 Jane Fenlon, in 'Old Pooley the Painter' (see note 34) disagrees with D. Wooley, 'Miscellanea in two parts', *Sonderdruck*, 1993, who thinks the picture is not by Pooley.

42 Fenlon, ibid.

43 NLI MS 2524. Quoted by Fenlon, ibid.

44 Quoted in Strickland. See Fenlon, note 34, above.

45 *Painters*, p. 24 illus.

46 Jane Fenlon, 'Garret Morphy and his circle', in *Irish Arts Review Yearbook 1991–1992*, pp. 135–48. The following quotations and information in footnotes 47, 48, 49, 50, 55, 56, 61, 63 are taken from this article.

47 Ibid., p. 135.

48 From Ozias Humphrey, *Memorandum Book*, quoted by Fenlon, ibid., p. 136.

49 Ibid.

50 Portland MSS, vol. III, p. 411.

51 This picture is mentioned as a Morphy in a MS catalogue at Weston Park of pictures sent from London to Weston in 1735. The signature is on the front: Fenlon, 'Morphy and his circle', op. cit. p. 142, cat. no. 27.

52 Information from W. L. van der Wetaring, formerly of the Rijksbureau voor Kunsthistorische Documentatie, The Hague, in a letter of 14 November 1973.

53 For a full discussion of this theme, see Roy Strong, 'The Elizabethan Malady …', in *Apollo*, vol. LXXIX (April 1964), pp. 264–9.

54 Ellis Waterhouse, *Dictionary of 16th and 17th Century British Painters*, Woodbridge, 1988, p. 114.

55 Charles H. Collins Baker, *Lely and the Stuart Portrait Painters …*, 2 vols, London 1912, vol. II, p. 70, where the account book for the second Duke of Newcastle for 28 August 1686 is quoted. See Fenlon, 'Morphy and his circle' op. cit., p. 143, cat. no. 33.

56 From Ozias Humphrey, *Memorandum Book*, quoted by Fenlon, 'Morphy and his circle' op. cit., p. 139.

57 Collins Baker, op. cit., illus. opp. p. 70.

58 John Aubrey, *Letters written by eminent persons … and Lives of Eminent Men*, 2 vols, London 1813, vol. II, p. 484.

59 Mellon collection, Dering MS an *Inventory of the pictures at King's Weston* in 1695. Kindly drawn to our attention by Sir Oliver Millar.

60 William Laffan (ed.), *Masterpieces by Irish artists 1660–1860*, Pyms, London 1999, pp. 8–13, illus.

61 Fenlon, 'Morphy and his Circle' op. cit., p. 140.

62 Collins Baker, op. cit., p. 71.

63 Fenlon, 'Morphy and his Circle' op. cit., p. 140.

64 Vertue, vol.I, p. 108.

65 *A Country House Portrayed. Hampton Court Herefordshire 1699–1840*, exhibition held in the Sabin Gallery, London, 1973, introduction by John Harris, no. 4.

66 *Calendar of State Papers, Domestic*, 1677–8, p. 255.

67 W. G. Strickland, 'Oil Picture, a view of Dublin, 1690', in *JRSAI*, Series 6, vol. XVI (1926), pp. 92–4.

68 The Waring papers have been extensively researched by Toby Barnard, who kindly gave us this information. The letters in the PRONI are D695–69.

69 Vertue, vol. I, p.31.

70 Jane Fenlon, 'John Michael Wright's Highland Laird identified', in *Burlington Magazine*, vol. 130, no. 1027, (Oct. 1988), pp. 767–9.

71 Ellis Waterhouse, *Painting in Britain 1530-1790*, 5th edition, London 1994, p. 109.

72 Vertue, vol. IV, p. 163.

73 *Portraits*, p. 29, no. 5, illus.

74 Jane Fenlon, 'The Talented and Idle Mr William Gandy', *Irish Arts Review Yearbook*, vol. 12, (1996) pp. 131–8, illus.

75 Vertue, vol. IV, p. 120.

76 Fenlon, 'Gandy' op. cit., p. 131 and p. 183, ft. 2.

77 Jane Fenlon, 'French influence in late 17th century portraits', *Irish Arts Review Yearbook* (1989–90), p. 161 and illus. pp. 160 and 162.

78 Ibid., p. 168, no. 19.

79 Sotheby's, 30 November 2000, lot 79.

80 Information kindly given to us by Jane Fenlon.

3. Portrait Painting in the First Half of the Eighteenth Century

1 TCD MS, 750 pp. Anne Crookshank and David Webb, *Paintings and Sculptures in Trinity College Dublin*, Dublin 1990, p. 79.

2 Alastair Laing (ed.), *Clerics and Connoisseurs* exhibition catalogue, Iveagh Bequest, Kenwood, London, 2001–2, p. 98.

3 TCD, Bursar's Accounts. Crookshank and Webb, op. cit., p. 57.

4 Charles Smith, *The Antient and Present State of the County and City of Cork*, 2 vols, Dublin, 1750, vol. 1, p. 140.

5 Vertue, vol. III, p. 97.

6 Ibid.

7 Ellis Waterhouse, *The Dictionary of British 18th Century Painters in Oils and Crayons*, Woodbridge 1981, p. 360.

8 Advertisement in *Apollo*, vol. CXLIV, no. 415 (September 1996), p. 30.

9 *European Magazine*, December 1788, pp. 397–9.

10 NLI. This reference was given to us by Jane Fenlon.

11 Toby Barnard, 'Art, Architecture, Artefacts and Ascendancy', *Bullán*, vol. 1, no. 2 (Autumn 1994), p. 23.

12 Benjamin Rand, *Berkeley and Perceval*, Cambridge 1914, p. 57.

13 Whaley Batson, *Henrietta Johnston*, The catalogue of an exhibition held in the Museum of Early Southern Decorative Arts, Winston-Salem, North Carolina and the Gibbs Museum of Art, Charleston, South Carolina, October 1991–February 1992, pp. 1–14.

14 W. Laffan (ed.), *The Sublime and the Beautiful, Irish Art, 1700–1830*, Pyms Gallery, London, 2001, pp. 38–43.

15 Most of the information on Trench comes from Vertue, see also Edward Croft-Murray, *Decorative Painting in England 1537–1837*, 2 vols, London, 1962–70, vol. II, p. 287; *Watercolours*, pp. 23–4 and Nicola Figgis, see next footnote.

16 Nicola Figgis, 'Henry Trench (*c.* 1685–1726): Painter and illustrator', *Irish Arts Review Yearbook*, vol. 10 (1994), pp. 217–22. His prize-winning drawings and others are illustrated in this.

17 Sheila O'Connell, 'Lord Shaftesbury in Naples, 1711–13', *Walpole Society*, vol. 54, 1988 (published 1991), p. 162.

18 NLI, Wicklow papers, pc 227 unsorted collection. Information from Nicola Figgis.

19 John Ingamells, *A Dictionary of British and Irish travellers in Italy, 1701–1800*, New Haven and London, 1997 (subsequently referred to as Ingamells), pp. 950–2, entry by Nicola Figgis.

20 BL Add. MS 47025, f.80. Information kindly given by Edward McParland.

21 Michael Wynne, 'Hugh Howard: Irish portrait painter', *Apollo*, vol. XC, no. 12 (October 1969), p. 316.

22 HMC, *Manuscripts of the Earl of Egmont, Diary of Viscount Percival*, London 1925, vol. 1, p. 225.

23 NLI, Wicklow Papers, MS 12149, p. 73.

24 Nicola Figgis and Brendan Rooney, *Irish Paintings in the National Gallery of Ireland*, vol. 1, Dublin, 2001, pp. 240–2. Henceforth cited as Figgis and Rooney.

25 Ellis Waterhouse, *Painting in Britain, 1530-1790*, London, 1953, p. 95.

26 Ibid., p.14.

27 Barnard, op. cit., p. 31, footnote 49.

28 Ibid., p. 31, footnote 48.

29 Ibid.

30 Ingamells, pp. 960–1, entry by Cynthia O'Connor.

31 Edward McParland, *Public Architecture in Ireland 1660–1760*, New Haven and London 2001, pp. 158–9.

32 These letters (BM Add. MSS 28. 882, ff 292, 3333, 28,885 f. 121) written by Jervas to John Ellis tell us that his companions were Robert Pooley, brother of the Dublin artist, Thomas Pooley and a Mr Greville. The Pooleys Jervases and Swifts were all related. See Jane Fenlon, *Irish Architectural and Decorative Studies, The Journal of the Irish Georgian Society*, 2001, pp. 48–51, also Edward Bottoms, 'Charles Jervas, Sir Robert Walpole and the Norfolk Whigs', *Apollo*, February 1997, vol. CXLV, no. 420 pp. 44–8. This article deals with the great Whig families who patronized Jervas in England. Figgis and Rooney, has a long article and a useful bibliography on Jervas.

33 Vertue, vol. III, p. 16.

34 M. Kirby Talley, 'Extracts from Charles Jervas's Sale Catalogues (1739): An Account of Eighteenth-century Painting Materials and Equipment', *The Burlington Magazine*, vol. CXX, no. 898 , January 1978, pp. 6–11.

35 Vertue, vol. III, p. 17.

36 Isaac Bickerstafe [i.e. Richard Steele, Joseph Addison and others], *The Tatler*, reprinted London 1759, p. 32, entry for 18 April 1709.

37 Sir F. R. Falkiner, 'The Portraits of Swift', in Temple Scott (ed.), *The Prose Works of Jonathan Swift*, 12 vols, vol. XII, London, 1908, pp. 1–24.

38 George Sherburn (ed.), *The Correspondence of Alexander Pope*, 5 vols, Oxford 1956, vol. 1, p. 34.

39 Christie's, *British Pictures*, 15 November 1993, lot 11.

40 Vertue, vol. III, p. 17.

41 British Museum, Whitley Papers, vol. 7, p. 808.

42 Edward Bottoms, 'Charles Jervas, Sir Robert Walpole and the Norfolk Whigs', *Apollo*, February 1997, vol. CXLV, no. 420, pp. 44–8.

43 Ellis Waterhouse, *Painting in Britain 1530–1790*, (5th ed.), New Haven and London 1994, p. 150.

44 Horace Walpole, *Anecdotes of Painting*, (ed. Ralph N. Wornum), 3 vols, London, 1849, vol. II, p. 654.

45 Tancred Borenius, Portland Catalogue, p. 453.

46 Sherburn, op. cit., vol. IV, p.177.

47 M. Kirby Talley, 'Extracts from Charles Jervas's Sale Catalogue', *The Burlington Magazine*, vol. CXX, no. 898, January 1978, pp. 6–11.

48 Vertue, vol. III, p. 102.

49 Richard and Samuel Redgrave, *A Century of British Painters*, Oxford 1947 (reprint), p. 10.

50 Ingamells, p. 91.

51 Harold Williams, *The Correspondence of Jonathan Swift*, vol. IV, (1732–6), Oxford, 1965, (15–16 June 1735), p. 352.

52 PRONI, Shannon papers, 56A.

53 Knight of Glin, 'Francis Bindon', *Bulletin of the Irish Georgian Society*, vol. X, nos 2 and 3 (April–September 1967), p. 3–36.

54 Painted in 1739. Houghton had £18.13.0 for his work on the oak frame. Bindon was paid £36.16.0.

55 Homan Potterton, 'A Commonplace Practitioner in

Painting and in Etching: Charles Exshaw', *The Connoisseur*, vol. CLXXXVII, no. 754 (December 1974), pp. 269–73.

56 Information from Nicola Figgis.

57 Ingamells, p. 345, entry by Nicola Figgis.

58 Vertue, vol. III, p. 77.

59 Vertue, vol. III, p. 123.

60 George Berkeley, *The Querist*, Part I, Dublin, 1735, pp. 162, 184.

61 There are two versions of this picture, one in Ireland and one in the British Art Center, Yale. See Judy Egerton, *British Sporting and Animal paintings 1655–1867*, New Haven and London, 1978, p. 39 and pl. 14.

62 *Portraits*, p. 38, no. 27, illus.

63 Vertue, vol. III, p. 111.

64 Christie's Great Tew Park Sale, 27–9 May 1987, lot 400. This is almost certainly a copy.

65 *Painters*, p. 42, pl. 23.

66 Sergio Benedetti, *The Milltowns, a Family Reunion*, NGI catalogue, 1997, pp. 14–19, illus.

67 A member of a Catholic family, often military, who during the period of the penal laws in Ireland found work on the continent, but returned home quite frequently.

68 Figgis and Rooney, pp. 336–44 . This entry provides more information on Lee.

69 *Fifth Report of the Deputy Keeper of the Public Records in Ireland*, Dublin, 1873, p. 55, fines levied in the Palatinate of Tipperary, no. 116.

70 Betham Abstracts of Prerogative wills 1700–1799, 'L-S', NLI MS 238.

71 *Fifth Report of the Deputy Keeper of the Public Records in Ireland*, op. cit., p. 55.

72 Anne Crookshank, 'James Latham 1696–1747', *The GPA Irish Arts Review Yearbook*, 1988, pp. 60, 61, illus. pp. 57 and 60.

73 Ph. Rombouts and Th. van Lerius, *De Liggeren en andere historische archieven der Antwerpsche sint Lucasgilde*, Amsterdam, 1961 reprint, vol. II, pp. 737–8.

74 Waterhouse, *Dictionary*, op. cit., p. 218.

75 Christie's, 16 July 1998, lot 37.

76 Figgis and Rooney, pp. 316–18.

77 Brian Allen, 'The Age of Hogarth', *The British Portrait 1660–1960*, Woodbridge, 1991, p. 131.

78 *Portraits*, p. 35, no. 18, illus.

79 Ibid., p. 35, no. 20, illus.

80 Ibid., p. 35, no. 21, illus.

81 Ibid. Addenda, no. 18, illus.

82 John Warburton, J. Whitelaw and R. Walsh, *History of the City of Dublin*, 2 vols, London 1818, vol. II, p. 1179.

83 Thomas Campbell, *A Philosophical Survey of the South of Ireland*, London 1777, p. 439.

84 Christie's, 17 July 1992, lot 5.

85 *Painters*, p. 45, pl. 27 illus.

86 Edward Malins and Knight of Glin, *Lost Demesnes*, London 1976, p. 19 pl. 21. The picture is now destroyed.

87 Sergio Benedetti, *The La Touche Amorino*, exhibition NGI 1998–9, no. 2, p. 26 illus.

88 *Portraits*, p. 40, no. 32.

89 Christie's, 9 October 1981, lot 82.

90 Information from Toby Barnard, NLI, Edgeworth papers, account book MS 1521; MS 1522, MS 1524. See also Figgis and Rooney, who discuss these Edgeworth portraits, pp. 255–62.

91 Information from Toby Barnard, PRONI, DIO/22/4A.

92 PRO T8622.

93 *Watercolours*, pp. 24, 25, 27, illus.

94 Leger Galleries, 30 May–25 July 1986, *English Pictures from the Country House*.

95 Sotheby's Irish Sale, 2 June 1995, lot 202.

96 Diary of the first Lord Egmont 1730–47, HMC 3 vols, vol. 3, (1920–3) pp. 89 and 308.

97 Christie's, 10 April 1992, lot 123.

98 Identified in a letter, dated 13 March 1998, to William Laffan by Elizabeth McGrath of the Warburg Institute, London. See William Laffan, 'Taste Elegance & Execution, John Lewis as a landscape painter', *Irish Arts Review Yearbook*, vol. 15, 1999, pp. 151–3, illus.; and his 'John Lewis', *The Sublime & the Beautiful, Irish Art 1700–1830*, Pyms Gallery, London, 2001, pp. 66–71.

99 Sotheby's, 21 May 1999, lot 244.

100 Sotheby's Derwydd Sale, 15 September 1998, lots 36, 38–42.

101 Her work is dealt with in chapter 5.

102 *Portraits*, p. 42, p. 35, illus.

103 Ibid, p. 16, fig. 6.

104 *Clerics and Connoisseurs*, p. 97 and illus, p. 155.

105 *Dublin Universal Advertiser*, 8 September 1753.

106 Christie's sale, Castletown House, Co. Kilkenny, 8 October 1991, lot 227.

107 *Dublin University Magazine*, vol. XL no. CCXXXIX, (Nov. 1852), p. 513.

108 Anon., *The Case of the Stage in Ireland*, Dublin, 1758, p. 27.

109 Christie's, 19 July 1993, lot 249.

110 Edward Edwards, *Anecdotes of Painters*, London 1808, pp. 30–1.

111 Maurice Grant, *A Chronological History of the Old English Landscape Painters*, reprinted Leigh-on-Sea, 1958, vol. II, p. 107.

112 Waterhouse, *Dictionary*, op. cit., pp. 222–3.

113 Sotheby's Irish Sale, 16 May 1996, lot 371, attributed to 'James Black', the Armagh painter of the early nineteenth century whom we mention later.

114 A. C. Elias Jr (ed.), *Memoirs of Mrs Laetitia Pilkington 1712–50 Written by Herself*, reprinted and annotated, Athens, Georgia, 1997, 2 vols, vol. I, p. 104–8 and 110 and for Worsdale throughout, see Elias index.

115 Harold Williams (ed.), *The Correspondence of Jonathan Swift*, 5 vols, Oxford, 1963–5, vol. V, p. 97.

116 *The Works in Verse of Daniel Hayes Esq.*, London, 1769, Eclogue III, p. 26.

117 Vertue, vol. III, p. 59.

118 Elias, op. cit.

119 Mary-Louise Legg (ed.), *The Synge Letters … 1746–1752*, Dublin 1996, p. 94, illus.

120 Barnard, op. cit., p. 26.

121 Sheffield Grace, *Memoirs of the family of Grace*, London, 1823.

122 Michael Wynne, 'Thomas Frye (1710–62)', *Burlington Magazine*, vol. CXIV, no. 827 (February 1972), pp. 79–84. In this article, most of the Fryes mentioned in this chapter are illustrated.

123 Benedict Nicolson, *Joseph Wright of Derby, Painter of Light*, 2 vols, London, 1968, vol. I, pp.42–4. Many of Frye's mezzotints are illustrated.

124 Michael Wynne, 'A pastel by Thomas Frye, c.1710–62', *British Museum Yearbook II*, 1977, pp. 242–5.

125 Waterhouse, *Dictionary*, op. cit., p. 131.

4. Patronage and Dealing from the Eighteenth Century

1 Pierpont Morgan Library, letter from Charles Ryskamp, 9 December 1976, enclosing a photocopy.

2 For the Ely family and touching on the importance of the decoration and collection at Rathfarnham, see Anthony Malcolmson, 'A house divided: the Loftus family, Earls and Marquesses of Ely, c.1600–1900', forthcoming.

3 PM and FO'K, 'The Assembly House, South William St', *Dublin Historical Record*, vol. 1 no. 1 (Dublin 1938–9), pp. 28–32.

4 John T. Gilbert *A History of the city of Dublin*, reprint, vol. III, Shannon, 1972, pp. 344–50, where he discusses the origins of the society and its exhibitions.

5 PM and F. O'K, op. cit., pp. 29–30.

6 Richard Pococke, *Pococke's Tour in Ireland in 1752*, ed., with an introduction and notes, by George T. Stokes, Dublin, 1891.

7 James Kelly (ed.), *The Letters of Lord Chief Baron Edward Willes*, 1757–62, Aberystwyth, 1990.

8 Richard Twiss, *A Tour in Ireland in 1775*, London, 1776.

9 A. W. Hutton (ed.), Arthur Young, *A Tour in Ireland … 1776–9*, 2 vols, reprinted Shannon, 1970.

10 TCD MSS 4024, 4026-8, 4029-30, 4033.

11 Mary Beaufort, wife of Daniel, TCD MSS 4035 and 6; Louisa Catherine, their daughter, TCD MS 4034.

12 RIA MS no. 12.W.14–17. Four volumes of diaries of Mr Justice Robert Day which cover the following years: 1794; 1801; 1827; 1828–30; and 1832–9.

13 Henry Heaney (ed.), *The Irish Journals of Robert Graham of Red Gorton*, Dublin, 1999.

14 Prince Pückler-Muskau, *Tour in England, Ireland and France, in the years 1828–29*, 2 vols, published anonymously, London, 1832.

15 Ibid., vol. I, p. 180.

16 Ibid, vol. I, p. 185

17 Mary Davies, 'Beauforts visits to Downhill', in Jane Fenlon *et al* (eds), *New Perspectives*, Dublin 1987, pp. 157–75. She gives an excellent account.

18 *A Tour through Ireland*, Dublin 1791, pp. 56–7.

19 Information from Edward McParland. The customs accounts are in the NLI MSS 353–376. It is an interesting point that the importation of fans was far greater than pictures, for example, in 1768, £5,463 for fans, as opposed to £647 2s. 11d. for paintings.

20 TCD, Department of Early Printed Books.

21 Villiers Stuart Papers, Dromana, Co. Waterford.

22 HMC Egmont MSS; Diary of the first Earl of Egmont, vol. III (1923) p. 366.

23 Information from D. M. Beaumont from his unpublished Ph.D. thesis for TCD on the Laois gentry.

24 T. C. Barnard, 'The world of a Galway Squire: Robert French of Monivea 1716–1779' in Gerard Moran and others (eds), *Galway: History Society*, Dublin 1966, pp. 272, 276, 282, 283.

25 TCD, Department of Early Printed Books.

26 M. Pollard, *Dictionary of Members of the Dublin Book Trade 1550–1800*, London 2000, p. 102.

27 John T. Gilbert, *History of the City of Dublin*, 1854–9, reprint Shannon, 1972, vol. III, p. 347–8.

28 Ingamells, pp. 81–2; a full account of Berkeley's grand tours and his cultural contacts in Italy and England is given by Edward Chaney *The Evolution of the Grand Tour*, London, 1998, pp. 314–76 and in A. A. Luce, *The Life of George Berkeley Bishop of Cloyne*, New York, 1968, pp. 69–80.

29 Charles Smith, *Antient and present state of the county and city of Cork*, Dublin, 1750, vol. 1, p. 146–7.

30 Chaney, op. cit., p. 322.

31 Charles Smith, op. cit., p. 213.

32 Angelique Day (ed.), *Letters from Georgian Ireland*, Belfast 1991, p. 87: 22 September 1731.

33 Countess of Cork and Orrery (ed.), *The Orrery Papers*, 2 vols, London 1903, vol. 1, p. 206.

34 Information brought to our attention by Edward McParland from a letter in the Archivio di Stato in Florence (Carte Galilei Filza V / no. 1, pp. 213–14).

35 Sir Charles King (ed.), *Henry's Upper Lough Erne*, reprint, Whitegate, 1987, p. 40.

36 Day, op. cit., p. 275, 3 June 1752.

37 Ibid., p. 46.

38 PRONI, T 3765/L/4 (part).

39 John Coleman, 'Evidence for the collecting and display of paintings in mid-eighteenth-century Ireland', *Bulletin of the Irish Georgian Society*, vol.XXXVI (1994), pp. 59–60.

40 These are mostly illustrated in Edgar Rogers Bowron (ed.), Anthony M. Clark, *Pompeo Batoni*, Oxford 1985.

41 Joseph McDonnell, 'Joseph Henry of Straffan: a connoisseur of Italian renaissance painting', Michael McCarthy (ed.), *Lord Charlemont and his Circle. Essays in honour of Michael Wynne*, Dublin, 2001, pp. 77–89.

42 Steffi Roettgen, *Anton Raphael Mengs 1728–1779 and his British Patrons*, London 1993. He also painted the Irish art historian Daniel Webb, a painting now lost; the author also discusses Daniel Webb's *Enquiry into the Beauties of Painting*, 1760, p. 150.

43 John Loughman, 'One of the finest pieces Rembrandt ever painted: Charlemont's collecting of Netherlandish paintings', in McCarthy (ed.), op.cit., pp. 103–11.

44 The catalogues are in the RIA library.

45 Caldwell MSS; information from Jane Meredith, who has been working on him and his circle. She quotes letters from his nephew George Cockburn, his uncle George Heywood, Dr William Cleghorn, the artist John Warren and others. See also Philip McEvansoneya, 'An Irish Artist goes to Bath: letter from John Warren to Andrew Caldwell, 1776–1784', *Irish Architectural and Decorative studies*, vol 2, 1999, pp. 147–73.

46 Anthony Blunt, *The Paintings of Nicolas Poussin*, London, 1966, p. 69, no. 100. The catalogue describes 'Landscape with St Francis', also called 'Une solitude' or 'St Francis at La Verna', as being in the Palace of the President of Yugoslavia. It had been in the Crozat sale.

47 Rebecca Minch, has kindly provided us with his sale catalogues and much information.

48 George Wright, *An historical guide to ancient and modern Dublin*, London, 1821.

49 John Preston Neale, *Views of Seats of noblemen and gentlemen in the United Kingdom*, 6 vols, London, 1819.

50 Ingamells, p. 835.

51 David Griffin and Caroline Pegum, *Leinster House*, Dublin, 2000, pp. 47–8.

52 James Malton, *A Picturesque and Descriptive View of the City of Dublin 1792–99*, London, 1792–9.

53 *Notes on the Pictures, Plate, Antiquities, etc., at Carton, Kilkea Castle, 18, Dominick Street, Dublin and 6, Carlton House Terrace*, London, 1885.

54 Bennett's 3-day sale, 2 December 1925. Kindly communicated by David Griffin of the Irish Architectural Archive.

55 For the 13-day Shelton sale and other collections, including Killua Castle and Charleville Castle, see Cynthia O'Connor, 'The Dispersal of the Country House Collections of Ireland', *Bulletin of the Irish Georgian Society*, 1992–3, vol. XXXV, pp. 38–47.

56 A description of the paintings in their various rooms, some of which had painted ceilings, can be found in Revd G. Vaughan Sampson's *Statistical Survey of County Londonderry*, Dublin, 1802, pp. 414–15 and pp. 420–22.

57 Nicola F. Figgis, 'The Roman Property of Frederick Augustus Hervey, 4th Earl of Bristol and Bishop of Derry (1730–1803)', *Walpole Society*, vol. LV, London, 1993, pp. 77–103 (pp. 77–8).

58 Ibid., pp. 89–103.

59 Nigel Everett, *In an Irish Arcadia*, Cork, 2000, pp. 23–6.

60 Alastair Laing (ed.), *Clerics and Connoisseurs*, exhibition catalogue, Iveagh Bequest, Kenwood, 2001–2, with contributions by Charles Sebag-Montefiore, Barbara Bryant, Julius Bryant, Alec Cobbe and William Laffan.

61 Ibid. pp. 87–9, Arthur K. Wheelock Jr and Alec Cobbe, *Wooded landscape from Newbridge*.

62 Barbara Bryant, 'Matthew Pilkington and the Gentleman's and Connoisseur's Dictionary of Painters 1770: a landmark in Art History', Alistair Laing (ed.), ibid., pp. 52–62.

63 A. Elias Jr, who has edited the *Memoirs of Laetitia Pilkington*, (Athens, Georgia, 2 vols, 1997) and is writing the entry on him for the *DNB*, in a letter to us indicates that he also considers it unlikely that Pilkington went to Italy.

64 Ann Stewart, *Irish Art Loan Exhibitions 1765–1927*, Dublin, 1990, 3 vols. See bibliography for her other reference books.

65 For a full discussion of this exhibition, see A. Jamie Saris, 'Imagining Ireland in the Great Exhibition of 1853' and Leon Litvack, 'Exhibiting Ireland, 1851–53: Colonial Mimicry in London, Cork and Dublin', in Leon Litvack and Glenn Cooper (eds), *Ireland in the Nineteenth Century: Regional Identity*, Dublin, 2000, pp. 15–57 and 66–86.

66 John S. Powell, *Pavilioned in Spendour, the Art and Artefacts of Emo Court, Co. Laois*, Portarlington, 2000.

67 Dublin National Archives, 999/16/6/2.

68 A full catalogue of this collection survives from the 1880s. Information from Lady Jennifer Bernard.

69 We are indebted to the late Judge Francis Murnaghan and his wife Diana, of Baltimore, for the list of his uncle's gift to the Walters Art Gallery, Baltimore.

5. Landscape in the First Half of the Eighteenth Century

1 Republished with all his illustrations in John Small (ed.), *John Derricke, Image of Ireland*, Edinburgh, 1883.

2 For the seventeenth century, see Anne Crookshank and the Knight of Glin, *The Watercolours of Ireland*, London, 1994, (subsequently referred to as *Watercolours*), pp. 13–21.

3 Allen B. Hinds (ed.), *Calendar of State Papers and Manuscripts, Relating to English Affairs, Existing in the Archives and Collections of Venice*, vol. XVI, 1619–21, London, 1910, p. 480.

4 British Art Center, Yale.

5 Walter G. Strickland, *A Descriptive Catalogue of the Pictures, Busts and Statues in Trinity College, Dublin*, Dublin, 1916, pp. 77–8.

6 W. G. Strickland, *JRSAI*, 1926, vol. 56, pp. 92–4, and see also Vivien Igoe and Frederick O'Dwyer, 'Early views of the Royal Hospital, Kilmainham', *The GPA Irish Arts Review Yearbook*, 1988, pp. 78–88, illus.

7 Christie's, 26 May 1993, lot 79.

8 Anne Crookshank, Desmond FitzGerald, Desmond Guinness, James White, *Irish Houses and Landscapes*, Exhibition Catalogue, Belfast and Dublin 1963, p. 6, illus.

9 Ruth Isabel Ross, 'Phillips' Pleasing Prospects', *Country Life*, 4 March 1976, pp. 552–3. A number of his drawings are illustrated in this article.

10 Thomas Dineley, *Observations made on his tour in Ireland and France, 1675-80*, NLI MS no. 392.

11 A large number of Place's Irish drawings are now in the NGI.

12 Peter Harbison, 'P. Burk(e)'s Painting of Youghal: The Earliest known signed Townscape by an Irish Artist' with a note by Michael Wynne, *Journal of the Cork Historical and Archaeological Society*, vol. LXXVIII (1973), pp. 66–79.

13 La Tourette Stockwell, *Dublin Theatres and Theatre Customs 1637-1820*, Kingsport Tennessee, 1938, p. 279, quotes from *Harding's Impartial Newsletter* for 1722, 'Alexander the Great ... with large lofty scenes entirely new and Painted by Mr Vanderhegan arriv'd lately from London'.

14 Mia Craig has made a thorough study of the van der Hagen family as a BA thesis (TCD 1992), but is unable to find his precise birthdate.

15 E. H. H. Archibald, *Dictionary of Sea Painters*, Woodbridge, 1980, p.115.

16 Mia Craig, op.cit., quotes J. K. van der Haagen *De Schilders Van der Haagen en hun werk*, 1932, p. 65 and M. J. F. W. van der Haagen, *Het geslacht Van der Haagen 1417–1932*, 1932, p. 65.

17 John Harris, *The Artist and the Country House*, London, 1979, pp. 98, 148 and 150–1.

18 *Harding's Impartial Newsletter*, Saturday, September 29 1722.

19 Poor Book, St Michan's, 1723–34, Representative Church Body Library, P.276/8.1, pp. 97, 99.

20 Anne Crookshank, 'Eighteenth-century alterations, improvements and furnishings in St. Michan's Church, Dublin', *Studies*, Winter 1975, p. 389. Since this article was written, the vestry books have been deposited in the Representative Church Body Library and William van der Hagen has been proved to be the only Irish resident of the van der Hagen family.

21 Charles Smith, *The Antient and Present State of the County and City of Waterford*, Dublin 1746, p. 181.

22 The minute book for the Corporation of Waterford for 29 June and 29 October 1736: kindly communicated by Mr T. F. Ryan.

23 William Laffan (ed.), *Masterpieces by Irish Artist 1660-1860*, essay van der Hagen by the authors, Pyms Gallery, London, 1999, pp. 14–19.

24 Smith, op. cit., p. 106.

25 Ibid., p. 97.

26 Sotheby's, 16 May 1996, lot 376.

27 Liam Price (ed.), *An Eighteenth Century Antiquary, The Sketches, notes and diaries of Austin Cooper, 1759–1830*, Dublin, 1942, pp. 96–7. Illus. Desmond Guinness and William Ryan, *Irish Houses and Castles*, London 1971, p. 243.

28 Charles Smith, *The Antient and Present State of the County of Kerry*, Dublin 1756, p. 216.

29 Quoted by Strickland from *Faulkner's Dublin Journal*, March 1733.

30 Lady Llanover (ed.), *Autobiography and Correspondence of Mary Granville, Mrs Delany*, 6 vols, London 1861–2, vol. I, pp. 308 and 337, or Angelique Day (ed.), *Letters from Georgian Ireland*, Belfast 1991, pp. 32–3.

31 Rameau's manual was republished and translated by Cyril Beaumont, London, 1930, *The Dancing Master*, chap. XXIII, p. 65, fig. 33. We are indebted to Grainne McArdle for this information. She is working on the Dublin theatres and includes a chapter on dance between 1732 and 1735.

32 A theory that this painting was executed by Joseph Tudor for the Duke of Dorset's second term as Lord Lieutenant in 1753 is incorrect and fully discussed in Edward McParland *Public Architecture in Ireland 1680–1760*, New Haven and London, 2001, pp. 102–4 and p. 219.

33 Quoted in Strickland from *Faulkner's Dublin Journal* for 13 and 20 November 1753.

34 Edward Croft-Murray, *Decorative Painting in England 1537–1837*, 2 vols, London, 1962–70, vol. II, p. 287.

35 *The Dublin Gazette* of 3–7 May 1743 recorded the activities of the Dublin Society: 'Several pieces of Landscape and History Painting were produc'd for the Premium of 25 Pounds but the Society were of Opinion that none of them deserved the Premium. But in regard that one of them, a large Landscape with cattle, made by Mr. Tudor was apparently the best Piece, they order'd that Ten Pounds should be given to Mr Tudor.' We are indebted to Mr Thomas J. Byrne for this reference.

36 Figgis and Rooney, pp. 451–4.

37 *Faulkner's Dublin Journal*, 20–23 April 1750. Information kindly given by Mary Boydell.

38 Sotheby's, 14 March 1990, lot 80.

39 E. H. H. Archibald, *Dictionary of Sea Painters*, Woodbridge 1980, p. 145, illus.; and Kim Sloane, *'A Noble Art': Amateur Artists and Drawing Masters circa 1600–1800*, London 2000, pp. 118–19, illus., for Berkeley see Frank Llewelyn Harrison, 'Music, Poetry and Polity, in the Age of Swift', *Eighteenth-Century Ireland*, vol. 1, 1986, p. 38.

40 Sotheby's, 14 March 1990, lot 88.

41 Charles Smith, *The Antient and Present State of the County and City of Cork*, Dublin 1750, Book II, opp. p. 222.

42 Information kindly given by Peter Murray.

43 Francis Grose, *Antiquities of Ireland*, 2 vols, London, 1791, vol. ii, p. 58. The two following illustrations are of Burnt Court.

44 See *Watercolours*, pp. 34–6. Ardfinnan illus. p. 36.

45 *Watercolours*, pp. 34–5; Christine Casey, 'Miscellanea Structura Curiosa', *Irish Arts Review*, 1991, pp. 85–91 and James Howley, *The Follies and Garden Buildings of Ireland*, New Haven and London 1993, pp. 31–2 and 218–19; Barbara Paca, 'Miscellanea Structura Curiosa', *The Journal of the Garden History Society*, (Oct. 1996) pp. 1–10; William Fraher, 'Charles Smith ...', *Decies: Journal of the Waterford Archaeological and Historical Society*, n. 53, 1997, pp. 41–4, who gives more information about the Chearnley family, particularly Anthony.

46 Toby Barnard, 'Art, Architecture, Artifacts and Ascendancy', *Bullán*, Autumn 1994, vol. I, no. 2, pp. 26 and 33.

47 Cynthia O'Connor Gallery exhibition catalogue, 1–15 April 1992, no. 7.

48 Maurice Grant, *The Old English Landscape Painters*, reprinted Leigh-on-Sea, 1958, vol. III, plate 15.

49 John Harris, *The Artist and the Country House*, London 1979, p. 256 and p. 298, pl. 333.

50 Elizabeth Einberg and Judy Egerton, *Tate Gallery collections, The Age of Hogarth*, London 1988, 2 vols, vol. 2, pp. 234–6, illus.

51 Sotheby's, 11 July 1990, lot 30.

52 Christie's, South Kensington, 9 April 2000, lot 244, attributed to Circle of Hermann van der Myn.

53 Angelique Day (ed.), *Letters from Georgian Ireland*, Belfast, 1991, p. 151.

54 Day, op.cit.; Ruth Hayden, *Mrs Delany: her life and her flowers*, London, 2nd ed., 1992. It is from Mrs Delany's letters and autobiography that her fascinating career can be traced.

55 *Watercolours*, pp. 28–9.

56 Bills for the building and decoration of Aldborough House see Aidan O'Boyle in *Irish Architectural and Decorative Studies, Journal of the Irish Georgian Society*, vol. 4, 2001, pp. 102–41.

57 Information kindly given by Peter Harbison who is working on Beranger and the antiquarians and gave us the letter from Beranger to Burton Conyngham which mentions Bigari's picture.

58 Michael Herity, formerly of UCD, is working on this subject and has published an article on a slightly earlier period, 1720–70, in *JRSAI*, vol. XC (1969), pp. 1–21. Peter Harbison has also published works on the antiquarians: *A collection of the principal antique buildings of Ireland / designed on the spot & collected by Gabriel Beranger*, Dublin, 1991; *Drawings of the principal antique buildings of Ireland*, Dublin 1998; *Cooper's Ireland: drawings and notes from an eighteenth-century gentleman*, Dublin, 2000.

59 Wicklow Papers NLI. Information from the late Mrs O'Connor.

60 Vertue, vol. III, pp. 89, 122.

61 Horace Walpole, *Anecdotes of Painting in England, with some account of the principal artists ... collected by the late George Vertue*, 1849 edition, Ralph N. Wornum (ed.), vol. II, p. 701.

62 Bennett and Son, Carton sale, 2 December 1925, lot 518.

63 For Collins, see William Laffan (ed.), *The Sublime and the Beautiful, Irish Art 1700–1830* Pym's Gallery, London, 2001, an entry by Laffan, pp. 56–65.

64 J. Murdoch, *Forty British Watercolours from the Victoria and Albert Museum*, London, 1977, no. 1.

65 Sotheby's, Madrid, 27 February 1985. Information kindly given by Jane Fenlon.

66 Iolo Williams, *Early English Watercolours ...*, London 1952, p. 27.

67 Sotheby's, 16 June 1926, and these are discussed by Murdoch.

68 For further details see *Watercolours*, pp. 109–12.

69 *Painters*, p. 64.

70 Figgis and Rooney pp. 401–5.

71 Fergus D'Arcy, 'A horse called *Flyer* ...', *Journal of the Kildare Archaeological Society*, vol. XVIII (1992–3), pp. 92–5.

72 Sally Mitchell, *Dictionary of British Equestrian Artists*, Woodbridge, 1985, pp. 365–6.

73 Edward Edwards, *Anecdotes of Painting*, London, 1808, p. 11; see also Judy Egerton, *British Sporting and Animals Paintings ... the Paul Mellon Collection*, London 1978, p. 110.

74 Information kindly given by Jane Fenlon.

75 Kindly contributed by Simon Dickinson.

76 Judy Egerton, *British Sporting and Animal Paintings … the Paul Mellon Collection*, London, 1978, pp. 50–1.

77 This was originally in the Hilton collection at Ammerdown and sold at Sotheby's, 15 June 2000, lot 21.

78 *Painters*, p. 64, illus.

79 Christie's, 24 June 1960, lot 87, a pair.

80 Waterhouse, *Dictionary*, op. cit., p. 223.

81 Christie's, 14 November 1997, lot 63.

82 Information from Christopher Foley.

83 Elizabeth Einberg, 'The Betts family: a lost Hogarth that never was, and a candidate for Slaughter', *Burlington Magazine*, July 1987, pp. 415–16.

84 John O'Keeffe, *Recollections of the Life of John O'Keeffe, written by himself*, 2 vols, London, 1826, vol. 1, p. 28.

85 Egerton, op. cit., pp. 105–6, pl. 37.

86 Nehemiah Curnock (ed.), *The Journal of the Rev. John Wesley, AM*, 8 vols, London 1909–16, vol. VI, p. 59. Wesley made this visit to Moira House in 1775.

6. The Dublin Society Schools and their Influence

1 George Berkeley, *The Querist*, 2 parts, Dublin 1725[1735]–1736, Part 1, p. 15, q. 71.

2 Published in Dublin, 1738, p. 10.

3 Charles Smith, *The Antient and Present State of the County and City of Cork*, 2 vols, Dublin 1750, vol. I, p. 147.

4 Vertue, vol. III, p. 98.

5 William Carey, *Some Memoirs of the Patronage and Progress of the Fine Arts in England and Ireland*, London, 1826, pp. 183–4.

6 Strickland, vol. II, p. 580. Turpin, *A School of Art in Dublin since the eighteenth century*, Dublin, 1995, where the author points out that the Dublin Society released information to *Faulkner's Dublin Journal*, where this communication appeared 14–18 May 1746.

7 Carey, op. cit., pp. 184–5.

8 John Warburton, J. Whitelaw, and R. Walsh, *History of the City of Dublin*, 2 vols, London, 1818, vol. II, p. 1180.

9 *Portraits*, pp. 44–5, illus.

10 John O'Keeffe, *Recollections of the Life of John O'Keeffe, written by himself*, 2 vols, London, 1826, vol. I, p. 2; referred to below in this chapter as O'Keeffe, *Recollections*.

11 Carey, op. cit., pp. 187–8.

12 Robina Napier (ed.), *Johnstoniana, Anecdotes of the late Samuel Johnston LLD …*, London, 1884, pp. 223–4. We are grateful to Ronald Lightbown for bringing this book to our attention.

13 Thomas James Mulvany, 'Memoirs of Native artists No.1 – Mr Francis R. West', *The Citizen*, no. XXIV (October 1841), p. 206.

14 Dublin, National Archives M3417.

15 Leslie Stephen and Sidney Lee (eds), *Dictionary of National Biography*, London 1908, (reissue) vol. II, p. 1018.

16 BL MS.no.4062 f. 4.

17 J. C. Walker, 'A short account of the origin and progress of the drawing school of the Dublin Society until the year 1790', *Transactions of the Dublin Society*, vol. 3 (1803), p. 133.

18 John Turpin, *A School of Art in Dublin since the Eighteenth Century*, Dublin, 1995, p. 9. Turpin's is the best modern account of the Schools.

19 O'Keeffe, *Recollections*, op. cit., vol. 1, pp. 13–16.

20 Dublin Society Minutes, 24 May 1750.

21 Revd Thomas Campbell, *An Essay on Perfecting the Fine Arts in Great Britain and in Ireland*, publ. by William Sleator; Gitta Willemson (compiler), *The Dublin Society Drawing School, Students and Award Winners 1746–1876*, Dublin, 2000.

22 This quotation from Strickland can no longer be found, but a somewhat similar list is given in the pamphlet mentioned in the last footnote and quoted later by us.

23 *Report of the First Public Distribution of Premiums, Royal Dublin Society*, Dublin 1842, p. 10.

24 Campbell, op. cit., p. 40.

25 John Turpin, *A School of Art in Dublin since the eighteenth century*, Dublin, 1995, pp. 39–42.

26 O'Keeffe, *Recollections*, op. cit., vol. 1, pp. 13–16.

27 Ingamells, pp. 338–9.

28 Figgis and Rooney pp. 132–4.

29 Campbell, op. cit., p. 38.

30 William Allen, *The Student's Treasure, a new drawing book consisting of a variety of Etchings nd Engravings executed by Irish Artists after the following great masters*, Dublin, 1804 (first published 1789). The print of Allen's shop front is

31 reproduced in Andrew and Charlotte Bonar Law, *The Irish Prints of James Malton*, Dublin, 1999, p. 105.

31 *Portraits*, p. 78. Entry by Jonathan Mayne gives further details; Paul Caffrey, *Treasures to Hold, Irish and English Miniatures 1650–1850 from the National Gallery of Ireland collection*, exhibition catalogue, Dublin, 2000.

32 Lady Llanover, *Autobiography and Correspondence of Mary Granville, Mrs Delany*, 6 vols, London 1861–2, vol. 2, p. 415; Angélique Day (ed.), *Letters from Georgian Ireland*, Belfast 1991, p. 97.

33 John Boyle, Earl of Orrery, *Remarks on the Life and Writings of Dr Jonathan Swift*, London 1752, illus. frontispiece.

34 *NCAD 250 Drawings 1746–1996*, Catalogue of an exhibition held in the National College of Art and Design to mark its 250th anniversary, Dublin, 1996, pp. 8 and 9.

35 Dublin, National Archives, MS.3417.

36 Michael Wynne, 'An influence on Robert Healy', *Burlington Magazine*, vol. CXVIII (June 1976), p. 413, pls. 95–7 and 100–5.

37 In a MS letter from Lady Louisa Conolly to her sister, Lady Sarah Napier, in the Conolly papers, kindly communicated to us by Eleanor Burgess. TCD Conolly MSS.

38 TCD MS 3964–65 and in the Irish Architectural Archive, 3939–3984a, Conolly papers on loan from the Castletown Foundation.

39 For further information about the Healy family, see *Watercolours*, pp. 63–4.

40 Patrick Montague-Smith, 'The Dexters of Dublin and Annfield, Co. Kildare', *The Irish Ancestor*, vol. II, no. 1 (1970), pp. 31–42, illus.

41 Thomas James Mulvany, 'Memoirs of Native Artists, No.1 – Mr Francis R. West,' *The Citizen*, no. XXIV (October 1841), pp. 205–8.

42 *Painters*, p. 81, illus.

43 *Portraits*, p. 18, the trade label illus.

44 *Portraits*, p. 18, illus. He also painted oils, one of which has recently been acquired by the NGI.

45 Figgis and Rooney pp. 458–9.

46 Much information on Nathaniel Bermingham is given in W. A. Thorpe, 'The Art of the Paper-cutter', *Country Life* (10 July 1943), pp. 194–6, where this quotation is said to be taken from Mrs Laetitia Pilkington; however, we cannot find it. He was advertising as a 'Herald Painter and Vellum Cutter' in *The Dublin Daily Advertiser*, 7 May 1736. Two further references in *The Dublin Newsletter* of 3–7 June and 12–15 July 1740 list his vellum cut work, coats of arms, landscapes etc., sometimes coloured, and his drawings and watercolours. He lived at the Sign of the Fan, at the corner of Aungier Street and Stephen Street.

47 Walker's *Hibernian Magazine*, (November 1794), pp. 437–9, 'Memoir of the Rev. William Peters LLB', 'was born in Capel-Street, in the city of Dublin, in the house wherein the late celebrated Dr. Sheridan lived'.

48 *Gentleman's Magazine* (January 1776), p. 31.

49 *Portraits*, p. 59, no. 81, illus.

50 For further information, and especially his American career, see *Watercolours*, pp. 53–8, illus.

7. Portraiture and Subject Painting in the Second Half of the Eighteenth Century

1 They also bought land in Clondalkin. Registry of Deeds, Book 130, No.89868, p. 459.

2 He was a leading figure in the famous Annesley trial of 1744. McKercher also appears in Smollett's *Adventures of Peregrine Pickle* as Mr M, in the famous novel based on the trial.

3 Reference kindly given to us by Toby Barnard. PRONI, Roden Papers, microfilm 147.

4 Sotheby's, 14 July 1993, lot 52.

5 Information kindly given by Peter Murray of the Crawford Art Gallery, Cork.

6 Christie's, South Kensington, 11 November 1999, lot 31. In the catalogue, the sitters are wrongly identified.

7 *Painters*, p. 84, illus.

8 Ibid., p. 90 illus.

9 Anne Crookshank, 'Robert Hunter', *Irish Arts Review 1989–90*, pp. 169–85.

10 William Carey, *Some Memoirs of the Patronage and Progress of the Fine Arts in England and Ireland*, London, 1826, p. 226.

11 Illustrated chapter 6, number 1.

12 Anne Crookshank and David Webb, *Paintings and Sculptures in Trinity College, Dublin*, Dublin, 1990, p. 94 and pp. 157–64.

13 Anne Crookshank, op. cit., 1989–90, pp. 169–85. The Hudson and the *Unknown Old Lady* are illus. p. 173.

14 Christie's, 22 March 1968, lots 91 and 92.

15 Information kindly supplied by the Hon. Thomas Pakenham.

16 Sergio Benedetti, *The La Touche Amorino*, NGI exhibition catalogue, 1998, p. 29 illus.

17 Edgar Peters Bowron (ed.), Anthony Clark, *Pompeo Batoni*, London, 1985, no. 242, p. 224.

18 *Portraits*, p. 17, fig. 8, illus.

19 *Charles Cameron c.1740–1812*, Exhibition Catalogue, The Arts Council, London 1967–8, frontispiece and pp. 14 and 15.

20 Nigel Gosling, *Leningrad*, London 1965, p. 158.

21 Figgis and Rooney, pp. 246–8.

22 N. Curnock (ed.), *The Journal of the Rev. John Wesley, A.M.*, London, 1909–16, vol. V, p. 139, and John Kerslake, *Early Georgian Portraits*, NPG, London, 1977, vol. II, pl. 861.

23 *Portraits*, p. 17, fig. 8, illus.

24 Carey, op. cit., p. 226.

25 W. B. Sarsfield Taylor, *The Origin, Progress and Present Condition of the Fine Arts in Great Britain and Ireland*, London, 1841, vol. II, pp. 283–4.

26 John Trotter to Edward Southwell, 18 April 1757, BL Add MS 21,131, f. 127. Information kindly given by Edward McParland.

27 Ingamells, entry by Nicola Figgis, p. 954.

28 Francis Beretti 'The first portraits of Pascal Paoli, two British artists, Henry Benbridge and John Trotter'. *The British Art Journal* vol. 11, No. 3, 2001 fig. 1, pp. 69–71.

29 Sotheby's, 12 July 1995, lot 64.

30 Sotheby's, 27 March 2000, lot 84.

31 Sotheby's, 10 July 1985, lot 47.

32 Sotheby's, 10 July 1985, lot 48.

33 Two interesting group interiors are (i) of the Hore family, reproduced in Valerie Pakenham, *The big house in Ireland*, London 2000, p. 87 and (ii) an unknown family group in the Art Institute of Chicago, and we thank Dr Malcolm Warner for bringing it to our attention.

34 For his family background, see John Magee, 'The Gowrie conspiracy and the Trotters of Down', *Familia*, vol. 2, no. 7, 1991, pp. 31–9.

35 Sotheby's, Round May sale, 2 October 1946.

36 Ellis Waterhouse, *Painting in Britain*, London, 1953, p. 183.

37 Sarsfield Taylor, op. cit., vol. II, p. 124, and *Portraits*, p. 47.

38 Hilary Pyle, 'Nathaniel Hone 1718–84. An eighteenth century Irish artist', *The Arts in Ireland*, vol. 1, no. 3, (1973), pp. 54–63.

39 BM MS, 1752–53, 44025.

40 Michael Wynne, 'Members from Great Britain and Ireland of the Florentine Accademia del Disegno 1700–1825', *Burlington Magazine*, vol. 132, (1990), pp. 535–8.

41 *Portraits*, p. 47, biographical note by Hilary Pyle; Hilary Pyle, 'Nathaniel Hone 1718–1784. An eighteenth century Irish artist', *The Arts in Ireland*, vol. 1 no. 3 (1973), pp. 54–63.

42 *Catalogue of the Exhibition of Pictures by Nathaniel Hone RA, mostly the works of his leisure …*, London, 1775, p. 3.

43 *Painters*, p. 86, illus.

44 Christie's, 7 April 1993, lot 26.

45 Sotheby's, 17 November 1988, lot 40.

46 John Fleming, *Robert Adam and his Circle*, London, 1962, p. 121.

47 William T. Whitley, *Artists and their friends in England 1700–99*, London, 1928, vol. 2, pp. 265–7, gives an account of White and the Conjuror. Figgis and Rooney, pp. 226–31.

48 J. T. Smith, *Nollekens and his Times*, London 1828, vol. I, pp. 146–55, includes many details of Hone's 1775 exhibition. See also Edward Edwards, *Anecdotes of Painting*, London, 1808, pp. 101–2.

49 Waterhouse, *Painting*, op. cit., pp. 183–4.

50 *Portraits*, p. 49, no. 51, illus.

51 Sotheby's, 9 March 1988, lot 47.

52 Christies, 19 May 2000, lot 105.

53 *Portraits*, p. 48, no. 48, illus.

54 Smith, op. cit., vol. I, p. 144.

55 Ibid. vol. II, p. 322.

56 Christie's, 14 July 1994, lot 58.

57 J. T. Gilbert, *A History of the City of Dublin*, Dublin, 1861, vol. III, p. 348.

58 Figgis and Rooney pp. 203–4.

59 Ibid, p. 207–8.

60 Unidentified newspaper cutting in the Courtauld Institute, criticizing Hickey's pictures in the RA 1775.

61 Smyth of Barbavilla, unsorted papers in NLI, pc 435,

folder labelled '1702–1708, correspondence of Mrs Bonnell …', information kindly given by Dr Edward McParland.

62 Alfred Spence (ed.), *Memoirs of William Hickey*, London, 1913–25, vol. II, p. 386.

63 Ibid., vol. IV, p. 493, note 23.

64 Ibid., vol. III, p. 202. We doubt the figure of £250.

65 Mildred Archer, 'Wellington and South India Portraits by Thomas Hickey', *Apollo* (July 1975), p. 32.

66 Sir William Foster, 'British Artists in India 1760–1820', *Walpole Society*, vol. XIX, (1930–1), p. 39.

67 Edward Edwards, *Anecdotes of Painters*, London, 1808, p. 70.

68 Sotheby's, 2 June 1995, lot 218. Figgis and Rooney write at length about these pictures pp. 394–400.

69 Fintan Cullen, 'The Oil Paintings of Hugh Douglas Hamilton', *Walpole Society*, vol. L, 1984, pp. 165–78.

70 John O'Keeffe, *Recollections of the life of John O'Keeffe, written by himself*, 2 vols, London, 1823, vol. I, p. 12.

71 Dublin Society Minutes, 9 December 1756.

72 John Turpin, *A School of Art in Dublin since the Eighteenth Century*, Dublin 1995, p. 43.

73 *Watercolours*, p. 67, illus.; Anne Hodge, 'The Practical and the Decorative …', *Irish Arts Review*, vol. 17, (2001), pp. 133–40, illus. p. 133. For *The Cries of Dublin*, see Christie's Irish Sale, 17 May 2002, lot 29.

74 Thomas James Mulvany, 'Hugh Douglas Hamilton', *Dublin Monthly Magazine* (January–June 1842) p. 68.

75 A. P. Oppé, *English Drawings at Windsor*, 1950, no. 288.

76 Alastair Laing, 'Sir Roland and Lady Winn: a conversation piece in the library at Nostell Priory', *Apollo*, CLI, no. 458 (April 2000), p. 15, illus. p. 14.

77 Ibid., p. 16 and p. 18 illus.

78 Mulvany, op. cit., pp. 68–9.

79 National Library of Wales, Wynnstay MSS, Box 115/21, no. 43.

80 *Painters*, p. 74, no. 57 illus.

81 *Watercolours*, p. 68 illus.

82 Ingamells, p. 451.

83 Ibid., p. 451.

84 Sotheby's, 17 Nov 1983, lot 29 and 12 July 1984, lot 14.

85 Christie's, Mere Hall, 3 May 1994, lots 232–7, Paestum is lot 237.

86 *Tricorne and Turbans* Exh. Martyn Gregory Gallery, London 6 April–2 May 1987, no. 3, p. 9, illus.

87 Christopher Wright, 'Un Opera di Hugh Douglas Hamilton', *Arte Illustrata*, LIII, (May 1973) pp. 147–8; Fintan Cullen, 'Hugh Douglas Hamilton in Rome 1779–92', *Apollo*, no. 240 (February 1982), pp. 87–9.

88 Sotheby's, Derwydd Mansion, Carmarthenshire, 15 September 1998, lot 82.

89 Figgis and Rooney, pp. 168–9.

90 Ibid.

91 Ian Jenkins and Kim Sloan, *Vases and Volcanoes*, London, 1996, pp. 262–3.

92 Christie's, 3 July 1964, lot 7.

93 Figgis and Rooney, pp. 170–2.

94 *Portraits*, p. 52, no. 63, illus. Benedetti: 1998, p. 31, no. 7.

95 Laing, op. cit., p. 17, illus.

96 Sergio Benedetti, *The La Touche Amorino*, NGI, 1998, p. 36, illus.

97 Anne Crookshank and the Knight of Glin, 'Some Italian Pastels by Hugh Douglas Hamilton', *Irish Arts Review Yearbook*, vol. 13 (1997), pp. 62–9, where more detail is given about these works.

98 Christie's, 9 June 1999, lot 11. The sarcophagus Dawkins is seated on is in the Capitoline Museum (no. 623) and he leans on another, now in the Louvre (no. MA475). Both were sold by Cardinal Albani to the pope for the Capitoline Museum in 1733. There is more information in an addendum to the Christie's catalogue entry.

99 *Portraits*, pp. 51–2. This information, supplied by Hugh Honour, provides many interesting further details about this picture. This pastel was in the exhibition, Andrew Wilton and Ilaria Bignamini (eds), *Grand Tour: The Lure of Italy in the Eighteenth Century*, Tate Gallery, London, 1996, p. 72.

100 Presentation made by Margaret Morgan Graselli to the donors of *Art for the Nation*, 15 March 1991 and *Art for the Nation* exhibition, Washington, 17 March–16 June 1991, Supplement.

101 BM Add. MSS 39780 f, folio no. 179, a letter 22 July 1788 from Mrs Flaxman to her sister.

102 Sotheby's, 14 July 1993, lot 61.

103 Benedetti op. cit., pp. 32–5.

104 *Dublin Monthly Magazine* (January–June 1842) p. 70.

105 Sotheby's, 12 July 1995, lot 58.

106 Paul Caffrey, *Treasures to hold Irish and English miniatures 1650–1850*, exhibition, NGI, 2000, pp. 98–9.

107 *Painters*, p. 94, no. 82 illus.

108 *Portraits*, p. 51, no. 61.

109 Mulvany, op. cit., p. 73.

110 Ibid., p. 74. Figgis and Rooney, pp. 173–5, where the picture is discussed at length.

111 Fintan Cullen, 'Hugh Douglas Hamilton in Rome, 1779–92', *Apollo*, vol.cxv (February 1982), pp. 86–91.

112 Mulvany, op. cit., pp. 71–2.

113 This portrait is in the possession of French descendants of the sitter. Information kindly given by Fintan Cullen.

114 Figgis and Rooney, pp. 176–9.

115 Quoted in Strickland.

116 Royal Irish Academy MS 24K14, p. 246, entry for 6 July 1801.

117 Fintan Cullen, 'Hugh Douglas Hamilton: "painter of the heart"', *Burlington Magazine*, vol. CXXV, no. 964 (July 1983), p. 417.

118 Mulvany, op. cit., p. 76.

119 Michael Wynne 'Frederick Prussia Plowman' *Irish Arts Review Yearbook 2001*, vol. 17 pp. 34–6.

120 Brinsley Ford, 'The Earl Bishop', *Apollo*, vol. LXCIX (June 1974), p. 428 quotes from a letter from James Irvine to George Cumberland dated 10 February 1781 (Cumberland Papers 3 BM Add. MSS 36493, f. 128).

121 'Memoirs of Thomas Jones', *Walpole Society*, vol. XXXII (1946–8), p. 62; NLI Limerick MSS special list 160, No.15.

122 *Watercolours*, p. 103.

123 *Painters*, p. 96 illus.

124 Ibid., p. 97.

125 J. T. Smith, *Nollekens and his times*, 2 vols, London, 1828, vol. I, p. 244.

126 BM, *Whitley Papers*, vol. XII, p. 1504.

127 A. Raimbach, *Memoirs and Recollections*, London, 1843, p. 30.

128 *Watercolours*, p. 74–5, illus.

129 Adrian Le Harivel and Michael Wynne, *NGI Acquisitions 1982–83*, NGI 1984, pp. 14–15.

130 Ingamells, pp. 763–4.

131 BM, *Whitley papers*, vol. IX, p. 1151.

132 Ingamells, p. 764.

133 BM, *Whitley Papers*, vol. IX, p. 1152, and the poem is vol. IX p. 1154.

134 Figgis and Rooney pp. 384–5.

135 Ellis Waterhouse, *Painting in England*, London 1953, p. 201.

136 R. R. M. See, *Gazette des-Beaux Arts* (November 1911), p. 339.

137 Róisín Kennedy, *Dublin Castle Art*, Dublin, 1999, pp. 64–5.

138 For a full discussion of this venture, see Robin Hamlyn 'An Irish Shakespeare Gallery', *Burlington Magazine*, vol. CXX, no. 905 (August 1978), pp. 515–29.

139 Ibid., p. 520.

140 Ingamells, p. 1004.

141 *Portraits*, p. 59, no. 82, illus.

142 Raleigh Trevelyan 'Robert Fagan, an Irish Bohemian in Italy', *Apollo*, vol. LXCVI (October 1972), pp. 198–303; for further information on Fagan, see our entry on Miss Emily Manly in *Masterpieces by Irish Artists 1660–1860*, Pyms Gallery, London, 1999, pp. 48–51 and William Laffan, *Robert Fagan in Sicily, the Acton family portrait*, Pyms Gallery, London, 2000.

143 Information kindly supplied by Alastair Laing.

144 *Portraits*, p. 65, nos. 92 and 93 illus.

8. The Genius of James Barry

1 We discuss Garvey in chapter 10 and Carver in chapter 9.

2 Joseph Farington, *The Diary of Joseph Farington*, vols 1–6, Kenneth Garlick and Angus Macintyre (eds); vols 7–16, Kathryn Cave (ed.)) New Haven and London 1978–84, vol. vii, p. 2505, 29 January 1805.

3 James Barry, *The Works of James Barry … containing his correspondence … his lectures …*, (ed. E. Fryer), 2 vols, London 1809, vol. I, p. 2. Referred to below in this chapter as Barry's *Works*.

4 Ibid., p. 18.

5 Ibid., p. 22.

6 Christie's, 10 and 11 April 1807, lot 76; William L. Pressly, *The life and art of James Barry*, New Haven and London, 1981, p. 3.

7 *Watercolours*, p. 100, illus.

8 Barry's *Works*, vol. I, p. 2.

9 Ibid., p. 7.

10 *Walker's Hibernian Magazine* (October 1810), pp. 194–5, gives a very full account of the picture and its exhibition. The later version which we discuss towards the end of this chapter is discussed by William L. Pressly in an article entitled 'James Barry's The Baptism of the King of Cashel by St Patrick', *Burlington Magazine*, vol. CXVIII, no. 882 (September 1976), pp. 643–6.

11 Gitta Willemson (compiler), *Dublin Society Drawing Schools Students and Award winners, 1746–1876*, Dublin, 2000, p. 4. We are indebted to the RDS Librarian, Mrs Kelleher, for a copy of the typescript before the book was published.

12 Memoir of James Barry Esq, *European Magazine*, London, vol. XLIX, April 1806.

13 Information kindly given by Jane Fenlon.

14 *Walker's Hibernian Magazine*, October 1810, pp. 196–7.

15 Barry's *Works*, vol. I, pp. 15–16.

16 Ibid., pp. 84–6.

17 Ibid., p. 31.

18 Figgis and Rooney, pp. 67–8.

19 Barry's *Works*, vol. I, p. 40.

20 Ingamells, p. 55.

21 Barry's *Works*, pp. 108–15.

22 Ibid., p. 75.

23 Ibid., pp. 71–3.

24 Ibid., pp. 115–16.

25 Ibid., p. 141.

26 For amusing comments on contemporary reactions to the nudity shown in this picture, see David H Solkin (ed.), *Art on the Line*, exhibition in the Courtauld Institute Gallery, 2001, Chapter 3, by C. S. Matheson, p. 42, illus p. 41. See also Figgis and Rooney pp. 68–70.

27 This view of Barry's politics was suggested to us in conversation with Kevin Whelan, who read our chapter and made several interesting suggestions.

28 Ibid., p. 110.

29 Daniel Webb, *An Inquiry into the Beauties of Painting and into the Merits of the most Celebrated Painters ancient and modern*, London, 1760, p. 45.

30 Jane Munro, 'Italian Landscape Drawings by James Barry', *Master Drawings*, vol. 29, no. 3, 1991.

31 William L. Pressly, *James Barry. The Artist as Hero*, Tate Gallery, London, 1983 p. 61.

32 Barry's *Works*, vol. I, p. 185 and vol. II, p. 35.

33 Ibid., vol. I, p. 203.

34 Ibid., vol. II, p. 128.

35 Published in vol. II of Barry's *Works*.

36 David Irwin, *English Neoclassical Art*, London, 1966, pp. 39–40.

37 Ibid., p. 40.

38 *Public Characters of 1800–1801*, Dublin, 1801, pp. 246–65.

39 William L. Pressly, *The Life and Art of James Barry*, New Haven and London, 1981, p. 55–8.

40 N. F. Lowe, 'James Barry, Mary Wollstonecraft and 1798', *Eighteenth century Ireland*, vol. 12, 1997, pp. 63–4.

41 Ibid., p. 64.

42 William Pressly mentions a number of portraits, including the recently discovered D Solly, in his article 'The reappearance of a portrait by James Barry …', *British Art Journal*, vol. I, no. 2, spring 2000, pp. 62–6.

43 David Irwin, 'James Barry, and the Death of Wolfe in 1759', *The Art Bulletin*, vol. XLI (1959), pp. 330–2.

44 James Barry, *An Account of a Series of Pictures in the Great Room of the Society of Arts, Manufacturers, and Commerce, at the Adelphi*, London, 1783, p. 40.

45 Edward Edwards, *Anecdotes of Painting*, London, 1808, p. 308 n.

46 David Allan, 'The Progress of Human Culture and Knowledge', *The Connoisseur*, vol. CLXXXVI (June 1974), pp. 104–5.

47 Croft-Murray, vol. II, p. 168.

48 William T. Whitley, *Artists and their Friends in England, 1700–99*, 2 vols, London, 1928, vol. I, p. 375.

49 James Northcote, *The Life of Sir Joshua Reynolds …*, second edition, 2 vols, London, 1818, vol. II, pp. 146–8.

50 Barry's *Works*, vol. II, p. 371.

51 Figgis and Rooney, pp. 76–8.

52 Pressly, 1983, op. cit., p. 144.

53 Ibid., p. 102–3.

54 Robert R. Wark, 'A note on James Barry, and Edmund Burke', *The Journal of the Warburg and Courtauld Institutes*, vol. XVII (1954), pp. 382–4.

55 David Bindman, 'Barry at the Tate' [Exhibition Review], *The Burlington Magazine*, vol. CXXV, no. 961 (April 1983), p. 241.

56 Barry's *Works*, vol. I, pp. 97–9 and 119.
57 Ellis Waterhouse, *Painting in Britain 1530–1790*, London, 1953, p. 189.
58 Figgis and Rooney, pp. 78–81.
59 Robert Wark, 'The Iconography and Date of James Barry's Self-portrait in Dublin', *Burlington Magazine*, vol. XCVI (1954), p. 153.
60 Ibid., p. 154.
61 Ibid., p. 184.
62 Pressly, 1981, op. cit., p. 192.
63 'K', 1801, p. 265, quoted in Figgis and Rooney, p. 66.
64 National Art Collections Fund, *Review 1999*, no. 4647.

9. Mid-Eighteenth-Century Painters and the Irish in Rome

1 See chapter 5.
2 p. 52.
3 See Alastair Laing (ed.), *Clerics and Connoisseurs, An Irish Art Collection through Three Centuries*, London, September 2001.
4 First of several editions, 1770.
5 A. C. Elias, Jr (ed.), *Memoirs of Laetitia Pilkington*, Athens, Georgia 1997, 2 vols. records her remarkable and immoral career.
6 Francis Elrington Ball, *Howth and its Owners, being the Fifth Part of a History of County Dublin*, Dublin, 1917, p. 134. A pair of classical landscapes signed 'RC', on panel may be overdoors by Richard Carver, Christie's Irish sale, 17 May 2001, lot 78. An obituary in *Pue's Occurrences*, 16 February 1754, No. 14, says he was 'a very eminent history painter'.
7 See William Laffan on Robert Carver in *The Sublime and the Beautiful, Irish Art 1700-1830*, Pym's Gallery, London, 2001, pp. 94–101 for further illustrative material.
8 Sybil Rosenfield and Edward Croft-Murray, 'A checklist of scene painters working in Great Britain and Ireland in the 18th Century', *Theatre Notebook*, vol. XIX, no. I, (Autumn 1964), p. 15.
9 Unpublished UCD Ph.D. thesis 2000 by Finola O'Kane, 'Mixing foreign trees with natives: Irish demesne landscape in the eighteenth century', pp. 126–7.
10 *Masterpieces by Irish Artists 1660–1860*, Pym's Gallery, London, p. 28, illus. a picture by Carver clearly dependent on the Dublin Drop.
11 *The Works of the late Edward Dayes …*, London, 1805, reprint with introduction by R. Lightbown, 1971, p. 323.
12 Ibid., p. 323.
13 Figgis and Rooney, pp. 99–101.
14 See our entry in *Masterpieces by Irish artists 1660-1860*, Pyms Gallery, London, 1999, pp. 26–9.
15 Christie's, 2 April 1954, lot 72.
16 Christie's, Irish Sale, 17 May 2002, lot 35.
17 Gorry Gallery October–November 1992, no. 21, illus. Coy's father was a silk weaver and later a grocer. In the Registry of Deeds 128-231-86698 for 1747, his father Thomas made a lease with Abdiel Edwards.
18 James Barry, works of James Barry …, (ed. E. Fryer), 2 vols, London, 1809, vol. I, pp. 200–1, referred to below in this chapter as Barry's *Works*.
19 See Peter Francis, *Irish Delftware: an Illustrated History*, London, 2000, pp. 95–9.
20 The copy was published in a leaflet of a lecture by Robert Walker, *The City of Cork, how it may be improved*, Cork, 1883. Boole Library, University College, Cork, (q-1 MP 72).
21 Figgis and Rooney pp. 96–7, illus.
22 Maurice Grant, *A Chronological History of the Old English landscape painters*, London, 1926, vol. I, pl. 28.
23 Christie's, 21 March 1975, lot 55.
24 Kenneth Garlick and A. MacIntyre (eds.), *The Farington Diaries*, London, 1978–85, vol. VIII, p. 3056, 3 June 1807.
25 Figgis and Rooney pp. 47–57.
26 Michael Wynne, 'Continental European Sources for George Barret', *Irish Arts Review Yearbook*, vol. 10 (1994), pp. 136–9.
27 Christie's 12 July 1991, lots 68a and 68b.
28 Arthur Samuels, *The Early Life, Correspondence and Writings of the Rt Hon. Edmund Burke Ll.D.*, Cambridge, 1923, p. 84.
29 Luke Herrmann, *British Landscape Painting of the 18th Century*, London, 1973, plate 49a.
30 This account was reproduced in two later guides, John Bushe, *Hibernia Curiosa, a letter from a Gentlman in Dublin, to his friend at Dover*, Dublin 1769 pp. 81–6 and Philip Luckombe, *A Tour through Ireland*, 1780, pp. 48–50.
31 Matthew Pilkington, *A Dictionary of Painters*, third ed., 1798, p. 781.

32 For a full discussion of this picture, see our *Masterpieces By Irish Artists, 1660-1860*, Pyms Gallery, London, 1999, no. 3, pp. 20–5.
33 Brian Fitzgerald, *Emily, Duchess of Leinster, 1731–1814*, London, 1949, pp. 106–7.
34 *Watercolours*, p. 53, illus.
35 Registry of Deeds, Dublin, no. 223.52.146588.
36 *Faulkner's Dublin Journal* of 11–15 September 1764 mentions that Barret arrived in London before his furniture and three of his paintings were auctioned in Dublin.
37 Barry's *Works*, vol. I, p. 37.
38 Ibid., p. 34.
39 Ibid., p. 16.
40 Peter Hughes, 'Paul Sandby and Sir Watkin Williams Wynne', *Burlington Magazine*, vol. CXIV (July 1972), pp. 459–66.
41 Barry's *Works*, vol. I, p. 89.
42 Ibid.
43 Figgis and Rooney, pp. 58–9.
44 MS letter in the Pierpont Morgan Library kindly communicated by Charles Ryskamp.
45 William Carey, *Some Memoirs of the Patronage and Progress of the Fine Arts …*, London, 1824, p. 4.
46 *Dayes*, op. cit., p. 316.
47 William Sandby, *History of the Royal Academy of Arts*, London 1862, vol. I, p. 100.
48 Richard W. Goulding and C. K. Adams, *Catalogue of the Pictures belonging to his Grace the Duke of Portland, K.G.*, Cambridge, 1936, p. 428.
49 Ivan Hall, *Catalogue of an Exhibition of Paintings … Collected … by William Constable Esq. of Burton Constable …*, Ferens Art Gallery, Kingston upon Hull, January–February 1970, p. 44 and plate I. Barret's views of Burton Constable shows the landscape not as it was but as projected. The lake was not yet constructed and the trees not mature.
50 V & A Museum, MS letter 13532-1976.
51 Barry's *Works*, vol. I, p. 94.
52 Edward Edwards, *Anecdotes of Painters*, London 1808, p. 97.
53 Joseph Farington, *The Diary of Joseph Farington*, vols 1–6, Kenneth Garlick and Angus Macintyre (eds); vols 7–16, Kathryn Cave (ed.), New Haven and London, 1978–84, vol. VII, p. 2597.
54 Registry of Deeds, Dublin, no. 296.24.193736.
55 Joseph Farington, *The Diary of Joseph Farington*, op. cit., vol. VI, p. 2074.
56 Croft-Murray, vol. II, p. 168.
57 Edwards, op. cit., p. 98.
58 Ibid., p. 99.
59 Martin Hardie, *Water-colour Painting in Britain*, 3 vols, London, 1967, vol. I, p. 87.
60 Unidentified newspaper cutting in the Courtauld Institute of Art.
61 Luke Herrmann, *British Landscape Painting of the 18th Century*, London 1973, p. 62.
62 Ibid.
63 Farington, op. cit., vol. VI, p. 2244.
64 V & A Museum, MS letter, 13532-1976.
65 William T. Whitley, *Artists and their Friends in England, 1700–99*, 2 vols, London, 1928, vol. I, p. 387.
66 We are indebted to the late Sir Brinsley Ford for allowing us access to his transcript of this journal, referred to below in this chapter as *Martin Journal*. For all these artists now, see Ingamells.
67 Father John Thorpe's letters written from Rome to his patron, Lord Arundell of Wardour, were brought to our attention by the late Sir Brinsley Ford, who most kindly allowed us access to his transcripts of them. These are referred to below in this chapter as *Thorpe Letters*.
68 Brinsley Ford (ed.), 'Letters of Jonathan Skelton', *The Walpole Society*, vol. XXXVI (1960), p. 59.
69 BM Print Room, Richard Haywood, MS list of English artists in Rome, covering the period 1753–75.
70 Paul Oppé (ed.), 'Memoirs of Thomas Jones', *The Walpole Society*, vol. XXXII (1951), pp. 63–4 and 74–5; and Brinsley Ford (ed.), 'Letters of Jonathan Skelton', *The Walpole Society*, vol. XXXVI, (1960), p. 75.
71 Stato delle Anime for S. Andrea delle Fratte, Archivio del Vicariato, S. Giovanni in Laterano, Rome.
72 Ingamells, pp. 255–6, entry by Nicola Figgis.
73 Bonham's, 5 June 1969, lot 180.
74 Edwards, op. cit., p. 59.
75 Ibid.
76 Ford, op. cit., p. 68.
77 Nicola Figgis 'Irish landscapists in Rome', *The GPA Irish Arts Review*, vol. 4, no. 4 , 1987, pp. 60–2.

78 Mere Hall sale, Christie's, 23 May 1994, lot 242.
79 *Finest Prospect*, Iveagh Bequest, Kenwood exhibition, 1986, no. 84, illus.
80 Grant, op. cit., vol. I, pl. 56.
81 *Martin Journal*, op. cit., 6 July 1764.
82 References in the Registry of Deeds of the family and their property, authors' files, TCD.
83 *Martin Journal*, op. cit., 10 July 1764.
84 Croft-Murray, vol. 2, p. 200. Tim Knox, 'A mortifying lesson to human vanity', *Apollo*, July 2000, p. 45, which illustrates a print of Wilson's painting, *Athens in its flourishing state*, as well as its pendant by Delane.
85 Barry's *Works*, vol. I, pp. 115–16. This letter to Burke, though undated, can be dated to early 1769, as it refers to Sir Watkin Williams Wynn's return from Naples. This information was kindly given to us by the late Sir Brinsley Ford.
86 *Thorpe Letters*, 15 December 1770.
87 Figgis and Rooney, pp. 125–7.
88 Ibid., pp. 126–7.
89 Ingamells, p. 290.
90 Christie's, 4 April 1778, lot 40.
91 *Martin Journal*, op. cit., 10 July 1764.
92 Information from the late Sir Brinsley Ford.
93 Noted on the tablets on the frames.
94 Information from the late Sir Brinsley Ford taken from an inventory of the contents of James Byres's house in Rome, made 1 May 1790.
95 NLI Pos 6016.
96 Ford, op. cit., p. 58.
97 *Watercolours*, p. 59, illus.
98 *Thorpe Letters*, 5 November 1774.
99 *Thorpe Letters* mentions the commission for Lord Arundel in numerous letters including one of 20 March 1771.
100 *Thorpe Letters*, 6 November 1771.
101 *Thorpe Letters*, 10 March 1770.
102 For a detailed study of Forrester, see Nicola Figgis, 'James Forrester', *The Sublime and the Beautiful: Irish Art 1700–1830*, Pyms Gallery, London 2001, pp. 72–93. She also refers to the painter's journal of his Italian tours.
103 *Thorpe letters*, 22 December 1768.
104 Grant, op. cit., vol. III, p. 17.
105 Ibid., vol. I, plate 54.
106 The late Sir Brinsley Ford kindly gave us this reference from the Account Books of Sir Watkin Williams Wynn in an entry for 7 January, 'Pd Mr Forrester for teaching Sr Watkin to Draw 20 Sq 410 Paoli - - -'.
107 *Thorpe Letters*, 14 December 1772.
108 Joe McDonnell, *Ecclesiastical Art of the Penal Era*, St Patrick's College Maynooth 1995, p. 10, where he records other information about this forgotten artist, illus.
109 Information from the late Sir Brinsley Ford, an addition to his note on Forrester in 'Letters of Jonathan Skelton', *The Walpole Society*, vol. XXXVI (1960), op. cit., pp. 58–9.
110 Christie's, 3 Feb 1922, lot 18.
111 Grant, op. cit., vol. I, pl. 54.
112 Christie's, 16 July 1998, lot 67.
113 Sotheby's, 10 April 1991, lot 19.
114 *Thorpe Letters*, 18 May 1771.
115 Ibid., 2 March 1771.
116 Edwards, op. cit., p. 109.
117 Oppé, op. cit., p. 12.

10. Landscapes, 1760–1826

1 A whole-length Volunteer portrait of Lt Anthony (Wood Collection on loan to the University of Limerick) painted on tin may be by Mullins, though all these attributions are speculative.
2 Figgis and Rooney, pp. 378–9.
3 Information from Miss Gordon of the Witt Library and David H. Solkin.
4 Algernon Graves, *The Royal Academy of Arts …*, 8 vols, London, 1906, vol. V, p. 322, exh. 1771, no. 266.
5 Morris R. Brownell, *The Prime Minister of Taste: A Portrait of Horace Walpole*, New Haven and London, 2001, p. 161.
6 Information from David H. Solkin.
7 Joseph Farington, *The Diary of Joseph Farington*, vols 1–6, Kenneth Garlick and Angus Macintyre (eds); vols 7–16, Kathryn Cave (ed.), New Haven and London, 1978–84, vol. VII, pp. 2503 and 2505.
8 Ingamells, p. 393.
9 Christie's, 14 November 1997, lot 65.
10 The other is illustrated, Ellis K. Waterhouse, *Dictionary of*

British Eighteenth Century Painters, Woodbridge 1981, p. 143, signed and dated 1769.

11 Philip MacEvansoneya, 'An Irish artist goes to Bath: letters from John Warren to Andrew Caldwell, 1776–84', *Irish Architectural and Decorative Studies, the Journal of the Irish Georgian Society*, 1999, vol. II, p. 156.

12 Farington, op. cit., vol. II p. 594 mentions the second visit of three months.

13 Sotheby's, 1 July 1925.

14 Christie's, 18 October 1985, lot 52a.

15 Farington, op. cit., vol. VI, p. 2244, 14 February 1804.

16 Sotheby's Mellon Collection sale, 18 November 1981, lot 119.

17 William Sandby, *The History of the Royal Academy of Arts*, 2 vols, London, 1862, vol. I, p. 193.

18 Richard Twiss, *A Tour in Ireland in 1775*, London 1776, p. 52.

19 Information kindly given by Peter Harbison. These latter drawings are now in the NLI no. 2122TX (8p), Cooper Collection.

20 For a discussion of the Slane Castle painting, see Crookshank and Glin, 'Thomas Roberts', *Masterpieces by Irish Artists, 1660–1860*, Pyms Gallery, London, 1999, pp. 30–5.

21 MacEvansoneya, op. cit., p. 160.

22 Christie's Irish sale, 21 May 1997, lot 121.

23 Michael Wynne, former Keeper of the National Gallery of Ireland, who made the identification, is the author of an article on Roberts in the Winter issue of *Studies*, 1977, pp. 299–308, and of the catalogue of an exhibition of Roberts work held in the NGI in January–February, 1978. Additional works by Roberts and Mullins are mentioned in these. The picture under its old title is mentioned in *Portraits*, p. 62, no. 87. See also Michael Wynne, 'Thomas Roberts 1748–1778', *Irish Arts Review Yearbook 1994*, vol. 10, pp. 143–52.

24 Figgis and Rooney, pp. 408–14.

25 Ibid., p. 414.

26 *Survey of London*, vol. XXIX, part 1, London, 1960, p. 170, which quotes from the Wynnstay MSS (1952 collection) National Library of Wales.

27 Sotheby's, Amsterdam, 8 May 2001, lot 59.

28 William B. Sarsfield Taylor, *The Origin, Progress and Present Condition of the Fine Arts in Great Britain and Ireland*, 2 vols, London 1841, vol. II, p. 283.

29 Christie's, 14 July 1989, lot 53.

30 William Laffan (ed.), *The Sublime and the Beautiful, Irish art 1700–1830*, Pym's Gallery, London, 2001, p. 127, illus.

31 Quoted in the *DNB*, Oxford, 1965 reprint, vol. XIII, p. 489.

32 *The Journals of the House of Commons of the Kingdom of Ireland*, Dublin, 1796–1802, vol. IX, part I, Appendix, p. cxxvii.

33 Ibid., vol. XIII, Appendix, p. cxliv.

34 Ibid., vol. VIII, part I, Appendix, p. li.

35 NLI, Aldborough papers MS 8021/10, kindly communicated by Aidan O'Boyle.

36 Figgis and Rooney, pp. 29–30.

37 *Public Characters of 1803–4*, London, 1804, p. 471.

38 Unidentified newspaper cutting in the Courtauld Institute.

39 The *Jacques* was, for instance, exhibited in the Society of Artists in London in 1790, no. 28; RA, 1795, no. 193; and again in the British Institution in 1808, no. 210; and the *Celia and Orlando* in the RA, 1795, no. 304; and in the British Institution, 1806, no. 30.

40 Figgis and Rooney, pp. 37–8.

41 The exhibition was held at No. 32, Dame Street. This quotation is from p. 7, no. 9. The catalogue is in the NLI.

42 Royal Irish Academy MS no. 24K14, p. 244.

43 MS private collection.

44 *A Catalogue of a collection of Modern Pictures and Drawings chiefly consisting of the Works and Property of Mr Serres, Junior, ... which will be Sold by Auction by Mr Greenwood ... on ... 22nd of April, 1790, and following day ...*, copy in the V & A.

45 A drawing of Bulloch Harbour, signed and dated 1788 exists in a private collection in Ireland.

46 *A Critical Review of the First Annual Exhibition of Paintings ... of the works of Irish Artists ...*, June, 1800, p. 7, no. 10.

47 Ibid., p. 10, no. 21.

48 Michael Wynne, *Bulletin of the Irish Georgian Society*, vol. X, no. 4 (October–December 1967), pp. 20–4, illus. and Figgis and Rooney, pp. 32–3.

49 William Laffan (ed.), *The Sublime and the Beautiful*, Pyms Gallery, London, 2001, pp. 116–21.

50 Royal Irish Academy MS. no. 24K14, p. 258.

51 Figgis and Rooney, pp. 38–9.

52 Ibid., pp 33–5.

53 His prices were also reasonable. Hugh Lane quoted in the RHA Winter Exhibition Catalogue of Old Masters in 1902–3 that Ashford was paid, according to an old account book at Moore Abbey, £57-9-3 on 17 July 1775 'for three pictures of Moore Abbey, and Frames'.

54 Sarsfield Taylor, op. cit., p. 282.

55 *Proceedings of the Dublin Society*, vol. LV (1819), pp. 55, 63.

56 NLI, Aldborough papers MS 8021/10, kindly communicated by Aidan O'Boyle.

57 *A Critical Review ...*, op. cit., no. 32.

58 Registry of Deeds 276-8-175814; 278-93-17701; and 308-142-204051.

59 Mrs Godfrey Clark, *Gleanings from an Old Portfolio*, 3 vols, Edinburgh, 1895, vol. 1, p. 53.

60 Jonathan Fisher, *Scenery of Ireland illustrated in a series of prints of select views, castles and abbies, drawn and engraved in aquatinta ...*, Dublin, 1795 [1796].

61 For a discussion of this painting see our entry in *Masterpieces by Irish Artists 160-1860*, Pyms Gallery, London, 1999, pp. 36–43.

62 Ibid., pp. 44–7.

63 Figgis and Rooney, pp. 145–7.

64 *A list of the Descendants of Mary Sautell and John Roberts* by Miss Margaret Price, their granddaughter, National Archive, Dublin, MS 4974.

65 Figgis and Rooney, pp. 418–19.

66 Royal Irish Academy, MS no. 24K14, p. 257.

67 Thomas J. Mulvany, 'Memoirs of Native Artists, No. 11 – Mr Thomas Sotelle [*sic*] Roberts RHA', *The Citizen*, no. XXV (November 1841), p. 243.

68 National Archive, formerly Dublin Castle, State Paper Office 517/106/34, a letter from T. S. Roberts to Lord Hardwicke, dated 18 December 1801.

69 Royal Irish Academy, MS no. 24K14, pp. 113–14, entry for 25 January 1802.

70 Dublin 'Monthly Museum', 1814.

71 *A Critical Review ...*, op. cit., p. 7, no. 11.

72 Mulvany, op. cit., p. 244.

73 Ibid., p. 244.

74 TCD MSS 4026-4029K6, 56–9.

75 Alfred Coxe Prime (ed), 'Arts and Crafts in Philadelphia, Maryland and South Carolina 1721–1785', *Walpole Society*, New York, 1929, p. 309.

76 *Watercolours*, p. 78. A drawing after Heemskirk by Grogan survives.

77 Ibid., p. 79.

78 Anne Crookshank, Desmond FitzGerald, Desmond Guinness, James White, *Irish Houses and Landscapes*, exhibition catalogue, Belfast and Dublin, 1963, nos 20, 21, 22, 23.

79 Figgis and Rooney, pp. 161–2.

80 Christie's sale, 19 November 1976, lots 55 and 90.

81 For Grogan in general see 'Cn.' [pseud.], 'Gleanings on Old Cork Artists', *Journal of the Cork Historical and Archaeological Society*, vol. VI, second series (1900), pp. 106–8.

82 Sotheby's, 18 November 1992, lot 90.

83 *Watercolours*, pp. 79–80.

84 Ibid., p. 90, illus.

85 Ibid., pp. 92–3, illus.

86 Royal Irish Academy MS no. 24K14, pp. 258–9.

87 *Watercolours*, pp. 76–7, illus; for some of his English works, see Kim Sloan, 'A Noble Art', *Amateur Artists and Drawing Masters c.1600-1800*, BM, London, 2000, pp. 199–200.

11. Visitors, Decorators and History Painters

1 William Carey, *Some Memoirs of the Patronage and Progress of the Fine Arts in England and Ireland*, London 1826, p. 179.

2 Revd Herbert Randolph, *Life of General Sir Robert Wilson*, London 1862, vol. I, pp. 8–17.

3 For Barber (fl. 1736–72), see *Portraits*, p. 78; *Painters*, p. 71; Paul Caffrey, *John Comerford and the portrait miniature in Ireland*, Kilkenny 1999, p. 20; and Paul Caffrey, *Treasures to Hold*, National Gallery of Ireland, 2000, pp. 55–7 and illus. He is frequently mentioned by Mrs Delany and helped her with her painting: see Angélique Day (ed.), *Letters from Georgian Ireland ...*, Belfast, 1991, where a number of Barber drawings and miniatures are illustrated.

4 John Boyle, Earl of Orrery, *Remarks on the Life and Writings of Dr Jonathan Swift*, fourth ed., London, 1752. Only the head was used, not the surrounding decorations.

5 Vertue, vol. III, p. 135. Bishop Synge mentions Mercier to his daughter Alicia in Dublin in September 1747, calling her 'Mrs Giddyboots' for not having gone to see his pictures. Marie-Louise Legg, *The Synge Letters*, Dublin, 1997, p. 89.

6 Ellis Waterhouse, *Dictionary of British Eighteenth Century Painters*, Woodbridge, 1981, p. 54.

7 Ibid., p. 56 See also John Caldwell and Oswaldo Rodriguez Roque, *American Paintings in the Metropolitan Museum of Art*, Princeton 1994, vol. 1, p. 56, where they state Mann's portrait was exhibited at the Dublin Society of Artists. We have been unable to trace this.

8 Mary Webster, 'John Astley, Artist and Beau', *The Connoisseur*, vol. CLXXII (December 1969), pp. 256–61, and Ingamells pp. 32–3.

9 Edward Edwards, *Anecdotes of Painting*, London, 1808, p. 124; this is referred to below in this chapter as Edwards, *Anecdotes*.

10 Hugh Montgomery Massingberd and Christopher Sykes, *Irish Houses and Castles*, London, 1999, p. 23, illus. A number of bust portraits taken from this conversation piece also exist.

11 Christie's Irish sale, 17 May 2001, lot 63.

12 David Mannings and Martin Postle, *Sir Joshua Reynolds*, 2 vols, New Haven and London 2000, vol. 2, plates 14 and 15. We are indebted to Philip Mould for bringing this to our attention.

13 J. Grieg (ed.), *The Farington Diary*, London, 1922, vol. 1, p. 211 a footnote referring to the *Life of Sir Joshua Reynolds* by Leslie and Taylor, vol. II, p. 83.

14 Kenneth Garlick and Angus Macintyre (eds), *The Diary of Joseph Farington*, New Haven and London, 1979, vol. III, p. 685. Farington gives us more information on pp. 687–8.

15 Edwards, *Anecdotes*, op. cit., p. 124.

16 William Betham, *The Baronetage of England*, 5 vols, London, 1801–5, vol. II, pp. 378–9.

17 *The European Magazine*, vol. XII (December 1787), pp. 467–8.

18 William Carey, *Some Memoirs of the Patronage and Progress of the Fine Arts in England and Ireland*, London, 1826, p. 189.

19 Lady Victoria Manners, *Angelica Kauffmann*, London, 1924, p. 38.

20 Lecture by Dr Wendy Wassyng Roworth, TCD, August 1999.

21 Carey, op. cit., p. 189.

22 Information on these portraits kindly given by Jane Meredith.

23 Michael Wynne, 'Tilly Kettle's Last Painting?', *The Burlington Magazine*, vol. CIX (September 1967), pp. 532–3, and James White, 'Tilly Kettle and William Cuming, Portrait of James Gandon, Architect', *Bulletin of the Irish Georgian Society*, vol. IX, no. 1 (January–March 1966), pp. 27–31. Figgis and Rooney, pp. 122–4.

24 Ingamells, pp. 517–18.

25 *The Drennan–McTier Letters*, Dublin, 1998, vol. 1, pp. 257, 258, 263, 264, 265.

26 Whitley papers, *Notes on artists*, vol. 6, p. 755, BM Add. MS.33623, 18 March 1785, letter from Lord Hardwicke about Home copying 'Certain portraits in Irish houses'.

27 Mary Webster, *Francis Wheatley*, London, 1970. All the pictures mentioned by Wheatley are illustrated in this book, which is the best account of the artist. See also James Kelly, 'Francis Wheatley: His Irish Paintings, 1779–83', in Adele M. Dalsimer (ed.), *Visualizing Ireland: National Identity and the Pictorial Tradition*, Boston and London, 1993, pp. 145–62.

28 Edwards *Anecdotes*, op. cit., p. 268.

29 Fintan Cullen *Visual Politics*, Cork, 1997, pp. 57–62 where he discusses the picture and its background at length.

30 Peter Harbison, '"Irish artists on Irish subjects": The Cooper Collection in the National Library', *Irish Arts Review Yearbook*, 2001, vol. 17, pp. 61–9; Glendalough, illus. p. 63.

31 James Kelly op.cit., p. 160.

32 Caldwell of Newgrange, letters and papers 1704–93, no.136. Kindly communicated by Jane Meredith.

33 Dorinda Evans, *The Genius of Gilbert Stuart*, Princeton, 1999, pp. 49–50, illus. pl. 41–2 and pl. 4. Hugh R. Crean, *Gilbert Stuart and the Politics of Fine Arts Patronage in Ireland, 1781–1793*, Ann Arbor: University Microfilms International, 1991.

34 Caldwell of Newgrange, letters and papers 1704–93, no. 139.

35 Ibid., pp. 50–1, fig. 43.

36 John Dowling Herbert, *Irish Varieties*, Dublin 1836, pp. 227–28.

37 Evans, op.cit., p. 52.
38 Charles Merrill Mount, *Gilbert Stuart*, New York, 1964.
39 Philip MacEvansoneya, 'An Irish artist goes to Bath: letters from John Warren to Andrew Caldwell, 1776–84', *Irish Architectural and Decorative Studies, the Journal of the Irish Georgian Society*, vol. 2 (1999), pp. 146–73.
40 Figgis and Rooney, pp. 460–1.
41 Figgis and Rooney, pp. 200–4, for Hickey's biography, and George Breeze, 'Thomas Hickey in Ireland', *Studies*, vol. LXXII, Summer 1983, pp. 156–69.
42 For a general biography of George Chinnery, see Patrick Connor, *George Chinnery*, Woodbridge, 1993, and *Watercolours*, pp. 127–8.
43 Mentioned in Strickland, though it is a publication which the authors have not seen.
44 *Portraits*, p. 69. This entry by R. Ormond contains most useful information about this artist.
45 Royal Irish Academy, MS no. 24K14, p. 250, 6 July 1801.
46 *Watercolours*, pp. 127–8 illus.
47 Christie's, 15 July 1988, lot 94.
48 Mention of many of these is made in *Watercolours*, and of all in H. L. Mallalieu, *The Dictionary of British Watercolour Artists up to 1920*, Woodbridge, 1976.
49 Marshall Hall, *The Artists of Cumbria*, Kendal, 1979, p. 53.
50 Granard papers PRONI j/9/1/24, kindly communicated by Aidan O'Boyle.
51 Alastair Laing (ed.), *Clerics and Connoisseurs*, exhibition, English Heritage, Kenwood, London 2001–2, p. 103 and plate 161.
52 Eileen Black, *Irish Oil Paintings, 1572–c.1830*, Belfast 1991, pp. 42–8, the Bateson family being on pp. 46–8.
53 Figgis and Rooney, pp. 358–60.
54 Andrew and Charlotte Bonar Law, *The Irish prints of James Malton*, Dublin 1999, pp. 14, and 88–9.
55 Figgis and Rooney, pp. 353–58.
56 Christie's, 11 November 1983, lot 96.
57 John Cornforth 'A Mill and its Master', *Country Life*, vol. 152, 28 December 1972, pp. 1778–81, plate 3.
58 For Polk, see Linda Crocker Simmons, 'Politics, Portraits and Charles Peale Polk', in Lilian B. Miller (ed.), *The Peale Family*, Washington, 1996; for the Washington portrait, see Christie's, New York, *American Painting*, 26 May 1999, lot 2, illus.
59 Exhibited Nelson Bell Gallery, Belfast, 1998.
60 Waterhouse, *Dictionary*, op. cit., p. 416.
61 Sydney Andrews, in John Burls (ed.), *Nine Generations, a History of the Andrews family, Millers of Comber*, Ipswich, 1958, includes several illustrations attributed to Wheatley, which are almost certainly Wilson's.
62 British Museum.
63 R. W. Lightbown, 'John Williams alias Anthony Pasquin', an introduction to the reprint of Pasquin's *Memoirs of the Royal Academicians and An Authentic History of the Artists of Ireland …*, London, 1970, p. 5. The Adelphi Club is reproduced in W. T. Pike (ed.), *Belfast and the Province of Ulster*, Brighton, 1909, p. 98.
64 Sotheby's Irish sale, 18 May 2001, lot 123, and William Laffan (ed.), *The Art of a Nation: Three Centuries of Irish Painting*, Pyms Gallery, London 2002, pp. 27–37 for a full discussion.
65 An unpublished thesis for A Level by A.T.G. Brett of Belfast is the best catalogue of the artist's surviving works: also David A. Cross, 'George Romney's Pupils', *Transactions of the Romney Society*, vol. 2, 1997, p. 18, records that Robinson was introduced to Romney in 1784/5 by John Christian Curwen of Belle Isle, Windermere. The 'Gothick' picture (Fig. 222) was influenced by Romney's subject picture drawings and Bishop Percy's *Reliques of Ancient English Poetry* (1765 and later editions) was probably the source of the subject. Robinson was President of the Society of Artists, Dublin, 1809–10.
66 Sotheby's, 31 March 1976, lot 51.
67 Edward Malins and The Knight of Glin, *Lost Demesnes*, London, 1976, illustrated on p. 132.
68 *Portraits*, p. 60, no. 84, illus., where it is discussed in detail in an entry by T. Pakenham.
69 A summary of the complicated history of this picture, taken from Jean Agnew and Maria Luddy (eds), *The Drennan McTier Letters*, Dublin, 1998–9, is in Fintan Cullen, *Sources in Irish Art*, Cork, 2000, pp. 232–4. W.A. Maguire *Up in Arms: The 1798 Rebellion in Ireland*, Belfast 1998.
70 Eileen Black, *Paintings, Sculptures and Bronzes in the collection of the Belfast Harbour Commissioners*, Belfast, 1983, p. 37.
71 Caldwell MSs, kindly communicated by Jane Meredith.

72 *Rutland Mss*, vol. III, p. 268, a letter from Reynolds dated 14 December 1785.
73 Ibid., p. 241, Reynolds's letter of 10 September 1785.
74 Croft-Murray, vol. II, p. 214, no. 7.
75 TCD, MS 4029, f2, (D.A. Beaufort Tour, 1788).
76 John Gilmartin, 'Vincent Waldré's ceiling paintings in Dublin Castle', *Apollo*, vol. XCV (January 1972), pp. 42–7.
77 Royal Irish Academy, MS no. 24K14, p. 253, 6 July 1801.
78 Róisín Kennedy, *Dublin Castle Art*, Dublin, 1999, pp. 18–23, illus.
79 Edward McParland, 'A Note on Vincent Waldré', *Apollo*, vol. XCV (November 1972), p. 46.
80 Information brought to our attention by Aidan O'Boyle.
81 Philip McEvansoneya, 'a colourful spectacle restored: the state coach of the Lord Mayor of Dublin', *Irish Arts Review Yearbook*, 2001, vol. 17, pp. 80–7.
82 Brian FitzGerald (ed.), *The Correspondence of Emily, Duchess of Leinster*, 3 vols, Dublin, 1949–53, vol. III, p. 156 (10 September 1775) on the decoration of Frascati, Blackrock.
83 Ann Keller, 'The Long Gallery of Castletown House', *Bulletin of the Irish Georgian Society*, vol. XXII (1979), pp. 1–53.
84 Croft-Murray, vol. II, p. 273.
85 Keller, op. cit., pp. 14–16, illus, p. 3.
86 Aidan O'Boyle, 'Aldborough House, Dublin: a construction history,' *Irish architectural and decorative studies, The Journal of the Irish Georgian Society*, vol. IV, 2001, pp. 103–141.
87 Aldborough Diary 1798, NLI MS 19,165, kindly communicated to us by Aidan O'Boyle.
88 Augustus J. C. Hare, *The Story of Two Noble Lives*, London, 1893, vol. I, pp. 9–10, and Ethel M. Richardson, *Long Forgotten Days*, London, 1928, pp. 322–3.
89 Of about 1860, collected by the Revd Walter Lawrence, late of the Austrian Hussars, now in the Galway County Archives. We are indebted to George Gossip for his help in listing and photographing this album.
90 Information from Father Egan, P. P. Portumna, who showed us copies of descriptions of Bellevue now deposited at Garbally College, Ballinasloe.
91 Rose E. McCalmont in Charles R. B. Barrett (ed.), *Memoirs of the Binghams*, London, 1915, pl. opp. p. 134, and Gordon St George Mark, 'Tyrone House', *Bulletin of the Irish Georgian Society*, vol. XIX, nos 3 and 4 (July–December 1976), illustration of Anne Bingham.
92 Hamilton Osborne King sale, Dublin, 6 June 2000, lot 508. It came from the Loreto Convent, Rathfarnham.
93 This information was brought to our attention by Thomas Pakenham, who owns a copy of the pamphlet on the case: *A Full and Accurate Report of the Trial of Sir John Piers, for Criminal Conversation with Lady Cloncurry*, Dublin, 1807.
94 Croft-Murray, vol. II, p. 209.
95 Ada K. Longfield, 'Some wall-paintings in Ireland in the 18th and early 19th centuries', in *JRSAI*, Centenary Volume, 1949, pp. 84–90.
96 Transcript in the possession of Edward McParland of Coote MSs, which shows that Gabrielli was arranging for pictures and statuary to be sent to Ballyfin, another mansion by Richard Morrison, in 1821 and 1822.
97 Croft-Murray, vol. II, p. 305.
98 Ibid., p. 252.

12. After the Act of Union

1 The Knight of Glin, 'Irish Interiors and Furniture', *Discovering Antiques*, part 49 (1971), p. 1.
2 Maria Edgeworth, *Tales and Miscellaneous Pieces*, 8 vols, London, 1825, vol. VII, p. 48. *Ennui*, one of *The Tales of Fashionable Life*, was first published in 1809.
3 Royal Irish Academy, MS no.24K14, vol. II, pp. 242–5.
4 Ann M. Stewart, *Irish Art Loan Exhibitions*, Dublin 1990, 3 vols.
5 W. G. Strickland, *Dictionary of Irish Artists*, Dublin, and London, 1913, 2 vols, vol. II, pl. 57, illus.
6 See Ann M. Stewart, *The Royal Hibernian Academy of Arts*, Dublin 1985, 3 vols. This lists all pictures exhibited at the Academy exhibitions till 1979 and has a history of the RHA by Catherine de Courcy in the first volume.
7 Strickland, op. cit., vol. II, p. 639.
8 James White and Kevin Bright, *Treasures of the Royal Dublin Society*, Dublin, 1998, p. 52.
9 *Portraits*, p. 70, no. 101.
10 Róisín Kennedy, *Dublin Castle Art*, Dublin, 1999, pp. 32–3, illus.

11 'B' [pseud.], 'Biographical Sketch of Mr Cuming', *Walker's Hibernian Magazine*, June 1811, p. 330.
12 See chapter 10, note 13, also Figgis and Rooney, pp. 122–4.
13 Society of Artists, 1800, no. 33, Figgis and Rooney, pp. 114–16.
14 Information from a draft catalogue of the Art Institute of Chicago by Dr Malcolm Warner.
15 Róisín Kennedy, op. cit., p. 32, illus.
16 'B' [pseud.], op. cit., p. 332.
17 Alfred Ten Eyck Gardner, 'Ingham in Manhattan', *The Metropolitan Museum of Art Bulletin* (May 1952), pp. 245–53.
18 William Dunlap, *History of the Rise and Progress of the Arts of Design in the United States*, New York, 1834, Vol. II, p. 271.
19 *Watercolours*, p. 238, illus; Dita Amory, Marilyn Symes and others, *Nature Observed, Nature Interpreted*, National Academy of Design, New York, 1995, pp. 98–9, illus.
20 Martin Archer Shee, *The Life of Sir Martin Archer Shee*, 2 vols, London, 1860, vol. I, p. 19.
21 Ibid., p. 37.
22 Judy Egerton, *The British School*, National Gallery catalogue, London, 1998, pp. 410–13.
23 Lady Victoria Manners, *Matthew William Peters R.A.*, London, 1913, pl. opp. p. 20.
24 Joseph Farington, *The Diary of Joseph Farington* (Yale Edition), New Haven and London, 1978–98, 17 vols, vol. 6 (1979), p. 2299 (17 April 1804).
25 Photocopy of typescript of the *Receipts of Martin Archer Shee*, NGI Library, L6.
26 William Sandby, *The History of the Royal Academy of Arts*, 2 vols, London, 1862, vol. 2, p. 141.
27 Shee, op. cit., vol. 1, chapter 9.
28 Lord Byron, *English Bards, and Scotch Reviewers*, 3rd edition, London, 1810, p. 66.
29 'B'[pseud], op. cit., p. 330.
30 Paul Caffrey, *John Comerford and the Portrait Miniature in Ireland c.1620–1850*, Kilkenny, 1999, p. 11 and *Treasures to Hold*, NGI, 2000.
31 Information from the Revd Edmund Langton Hayburn of Concorde, California.
32 Thomas J. Mulvany (ed.), *The Life of James Gandon …*, Dublin, 1846, pp. 153–4.
33 P Caffrey, *Treasures to Hold, Irish and English miniatures 1650–1850*, exhibition, NGI Dublin, 2000, p. 117, no. 100.
34 The anonymous diarist frequently mentions Kirchhoffer, (RIA, MS no. 24K14).
35 Kennedy, op. cit., pp. 75–6, illus.
36 *Portraits*, cover, illus.
37 Granard Papers, PRONI 2/31/1–4. We are indebted to Valerie Pakenham for bringing this to our attention.
38 *Watercolours*, p. 126, illus.
39 *Watercolours*, pp. 129–30.
40 Paul Oppé, *English Drawings – Stuart and Georgian Periods …at Windsor Castle*, London, 1950, p. 81, where the drawings are ascribed to Pope. The actor is labelled 'Mr Kemble', the other 'Mrs Siddons', though Oppé thought her unrecognizable as such.
41 Shee, op. cit., vol. I, p. 93.
42 Many of his paintings are mentioned in the MS list of the cases of pictures, all lost, containing works by the West family, Dublin, National Archive M3417.
43 Christie's Irish sale, 17 May 2001, lot 76.
44 Information from a scrapbook about Foster compiled by his friend Thomas Crofton Croker, given to us by William Laffan. Another artist of the period who should be mentioned is John James Masquerier (1778–1855). He was a French artist who paid several visits to Ireland, painting society portraits including John Philpot Curran and was patronised by the Donegal family. His most notable Irish portraits are of the two daughters of the second Marquess of Donegal giving alms to a beggar (Lane Fine Art), and another where their mother dressed as a gypsy, tells the fortunes of members of her family. (RRM see, *Masquerier and his Circle*, London 1922, illus. pl. 111).
45 Sotheby's, 23 February 1926, lot 58.
46 *Watercolours*; for the Grattans, see pp. 135–7, illus.
47 A pattern or patron was the celebration of a patron saint's day, usually involving a fair.
48 *Watercolours*, p. 135, illus.
49 W. H. Crawford, 'The Patron, or Festival of St Kevin at the Seven Churches, Glendalough, County Wicklow 1813', in *Ulster Folklife*, vol. 32, (1986), pp. 37–47.
50 *Painters*, p. 196, illus.
51 Ibid., p. 182, illus. and *Watercolours* pp. 150–1.
52 *Watercolours*, pp. 154–5, illus.

13. Genre, Landscape and Seascape in the First Half of the Nineteenth Century

1 William Laffan, 'William Sadler', in The *Sublime and the Beautiful: Irish Art 1700–1830*, Pym's Gallery, London, 2001, p. 141.
2 William Laffan, 'William Sadler II, The Battle of Waterloo', in *Masterpieces by Irish Artists*, Pyms Gallery, London, 1999, pp. 52–61.
3 Wanda Ryan Smolin, *Irish Arts Review Yearbook*, vol. 12 (1996), p. 66.
4 William Laffan, 'The Battle of Waterloo', op. cit., pp. 52–61, illus.
5 *Watercolours*, p. 173, illus.
6 Róisín Kennedy, *Dublin Castle Art*, Dublin, 1999, frontispiece, illus.
7 Cyril Barrett, 'MichaelAngelo Hayes, RHA, and the Galloping Horse', *The Arts in Ireland* vol. I, no. 3, Dublin (1972/3), pp. 42–7.
8 A. C. Mulvany (ed.), *Letters from Professor Thomas J. Mulvany, RHA, to his eldest son William T. Mulvany Esqre … from 1825–1845* (n.p), 1908.
9 Ibid., p. 51. In a letter of 27 December 1831.
10 Ibid., pp. 75–6. In a letter of 24 July 1840.
11 Ibid., p. 76.
12 Ibid., p. 97. In a letter of 25 August 1822.
13 Cyril Barrett, *Irish Art in the Nineteenth Century*, Cork, Crawford Art Gallery exhibition 1971, p. 8.
14 Patricia Butler, *The Brocas Collection*, National Library of Ireland, Dublin, 1997, p. 18, illus.
15 Several are illustrated in Butler, ibid., and in the authors' book, *The Watercolours of Ireland*, London, 1994, p. 140.
16 Major Guy Paget, *The Melton Mowbray of John Ferneley*, Leicester, 1931, pp. 16–18.
17 Sotheby's Irish sale, 2 June 1995, lots 235–8.
18 Sally Mitchell, *The Dictionary of British equestrian artists*, Woodbridge, 1985, p. 406, illus.
19 Ibid., colour plate, p. 89, which does not identify the family depicted. See also pp. 98–9 for further information about this artist.
20 Christie's Irish sale, 17 May 2001, lot 81. For Maguire see William Laffan (ed.), *The Art of a Nation: Three Centuries of Irish Painting*, Pyms Gallery, London, 2002, pp. 49–53, entry by Eileen Black.
21 There are two artists of the name James Mahoney, but the second one, about whom little is known, was not a watercolourist but an engraver and illustrator. For further information, see *Watercolours*, pp. 185–7 and Nancy Netzer, 'Picturing an Exhibition: James Mahony's Watercolors of the Irish Industrial Exhibition of 1853', in Adele M. Dalsimer (ed.), *Visualizing Ireland: National Identity and the Pictorial Tradition*, Boston and London, 1993.
22 *Country Life* (3 July 1997) p. 74.
23 Sotheby's, 6 July 1977, lot 53.
24 Anne Crookshank, Desmond FitzGerald, Desmond Guinness and James White, *Irish Houses and Landscapes*, exhibition catalogue, Ulster Museum 1965, p. 30, no. 61.
25 *Watercolours*, pp. 188–9, illus., and the Limerick exhibition catalogue of 1821 is in the Limerick City Library. See also Maurice Grant, *A Chronological History of the Old English Landscape Painters*, London, 1961, vol. VIII, p. 628.
26 Signed with a monogram.
27 *Painters*, p. 189, illus.
28 *Watercolours*, p. 142, illus.
29 Patricia Butler, *The Brocas Collection*, National Library of Ireland, 1997.
30 Christie's, 18 November 1988, lot 69.
31 *Watercolours*, p. 143. For the Brocases in general, see pp. 139–44, illus. and Butler, op. cit., illus.
32 *Irish Topographical Pictures*, exhibition held in the Cynthia O'Connor Gallery, Dublin, 1976, no.30 and cover plate; see also Michael Wynne 'James Hore, Gentleman View-Painter, *Irish Arts Review*, vol. 2 (spring 1985), pp. 38–42.
33 Gorry Gallery, July 1999, no. 10. The picture may be *The Bay of Carlingford taken from near the Hilltown Road*, RHA, 1826, no. 62.
34 Gorry Gallery, November 1992, no. 27, illus.
35 Lord John Russell (ed.), *Memoirs … of Thomas Moore*, London, 1856, vol. viii, pp. 273–4. We are indebted to Helen O'Neill for this information.

36 Introduction to the exhibition catalogue, *Jeremiah Hodges Mulcahy and his circle*, Cynthia O'Connor Gallery, August 1980.
37 Sotheby's, 14 November 1990, lot 111.
38 Christie's, Belfast, 26 October 1990, lot 164.
39 Information kindly given by Stella Harte.
40 Also known as McDaniel.
41 Christie's, Belfast, 26 October 1990, lot 167.
42 For a study of famine pictures, see James S. Donnelly, *The Great Irish Potato Famine* , Stroud, 2001.
43 Gallery, November–December 1990, no. 25.
44 *Andrew Nicholl, 1804–86*, an exhibition catalogue, Ulster Museum, 1973, which contains numerous illustrations of his work and an excellent introduction by Martyn Anglesea.
45 Exhibition compiled by Martyn Anglesea in the Ulster Museum, *Portraits and Prospects*, Belfast, 1989, p. 78; see also R. K. de Silva exhibition of *Andrew Nicholl* in the National Museum, Colombo, 1998.
46 Nicholl wrote up his experiences in Ceylon in articles in the *Dublin University Magazine* entitled 'A sketching tour of five weeks in the forests of Ceylon – its ruined temples, colonial statues, tanks, dagobaths etc.', (November and December 1852), pp. 527–40 and 691–700 respectively.
47 *Watercolours*, pp. 117–19, illus.
48 *James Moore 1819–83*, an exhibition catalogue, Ulster Museum, 1973, which contains many illustrations, including all the works mentioned.
49 Ibid., p. 5.
50 *Watercolours*, pp. 165–6, illus. p. 166.
51 John K. Howat, 'A picturesque site in the Catskills: the Cauterskill falls as painted by William Guy Wall', *Honolulu Academy of Arts Journal*, vol. 1 (1974), pp. 16–29, quoted in Edward K. Nygren, *Views and Visions, American Landscape before 1830*, Washington, 1986, p. 173.
52 Whyte's *Irish Art*, Dublin, 13 March 2001, lot 81.
53 *Watercolours*, pp. 238–40, illus.
54 *Watercolours*, p. 241 illus.
55 *Watercolours*, pp. 248–9, illus; Henry C. Campbell, *Early days on the great lakes, the art of William Armstrong*, Toronto-Montreal, 1971, illus.; R. H. Hubbard, *Canadian Landscape Painting, 1670–1930, The Artist and the Land*, Madison, 1973, p. 187.
56 *Watercolours*, pp. 244–5, illus.
57 *Watercolours*, pp. 243–4 and illus. Honor de Pencier, *Posted to Canada*, Toronto, 1987, illus.
58 Edith Firth, *Toronto in Art*, Toronto 1983, pp. 26–7, illus.
59 Joan Kerr (ed.), *The Dictionary of Australian Artists*, Melbourne 1992, pp. 206–07 illus. See also Patricia R. McDonald and Barry Pearce, *The Artist and the Patron – Aspects of Colonial Art in New South Wales*, Sydney, 1988, pp. 95–96 and another portrait attributed to Dennis is shown pp. 61–62.
60 Ibid., pp. 17–18, illus.
61 Ibid., pp. 219–20.
62 Ibid., pp. 226–7, illus.
63 Peter Sheen in Joan Kerr (ed.), *The Dictionary of Australian Artists*, Oxford, 1992, pp. 856–7, illus.
64 Tim Bonyhady, *Images in Opposition, Australian Landscape Painting 1801–1890*, Melbourne, 1981, pp. 109–15.
65 *Australian Dictionary of Biography*, Melbourne, 1972, vol. 4; Lee Astbury, 'George Folingsby', in Ann Galbally and Margaret Plant (eds) *Studies in Australian Art*, Melbourne, 1978.
66 See Eileen Black in Kerr, op. cit., pp. 866–7, where all references to Wilson are given.
67 *Painters*, pp. 203–4, illus.
68 Gorry Gallery, *The Hookers*, June 1977 and *Slea Head*, November–December 1990.
69 Anne Crookshank, Knight of Glin and William Laffan, *Masterpieces by Irish Artists 1660–1860*, Pyms Gallery, London, 1999, pp. 62–6, illus.
70 *Masterpieces*, no. 10, illus.
71 John Munday, *E. W Cooke 1811–1880: A Man of his Time*, Woodbridge, 1996, pls 152 and 72, pp. 232 and 301.
72 Christie's Irish sale, 22 May 1998, lot 127.
73 Gorry Gallery, May–June 1998, no. 9.
74 *Cork Examiner*, 22 January 1845, p. 2, col. 4.
75 Christie's, Irish Paintings and Drawings, 26 May 1989, lot 251.
76 Elizabeth Muir Robinson, *W. A. Coulter: Marine Artist*, Sausalito, 1981, illus. This booklet is a short account of his life and works. He is also mentioned in Theo Snoddy, *A Dictionary of Irish Artists, 20th Century*, Dublin, 1996, pp. 83–4.

14. Petrie, Danby and O'Connor

1 J. P. Neale, *Views of Seats of Noblemen and Gentlemen in the United Kingdom*, 11 vols, London, 1818–23 and 1824–9.
2 James N. Brewer, *The Beauties of Ireland*, 2 vols, London, 1825–6.
3 William Stokes, *Life and Labours in Art and Archaeology of George Petrie*, Dublin, 1868, pp. 7–9.
4 George Petrie, 'Ecclesiastical Architecture of Ireland anterior to the Anglo-Norman invasion', *The Transactions of the Royal Irish Academy*, vol. XX, Dublin, 1845.
5 Stokes, op. cit., p. 11.
6 Ibid., p. 21.
7 Ibid., p. 395.
8 William Makepeace Thackeray, *The Irish Sketchbook*, 1842, London, 1843, Belfast and Dover, New Hampshire edition, 1985, pp. 21–2. For further information on Petrie, see *Watercolours*, pp. 161–3, illus.
9 An exhibition of his work was held in the NGI in 1995, when a full catalogue was issued with essays by many scholars. Drawings are to be found in the Natural History Museum, the Geological Society, the Royal Society of Antiquaries and the National Botanic Gardens, as well as the NGI and the RIA.
10 John Hutchinson, *James Arthur O'Connor*, catalogue of an exhibition held in the NGI, Ulster Museum and Crawford Art Gallery Cork, 1985–6, p. 84.
11 Ibid., p. 2.
12 J. Dowling Herbert, *Irish Varieties …*, London, 1836, p. 57.
13 Letter from Danby to John Gibbons dated 29 February 1836, still owned by a descendant (information from John Hutchinson).
14 William Laffan (ed.), *The Sublime and the Beautiful: Irish Art 1700–1830*, Pyms Gallery, London 2001, pp. 152–69, for an entry on this picture by Brendan Rooney.
15 *Painters*, pp. 212 and 213, illus.
16 We are indebted for much of this information to John Hutchinson whose unpublished M.Litt. thesis (TCD) on the artist was the basis for the catalogue, see footnote 10.
17 Letter from O'Connor to John Gibbons dated August 1830, still owned by a descendant (information from John Hutchinson).
18 There is a pencil and wash drawing in the RA of *The Angel Appearing to the Shepherds* which is after Rembrandt, and *Walker's Hibernian Magazine* for May 1810, p. 312, describes in a Critical Notice 'Three Etchings', which sound close to Teniers in subject-matter.
19 Martyn Anglesea, 'Five unpublished drawings by Francis Danby', *Burlington Magazine*, vol. CCVII (January 1975), pp. 47–8, where the four in the Ulster Museum are illustrated.
20 Eric Adams, *Francis Danby*, New Haven and London, 1973. All the works mentioned by Danby are illustrated in this biography.
21 This theory is accepted and discussed fully by Francis Greenacre in the exhibition catalogue *Francis Danby 1793–1861*, Tate Gallery and City of Bristol Museum and Art Gallery, 1988, p. 78, illus.
22 Stokes, op. cit., p. 8.
23 Adams, op. cit., pp. 8–16.
24 G. F. Waagen, *Treasures of Art in Great Britain …*, 4 vols, London, 1854–7, vol. IV, p. 177.
25 Adams, op. cit., pp. 21–3; Greenacre, op. cit., pp. 91–3, illus.
26 Adams, op. cit., p. 102; Greenacre, op. cit., pp. 113–14.
27 Adams, op. cit., p. 104.
28 Stokes, op. cit., pp. 8 and 10.
29 Adams, op. cit., p. 115.
30 F. M. Redgrave, *Richard Redgrave, CB, RA: A Memoir …*, London, 1891, p. 251, in a diary entry for 23 February 1861.
31 Greenacre, op. cit., illus. p. 48 and pp. 93–5 and the latter is illus. p. 57 and pp. 118–19.

15. Portraits and Subject Pictures in the Nineteenth Century

1 Jeanne Sheehy, *The Rediscovery of Ireland's Past. The Celtic Revival*, London, 1980; Fergus O'Farrell, 'Daniel O'Connell, the "Liberator", 1775-1847: Changing Images', in Raymond Gillespie and Brian P. Kennedy (eds) *Ireland Art into History*, Dublin and Colorado 1994, pp. 91–102.
2 The earlier, 1844, is now in Limerick University and the later in the NGI.

53 Christie's Irish sale, 17 May 2001, lot 73; Department of Irish Folklore, University College, Dublin.

3 *Crawford Municipal Art Gallery summary catalogue*, Cork, 1991, p. 170.
4 Michael J. F. McCarthy, *Five Years in Ireland, 1895–1900*, 6th ed., London and Dublin, 1901, p. 351.
5 Eamonn Mallie (ed.), *One Hundred Years of Irish Art*, Belfast, 2000, p. 148, illus. 149.
6 *Derrynane Abbey*, Official Guide Book, published by Office of Public Works, Dublin. Three pictures by Gubbin are illustrated.
7 *The Nation* was a newspaper of the time.
8 Peter Murray, 'Artist and Artisan: James Brenan as Art Educator', in *America's Eye: Irish Paintings from the Collection of Brian P. Burns*, edited by Adele M. Dalsimer and Vera Kreilcamp, Boston College of Art, 1996, pp. 40–6.
9 Peter Murray in *Irish Art 1770–1995, History and Society. A touring exhibition from the collection of the Crawford Municipal Art Gallery*, Cork, 1995, pp. 22–5.
10 Claudia Kinmonth, *Irish Country Furniture 1700–1950*, New Haven and London 1993. Her book and articles give the best information on rural life and interiors. Other artists who worked in this genre of peasant interiors are David Wilkie (1785–1841) who was in Ireland in 1835 and painted two pictures, one called *Peep-o'-day Boys' Cabin* (Tate Britain) and whose early style was so influential; Edward Lees Glew (1817–70) who spent much of his working life in America painted and wrote an article on *Donnybrook Fair* (see Brendan Rooney, 'All the Fun of the Fair', *Irish Arts Review*, Summer 2002, pp. 100–4; Alfred Downing Fripp (1822–95) one of several English artists we dealt with in *Watercolours*, chapter 10, who visited Ireland three times mainly painting watercolours but in 1863 he exhibited 'Interior of a Galway Cabin', in the RHA.
11 Peter Murray, op. cit., p. 89, illus.
12 *Whitley Papers*, vol. X, p. 1309.
13 Christie's Irish sale, 20 May 1999, lot 140.
14 Strickland quotes from a pamphlet by Richard Rothwell, *Letters addressed to the Right Honourable the Earl of Granville, KG, … containing an appeal against the injustice … of the persons to whom the hanging of the pictures was entrusted*, Dublin, 1862.
15 *Portraits*, p. 75, no. 114.
16 *Portraits*, p. 75, no. 113, illus.
17 Sotheby's, Moyglare House, 13 and 14 December 1976, lot 536, illus.
18 Cyril Barrett, *Irish Art in the 19th century*, ROSC exhibition, Crawford Art Gallery, Cork, 1972, no. 24.
19 Sotheby's Irish sale, 21 May 1999, lot 280, illus.
20 Sotheby's, 2 June 1995, lot 209.
21 Hamilton Osborne King, Dublin, 20 November 1996, lot 354.
22 Margaret MacCurtain, 'The Real Molly Macree', in Adele Dalsimer (ed.), *Visualizing Ireland*, Boston and London, 1993, pp. 921.
23 Nancy Weston, *Daniel Maclise, Irish Artist in Victorian London*, Dublin, 2001, is the most recent biography of Maclise.
24 Richard Ormond and John Turpin, *Daniel Maclise 1806–70*, catalogue of an exhibition organized by the Arts Council of Great Britain in the NPG and the NGI (1972), illus. p. 20, no. 1.
25 Ibid., p. 47, no. 48, illus.
26 Ibid., p. 54, no. 61, illus.
27 London, 1841.
28 First published in London 1807; the edition illustrated by Maclise was published in London in 1845.
29 Ormond and Turpin, op. cit., pp. 73–9, where details of its very interesting iconography are given.
30 Ibid., p. 58, no. 63, illus.
31 Nancy Weston, op.cit, p. 72.
32 William J. O'Driscoll, *A Memoir of Daniel Maclise*, London, 1871, p. 224. The picture is included in a list of unexhibited works drawn up by Maclise and recorded as commissioned by Lord Lytton. We are indebted to the late Sydney Sabin, who drew this picture to our attention.
33 John Turpin, 'German Influence on Daniel Maclise', *Apollo*, xcvii, 1973, pp. 169–75.
34 Ormond and Turpin, op. cit., pp. 81–9.
35 Ibid., p. 92, no. 98, illus.
36 Ibid., p. 64, no. 70; p. 66, no. 71, and p. 99, no. 104 illus.
37 Ibid., p. 74, no. 80, illus.
38 A seminar on the picture was held in the NGI in 2001, where every aspect was discussed. The contribution of Raghnall Ó Floinn, on the 'Antiquarian influences in the Marriage of Strongbow and Aoife' was particularly important.

39 Ibid., pp. 110–11, nos. 117 and 121, illus.
40 William Michael Rossetti, *Fine Arts, Chiefly Contemporary: Notices Reprinted, with Revisions*, London, 1867, p. 245.
41 Walker Art Gallery, Liverpool.
42 Anne Rorimer, *Drawings by William Mulready*, exhibition catalogue, V & A, London, 1972, p. 33.
43 Alison Smith, (ed.), *Exposed: the Victorian nude*, exhibition, Tate Britain, London, 2001, no. 22, p. 83.
44 Rorimer, op. cit., p. 32, no. 35; *Painters*, p. 242, illus.
45 Rorimer, op. cit., p. 56–7, nos. 77, 78 and 79.
46 William Holman Hunt, *Pre-Raphaelitism and the Pre-Raphaelites*, 2 vols, London, 1905, vol. I, p. 95.
47 Paul Caffrey, *Treasures to Hold: Irish and English Miniatures 1650–1850*, Dublin NGI 2000, pp. 135–7.
48 Unpublished MS (NGI) and quoted in an unpublished BA thesis (TCD, 1976) by Jane McFarlane on Burton.
49 *Watercolours*, p. 183, quoting a letter to Robert Callwell dated 1840, transcribed by Margaret Stokes for Burton's *Biography*, NGI.
50 Ibid.
51 Richard Ormond, 'Helen Faucit', *Country Life* (7 December 1976), p. 1507.
52 Cyril Barrett, 'Irish Nationalism and Art 1800–1921', *Studies* (Winter 1975), pp. 393–409.
53 Unpublished MS owned by a descendant of Burton and quoted in an unpublished BA thesis (TCD, 1976) by Jane McFarlane on Burton.
54 Marie Bourke, 'The Aran Fisherman's Drowned Child', *The GPA Irish Arts Review Yearbook, 1988*, p. 193; Marie Bourke, 'Frederick William Burton 1816–1900', *Eire Ireland*, vol. XXVIII, Fall 1993, no. 3, pp. 45–60.
55 Ibid.
56 Quoted in sale catalogue, Christie's, 11 November 1999, lot 21, where there is an extensive entry on Burton and his works.
57 H. C. Marillier, *The Liverpool School of Painters*, London 1904, p. 99.
58 Ibid., p. 101.
59 Christie's, 9 June 1995, lot 330.
60 Marillier, op. cit., p. 108.
61 Allen Staley, *The Pre-Raphaelite Landscape*, Oxford, 1973, p. 144.
62 Marillier, op. cit., p. 112.
63 Ibid., p. 112; Sotheby's, 27 March 1996, lot. 120.
64 Frederick Cummings and Allen Staley, *Romantic Art in Britain … 1760–1860*, catalogue of an exhibition held in Detroit and Philadelphia, 1968, p. 279, in an entry by Allen Staley.
65 *The Times*, 5 May 1866.
66 *Watercolours*, pp. 192–4, illus.
67 Brian P. Kennedy, *Irish Painting*, Dublin 1999, p. 20, p. 77, illus.
68 Adele M. Dalsimer and Vera Kreilkamp, *America's Eye: Irish Paintings from the Collection of Brian P. Burns*, Boston, 1996, p. 86. Entry by Catherine Marshall; see also Kevin Whelan interpreting this picture on pp. 57–61.
69 Julian Hawthorn, *Shapes that Pass*, London, 1928, p. 119: see also William Laffan (ed.), *The Art of a Nation: Three Centuries of Irish Painting*, Pyms Gallery, London, 2002, pp. 64–8. Entry by Brendan Rooney for a full discussion.
70 Theo Snoddy, *A Dictionary of Irish Artists, 20th century*, Dublin, 1996, pp. 168–9.
71 *Painters*, p. 250, illus.
72 A. L. Baldry, 'Our rising artists; St George Hare', *Magazine of Art* (1899–1900) p. 372, illus.
73 *Watercolours*, p. 263–4, p. 266, illus.
74 Information from Tony Mitchell, late of the National Trust. Brendan Rooney is publishing an article in 2002 on this artist for the Limerick Civic Trust.
75 Snoddy, op. cit., pp. 393–4.
76 Snoddy, op. cit., pp. 265–6.

16. The Influence of Continental Europe and England in the Late Nineteenth Century

1 Thomas Bodkin, *Four Irish Landscape Painters*, Dublin and London, 1920. This includes many illustrations of Hone and a list of his pictures; also Julian Campbell, *The Irish Impressionists*, catalogue of an exhibition, NGI, 1984, chapter 4, Nathaniel Hone; and J. Campbell, *Nathaniel Hone the Younger*, NGI, 1991.
2 Albert Boime, *The Academy and nineteenth century French painting*, London, 1971, p. 74.
3 Brian Fallon, *Irish Art 1830–1990*, Belfast, 1994, p. 46.

4 George Moore, 'Modern Landscape Painters à propos of Mr Hone', *A loan Collection of Pictures by Nathaniel Hone RHA and John Butler Yeats RHA*, Dublin, 1904, pp. 6 and 5 respectively.
5 Julian Campbell, *Nathaniel Hone the Younger*, catalogue of an exhibition held in the NGI in 1991, pp. 14 and 15.
6 Mary Stratton Ryan, 'Augustus Nicholas Burke, R.H.A.', in *Irish Arts Review Yearbook*, 1990–1, pp. 103–10.
7 Julian Campbell, *Peintres irlandais en Bretagne*, catalogue of an exhibition held in the Musée de Pont-Aven, 1999, pp. 10–12.
8 Hilary Pyle, *Irish Art 1900–50*, ROSC exhibition, Cork, 1975–6, p. 25, no. 20.
9 Like so many Victorian paintings, both of these were in exhibitions at the Gorry Gallery, Dublin.
10 Will H. Low, *A Chronicle of Friendships 1873–1900*, London, 1908, pp. 67–8.
11 Anon, 'The Late Frank O'Meara', *The Scottish Art Review*, vol. I, no. 6 (Nov. 1888), p. 156.
12 Christie's, Irish sale, 20 May 1999, lot 189, with an extensive essay.
13 Julian Campbell, *Frank O'Meara and his contemporaries*, exhibition, Hugh Lane Gallery, Dublin; Crawford Gallery, Cork; Ulster Museum, Belfast, 1989, pp. 45–6.
14 Helen M. Trevor, *The ramblings of an artist; selections from the letters of H. M. Trevor to E. H.*, London, 1901.
15 For further discussion of the Antwerp Academy, see J. Campbell, *The Irish Impressionists*; Jeanne Sheehy, 'The Irish at Antwerp', in *Irish Arts Review Yearbook*, (1994), pp. 163–6; and J. Sheehy, 'The flight from South Kensington: British Artists of the Antwerp Academy, 1877–1885', *Art History*, vol. 20, no. 1, March 1977.
16 R. Jope-Slade, '"The Outsiders", some eminent artists of the day not members of the Royal Academy', in *Black and White Handbook to the RA and New Gallery Exhibitions*, London, 1893, p. 8.
17 Archibald S. Hartrick, *A Painter's Pilgrimage through fifty years*, Cambridge, 1939, p. 28.
18 Jeanne Sheehy, *Walter Osborne*, Ballycotton, Co. Cork, 1974. A large number of his works are illustrated in this book and we are greatly indebted to it for our information on Osborne and the whole period in Ireland. This book is referred to as Sheehy below in this chapter. The biographer of Lavery is Kenneth McConkey, *Sir John Lavery*, Edinburgh 1993, illus.; of Orpen, Bruce Arnold, London 1981, illus.
19 Ibid., pp. 20–1, where a letter of 12 October is quoted in full.
20 *Irish Times*, 11 December 1902.
21 Information kindly given by Robert O'Byrne. Lane got Humphrey Ward, art critic of the *London Times*, and Morland Agnew, head of Agnew's, to confirm the attribution to Reynolds.
22 Robert Anderson, 'Whistler in Dublin', in *Irish Arts Review*, 1986, vol. 3, no. 3, pp. 45–51.
23 Walter Osborne exhibition NGI 1983, p. 108, no. 53. Catalogue by Jeanne Sheehy.
24 Fallon, op. cit., p. 47.
25 Christie's Irish sale, 20 May 1999, lot 173, illus.
26 Sheehy, op. cit., p. 37.
27 J. Campbell, *The Irish Impressionists*, 1984.
28 *Celtic Splendour*, Pyms Gallery exhibition, London, 1985, p. 44.
29 J. Campbell, op. cit., p. 88 and *Peintres irlandais en Bretagne*, catalogue of an exhibition held in the Musée de Pont Aven, 1999, pp. 78–83.
30 Niamh O'Sullivan., *Aloysius O'Kelly*, Dublin, 1999, p. 28, catalogue of an exhibition held in the Hugh Lane Gallery, 1999.
31 Julian Campbell, 'A Double Identity Aloysius O'Kelly and Arthur Oakley', in *Irish Arts Review Yearbook*, vol. 16, 2000, pp. 81–5.
32 Christie's, Irish sale, 28 June 1995, lot 49, illus., where there is a useful discussion; James Thompson, *The East, imagined, experienced, remembered*, catalogue of an exhibition, NGI, 1988 no. 79; and Niamh O'Sullivan, *Aloysius O'Kelly*, 1999, no. 30, illus. p. 70.
33 *Watercolours*, p. 178, p. 180, illus.
34 Niamh O'Sullivan, *Aloysius O'Kelly*, catalogue of the exhibition held in the Hugh Lane Gallery in 1999, p. 10.
35 Exhibited *Peintres Irlandais en Bretagne*, Pont-Aven, 1999; and *Aloysius O'Kelly*, Hugh Lane Gallery, Dublin, 1999.
36 Julian Campbell, *Peintres Irlandais en Bretagne*, catalogue of an exhibition held in Pont-Aven in 1999, pp. 11, 13 and 46 and 47, illus.: Peter Murray, *Illustrated Summary of the Cork*

Municipal Art Gallery, Cork, 1991, p. 237; David Solkin, *Americans in Normandy and Brittany*, catalogue of an exhibition, Phoenix, 1982; J. Campbell, 'Thomas Hovenden, a Cork artist in Brittany and America', in *New Perspectives*, J. Fenlon, Nicola Figgis and Catherine Marshall (eds), Dublin, 1987, pp. 187–93.

37 Julian Campbell, *Peintres Irlandais en Bretagne*, Exhibition Musée de Pont-Aven, 1999, pp. 46–7, illus.

38 Ethna Waldron, 'Joseph Malachy Kavanagh', *The Capuchin Annual*, 1968, pp. 314–25, where many of the pictures referred to are illustrated.

39 Cyril Barrett, *Irish Art in the nineteenth century*, ROSC exhibition, Cork, 1971, no. 39, illus.

40 H. J. Thaddeus, *Recollections of a Court Painter*, London, 1912; J. Campbell, *The Irish Impressionists*, 1984; and Brendan Rooney, *The Life and Work of H. J. Thaddeus 1859–1929*, unpublished Ph.D. thesis, TCD, 2000. He will be publishing this work in 2002.

41 Brendan Rooney, 'Henry Jones Thaddeus', *Sale of Irish Art*, Gorry Gallery, Dublin, 1997, p. 5.

42 See Paul Usherwood and Jenny Spencer-Smith, *Lady Butler, Battle Artist 1846–1933*, National Army Museum, London, 1987; P. Usherwood, 'Lady Butler's Irish Pictures', *Irish Arts Review*, vol. 4, no. 4, pp. 47–9.

43 Fintan Cullen, *Sources in Irish Art*, Cork, 2000, pp. 85–96, who quotes Elizabeth Thompson's *An Autobiography*, London, 1922, pp. 199–200.

44 Brendan Rooney, 'Henry Jones Thaddeus: An Irish Artist in Italy', in *Irish Arts Review Yearbook*, 1999, pp. 126–33.

45 Illustrations of O'Conor's work can be found in the article by Denys Sutton, 'Roderic O'Conor ...', *The Studio*, vol. CLIX, 1960, and in the chapter on O'Conor in Wladyslawa Jaworska, *Paul Gauguin and the Pont-Aven School*, London, 1972; J. Campbell, *The Irish Impressionists*; Roy Johnston, *Roderic O'Conor, 1860–1940*, catalogue of exhibition, Barbican Art Gallery, London, 1985; Jonathan Benington, *Roderic O'Conor*, Dublin, 1992; Paula Murphy, *Roderic O'Conor*, Dublin 1992.

46 Clive Bell, *Old Friends*, London, 1956, p. 163.

47 Sutton, op. cit., p. 171.

48 Ibid., p. 173.

49 Bell, op. cit., p. 167.

50 J. Campbell, *The Irish Impressionists*, 1984.

51 Ibid., p. 163.

52 Sutton, op. cit., p. 174.

53 Ibid., p. 173.

54 Roy Johnston, *The Prints of Roderic O'Conor*, catalogue of an exhibition, Musée de Pont-Aven, 1999.

55 Bell, op. cit., p. 164.

56 Ibid., p. 165.

57 Sutton, op. cit., p. 194.

58 Ibid., p. 194.

59 Ibid., p. 173.

60 Paul Spellman, 'Recollections of Roderic O'Connor', *Irish Arts Review Yearbook*, 1998, vol. 14, pp. 84–9.

61 Bell, op. cit., p. 16.

62 The two Breton paintings discussed here, one of which came from the Doon Westmeath, were sold in Christie's *Sale of Irish Paintings*, Dublin, 6 June 1990 and 12 December 1990, respectively.

63 J. Campbell, 'A forgotten artist, Walter Chetwood-Aiken', in *Irish Arts Review Yearbook* (1995), pp. 164–7.

64 Adele M. Dalsimer and Vera Kreilkamp (eds), *America's Eye: Irish Paintings from the Collection of Brian P. Burns*, Waltham, Mass., 1996, pp. 122–3.

65 J. Campbell, *The Irish Impressionists*, op. cit.

66 J. Campbell, *Onlookers in France*, Crawford Art Gallery, Cork, 1993; and *Peintres Irlandais en Bretagne*, 1999.

67 Christie's, 24 Oct 1988, lot 30a.

68 Christie's, 15 March 1985, lot 84.

69 Brian P. Kennedy, *Irish Painting*, Dublin, p. 199

70 Brian Burns catalogue, op. cit., pp. 106–7.

71 *Irish Builder*, vol. XXXVIII, 1 May 1896.

72 J. Campbell, *The Irish Impressionists*; *Frank O'Meara and his Contemporaries*, 1989; P. Murray (ed), *Irish Art, History and Society*; T. Snoddy, *Dictionary of Irish Artists*.

73 *Irish Impressionists*, p. 234.

74 *Watercolours*, pp. 221–34, illus.

75 Raymond F. Brooke, *The Brimming River*, Dublin, 1961, pp. 82–5 where some facts about the early life of the artist are given; *Rose Barton*, exhibition catalogue, Crawford Gallery, Cork, 1986, by Rebecca Rowe and others.

76 Lennox Robinson, *Palette and Plough*, Dublin, 1948, p. 61.

77 Terence de Vere White, 'Art and the Irish Renaissance', article in *Aspects of Irish Art*, catalogue of an exhibition

78 Man of his works are illustrated in James White, *John Butler Yeats and the Irish Renaissance*, exhibition catalogue, NGI, 1972; William A. Murphy's biography, *Prodigal Father: The Life of John B. Yeats*, Ithaca and London, 1978, provides a detailed study of Yeats's career.

79 Elizabeth Coxhead, *Daughters of Erin*, London, 1965, p. 134.

80 See Murphy, op. cit., for a detailed account of this exhibition.

81 Bennard B. Perlman, *Robert Henri his life and work*, New York 1991, pp. 110–35, illus; William Innes Homer, *Robert Henri and his circle*, Ithaca and London, 1969, pp. 202–8, illus. Exhibition catalogue, Berry-Hill Galleries, New York (December–January, 1998–9), *Ashcan Kids*, pp. 9–12, illus.

82 Rockwell Kent *It's Me O Lord, the autobiography of Kent*, chapter 2, pp. 414–20 and chapter 3, pp. 421–3, describes the Irish visit: Fridolf Johnson, *Rockwell Kent An anthology of his works*, New York, 1982, illus; Scott R. Ferris and Ellen Pearce, *Rockwell Kent's forgotten landscapes*, Camden, 1998, illus.

83 See Coxhead, op. cit.; John O'Grady, *The Life and Work of Sarah Purser*, Dublin, 1996, for a detailed biography and catalogue raisonné of Purser's work; and J. O'Grady, 'Sarah Purser, 1848–1943', in *Capuchin Annual*, 1977. See also Mary Brennan Holahan, *A portrait of Sarah Purser*, Dublin, 1996.

84 Coxhead, op. cit., p. 129.

85 J. O'Grady, op. cit., pp. 28–31, cat. no. 41, p. 173.

86 Coxhead, op. cit., pp. 131–2.

87 J. O'Grady, op. cit., pp. 76, 221, catalogue no. 262; and plate 25, cat. no. 200, p. 207.

88 Coxhead, op. cit., plate 5, opp. p. 97.

89 Ibid., p. 131.

90 Ibid., p. 154. See also William Laffan (ed.), *The Art of a Nation: Three Centuries of Irish Painting*, Pyms Gallery, London, 2002, pp. 69–73. Entry by Kevin McConkey.

91 William Orpen, *Stories of Old Ireland and Myself*, London, 1924, pp. 41–2.

92 *Art Journal*, September 1890, no. 69, pp. 264–7.

93 See Frances Gillespie, *Edith Somerville*, catalogue of an exhibition, Castletownshend, 1984.

94 Sir John Lavery, *The Life of a Painter*, London, 1940, pp. 48–9. In this, together with the biographies listed in note 96, a great many of the painter's works are illustrated.

95 Ibid., p. 48.

96 Walter Shaw Sparrow, *John Lavery and his work*, London, 1912, pp. 53–4; Kevin McConkey, *Sir John Lavery*, Edinburgh, 1993.

97 Ibid., pp. 76–7, plate no. 6.

98 Snoddy, op. cit., p. 254.

99 Sparrow, op. cit., plate 9, illus.

100 Burns cat., op. cit., p. 75.

17. Orpen and his Shadow

1 Denys Sutton, 'The Heroic Energy of Cuchulain', *Apollo*, vol. LXXXIV (October 1966), pp. 256–9.

2 Adrian Frazier, *George Moore, 1852–1933*, New Haven and London, 2000, pp. 54–65, chronicles in great detail Moore's Paris life and his contacts with Manet and other French artists.

3 W. B. Yeats, *The Municipal Gallery Revisited*; the catalogue of an exhibition entitled *Yeats at the Municipal Gallery*, Dublin, 1959, reprinted the poem and illustrated most of the pictures mentioned in it.

4 Robert O'Byrne, *Hugh Lane*, Dublin, 2000.

5 Kenneth McConkey, *A Free Spirit. Irish Art 1860–1940*, Woodbridge, 1990, p. 42.

6 Frazier, op. cit., pp. 24–5.

7 Robert Becker, 'George Moore, Artist and Critic', *Irish Arts Review*, vol. 2, no. 3, 1985, pp. 49–55.

8 William Orpen, *Stories of Old Ireland and Myself*, London, 1924, p. 49.

9 *Catalogue of the Exhibition of Works by Irish Painters*, held in the Art Gallery of the Corporation of London, 1904, Honorary Director Hugh Lane; descriptive and biographical notes by A. G. Temple, F S A. For Lane, see Robert O'Byrne, *Hugh Lane*, Dublin, 2000.

10 William Orpen, op. cit., p. 55.

11 S. B. Kennedy, *Irish Art and Modernism 1880–1950*, Belfast, 1991, p. 15.

12 Ibid., p. 16.

13 For information on the Friends by various prestigious authors, see the catalogue of the exhibition held in the Hugh Lane Gallery, *75 years of Giving. The Friends of the National Collections of Ireland*, Dublin, 1999.

14 Paul George Konody and Sidney Dark, *William Orpen: Artist and Man*, London, 1932, plate XXVIII.

15 Bruce Arnold, *Orpen: Mirror to an Age*, London 1981, pp. 231–2.

16 K. McConkey, op. cit., p. 127.

17 Sotheby's Irish sale, 18 May 2001, lot 191.

18 Vivien Winch, *A Mirror for Mama*, London, 1965, illus. facing p. 12.

19 Andrew Wilton, *Swagger Portrait*, Tate Gallery, 1992, no. 73, p. 208.

20 Paul George Konody and Sidney Dark, op. cit., p. 73.

21 *William Orpen 1878–1931 Centenary Exhibition*, NGI, 1978. Introduction by James White, pp. 7–13, p. 7.

22 From the poem by Siegfried Sassoon, *Base Details*.

23 Now in the Imperial War Museum, London.

24 Thomas Ryan, 'William Orpen', *The Dubliner*, vol. III (Winter, 1964), p. 31.

25 Only the study for this picture survives. It is illustrated, with the other two in the series, in Paul George Konody and Sidney Dark, op. cit., plates XXXVI, XXXVII and XL. A note on all three is given in Hilary Pyle, *Irish Art 1900–50*, catalogue of the Cork ROSC Exhibition, 1975–6, nos 114 and 115. Arnold, op. cit., p. 291, n. 14, says *The Western Wedding* was probably destroyed in World War II.

26 Justin Keating, 'Sean Keating and Ardnacrusha', *Tracings*, vol. 1, Spring 2000, pp. 52–63, illus.; *Keating and Ardnacrusha*, (ed.) Robert Yacomini, catalogue of exhibition, University College, Cork, 2000.

27 Keating, op. cit., p. 63.

28 Dorothy Walker, *Modern Art in Ireland*, Dublin, 1997, p. 21.

29 *Watercolours*, p. 284, illus.

30 Rosemarie Mulcahy, 'Patrick J. Tuohy 1894–1930', *The GPA Irish Arts Review*, 1989–90, p. 110.

31 William Orpen, *Stories of Old Ireland and Myself*, London, 1924, p. 69.

32 Information kindly communicated by Professor J. O'Meara of University College, Dublin. The rhyme is among the Joyce MSS in the University Library, New York State University at Buffalo.

33 Rosemarie Mulcahy, op. cit., p. 114.

34 Ibid.

35 Carla Briggs, *Margaret Clarke RHA*, unpublished MA thesis, NUI, 1994.

36 Nicola Gordon Bowe, *Harry Clarke*, Dublin 1979.

37 Hilary Pyle, '"The Hamwood Ladies": Letitia and Eva Hamilton', *Irish Arts Review Year Book* vol. 13, 1997, pp. 122–34, illus.

38 Nicola Gordon Bowe, 'The Art of Beatrice Elvery, Lady Glenavy (1883–1970)', *Irish Arts Review Yearbook*, vol. 11, 1995, p. 169.

39 H. Pyle, *Portraits of Patriots*, 1968; H. Pyle, *Estella Solomons*, catalogue of an exhibition, Crawford Art Gallery, Cork, 1985.

18. The Advent of Modernism

1 Robert O'Byrne, *Hugh Lane*, Dublin, 2000.

2 Brian O'Doherty, 'Paul Henry – the early years', *University Review*, no. 7 (1960), p. 25.

3 Ibid., p. 29.

4 George Dawson, Introduction to the catalogue of an exhibition Paul Henry held in the TCD gallery, 1973, where many of his works are illustrated; S. B. Kennedy, 'Paul Henry, An Irish Portrait', in *Irish Arts Review Yearbook* (1989–90), pp. 43–54; S. B. Kennedy, 'Paul Henry and the Realism of Fiction', in *Irish Arts Review Yearbook* (1999); S. B. Kennedy, *Paul Henry*, New Haven and London, 2000.

5 J. Campbell, *The Irish Impressionists*, op. cit.

6 S. B. Kennedy, 'Paul Henry', *Lives of Irish Artists*, Dublin, 1991, p. 30.

7 Antoinette Murphy and S. B. Kennedy, *Paul Henry and Grace Henry*, exhibition catalogue, Hugh Lane Gallery, 1991.

8 See S. B. Kennedy, *Irish Art and Modernism*, Belfast, 1991, gives an excellent account of the various groups and their painters.

9 *William Conor, 1881–1968*, catalogue of an exhibition organized by the Northern Ireland Arts Council, 1968, with an introduction by Denis Ireland. It includes many illustrations of the artist's work.

10 Kenneth McConkey, *A Free Spirit, Irish Art 1860–1960*, Woodbridge, 1990, p. 63.

11 Marie Bourke, 'The growing sense of National identity: Charles Lamb and the West of Ireland', *History Ireland*, vol. 8, no. 1, (Spring 2000), pp. 30–4.

12 Sotheby's Irish sale, 18 May 2001, lots 216–31, all illus.

13 Christie's Irish sale, 20 May 1999, lots 215–20.

14 Theo Snoddy, *Dictionary of Irish Artists, 20th century*, Dublin, 1996, p. 267.

15 Alan Denson, *An Irish artist, W. J. Leech, RHA (1881–1968)*, 2 vols, Kendal, 1968–9, in which many of the artist's works are illustrated.

16 Denise Ferran, *William John Leech, an Irish Painter Abroad*, London, 1996, pl. 26., based on her Ph.D. thesis, TCD.

17 Ibid., p. 62.

18 Ibid., pp. 72–74.

19 Ibid., p. 236.

20 S. B. Kennedy, *Irish Art and Modernism 1880–1950*, Belfast, 1991, p. 222.

21 Marianne Hartigan, 'Irish Women Painters and the Introduction of Modernism', in James Christen Steward (ed.), *When Time Began to Rant and Rage Figurative Painting from Twentieth-Century Ireland*, Berkeley Art Museum, Grey Art Gallery, New York and the Barbican Art Gallery, London, 1998–9, pp. 63–77.

22 The catalogue of *Irish Women Artists*, an exhibition held in the NGI, TCD and the Hugh Lane Gallery in Dublin in 1987, is an invaluable source for all Irish women artists, including those that follow in this chapter. See also note 21.

23 *Mary Swanzy*, catalogue of exhibition, Pyms Gallery,

London, 1986, by J. Campbell; see also *Mary Swanzy*, Pyms Gallery, London, 1988, Fionualla Brennan.

24 S. B. Kennedy, *Irish Art and Modernism*, Belfast, 1991; Bruce Arnold, *Mainie Jellett and the Modern Movement in Ireland*, New Haven and London, 1991; *Mainie Jellett*, exhibition catalogue, IMMA, 1991.

25 Snoddy, *Dictionary*, op. cit., p. 159; Daire O'Connell, *May Guinness*, unpublished MA thesis.

26 Michael Wynne, James White and Nicola Gordon Bowe, *Stained Glass in Ireland*.

27 Nicola Gordon Bowe, 'Wilhelmina Geddes, Harry Clarke, and their Part in the Arts and Crafts Movement in Ireland', *The Journal of Decorative and Proganda arts*, 1875–1945, Spring 1988, pp. 58–79.

28 Anne Crookshank, catalogue of an exhibition, *Norah McGuinness*, TCD, October–November 1968, p. 5 and p. 12.

29 S. B. Kennedy, catalogue of an exhibition, *Elizabeth Rivers*, Gorry Gallery, Dublin.

30 Catalogue of an exhibition of paintings by George Russell at the Oriel Gallery, Dublin, 1975, which includes sixteen colour plates of his work.

31 James White, 'AE's Museum Square murals and other paintings', *Arts in Ireland*, vol. I, no. 3, (1973) pp. 4–11 and 49–52.

32 Exhibition catalogue, Newtown School, Waterford and RHA Galleries, 1998, introduction Peter Murray.

33 Kennedy, op. cit., p. 244.

34 Ibid., appendix 2, pp. 370–4.

35 Ibid., p. 93.

36 Andrew Causey, *Edward Burra Complete Catalogue*, Oxford, 1985, pp. 69–70, illus. nos 182–6, and colour plate 20.

37 Kennedy, op. cit., p. 274.

38 S. B. Kennedy, *Irish Art and Modernism 1880–1950*, Belfast, 1991, p. 287, illus. See also Arts Council exhibition, 1974–5, introduction by Jeanne Sheehy.

39 Hilary Pyle, *Jack B. Yeats*, London, 1970, (rev. 1989), and Bruce Arnold, *Jack Yeats*, New Haven and London 1998, are the two most recent biographies. See also Hilary Pyle's three catalogues of his work: *Jack B. Yeats: A Catalogue Raisonné of the Oil Paintings*, London, 1992; *Jack B. Yeats: His Watercolours, Drawings and Pastels*, Dublin, 1993, and *The Different Worlds of Jack B. Yeats: His Cartoons and Illustrations*, Dublin, 1994.

40 Catalogue of *Jack B. Yeats 1871–1957, A Centenary Exhibition*, NGI, 1957, p. 12.

41 Kenneth Clark, 'Jack Yeats', *Horizon*, vol. 5, no. 25 (January 1942).

42 Theo Snoddy, *Dictionary of Irish artists Twentieth century*, Dublin, 1996, p. 562, gives a very full account of the collaboration.

43 Arnold, op. cit., p. 182.

44 S. B. Kennedy, *Irish Art and Modernism*, Belfast, 1991, p. 27, quoting a letter to Quinn, 24 June 1913.

45 T. G. Rosenthal, 'Yeats', *The Masters Series*, no. 40, Bristol, 1966, p. 5.

46 Denys Sutton, *Walter Sickert*, London, 1976, p. 215.

47 Arnold, op. cit., p. 305.

48 Hilary Pyle, *Yeats portrait of an artistic family*, NGI, London, 1997, p. 210.

49 Brian Fallon, *Irish Art 1830–1990*, Belfast, 1994, p. 116.

50 Arnold, op. cit., p. 311.

51 Brian O'Doherty, in communication to us.

Bibliography

BOOKS AND CATALOGUES

Anon, *A Critical Review of the First Annual Exhibition of Paintings…of the Works of Irish Artists*, Dublin, 1800

Anon, *Public Characters of 1803–1804*, London, 1804

Adams, Elizabeth, and Redstone, David, *Bow Porcelain*, London, 1981

Adams, Eric, *Francis Danby*, New Haven and London, 1973

Adams, Eric, *Visions of Poetic Landscape*, London, 1973

Agnew, Jean, and Luddy, Maria (eds), *The Drennan McTier Letters*, Dublin, 1998–9

Allen, William, The Student's Treasure, a new drawing book consisting of a variety of Etchings and Engravings executed by Irish Artists after the following great masters…, Dublin, 1789 and 1804

Amory, Dita, and Symes, Marilyn, et al., *Nature Observed, Nature Interpreted*, National Academy of Design, New York, 1995

Andrews, J.A., *Irish Maps*, Irish Heritage Series, No. 18 Dublin, 1978

Andrews, Sydney, *Nine Generations, A History of the Andrews Family, Millers of Comber*, Ipswich, 1958

Angelo, Henry, *Reminiscences of him with Memoirs of his Late Father and Friends*, 2 vols, London, 1828–30

Anglesea, Martyn, *Andrew Nicholl 1804–1886*, Exhibition Catalogue, Ulster Museum, Belfast, 1973

———, *James Moore (1819–1883)*, Exhibition Catalogue, Ulster Museum, Belfast, 1973

———, *Royal Ulster Academy of Arts – A Centennial History*, Lisburn, 1981

———, *Portraits and Prospects*, Belfast, 1989

Archer, Mildred, *India and British Portraiture, 1780–1825*, London, 1979

Archibald, E.H.H., *Dictionary of Sea Painters*, Woodbridge, 1980

Archibald, Douglas N., *John Butler Yeats*, Bucknell, 1974

Arnold, Bruce, *William Orpen, Early Work*, Exhibition Catalogue, Pyms Gallery, London, 1981

———, *Orpen, Mirror of an Age*, London, 1981

———, *Mainie Jellett and the Modern Movement in Ireland*, New Haven and London, 1991

———, *Jack Yeats*, New Haven and London, 1998

———, *Swift: An Illustrated Life*, Dublin, 1999

Art and the Empire City, New York, 1825–1861, Exhibition Catalogue, Metropolitan Museum of Art, New York, 2000

Art Treasures of England, The Regional Collections, Exhibition Catalogue, Royal Academy of Arts, London, 1998

Aubrey, John, *Letters written by Eminent Persons…and Lives of Eminent Men*, 2 vols, London, 1813

Auerbach, Erna, and Adams, C. Kingsley, *Paintings and Sculpture at Hatfield House*, London, 1971

Australian Dictionary of National Biography, Melbourne, 1966–7

Baker, Charles H. Collins, *Lely and Stuart Portrait Painters…*, 2 vols, London, 1912

Ball, Francis Elrington, *Howth and its Owners being the Fifth Part of a History of County Dublin*, Dublin, 1917

Barnard, Toby, and Fenlon, Jane (eds), *The Dukes of Ormonds, 1610–1745*, Woodbridge, 2000

Barrett, Cyril, *Irish Art in the Nineteenth Century*, introduction to the Exhibition Catalogue, ROSC, Crawford Art Gallery, Cork, 1971

Barry, James, *An Inquiry into the Real and Imaginary obstructions to the Acquisition of the Arts in England*, London, 1775

———, *An Account of a Series of Pictures in the Great Room of the Society of Arts, Manufacturers, and Commerce, at the Adelphi*, London, 1783

———, (E. Fryer, ed.), *The Works of James Barry…containing his correspondence…*, 2 vols, London, 1809

Bell, Clive, *Old Friends*, London, 1956

Bell, Mrs G.H., *The Hamwood Papers*, London, 1930

Benedetti, Sergio, *The Milltowns, A Family Reunion*, Exhibition Catalogue, National Gallery of Ireland, Dublin, 1997

———, *The La Touche Amorino, Canova and his Fashionable Patrons*, Exhibition Catalogue, National Gallery of Ireland, Dublin, 1998

Bénézit, E., *Dictionnaire critique et documentaire des peintres, sculpteurs, dessinateurs et graveurs*, 14 vols, Paris, 1999

Benington, Jonathan, *Roderic O'Conor*, Dublin, 1992

Berkeley, George, *The Querist*, 2 parts, Dublin, 1725, 1735–6

———, (A.A. Luce and T.E. Jessop, eds), *The Works of George Berkeley*, 9 vols, London, 1948–57

Berry, Henry Fitzpatrick, *Register of Wills and Inventories in the Dioceses of Dublin, 1457–83*, Dublin, 1898

———, *A History of the Royal Dublin Society*, London, 1915

Betham, William, *The Baronetage of England*, 5 vols, London, 1801–5

Bignamini, Ilaria, and Wilton, Andrew (eds), *Grand Tour: The Lure of Italy in the Eighteenth Century*, Exhibition Catalogue, Tate Gallery, London, 1996

Black, Eileen, *Paintings, Sculptures and Bronzes in the Collection of the Belfast Harbour Commissioners*, Belfast, 1983

———, *Irish Oil Paintings, 1572–c. 1830*, Ulster Museum, Belfast, 1991

———, *Irish Oil Paintings, 1831–1900*, Ulster Museum, Belfast, 1997

Black, Eileen, Kennedy, S.B., and Maguire, W.A., *Dreams and Traditions, 300 Years of British and Irish Painting from the Collection of the Ulster Museum*, Belfast, 1997

Blacker, Stewart, *Irish Art and Artists*, Dublin, 1845

Bliss, Alan Joseph (ed.), *A Dialogue in Hibernian Stile between A and B*, vol. 6 of *Irish Writings from the Age of Swift*, Dublin, 1977

Blunt, Anthony, *The Paintings of Nicholas Poussin*, London, 1966

Boase, Thomas S.R., *English Art 1800–1870*, Oxford, 1959

Bodkin, Thomas, *Four Irish Landscape Painters*, Dublin and London, 1920, (edition with an introduction by Julian Campbell, Dublin, 1987)

———, *Memorial Exhibition Patrick Tuohy, RHA, Paintings, Drawings, Sketches 1911–1930*, introduction to the Exhibition Catalogue, Mills Hall, Dublin, 1931

———, *Hugh Lane and His Pictures*, Dublin, 1932

Boime, Albert, *The Academy and Nineteenth-Century French Painting*, London, 1971

———, *Art in an Age of Revolution, 1750–1800*, Chicago, 1987

Bonar Law, Andrew and Charlotte, *The Irish Prints of James Malton*, Dublin, 1999

Bonyhady, Tim, *Images in Opposition, Australian Landscape Painting, 1801–1890*, Oxford, 1985

Bourke, Marie, *The Aran Fisherman's Drowned Child by Frederick William Burton*, Dublin, 1987

———, *Charles Lamb, RHA: Galway Paintings*, Exhibition Catalogue, Galway Arts Centre, 1998

Bourke, Marie, and Bhreathnach-Lynch, Síghle, *Discover Irish Art at the National Gallery of Ireland*, Dublin, 1999

Bowe, Nicola Gordon, *Harry Clarke*, Dublin, 1989

Boydell, Barra, *Music and Paintings in the National Gallery of Ireland*, Dublin, 1985

Boyle, John, Earl of Orrery, *Remarks on the Life and Writings of Dr Jonathan Swift*, 4th edn., London, 1752

Boyne, Patricia, *John O'Donovan, (1806–1861) a Biography*, Kilkenny, 1987

Breeze, George, *Society of Artists in Ireland, Index of Exhibits, 1765–80*, Dublin, 1985

De Breffny, Brian (ed.), *The Irish World*, London, 1977

Brennan, Fionnuala, *Mary Swanzy, HRHA, (1882–1978)*, Exhibition Catalogue, Pyms Gallery, London, 1989

Brewer, James, N., *The Beauties of Ireland*, 2 vols, London, 1825–6

Bright, Kevin, and White, James, *Treasures of the Royal Dublin Society*, Dublin, 1998

Brooke, Raymond, *The Brimming River*, Dublin, 1961

Browne, Jonathan, *Kings and Connoisseurs, Collecting Art in Seventeenth-Century Europe*, Washington, 1995

Brownell, Morris, *The Prime Minister of Taste, A Portrait of Horace Walpole*, New Haven and London, 2001

Bryan's Dictionary of Painters and Engravers, 5 vols, revised edition, London, 1921

Burbridge, William F., *A Dictionary of Flower, Fruit and Still Life Painters, 1515–1950*, 2 vols, London, 1974

Burke, Edmund, *A Philosophical Enquiry into the Origin of our Ideas of the Sublime and the Beautiful*, London, 1767 (ed. J.T. Boulton, Oxford, 1987)

————, (Thomas W. Copeland et al., eds), *The Correspondence of Edmund Burke*, 10 vols, Cambridge, 1958–78

Burke, Joseph, *English Art, 1714–1800*, Oxford, 1976

Burke's Landed Gentry of Great Britain and Ireland, London, 1868

Burke's Landed Gentry of Ireland, London, 1912

Butler, Elizabeth, *From Sketch-book and Diary*, London, 1909

Butler, Patricia, *The Brocas Collection; An Illustrated Selective Catalogue of Original Watercolours, Prints and Drawings in the National Library of Ireland*, Exhibition Catalogue, National Library of Ireland, Dublin, 1997

Byron, Lord, *English Bards and Scotch Reviewers*, 3rd edn., London, 1810

Caffrey, Paul, *John Comerford and the Portrait Miniature in Ireland c. 1620–1850*, Exhibition Catalogue, Kilkenny, 1999

————, *Treasures to Hold, Irish and English Miniatures 1650–1850 from the National Gallery of Ireland Collection*, Exhibition Catalogue, National Gallery of Ireland, Dublin, 2000

Caldwell, John, and Roque, Oswaldo Rodriguez, *American Paintings in the Metropolitan Museum of Art*, Princeton, 1994

Charles Cameron c. 1740–1812, Exhibition Catalogue, The Arts Council, London, 1967

Campbell, Henry C., *Early Days on the Great Lakes, the Art of William Armstrong*, Toronto and Montreal, 1971

Campbell, Julian, *The Irish Impressionists in Ireland, France and Belgium*, Exhibition Catalogue, National Gallery of Ireland, Dublin, 1984

————, *Paintings by Mary Swanzy, HRHA*, Exhibition Catalogue, Pyms Gallery, London, 1986

————, *Frank O'Meara and his Contemporaries*, Exhibition Catalogue, Hugh Lane Municipal Gallery, Dublin, Crawford Art Gallery, Cork and Ulster Museum, Belfast, 1989

————, *Nathaniel Hone the Younger 1831–1917*, Exhibition Catalogue, National Gallery of Ireland, Dublin, 1991

————, *Onlookers in France: French Realist and Impressionist Painters*, Exhibition Catalogue, Crawford Municipal Art Gallery, Cork, 1993

————, *Peintres Irlandais en Bretagne*, Exhibition Catalogue, Musée de Pont-Aven, 1999

Campbell, Thomas, *An Essay on Perfecting the Arts in Great Britain and Ireland*, Dublin, 1767

————, *A Philosophical Survey of the South of Ireland*, London, 1778

Carey, William, *Some Memoirs of the Patronage and Progress of the Fine Arts in England and Ireland*, London, 1826

Carty, J., *Ireland from the Flight of the Earls to Grattan's Parliament*, Dublin, 1949

Casey, Christine, *Folk Traditions in Irish Art…Paintings from the Department of Irish Folklore*, Dublin, 1993

Catto, M., Hewitt, John, and Snoddy, Theo, *Art in Ulster*, 2 vols, Belfast, 1977

Causey, Andrew, *Edward Burra, Complete Catalogue*, Oxford, 1985

Chaloner Smith, John, *British Mezzotinto Portraits*, 4 vols, London, 1884

Chamot, Mary, *The Tate Gallery, British School*, London, 1953

Chaney, Edward, *The Evolution of the Grand Tour*, London, 1998

The MSS and Correspondence of James 1st Earl of Charlemont, Historical Manuscripts Commission, 12th Report, Appendix, part X, vols 1 & 2, London, 1891–4

Childe-Pemberton, W., *The Earl Bishop: the Life of Frederick Bishop of Derry, Earl of Bristol*, 2 vols, London, 1924

Clark, Anthony, *Pompeo Batoni, A Complete Catalogue of his Works with an Introductory Text*, Oxford, 1985

Clark, Jane, *The Great Eighteenth Century Exhibition*, National Gallery of Victoria, 1995

Clark, Kenneth, *Jack B. Yeats, 1871–1957*, introduction to the exhibition catalogue, Toronto, 1971

Clark, Mrs Godfrey, *Gleanings from an Old Portfolio*, Edinburgh, 1895

Clarke, Michael, *The Tempting Prospect*, London, 1981

Cockett, F.B., *Early Sea Painters, 1660–1730*, Woodbridge, 1995

Colvin, Christina (ed.), *Maria Edgeworth, Letters from England*, Oxford, 1972

Colvin, Christina, *Maria Edgeworth in France and Switzerland*, Oxford, 1979

Comyns-Carr, Mrs J., *Reminiscences*, London, 1925

Conner, Patrick, *George Chinnery, 1774–1852, Artist of India and the China Coast*, Woodbridge, 1993

Constable, W.G., *Richard Wilson*, London, 1953

Cork and Orrery, Countess of, *The Orrery Papers*, 2 vols, London, 1903

Cormack, Malcolm, *A Concise Catalogue of Paintings in the Yale Centre for British Art*, New Haven, 1985

Courcy de, Catherine, and Maher, Ann, *National Gallery of Ireland, Fifty Views of Ireland*, Dublin, 1985

Coxhead, Elizabeth, *Daughters of Erin*, London, 1965

Craig, Maurice, *The Volunteer Earl, Being the Life and Times of James Caulfield, First Earl of Charlemont*, London, 1948

————, *Georgian Dublin: Aquatint Views by James Malton*, Dublin, 1985

Crampton Walker, J., *Irish Life and Landscape*, Dublin and Cork, c. 1925

Crean, Hugh R., *Gilbert Stuart and the Politics of Fine Arts Patronage in Ireland, 1781–1793*, Ann Arbor: University Microfilms International, 1991.

Croft-Murray, Edward, *Decorative Painting in England 1537–1837*, 2 vols, London, 1962–70

Crofton Croker, T., *Researches in the South of Ireland*, London, 1824

————, *Fairy Legends and Traditions of the South of Ireland*, 3 vols, London, 1825–8

Cromwell, Thomas K., *Excursions through Ireland*, 3 vols, London, 1820

Crookshank, Anne, *Norah McGuinness*, Exhibition Catalogue, Trinity College, Dublin, 1968

————, *Irish Art from 1600 to the Present Day*, Dublin, 1979

————, *Irish Sculpture from 1600 to the Present Day*, Dublin, 1984

————, *Mildred Anne Butler*, Dublin, 1992

Crookshank, Anne, and Glin, Knight of, *Irish Portraits 1660–1860*, Exhibition Catalogue, National Portrait Gallery and elsewhere, London, 1969

————, *The Painters of Ireland, 1660–1920*, London, 1978

————, *The Watercolours of Ireland: Works on Paper, in Pencil, Pastel and Paint, c. 1660–1914*, London, 1994

Crookshank, Anne, Glin, Knight of, Guinness, Desmond, and White, James, *Irish Houses and Landscapes*, Exhibition Catalogue, Dublin and Belfast, 1963

Crookshank, Anne, and Webb, David, *Paintings and Sculptures in Trinity College, Dublin*, Dublin, 1990

Crouan, C., *Maurice MacGonigal*, Exhibition Catalogue, Hugh Lane Municipal Gallery, Dublin, 1991

Cullen, Fintan, *Visual Politics, the Representations of Ireland 1750–1930*, Cork, 1997

————, (ed.), *Sources in Irish Art, A Reader*, Cork, 2000

Cullen, Fintan, and Murphy, William M., *The Drawings of John Butler Yeats*, Exhibition Catalogue, Albany Institute of Art, Albany, 1987

Cummings, Frederick, and Staley, Alan, *Romantic Art in Britain…1760 – 1860*, Exhibition Catalogue, Detroit and Philadelphia, 1968

Curnock, Nehemiah (ed.), *The Journal of the Rev. John Wesley, A.M.*, 8 vols, London, 1909–16

Curtis, L. Perry, *Apes and Angels; the Irishman in Victorian Caricature*, Newton Abbot, 1971

Dalsimer, Adele M. (ed.), *Visualizing Ireland, National Identity and the Pictorial Tradition*, Boston and London, 1993

Dalsimer, Adele M., and Kreilkamp, Vera, *America's Eye: Irish Paintings from the Collection of Brian Burns*, Exhibition Catalogue, Boston College Museum of Art, Boston, 1996

————, *Irish Paintings from the Collection of Brian P. Burns*, Exhibition Catalogue, Kennedy Centre, Boston, 2000

Davis, Thomas (D.J. O'Donoghue, ed.), *Essays Literary and Historical*, Dundalk, 1914

Day, Angelique (ed.), *Letters from Georgian Ireland*, Belfast, 1991

Dayes, Edward, *The Works of the Late Edward Dayes*, London, 1805, (ed. R.W. Lightbown, 1971)

Denson, Alan, *Printed Writings on George Russell (A E), a Bibliography*, London, 1961

————, *An Irish Artist, W.J. Leech, RHA (1881 – 1968)*, 2 vols, Kendal, 1968–9

Deuchar, Stephen, *Sporting Art in Eighteenth-Century England, A Social and Political History*, London, 1988

Dickinson, P.L., *The Dublin of Yesterday*, London, 1929

Doyle, Michael, *The Doyle Diary*, London, 1978

Duffy, Hugo, *James Gandon and his Times*, Kinsale, 1999

Dunlap, William, *History of the Rise and Progress of the Arts of Design in the United States*, New York, 1834

Dunlevy, M., *Dress in Ireland*, Dublin, 1989

Edgeworth, Maria, *Tales and Miscellaneous Pieces*, 8 vols, London, 1825

Edwards, Edward, *Anecdotes of Painters, who have resided or been born in England with critical remarks on their productions*, London, 1808

Egerton, Judy, *British Sporting and Animal Paintings*, The Paul Mellon Collection, London, 1978

————, *George Stubbs, 1724–1806*, Exhibition Catalogue, Tate Gallery and Yale Centre for British Art, London, 1984

————, *The British School*, National Gallery Catalogue, London, 1998

Einberg, Elizabeth, *Manners and Morals – Hogarth and British Painting 1700–1760*, Exhibition Catalogue, Tate Gallery, London, 1987

Einberg, Elizabeth, and Egerton, Judy, *Tate Gallery Collections, The Age of Hogarth*, 2 vols, London, 1988

Elmes, James, *The Art and Artists*, 3 vols, London, 1825

Elmes, Rosalind M., *National Library of Ireland, Catalogue of Irish Topographical Prints and Original Drawings*, Dublin, 1932

————, *Catalogue of Irish Topographical Prints and Original Drawings, mainly in the Joly Collection*, Dublin, 1937

Evans, Dorinda, *The Genius of Gilbert Stuart*, Princeton, 1999

Everett, Nigel, *An Irish Arcadia*, Cork, 1999

Fallon, Brian, *Irish Art 1830–1990*, Belfast, 1994

————, *An Age of Innocence, Irish Culture 1930–1960*, Dublin, 1998

Farington, Joseph (Kenneth Garlick, Angus Macintyre and Kathryn Cave, eds.), *The Diary of Joseph Farrington*, 16 vols, New Haven and London, 1978–98

Fenlon, Jane, *The Ormonde Picture Collection*, Dublin, 2001

Fenlon, Jane, Figgis, Nicola, and Marshall, Catherine, (eds), *New Perspectives*, Dublin, 1987

Ferran, Denise, *Leech: An Irish Painter Abroad*, Exhibition Catalogue, National Gallery of Ireland, Dublin, 1996

Ferris, Scott R., and Pearce, Ellen, *Rockwell Kent's Forgotten Landscapes*, Camden, 1998

Figgis, Nicola, and Rooney, Brendan, *Irish Paintings in the National Gallery of Ireland*, vol. 1, Dublin, 2001

Finlay, Sarah, *The National Self-Portrait Collection of Ireland*, Limerick, 1989

Firth, Edith, *Toronto in Art*, Toronto, 1983

Fisher, Jonathan, *A Picturesque Tour of Killarney describing in twenty views the most pleasing scenes…accompanied by some observations etc.*, Dublin, 1789

Fisher, Jonathan, *Scenery of Ireland, illustrated in a series of prints of select views, castles and abbeys, drawn and engraved in acquatinta*, Dublin, 1795–6

FitzGerald, Brian (ed.), *The Correspondence of Emily, Duchess of Leinster*, 3 vols, Dublin, 1949–57

Fitz-Simon, Christopher, *The Arts in Ireland, A Chronology*, London, 1982

Fitz-Simon, Christopher, *The Irish Theatre*, London, 1983

Fleming, John, *Robert Adam and his Circle*, London, 1962

Foskett, Daphne, *A Dictionary of British Miniature Painters*, 2 vols, London, 1972

Foster, R.F., *Modern Ireland, 1600–1972*, London, 1988

———, *The Oxford Illustrated History of Ireland*, Oxford, 1989

Francis, Peter, *Irish Delftware: an Illustrated History*, London, 2000

Frazer, Hugh, *Essay on Painting*, Belfast and Dublin, 1825

Frazier, Adrian, *George Moore, 1852–1933*, New Haven and London, 2000

Frost, Stella (ed.), *A Tribute to Evie Hone and Mainie Jellett*, Dublin, 1957

Gandon, James Jr, and Mulvany, Thomas, *The Life of James Gandon Esq.*, Dublin, 1846 (Maurice Craig, ed.), London, 1968

Garstang, Donald (ed.), *The British Face, A View of Portraiture 1625–1850*, Exhibition Catalogue, Colnaghi, London, 1986

Gaze, Delia, Dictionary of Woman Artists, 2 vols, Chicago, 1997

Gerard, F.A., *Angelica Kauffmann, A Biography*, London, 1892

Gilbert, John T., *A History of the City of Dublin*, 3 vols, Dublin, 1861, (new ed. with index, Shannon, 1972)

Gilbey, Sir Walter, *Animal Painters of England from 1650*, 2 vols, London, 1900

Gillespie, Frances, *Edith Somerville*, Exhibition Catalogue, Castletownsend, 1984

Gillespie, R., and Kennedy, Brian P., (eds), *Ireland – Art into History*, Dublin, 1994

Goodison, J.W., *Fitzwilliam Museum, Cambridge, Catalogue of Paintings*, vol. 3, British School, Cambridge, 1977

Goulding, Richard W., and Adams, C.K., *Catalogue of the Pictures Belonging to his Grace the Duke of Portland, K.G.*, Cambridge, 1936

Glin, Knight of, and Craig, Maurice, Introduction to reprints of Malton's *Dublin* of 1799, Dublin, 1978, and Malton's *Dublin Views in Colour*, Dublin, 1981

Gordon Bowe, N., *The Life and Work of Harry Clarke*, Dublin, 1989

Gordon Bowe, N., and Cumming, S. E., *The Arts and Crafts Movement in Dublin and Edinburgh*, Dublin, 1998

Grant, Col. Maurice Harold, *A Chronological History of the Old English Landscape Painters*, 3 vols, London and Leigh-on-Sea, 1926–47 (reprinted 1958)

Grattan, William, *Patronage Analysed*, Dublin, 1818

Graves, Algernon, *A Dictionary of Artists who have exhibited works in the principal London exhibitions from 1760–1889*, London, 1885 (new and enlarged edn. 1895)

———, *The Royal Academy of Arts: a Complete Dictionary of Contributors and their Work… 1769–1904*, 8 vols, London, 1905–6

———, *The Society of Artists of Great Britain…The Free Society of Artists*, London, 1907

Greenacre, Francis, *The Bristol School of Artists…*, Exhibition Catalogue, Bristol City Art Gallery, Bristol, 1973

Greenacre, Francis, *Francis Danby, 1793–1861*, Exhibition Catalogue, Tate Gallery, London, 1988

Gregory, Lady, *Hugh Lane's Life and Achievement*, London, 1921

Griffin, David, and Pegum, Caroline, *Leinster House*, Dublin, 2000

Grosart, The Revd Alexander B., *The Lismore Papers*, 10 vols, London, 1886–8

Grose, Daniel Charles, *The Antiquities of Ireland*, (Roger Stalley ed.), Dublin, 1992

Grose, Francis, *Antiquities of Ireland*, 2 vols, London, 1791

Groseclose, Barbara, *Nineteenth-Century American Art*, Oxford, 2000

Haagen, J.K. Van der, *De Schilders Van der Haagenen en hun Werk*, Voorburg, 1932

Haagen, M.J.F.W. Van der, *Het Geslacht Van der Haagen 1471–1932*, The Hague, 1932

Hall, Ivan, *Catalogue of an Exhibition of Paintings…Collected by William Constable Esq. Of Burton Constable….*, Ferens Art Gallery, Kingston upon Hull, 1970

Hall, Marshall, *The Artists of Cumbria*, Kendal, 1979

Hall, Mr and Mrs S.C., *Ireland, its Scenery and Character…*, 3 vols, London, 1841–3

Harbison, Peter, *Beranger's Views of Ireland*, Dublin, 1991

Harbison, Peter, Potterton, Homan, and Sheehy, Jeanne, *Irish Art and Architecture*, London, 1987

Hardwick, J., *The Yeats Sisters*, London, 1996

Hardy, Francis, *Memoirs of…James Caulfield, Earl of Charlemont…*, London, 1810

Hare, Augustus (ed.), *Life and Letters of Maria Edgeworth*, 2 vols, London, 1884

Hare, Augustus, *The Story of Two Noble Lives*, 3 vols, London, 1893

Harris, Eileen, *British Architectural Books and Writers 1556–1785*, Cambridge, 1990

Harris, John, *The Artist and the Country House*, London, 1979

Hartrick, Archibald S., *A Painter's Pilgrimage through Fifty Years*, Cambridge, 1939

Hayden, Ruth, *Mrs Delany: her Life and Flowers*, London, 1980

Hayes, Daniel, *The Works in Verse of Daniel Hayes Esq.*, London, 1769

Hayward, Richard, *In Praise of Ulster*, with thirty-two drawings by J. Humbert Craig, RHA, Belfast, 1938

Heaney, Henry (ed.), *The Irish Journals of Robert Graham of Red Gorton*, Dublin, 1999

Henry, Paul, *An Irish Portrait*, London, 1951

———, *Further Reminiscences*, (Edward Hickey ed.), Belfast, 1973

Herbert, Dorothea, *Retrospections on Dorothea Herbert 1770–1789*, 2 vols, London, 1929 (reprint, ed. Louis Cullen, Dublin, 1988)

Herbert, John Dowling, *Irish Varieties….*, London, 1836

Herrmann, Frank (ed.), *The English as Collectors, A Documentary Sourcebook*, London, 1999

Herrmann, Luke, *British Landscape Painting of the Eighteenth Century*, London, 1973

Hill, The Revd George (ed.), *The Montgomery Manuscripts*, Belfast, 1869

Hill, J., *Irish Public Sculpture*, Dublin, 1998

Hinds, Allen B. (ed.), *Calendar of State Papers and Manuscripts, Relating to English Affairs, Existing in the Archives and Collections of Venice…1619–21*, vol. XVI, London, 1910

Hobart, Alan and Mary, *An Exhibition of Paintings by Mary Swanzy, H.R.H.A, (1882–1978)*, Exhibition Catalogue, Pyms Gallery, London, 1998

Hobart, Mary, *The Irish Revival*, Exhibition Catalogue, Pyms Gallery, London, 1982

Hodge, Anne, *NCAD 250, Drawings 1746–1996*, Exhibition Catalogue, National College of Art and Design, Dublin, 1996

Holmes, George, *Sketches of some of the Southern Counties of Ireland*, London, 1801

Homer, William Innes, *Robert Henri and his Circle*, Ithaca and London, 1969

Catalogue of the Exhibition of Pictures by Nathaniel Hone, RA, mostly the works of his leisure, London, 1775

Hooper, Glen, and Litvack, Leon (eds) *Ireland in the Nineteenth Century, Regional Identity*, Dublin, 2000

Hoppen, K. Theodore, *The Common Scientist in the Seventeenth Century. A Study of the Dublin Philosophical Society 1683–1708*, London, 1970

Houfe, Simon, *A Dictionary of British Book Illustrators and Caricaturists 1800–1914*, Woodbridge, 1978

Houghton, Raymond W., Berman, David, and Lapan, Maureen, *Images of Berkeley*, Dublin, 1986

Hubbard, R.H., *Canadian Landscape Painting, 1670–1930, The Artist and the Land*, Madison, 1973

Hunt, William Holman, *Pre-Raphaelitism and the Pre-Raphaelites*, 2 vols, London, 1905

Hutchinson, John, *James Arthur O'Connor*, Exhibition Catalogue, National Gallery of Ireland, Dublin, 1985

Hutton, A.W. (ed.), *Arthur Young's Tour in Ireland 1776–1779*, 2 vols, London, 1892 (new ed. Shannon, 1970)

Ingamells, John (ed.), *A Dictionary of British and Irish Travellers in Italy, compiled from the Brinsley Ford Archive*, New Haven and London, 1997

Ireland, Denis, *William Conor 1881–1968*, Exhibition Catalogue, Northern Irish Arts Council, Belfast, 1968

Irwin, David, *English Neoclassical Art, Studies in Inspiration and Taste*, London, 1966

Irwin, David and Francina, *Scottish Painters*, London, 1975

Jackson, Christine E., *Dictionary of Bird Artists of the World*, Woodbridge, 1999

Jacobs, Phoebe, and Lloyd, John, *James Barralet and the Apotheosis of George Washington*, Winterthur Portfolio 12, Charlottesville, 1977

Jaworska, Wladyslawa, *Paul Gaugin and the Pont-Aven School*, London, 1972

Jellett, Mainie, *The Artist's Vision, Lectures and Essays on Art*, Dundalk, 1958

Jenkins, Ian, and Sloan, Kim, *Vases and Volcanoes*, Exhibition Catalogue, British Museum, London, 1996

Johnston, Fridolf, *Rockwell Kent, an Anthology of his Work*, New York, 1982

Johnston, J., and Greutzner, A., *The Dictionary of British Artists, 1880–1940*, Woodbridge, 1976

Johnston, Roy, *Roderic O'Conor 1860–1940*, Exhibition Catalogue, Musée de Pont-Aven, 1984

———, *Roderic O'Conor 1860–1940*, Exhibition Catalogue, Barbican Art Gallery and Ulster Museum, 1985

———, *Roderic O'Conor Vision and Expression*, Exhibition Catalogue, Hugh Lane Municipal Gallery, Dublin, 1996

———, *The Prints of Roderic O'Conor*, Exhibition Catalogue, Musée de Pont-Aven, 1999

Jordan, Peter, *Waterford Municipal Art Collection*, Waterford, 1987

The Journals of the House of Commons of the Kingdom of Ireland, Dublin, 1796–1802

Kelly, James (ed.), *The Letters of Lord Chief Baron Edward Willes…, 1757–62*, Aberystwyth, 1990

Kennedy, Brian P., *Irish Painting*, Dublin, 1993

Kennedy, Brian P., et al., *The Anatomy Lesson, Art and Medicine*, Exhibition Catalogue, National Gallery of Ireland, Dublin, 1992

Kennedy, Róisín, *Dublin Castle Art*, Dublin, 1999

Kennedy, S.B., *Irish Art and Modernism, 1880–1950*, Belfast, 1991

———, *Paul Henry*, Lives of Irish Artists, Dublin, 1991

———, *Great Irish Artists From Lavery to Le Brocquy*, Dublin, 1997

———, *Paul Henry*, New Haven and London, 2000

Kerr, Joan (ed.), *Dictionary of Australian Artists*, Oxford, 1992

Kerslake, John, *Early Georgian Portraits*, 2 vols, National Portrait Gallery, London, 1977

Catalogue of the Pictures at Kilkenny Castle, Kilkenny, 1875

King, Sir Charles (ed.), *Henry's Upper Lough Erne in 1739*, Whitegate, 1987

Kingdom of Heaven, Exhibition Catalogue, Limerick City Gallery of Art, Limerick, 1999

Konody, P.G., and Dark, Sydney, *Sir William Orpen, Artist and Man*, London, 1932

Küttner, Gottfried, *Briefe über Irland*, Leipzig, 1785

Laffan, William (ed.), *Masterpieces of Irish Artists, 1660–1860*, Exhibition Catalogue, Pyms Gallery, London, 1999

———, (ed.), *The Sublime and the Beautiful, Irish Art 1700–1830*, Exhibition Catalogue, Pyms Gallery, London, 2001

———, *Robert Fagan in Sicily – The Acton Family Portrait*, Exhibition Catalogue, Pyms Gallery, London, 2000

———, (ed.), *The Art of a Nation, Three Centuries of Irish Painting*, Exhibition Catalogue, Pyms Gallery, London, 2002

Laing, Alastair (ed.), *Clerics and Connoisseurs, An Irish Art Collection through Three Centuries*, London, 2001

Larmour, Paul, *The Arts and Crafts Movement in Ireland*, Belfast, 1992

Lavery, Sir John, *The Life of a Painter*, London, 1940

Le Harivel, Adrian, *Illustrated Summary Catalogue of Drawings, Watercolours and Miniatures in the National Gallery of Ireland*, Dublin, 1983

——— (ed.), *Illustrated Summary Catalogue of Prints and Sculpture in the National Gallery of Ireland*, Dublin, 1988

———, *Nathaniel Hone the Elder*, Dublin, 1992

———, *Frederic William Burton*, Dublin, 1997

Le Harivel, Adrian, Hutchinson, John, and Wynne, Michael, *Illustrated Summary Catalogue of Paintings in the National Gallery of Ireland*, Dublin, 1981

Le Harivel, Adrian, and Wynne, Michael, *National Gallery of Ireland, Acquisitions 1982–83*, Dublin, 1984

———, *National Gallery of Ireland, Acquisitions 1984–86*, Dublin, 1986

Lewis, Gifford, *Somerville and Ross*, London, 1985

——— (ed.), *The Selected Letters of Somerville and Ross*, London, 1989

Lewis, Samuel, *A Topographical Dictionary of Ireland*, 2 vols, London, 1837

Llanover, Lady (ed.), *Autobiography and Correspondence of Mary Granville, Mrs Delany*, 6 vols, London, 1861–2

Loeber, Rolf, *A Biographical Dictionary of Architects in Ireland, 1600–1720*, London, 1981

Loizeaux, Elizbeth Bergmann, *Yeats and the Visual Arts*, New Brunswick and London, 1986

Low, William, *A Chronicle of Friendship, 1873–1900*, London, 1908

Luce, A.A., *The Life of George Berkeley, Bishop of Cloyne*, New York, 1968

McCalmont, Rose E., *Memoirs of the Binghams* (Charles R.B. Barrett, ed.), London, 1915

McCarthy, Michael (ed.), *Lord Charlemont and his Circle*, Dublin, 2001

McCarthy, Michael, J.F., *Five Years in Ireland, 1895–1900*, 6th edn., London and Dublin, 1901

McConkey, Kenneth, *Sir John Lavery, R.A.*, Exhibition Catalogue, National Gallery of Ireland, Ulster Museum, Belfast and elsewhere, 1984

———, *Orpen and the Edwardian Era*, Exhibition Catalogue, Pyms Gallery, London, 1987

———, *British Impressionism*, London, 1989

———, *A Free Spirit, Irish Art, 1860–1960*, Woodbridge, 1990

———, *Orpen at Howth*, Exhibition Catalogue, Pyms Gallery, London, 1991

———, *Sir John Lavery*, Edinburgh, 1993

McConkey, Kenneth, Benington, Jonathan, et al., *Celtic Splendour*, Exhibition Catalogue, Pyms Gallery, London, 1985

———, *Irish Renascence, Irish Art in a Century of Change*, Exhibition Catalogue, Pyms Gallery, London, 1986

McConkey, Kenneth, and Robins, Anna Gruetzner, *Impressionism in Britain*, Exhibition Catalogue, Barbican Art Gallery and Hugh Lane Municipal Gallery, Dublin, 1995

McCormack, Tim, et al., *First Views of Australia, 1785–1815*, Sydney, 1987

McDonald., Patricia R., and Pearce, Barry, *The Artist and the Patron – Aspects of Colonial Art in New South Wales*, Sydney, 1988

McDonnell, Joseph, *Ecclesiastical Art of the Penal Era*, Exhibition Catalogue, Maynooth College, Maynooth, 1995

———, *500 Years of the Irish Book – 1500 to the Present*, Exhibition Catalogue, National Gallery of Ireland, Dublin, 1997

MacGonigal, Ciaran, *Harry Kernoff*, Exhibition Catalogue, Hugh Lane Municipal Gallery, Dublin, 1976

MacGreevy, Thomas, *Jack B. Yeats: An Appreciation and an Interpretation*, Dublin, 1945

McParland, Edward, *James Gandon Vitruvius Hibernicus*, London, 1985

———, *Public Architecture in Ireland 1680–1760*, New Haven and London, 2001

Maas, Jeremy, *Victorian Painters*, London, 1969

Macmillan Dictionary of Art, (ed. Jane Turner), 34 vols incl. index, London, 1996

Madden, Samuel, *Reflections and Resolutions proper for the Gentlemen of Ireland as to their conduct for the service of their country*, Dublin, 1738

Malins, Edward, and Bishop, Morchard, *James Smetham and Francis Danby*, London, 1974

Malins, Edward, and Glin, Knight of, *Lost Demesnes*, London, 1976

Mallalieu, H.L., *A Dictionary of British Watercolour Artists up to 1920*, 2 vols, Woodbridge, 1976 (new edn. 1985)

Mallie, Eamonn (ed.), *One Hundred Years of Irish Art*, Belfast, 1992

Malton, James, *A Picturesque and Descriptive View of the City of Dublin*, London, 1792–9

Manners, Lady Victoria, *Matthew William Peters R.A., His Life and Work*, London, 1913

Mannings, David, *Sir Joshua Reynolds, A Complete Catalogue of his Paintings*, New Haven and London, 2000

Marillier, H.C., *The Liverpool School of Painters*, London, 1904

Mayes, Elizabeth, and Murphy, Paula, *Images and Insights*, Exhibition Catalogue, Hugh Lane Municipal Gallery of Art, Dublin, 1993

Millar, Oliver, *The Tudor, Stuart and Early Georgian Pictures in the Collection of Her Majesty the Queen*, London, 1963

———, *Sir Peter Lely*, London, 1978

Miller, Liam, *The Dun Emer Press, Later the Cuala Press*, Dublin, 1973

——— (ed.), *Retrospect: the Work of Seamus O'Sullivan and Estella Solomons*, Dublin, 1973

——— (ed.), *Pictures at the Abbey, The Collection of the Irish National Theatre*, Portlaoise, 1983

Milton, Thomas, *The Seats and Desmenes of tibe Nobility and Gentry of Ireland in a collection of the most interesting and picturesque views....*, London, 1783–93

Mitchell, Sally, *Dictionary of British Equestrian Artists*, Woodbridge, 1985

Moody, T.W,. and Vaughan, W.E. (eds), *Eighteenth Century Ireland, 1691–1800*, A New History of Ireland, vol. IV, Oxford, 1986

Moore, George, *Modern Painting*, London, 1893

——— (Susan Dick, ed.), *Confessions of a Young Man*, Montreal, 1972

Moore, George, and Powell. F. York, (introductions), *A Loan Collection of Pictures by Nathaniel Hone, RHA and John Butler Yeats, RHA*, Dublin, 1904

Moore, Thomas, *The Life and Death of Lord Edward FitzGerald*, 2 vols, London, 1831

Moran, Gerard, and Gillespie, Raymond, *Galway, History and Society*, Dublin, 1996

Morris, Thomas, *Holy Cross Abbey*, Dublin, 1986

Mount, Charles Merrill, *Gilbert Stuart*, New York, 1964

Jeremiah Hodges Mulcahy, Exhibition Catalogue, Cynthia O'Connor Gallery, Dublin, 1989

Mulvany, A.C. (ed.), *Letters from Professor T.J. Mulvany R.H.A. to his eldest son William T. Mulvany esq…from 1825–45*, no place of publication given, 1908

Mulvany, Thomas J. (ed.), *The Life of James Gandon…*, Dublin, 1846

Munday, John, *E.W. Cooke 1811–1880, A Man of his Time*, Woodbridge, 1996

Murdoch, John, *Forty British Watercolours from the Victoria and Albert Museum*, London, 1977

Murphy, Antoinette, *The Paintings of Paul and Grace Henry*, Exhibition Catalogue, Hugh Lane Municipal Gallery, Dublin, 1991

Murphy, Denis (ed.), *Triumphalia Chronologica Monasterii Sanctis Crucis in Hibernia 1640*, Dublin, 1891

Murphy, William M., *The Prodigal Father – The Life of John Butler Yeats 1839–1922*, Ithaca and London, 1978

Murray, Peter, *Illustrated Summary Catalogue of the Crawford Municipal Art Gallery*, Cork, 1992

Murray, Peter (ed.), *Irish Art 1770–1995, History and Society*, Exhibition Catalogue, touring exhibition from the Crawford Municipal Art Gallery, Cork, 1995

Napier, Robina (ed.), *Johnsoniana, Anecdotes of the Late Samuel Johnson, LLD*, London, 1884

Neale, John Preston, *Views of Seats of Noblemen and Gentlemen in the United Kingdom*, 11 vols, London, 1818–29

Nicolson, Benedict, *Joseph Wright of Derby, Painter of Light*, 2 vols, London and New York, 1968

Nolan, William, and Power, Thomas P. (eds), *Waterford History and Society*, Dublin, 1992

Norman, Geraldine, *Nineteenth Century Painters and Painting: a Dictionary*, London, 1977

Northcote, James, *The Life of Sir Joshua Reynolds…*, 2nd edn., 2 vols, London, 1818

Nygren, Edward K., *Views and Visions, American Landscape before 1830*, Washington, 1986

O'Byrne, Robert, *Hugh Lane, 1875–1815*, Dublin, 2000

O'Connell, Daire, et al, *Mainie Jellett, 1897–1944*, Exhibition Catalogue, Irish Museum of Modern Art, Dublin, 1991

O'Connor, Cynthia, *The Pleasing Hours: The Grand Tour of James Caulfield, First Earl of Charlemont (1728–1799) Traveller, Connoisseur and Patron of the Arts*, Cork, 1999

O'Dowda, Brendan, *The World of Percy French*, Belfast, 1981

O'Driscoll, William Justin, *A Memoir of Daniel Maclise R.A.*, London, 1871

O' Faolain, Sean, with illustrations by Paul Henry, *An Irish Journey*, London, 1941

O'Grady, John, *The Life and Work of Sarah Purser*, Dublin, 1996

O'Keeffe, John, *Recollections of the Life of John O'Keeffe, Written by Himself*, 2 vols, London, 1826

O'Neill, Henry, *The Fine Arts and Ancient Civilisation of Ancient Ireland*, London, 1863

———, *The Round Towers of Ireland, part the first, containing the descriptions of the four round towers in the county of Dublin*, Dublin, 1877

Ormond, Richard, *Early Victorian Portraits*, 2 vols, National Portrait Gallery, London, 1973

Ormond, Richard, and Turpin, John, *Daniel Maclise, 1806–70*, Exhibition Catalogue, National Portrait Gallery and National Gallery of Ireland, 1972

A Catalogue of the Ormonde Collection of Pictures which will be exhibited in the Museum, Kilkenny, 1840

Orpen, William, *Stories of Old Ireland and Myself*, London, 1925

O'Raifeartaigh T. (ed.), *Royal Irish Academy: a Bicentennial History, 1785–1985*, Dublin, 1985

O'Sullivan, Niamh, *Aloysius O'Kelly*, Exhibition Catalogue, Hugh Lane Municipal Gallery, Dublin, 1999

O'Toole, Fintan, introduction, *Labour in Art, Representations of Labour in Ireland (1870–1970)*, Exhibition Catalogue, Irish Museum of Modern Art, Dublin, 1994

Paget, Major Guy, *The Melton Mowbray of John Ferneley*, Leicester, 1931

Parkinson, Henry (ed.), *The Illustrated Record and Descriptive Catalogue of the Dublin International Exhibition of 1865*, London, 1866

Parkinson, Ronald, *Catalogue of British Oil Paintings, 1820–1860*, Victoria and Albert Museum, London, 1990

Pasquin, Anthony, (John Williams), *Memoirs of the Royal Academicians and an Authentic History of the Professors of Painting, Sculpture and Architecture in Ireland*, London, 1796 (reprinted with an introduction by R.W. Lightbown, London, 1970)

Penny, Nicholas (ed.), *Reynolds*, Exhibition Catalogue, Royal Academy, London, 1986

Perlman, Bernard, B., *Robert Henri his Life and his Work*, New York, 1991

Peters Bowran, Edgar, and Rishel, Joseph J. (eds), *Art in Rome in the Eighteenth Century*, Philadelphia, 2000

Petrie, George, et al., *Picturesque Sketches of Some of the Finest Landscape and Coast Scenery of Ireland with drawings by F. Petrie, RHA, A. Nicholl & H.O'Neill*, vol. 1, Dublin, 1835, vol. 2, Dublin, 1843

A Full and Accurate Report of the Trial of Sir John Piers for Criminal Conversation with Lady Cloncurry, Dublin, 1807

Piggott Stuart, *Ruins in a Landscape. Essays in Antiquarianism*, Edinburgh, 1976

Pilkington, Letitia, *Memoirs of Letitia Pilkington*, 2 vols, (A C. Elias Jr, ed.), Athens, Georgia and London, 1997

Pilkington, Matthew, *The Gentleman's and Connoisseur's Dictionary of Painters*, London, 1770, and sub. edns

Piper, David, *Catalogue of the Seventeenth Century Portraits in the National Portrait Gallery 1625–1714*, Cambridge, 1963

Pococke, Richard, *Pococke's Tour in Ireland in 1752*, edited with an introduction and notes by George T. Stokes, Dublin, 1891

Pointon, Marcia R., *Mulready*, Exhibition Catalogue, Victoria & Albert Museum, National Gallery of Ireland and Ulster Museum, London, 1986

———, *Hanging the Head, Portraiture and Social Formation in Eighteenth Century England*, New Haven and London, 1993

Pollard, M., *Dictionary of Members of the Dublin Book Trade, 1550–1800*, London, 2000

Postle, Martin, *Angels and Urchins, The Fancy Picture in 18th-Century British Art*, Exhibition Catalogue, Djanogly Art Gallery, Nottingham and Kenwood House, London, 1998

Pott, Joseph Holden, *An Essay on Landscape Painting with Remarks General and Critical on the Different Schools and Masters, Ancient or Modern*, London, 1782

Powell, John S., *Pavillioned in Splendour, the Art and Artefacts of Emo Court, Co. Laois*, Portarlington, 2000

Praeger, R.L., *The Way that I Went*, Dublin and London, 1937

Pressly, Nancy L., *The Fuseli Circle in Rome*, Exhibition Catalogue, Yale Centre for British Art, 1979

Pressly, William, *The Life and Art of James Barry*, New Haven and London, 1981

———, *James Barry: the Artist as Hero*, Exhibition Catalogue, Tate Gallery, London, 1983

Price, Liam (ed.), *An Eighteenth Century Antiquary, the Sketches, Notes and Diaries of Austin Cooper, 1759–1830*, Dublin, 1942

Pückler-Muskau, Prince, *Tour in England, Ireland and France in the Years 1828–29*, 2 vols, Published anonymously, London, 1832

Purser, Sean, introduction, *Mary Swanzy*, Exhibition Catalogue, Hugh Lane Municipal Gallery, Dublin, 1968

Puyvelde, Leo van, *The Dutch Drawings in the Collection of H.M. the King at Windsor Castle*, London, 1944

Pyle, Hilary, *Portraits of Patriots*, Dublin, 1966

———, *Jack B. Yeats; a Biography*, London, 1970

———, *Irish Art, 1900–1950*, Exhibition Catalogue, ROSC, Crawford Municipal Art Gallery, Cork, 1975

———, *Estella Solomons*, Exhibition Catalogue, Crawford Municipal Art Gallery, Cork, 1985

———, *Jack B. Yeats in the National Gallery of Ireland*, Dublin, 1986

———, *Catalogue Raisonné of the Oil Paintings*, 3 vols, London, 1992

———, *Jack B. Yeats His Watercolours, Drawings and Pastels*, Dublin, 1993

———, *Yeats: Portrait of an Artistic Family*, Dublin, 1997

Raimbach, M.T.S., (ed.), *Memoirs and Recollections of Abraham Raimbach*, London, 1843

Rand, Benjamin, *Berkeley and Percival*, Cambridge, 1914

Randolph, Revd Herbert, *Life of General Sir Robert Wilson*, London, 1862

Rankin, Peter, *Irish Building Ventures of the Earl Bishop of Derry*, Belfast, 1972

Redgrave, Samuel, *A Dictionary of Artists of the English School…*, London, 1878

Reid, B.L., *The Man from New York, John Quinn and his Friends*, New York, 1968

Richardson, Ethel, *Long Forgotten Days*, London, 1928

Robinson, Elizabeth Muir, *W.A. Coulter: Marine Artist*, Sausalito, 1981

Robinson, Lennox, *Palette and Plough*, Dublin, 1948

Roettgen, Steffi, *Anton Raphael Mengs 1728–1779 and his British Patrons*, London, 1993

Rombouts, Ph., and Lerius, Th. Van, *De Liggeren en andere historische archiven der Antwerpsche sint Lucasgilde*, 2 vols, Amsterdam, (reprint) 1961

Rooney, Brendan, *The Life and Work of Harry Jones Thaddeus, 1859–1929*, Dublin, 2002

Rorimer, Anne, *Drawings by William Mulready*, Exhibition Catalogue, Victoria and Albert Museum, London, 1972

Rose, Mary Gaddis, *Jack B. Yeats, Painter and Poet*, Berne and Frankfurt, 1972

Rosenblum, Robert, *Transformation in late Eighteenth-Century Art*, Princeton, 1967

Rosenthal, T.G., *Yeats*, Bristol, 1966

Rossetti, William Michael, *Fine Arts Chiefly Contemporary: Notices Reprinted with Revisions*, London, 1867

Rowe, Rebecca, and Nugent, Charles, *Rose Barton, RWS, Exhibition of Watercolours and Drawings*, Exhibition Catalogue, Crawford Gallery, Cork; Fine Art Society, London; Ulster Museum, Belfast; Butler Gallery, Kilkenny, 1986

Ryan-Smolin, Wanda, *King's Inns Portraits*, Dublin 1992

Ryan-Smolin Wanda, Mayes, W., and Rogers, J., (eds), *Irish Women Artists from the Eighteenth Century to the Present Day*, Exhibition Catalogue, National Gallery of Ireland, Hugh Lane Municipal Gallery, Douglas Hyde Gallery, Dublin, 1987

Samuels, Arthur, *The Early Life, Correspondence and Writings of the Rt Hon. Edmund Burke, LlD*, Cambridge, 1923

Sandby, William, *The History of the Royal Academy of Arts*, 2 vols, London, 1862 (reprinted London, 1970)

Sarsfield-Taylor, W.B., *The Origin, Progress and Present Condition of the Fine Arts in Great Britain and Ireland*, 2 vols, London, 1841

A Catalogue of a collection of Modern Pictures and Drawings chiefly consisting of the Works and Property of Mr Serres Junior:…which will be sold by Auction by Mr Greenwood…on…22nd of April 1790…., London, 1790

Shee, Martin Archer, *The Life of Sir Martin Archer Shee*, 2 vols, London, 1860

Sheehy, Jeanne, *Walter Osborne*, Ballycotton, 1974

———, *The Discovery of Ireland's Past: The Celtic Revival, 1830–1930*, London, 1980

———, *Walter Osborne*, Exhibition Catalogue, National Gallery of Ireland, Dublin, 1983

Sherburn, George (ed.), *The Correspondence of Alexander Pope*, 5 vols, Oxford, 1956

Simms J.G. (P.H. Kelly, ed.), *William Molyneux of Dublin*, Dublin, 1982

Simon, Robin, *The Portrait in Britain and America*, Oxford, 1987

Singer, Samuel W. (ed.), *The Correspondence of Henry Hyde, Earl of Clarendon…*, 2 vols, London, 1828

Sleator, William (printer), *An Essay on perfecting the Fine Arts in Great Britain and Ireland*, Dublin, 1767

Sloan, Kim, *'A Noble Art': Amateur Artists and Drawing Masters circa 1600–1800*, London, 2000

Small, John (ed.), *John Derricke, Image of Ireland*, Edinburgh, 1883

Smith, Alistair, *Louis le Brocquy, Paintings 1939–1996*, Exhibition Catalogue, Irish Museum of Modern Art, Dublin, 1996

Smith, Charles, *The Antient and Present State of the County and City of Waterford*, Dublin, 1746

———, *The Antient and Present State of the County and City of Cork*, 2 vols, Dublin, 1750

———, *The Antient and Present State of the County of Kerry*, Dublin, 1756

Smith, John Thomas, *Nollekens and his Times*, 2 vols, London, 1829 (annotated edn. London, 1920)

Snoddy, Theo, *A Dictionary of Irish Artists in the Twentieth Century*, Dublin, 2001

Solkin, David H., *Richard Wilson, The Landscape of Reaction*, Exhibition Catalogue, Tate Gallery, London, 1982

———, *Painting for Money, The Visual Arts and the Public Sphere in Eighteenth-Century England*, New Haven and London, 1993

Snyder, Martin, P., *City of Independence, Views of Philadelphia before 1800*, New York, 1975

Somers, Lord (ed.), *A collection of scarce and valuable Tracts…*, 2nd edn., 13 vols, London, 1809

Sparrow, Walter Shaw, *John Lavery and his Work*, London, 1912

Spencer, Alfred (ed.), *Memoirs of William Hickey*, 4 vols, London, 1913–25

Sproule, John (ed.), *The Irish Industrial Exhibition of 1853*, Dublin, 1854

Stalley, Roger, *The Cistercian Monasteries of Ireland*, London and New Haven, 1987

Stanford, W.B., and Finopoulos, E.J., (eds), *The Travels of Lord Charlemont in Greece and Turkey, 1749*, London, 1985

Steegman, John, *The Artist and the Country House*, London, 1949

Stephen, Leslie, and Lee, Sidney (eds), *The Dictionary of National Biography*, 66 vols, London, 1885–1901, and sub. edns

Stevenson, Sara, and Thomson, Duncan, *John Michael Wright: The Kings Painter*, Exhibition Catalogue, Scottish National Portrait Gallery, Edinburgh, 1982

Steward, James Christen (ed.), *When Time Began to Rant and Rage: Figurative Paintings from Twentieth-Century Ireland*, Berkeley, 1998

Stewart, Ann M., *Royal Hibernian Academy of Arts: Index of Exhibitors, 1826–1979*, 3 vols, Dublin, 1985–7

———, *Irish Art Loan Exhibitions, 1765–1927*, Index of Artists, 3 vols, Dublin, 1990

———, *Irish Art Societies and Sketching Clubs 1870–1980*, 2 vols, Dublin, 1997

Stewart, Brian, and Cutler, Mervyn, *Chichester Artists*, Canterbury, 1987

Stewart, Brian, and Cutler, Mervyn, *The Dictionary of Portrait Painters in Britain up to 1920*, Woodbridge, 1997

Stockwell, La Tourette, *Dublin Theatres and Theatre Customs 1637–1820*, Kingsport, Tennessee, 1938

Stokes, William, *Life and Labours in Art and Archaeology of George Petrie*, London, 1868

Strickland, Walter G., *Dictionary of Irish Artists*, 2 vols, Dublin, 1913, reprinted 1989

———, *A Descriptive Catalogue of the Pictures, Busts and Statues in Trinity College Dublin...*, Dublin, 1916

Strong, Roy, *National Portrait Gallery: Tudor and Jacobean Portraits*, 2 vols, London, 1969

Strong, Roy, et al., *The British Portrait, 1660–1960*, Woodbridge, 1991

Sutton, Denys, *Walter Sickert*, London, 1976

Temple, A.G., *Catalogue of the Exhibition of Works by Irish Painters*, Art Gallery of the Corporation of London, Guildhall, London, 1904

Thackeray, William Makepeace, *The Irish Sketchbook*, London, 1842 (New Hampshire edn., 1985)

Thaddeus, H. Jones, *Recollections of a Court Painter*, London, 1912

Thompson, Elizabeth (Lady Butler), *An Autobiography*, London, 1922

Tinney, Donal (ed.), *Jack B. Yeats at the Niland Gallery, Sligo*, Sligo, 1998

Trevor, Helen M., *The ramblings of an artist: selections from the letters of H.M. Trevor to E.H.*, London, 1901

Tongue, Alan, *A Picture of Percy French*, Antrim, 1990

Turpin, John, *John Hogan, Irish Neo-Classical Sculptor in Rome, 1800–1858*, Dublin, 1982

———, *A School of Art in Dublin since the Eighteenth Century*, Dublin, 1995

Turpin, John, and Ormond, Richard, *Daniel Maclise, 1808–70*, Exhibition Catalogue, National Gallery of Ireland, and National Portrait Gallery London, 1972

Twiss, Richard, *A Tour in Ireland in 1775*, London, 1776

Tyler, Richard, *Francis Place, 1647–1728*, Exhibition Catalogue, York and Kenwood, London, 1971

Usherwood, Paul, and Spencer-Smith, Jenny, *Lady Butler, Battle Artist, 1846–1933*, Exhibition Catalogue, National Army Museum, London, 1987

Waagen, G.F., *Treasures of Art in Great Britain...*, 4 vols, London, 1854–7

Walker, Dorothy, *Modern Art in Ireland*, Dublin, 1997

Walker, Joseph Cooper, *Outlines of a Plan for Promoting the Art of Painting in Ireland: with a List of Subjects for Painters drawn from the Romantic and Genuine Histories of Ireland*, Dublin, 1790

Walker, Richard, *Regency Portraits*, 2 vols, National Portrait Gallery, London, 1985

Walker, Stella A., *Sporting Art, England 1700–1900*, London, 1972

Wallace, W.A., *John White, Thomas Harriot and Walter Raleigh in Ireland*, London, 1985

Walpole, Horace, *Anecdotes of Painting in England with some Account of the Principal Artists...*, 3 vols, Strawberry Hill, 1762–3 (ed. Ralph N. Wornum, London, 1888)

Walsh, Edward, *A Narrative of the Expedition to Holland, in the Autumn of the Year 1799: illustrated with a Map of North Holland and Seven Views of the Principal Places Occupied by British Forces*, London, 1800

Warburton, John, Whitelaw, J., and Walsh, R., *History of the City of Dublin*, 2 vols, London, 1818

Waterhouse, Ellis, *Painting in Britain*, London, 1953, (revised with an introduction by Michael Kitson, 1994)

———, *British Eighteenth Century Painters in Oils and Crayons*, Woodbridge, 1981

———, *The Dictionary of 16th and 17th Century British Painters*, Woodbridge, 1988

Webb, Daniel, *An Inquiry into the Beauties of Painting and into the merits of the most celebrated painters ancient and modern*, London, 1760

Webster, Mary, *Francis Wheatley*, London, 1970

Wedd, A.F., *The Fate of the Fenwicks, letters to Mary Hayes, 1798–1828*, London, 1927

Weston, Nancy, *Daniel Maclise, Irish Artist in Victorian London*, Dublin, 2001

White, James, *Evie Hone*, Exhibition Catalogue, Dublin, 1958

———, *John Butler Yeats and the Irish Renaissance*, Exhibition Catalogue, National Gallery of Ireland, Dublin, 1972

———, *William Orpen, 1878–1931, A Centenary Exhibition*, Exhibition Catalogue, National Gallery of Ireland, Dublin, 1978

———, *Séan Keating, PRHA, 1889–1977*, Exhibition Catalogue, Royal Hibernian Academy, Dublin, 1989

Whitley, William T., *Artists and their Friends in England, 1700–99*, 2 vols, London, 1928

Wilde, Sir William Robert W., *Memoirs of Gabriel Beranger and his Labours in the Cause of Irish Art and Antiquities from 1760–1780*, Dublin, 1880

Willemson, Gitta (ed.), *The Dublin Society Drawing School, Students and Award Winners 1746–1876*, Dublin, 2000

Willet, Ralph, *A Description of the Library at Merly*, London, [1785?]

Williams, Iolo, *Early English Watercolours....*, London, 1952

Williams, Harold (ed.), *The Correspondence of Jonathan Swift*, 5 vols, Oxford, 1963–5

Wilton, Andrew, *British Watercolours, 1750–1850*, Oxford, 1977

———, *The Swagger Portrait, Grand Manner Portraiture in Britain from Van Dyck to Augustus John, 1630–1930*, London, 1992

Winch, Vivien, *A Mirror for Mamma*, London, 1965

Wood, Christopher, *Dictionary of Victorian Painters*, Woodbridge, 1971

Wright, George, *An Historical Guide to Ancient and Modern Dublin*, London, 1821 (Dublin edn., 1980)

———, *Guide to the County of Wicklow*, London, 1823

Wright, Thomas, *Louthiana: or an Introduction to the Antiquities of Ireland*, London, 1748

Wynne, Michael, *National Gallery of Ireland, Catalogue of the Paintings*, Dublin, 1971

———, *National Gallery of Ireland, Catalogue of the Sculptures*, Dublin, 1975

———, *Thomas Roberts 1748–1778*, Exhibition Catalogue, National Gallery of Ireland, Dublin, 1978

———, *Fifty Irish Painters*, Dublin, 1983

Yacomini, Robert (ed.), *Keating and Ardnacrusha*, Exhibition Catalogue, University College, Cork, 2000

Yeats, William Butler, *Essays and Introductions*, London, 1961

Jack B. Yeats, 1871–1957, A Centenary Exhibition, National Gallery of Ireland, Dublin, 1971

Jack B. Yeats, the Late Paintings, Exhibition Catalogue, Arnolfini Gallery Bristol and elsewhere, 1991

ARTICLES

Adams, Ronald, 'Andrew Nicholl', *Irish Arts Review*, vol. 1, No. 4, 1984, pp. 29–34

Allan, David, 'The Progress of Human Culture and Knowledge', *The Connoisseur*, vol. CLXXXVI, No. 748, June 1974, pp. 100–9

Anderson, Robert, 'Whistler in Dublin', *Irish Arts Review*, vol. 3, No. 3, 1986, pp. 45–51

Andrews, Patricia, 'Jacob More and the Earl Bishop of Derry', *Apollo*, vol. CXXIV, No. 294, August 1986, pp. 88–94

Angelsea, Martyn, 'Five Unpublished Drawings by Francis Danby', *The Burlington Magazine*, vol. CCVII, No. 862, January 1975, pp. 47–8

———, 'Andrew Nicholl and his Patrons in Ireland and Ceylon', *Studies*, vol. 71, 1982, p. 134

———, 'Belfast's Surgeon Artist: Dr James Moore (1819–1883)', *Irish Arts Review Yearbook*, vol. 8, 1991–2, pp. 185–97

Angelsea, Martyn, and Preston, John, 'A Philosophical Landscape', *Art History*, vol. 3, No. 3, 1980, p. 252

Archer, Jean, 'Geological Artistry: the Drawings and Watercolours of George Victor du Noyer in the Geological Survey of Ireland', *Visualising Ireland*, (ed. Adele M. Dalsimer), Boston and London, 1993, pp. 133–44

Archer, Mildred, 'Wellington and South India, Portraits by Thomas Hickey', *Apollo*, vol. CII, No. 161, July 1975, pp. 30–5

'B', 'Biographical Sketch of Mr Cuming', *Walker's Hibernian Magazine*, June 1811, p. 330

'B', 'A Pilgrimage to Quilca in the year 1852, with some accounts of the old belongings of that place', *Dublin University Magazine*, vol. XL, No. CXXXIX, November 1852, pp. 509–26

Bailey, Christopher, 'Matthew James Lawless', *Irish Arts Review*, vol. 4, No. 2, 1987, pp. 20–4

Baldry, A.L., 'Our Rising Artists: St George Hare', *Magazine of Art*, 1899–1900, pp. 370–5

Barnard, Toby, 'Art, Architecture, Artefacts and Ascendancy', *Bullán*, vol. 1, No. 2, Autumn 1994, pp. 17–34

———, 'The World of a Galway Squire: Robert French of Monivea, 1716–1779', *Galway: History and, Society*, eds Gerard Moran and Raymond Gillespie, Dublin, 1996, pp. 271–96

Barret, Cyril, 'Michael Angelo Hayes, RHA and the Galloping Horse', *The Arts in Ireland*, vol. 1, No. 3, 1972–3, pp. 42–9

———, 'Irish Nationalism and Art', *Studies*, Winter 1975, pp. 393–409

———, 'Mainie Jellett and Irish Modernism', *Irish Arts Review Yearbook*, vol. 9, 1993, pp. 167–73

Barton, Ruth, '"Yeats Souvenirs": Clues to a Lost Portrait by W.B. Yeats', *Irish Arts Review Yearbook*, vol. 12, 1996, pp. 96–7

Beaufort, Daniel Augustus, 'Tour of Kerry', *Journal of the*

Kerry Archaeological and History Society, No 18, 1985, p. 193

Becker, Robert, 'George Moore – Artist and Critic', *Irish Arts Review*, vol. 2, No. 3, 1985, pp. 49–55

Berger, Pamela, 'The Historical, the Sacred, the Romantic: Medieval Texts into Irish Watercolours', *Visualising Ireland*, (ed., Adele M. Dalsimer) Boston and London, 1993, pp. 71–88

Beretti, Francis, 'The First Portraits of Pascal Paoli, Two British Artists, Henry Benbridge and John Trotter', *The British Art Journal*, vol. 2, No. 3, pp. 69–71

Bindman, David, 'Barry at the Tate', Exhibition Review, *The Burlington Magazine*, vol. CXXV, No. 961, April 1983, p. 241–2

Black, Eileen, 'James Glen Wilson (1827–1863), an Irish Artist in Australia', *Familia, Ulster Genealogical Review*, vol. 2, No. 3, 1987, pp. 37–46

———, 'James Glen Wilson', *Irish Arts Review Yearbook*, vol. 7, 1990–1, pp. 99–102

———, 'Practical Patriots and True Irishmen: The Royal Irish Art Union 1839–59', *Irish Arts Review Yearbook*, vol. 14, 1998, pp. 140–6

———, 'Scenes of Ulster Life: The Paintings and Drawings of William Conor', *Irish Arts Review Yearbook*, vol. 18, 2002, pp. 146–52

Bodkin, Thomas, 'James Barry', *Studies*, March 1922, pp. 83–96

———, 'Thomas Hickey', *Apollo*, vol. III, No. 14, 1926, pp. 96–102

Bottoms, Edward, 'Charles Jervas, Sir Robert Walpole and the Norfolk Whigs', *Apollo*, vol. CXLV, No. 420, Feb. 1997, pp. 44–8

Bourke, Marie, '"The Piping Boy" by Nathaniel Hone 1718–1784', *Sacred Heart Messenger*, August 1983, pp. 18–19

———, 'Frederick William Burton 1816–1900', *Eire: Ireland*, vol. XXVIII, No. 3, Autumn 1993, pp. 45–60

———, 'A Growing Sense of National Identity, Charles Lamb (1893–1964) and the West of Ireland', *History Ireland*, vol. 8, No. 1, Spring 2000, pp. 30–4

Bowe, Nicola Gordon, 'The Art of Beatrice Elvery, Lady Glenavy (1883–1970)', *Irish Arts Review Yearbook*, vol. 11, 1995, pp. 168–75

Boylan, Lena, 'The Conollys of Castletown: A Family History', *Bulletin of the Irish Georgian Society*, vol. XI, No. 4, October–December 1968, pp. 1–46

Breathnach-Lynch, Síghle, 'The Peasant at Work: Jack B. Yeats, Paul Henry and Life in the West of Ireland', *Irish Arts Review Yearbook*, vol. 13, 1997, pp. 143–51

Breeze, George, 'Thomas Hickey in Ireland', *Studies*, vol. LXXII, Summer 1983, pp. 156–69

Brooke-Tyrell, Alma, 'Mr Howis the Artist of Jervis Street 1804–1882', *Dublin Historical Record*, vol. XXXII, No. 1, 1978, pp. 27–38

Butler, Patricia, 'The Ingenious Mr Francis Place', *Irish Arts Review*, vol. 1, No. 4, 1984, pp. 38–40

Caffrey, Paul, 'Samuel Lover's Achievement as a Painter', *Irish Arts Review*, vol. 3, No. 1, 1986, pp. 51–4

———, 'Sampson Towgood Roch, Miniaturist', *Irish Arts Review*, vol. 3, No. 4, 1986, pp. 14–20

Cahill, Katharine, 'In the Mainstream of Irish Naturalism: The Art of Lilian Lucy Davidson', *Irish Arts Review Yearbook*, vol. 15, 1999, pp. 34–45

Campbell, Julian, 'Jour de Marché, Finistère', *Irish Arts Review*, vol. 3, No. 3, 1986, pp. 16–18

———, 'Thomas Hovenden, a Cork Artist in Brittany and America', *New Perspectives* (ed. Jane Fenlon, et al.), Dublin, 1987, pp. 187–93

———, 'A Forgotten Artist: Walter Chetwood-Aitken (1866–1899)', *Irish Arts Review Yearbook*, vol. 11, 1995, pp. 164–7

———, 'Nathaniel Hone's Paintings of Ancient Construction', *Irish Arts Review Yearbook*, vol. 8, 1991–2, pp. 80–6

———, 'Irish Painters in Paris 1868–1914', *Irish Arts Review Yearbook*, vol. 11, 1995, pp. 163–4

———, 'Aloysius O'Kelly in Brittany', *Irish Arts Review Yearbook*, vol. 12, 1996, pp. 80–4

———, 'A Double Identity, Aloysius O'Kelly and Arthur Oakley', *Irish Arts Review Yearbook*, vol. 16, 2000, pp. 81–5

———, 'Postcards from Brittany: Walter Osborne's Wallet of Photographs', *Irish Arts Review Yearbook*, vol. 17, 2001, pp. 150–5

Cappock, Margarita, 'Aloysius O'Kelly and the Illustrated London News', *Irish Arts Review Yearbook*, vol. 12, 1996, pp. 85–90

Casey, Christine, 'Miscellanea Structura Curiosa', *Irish Arts Review Yearbook*, vol. 7, 1990–1, pp. 85–91

'Cn', 'Gleanings on Old Cork Artists', *Journal of the Cork Historical and Archaeological Society*, vol. VI, 2nd series, 1900, pp. 104–11 and 174–81

Coleman, John, 'Evidence of the Collecting and Display of Paintings in Mid Eighteenth-century Ireland', *Irish Georgian Society*, vol. XXXVI, 1994, pp. 48–62

———, 'Sir Joshua Reynolds and Richard Robinson, Archbishop of Armagh', *Irish Arts Review Yearbook*, vol. 11, 1995, pp. 131–6

———, 'Luke Gardiner (1745–1798): An Irish Dilettante', *Irish Arts Review Yearbook*, vol. 15, 1999, pp. 160–8

———, 'A Lost Portrait of Lord Charlemont by Sir Joshua Reynolds', *Lord Charlemont and his Circle*, (ed. Michael McCarthy), Dublin, 2001, pp. 38–46

Cornforth, John, 'A Mill and its Master', *Country Life*, 28 December 1972, p. 1779

Cooper, Richard A., 'Genealogical Notes on the (Austin) Cooper Family in Ireland, 1660–1960', *The Irish Genealogist*, vol. 3, No. 9, October 1964, pp. 351–5

Crawford, W.H., 'The Patron or Festival of St Kevin at the Seven Churches, Glendalough', *Ulster Folk Life*, vol. 32, 1986, pp. 37–47

Crofts, Sinead, 'Maurice MacGonigal, PRHA and his Western Paintings', *Irish Arts Review Yearbook*, vol. 13, 1997, pp. 135–142

Crookshank, Anne, 'Portraits of Irish Houses', *Bulletin of the Irish Georgian Society*, vol. V, October–December 1962, pp. 41–9

———, 'Irish Artists and their Portraiture', *The Connoisseur*, vol. CLXXII, No. 694, December 1969, pp. 235–43

———, 'Early Landscape Painters in Ireland', *Country Life*, 22 August 1972, pp. 468–72

———, 'James Latham 1696–1747', *Irish Arts Review Yearbook*, vol. 5, 1988, pp. 56–72

———, 'Robert Hunter', *Irish Arts Review Yearbook*, vol. 6, 1989–90, pp. 169–85

———, 'The Conversation Piece in Irish Painting in the Eighteenth Century', *Decantations, A Tribute to Maurice Craig*, Dublin, 1992, pp. 16–20

———, 'A Life Devoted to Landscape Painting – William Ashford c. 1746–1824', *Irish Arts Review Yearbook*, vol. 11, 1995, pp. 119–30

Crookshank, Anne, and Glin, Knight of, 'Note on a Newly Discovered Landscape by Joseph Tudor', *Studies*, Autumn 1976, pp. 235–8

———, 'Some Italian Pastels by Hugh Douglas Hamilton', *Irish Arts Review Yearbook*, vol. 13, 1997, pp. 62–9

Cruickshank, J.G., 'Grace Henry', *Irish Arts Review Yearbook*, vol. 9, 1993, pp. 174–8

Cullen, Fintan, 'Hugh Douglas Hamilton in Rome 1779–1792', *Apollo*, vol. CXV, No. 240, February 1982, pp. 86–91

———, 'Hugh Douglas Hamilton: "Painter of the Heart"', *The Burlington Magazine*, vol. CXXV, No. 964, July 1983, pp. 417–21

———, 'The Oil Paintings of Hugh Douglas Hamilton', *Walpole Society*, vol. L, 1984, pp. 165–208

———, 'Hugh Douglas Hamilton's Letters to Canova', *Irish Arts Review*, vol. 1, No. 2, 1984, pp. 31–5

———, 'Lord Edward FitzGerald: the Creation of an Icon', *History Ireland*, vol. 6, No. 4, Winter 1998, pp. 17–20

———, 'Radicals and Revolutionaries: Portraits of the Late 1790s in Ireland', *Revolution, Counter Revolution and Union, Ireland in the 1790s*, (ed. Jim Smyth), Cambridge, 2000, pp. 161–94

Dalsimer, Adele M., 'The Irish Peasant had all his Heart', *Visualising Ireland*, (ed. Adele M. Dalsimer), Boston and London, 1993, pp. 201–30

D'Arcy, Fergus, 'A Horse called Flyer, a Problem in Irish Art History', *Journal of the Kildare Archaeological Society*, vol. XVIII, 1992–3, pp. 92–5

Davies, Marie, 'Beaufort's Visits to Downhill', *New Perspectives*, (ed. Jane Fenlon, et al.), Dublin, 1987, pp. 157–75

Davis, Graham, 'Social Decline and Slum Conditions: Irish Migrants in Bath's History', *Bath History*, vol. VIII, 2000, pp. 134–47

De Breffny, Brian, 'Robert Fagan, Artist', *The Irish Ancestor*, vol. III, No. 2, 1971, pp. 71–8

———, 'An Elizabethan Political Painting', *Irish Arts Review*, vol. 1, No. 1, 1984, pp. 39–41

———, 'Christopher Hewetson', *Irish Arts Review*, vol. 3, No. 3, 1986, pp. 52–75

Duncan, Ellen, 'The Irish National Portrait Collection', *The Burlington Magazine*, vol. XII, 1907, pp. 6–20

Einberg, Elizabeth, 'The Betts Family: a Lost Hogarth that Never Was and a Candidate for Slaughter', *The Burlington Magazine*, vol. CXXV, No. 964, July 1983, pp. 415–16

Ellwood, C.V., and Harvey, J.M.V., 'Lady Blake', *Bulletin of the British Museum Historical Series*, vol. 18, No. 2, November. 1990, pp. 145–202

Falkiner, Sir F.R., 'The Portraits of Swift', *The Prose Works of Jonathan Swift*, 12 vols, (ed. Temple Scott), London, 1897–1908

Fenlon, Jane, 'The Painters Stainers Companies of Dublin and London, Craftsmen and Artists, 1670–1740', *New Perspectives* (ed. Jane Fenlon, et al.), Dublin, 1987, pp. 101–8

———, Fenlon, Jane, 'John Michael Wright's Highland Laird Identified', *Burlington Magazine*, vol. CXXX, October 1988, pp. 767–9

———, 'French Influence in Late Seventeenth-Century Portraits', *Irish Arts Review Yearbook*, vol. 6, 1989–90, pp. 158–68

———, 'Garret Morphey and his Circle', *Irish Arts Review Yearbook*, vol. 8, 1991–2, pp. 135–48

———, 'The Talented and Idle Mr William Gandy in Ireland', *Irish Arts Review Yearbook*, vol. 12, 1996, pp. 131–8

———, 'The Duchess of Ormonde's House at Dunmore, County Kilkenny', *Kilkenny Studies*, published in honour of Margaret N. Phelan by the Kilkenny Archaeological Society, 1997, pp. 79–87

———, 'The Ormonde Picture Collection', *Irish Arts Review Yearbook*, vol. 16, 2000, pp. 143–9

———, 'Episodes of Magnificence…', *The Dukes of Ormonde, 1610–1745*, (Toby Barnard and Jane Fenlon eds), Woodbridge, 2000

———, 'More about the Portrait of Jonathan Swift when a Student at Trinity College, Dublin', *Swift Studies*, 2000, pp. 33–83

Ferran, Denise, 'W.J. Leech's Brittany', *Irish Arts Review Yearbook*, vol. 9, 1993, pp. 224–32

Ffolliot, Rosemary, 'Provincial Town Life in Munster',

The Irish Ancestor, vol. V, No. 1, 1973, pp. 37–52

———, 'Fashion as a Guide to Dating Irish Portraits, 1660–1880', *Irish Arts Review Yearbook*, vol. 6, 1989–90, pp. 214–32

Figgis, Nicola, 'Irish Artists and Society in Eighteenth-Century Rome', *Irish Arts Review*, vol. 3, No. 3, 1986, pp. 28–36

———, 'Irish Landscapists in Rome, 1750–1780', *Irish Arts Review*, vol. 4, No. 4, 1987, pp. 60–5

———, 'Irish Portrait and Subject Painters in Rome 1750–1800', *Irish Arts Review Yearbook*, vol. 5, 1988, pp. 125–36

———, 'The Roman Property of Frederick Augustus Hervey, 4th Earl of Bristol and Bishop of Derry, 1730–1803', *Walpole Society*, vol. LV, 1993, pp. 77–103

———, 'Henry Trench', *Irish Arts Review Yearbook*, vol. 10, 1994, pp. 217–22

Ford, Brinsley, 'The Letters of Jonathan Skelton…', *Walpole Society*, vol. XXXVI, 1956–8, pp. 23–82

Fraher, William, 'Charles Smith…', *Decies, The Journal of the Waterford Archaeological and Historical Society*, No. 53, 1997, pp. 41–4

Gardiner, Albert Ten Eyck, 'Ingham in Manhattan', *The Metropolitan Museum of Art Bulletin*, May 1952, pp. 245–53

Gibbons, Luke, '"A Shadowy Narrator": History, Art and Romantic Nationalism in Ireland, 1750–1850', *Ideology and the Historians*, (ed. Ciaran Brady), Dublin, 1991, pp. 99–127

Gillispie, France, 'Edith Somerville 1858–1949', *New Perspectives*, (ed. Jane Fenlon, et al.) Dublin, 1987, pp. 195–206

Gillespie, Raymond, 'Describing Dublin, Francis Place's Visit 1698–1699', *Visualising Ireland*, (ed. Adele M. Dalsimer), Boston and London, 1993, pp. 99–118

Gilmartin, John, 'Vincent Waldré's Ceiling Paintings in Dublin Castle', *Apollo*, vol. XCV, No. 119, January 1972, pp. 42–7

Glin, Knight of, 'Francis Bindon', *Bulletin of the Irish Georgian Society*, vol. X, Nos 2 and 3, April–September 1967, pp. 3–36

Hamlyn, Robin, 'An Irish Shakespeare Gallery', *The Burlington Magazine*, vol. CXX, No. 905, August 1978, pp. 515–29

Harbison, Peter, with a note by Michael Wynne, 'P. Burk[e]'s Painting of Youghal: the Earliest Known Signed Townscape by an Irish Artist', *Journal of the Cork Historical and Archaeological Society*, vol. LXXVIII, 1973, pp. 66–79

Harbison, Peter, '"Irish Artists on Irish Subjects": The Cooper Collection in the National Library', *Irish Arts Review Yearbook*, vol. 17, 2001, pp. 61–9

Hartigan, Marianne, 'Irish Women Painters and the Introduction of Modernism', *When Time Began to Rant and Rage, Figurative Painting from Twentieth-Century Ireland*, (ed. James C. Steward), Berkeley, 1998, pp. 63–77

Hayes, Michael Angelo, 'Delineation of Animals in Rapid Motion, a paper read before the Royal Dublin Society', Dublin, 1877

Hodge, Anne, 'The Practical and the Decorative, The Kildare Estate Maps of John Rocque', *Irish Arts Review Yearbook*, vol. 17, 2001, pp. 133–40

Horner, Arnold, 'Cartouches and Vignettes on the Kildare Estate Maps by John Rocque', *Irish Georgian Society*, vol. XIV, No. 4, October–December 1971, pp. 57–76

———, 'Carton, County Kildare', *Irish Georgian Society*, vol. XVIII, Nos 2 and 3, April–September 1975, pp. 45–104

Howat, John K., 'A Picturesque Site in the Catskills: the Cauterskill Falls as Painted by William Guy Wall',

Honolulu Academy of Arts Journal, vol. 1, 1974, pp. 16–29

Hughes, Peter, 'Paul Sandby and Sir Watkin Williams Wynn', *The Burlington Magazine*, vol. CXIV, No. 832, July 1972, pp. 459–66

Igoe, Vivien and O'Dwyer, Frederick, 'Early Views of the Royal Hospital Kilmainham', *Irish Arts Review Yearbook*, vol. 5, 1988, pp. 78–88

Irwin, David, 'James Barry and the Death of Wolfe in 1759', *The Art Bulletin*, vol. XLI, 1959, pp. 330–2

Jenkins, Ian, 'Adam Buck and the Vogue for Greek Vases', *The Burlington Magazine*, vol. CXXX, No. 1023, June 1988, pp. 448–57

Johnston, Roy, 'Roderic O'Conor in Brittany', *Irish Arts Review*, vol. 1, No. 1, 1984, pp. 16–17

———, 'Roderic O'Conor – the Elusive Personality', *Irish Arts Review*, vol. 2, No. 4, 1985, pp. 31–40

Jope-Slade, R., '"The Outsiders" some Eminent Artists of the Day not Members of the Royal Academy', *Black and White, Handbook to the RA and New Gallery Exhibitions*, London, 1893

Keating, Justin, 'Sean Keating at Ardnacrusha', *Tracings*, vol. 1, Spring 2000, pp. 52–63,

Keller, Ann, 'The Long Gallery of Castletown House', *Bulletin of the Irish Georgian Society*, vol. XXII, 1979, pp. 1–53

Kelly, James, 'Francis Wheatley, His Irish Paintings, 1779–1783', *Visualising Ireland*, (ed. Adele M. Dalsimer), Boston and London, 1993, pp. 145–54

Kennedy, Brian P., 'The Oil Painting Technique of Jack B. Yeats', *Irish Arts Review Yearbook*, vol. 9, 1993, pp. 115–23

Kreilkamp, Vera, 'Going to the Levée as Ascendancy Spectacle…', *Visualising Ireland* (ed. Adele M. Dalsimer), Boston and London, 1993, pp. 37–54

Laffan, William, '"Taste, Elegance and Execution" John Lewis as a Landscape Painter', *Irish Arts Review Yearbook*, vol. 15, 1999, pp. 151–3

———, 'Through Ancestral Patterns Dance: The Irish Portraits at Newbridge House', *Clerics and Connoisseurs, An Irish Art Collection through Three Centuries*, (ed. Alastair Laing), London, 2001, pp. 80–6

Laing, Alastair, 'Sir Roland and Lady Winn; a Conversation Piece in the Library at Nostell Priory', *Apollo*, vol. CLI, No. 458, April 2000, pp. 14–18

Leask, Ada, 'Samuel Dixon', *Irish Georgian Society*, vol. XVIII, No. 4, October–December 1975, pp. 109–36 and vol. XXIII, Nos 1 and 2, January–June 1980, pp. 1–32

Ledbetter, Gordon T., 'Alexander Williams 1846–1930: Sidelights on a Victorian Painter', *The Irish Ancestor*, No. 2, 1975, pp. 83–90

Lightbown, Ronald, '18th and 19th Century Visitors – Part II', *Old Kilkenny Review*, Second series, vol. 3, No. 2, 1985, pp. 161–73

Lillis, Marguerite, 'A Roman Landscape Painter in Ireland', *Apollo*, vol. CXV, No. 240, February 1982, pp. 114–15

Litvack, Leon, 'Exhibiting Ireland 1851–53; Colonial Mimicry in London, Cork and Dublin', *Ireland in the Nineteenth Century, Regional Identity* (eds. Glen Hooper and Leon Litvack, Dublin, 2000, pp. 15–57

Loeber, Rolf, 'An Unpublished View of Dublin in 1698 by Francis Place', *Irish Georgian Society*, vol. XXI, Nos 1 and 2, January–June 1978, pp. 7–15

Loughman, John, '"One of the Finest Pieces Rembrandt ever Painted" Charlemont's Collecting of Netherlandish Paintings', *Lord Charlemont and his Circle* (ed. Michael McCarthy), Dublin, 2001, pp. 103–11

Lowe, N.F., 'James Barry, Mary Wollstonecraft and 1798', *Eighteenth Century Ireland*, vol. 12, 1997, pp. 60–75

McConkey, Kenneth, 'The White City – Sir John Lavery in Tangier', *Irish Arts Review Yearbook*, vol. 6, 1989–90, pp. 55–62

MacCurtain, Margaret, 'The Real Molly Macree', *Visualising Ireland*, (ed. Adele M. Dalsimer), Boston and London, 1993, pp. 9–22

McDonnell, Hector, 'Seventeenth Century Inventory from Dunluce Castle, County Antrim', *Journal of the Royal Society of Antiquarians of Ireland*, vol. 122, 1992, pp. 109–27

McDonnell, Joseph, 'Joseph Straffan: a Connoisseur of Italian Renaissance Painting', *Lord Charlemont and his Circle*, (ed. Michael McCarthy), Dublin, 2001, pp. 77–90

McEnroy, Marrion, '"Joannes Clericus": the Life and Work of the Revd John Rooney', *Irish Arts Review Yearbook*, vol. 17, 2001, pp. 122–6

McEvansoneya, Philip, 'Daniel Maclise and a Bankrupt Patron', *Irish Arts Review Yearbook*, vol. 12, 1996, pp. 126–30

———, 'An Irish Artist Goes to Bath: Letters from John Warren to Andrew Caldwell, 1776–1784', *Irish Architectural and Decorative Studies, The Journal of the Irish Georgian Society*, vol. II, 1999, pp. 146–73

McEvansoneya, Philip, 'A Colourful Spectacle Restored: The State Coach of the Lord Mayor of Dublin', *Irish Arts Review Yearbook*, vol. 17, 2001, pp. 80–87

Macreevy, Thomas, 'Picasso, Mainie Jellett and Dublin Criticism', *Klaxon*, 1923–4, pp. 23–7

McGuire, Edward A., 'Pastel Portrait Painting in Ireland in the XVIII Century', *The Connoisseur*, vol. 103, January 1939, pp. 12–13

McParland, Edward, 'A Note on Vincent Waldré', *Apollo*, vol. XCV, 1972, p. 467

———, 'Emo Court, Co. Leix', *Country Life*, 23 May 1974

Maguire, Hugh, 'A James Gandon, Discovery', *Irish Arts Review Yearbook*, vol. 11, 1995, pp. 138–9

Mallalieu, H.L., 'Francis Nicholson', *Watercolours and Drawings*, vol. IV, No 3, Summer 1989, pp. 15–18

Merrill Mount, Charles, 'The Irish Career of Gilbert Stuart', *Bulletin of the Irish Georgian Society*, vol. VI, No. 1, January–March 1963, pp. 5–23

Montagu-Smith, Patrick, 'The Dexters of Dublin and Annfield, Co. Kildare', *The Irish Ancestor*, vol. II, No. 1, 1970, p. 342

Morgan, Hiram, 'Tom Lee: the Posing Peacemaker', *Representing Ireland: Literature and the Origins of Conflict, 1534–1660* (ed. B. Bradshaw, et al.), Cambridge, 1993, pp. 132–65

Morrison, Kristin, 'Ancient Rubbish and Interior Spaces: M.A. Butler and M.J. Farrell, Discovered', *Visualising Ireland*, (ed. Adele M. Dalsimer), Boston and London, 1993, pp. 23–36

Mulcahy, Rosemarie, 'Patrick Tuohy 1894–1930', *Irish Arts Review Yearbook*, vol. 6, 1989–90, pp. 107–18

Mulvany, Thomas James, 'Memoirs of Native Artists, No. 1, Mr Francis West', *The Citizen*, No. XXIV. October 1841, p. 206

———, 'Memoirs of Native Artists, Hugh Douglas Hamilton', *Dublin Monthly Magazine*, January–June 1842, p. 65–78

Murray, Peter, 'Artist and Artisan: James Brennan as Art Educator', *America's Eye: Irish Paintings from the Collection of Brian P. Burns*, (eds Adele M. Dalsimer, and Vera Kreilkamp), Boston, 1996, pp. 40–6, Exhibition Catalogue, Boston College Museum of Art, Boston, 1996

Netzer, Nancy, 'Picturing an Exhibition: James Mahoney's Watercolours of the Irish Industrial Exhibition of 1853', *Visualising Ireland*, (ed. Adele M. Dalsimer), Boston and London, 1993, pp. 89–98

Newman, John, 'Reynolds and Hone "The Conjuror Unmasked"', Reynolds, Exhibition Catalogue (ed.

Nicholas Penny), Royal Academy, London, 1986, pp. 344–54

Nicholl, Andrew, 'A Sketching Tour of Five Weeks in the Forests of Ceylon – its Ruined Temples, Colonial Statues, Tanks, Dagobaths etc', *Dublin University Magazine*, November and December 1852, pp. 527–40 and 691–700

O'Connell, Sheila, 'Lord Shaftsbury in Naples 1711–1713', *Walpole Society*, vol. 54, 1988, (published 1991), p. 162

O'Connor, Andrew, 'James Latham: Two Portraits', *The Burlington Magazine*, vol. CXVI, No. 852, March 1974, pp. 154–7

———, 'John Lewis, A Smock Alley Scene Painter', *Studies*, Spring 1977, pp. 51–9

O'Connor, Cynthia, 'The Dispersal of the Country House Collections of Ireland', *Bulletin of the Irish Georgian Society*, vol. XXXV, 1992–3, pp. 38–47

O'Dalaigh, Brian, 'A Comparative Study of the Wills of the 1st and 4th Earls of Thomond', *North Munster Antiquarian Journal*, vol. XXIV, 1992, pp. 48–57

O'Farrell, Fergus, 'Daniel O'Connell, the "Liberator" 1775–1847; Changing Images', *Ireland Art into History*, (eds Raymond Gillespie and Brian P. Kennedy), Dublin, 1994

O'Neill, Kevin, 'Looking at the Pictures: Art and Artfulness in Colonial Ireland', *Visualising Ireland* (ed. Adele M. Dalsimer), Boston and London, 1993, pp. 55–70

Ormond, Richard, 'Helen Faucit', *Country Life*, 7 December 1976, p. 1507

O'Sullivan, Niamh, 'Painters and Illustrators: Aloysius O'Kelly and Vincent van Gogh', *Irish Arts Review Yearbook*, vol. 14, 1998, pp. 134–9

P.M. and F.O.'K, 'The Assembly House, South William Street', *Dublin Historical Record*, vol. 1, No, 1, 1938–9, pp. 28–32

Paca, Barbara, 'Miscellanea Structura Curiosa…', *The Journal of the Garden History Society*, October 1996, pp. 1–10

De Paor, Maire, 'Irish Antiquarian Artists', *Visualising Ireland*, (ed. Adele M. Dalsimer), Boston and London, 1993, pp. 119–32

'Memoir of the Rev. William Peters LLB', *Walker's Hibernian Magazine*, November 1794

Petrie, George, 'Ecclesiastical Architecture of Ireland Anterior to the Anglo-Norman Invasion', *Transactions of the Royal Irish Academy*, vol. XX, 1845

Potterton, Homan, 'Rev. Mathew William Peters, R.A.', *Hibernia*, 3 August 1972, p. 17

———, 'A Director with Discrimination – Sir Frederic Burton in the National Gallery', *Country Life*, vol. CIV, 9 May 1974, pp. 1140–1

———, 'A Commonplace Practitioner in Paintings and Etching: Charles Exshaw', *The Connoisseur*, vol. CLXXXVII, No. 754, Dec. 1974, pp. 268–73

———, 'Jack B. Yeats and John Quinn', *Irish Arts Review Yearbook*, vol. 9, 1993, pp. 102–14

———, 'Aloysius O'Kelly in America', *Irish Arts Review Yearbook*, vol. 12, 1996, pp. 91–5

Pressly, William L., 'James Barry's The Baptism of the King of Cashel by St Patrick', *The Burlington Magazine*, vol. CXVIII, No. 882, Sept. 1976, pp. 643–6

———, 'The Reappearance of a Portrait by James Barry, "D. Solly" and "Thought's Exchange"', *The British Art Journal*, vol. 1, No. 2, Spring 2000, pp. 62–6

Pyle, Hilary, 'Nathaniel Hone 1718–1784; an Eighteenth-Century Irish Artist', *The Arts in Ireland*, vol. 1, No. 3, 1973, pp. 54–64

———, 'Clare Marsh Remembered', *Irish Arts Review Yearbook*, vol. 5, 1988, pp. 89–92

———, '"Handcuffs Off"', Jack B. Yeats and other Painters', *Eire-Ireland, The Journal of Irish Studies*, vol. XXVII, No. 4, 1992, pp. 69–77

———, 'The Hamwood Ladies: Letitia and Eva Hamilton', *Irish Arts Review Yearbook*, vol. 13, 1997, pp. 122–34

Raferty, P.J., 'The Brocas Family, Notable Dublin Artists', *Dublin Historical Record*, vol. XVII, No. 1, December 1961, pp. 25–34

Rooney, Brendan, 'Henry Jones Thaddeus: An Irish Artist in Italy', *Irish Arts Review Yearbook*, vol. 15, 1999, pp. 126–33

Ross, Ruth Isobel, 'Phillips' Pleasing Prospects', *Country Life*, 4 March 1976, pp. 553

Ryan-Smolin, Wanda, 'The Portraits of Kings Inns', *Irish Arts Review Yearbook*, vol. 8, 1991–2, pp. 109–13

———, 'Leo Whelan 1892–1956', *Irish Arts Review Yearbook*, vol. 10, 1994, pp. 227–34

———, 'William Sadler's Views of Killua Castle, Co. Westmeath', *Irish Arts Review Yearbook*, vol. 12, 1996, pp. 66–70

Saris, A. Jamie, 'Imagining Ireland in the Great Exhibition of 1853', *Ireland in the Nineteenth Century, Regional Identity* (eds Glen Hooper and Leon Litvack), Dublin, 2000, pp. 66–86

Sheehy, Jeanne, 'The Irish at Antwerp', *Irish Arts Review Yearbook*, vol. 10, 1994, pp. 163–6

Simmons, Linda Crocker, 'Politics, Portraits and Charles Peale Polk', *The Peale Family* (ed. Lillian B. Miller), Washington, 1996

Strattan-Ryan, Mary, 'Augustus Nicholas Burke, RHA', *Irish Arts Review Yearbook*, vol. 7, 1990–1, pp. 103–110

Starkey, David, 'Holbein's Irish Sitter?', *The Burlington Magazine*, vol. CXXIII, No. 938, May 1981, pp. 300–3

Sutton, Denys, 'The Heroic Energy of Cuchulain', *Apollo*, vol. LXXXIV, No. 56, October, 1966, pp. 256–59

Thorpe, W.A., 'The Art of the Paper-Cutter', *Country Life*, 10 July 1943, pp. 194–6

Trench, C.E.F., 'William Burton Conyngham (1733–1796)', *Journal of the Royal Society of Antiquaries of Ireland*, vol. 115, 1985, pp. 40–61

Trevelyan, Raleigh, 'Robert Fagan, an Irish Bohemian in Italy', *Apollo*, vol. XCVI, No. 128, Oct. 1972, pp. 298–311

Turpin, John, 'The Dublin School of Landscape and Ornament, 1800–1854', *Irish Arts Review*, vol. 3, No. 2, Summer 1986, pp. 45–52

———, 'The School of Ornament of the Dublin Society in the 18th Century', *Journal of the Royal Society of Antiquaries of Ireland*, vol. 116, 1986, pp. 38–50

———, 'Continental Influences in 18th Century Ireland', *Irish Arts Review*, vol. 4, No. 4, 1987, pp. 50–7

———, 'French Influence on Eighteenth Century Art Education in Dublin', *Eighteenth-Century Ireland*, vol. 5, 1990, pp. 105–16

———, 'The Royal Hibernian Academy Schools: The First Eighty Years (1826–1906)', *Irish Arts Review Yearbook*, vol. 8, 1991–2, pp. 198–209

———, 'Irish Art and Design Education from the Eighteenth Century to the Present', *Irish Arts Review Yearbook*, vol. 10, 1994, pp. 209–16

———, 'The Education of Irish Artists 1877–1975', *Irish Arts Review Yearbook*, vol. 13, 1997, pp. 188–93

Usherwood, Paul, 'Lady Butler's Irish Pictures', *Irish Arts Review*, vol. 4, No. 4, 1987, pp. 47–9

Vertue, George, 'Notebooks', *Walpole Society*, vol. XVIII, 1929–30; vol. XX, 1931–2; vol. XXII, 1933–4: vol. XXIV, 1935–6; vol. XXVI, 1937–8; vol. XXX, 1951–2

Vigne, Randolph, 'The Eustaces and Hardys A Carlow Background to two Chinnery Portraits', *Carloviana*,

The Journal of the Old Carlow Society, New Series, vol. 2, no. 25, pp. 32–3

Waldron, Ethna, 'Joseph Malachy Kavanagh', *The Capuchin Annual*, 1968, pp. 314–25

Walker, J.C., 'A Short Account of the Origin and Progress of the Drawing School of the Dublin Society until the Year 1790', *Transactions of the Dublin Society*, vol. 3, 1803, p. 133

Wark, Robert R., 'A Note on James Barry and Edmund Burke', *The Journal of the Warburg and Courtauld Institutes*, vol. XVII, 1954, pp. 382–4

———, 'The Iconography and Date of James Barry's Self-Portrait in Dublin, *The Burlington Magazine*, vol. XCVI, No. 614, May 1954, pp. 153–4

Webster, Mary, 'John Astley, Artist and Beau', *The Connoisseur*, vol. CLXXII, No. 694, Dec. 1969, pp. 256–61

Webster, Mary, 'Wheatley's Lord and Lady Antrim', *Irish Arts Review*, vol. 1, No. 1, 1984, pp. 42–5

Weld, Isaac, 'Report of the First Public Distribution of Premiums', *Proceedings*, vol. LXXXI, Dublin, 1843

Westropp, T.J., 'Clare Island Survey…', *Proceedings of the Royal Irish Academy*, 31 Section 1, 1911, pp. 31–7

White, James, 'AE's Museum Square Murals and other Paintings', *Arts in Ireland*, vol. 1, No. 3, 1973, pp. 4–11 and 45–52

———, 'Tilly Kettle and William Cuming's, Portrait of James Gandon, Architect', *Bulletin of the Irish Georgian Society*, vol. IX, No.1, January–March 1966, pp. 27–31

Wind, Edgar, 'Shaftesbury as a Patron of the Arts', *Journal of the Warburg and Courtauld Institutes*, vol. 2, 1938–9, pp. 185–8

Wright, Christopher, 'Un Opera de Hugh Douglas Hamilton', *Arte Illustrata*, vol. LIII, 1973, pp. 147–8

Wynne, Michael, 'Curragh Chase by Jeremiah Hodges Mulcahy', *Quarterly Bulletin of the Irish Georgian Society*, vol. X, 1967, pp. 27–9

———, 'Tilly Kettle's Last Painting?', *The Burlington Magazine*, vol. CIX, No. 774, September 1967, pp. 532–3

———, 'Hugh Howard, Irish Portrait Painter', *Apollo*, vol. XC, No. 92, October 1969, pp. 314–17

———, 'Thomas Frye *c.* 1710–1762', *The Burlington Magazine*, vol. CXIV, No. 827, February 1972, pp. 78–85

———, 'James Hore, Active, 1829–1837, *Studies*, Spring 1976, pp. 46–51

———, 'An Influence on Robert Healy', *The Burlington Magazine*, vol. CXVIII, No. 879, June 1976, p. 413

———, 'Thomas Roberts, 1748–1778'; some Reflections on the Bicentenary of his Death', *Studies*, Winter 1977, pp. 299–308

———, 'Lord Charlemont's Album', *Bulletin of the Irish Georgian Society*, vol. 21, Nos 1–2, January–June 1978, pp. 1–4

———, 'Elegant Travellers from Fermanagh', *Irish Arts Review*, vol. 1, No. 3, 1984, pp. 44–6

———, 'James Hore, Gentleman View Painter', *Irish Arts Review*, vol. 2, No. 1, 1985, pp. 38–42

———, 'Members from Great Britain and Ireland of the Florentine Accademia del Disegno 1700–1825', *The Burlington Magazine*, vol. CXXXII, No. 1049, August 1990, pp. 535–8

———, 'Continental European Sources for George Barret', *Irish Arts Review Yearbook*, vol. 10, 1994, pp. 136–9

———, 'Thomas Roberts, 1748–1778', *Irish Arts Review Yearbook*, vol. 10, 1994, pp. 143–52

———, 'Frederick Prussia Plowman: A Dublin Painter of the Late Eighteenth Century', *Irish Arts Review Yearbook*, vol. 17, 2001, pp. 34–6

MANUSCRIPTS AND THESES

Unknown Diarist, Royal Irish Academy, ms 24K 14/15, 2 Cols, 1801–3,

Armstrong Duffy, Shirley, *Late Nineteenth-Century Sketching Clubs*, B.A. thesis, Trinity College, Dublin, 1984,

Beaufort, Louisa, *Scraps to Amuse by dear Admiral from LCB*, 1857, Trinity College, Dublin, ms. 8264,

Breeze, George, *Thomas Hickey 1741–1824*, M.A. thesis, University of Birmingham, 1973

Brennan Holohan, Mary, *Sarah Purser*, B.A. thesis, Trinity College, Dublin, 1989,

Casey, Christine, *Books and Builders...*, PhD thesis, Trinity College, Dublin, 1991

Conolly Papers, Trinity College, Dublin

The City of Cork, how it may be improved, leaflet of a lecture by Robert Walker, 1883, University College, Cork, q-1 MP 72,

Craig, Mia, *The Van der Hagen Problem in the British Isles*, B.A. dissertation, Trinity College, Dublin, 1992

Dineley, Thomas, *Observations made on his tour in Ireland and France*, 1675–80, National Library of Ireland, ms. 392

Dufferin and Ava, Marquess of, Typescript Diary, 1839, The Dufferin Foundation, Clandeboye

Granard Papers, Public Records Office of Northern Ireland, J/9/1/24,

Hamilton, Alexander, *Manuscript diaries of A.H., 1793 – 1807*, Hamwood Colletion

Harding, George, *Two Tours of Ireland in the Years 1792–1793*, Lough Fea, Shirley Papers

Hayward, Richard, *Ms. List of British Artists in Rome, 1753–75*, British Museum, Print Room

Hunt, Sir Vere, *Journals*, Mid-Western Archives, The Granary, Limerick

Johnston, Roy, *Roderic O'Conor*, B.A. thesis, Trinity College, Dublin

Kilruddery mss., The Earl of Meath

A List of the Descendants of Mary Sautell and John Roberts by Miss Margaret Price, National Archive, Dublin, ms. 4974

Loeber, Rolf (ed.), *An Alphabetical List of Artists worked in Dublin During the Seventeenth and Eighteenth Centuries*, typescript, Kingston, Ontario, 1973

McCarthy, Michael, *Beyond the Grand Tour*, Anglo Irish Travellers to Greece and the Levant 1740–1750, Lecture given in Toronto University, 1992

MacFarlane, Jane, *Sir Frederick William Burton, RHA, (1816–1900): His Life and Work*, B.A. thesis, Trinity College, Dublin, 1976

Millar, Oliver, *The Pictures at Malahide Castle*, unpublished typescript *c.* 1976

Murray, Peter, *George Petrie*, M.Litt. thesis, Trinity College, Dublin, 1980

Poor Book, St Michan's 1723–34, Representative Church Body Library, P. 276/8.1

Robertson, James George, *Album of Kilkenny Material*, Royal Society of Antiquaries of Ireland

Roden Papers, Public Records Office of Northern Ireland, Microfilm 147

Stato delle Anime, For S. Andrea delle Fratte, Archivio del Vicario, Vatican Library

Stokes, Margaret, *Notes for Biography of Burton*, National Gallery of Ireland Archives

Whitley Papers, British Museum Print Room

Wicklow Papers, National Library of Ireland Archives

Williams, Alexander, *Ms Autobiography*, Private Collection

Index

Page references in *italics* indicate illustrations. Works are listed under artist and subject.

Photographic Credits

James Adam & Son 405; Adirondack Museum, New York 240; Albright Knox Art Gallery, Buffalo, New York, Gift of Seymour H. Knox Jr, 1945.21, 77; Robert Allen 315; Annaghmarkerrig House, Co. Monaghan 314; Art Gallery of South Australia, Adelaide 284; Ashmolean Museum, Oxford 178; Ballymaloe Hotel 30; Bath Preservation Trust 22; Brian Burns Collection 335, 341, 360, 362, 366, 379; Bristol City Museum and Art Gallery 300; British Museum, London 157; Patrick Brown 251; Bryn Mawr College Collections, Gift of Mary K. Woodworth 113; The University of Buffalo N.Y., University Libraries, Poetry/Rare Books Collection 390; Dr Julian Campbell 363; Marquis of Cholomondley, Houghton Hall 380; Christie's Images Limited 19, 42, 46, 55, 65, 78, 95, 108, 126, 131, 134, 168, 169, 176, 181, 257, 263, 307, 325, 328, 332, 334, 346, 351, 368, 371, 376, 383; Cleveland Museum of Art 211; Cobbe Foundation 81; A.C. Cooper 119; Cotswold Studio 43; Photographic Survey, Courtauld Institute of Art, London 7, 9, 17, 27, 32, 33, 39, 41, 51, 53, 62, 63, 64, 66, 75, 87, 102, 103, 107, 116, 117, 118, 123, 124, 128, 136, 170, 172, 186, 191, 193, 194, 204, 205, 206, 212, 214, 220, 223, 225, 230, 231, 236, 238, 246, 248, 255, 256, 261, 264, 268, 271, 273, 274, 287, 356; Crawford Municipal Art Gallery, Cork (Peter Murray) 86, 153, 165, 197, 292, 298, 308, 309, 320, 367, 369, 375, 413; Simon Dickinson Ltd. 151, 183, 213; Dromoland Castle Hotel 35; Dublin Corporation 237; Dúchas, The Heritage Service 177, 224, 227; E.S.B. 190, 386; Dr Jane Fenlon 28; Fitzwilliam Museum, University of Cambridge 152; Gavin Frankel 229, 232, 349; Frederick Art Gallery 352, 353, 364, 365, 385, 388, 394, 397, 406; Frick Art Reference Library 6; Frick Collection, New York 73; Christopher Gibbs 250; Gorry Gallery, Dublin 163, 269, 272, 278, 286, 291, 319, 331, 340, 343, 401, 407; George Gossip 228; Graves Art Gallery, Sheffield 158; Richard Green Fine Paintings 57, 58, 106, 377; Martyn Gregory 289; Guildhall Art Gallery, Corporation of London 347; Harris Museum, Preston 301; Jonathan Harsch 110, 121, 201, 270, 317, 372; Historical Portraits, Philip Mould 99, 111, 144; Honolulu Academy of Arts 279; Hugh Lane Municipal Gallery of Modern Art, Dublin 344, 389, 399, 400, 404, 414; Hunt Museum, Limerick 150, 219; Huntington Museum and Art Gallery 149; Paul and Christopher Johnson 294; S.B. Kennedy 410, 417; Lane Fine Arts, Christopher Foley 109, 135, 166; Leeds Museums and Galleries (Lotherton Hall) 208; Lispopple Custom Photography Ltd 305; Mallet & Co. 173; The Maas Gallery, London 313; Metropolitan Museum of Art, New York, 239; National Archives of Canada 282; National Galleries of Scotland 127; National Gallery of Art, Washington 80, 141; National Gallery of Ireland, Dublin 4, 10, 24, 34, 38, 45, 79, 85, 94, 112, 125, 132, 140, 147, 161, 187, 198, 202, 209, 244, 245, 267, 290, 295, 310, 323, 324, 327, 329, 333, 336, 339, 348, 355, 361, 408, 423, 425; National Gallery, London 241; National Gallery of Victoria, Melbourne 171, 337; National Library of Ireland, Dublin 15, 84; National Maritime Museum, London, 26; National Portrait Gallery, London 114, 133, 160, 321; National Trust 130, 207, 312, 137 & 338 (John Hammond), 138 (Angelo Hornak); National Trust for Northern Ireland Half title page (i), 59, 60, 61 (Bill Portee); The Nelson-Atkins Museum of Art, Kansas City, Missouri (Purchase: Nelson Trust) 373; Sydney Newberry 65; Niland Gallery, Sligo 398; OPW/Dublin Castle 148, 258; Phillips Fine Art Auctioneers 374; Pym's Gallery, London endpapers, 56, 92, 104, 174, 175, 185, 192, 221, 254, 288, 311, 322, 345, 350, 359, 370, 381, 382, 384, 387, 396, 402, 403, 409, 415, 420, 421; The Reform Club 303; The Royal Academy, London 146; The Royal Collection, Her Majesty Queen Elizabeth II 3, 11; Royal Dublin Society 159, 167, 215, 226, 249; Royal Society of Arts, London 155, 156; Marquess of Salisbury, Hatfield House 13; John Searle 52, 164, 180, 222, 260, 306; Sotheby's: 20, 47, 48, 49, 98, 105, 122, 199, 200, 242, 243, 293, 342, 411; Spink Leger Gallery 54; Professor Roger Stalley 1, 2; Tasmanian Museum and Art Gallery 283; Tate Britain, London 5, 25, 326; Trinity College Dublin 29, 67, 68, 69, 70, 71, 76, 90, 100, 129, 210, 216, 234, 259, 262, 296, 318, 395; Tryon Palace, New Bern, N.C. 189; Ulster Museum, Belfast 12, 21, 23, 96, 101, 162, 203, 218, 235, 252, 266, 276, 285, 354, 358, 378, 409, 416, 419; University College Dublin 44; University College Dublin, Department of Irish Folklore 253, 275, 357; University of Limerick 304; Vance Jordan Fine Art 281; Victoria & Albert Museum, London 142; Victoria Art Gallery, Bath and North East Somerset Council 154; Walker City Art Gallery, Liverpool 330; The Walters Art Museum, Baltimore 82, 83; Waterford Treasures Exhibition 89; Weston Park 18; Christopher Wood Ltd 316; Yale Center for British Art, New Haven 115, 247 (Richard Caspole), 299, 302

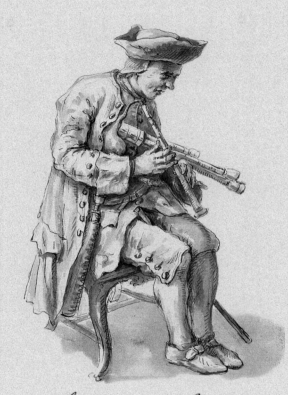

Blind Daniel the Piper